IN SEARCH OF
A MASTERPIECE

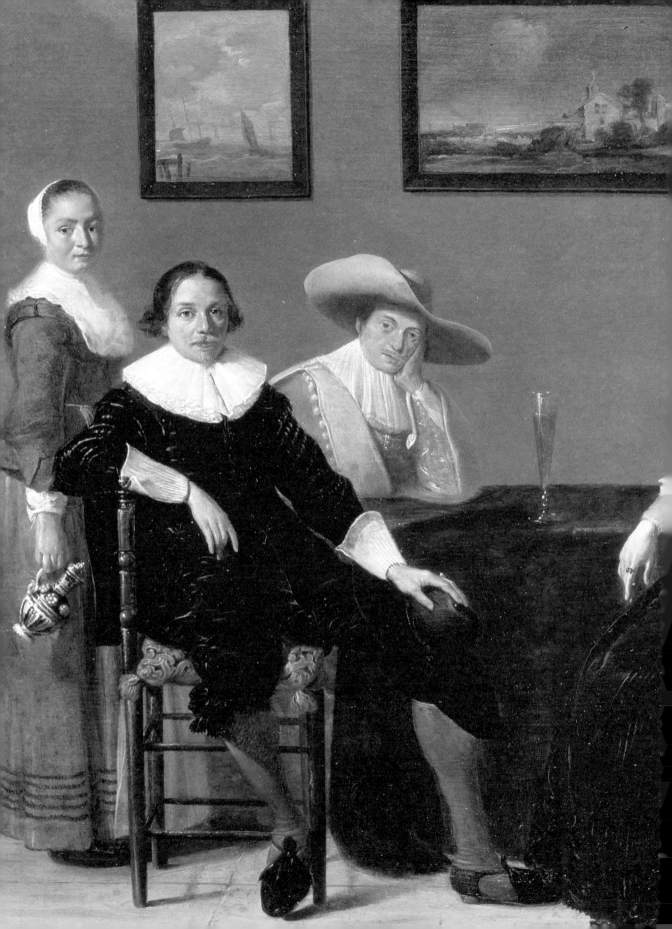

CHRISTOPHER LLOYD

IN SEARCH OF
A MASTERPIECE

AN ART LOVER'S GUIDE
TO GREAT BRITAIN
AND IRELAND

*With 273 colour
illustrations*

Thames & Hudson

For Frances, a fellow Bunburyist!

pp. 2–3 Jan Olis, *Dutch Family in an Interior* (detail)
Ferens Art Gallery, Hull: see pp. 319–20

pp. 6–7 Paolo Uccello, *The Hunt in the Forest* (detail)
Ashmolean Museum, Oxford: see pp. 270–71

First published in the United Kingdom in 2011 by
Thames & Hudson Ltd, 181A High Holborn,
London WC1V 7QX

Copyright © 2011 Thames & Hudson Ltd, London
Text copyright © 2011 Christopher Lloyd

British Library Cataloguing-in-Publication Data
A catalogue record for this book is available from the
British Library

ISBN 978-0-500-23884-4

Printed and bound in China by C&C Offset Printing Co. Ltd

To find out about all our publications, please visit
www.thamesandhudson.com. There you can subscribe to our
e-newsletter, browse or download our current catalogue, and buy
any titles that are in print.

ACKNOWLEDGMENTS

There are few pleasures greater than exploring museums and art galleries – even those you know well. Unsuspected surprises abound. Writing this book has been very much a personal odyssey, and I have tried hard not to impose myself on too many people. I have, however, taken advantage of some friends and former colleagues for hospitality or information. My thanks in these respects go to the following: Anna and Rodney Jago, Sally and Henry Machin, David Rankin-Hunt, Paul Simons, and Valerie and Martin Strauss. Nearer to home, I have relied heavily on the considerable skills of Sonia Sharman for turning my handwritten pages into a neat and respectable typescript. Her patience and efficiency have been truly remarkable.

My family have been a wonderful support. As on former occasions, the younger generation observed proceedings from a discreet distance, occasionally checking on progress. But the debt to my wife, Frances, is incalculable. She commented on the text and applied her technical skills in its preparation for the publisher. Without her, it is true to say, there simply would have been no book at all.

Finally, my heartfelt thanks to those at Thames & Hudson who took responsibility for this book and saw it through the press.

CONTENTS

A life passed among pictures, in the study and the love of art, is a happy noiseless dream: or rather, it is to dream and to be awake at the same time; for it has all 'the sober certainty of waking bliss', with the romantic voluptuousness of a visionary and abstracted being. They are the bright consummate essences of things.

WILLIAM HAZLITT, 'On a Landscape of Nicolas Poussin',
Table-Talk, Essays on Men and Manners, II, 1822

Thanks to art, instead of seeing one world only, our own, we see that world multiply itself and we have at our disposal as many worlds as there are original artists, worlds more different one from the other than those which revolve in infinite space.

MARCEL PROUST, *Time Regained*, vol. VII of
Remembrance of Things Past, 1927

Looking can be a form of worship and also an exact science. The great thing is to be able to look correctly and with attention, with as much objectivity as possible. This is not only plausible as a contemplative process but it also provides the basis for feeling.

CHRISTOPHER NEVE, *Unquiet Landscape. Places and Ideas
in Twentieth-Century English Painting*, 1990

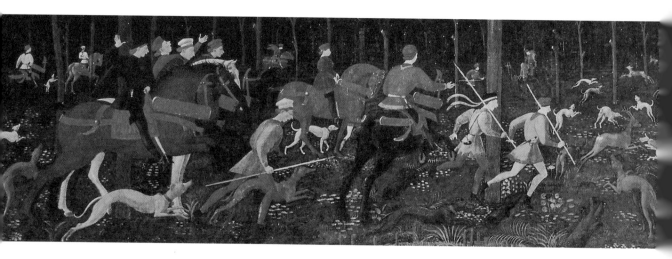

PREFACE

IN SEARCH OF A MASTERPIECE is a personal selection of paintings that I have come across and enjoyed or admired in public collections during the course of my career, and its purpose is to encourage others to visit the same places and experience the same pleasures.

Most people are aware of how rich the holdings of paintings in public collections in the British Isles are, but not everyone perhaps appreciates how widely diffused those paintings are geographically. My search begins in London, but very much lies further afield, including many pictures of marvellous quality. Throughout, I have given short outlines of the history of the museums and galleries from which I have made my selection

I cannot guarantee that the pictures chosen will always be on view. My choice is based as far as possible on recent visits, and only very rarely have I had to rely on memory, but fashions change in methods of presenting paintings. The traditional arrangement, according to chronology or school, has been joined by a themed approach. Both are open to criticism – the first because it is too static, and the second because it is too ephemeral. Ultimately it is the pictures that count, and the viewer's own relationship with them. So, whatever you do, please persevere, as my intention is to share the thrill of expectation that I experience whenever I walk into a gallery full of pictures.

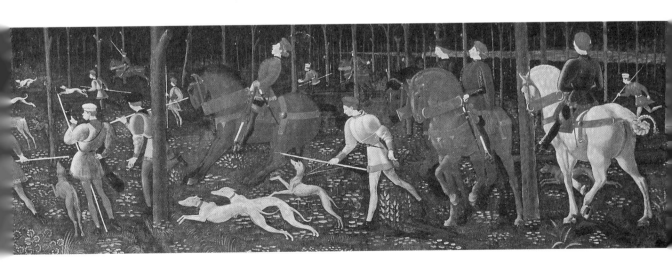

INTRODUCTION

One of the most significant developments in the British Isles in the late 20th and early 21st centuries has been the growth in popularity of public museums and galleries. When in 1768 the German poet Johann Wolfgang von Goethe visited the famous gallery of old master paintings in Dresden he referred to 'a unique feeling of solemn splendour that is more akin to the sensation one has upon entering a church'. Nowhere – or at least only on extremely rare occasions – would such a sensation be replicated today.

As an anthology *In Search of a Masterpiece* sets out to celebrate the treasure trove of paintings that exists in the museums and galleries of England, Scotland, Wales and Ireland, which are for the most part – it should never be forgotten – open to the public free of charge. The book has been prompted by the exceedingly rewarding historical and cultural advantages that these museums and galleries bring to our life.

Their diversity has come about because, unlike the rest of Europe where more centralized systems of government prevail, their establishment and development has never directly been a matter for the state. Even where the foundation of designated 'national' museums and galleries was concerned, the initiative nearly always came from private individuals, or a body of supporters, often accompanied by financial assistance. The National Gallery in London, for example, was founded in 1824 at the instigation of a private individual, who won government support, but had begun by acting alone in deciding what was required for the nation. (Interestingly, such people, although wealthy, did not belong to the landed aristocracy, who tended to protect their own collections for themselves, comfortably installed on their country estates or in their town houses.) What happened at the National Gallery in London is more or less true of the foundation of the National Gallery of Scotland (1850), the National Portrait Gallery in London (1856) and its opposite number in Edinburgh (1882), the Walker Art Gallery in Liverpool (1877), the Tate Gallery in London (1897), the National Museum of Wales in Cardiff (1907), and the National Maritime Museum in London (1934).

Another source of inspiration for founding national institutions was public exhibitions: the Victoria and Albert Museum (1852), for example, followed the Great Exhibition of 1851, and the National Gallery of Ireland in Dublin (1854) followed the Great Industrial Exhibition of 1853.

A rewarding feature of all the national museums is their architectural distinction, together with their often remarkable settings – the National Gallery in London on Trafalgar Square, the National Gallery of Scotland on the Mound below the Castle

alongside Princes Street in Edinburgh, the National Museum of Wales in Cathays Park in Cardiff, and the National Gallery of Ireland on Merrion Square in Dublin.

The situation in the cities outside London, Edinburgh, Cardiff and Dublin was more uncertain, though full of possibilities. The Industrial Revolution brought great wealth and a dramatic increase in population to Belfast, Birmingham, Bradford, Glasgow, Leeds, Liverpool, Manchester, Newcastle upon Tyne, Nottingham and Sheffield. Together with this came a pronounced regional identity. The desire for cultural institutions was a natural concomitant of commercial and financial success, but it had to be achieved without any help from central government, which had always allowed regional cities considerable independence when it came to running their own affairs. The Museum Act of 1845 and the Museums and Libraries Act of 1850 enabled boroughs to divert a proportion of the rates towards local amenities.

Even before such legal blessings were given, the regions had in effect taken matters into their own hands by operating outside official limits. There was, first of all, a growth in the number of liberally inclined learned societies (scientific, philosophical, literary) intent upon the spread of knowledge. Such societies were founded in England (for example at Bristol, Canterbury, Leicester, Liverpool, Manchester, Newcastle upon Tyne, Truro and York), Scotland (Dundee, Inverness, Montrose, Perth), Northern Ireland (Belfast), and what is now the Republic of Ireland (Cork). They built their own premises, which were privately administered and financed by subscriptions; they provided facilities such as reading rooms, scientific demonstrations, libraries, lecturers and sometimes art schools; they formed collections of items mainly of local scientific or archaeological interest, but also of paintings, usually by artists living in, or associated with, the area. These learned societies flourished during the first quarter of the 19th century, but many ran into financial difficulties.

Another way in which the growing wealth of the industrialized regional cities challenged London was in the organization of their own exhibitions relating to art and commerce. The 'Art Treasures' exhibition held in Manchester in 1857 was an international event of immense European importance. Other cities held regular exhibitions that served to promote local schools of art, but also attracted artists from all over the country seeking outlets for their work other than in the capitals. Liverpool, Brighton, York and Glasgow hosted exhibitions of this kind, which encouraged local authorities and private collectors to think of establishing permanent holdings of art in specially designed museums with admission free or at affordable rates.

These, then, were the two strands that led to the explosion of museums and galleries in many parts of the British Isles outside London during the second half of the 19th century and into the early decades of the 20th.

The preferred architectural style for such buildings initially was Renaissance or Neoclassical. The results could sometimes appear very severe, but they were certainly

imposing and occasionally surprisingly pure (Aberdeen, Birmingham, Bury, Cardiff, Liverpool, Manchester, Port Sunlight, Preston, Wolverhampton). At a later stage, Edwardian Baroque gave the buildings greater swagger (Bradford and Bristol). The obvious connotation was that such styles gave the art, or the experience of looking at art, a greater dignity – *gravitas* in short. Other architectural styles were chosen to suggest the circumstances of the institutions' foundations: thus the Royal Albert Museum in Exeter, founded in memory of Prince Albert, echoes the buildings of 'Albertopolis' in South Kensington, and the interior of the Kelvingrove Art Gallery and Museum in Glasgow is redolent of the exhibition hall which helped to finance it. All these buildings, irrespective of the chosen architectural vocabulary, were essentially multi-purpose, often with an art school or a library on the premises: they exuded civic pride while at the same time benefiting the community at large.

But there was another important element. This was the role played by individuals, who exercised patronage on a considerable scale, followed by acts often of supreme generosity in providing funds for buildings or donating their collections to be housed in them. These were genuine acts of philanthropy, inspired by a sense of civic duty, even if they served to display the donors' wealth or to perpetuate their names. Many municipal museums and galleries in the British Isles were founded in this way, such as the Walker Art Gallery in Liverpool, the Harris Museum in Preston, the Usher Gallery in Lincoln, Cartwright Hall in Bradford, the Holburne Museum in Bath, the Laing Art Gallery in Newcastle upon Tyne, the Williamson Art Gallery in Birkenhead, the Graves Gallery in Sheffield, the Ferens Art Gallery in Hull and the Burrell Collection in Glasgow. A similar pattern is repeated in borough museums such as those of Southampton (Robert Chipperfield), Swindon (H. J. P. Bomford), Ipswich (F. T. Cobbold), Rochdale (Thomas Kay) and Bury (Thomas Wrigley).

A striking feature of all these civic and borough museums today is the degree to which they uphold their founding principles. The architecture is often readily identifiable as a specific building type; the locations in town centres, squares and parks are nearly always surprisingly appropriate; and the sense of pride in their achievements (often in adverse circumstances and within financial restrictions) is palpable. It is fascinating, too, how well late 19th-century and early 20th-century British art is represented almost everywhere in the regions and how every effort is being made to add contemporary art (not solely British), as well as continuing to support local artists. All of this could not be done, of course, without the help of friends' organizations and other supporting groups that are such a vital element in the life of museums and galleries today.

Another category of museums and art galleries is the one that has flourished under the auspices of universities, very often out of London, where only the Courtauld Institute of Art has a major collection, and a fairly young one at that, having been

founded in 1932. Oxford led the way in the 17th century with the Ashmolean Museum, which was one of the earliest in Europe to grant public access, although not in its present Neoclassical building designed in 1839. Just before that, in 1834, a superb Neoclassical building had been designed for Cambridge to house the bequest that the 7th Viscount Fitzwilliam made to his old university in 1816. Dr William Hunter was a memorable benefactor of Glasgow University in 1783; Thomas Holloway's generosity is evident at Royal Holloway College at Egham in Surrey (now part of the University of London), built between 1879 and 1886; Sir Henry Barber entrusted the foundation of the Barber Institute of Fine Arts to his widow, who carried out his wishes in 1932; the Whitworth Art Gallery was handed over to the University of Manchester in 1958; and in 1973 Sir Robert and Lady Sainsbury gave a collection of world art to the University of East Anglia at Norwich. In each case such gifts generated special architectural projects, usually on campus. Where universities have not been lucky enough to secure benefactions, they have sometimes deemed it necessary to form collections or create exhibition spaces for teaching purposes, as at Hull, Newcastle upon Tyne, Nottingham and Warwick. Often on a small scale and initiated with limited funds by people within the university, the results are undeniably stimulating.

An even more remarkable connection with the world of education occurred at Dulwich College, a school in south London. In bequeathing a collection of old masters put together by himself and by Noel Desenfans, Sir Francis Bourgeois in 1811 stipulated the construction of a special building for the display of the pictures. The gallery that Sir John Soane designed in 1811 has been of the greatest significance for museum building ever since, especially as regards the division of gallery spaces and sources of natural light. Dulwich was the first purpose-built art gallery in the British Isles, and has been open to the public since it first received visitors in 1814.

Finally, certain public museums and art galleries evolved out of buildings that originally served other, usually private, purposes. At the grander end of the scale there are the Wallace Collection in London, Temple Newsam in Leeds, and the Bowes Museum at Barnard Castle (although the last was not technically a residence), and at the other the Russell-Cotes Art Gallery and Museum at Bournemouth, Christchurch Mansion at Ipswich, Pallant House at Chichester, Chillington Manor House at Maidstone, and Kettle's Yard at Cambridge. More dramatically, there are the castles at Norwich and Nottingham around which galleries have grown and which have come to symbolize their respective cities.

It is this diversity, together with the great number of vastly impressive new museums and arts venues that have been opened outside London in recent years, that has made the writing of *In Search of a Masterpiece* so stimulating. Discovering the buildings and their contents is an activity that I would recommend to everyone, and it is a pastime that this book aims to encourage.

Part One

--

SETTING OUT: LONDON

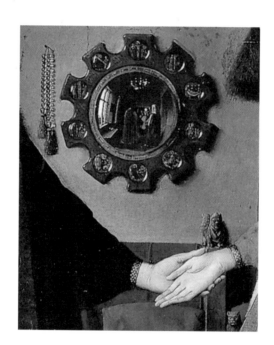

Jan van Eyck
*Portrait of Giovanni (?) Arnolfini
and his Wife* (detail)
National Gallery, London
(see pp. 21–23)

NATIONAL GALLERY

As befits the United Kingdom's premier picture collection, the National Gallery is perfectly situated at the very heart of the capital. It is moored like an ocean liner on the north side of Trafalgar Square, and the pedimented portico of its main entrance commands a striking view over the famous public space extending before it. The Square is dominated by the column bearing a statue commemorating Britain's greatest naval hero, Admiral Lord Nelson, erected several years after his death in 1805. Straight ahead, to the south, are the Houses of Parliament and Westminster Abbey. To the left, beyond the evocatively named church of St Martin-in-the-Fields by James Gibbs, is the Strand leading east to the Royal Courts of Justice, the City and St Paul's Cathedral. To the right, the Mall leads west to Buckingham Palace.

As a symbol – conscious or unconscious – of the role of art in British society the National Gallery, however, does not stand alone in Trafalgar Square. On the south side, directly opposite, is the bronze equestrian statue of Charles I, the greatest of all British royal collectors of pictures. Commissioned from Hubert Le Sueur and completed in 1633, it survived the Civil War only by being buried in the ground. Following the Restoration in 1660, it was unearthed and erected in its present position.

Another royal statue in bronze, of a later date, is positioned closer to the National Gallery, on a line with the east (right) entrance to the building. This is of George IV, by Sir Francis Chantrey, dating from 1828. The King, portrayed as a rather benign and somewhat overweight figure in military uniform seated on a placid horse, was an ardent, prolific and financially reckless collector. The National Gallery was founded during his reign, with his enthusiastic blessing – though he resisted the suggestion of surrendering the royal pictures, and did not contribute to any of the funding.

Even by British standards the foundation of the Gallery in 1824 was a remarkable compromise. Although the idea of having a national gallery in one form or another had been articulated in the mid-18th century in Parliament by the famous Radical John Wilkes, it was not one that garnered much support. Elsewhere in Europe, historical events precipitated the formation of national (or state) collections, which to a certain extent had in Italy been anticipated much earlier by the Papacy in Rome and the Medici in Florence. The revolutionary fervour that gripped France in 1789 and the social and cultural upheaval of the Napoleonic Wars that followed introduced new opportunities for change. The national galleries established in Vienna (1781), Paris (1793), Amsterdam (1808), Madrid (1809) and Berlin (1823) were born of a sense of history underpinning a desire for national identity. By the beginning of the 19th century a pattern of museum building in a suitably imposing architectural style had emerged.

Britain was in danger of being left behind. Most European countries benefited from having had a royal collection as the basis for their national galleries – often handed over under duress – but this did not apply in Britain. A general distrust of the arts, and economic pressures in the aftermath of the wars, meant that plans for a national gallery were never properly pursued. London lacked both pictures and a building.

The peculiarities of this situation determined the character of the National Gallery in Trafalgar Square from the start. The collection was essentially formed – and indeed continues to be so today – as the result of a series of bequests, donations and purchases. Consequently it is relatively small compared with its European counterparts (some two thousand or so pictures only) – but exceedingly choice. The initiative for its foundation came in the end from an individual, Sir George Beaumont (1753–1827), who was a distinguished collector, a passable landscape painter and a close friend of artists and poets. In 1823 he uttered the immortal words, 'I think the public already begin to feel works of art are not merely toys for connoisseurs, but solid objects of concern to the nation.' These words did not fall on stony ground, and the process was triggered by the prospect of the sale of the collection formed by John Julius Angerstein (1735–1823), which the writer William Hazlitt had described as 'the finest gallery, perhaps, in the world'. The purchase of this collection, formed by a man of Russian origin associated with the foundation of Lloyd's insurance and the world of banking, was prompted, as it was reported to Parliament, by George IV. The Prime Minister, Lord Liverpool, took the hint. A sum of money was voted in Parliament and a keeper, together with a group of trustees, appointed to oversee the purchase, conservation and exhibition of the Angerstein collection.

The lack of a suitable building was an immediate embarrassment, only solved by Lord Liverpool's purchase of the lease on Angerstein's house at 100 Pall Mall. This was the first, somewhat incongruous, address of the National Gallery, and Angerstein's enormous picture of *The Raising of Lazarus* by Sebastiano del Piombo has the distinction of being No. 1 in the Gallery's inventory. The novelist Anthony Trollope described the premises as 'a small dingy house on the south side of Pall Mall', adding that it was a 'dull, narrow house, ill-adapted for the exhibition of the treasures it held'. The deficiencies of No. 100 Pall Mall soon proved apparent and so in 1834 the collection was moved to a neighbouring house (No. 105), which was not much of an improvement. Distinguished foreign visitors such as Gustav Waagen, Director of the gallery in Berlin, observed of No. 105 in 1835 that there was 'so little light that most of the pictures are but imperfectly seen'.

Thought had already been given to the problem a few years previously by the government, who decided that a new building was necessary and had chosen a site on the north side of Trafalgar Square – which was being created on the site of the Royal Mews – described by the art-loving future Prime Minister Sir Robert Peel as 'the finest

site in Europe'. The architect chosen was William Wilkins, an exponent principally of the Greek Revival style. Money was voted for the building in 1833 and construction began the following year. Completion was marked by a visit from George IV's successor, William IV – not in the slightest degree interested in painting – in 1837, two months before he died. A year after this, with the pictures in place, the young Queen Victoria was shown the new gallery before it opened officially to the public.

Opinions about the building varied from the start. Wilkins was out of touch with developments in museum design as practised on the Continent by such architects as Leo von Klenze in Munich and St Petersburg, Karl Friedrich Schinkel in Berlin, or, later, Gottfried Semper in Dresden. The classicizing severity of the long façade with its fine pedimented raised portico and central dome characterized by a surprisingly tall drum is only relieved by the affectionately called 'pepper pots' surmounting the pavilions on the west and east flanks. Wilkins's conception was partly dictated by the instruction to provide a building that could accommodate not just the nation's pictures but also the Royal Academy (and even at the start the Public Records). The conflict of interest was reflected in the building, which was also too shallow, being only one room deep – too small even after the departure of the Royal Academy in 1868. (The shallowness was forced upon Wilkins, who was made to leave an open view from the west to St Martin-in-the-Fields and could not expand further to the north.)

Over the years Wilkins's building has received a number of accretions. The most important were the richly decorated galleries added on the east side in 1872–76 by E. M. Barry (son of Sir Charles, the architect of the Houses of Parliament), matched by the more sober rooms designed by Sir John Taylor on the central axis (1884–87). The spatial balance within the building was maintained on the west side by additions made during the first part of the 20th century. A prosaic extension with an entrance from Orange Street at the back was built in 1973–75, and the Sainsbury Wing, added on a different alignment to the western end of the façade, was opened in 1991. Designed by Denise Scott Brown and Robert Venturi, it had the virtue of honouring Wilkins's architectural vocabulary in a sophisticated, almost playful, Postmodern style. Paintings dating from the earlier centuries are shown to great effect in these galleries articulated by engaged columns and rich cornices, while the rest of the Sainsbury Wing is devoted to those facilities required for a successful national gallery today – exhibition space, shop, restaurant, lecture theatre. The new Getty Entrance on the east side, on a line with Chantrey's equestrian statue of George IV, opened in 2005.

Setting out on a personal quest from the National Gallery in London should not be interpreted as reflecting a hierarchical ordering of art galleries in the British Isles. Rather, it is based on my own experiences. When I was at school at Marlborough College during the early 1960s an inspired art master, Guy Barton, unconsciously

sowed the seeds of my love of the history of art by devising brilliant lectures delivered on winter afternoons (as I remember) after exhausting sessions on the games field. Barton successfully appealed to the baser instincts of pubescent boys by clever recourse to particular pictures in the National Gallery. One such, for instance, was *The Judgment of Paris* (or more correctly *Paris awards the Golden Apple to Venus*) by Rubens, which was particularly effective owing to the large expanse of female flesh embellished with warm tones. The choice of William Hogarth's *Marriage-à-la-mode* was equally compelling. This series of six scenes from contemporary life, which the artist himself referred to as 'modern moral subjects', tells of an arranged marriage made by two self-seeking fathers that inevitably ends in disaster for all parties. It allowed Hogarth to expose some basic social foibles of his time. The unravelling of the story across the six scenes was gripping. The revelation for me stemmed from the fact that Hogarth's pictures could be 'read' like a novel or experienced like a theatrical performance.

My association with the National Gallery, therefore, was at first indirect, but it soon became a dependency. School was followed by university, where I read modern history at Christ Church, Oxford. By the end of my time there I stumbled into what turned out to be a museum career, beginning in 1967 for a short time as the first Assistant Curator of Pictures at Christ Church Picture Gallery, before being appointed for a much longer period to the Ashmolean Museum. My initial experience as a curator was gained from working at Christ Church as an amanuensis to James Byam Shaw, one of the leading connoisseurs of his day. Never having studied the history of art, either at the Courtauld Institute of Art in London or at a university – where few such courses were then on offer – I was essentially self-taught.

It is for this reason that the National Gallery assumed such an importance in my life. The collection provides as comprehensive a view of the development of painting in Western Europe as it has been possible to put together within certain financial constraints and the dictates of changing fashion. The gallery has for me served as a visual dictionary, where the evolution of several outstanding artists may be studied or the characteristics of a particular school of painting identified. Visiting it regularly in a disciplined way helped to broaden my knowledge and to develop my visual memory, aided by the purchase of black-and-white photographs for reference at home.

Additionally, the National Gallery has in my opinion set standards to which all galleries should aspire. The expectations and needs of the museum-going public have grown in recent years, as evidenced by the opening of whole new departments and extra facilities, but the great virtue of the National Gallery is that it has never forgotten that its primary duty is to present pictures in a way that heightens aesthetic response and informs the mind – preferably both at the same time. The displays change according to fluctuations in taste, but its principal aim has always been to

present a visually coherent and imposing arrangement of the unfolding of the pictorial traditions of Western European art from the 13th century to the late 19th. The sight-lines connecting the galleries, the proportions of many of the spaces, the rich tones of the fabrics and the quality of the architectural fittings, and, above all, the careful distribution of the paintings makes for one of the most pleasurable visual experiences in the world.

The success of the National Gallery, however, has been hard won. Gaps have had, and still need, to be filled in schools of painting that are on the whole well represented, such as the Italian, early Netherlandish, or Dutch, while the representation of other schools such as the German, French, Spanish or Danish needs to be extended. Similarly, the transition from the 19th-century world of the French Impressionists to the dramatic breakthroughs made at the beginning of the 20th has to be more closely defined. An awareness of lacunae was apparent from the start and is reflected in the appointment during the second half of the 19th century of several parliamentary select committees and then by the acquisitions policy of each director in turn.

The development of the collection was only one concern. Another was its preservation. For a time the environmental conditions of London were as much of a threat as the open fireplaces in the galleries or unscientific methods of cleaning. A proper Conservation Department was set up in 1946, supported by the Scientific Department that had been at work since 1934. For many years now the National Gallery has led the world in these areas, although not without criticism, since to be overzealous in the treatment of a picture is as heinous a crime as to be neglectful. Even so, there is no denying that the well-cared-for appearance of the pictures on the walls is responsible in large part for the gallery's success, just as the scientific examination of the collection over a number of years has added considerably to scholarly knowledge.

Apart from looking at the pictures in the National Gallery, I also had recourse to its publications. These were principally catalogues of different parts of the collection. For the most part, these had been written by Sir Martin Davies, who spent all his working life at the National Gallery, becoming Director in 1968. During the Second World War Davies had been appointed to look after the paintings in North Wales, where they had been stored for safekeeping in a quarry. This gave him unique access to them, which when combined with the gallery's library, also deposited there, enabled him to continue the task of re-cataloguing the whole collection according to modern principles. Davies's intellectual approach (he was known as 'Dry Martini' to his staff) resulted in what Sir Ellis Waterhouse described as 'one of the great revolutions in the curatorial treatment of public collections in our time'. Thanks to Davies and to those who worked alongside him, and to younger generations who have followed in his footsteps, the National Gallery can claim to be the best catalogued of all the great public galleries in the world.

FRENCH SCHOOL (?)
The 'Wilton Diptych' (Richard II Presented to the Virgin and Child by his Patron Saints) c. 1395
Wood, each panel 45.7 × 29.2 cm / 18 × 11½ in.

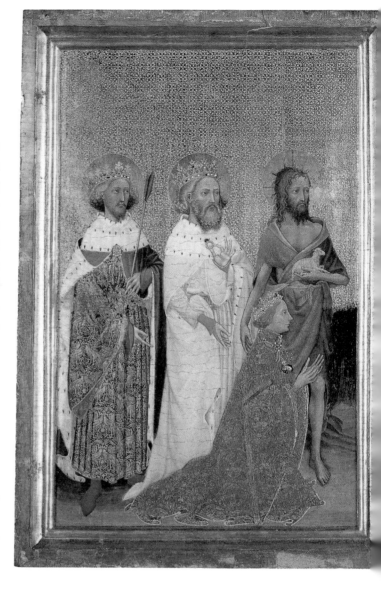

The appeal of the *'Wilton Diptych'* is twofold: its historical significance and the consummate quality of its craftsmanship. The kneeling figure in the left half is Richard II, King of England (reigned 1377–99). He is attended by three saints, each with his attributes – St Edmund of East Anglia, St Edward the Confessor and St John the Baptist. In the right half the figure of the standing Virgin holding the Christ Child is attended by eleven angels. The narrative extends across the diptych, so that when it is seen as a whole St John the Baptist presents the King to the Virgin and Child in a composition reminiscent of the Adoration of the Magi. The painting has numerous internal references to Richard II: the white hart with golden antlers scattered profusely throughout (including the reverse side of the diptych, where it balances a heraldic device with a royal coat of arms) is his personal badge; the standard is topped by an orb with a minute depiction of England; and the three saints accompanying the King as his protectors are ones with whom he personally identified closely.

This is court art at its very best, comparable in its high finish and attention to detail with manuscript illumination. As such, it has an international flavour in keeping with Richard II's court (his first wife from 1382 was Anne of Bohemia, and his second from 1394 Isabelle of France); but uncertainty about the place of origin of the diptych remains. The broom-cod collars worn by many of the figures suggest a French connection.

The intensity of the visual language is matched only by the searing poetry of William Shakespeare's play, *Richard II* (Act III, scene 2): 'Not all the water in the rough rude sea / Can wash the balm off from an anointed king; / The breath of worldly men cannot depose / The deputy elected by the Lord.'

Courtly art
at its most refined,
in a work
that tantalizingly
remains anonymous

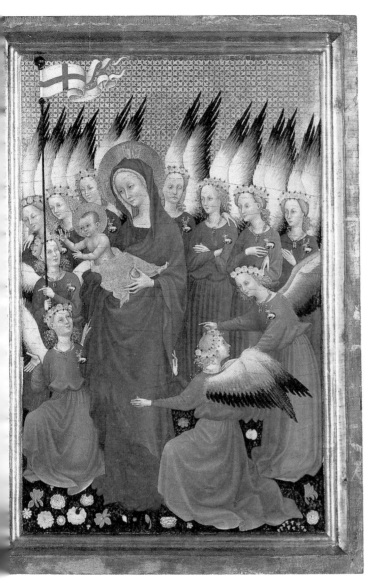

The King acceded to the throne in 1377 aged only ten. The difficulties of his minority were not allayed later in the reign by his capricious and headstrong character. Eventually his reckless and irresponsible policies edged him towards tyranny, which led directly to his deposition in 1399. Even so, he believed in the mystique of monarchy, he was devout, and he was also sensitive to beauty in many forms. His reign has the air of a personal tragedy.

The 'Wilton Diptych' obtained its name on acquisition in 1929 as a result of its ownership by the Earls of Pembroke at Wilton House in Wiltshire. There is some poetic justice in the fact that before the Earls of Pembroke it belonged to Charles I.

MASACCIO (1401–27/29)
The Virgin and Child 1426
Wood, 135.3 × 73 cm / 53¼ × 28¾ in.

One of the seminal works of the early Italian Renaissance, this painting was formerly the central panel of a large altarpiece of which numerous other parts are now identifiable in other collections. The completed work, which is documented, was painted for a chapel in the church of S. Maria del Carmine, Pisa. The original format of the altarpiece has been widely discussed, but it is now known to have been traditionally hierarchical, with saints in the upper and main sections and narrative scenes below in the predella, each element set in elaborate framework. The central vertical axis with this Virgin and Child as the main focus had the Crucifixion above (now Naples, Museo di Capodimonte) and the Adoration of the Magi below (Berlin, Gemäldegalerie) – both narrative scenes rendered in a memorably dramatic way.

The most striking fact is that the revolutionary nature of Masaccio's style, with its emphasis on monumentality of form and a strong sense of physical presence, was achieved within the constraints of a traditional multi-tiered altarpiece. The artist's use of light and his treatment of figures would have helped to unify the overall composition.

Such an advance in painting was due to two factors – firstly, an awareness of contemporary sculpture, and secondly, a desire to emulate the example of Classical art. The pose of the Virgin with the Child on her knee leaning slightly forward to create a dominant pyramidal form with a sense of space surrounding them can only have been achieved after observing Donatello's sculpture. Similarly, the type and decoration of the marble throne, as well as the figure of the Christ Child, reveal Masaccio's awareness of Classical art, or of art inspired by Antiquity.

Yet the figures are not alien: they are very much part of the everyday world. The 16th-century artist and writer Giorgio Vasari was an early admirer of Masaccio's skill in portraying the divine in a way that was recognizably human, as in his description of the angel on the left of this panel, 'sounding a lute and inclining his ear very attentively to listen to the music he is making'.

JAN VAN EYCK (active by 1422–d. 1441)
Portrait of Giovanni (?) Arnolfini and his Wife 1434
Wood, 84.5 × 62.5 cm / 32¼ × 23½ in. Signed and dated

For many years popularly known as '*The Arnolfini Marriage*', this picture is one of the most famous in the history of Western European art. Like certain works by Vermeer, its familiarity has been such that it has been regularly quarried by artists of all types, and especially cartoonists.

Jan van Eyck, who belonged to the household of Philip the Good, Duke of Burgundy, and worked for many years in Bruges, was highly regarded in his own lifetime, being described by the Italian humanist Bartolomeo Fazio as 'the principal painter of our century'. Not surprisingly, therefore, the painting, which originally had folding shutters, has a remarkable provenance, having belonged to Margaret of Austria and Mary of Burgundy before entering the Spanish royal collection during the reign of Philip II. It left Spain some time during the Peninsular War and came into the possession of a Scottish soldier, James Hay. Eventually coming to the attention of picture dealers, it was offered to the Prince Regent (later George IV), who after retaining it for two years decided not to acquire it. When purchased by the National Gallery in 1842 '*The Arnolfini Marriage*' was the first painting dating from the 15th century to enter the collection.

The figures cannot be firmly identified, although from an early date the man has been identified as a member of the Arnolfini family, who were silk merchants originally from Lucca residing for many years in Bruges. Exactly which of the many Arnolfinis this specific person is cannot for the present be determined. For some time the painting was interpreted as a marriage portrait on account of the artist's elaborate signature made in a pseudo-notarial style combined with an abundant use of symbolism, but such a theory

is now thought be too ingenious. Similarly, the assertion that the woman is pregnant is incorrect: she is simply holding her dress up in the fashion of the day.

Van Eyck has here painted a double portrait set in a reception room on the first floor of a private house. At that time it was usual to include a bed amongst the furnishings of reception rooms. The surprise comes from the fact that, although the subjects are clearly wealthy, they are not from the ruling class or the nobility and they are seen in a totally domestic context. Indeed, this could very well be the first secular portrait of its kind in Western European art. The technical skill shown by Van Eyck throughout – the sophisticated composition, the use of the oil medium, the excessive amount of detail, the treatment of the interior – is remarkably assured. Although the underdrawing is freely done with many changes, the precision of the finish and the degree of objectivity result in a totally convincing and thoroughly engaging image.

The exuberant personality of the artist is evident in the signature on the wall above the mirror ('Jan van Eyck was here'). This not only denotes pride in his achievement, but also by implication indicates his physical presence, which is further recorded by the reflection in the mirror where two male figures (the leading one being the artist himself) are seen entering the room. A member of the Arnolfini family and his wife, therefore, are depicted welcoming the artist and by extension us, the viewer, into their private domain.

ALBRECHT ALTDORFER (c. 1480–1538)
Christ Taking Leave of his Mother 1520(?)
Wood, 141 × 111 cm / 55 × 43½ in. Dated indistinctly

The National Gallery's representation of German painting is by no means comprehensive, and so the addition of this large painting by Altdorfer in 1980 to its Renaissance holdings was a major advance.

The artist came from Regensburg in southern Germany, close to the River Danube, and he made good use in his paintings, drawings and prints of the wild forested landscapes characterizing that area. Altdorfer was influenced by Albrecht Dürer and at the start of his career by Lucas Cranach the Elder, but he was also aware of developments in Italian art through prints.

The subject of Christ taking leave of his Mother does not occur in the Bible, but in texts of the early 14th century, which present the narrative of Christ's life with an emphasis on more mystical interpretations. Altdorfer highlights this element in the various emotional responses of the grieving holy women on the left (prominent among them the prostrate Virgin Mary), whose anxieties are paralleled in the unbounded forces of nature evident in the landscape. By contrast with the holy women, Christ, accompanied by St Peter and St John the Evangelist, remains calm and passive. The artist

Stark realism combined with strong imaginative impulses

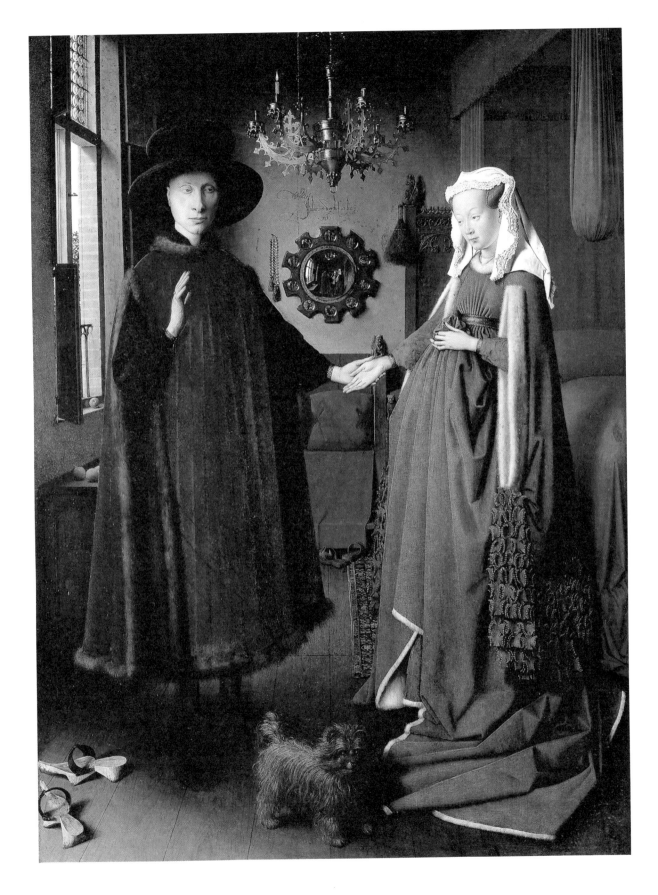

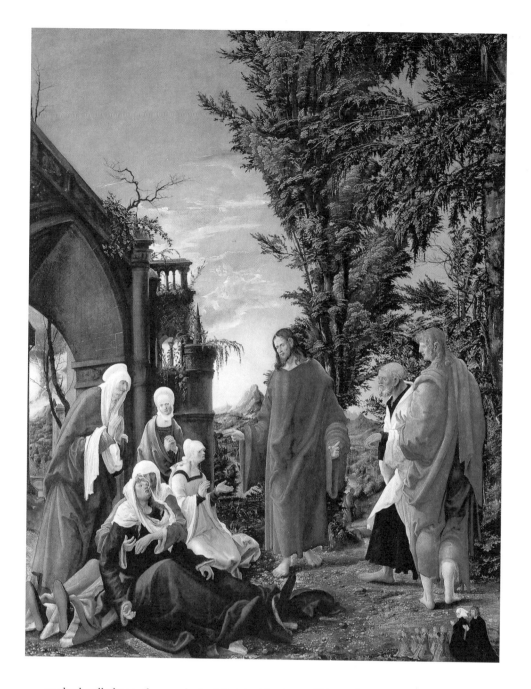

undoubtedly knew the woodcut of *Christ taking leave of his Mother* by Dürer (1511), but he must also have witnessed the scene as performed in contemporary religious plays or processions. This gives his painting a feeling of heightened drama. There is a sense of unreality apparent in the treatment of the figures – tall and ungainly, with gnarled features, claw-like hands and large feet – and of the draperies, which enfold the protagonists in voluminous cascades anticipating the Brothers Grimm. A certain amount of symbolism is intended by the ruined building surmounted with a dead tree representing

the world before Christ's presence on earth and the intensely coloured fresh growth apparent throughout the painting signalling the life to come after Christ's resurrection. The composition is illuminated by the rays of the sun seen through the arch on the left, which heighten the effect of glossy colour throughout.

An unintentionally amusing passage occurs in the lower right corner, where the patron and his family seem to cower in the presence of the religious figures towering over them. The name of the patron is unknown, but his generosity of spirit lives on in Altdorfer's painting.

TITIAN (c. 1490–1576)
Bacchus and Ariadne 1520–23
Canvas, 176.5 × 191 cm / 69 × 75 in. Signed

A case can be made for the Venetian artist Titian being the greatest painter of the High Renaissance in Italy

Owing to the enthusiasm shown by British collectors from the early 17th century onwards for paintings by Titian, regarded as the finest Renaissance painter emanating from Venice, there has always been a strong representation of his work in this country. His reputation rested on the variety of his work and on its undeniable quality in terms both of interpretation and of technique. Armed with these skills, he was in constant demand, receiving commissions from the highest level of secular and ecclesiastical society in Italy and beyond. By the end of his long career – he died at a very advanced age – his fame extended throughout Europe.

Bacchus and Ariadne originally formed part of a decorative scheme painted for the Camerino (private room) of Alfonso d'Este's principal residence in Ferrara. The quality of the paintings in this room, which included *The Feast of the Gods* (Washington, National Gallery of Art), begun and for the most part executed by Giovanni Bellini but later altered by Titian, *The Andrians* and *The Worship of Venus*, by Titian (both in the Prado, Madrid), is breathtaking – a landmark in the development of Western European art on account of the artist's interpretative power and technical skills.

Bacchus, accompanied by his followers, finds the distraught Ariadne wandering on the seashore of Naxos, having been abandoned by her lover Theseus, whose ship is just visible on the horizon at the left edge. The god leaps from his chariot to comfort Ariadne by offering her marriage – and ultimately a place among the stars as a constellation, which is depicted in the sky over her head. Although the story is based on Classical authors such as Catullus and Ovid and although the artist is at pains to display his knowledge of Classical art, the exuberance of the figures and the dramatic tension between the two protagonists are due solely to the fertility of Titian's visual imagination. The rich colouring, the realistic lighting, the vivid botanical detail in the foreground and the poetic feeling in the distant landscape are a superb demonstration of a still youthful artist fulfilling his potential. The visual contrast between Ariadne and

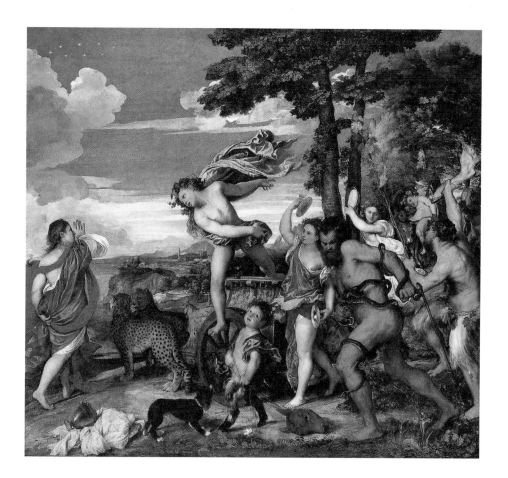

Bacchus – a balance between the passive and the active or between the reactive and proactive – is offset by the intensity of the look of sudden recognition. The leaping figure of Bacchus, like the Angel Gabriel in the scene of the Annunciation but more startling in his pose, is a totally convincing and unforgettable image because it is so beautifully observed and executed with such control.

REMBRANDT VAN RIJN (1606–69)
Belshazzar's Feast 163-[?]
Canvas, 167.6 × 209.2 cm / 66 × 82⅜ in. Signed and dated (the last digit illegible)

The National Gallery has one of the greatest holdings of paintings by Rembrandt in the world. They reveal not only his supreme technical ability in the use of paint but also his profound understanding of, and sympathy for, human nature. He was a total artist – the drawings and prints are as numerous, wide-ranging and as impressive as the paintings – and his generous feeling for humanity stemmed in large part from personal experience.

 Rembrandt started his career in Leiden and moved in 1631–32 to establish his reputation to Amsterdam, then the centre of the art world in Northern Europe. Here

And now for a moment of high drama

he lived for the rest of his life, in 1634 marrying Saskia von Uylenburgh, with whom he had a son, Titus. After Saskia's death in 1642 Rembrandt took up with Hendrickje Stoffels, who had begun life in his household as nurse and housekeeper: they were never formally married. Despite his constant output and the high regard in which he was held as an artist, Rembrandt, who always appreciated good living, was declared bankrupt in 1655, with the result that all his property and art collection were sold. Thereafter he was forever on the edge of financial disaster, and in 1662 he even sold Saskia's grave in the Oude Kerk in Amsterdam. Both Hendrickje and Titus predeceased him, but even when confronted by such terrible vicissitudes Rembrandt kept working until the end.

The works by Rembrandt in the National Gallery reveal his competence in most areas of his art, but *Belshazzar's Feast* is a dramatic picture painted at an important transitional moment in his life, shortly after he took up residence in Amsterdam, when his style

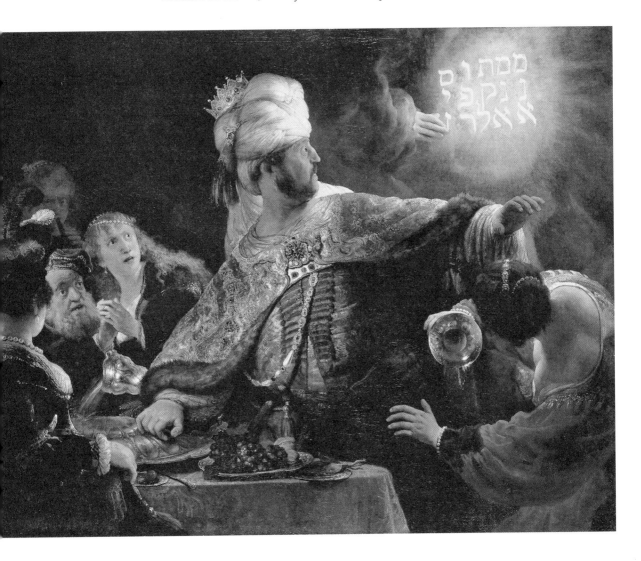

opens out and becomes more Baroque. The subject is taken from the Book of Daniel in the Old Testament and is about the Babylonian King Belshazzar, who during a feast profanes treasures stolen from the Temple in Jerusalem. He is immediately admonished by God. A hand inscribes a text ('Mene, Mene, Tekel, Upharsin') which only the banished Jew, Daniel, can interpret. The words predict Belshazzar's death, which occurs that very night.

The story encouraged Rembrandt to paint with full dramatic force. The startled reactions of the revellers are enhanced by the nocturnal lighting striking the still-life objects and illuminating the elaborate garments, bejewelled coiffures and cascading wine. The chiaroscural effect allows Rembrandt to exaggerate the facial expressions. The dramatic effect is further heightened by the positioning of the figures in the immediate foreground with the two courtesans in the lower corners framing the composition.

Rembrandt loved exotic garments and objects, just as he would have enjoyed consulting his neighbour, the scholar Menasseh ben Israel, about the Hebraic inscription. He lived life to the full, but *Belshazzar's Feast* is in essence a warning against over-indulgence. Possibly the artist failed to heed his own warning, but for a man with such an appetite for life who can blame him.

CLAUDE LORRAIN (1604/5?–82)
Seaport with the Embarkation of the Queen of Sheba 1648
Canvas, 149.1 × 196.7 cm / 58½ × 76¼ in. Signed and dated

This picture forms a pair with *Landscape with the Marriage of Isaac and Rebecca*, painted for the same patron, Frédéric-Maurice de La Tour d'Auvergne, Duc de Bouillon. Both later belonged to John Julius Angerstein, whose collection formed the basis of the National Gallery.

Although born in Lorraine, Claude spent nearly all his life in Rome and its environs, particularly admiring the landscape of the Campagna to the south. He became the most successful landscape painter of his day, with important patrons – popes, cardinals, kings, princes, aristocrats – and commanding high prices. Most of his subject-matter was inspired by written sources such as the Bible, Ovid or Virgil, but he often gave his narrative compositions idealized settings, mixing the fictive with the real. He specialized in harbour scenes, which allowed him to depict the magical effects of light on water, and his pictures were especially admired for their panoramic scale and their atmosphere. British collectors became so partial to Claude's paintings that during the 18th century his aesthetic values governed many aspects of cultural life in Britain – not least garden design.

The visit of the Queen of Sheba to King Solomon in Jerusalem is narrated in the Book of Kings in the Old Testament, but the actual preparations made by the Queen as shown here are not described, and it is an exceptionally rare subject in art. Claude creates an exotic mythical kingdom, with the Queen descending the steps of her palace on the right. The buildings are carefully placed so that the eye is led to the horizon line, forcing the

British collectors found the charms of the French 17th-century painter Claude Lorrain particularly seductive

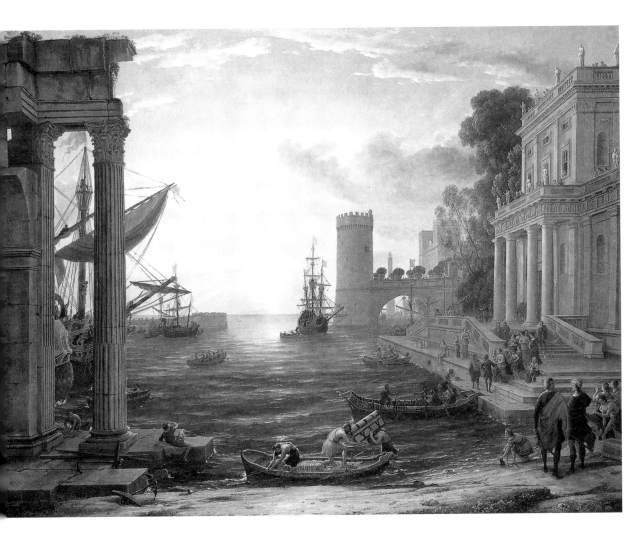

viewer to look directly into the rising sun. The artist was renowned for his ability to record the effects of nature. According to a contemporary, Joachim von Sandrart, he 'tried by every means to penetrate nature, lying in the fields before the break of day and until night in order to learn to represent very exactly the red morning sky, sunrise and sunset and the evening hours'.

Claude's paintings can be remarkably dream-like in their gentleness. The architecture is clearly inspired by the ancient world, but the figures are given theatrical airs in the attempt to portray a vanished past. Although the composition is on a grand scale, the amount of detail is almost obsessive, as seen in the architecture, the sailing vessels, the ripples of the waves and the flowers in the foreground. The soft light, the warm colours (I am very fond of the pink trunk being loaded onto the boat in the foreground), and the bustle of a port at the start of the day are immensely evocative. It looks and feels like the Mediterranean. The mood suggests an early Campari before lunch, imbibed to the sound of Felix Mendelssohn's overture *Calm Sea and Prosperous Voyage*.

The reputation of Angerstein's two Claudes was exceedingly high, and one of their keenest admirers was J. M. W. Turner, to the extent that a specific condition of his bequest to the nation of his own paintings and drawings was that two of his works – *Sun rising through Vapour* and *Dido building Carthage* – should hang between them. This condition proved somewhat controversial, but is now admirably upheld by the National Gallery.

GIOVANNI BATTISTA TIEPOLO (1696–1770)
An Allegory with Venus and Time c. 1754
Canvas, painted area 44.2 × 65.7 cm / 115 × 75 in.

Tiepolo's art is the summation of Venetian painting. As adept in fresco as on canvas, he was the heir to Titian, Tintoretto and Veronese on every scale – sketch, altarpiece, wall, and ceiling. No challenge was too much for him, and the results, even at their most spectacular, were always graceful in colour, drawing and design. His imagination matched his technique fully and no subject, however obscure, in religion, history or mythology was beyond his reach. Tiepolo's paintings are, in short, an outburst of creative joy and energy. He worked extensively in the palaces and churches of Venice, as well as villas in the Veneto, and then in many of the leading towns of northern Italy. His masterpiece is the fresco decoration of the Residenz in Würzburg (1750–53) – a lavish, complicated and audacious undertaking beyond the powers of most artists. A decade later he received a royal commission from Charles III of Spain, which took him to Madrid, where he died. He was mourned back home in Venice as 'the most famous Venetian painter, truly the most renowned . . . well known in Europe and the most highly praised in his native land'.

The visual impact of a painting by Tiepolo is dizzying – almost literally so in the case of his ceiling paintings, since they are usually only seen to best effect when the viewer is straining every sinew of the body. His work often induces reactions comparable with an outburst of applause in the opera house. The softness of colour, the fluency of the brush-work, the deftness of the drawing and the variety of the composition are transporting. There is a feeling of stupefaction, almost as if confronting a vision.

An Allegory with Venus and Time displays all Tiepolo's best qualities. It was first recorded in 1758 as a ceiling decoration for the Contarini family in Venice, surrounded by four allegorical roundels. Arriving in London by the end of the 19th century, the whole decorative scheme was installed by H. L. Bischoffsheim at Bute House in South Audley Street. That became the Embassy of the Egyptian Government, later the United Arab Republic, who sold the ensemble in 1969; the central part was then acquired by the National Gallery.

Fortunately, the cast in this present allegory is fairly restricted. Venus, identifiable by her chariot and the doves over her head, consigns her baby boy, Aeneas – the future hero of the Trojan War and founder of Rome – to the arms of the winged figure of Time. Above him are the Three Graces and below him, half in shadow, Cupid carrying a quiver of arrows.

In the world as depicted by Giovanni Battista Tiepolo anything and everything is possible

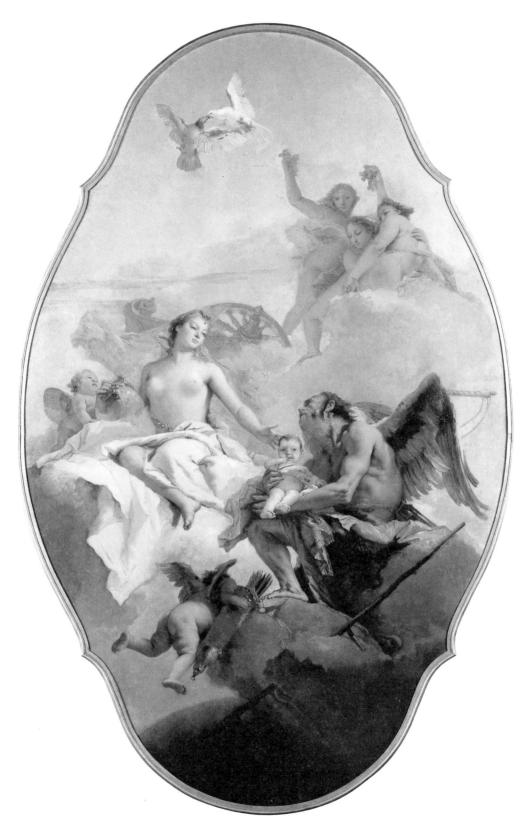

The composition was probably devised in honour of the birth of a Contarini heir, whose potential was likened to that of Aeneas: a historical connotation of this type would have been appropriate for the Contarini family, who, although Venetian (with eight doges to their name), traced their origins back to Roman Antiquity. They would equally have derived satisfaction from the fact that their child was shown as having been born of Beauty and being offered Eternity.

As usual Tiepolo treats such unpromising subject-matter with an effortless grace. There can be no doubting the physical attributes of Venus, who pushes herself forward in a knowing way, but the painter allows us only a glimpse as it were of a scene which is fleeting. Our engagement stems from the fact that such illusory material has been given such substance in reality. We can only marvel at these figures floating above our heads who seem to float with the skill and apparent abandon of circus performers. To be open-mouthed is the only reaction.

FRANCISCO DE GOYA (1746–1828)

Doña Isabel de Porcel 1805

Canvas, 82 × 54.6 cm / 32¼ × 21½ in. Inscribed with the name of the sitter and signed on the reverse

Although there is a far more important group of paintings in the National Gallery by the 17th-century Spanish artist Diego Velásquez (including 'The Rokeby Venus'), Goya is a painter who can always deliver a knockout punch. Very often this occurs in his portraiture, where his perception of human nature is deepened by his own experience of life and his personal difficulties. Goya witnessed a Europe in transition – the toppling of monarchies, the spirit of revolution and the march of armies. He observes heroes and villains with equal detachment, just as he records with similar fidelity the joys of outdoor life, the longueurs of the court, and the miseries of war. His style begins in a light Rococo manner full of innocence, but gradually descends into darkness and horror.

Goya personifies the predicament of the Enlightenment – the importance of the search for truth and the exercise of reason, which can at any time be overwhelmed by irrationality and the descent into insanity. The artist lived on a knife edge: he was for many years plagued by an undiagnosed illness connected with his increasing deafness. And as a liberal he was driven into exile during the reign of the restored Ferdinand VII and died in Bordeaux. Yet his artistic curiosity lasted to the end, when a friend described him as 'deaf, old, awkward and weak', but 'so happy and anxious to see the world'.

Doña Isabel de Porcel is about pure painting. She wears a black mantilla as ladies of fashion did in Spain at the beginning of the 19th century in order to emphasize their 'Spanishness'. The turn of the head, the restive eyes, the full mouth and strong neck together with the angle of the shoulders and the hands on the hips give a sense of

After Tiepolo's ballet, something more full-bodied and red-blooded is the order of the day

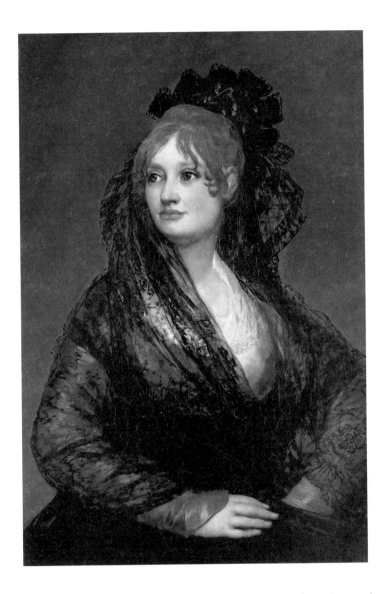

assertiveness underpinned by an air of coquetry. Many of Goya's portraits of women are less assertive, with the figure being positioned further back in the picture space and more restrained in dress, but he knew both Doña Isabel and her husband, Don Antonio. Here in the hot flesh tones contrasted with the darker hues of black and purple you sense animal passions, a sitter with a strong physical presence bursting with pride and unafraid to draw attention to her beauty. The viewer cannot resist.

The portrait was exhibited in Madrid in 1805. It was painted over another of a male figure: an eye from the earlier image is discernible in the lower part of Doña Isabel's face. Maybe the need to cover one painting with another added to Goya's sense of urgency and required a more vigorous application of paint, which may account for the power of the portrait.

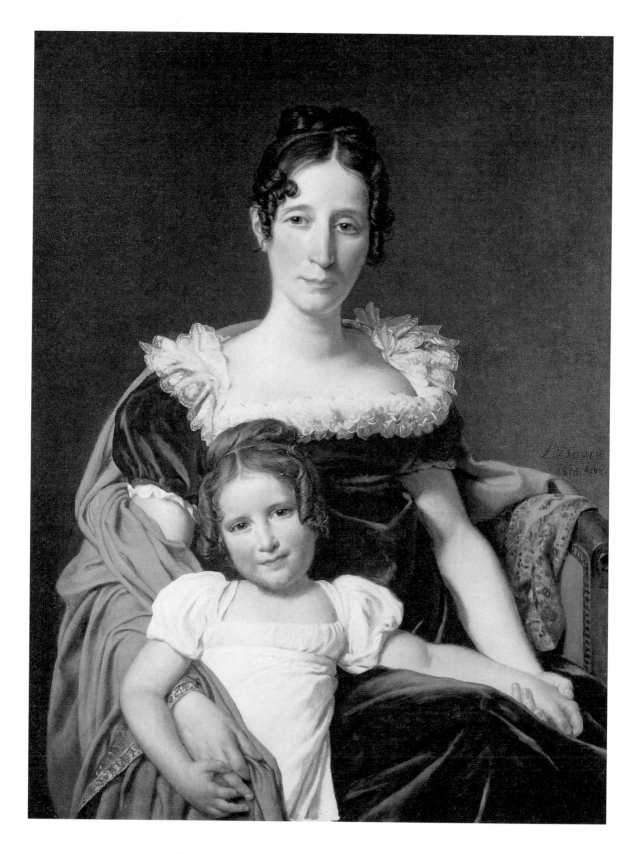

34 LONDON *National Gallery*

JACQUES-LOUIS DAVID (1748–1825)

The Vicomtesse Vilain XIIII and her Daughter 1816
Canvas, 95 × 76 cm / 37⅜ × 29⅞ in. Signed and dated

Like Goya,
Jacques-Louis David
was a witness
to history

David was one of the great survivors of history, and as a gifted artist one of its most important witnesses. He was born in the middle of the 18th century and his early style follows Rococo precepts, but as France edged towards revolution so David adopted the Neoclassical manner of painting and used it as a vehicle for artistic reform. He chose Classical subjects to give expression to revolutionary ideals (*The Oath of the Horatii, The Death of Socrates* and *The Lictors Bringing Brutus the Bodies of his Sons*). On this basis he was also an active participant in the Revolution: he voted for the execution of Louis XVI, and was responsible for the abolition of the Académie Royale de Peinture et de Sculpture. Close to Robespierre, he was acknowledged as the Revolution's leading recorder (*The Oath of the Jeu de Paume,* and *Marat Assassinated*), as well as the designer of its main insignia, festivals, celebrations and processions. A lasting image is the drawing he made from his window of Marie-Antoinette on the way to the guillotine.

Imprisoned in 1794 after the death of Robespierre, David then became the official painter for Napoleon, following the course of his career by illustrating not only its main events but also its ultimate failure, and in so doing establishing much of the Emperor's personal iconography. After Napoleon's defeat in 1815 David was exiled permanently to Brussels, where he died. The artist's political actions are open to interpretation, but his art has great integrity and his influence was immense, as evidenced by his numerous pupils.

As a history painter David's credentials are undeniable, but he was also a memorable portraitist at all times in his career, although those done in Brussels are often, sadly, not so admired. The qualities of this portrait dating from 1816, acquired by the National Gallery in 1994, are unmissable. The sitter, like the artist himself, had been swept along by historical events. Her husband, Philippe Vilain XIIII, was from an old Flemish family and had served Napoleon, being ennobled in 1811. The number after his name refers to the ancestry of his family. He married Sophie-Marie-Zoë de Felz (1780–1853) in 1802. She had been a lady-in-waiting to Napoleon's second wife, the Empress Marie-Louise, and held Napoleon's son, the King of Rome, at his baptism. After the fall of Napoleon both husband and wife had positions at the newly established court of Leopold I in Brussels. The young girl shown with her mother is their third child (of six) and eldest daughter, Marie-Louise-Victoire.

David's art is based on concision. The pyramidal composition and exactness of the drawing are reminiscent of Raphael, but any cerebral effect this might have is negated by the colour of the clothes, specifically the clash of blue with orange. The essence of the portrait, however, is the tenderness between mother and child, emphasized by their intertwined arms. Both sitters engage directly with the viewer – one with the look of experience and the other with the look of innocent curiosity.

Letters passed between husband and wife record progress made on the portrait and describe David's working procedures on it between May and July 1816. Although the Vicomtesse Vilain found the sittings tedious (on average they lasted four hours) and fatiguing (she was three months pregnant with her next child), the result was well received. At various earlier stages of his life David may have been full of dogma, but his years in exile (he never saw Paris again), when he was often in the company of other exiles who had links with Napoleon, brought out his more human side.

PAUL CÉZANNE (1839–1906)
Bathers (Les Grandes Baigneuses) c. 1894–1905
Canvas, 127.2 × 196.1 cm / 50⅛ × 77⅛ in.

The late works of Cézanne – paintings and watercolours – were deeply influential. For painters at the beginning of the 20th century they were a signpost and opened up new possibilities, heralding many aspects of modern art. The impact of Cézanne's work only began to be fully felt as a result of exhibitions held towards the end of his life.

Born in Provence, the son of a banker and destined for the law, Cézanne came to Paris during the 1860s, but subsequently returned to the south, living on the outskirts of Aix-en-Provence, where he remained for the rest of his life with only occasional forays to Paris. From the start he was recognized as an exceptional painter, with a highly charged individual style related to a temperament that was self-absorbed, stubborn, single-minded, hard-working and inclined to the solitary.

The subject of male and female bathers in a sylvan setting was one that had interested the artist since the 1870s, but the project of Les Grandes Baigneuses can be considered the culmination. There are three such late pictures on a comparatively large scale, of which the one in London is in all likelihood the first. The others are in the Barnes Foundation at Merion, Pennsylvania, and the Philadelphia Museum of Art. Each is a different interpretation of the subject. Begun at different times, they remained in the artist's studio and so were probably worked on simultaneously. All three to a certain extent resemble work in progress, and the most satisfactory compositionally is the one in Philadelphia. Cézanne's purpose was to reinterpret a subject – figures in the landscape – that had preoccupied such illustrious forebears as Titian, Rubens and Poussin. His respect for tradition is attested by the concentration on the nude, which he studied incessantly throughout his life, either from the live model or from copying the old masters, and sometimes from memory.

The Bathers in the National Gallery is a wholly disconcerting picture. The viewer is very much aware of the actual process of painting: there are alterations to the size of the canvas, clumsy drawing, heavily impasted surface, repeated brushstrokes, and a distinct lack of 'finish'. Cézanne revelled in the sheer difficulty of his art, emanating from his perpetual search for the best way to record the sensations he personally experienced before nature.

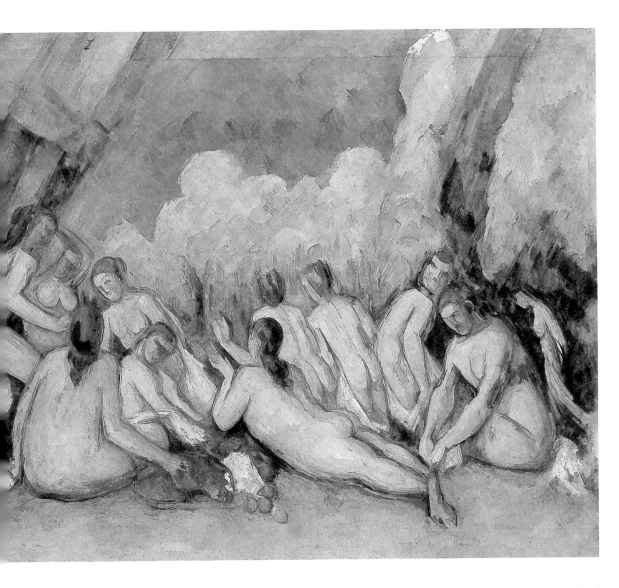

Looking to
the future

The figures – all female – are seen in a clearing in a wood. Although they are naked and clearly bathers, there is no sign of a river. The bodies are blurred and ungainly although highly individualized, with no attempt at idealization. There is a sense of unity in the merging of figures and landscape and this is emphasized by the blue colour that suffuses the whole composition, giving it almost a transcendental quality. Although the image is in itself so strong and shocking in its forcefulness, it is at the same time supremely lyrical. Notice how the bodies are seen in conjunction with the trees and how any danger of the static is overcome by implied movement. Matching this is the rainbow effect of the colours, derived from the mixing of blue-green, lavender, yellow, orange, and ochre. This is a painting on a symphonic scale, and it assuredly impressed the Cubists when it was shown in Paris at the Salon d'Automne in 1907. Indeed, Picasso's *Les Demoiselles d'Avignon* was painted in that very same year.

IMPERIAL WAR MUSEUM

There can be no mistaking the Imperial War Museum, guarded as it is by two 15-inch naval guns, formerly mounted on battleships, that greet the visitor on the approach to the main entrance. The museum was founded in 1917 specifically to commemorate the sacrifices of the First World War and formally opened in 1920, although not at the present location in Lambeth, which was made available in 1936. This was the site of Bethlem Hospital – a lunatic asylum – from which the central portico and dome survive, to make a rather incongruous setting for the artefacts and instruments of war. The museum's brief has of necessity had to be extended to include all wars of the modern era. The displays and exhibitions concentrate not just on the mechanics of war, but also on its social impact in the broadest sense.

Art has had a major role in the development of the Imperial War Museum, and its collection of pictures is not as well known as it should be. At the outset they were intended to form a visual record of the prosecution of war, as well as a memorial to those involved in war. The accumulation of works was the responsibility of the British War Memorials Committee and involved artists of the calibre of William Orpen, Wyndham Lewis, Stanley Spencer, William Roberts, Paul Nash and C. R. W. Nevinson. One advantage of a mixture of styles was that it encouraged a wider interpretation of scenes observed in the front line or on the home front. To all intents and purposes, the commissioned artists represent the British art scene in microcosm: there is the Futurism of Nevinson's *French Troops Resting* (1916), the social realism of Walter Bayes' *The Underworld: Taking Cover in a Tube Station during a London Air Raid* (1918), and the Surrealism of Paul Nash's *The Menin Road* (1919). Some artists, such as Paul Nash, Muirhead Bone and Stanley Spencer, worked in both the First and the Second World Wars. But the main figures featured on the lists of the War Artists Advisory Committee of the Second World War, administered by Kenneth (later Lord) Clark, were Henry Moore, Graham Sutherland and John Piper.

The range of subject-matter and the variety of painting in the collection of the Imperial War Museum are far wider than might be assumed, and the best work is both factual and imaginative – an art that adheres to a terrible truth but at the same time remains detached almost to the point of abstraction. The depiction of war, and reflection on its impact on artistic consciousness, continues to this day.

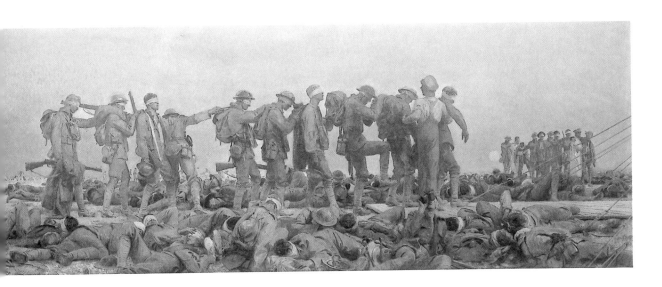

JOHN SINGER SARGENT (1856–1925)
Gassed 1918
Canvas, 231 × 611 cm / 91 x 240⅝ in. Signed and dated

Not just a painter of
society portraits

This pitiful scene, witnessed by the American-born artist on 21 August 1918 at Le Bac-du-Sud on the Arras–Doullens road in northern France, is conceived on a massive scale comparable with a fresco. The soldiers are suffering from the effects of mustard gas laid down by the Germans in order to stem the British advance. The composition was originally commissioned by the British War Memorials Committee as the centrepiece of a projected Hall of Remembrance, which after the end of the war never came to fruition. The picture devolved to the Imperial War Museum and so *Gassed* is in effect a very prominent part of the early history of the museum.

The monumental composition is centred on nine wounded soldiers accompanied by two orderlies silhouetted against the sky. They are making their way along a boarded path to a dressing station on the right, which is out of the picture space but is indicated by the stretched guy ropes. Another column, seen obliquely on the right, makes its way to the same dressing station. A football match is being played in the background and bivouacs are visible at the left. The foreground is filled with the recumbent figures of wounded soldiers. The golden glow suggests the end of the day, with the rising moon above the horizon.

Although inspired by an incident he actually saw, Sargent has depicted the scene on a heroic scale. There are also religious overtones, in the sense that at the end of their journey to the dressing station these soldiers will experience healing or salvation. The processional form is reminiscent of Classical sarcophagi and other sculpture such as the 'weepers' on medieval tombs or Rodin's *Burghers of Calais*, just as the sprawling sharply foreshortened figures in the foreground suggest a Last Judgment.

Such an elaborate composition required an immense amount of preparation with drawings, but the finished work is surprisingly thinly painted, although not lacking

Sargent's usual élan. It is as if having spent so long contemplating the composition he could not wait to rid himself of such a nightmare vision. Indeed, although *Gassed* follows hard upon Sargent's murals of *The Triumph of Religion* painted for Boston Public Library, this is an unusual undertaking for the artist, who thrived mainly as a brilliant portrait painter. The impact of this picture, however, leaves one in no doubt that Sargent was totally committed.

PAUL NASH (1889–1946)
We Are Making a New World 1918
Canvas, 71 × 91.5 cm / 28 × 36 in.

Paul Nash was one of the most original landscape painters of the first half of the 20th century. He studied first at Chelsea Polytechnic and then at the Slade School of Fine Art (1910), but also had an interest in design and photography, and kept in touch with new movements in art in Europe through his art criticism supplemented by visits to France.

 Nash's involvement in the First World War was a crucial moment in his development. Enlisted in the Artists' Rifles, he saw active service with the Hampshire Regiment before becoming an official war artist.

There are many ways of depicting a battlefield

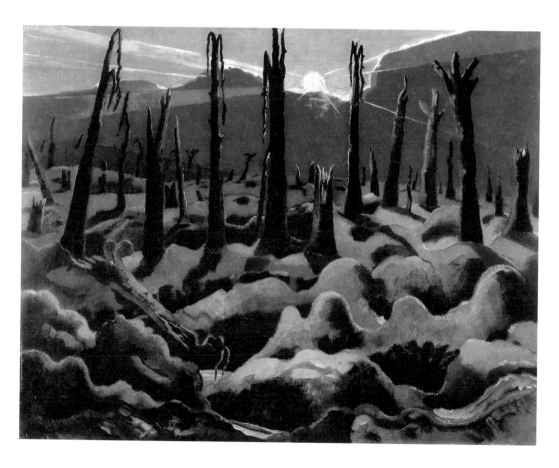

We Are Making a New World shows a landscape marked by the scars of war, but warmed by the rising sun. The title is meant ironically and it is significant that the scene is unpopulated. Already in these 1914–18 landscapes Nash uses shapes and forms verging on the abstract that provide added poignancy to his work, but they also demonstrate how the changing contours of the landscape opened up his imagination. This process continued during the 1920s when he painted along the south coast in Kent. Gradually his landscapes became more and more overlaid with abstract and eventually Surrealist features. Formal acknowledgment of this came in the early 1930s with the formation of Unit One in which he played a leading part alongside Ben Nicholson, Barbara Hepworth and Henry Moore.

Landscapes in Nash's work associated with prehistoric sites such as the ancient stone circle at Avebury in Wiltshire or the Wittenham Clumps near Dorchester in Oxfordshire became recurring motifs and open to increasingly imaginative interpretations, often enhanced by his wide reading.

Nash was made an official war artist again for the Second World War, and he died one year after its cessation.

NATIONAL ARMY MUSEUM

A visit to the National Army Museum can be a sobering experience. It gleams; it bristles; it bustles. Located close to the Royal Hospital in Chelsea in a new building opened in 1971 and ostensibly protected by various pieces of artillery and mobilized armour, it is dedicated to the history of the British army from its origins up until our own times. And it is a treasure house of information about military campaigns, uniforms, medals, tactics, communications, weapons and armoury.

Paintings are not neglected. They are hung along corridors and form part of installations, and a considerable number are presented in a dedicated gallery. The quality varies inevitably, because pictures are collected more for their subject-matter than for their intrinsic artistic significance. Portraits, therefore, compete for space with views of battlefields, scenes of individual bravery, and important moments in regimental history.

BENJAMIN WEST (1738–1820)
General The Hon. Robert Monckton c. 1764
Canvas, 240 × 175 cm / 94½ × 68⅜ in.

Monckton (1726–1782) was a valiant soldier who fought mainly against the French in America. He was second-in-command to General Wolfe at Quebec in 1759 and is commemorated in West's most famous painting, *The Death of Wolfe* (Ottawa, National Gallery of Canada), in which he is shown wounded. Subsequently he served in Pennsylvania and was Governor of New York. The paper Monckton holds here is inscribed 'Martinique' and refers to a further campaign he conducted on that island against the French in 1764. The wonderful pose alone suggests martial valour of the highest sort, and the heavy artillery piece entering the composition on the right might almost seem surplus to requirements.

This was a most important painting in the career of Benjamin West, who came to London from America via Italy in 1763. He never returned home, winning plaudits from the leading portrait painters of the day such as Sir Joshua Reynolds. Interestingly, by putting Monckton in the pose of the *Apollo Belvedere* West was emulating Reynolds's own practice of using sources from the art of the past in the context of contemporary portraiture. In commissioning this portrait from West so soon after the artist's arrival, Monckton in effect established his reputation, which in turn helped him decide to settle in England. West went on to be Historical Painter to George III and to become the second President of the Royal Academy, in succession to Reynolds.

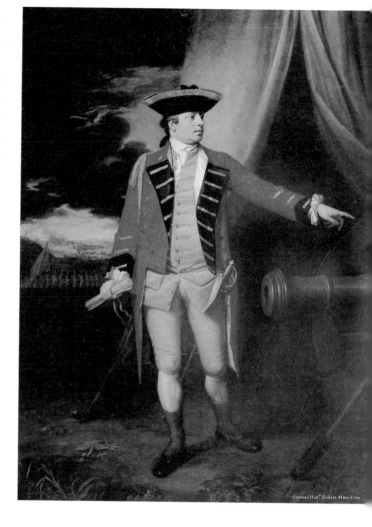

General Hon. Robert Monckton

A British soldier with American connections, by an American artist recently arrived in Britain

HENRY NELSON O'NEIL (1817–80)
Home Again, 1858 1859
Canvas, 91 × 71 cm / 35¾ × 27⅞ in.

Painted as a pair to *Eastward Ho! August 1857* (Elton Hall Collection), and like it inspired by the Indian 'Mutiny', when British troops were sent in great numbers to put down the revolt of the Bengal army. Such depictions were hugely popular with the Victorian public

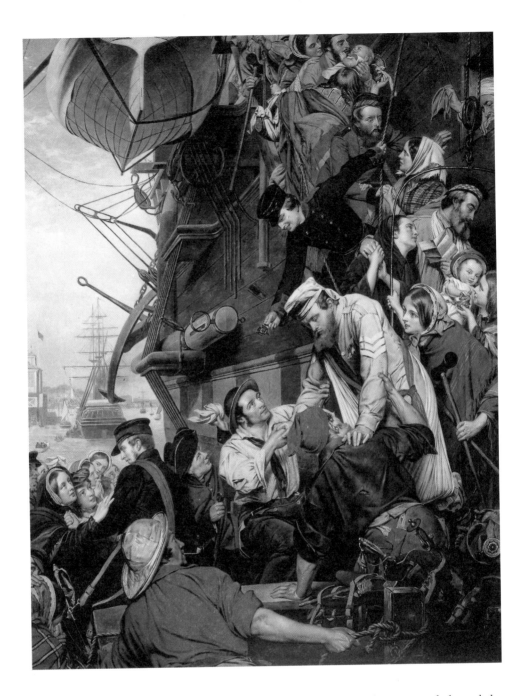

Changing attitudes
to war

when shown, as both these were, at the Royal Academy. Their success bolstered the artist's reputation, while the sale of the engravings made from the pictures was a welcome source of income.

Interest in paintings like these was enhanced not only by the subject-matter, which related to hotly debated topical issues of government policy, but also by a new phase in the portrayal of military themes. These images are not anti-war, but they do show the

impact of military life on individual soldiers and by extension on civilians, which had previously been overlooked. The conduct of war at this time was as much the focus of attention as the call for reforms to the army.

O'Neil was not just popular with the public: he was also much liked by his fellow artists such as W. P. Frith and writers such as Anthony Trollope. Admittedly his paintings are pedestrian, but he liked the challenge of crowded compositions, which sometimes succeed very well – as here. Note the use of the diagonal to emphasize the tidal flow of people disembarking from the ship that has just arrived back from India. It is a moving scene and must have been a poignant image at the time it was painted, including depictions of the sick and wounded and the bereaved, as well as a young man who has been awarded a medal for valour.

REX WHISTLER (1905–44)
Self-Portrait 1940
Canvas, 71 × 58.5 cm / 27⅞ × 23⅛ in.

Rex Whistler was a brilliantly imaginative artist who specialized in trompe-l'œil mural paintings in a rather whimsical, highly personalized Rococo revival style. An early example of his talent known to many is the decoration entitled *The Expedition in Pursuit of Rare Meats* (1926–27) done for the Tate Gallery (now Tate Britain) restaurant. Several commissions for aristocratic friends followed, notably at Plas Newydd, Isle of Anglesey, and at Mottisfont Abbey in Hampshire (both now owned by the National Trust), and at the house of Sir Philip Sassoon at Port Lympne in Kent. A hilarious episode from near the end of his life was the painting done one rainy afternoon at a military barracks in Brighton entitled *Allegory. HRH The Prince Regent awakening the Spirit of Brighton*, showing an overweight future George IV scantily attired as a winged Cupid unveiling the naked Venus representing Brighton (now in the Royal Pavilion). On the whole, however, Whistler's style was better suited to book design, illustration and the theatre, to which his humour and playfulness were perfectly attuned.

At the beginning of the Second World War Whistler took a commission in the Welsh Guards. He did not see action until the invasion of Normandy in 1944, by which time he was in the armoured division: his death occurred during a tank skirmish near Caen on 18 July – his first day in action after four years training. His proper place was as an official war artist, but for some reason he was overlooked in this respect.

The *Self-Portrait* was painted on the balcony of a borrowed apartment in York Terrace (No. 27) overlooking Regent's Park in London. Self-portraiture is particularly challenging, and this has an unusually complicated pose and a background requiring a demanding application of perspective. It was painted on the very day his officer's uniform arrived. Reference to his career as an artist is made with the brushes in the lower left corner, but

An unlikely warrior

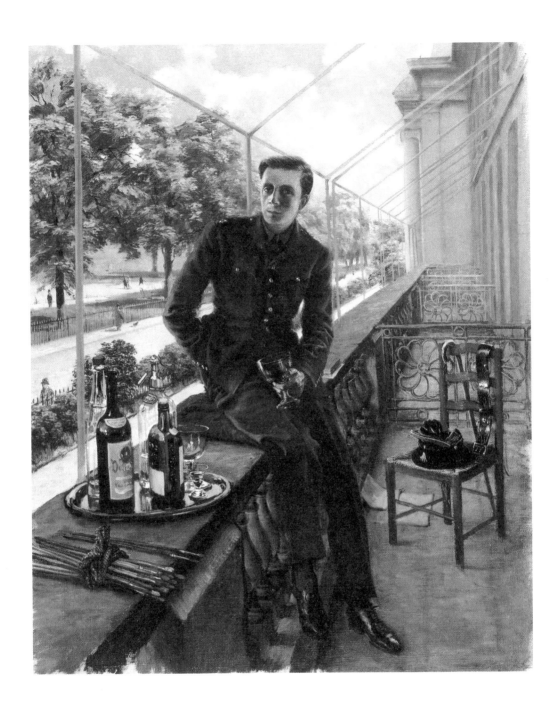

most welcome is the silver salver with bottles of gin and Dubonnet. The artist characterizes himself as a casual person, but at the same time he seems pensive and even apprehensive. As a portrait it reveals insouciance, charm and distinction, but there is also an awareness of how that could all be so easily destroyed, as indeed was the case with Rex Whistler.

NATIONAL MARITIME MUSEUM

The National Maritime Museum is at Greenwich and should ideally be approached by boat so that the full visual effect of the setting can be experienced. The outline of the buildings is offset by the hillside of Greenwich Park, at the summit of which is the Royal Observatory with its commanding view over London. There was at Greenwich itself in the 16th century a royal palace closely associated with the early life of Henry VIII. Nowadays the town has an undeniable nautical air – even if it is a somewhat retrospective one – and the breezy atmosphere encourages a brisk step.

The dominant building at Greenwich is the former Royal Naval Hospital, designed in the late 1690s by Sir Christopher Wren and carried out by Nicholas Hawksmoor with Sir John Vanbrugh. This famous landmark was later transformed into the Royal Naval College, and again more recently into the University of Greenwich.

Inland from the Hospital lies the National Maritime Museum, centred on the Queen's House, designed by Inigo Jones for James I, but finished during the reign of Charles I, 1630–35, for use by Queen Henrietta Maria. This gloriously chaste building with its magnificent hall and 'tulip' stair is in the Palladian style, but it has a distinctive H shape because originally it was constructed over a public thoroughfare and assumed the function of a bridge. The Queen's House was first absorbed into the Royal Naval Hospital, but it was later given to the Royal Naval Asylum for the education of children. In 1807 west and east wings were added, joined by long colonnades. It is these buildings that in 1934 became the National Maritime Museum, officially opened three years later – one of the youngest of the national museums.

Paintings form only one element of an extremely diverse range of exhibits, recording as comprehensively as possible the maritime history of the nation. In the Queen's House space is reserved specifically for the display of the art collection. Since Charles I and Henrietta Maria were such connoisseurs, this seems most appropriate.

The collection obviously concentrates on maritime paintings (it is very strong in Dutch pictures of that type), but there are also many portraits of famous sailors and naval heroes. One main feature is the work of the Willem van de Veldes (Elder and Younger), who were given a studio in the Queen's House by Charles II. On a spectacular scale are *The Battle of the Glorious First of June, 1794* by Philip James de Loutherbourg and its pair by J. M. W. Turner, *The Battle of Trafalgar, 21 October 1815*, which were painted for George IV to be shown in St James's Palace. Courtiers apparently criticized the nautical inaccuracies in these two pictures and out of understandable pique the King presented them to the Royal Naval Hospital in 1829, thereby adding to his previous gift made in 1824 of the sets of 'Flagmen' by Lely and naval portraits by Kneller. In time this act of generosity benefited the National Maritime Museum and was the Royal Collection's loss.

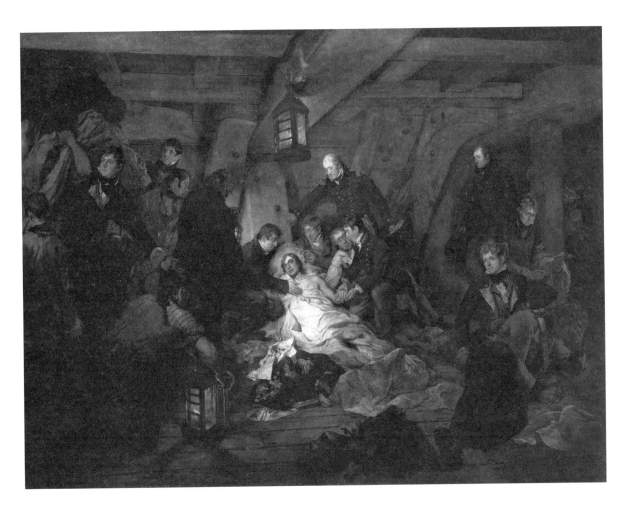

ARTHUR WILLIAM DEVIS (1762–1822)

The Death of Nelson c. 1805–7

Canvas, 195.6 × 261.6 cm / 77 × 103 in.

The death of
a hero

Few can fail to be stirred by the career of Horatio Nelson and his role in the wars of the French Revolution. He was present at four of the six main naval engagements against the French and was in command at three of them. His most famous battle, at Trafalgar off the southern tip of Spain on 21 October 1805, was also his last.

Even by modern standards of well-rehearsed ritual and ease of communication, the arrangements made following Nelson's death, involving the return of his body and a state funeral in St Paul's Cathedral in London, were remarkably impressive. A violent storm broke immediately after the battle, adding to the difficulties. H.M.S. *Victory* sailed to Gibraltar for repairs with Nelson's body aboard preserved in a barrel of brandy and then began the journey home. News of Nelson's death in the hour of victory (he was shot at 1.15 p.m. and died at 4.30 p.m.) reached London on 6 November and the *Victory* arrived at Portsmouth on 4 December. Nelson's body was then transferred to a coffin, at which time

the fatal bullet was extracted. The body lay in state in the Painted Hall of the Royal Naval Hospital from 26 December. The state funeral took place on 9 January, with a procession so long that when its head reached St Paul's Cathedral the tail had not left Whitehall.

Artists were much exercised by the need to record the death of Nelson in paint. A competition announced in November 1805 by the print publisher Alderman Josiah Boydell (who was really only interested in the financial potential of the engraving based on the picture) was won by Arthur William Devis. He was given preferential treatment by being allowed to board H.M.S. *Victory* at Portsea to see Nelson's body, interview the officers and crew, and sketch a re-enactment of the scene in the ship's cockpit. Devis was not an obvious choice, having so far pursued a career as a portrait painter in India and subsequently spent a great deal of his time in Britain in prison for debt. But his depiction has a ring of authenticity, with the right people in the right places, although he obeyed the conventions adopted for scenes of dying heroes by quoting from religious iconography (the Lamentation of Christ), as in Benjamin West's famous picture, *The Death of Wolfe* (1770), which Nelson knew and had apparently discussed with West.

Interestingly, West overreached himself in his own depiction of the death of Nelson, in 1806 (Liverpool, Walker Art Gallery), by locating the scene on deck in order to raise the drama of the occasion to the level of an epic ('No Boy, sd. West, wd. be animated by a Representation of Nelson dying like an ordinary man'). A second attempt by West corrects this mistake, but even then it is not a wholly successful picture. Not to be outdone, he tried again and produced an allegorical version, which is even worse (both are in the collection of the National Maritime Museum).

HUMPHREY OCEAN (b. 1951)
The First of England 1999
Canvas, 249 × 310 cm / 98 × 122 in.

The National Maritime Museum is keen to continue the tradition of maritime painting and specially commissions works for this purpose. The artist, who trained at Canterbury Art School and is a member of the Royal Academy, has depicted the deck of a cross-Channel ferry. The title can be read as a response to Ford Madox Brown's *The Last of England* (Birmingham Museum and Art Gallery). Ocean writes, 'I imagine a fair proportion of Britons have at one time or another been on a ferry, which is now an extension of the car as well as being a floating high street.' The passengers he depicts are day-trippers 'bearing a trolley load of duty-free lager and three toblerones for the price of two'.

Ocean has stated that as the painting developed he had in mind a comparison with all those others who have returned home in different circumstances and for whom the white cliffs of southern England were a symbol of hope. This was suggested to him by reading Philip Larkin's ironical poem about war written in 1960 entitled 'MCMXIV', referring

A metaphor for life

retrospectively to Britain on the eve of the First World War. Larkin referred to 'MCMXIV' as 'a "trick" poem, all one sentence & no main verb!', but in its nostalgic evocation of Britain at the start of the 20th century he had a serious intention, ending the poem with the declaration, 'Never such innocence again.' Ocean's picture seems to be a response to that line denoting a loss of innocence. It is as though for him the symbolic meaning of the cliffs of Dover reflected in literature by Shakespeare and Matthew Arnold and in song during the Second World War by Vera Lynn has now been eroded in a world dominated by materialism and commercialism.

This is a surprisingly powerful and thoughtful picture, with a striking composition notable for its emphatically drawn figures and strong patchwork of colour. What looks straightforward is really a metaphor for life, transmitted through the juxtaposition of the permanent historical dimension of the cliffs and the transience of the ferry with its passengers – an image perhaps worthy of Dante quite apart from Larkin.

NATIONAL PORTRAIT GALLERY

The National Portrait Gallery could easily suffer from its location in St Martin's Place just round the corner from the National Gallery, but it remains hugely popular with the public and has an uncanny knack of keeping its finger on the national pulse. This is important since the gallery exists to provide a panoramic display of British history centred on all those people who have made a significant contribution to British life through the centuries. It is an extensive panorama (arranged chronologically) and in effect an illustrated *Dictionary of National Biography*, which by the same token means that its excellent catalogues of the permanent collection are definitive iconographies of all the individuals represented in the collection.

When it was founded in 1856 it was the first national portrait gallery in the world, and it is strange to think that its example has not been followed wholeheartedly elsewhere. It is fitting that the first portrait associated with the gallery was of William Shakespeare (the '*Chandos Portrait*'), presented by one of the founder Trustees, the first Earl of Ellesmere (1800–1857).

The National Portrait Gallery is an important reference collection and the emphasis here, as opposed to the National Gallery next door, is on history and biography and not the artist. This sense of purpose is enshrined in words penned in a letter from William Gladstone to the Earl of Ellesmere: 'the authenticity of the portrait, and the celebrity of the person represented, will be the grounds for the admiration of a picture, and not its excellence as a work of art.' These words are borne out today by the way each label is written.

An added excitement is the element of controversy when it comes to contemporary choices and commissions (a policy initiated only in 1969), and one of the reasons for the gallery's popularity is the desire to see who is included and who excluded – rather like the annual Honours List.

To a certain extent, every work of art in the National Portrait Gallery is important, but some works are more important than others. No-one denies that the quality varies enormously – and the collection now includes photographs and video in addition to paintings, sculpture, prints and drawings – but on some occasions the inspired matching of artist and sitter can produce spectacular results. One of the problems faced by the gallery today is the high rate of acquisitions made each year. The space is already crowded, and even taking into account the various outstations (Montacute House in Somerset, Beningbrough Hall in Yorkshire and Bodelwyddan Castle in Denbighshire, Wales) a solution will have to be found soon.

The present building in St Martin's Place was designed in a classical style by Ewan Christian, paid for by the philanthropist W. H. Alexander, and opened in 1896. Since then there have been two major extensions: the first (1933) financed by Lord Duveen

along Orange Street and modified several times since, and the larger second, the Ondaatje Wing (2000 – named after Sir Christopher Ondaatje, businessman, traveller and writer and a life patron), using a narrow strip of land between the gallery and its neighbour the National Gallery. The architects of the Ondaatje Wing, Jeremy Dixon and Edward Jones, installed a spectacular escalator to link the ground floor to the upper galleries so that now on entering you feel as though you were in a Powell and Pressburger film. To add to this effect, the visitor then feels like a time traveller, starting at the top with the 16th century and descending floor by floor to the present day.

GUILLIM SCROTS (active 1537–53)
Edward VI Aged Nine 1546
Wood, 42.5 × 160 cm / 16¾ × 63 in. Once inscribed with the artist's name and dated 1546 on the frame

Starting off with a Tudor joke

Apart from the official portraits, paintings involving Edward VI (1537–53) tend to refer to religious matters, since his short reign of six years was dominated by the consequences of the break with the Church of Rome initiated by his father, Henry VIII. Unlike *Edward VI and the Pope: an Allegory of the Reformation*, also in the National Portrait Gallery, however, the present portrait marks a refreshing change and amused the court at Whitehall Palace after it was painted, just as it has continued to make people smile ever since. Known as an anamorphosis, it deliberately distorts the sitter's features and was drawn by the artist to be seen correctly from only one particular angle, which in this case is from the right-hand side. A special device was attached to the frame comprising a metal plate and a pinhole through which the viewer peered to obtain an undistorted image. The landscape is a later addition.

The artist was from the Netherlands, but was appointed official painter to Henry VIII and after his death to Edward VI. He was highly paid, and rightly so, since perspectival distortions of this kind must have been difficult to paint. Another famous example occurs in 'The Ambassadors' by Hans Holbein the Younger (National Gallery).

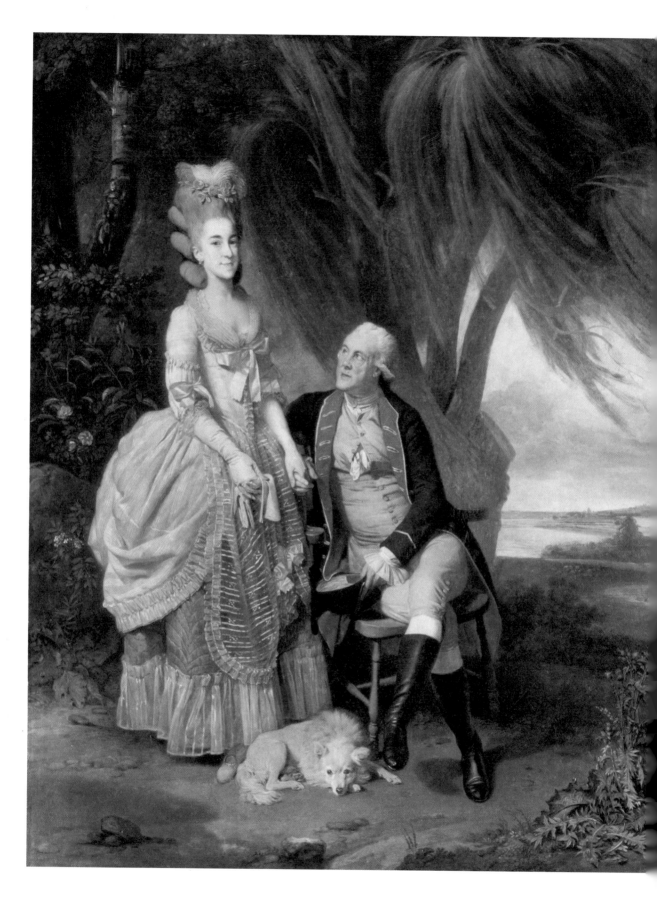

JOHANN ZOFFANY (1733–1810)
John Wilkes and his Daughter Mary 1779–82
Canvas, 126.4 × 100.3 cm / 49¾ × 39½

Looks can be deceptive

Even by the standards of the 18th century John Wilkes (1727–97) led an expansive and colourful life. He spent many years in and out of Parliament, adopting radical views, which he advocated passionately in his weekly publication, the North Briton. This riled successive governments of the day, but won considerable public support. Having been put on trial for libel in 1763, he spent four years in exile in France before returning to play a prominent part in the politics of the City of London, becoming a successful and popular Lord Mayor in 1774. The cry 'Wilkes and Liberty' has ever since been associated with radical politics.

This portrait points up the contrast between the public and the private spheres in Wilkes's career. He was a notorious *bon vivant* and rake, on a par with James Boswell. His daughter, Mary (also called Polly), was the child of an arranged marriage with an older woman, which ended in divorce in 1757; Wilkes was very fond of her and she acted as Mayoress during her father's mayoralty. He was also a formidable Classical scholar, and was one of the first to acknowledge the need for the foundation of a national gallery in this country. Above all, everyone testifies to Wilkes's humour and good company.

Zoffany was born in Germany. After arriving in London he quickly won the confidence of George III and Queen Charlotte, before making a journey to India (1783–89) in search of further commissions. This portrait, which Horace Walpole described as 'horribly like', is a fair example of Zoffany's style. The pose is suggestive of the warmth of the relationship between father and daughter, even though they seem somewhat incongruous in the landscape setting and rather awkwardly positioned on the uneven ground.

JAMES TISSOT (1836–1902)
Captain Frederick Burnaby 1870
Wood, 49.5 × 59.7 cm / 19½ × 23½ in. Signed and dated

The strong characterization and technical brilliance of this portrait make it irresistible. Dressed in the military uniform of the Royal Horse Guards ('the Blues'), Captain Burnaby (1842–85) poses nonchalantly, cigarette in hand, on a sofa below a map which makes clear references to the British Empire. There is a deliberate contrast between the military items from his full dress uniform visible in the corner on the right and the books placed alongside him. Burnaby was renowned for his physical strength ('the modern Hercules') and bravery as soldier, adventurer and pioneer balloonist, but he was also a good linguist, a travel writer, and a regular contributor to the magazine *Vanity Fair*, which he helped to found. Tissot sets up other contrasts – portraiture and

genre painting, masculinity (martial valour) and gentlemanliness (waxed moustache, cigarette, conversational skills) – just as he allows the figure to dominate the space by choosing a small format for the painting.

In contrast to his public persona, Burnaby's private life was unhappy and his appearance when not in military uniform was unkempt and bohemian. His complexion was unduly sallow owing to bouts of poor health, and he apparently powdered his stubble to blend in with his pallor. He died in the Sudan fighting with the force hoping to relieve General Gordon at Khartoum.

Tissot was French, but spent more than a decade in London following his role in the Commune in Paris. As a successful and popular painter of modern life (cf. pp. 114–15) he spans the Victorian art scene and the world of the Impressionists. Later, after returning to France, he became primarily a religious artist on the basis of his interest in spiritualism.

'I am the very model of a modern Major-General'

W. S. GILBERT,
THE PIRATES OF PENZANCE,
1879

JOHN SINGER SARGENT (1856–1925)
Arthur James Balfour, 1st Earl of Balfour 1908
Canvas, 260 × 150 cm / 102⅜ × 59 in. Signed and dated

Politics was
very different
in those days

Balfour (1848–1930) was a puzzle to his contemporaries and possibly even to himself. Prodigiously gifted intellectually, he made his career in politics while philosophy remained a lifelong interest. Although a brilliant debater in the Houses of Parliament, Balfour was more at home in country house society and was a member of a group of like-minded intellectuals called the Souls, who all played important roles in public life. Beyond political organizations, Balfour was also President of the British Academy and a Fellow of the Royal Society. He succeeded his uncle, the 3rd Marquess of Salisbury, as Prime Minister in 1902, but presided over a Conservative party that was in the throes of change and he resigned in 1911. Balfour's main concerns in politics were Ireland, educa-tion and imperialism, but at the time of the First World War he was appointed First Lord of the Admiralty and then during the coalition government led by David Lloyd George

crucially he was Foreign Secretary, playing a leading role at the Peace Conference of 1919. He is now known principally for the Balfour Declaration (1917) which promoted a Jewish 'homeland' in Palestine.

Balfour's character was formed by the experience of being born into wealth and equipped with a brilliant brain. His manner was languid and he was prone to laziness, giving the impression that he found life too easy. This was not actually true, and he himself said of his mental processes: 'I can remember every argument, repeat all pros and cons, and even make quite good speeches on the subject. But the conclusion, the decision, is a perfect blank in my mind.' Seeing every side of an argument made it difficult for Balfour to reach decisions. Contrary to appearances he was not without physical prowess, particularly enjoying real tennis and golf.

Balfour never married and was rather detached in his relationships, but he enjoyed the company of women. His smile was said to be 'like moonlight on a tombstone'. Lloyd George said of Balfour's reputation in history that he would be 'like the scent of a pocket handkerchief'.

Sargent's portrait, which is conceived in the tradition of Van Dyck, captures the essence of Balfour when he was Prime Minister. The tall, stooping figure, so beloved by caricaturists such as Max Beerbohm, is exaggerated by the alignment with the pilaster against which he leans. A degree of foppishness presents itself in the extended arm, and a sense of intellectual peevishness is detectable in the grasping of the lapel. The portrait was commissioned by members of the Carlton Club – a bastion of the Conservative party, where it hung over the fireplace in the dining room – and was sold to the National Portrait Gallery in 2002. The tone is sombre and monochromatic, a skilful exercise in blacks, greys and silvery whites, with subdued colours in the marbling. G. K. Chesterton wrote: 'It is the portrait of a philosopher and statesman – a sad philosopher and a sad statesman. In its presence we feel the sober truths about the English governing class, its wide and ruinous scepticism, its remaining pillars of responsibility and reason. We feel the dark belief in the dignity of England, which has outlived all other beliefs.'

DAME LAURA KNIGHT (1877–1970)
Self-Portrait with Nude Model 1913
Canvas, 152.4 × 127.6 cm / 60 × 50¼ in. Signed

Laura Knight had a long and productive career, becoming the first woman in the modern era to be elected a member of the Royal Academy (1936) – her predecessors being Angelica Kauffmann and Mary Moser who were founding members in 1768. Both Laura and her husband, Harold, who was also an artist, were trained at Nottingham School of Art, but worked for long periods at Staithes in Yorkshire and notably Newlyn in Cornwall, followed by periods in London and Colwall near Malvern.

Wit and intelligence cleverly combined

Laura Knight was attracted to outdoor subjects in Cornwall ('simple truth of nature'), particularly bathers and landscapes full of shifting light, but she also became interested in theatrical subjects and those relating to circus and gypsy life. Pursuing a career to some extent parallel to that of Sir Alfred Munnings, of whom she was a friend, and Augustus John, she liked large canvases full of flamboyant brushwork and exuberant movement. Her pictures, however, were always carefully prepared and preceded by a quantity of studies. She became an official war artist during the Second World War, culminating in her depiction of the war criminals' trial at Nuremberg (Imperial War Museum).

This *Self-Portrait* is, I think, remarkably clever and typical of Knight's measured approach to her subject-matter. The emphasis on the importance of the nude (seen full-length) is a fair reflection of her priorities in art, just as the treatment of light and spatial

divisions honour her love of Dutch 17th-century painting. The artist, on the other hand, shows herself in three-quarters length from the back, while her face is seen in sharp profile. A surprising aspect is her mode of dress, which seems formal (or semi-formal) and includes a hat: strange attire for working in a studio.

GRAHAM SUTHERLAND (1903–80)
Baron Clark of Saltwood 1963–64
Canvas, 54.6 × 45.7 cm / 21½ × 18 in. Signed and dated

This portrait was born of the friendship formed between two people who in their different ways dominated the world of British art during the middle decades of the 20th century. It is included here because of my unalloyed admiration for Kenneth Clark (1903–83), who in the words of another inspiring museum director, Sir David Piper, 'made art accessible to a whole generation as no other English-speaking writer was able to do'.

Clark's main spheres of activity early on were in museum life (Keeper of the Department of Fine Art at the Ashmolean Museum, Oxford, then Director of the National Gallery at the age of thirty-one, and Surveyor of the King's Pictures). He was also the author of numerous catalogues, monographs and surveys of art written in lucid, elegant, lapidary prose (notably *The Gothic Revival, Landscape into Art, The Nude, Leonardo da Vinci, Piero della Francesca*). Later he gained a reputation as a television presenter, most famously of the series *Civilization* (1969). He was an important link with the pioneering art historian Bernard Berenson, whom he assisted for two years at Villa I Tatti near Florence at the start of his career and who helped him to develop his powers of connoisseurship.

'Let us now praise famous men, and our fathers that begat us'

ECCLESIASTICUS, 44:1

Regardless of his success, and in spite of his outwardly urbane manner, Clark was often detached and aloof. Even so, he was a generous patron, and from the outset supported artists including Henry Moore, Graham Sutherland and John Piper. He seems to have regarded his writings as his most important contribution: 'I will confess that the few passages – there are some in *The Nude, Piero della Francesca* and even in *Rembrandt and the Italian Renaissance* – in which I feel I have been lifted off my feet, are the things which (except for my family) have given me the most pleasure in my life.' This can be tested by reading the concluding paragraphs of *Piero della Francesca* or *Civilization*.

For a British artist Sutherland's work is characterized by a rare intensity, particularly in his depiction of the landscape and of natural forms which combine stylistic elements inspired by Romanticism and Surrealism. This same intensity is also evident in his treatment of religious subjects.

Sutherland began to paint portraits – some of them controversial – in 1949. Clark is appropriately posed in profile, reminiscent of portraits by Italian Renaissance artists such as Piero della Francesca. As an image it is well drawn and acutely observed, notably in the tilt of the head and the heavy-lidded eyes.

ALLEN JONES (b. 1937)
Darcey Bussell 1994
Canvas, 182.9 × 152.1 cm / 72 × 59⅞ in.

The perfect
partnership

The commissioning of Allen Jones to paint Darcey Bussell (b. 1969) at the height of her career is a cause for celebration. Jones had demonstrated early in his career his facility in both painting and sculpture to bend or manipulate the female form into a variety of positions, while Bussell rose to prominence in a profession that demanded an exacting programme of training for the attainment of physical perfection. It was a good pairing.

Jones had two spells at Hornsey College of Art, either side of a year (1959–60) at the Royal College of Art where he overlapped with R. B. Kitaj and David Hockney. Although now based in Britain, he has lived and taught in America and Germany, involving himself in painting, sculpture, printmaking and theatre design (for example, *Oh! Calcutta* in 1969–70). While his style contains elements of Pop Art, the rationalization for his work (which is often misinterpreted) lies in philosophy (Friedrich Nietzsche) and psychoanalysis (Sigmund Freud and Carl Jung). Thus the artist is not afraid to acknowledge the erotic potency of the female body (especially the legs) or its trappings (high heels, stockings, PVC) as his muse.

Bussell began dancing fairly late, emerging from the Royal Ballet School in 1987, when she joined Sadler's Wells Ballet for a single season. She transferred to the Royal Ballet in 1988 and the following year was made the youngest Principal ever. Closely associated thereafter with the work of the choreographer Sir Kenneth MacMillan, she created many new roles, as well as successfully dancing the full range of the classical repertoire and experimenting with modern dance. Bussell retired as Principal in 2006, but remained dancing as a Guest Principal Artist at the Royal Ballet. Her final performance was given at the Royal Opera House on 8 June 2007, and featured MacMillan's *Song of the Earth* as her farewell.

Jones depicts the dancer's face and legs in silhouette, while twisting her torso slightly as if she were about to pirouette. Height is emphasized by the low viewpoint, suggesting that she is seen from the front row of the stalls across the orchestra pit. Positioning her

on her points suggests her technical skill, but it also introduces an element of tension. Linearity is the key to the image, but colour, too, has a role, differentiating parts of the body against a diaphanous background of broadly brushed strawberry red and creamy white, revealing Jones's debt to German Expressionism and American Abstract art. The handling of the colour is exuberant and distinctive.

It is a magical portrait because it captures the beauty of one of the most physically exacting art forms, where poise and control can all too easily be overcome by exhaustion.

STEPHEN CONROY (b. 1964)
Sir Jonathan Miller 1999
Canvas, 182.9 × 121.9 cm / 62 × 43 in. Signed and dated

Many of the commissions made by the National Portrait Gallery are done in conjunction with the annual exhibition for the Portrait Award. Conroy attended Glasgow School of Art (1982–87) and quickly established himself as a powerful figurative painter. His rather sombre style suits this depiction of a brooding figure who has been given the traditional pose of melancholy.

Jonathan Miller (b. 1934) studied natural sciences and medicine at Cambridge University before specializing in pathology at University College Hospital in London. At the same time, his skill as a humorist and impersonator led to his participation in the epoch-making satirical review 'Beyond the Fringe' (1960). The pattern of Miller's life has followed this division between science (neuropsychology with a Research Fellowship at Sussex University) and a career in the arts, although in the public's mind it is his activity as a maker of documentary television programmes during the 1970s and subsequently as a director of plays and opera that has been the more visible outlet for his mental agility. As with Anton Chekhov, also a doctor by training, the connection between Miller's various pursuits is the ability to observe, the recognition of the relevance of

what is observed, and then to give what has been observed, however insignificant, the semblance of permanence.

Miller's distinctive appearance ('built like an Anglepoise lamp') and somewhat manic energy (unruly hair, torrential flow of words, surrealistic humour) are played down by Conroy, who emphasizes the more reflective side of his character. Since Miller is himself the great-nephew of the French philosopher Henri Bergson and since one of the funniest sketches in 'Beyond the Fringe' involves a hilarious spoof of Bertrand Russell and G. E. Moore, this characterization seems remarkably apt.

TATE

The establishment of the Tate Gallery (now known simply as Tate) was as seren-dipitous as the foundation of the National Gallery. From the start the building in Trafalgar Square had included British paintings, but the increasing number of important collections of such pictures (many of them by contemporary artists) made it difficult to maintain a proper balance between the British School and works by international painters for which the National Gallery was now becoming famous. Added to this was the complication of the mass of material bequeathed to the nation (ostensibly therefore to the National Gallery) by the country's most famous artist, J. M. W. Turner, for which there was insufficient space in Trafalgar Square.

The need for a 'National Gallery of British Art' rapidly became clear and it was promoted by the philanthropist Sir Henry Tate (1819–99), who had made his fortune in sugar refining. Tate himself had formed a collection of contemporary British paintings in accordance with his rather conservative taste, and in offering it to the nation he was anxious for it to be properly housed. The site of the old penitentiary at Millbank (once the largest in Europe) on the north bank of the River Thames upstream from Westminster was eventually chosen and an architect, Sidney R. J. Smith, commissioned to execute the design in a suitably dignified classical style. The building was opened in 1897. The name by which the gallery is formally known today came about by popular demand, although it was not officially designated as such until 1932.

The Tate Gallery evolved slowly over a lengthy period, reflecting uncertainty over its exact purpose. On an administrative basis it remained answerable to the National Gallery until 1917, when it was granted its own constitution and some degree of inde-pendence. Full independence, however, was delayed until 1954. Of course, the National Gallery retains an important though necessarily limited representation of pictures by British artists, including Hogarth, Gainsborough, Reynolds, Stubbs, Constable and Turner, the purpose being to show these in the context of European art as a whole.

Many of the problems faced by the Tate Gallery over the ensuing years resulted from one of those famous British compromises whereby it was ordained that the Tate Gallery should house not just works by British artists but also the nation's collection of modern international art. This situation led to growing confusion and increasing pressure on space that was only resolved by the creation of Tate Modern in 2000. The points of emphasis accruing from the overlaps between the National Gallery and the Tate Gallery were left as matters of adjustment settled by the Directors of each institution – as still happens today.

The first major extension was financed by the art dealer Sir Joseph Joel Duveen to accommodate a selection of paintings by Turner. These new galleries opened in 1910,

but it was Duveen's son, also Joseph Joel, who made a far greater impact on the spatial organization of the building. This second Duveen (later significantly to become Lord Duveen of Millbank) was not only the leading dealer in old masters of his day, but also a generous benefactor of many of Britain's leading public art institutions – a role that is sometimes forgotten. The Duveen Galleries at Millbank, built for what was termed 'Modern Foreign' art (which included a whole room devoted to John Singer Sargent), were opened in 1926. What then ensued in 1937 was even more significant for today's visitors – the building of the commanding axial gallery extending from the rotunda at the entrance to the central octagon screened by Ionic columns and continuing for a similar distance beyond. Originally intended for the display of sculpture, this is now the main artery of the building on the upper level, off which the principal galleries are distributed, and lends itself to multifarious uses.

Further expansion to the Tate Gallery occurred in 1979 with a new set of galleries on the north-east side designed by Richard (later Lord) Llewellyn-Davies for the display of what was designated the 'Modern Collection'. This was followed in 1987 by the opening of the Clore Gallery to the east of the main building, specifically to house the paintings and drawings of J. M. W. Turner. This extension was designed by James Stirling and to all intents and purposes finally resolved the long-running saga over the artist's will. More recently still, the architects John Miller and Partners were invited to create a new entrance on the west side off Atterbury Street, which was opened in 1997 as part of the centenary celebrations; it was subsequently named the Manton Entrance in memory of one of the museum's more recent benefactors, Sir Edwin Manton. Just inside this entrance and part of the same project are the Linbury Galleries (donated by Sir John and Lady Sainsbury through their charitable fund the Linbury Trust) for temporary exhibitions and the fine staircase leading to the new galleries on the principal level, also created by John Miller and Partners, filling the original north-west quadrangle.

Under its more recent directors the Tate Gallery has established the principle of creating outstations, in part to make the collections better known and in part to relieve pressure on the main building at Millbank. The first of these hubs was Tate Gallery Liverpool (originally called 'Tate in the North'), situated on Albert Dock, transformed into a gallery by James Stirling and opened in 1988. Suitably, Liverpool was the headquarters of Sir Henry Tate's sugar-refining business – Tate and Lyle. Then came the second hub, at St Ives in Cornwall, overlooking Porthmeor Beach on the site of a derelict gasworks in the centre of the town. The Tate had already assumed responsibility (in 1980) for the Barbara Hepworth Museum and Sculpture Garden located in the same town, and so the siting of another gallery for modern art (albeit on a fairly intimate scale) was logical. Tate St Ives was designed by David Shalev and Eldred Evans and opened in 1992.

All of these developments, however, were comparatively minor when seen in the context of the announcement made in 1994 that the Tate Gallery would convert the power station at Bankside opposite St Paul's Cathedral for the display of its collection of modern art. Designed by Sir Giles Gilbert Scott and built between 1948 and 1963, it had been decommissioned and was in danger of being demolished. The decision to convert it into a gallery was the most daring and imaginative idea that the British art scene has experienced in living memory. The architects appointed to redesign the interior were the Swiss firm of Herzog & de Meuron, who in the light of their successful adaptation are now charged with building an extension. As an undertaking the conversion is comparable with the creation of the Musée d'Orsay in Paris, but in many respects the designated gallery spaces within the power station have proved more suitable for art than those offered by a former railway station. The creation of Tate Modern was the Tate Gallery's millennium project of 2000 and surpassed all expectations. It has proved immensely popular and influential, transcending even the aspirations that the Director, Sir Nicholas Serota, voiced at the opening ceremony.

The advantages of creating Tate Modern were manifold. The overcrowding at Millbank was eased, and the division of the collection between British art and international modern art clarified. And there were benefits on a wider basis. The re-use of Bankside helped in the regeneration of Southwark and other areas on the south bank of the Thames, just as the building of the Millennium Bridge provided pedestrian access across the river. Similarly, the launch of the Tate Boat running between Tate Britain at Millbank and Tate Modern at Bankside carrying art lovers between the two galleries is a welcome return to the use of this famous waterway in earlier centuries as so vividly depicted by Canaletto in the mid-18th century in his views of London.

In both Tate Britain and Tate Modern a policy of changing displays has been initiated. These are usually arranged thematically as opposed to chronologically, and reflect changing attitudes to art history as much as the personal taste of individual curators. The chief benefit is that more of the collections can be seen, and often in an enlivening way with fascinating juxtapositions.

TATE BRITAIN

Tate Britain houses British art from the 16th century to the present day. I am moved by the shrapnel marks in the walls dating from the Second World War seen when approaching the Manton Entrance; by the bronze statue of Sir John Everett Millais – a friend of Sir Henry Tate's – standing guard on the pavement at the north-west corner; by the magisterial quality of the central Duveen Gallery contrasting with the slightly quaint murals in the restaurant by Rex Whistler, entitled *The Expedition in Pursuit of Rare Meats* (1926–27); and the view from the portico over the Thames.

DAVID DES GRANGES (1611/13–?75)
The Saltonstall Family c. 1636–37
Canvas, 214 × 276.2 cm / 84½ × 108¾ in.

To begin at the beginning

The treatment of such a subject on this monumental scale is most unusual. The explanation lies in a possible relationship with the tomb sculpture made for churches, where in the 17th century the living also very often inhabit the same space as the dead. The standing figure of Sir Richard Saltonstall (1595–1650) dominates a composition showing a bedchamber where the walls are lined with tapestries. He draws back the curtain to reveal his first wife, who had died in 1630. Her gesture seems to indicate the two children alongside Sir Richard, who are probably her own. The seated woman on the right must be his second wife, Mary, whom he married in 1630. She holds the latest addition to the family.

The painting appeals today because of its very literal representation, which is purely dynastic in intent, indicating the continuation of the Saltonstall line. David Des Granges was a reputable miniaturist, or painter 'in small', and this is the only known large painting by him. All the more strange that it is on such a huge scale. It would be easy to dismiss the style of the figures as unsophisticated, but in fact the depiction of the children on the left shows knowledge of Van Dyck's work for Charles I. Most of Des Granges's surviving work was for supporters of the royalist cause.

The Saltonstall Family thus represents the birth pangs of the British school of painting, which arose out of a combination of native talent and Continental influence.

GEORGE STUBBS (1724–1806)

Haymakers 1785
Wood, 89.5 × 135.3 cm / 35¼ × 53¼ in. Signed and dated

Reapers 1785
Wood, 89.9 × 136.8 cm / 35¼ × 53⅞ in. Signed and dated

There has been a danger until recently to assess the art of George Stubbs in very narrow terms, namely the horse. He was undoubtedly an extremely skilful painter of horses and an accurate recorder of all aspects of equestrian life, including hunting and racing, but his range also extended across portraiture and landscape to wild animals (see p. 370). The only categories that he seems not to have explored to any serious degree are history painting and literary subjects, although this might just be an accident of survival. An added variety comes from his ability to work on different scales, extending from the life-size to small ovals. Underpinning Stubbs's art is a scientific curiosity exemplified by the amount of dissection he undertook culminating in his publication *The Anatomy of the Horse* (1766) and in his use of enamel paints on Wedgwood biscuit earthenware in addition to the more traditional application of oil on canvas or wood.

Stubbs was born in Liverpool and spent the first part of his working life in the north of England at York and Hull, gradually moving southwards through Lincolnshire before establishing himself in London by 1760. A visit to Italy in 1754 was brief. He achieved considerable success with royal and aristocratic patrons from the 1760s onwards, being elected President of the Society of Artists in 1772 and a member of the Royal Academy in 1781. One of the most engaging features of Stubbs's art is his interest in all levels of society, often expressed with gentle humour without any hint of satire. It is perhaps characteristic of the artist that unusually we even know his weight (13 stone 12 lbs / 83.5 kg in 1782). Although Stubbs was much admired, his life was not without financial difficulties. He lived to the age of eighty-one.

Reapers and *Haymakers* were painted as a pair in 1785. Although each scene has been carefully plotted and the poses meticulously arranged, the overall impression is one of naturalness. Stubbs is always a very clear and direct painter.

The composition of *Reapers* reads like a low-relief sculpture and that of *Haymakers* depends on a pyramid. The figures in both paintings perform as if in a ballet. Life in the country was harsh during the 18th century and it could be said that Stubbs has idealized these two scenes. However, he was perhaps more concerned to depict the dignity of labour in the manner of Arthur Young's contemporary descriptions of rural life in Britain.

Although the topography is not recognizable, the church and the farm manager in *Reapers* indicate some sense of social hierarchies. The treatment of light and the tonal qualities of the landscape backgrounds heighten the poetic quality of these pictures. Individual figures stand out – the women at the centre of each composition, the man silhouetted against the sky in *Haymakers*, and the farm manager on horseback in *Reapers*.

A quintessential
British painter

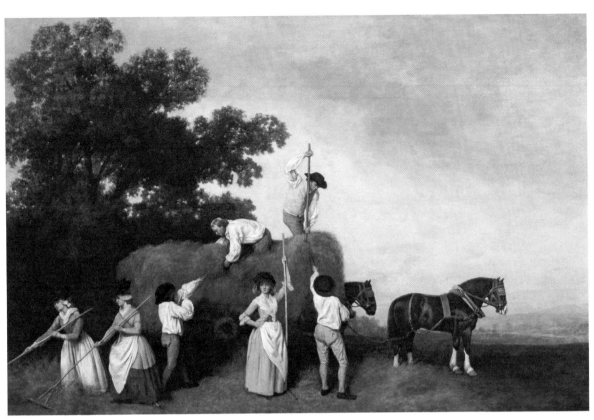

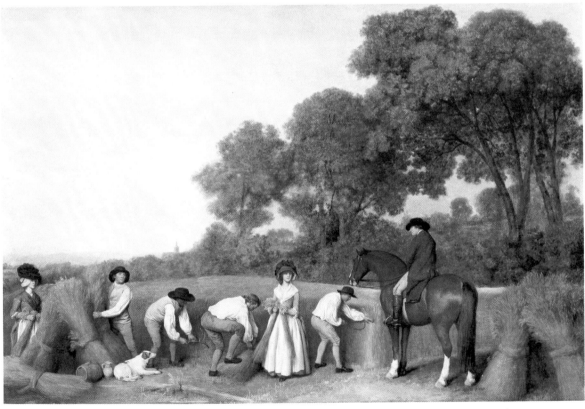

SIR JOSHUA REYNOLDS (1723–92)

Three Ladies Adorning a Term of Hymen 1773

Canvas, 233.7 × 290.8 cm / 92 × 114½ in.

No artist did more to establish a British school of painting than the first President of the Royal Academy, a post to which Reynolds was appointed on its foundation in 1768. Born in the West Country near Plymouth, the son of a schoolmaster, and trained in London, Reynolds was deeply influenced by his protracted visit to Italy (1749–52). The works that he saw there – Classical, Renaissance, Baroque – became the yardstick for his own work, which concentrated on the search for a universal truth in art. Reynolds regarded his 'borrowings' from the past as a way of achieving grandiloquence and revelation: they do not indicate any lack of imagination. Although in his all-important and often eloquent discourses (lectures delivered in his Devonian accent to the students of the Royal Academy between 1769 and 1790) primacy was given to history painting, Reynolds's own reputation rested on portraiture, which he lifted to new heights. The aim in his portraiture was to give a sense of permanence to the fleeting and of substance to the immaterial.

Reynolds never married, but he was a most sociable being and the prime mover in the Literary Club formed in 1764 to which leading writers, actors, musicians, and politicians of the day belonged. He also entertained a great deal at home and devised several ingenious methods to keep his name before the public. At the same time he worked extremely hard, and an inspection of his sitter books reveals a punishing schedule. Like his rival Thomas Gainsborough, he painted most of the leading members of society, but unlike Gainsborough he preferred city life to the country. Increasing deafness and deteriorating sight heralded Reynolds's death, when he was accorded burial in St Paul's Cathedral.

Three Ladies adorning a Term of Hymen is one of the artist's largest and most audacious demonstrations of what he hoped to achieve in portraiture. In adopting what he referred to as his 'great style' Reynolds elevated straightforward portrait painting on to a higher level. The occasion for this picture was a commission from a Member of Parliament, Luke Gardiner, to mark his marriage in 1773 to Elizabeth Montgomery, one of the three daughters of Sir William Montgomery, all of whom are shown together in this painting as the Three Graces. Barbara is on the left gathering flowers and Elizabeth in the centre handing a garland of flowers to Anne on the right, who decorates a statue of Hymen, the Roman god of marriage. The theme is thus, as might be expected, a celebration of marriage. Reynolds arranges the figures on a diagonal that makes the composition seem deliberately and solidly structured, suggesting that the painting was intended for an important position in a specific building. Apart from the arrangement of the figures, he gives each of the sisters one of his 'historical attitudes' taken from earlier French or Italian sources, which contemporaries in the mid-18th century would in all probability have recognized. Although all three of the likenesses are individual and the hairstyles are of the period, the design of the dresses is essentially timeless.

Enter the first President of the Royal Academy of Arts

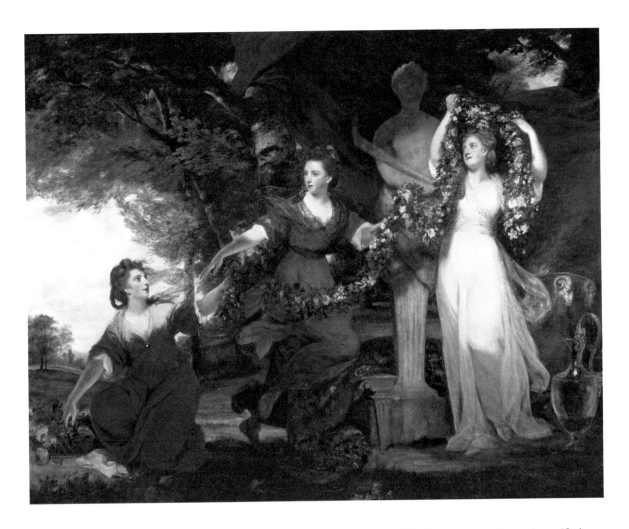

Reynolds is seen at his best in this painting of the Montgomery sisters. The unified composition is derived not simply from the poses but also from the treatment of the light flickering across the surface and the warm colours. Neither are the landscape elements – flowers, trees, fields – neglected, which shows how efficient Reynolds was in all departments of his art. 'Damn the man, how various he is' was how the exasperated Gainsborough expressed it.

JOSEPH MALLORD WILLIAM TURNER (1775–1851)
England: Richmond Hill on the Prince Regent's Birthday 1819
Canvas, 180 × 334.6 cm / 70⅞ × 131⅞ in.

A Titan of the age

J. M. W. Turner was the greatest artist working in Britain during the 19th century. By rights his works deserve to enter the nation's visual consciousness at an early stage in life, since he has not only achieved international significance, but is also recognized as having made a major contribution to the development of art as a whole.

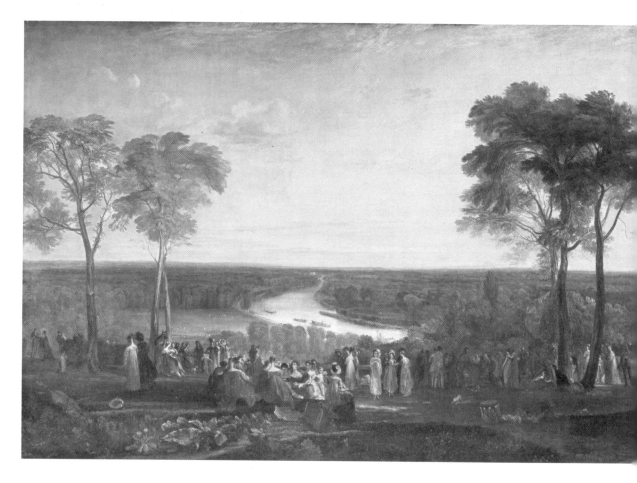

Turner painted a great deal and the Turner Bequest of 1856, now housed mainly in the Clore Wing of Tate Britain, which officially includes some 300 oil paintings (100 of them technically described as 'finished') and some 1,900 watercolours and drawings, gives a sense of the huge output resulting from a lifetime's total dedication to painting.

Turner was born in London in Covent Garden, the son of a barber and wig-maker. To a certain extent he was a prodigy, attending the Royal Academy schools from 1789 when he was fourteen and exhibiting there for the first time the following year. His election to Royal Academician occurred in 1802 when he was only twenty-six. He remained loyal to the Royal Academy throughout his life, becoming Professor of Perspective in 1807. On his death he was buried in St Paul's Cathedral close to Reynolds and Sir Thomas Lawrence – both former Presidents of the Academy whom he had known.

The essence of Turner as an artist was his awareness of tradition and his determination to surpass the achievements of his predecessors. He certainly admired the work of Poussin, Claude, Salvator Rosa, Willem van de Velde the Younger, Rembrandt and Watteau. But at the same time his own observations of nature derived from his frequent travelling, both in his own country and on the Continent (especially his numerous

crossings of the Alps). These experiences encouraged him to essay grandiloquent themes requiring him to push his technique both in oil and watercolour to its limits. He was inspired by history and literature as much as by the forces of nature, and it is often the fusion of these two aspects that makes his mature work so powerful. Even though so deeply immersed in the past, Turner celebrated modernity and accepted it as part of the advance of man. As a landscape painter he transcended topographical delineation and wrestled with the Sublime, and it is this struggle (technical as much as intellectual) that sometimes gives so many of his paintings the appearance of alchemy.

Turner himself was intensely private. He had few friends, of whom several were his patrons. A man of contrasts, he could swing from being friendly to cantankerous or from being generous to meanness. He never lost his cockney accent. John Constable reported of Turner that he was 'uncouth but has a wonderful range of mind'. In appearance he was short, often scruffily dressed, and increasingly corpulent. A comparison with Beethoven comes to mind – that other great figure of the Romantic age.

Richmond Hill on the Prince Regent's Birthday was an intensely personal picture for Turner, and it is also one of the largest canvases he ever painted. He exhibited it at the Royal Academy in 1819, but it was unsold. At the Academy he had provided an accompanying text from James Thomson's poem *The Seasons* referring to 'the matchless vale of Thames', which was indeed one of the most famous views in England at the time, and it was also an area that the artist himself knew well, since he had built a country villa, Sandycombe Lodge, near Twickenham. Subsequently, the painting was hung on the walls of the private picture gallery he had had built as an extension to his house in Harley Street, and it was in front of this picture that his coffin was placed before his funeral.

The repoussoir effect of the trees and the nectar quality of the light are in the manner of Claude, while the wraith-like figures, becalmed by the beauty of the setting or else self-absorbed in their own alembicated existences, evoke the spirit of Watteau.

There is added significance in the title, since the Prince Regent (later George IV) officially celebrated his birthday on 23 April, which was also St George's Day, as well as the birthday of Shakespeare and of the artist himself. Such interconnections – here personal rather than historical – are typical of Turner, who on this occasion in celebration elects to depict an idealized image of a peaceful Britain in the aftermath of the Napoleonic Wars.

RICHARD DADD (1817–86)
The Fairy Feller's Master-Stroke 1855–64
Canvas, 54 × 39.4 cm / 21¼ × 15½ in.

This elaborate painting was made in the saddest circumstances, following the artist's incarceration in the lunatic asylum attached to Bethlem Hospital in Southwark (now the site of the Imperial War Museum). Dadd was certified insane after stabbing his father

to death in 1843 and remained locked away for the rest of his life, first at the Bethlem Hospital and, after 1864, at the newly opened asylum at Broadmoor in Berkshire.

Dadd made a promising beginning to his career at the Royal Academy Schools where he became friends with several painters – W. P. Frith, Augustus Egg, John Phillip among them – who were later to become famous artists. Dadd was also a considerable scholar and a keen Latinist. It was natural that his earliest forays into painting should have scenes from history and literature as their subjects. He was acknowledged early on as a superb draughtsman, being especially able at depicting the nude, and he developed a remarkably refined style as a watercolourist.

Signs of mental instability were manifest in 1842 while on an extended tour of Europe and the Near and Middle East as the official artist and travelling companion of a wealthy lawyer, Sir Thomas Phillips: Dadd feared that he was pursued by evil spirits and that his actions were controlled by the Egyptian god Osiris. While incarcerated after his return he continued to paint in oil and watercolour (including a long series entitled 'Sketches to Illustrate the Passions') relying on his memory and sketchbooks, but he was also encouraged by enlightened staff at Bethlem Hospital to return to traditional subject-matter, including portraiture.

During the early part of his career Dadd had gained a considerable reputation for fairy painting – a type of picture much appreciated by the Victorians in view of the contemporary debate on theological and scientific issues. Dadd was also inspired by Shakespearean subjects (mainly from *A Midsummer Night's Dream* and *The Tempest*).

The Fairy Feller's Master-Stroke was painted for George Henry Haydon, the Steward of Bethlem Hospital, over a period of years (1855–64). The style is meticulous, almost microscopic, and the patterned surface with no horizon line resembles embroidery. It teems with a multitude of figures watching the fairy woodsman (the 'feller' of the title) waiting to axe a hazelnut on the order of the patriarch hiding under his hat in the centre. The numerous figures of varying sizes, representing a cross-section of society, are identified for the most part in a poem written by Dadd in 1865. The picture is as much a homage to nature as to the artist's imagination and the viewer feels compelled to reach for a magnifying glass for fear of missing something. There is possibly a kinship with Lewis Carroll's *Alice's Adventures in Wonderland* (1865) and *Through the Looking-glass* (1872).

Owing to Dadd's circumstances, which his sister Mary Ann described as 'a living death', his work was largely forgotten until the second half of the 20th century. *The Fairy Feller's Master-Stroke* was owned by the poet Siegfried Sassoon and presented by him to the Tate Gallery in 1963 in memory of the artist's great-nephews, two of whom had been killed in the First World War, while the third, Julian, had been Sassoon's friend and fellow officer in France (1st Battalion of the Royal Welsh Fusiliers) and had survived, only to commit suicide later. Julian Dadd is commemorated as Julian Durley in Sassoon's *Memoirs of a Fox-Hunting Man* (1928).

ARTHUR HUGHES (1832–1915)

April Love 1856

Canvas, 88.9 × 49.5 cm / 35 × 19½ in. Signed and dated

The artist was closely associated with the Pre-Raphaelites, whose style he adopted early in his career. His first paintings, of which *April Love* is one, have in common with those of John Everett Millais, William Holman Hunt, Dante Gabriel Rossetti and Ford Madox Brown vibrancy of colour, close observation of nature and love of narrative. Hughes, however, failed to sustain the intensity of his early work throughout his long life and found it difficult to retain his popularity. He did not always succeed in having his work publicly exhibited, relying instead on a group of loyal patrons. A prolific book illustrator, he was a modest man who was too often condemned with faint praise.

An enigmatic meeting

April Love, however, was extremely well received when it was shown at the Royal Academy in 1856. The leading critic of the day, John Ruskin, was a firm champion of the young Pre-Raphaelites and wrote a glowing review of this picture: 'Exquisite in every way; lovely in colour, most subtle in the quivering expression of the lips, and sweetness of the tender face, shaken, like a leaf by winds upon its dew, and hesitating back into peace' (*Notes on some of the Principal Pictures exhibited in the Rooms of the Royal Academy*, 1856, p. 34). The vibrant blue of the dress stays in the memory.

The subject of the various stages of the course of young love was popular in Victorian art, and several of the Pre-Raphaelites explored the theme. *April Love* is enigmatic, as the young woman turns away from the suitor kissing her hand. The stooping male figure is placed in shadow and is difficult to make out at first – indeed he is slightly sinister. The format of the painting is perfectly chosen, emphasizing the slender figure of the young woman and the feeling of enclosure within a private meeting place. Hughes himself referred to the picture by several titles while painting it – '*The Lovers' Quarrel*' and '*Hide and Seek*' – and ultimately exhibited it accompanied by a quotation from Tennyson's

poem 'The Miller's Daughter', though it is unlikely to be a specific illustration of the poem. The symbolism would have been easily interpreted by Victorian viewers. The rose represents love and the ivy everlasting life. The fallen rose petals in the foreground signify the fragility of love or even lost love.

The model for the young woman was the artist's wife, Tryphena, whom he married in 1855 after an engagement lasting five years, an event that Hughes commemorated in another beautiful early painting, entitled *The Long Engagement* (Birmingham Museum and Art Gallery). The model for the young man was Alexander Munro, a sculptor and close friend of the artist. *April Love* was bought at the time of its exhibition at the Academy by Edward Burne-Jones on behalf of William Morris, exemplifying the strong sense of camaraderie in the early years of the Pre-Raphaelite movement.

JOHN WILLIAM WATERHOUSE (1849–1917)
The Lady of Shalott 1888
Canvas, 153 × 200 cm / 60¼ × 78¾ in.

An icon of the
Victorian world

This painting formed part of the collection of Sir Henry Tate, the founder of the Tate Gallery, who acquired it at the time of the Royal Academy exhibition of 1888. Waterhouse gained a massive reputation for his depiction of Classical and mythological subjects, often on a large scale, but after 1900 when narrative painting based on literary sources went into decline he undertook more portraiture and cultivated less specific themes that lent themselves to Symbolist interpretations. As was the case with many comparable artists (for example Sir Lawrence Alma-Tadema, Albert Moore and Lord Leighton), Waterhouse's work fell dramatically from favour after his death and has only recently been reassessed.

The Lady of Shalott is based on the famous poem by Tennyson. It was a subject that had been popular with the Pre-Raphaelites and Waterhouse himself painted it several times. Tennyson's poem is set in the world of Arthurian legend, although no such figure as the Lady of Shalott occurs in Sir Thomas Malory's translation of *Le Morte d'Arthur*.

The Lady of Shalott's castle is on the road leading to Camelot, where King Arthur had established his court. A curse laid on her means that she is condemned to view passers-by only in a mirror, and she spends her time weaving images of such scenes into a magic web. Her mistake is to look directly at the handsome Sir Lancelot as he passes on the road outside: the mirror cracks and her web unwinds so she can no longer live in her own magical world and has no hope of survival in the real world.

It is the dénouement of the story that Waterhouse does full justice to in this painting, as the Lady of Shalott leaves her castle to die on the way to Camelot. He plays down symbolic interpretation and emphasizes the narrative elements. She is shown dressed in white, a sorrowful figure still youthful with long hair and parted lips. Her castle is dimly

visible to the left of the stone steps from where she has cast off her boat to begin her slow journey. She is sitting on a pink shawl decorated with scenes of life at Camelot that she will now never experience for herself. On the prow of the boat is a crucifix, implying her spirituality and pending martyrdom, together with three candles, two of which are already snuffed out, suggesting her imminent demise. The image is undeniably sensual and the dominance of the figure fits into the pattern of those *femmes fatales* that so preoccupied artists towards the end of the 19th century.

Waterhouse was an excellent figure draughtsman, but what is surprising here is the treatment of the landscape, which is almost Impressionistic in the handling of the foreground and reveals the influence of *plein-air* French painting. Apart from French art, you could be forgiven for overhearing strains of the *Liebestod* from Wagner's *Tristan and Isolde* (1865).

DAVID HOCKNEY (b. 1937)
Mr and Mrs Clark and Percy 1970–71
Canvas, 214 × 305 cm / 84 × 120 in.

A champion
of our times:
the golden boy

The artist was born in Bradford. His father was an accountant's clerk with radical political views and eccentric habits; his mother a strict vegetarian, teetotaller and committed Methodist. Although he has spent many years in Los Angeles, his upbringing in Yorkshire and his parental background have been a marked and continuing influence. The portraits done of his mother over the years until her death in 1999 are in some ways comparable with Rembrandt's series known as 'The Artist's Mother'.

Hockney attended the Royal College of Art (1959–62) and began his long association with California two years later. For most of his working life he has been a figurative artist and only towards the very end of the 1990s did he begin to concentrate on landscape in addition to portraiture.

Versatility is Hockney's hallmark as an artist, matched by an irrepressible curiosity for all aspects of life. Besides paintings he has made numerous finished drawings, illustrated the poems of C. P. Cavafy and the fairy tales of the Brothers Grimm, as well as designing a production of Stravinsky's *The Rake's Progress* (1975) for the Glyndebourne Festival Opera. This wide range of subject-matter is matched by a fascination for different types of media. Oil, acrylic, colour crayons, pen and ink, photocollage, Polaroid composites are all grist to his mill. Given this omnivorous appetite for art it is hardly surprising that Hockney is a keen admirer of Picasso, with whom he shares a hunger for inventiveness and technical adroitness.

The mood of Hockney's paintings is one of optimism. The light-filled canvases seem to exude a sense of joy derived from the pleasure of simply being alive. Tate Britain's collection includes *The First Marriage* (1962), *A Bigger Splash* (1967) and *My Parents* (1977), but my choice here has been made on the basis that *Mr and Mrs Clark and Percy* is very much an image of London in the late 1960s and early 1970s – a time, paradoxically, that Hockney himself stood apart from since he was then living mostly in America. The sitters are the fashion designers Ossie Clark (1942–96), another hugely successful fellow student at the Royal College of Art, and the textile designer Celia Birtwell (b. 1941), who studied at Salford Art School and remains a friend of the artist, continuing to sit for him today. Hockney was best man at their marriage in 1969 and this painting followed as a wedding gift. It is, in fact, the equivalent in Hockney's œuvre of Van Eyck's *Arnolfini Portrait* (see p. 23). Ossie Clark became a business partner in the fashion boutique Quorum until 1974. His marriage to Celia Birtwell was short-lived, but his association with many of the leading figures from the world of music, stage and film continued until his early, tragic death by murder.

The double portrait is a difficult and testing format – both Rembrandt and Hals painted only a very few – but it is one that Hockney has handled with great aplomb. The

figures are nearly life-size. For some reason the head of Ossie Clark presented particular problems and another challenge was the contre-jour lighting effect, which involved the careful plotting of the tonal values of the interior. Overall, the technical issues stemmed from the fact that the artist had in his own words set out 'to paint the relationship of these two people'. The composition showing the figures set so far apart can be read as a prescient image.

Hockney is an extremely articulate and often witty painter: the carefully arranged poses, the precise positioning and choice selection of a few objects, and the rigid control over the acrylic paint result in a tautness and stillness which in turn promote a sense of enigma. He was very conversant with tradition and openly acknowledged his sources, and it is not difficult to see how artists as different as Piero della Francesca, Vermeer, Magritte and Meredith Frampton hover over this painting. Hockney's double portraits have been compared with scenes of the Annunciation and in the statuesque figure of Celia Birtwell, whose dress exemplifies Ossie Clark's great skill in cutting clothes to sculpt the female form, a little of Arezzo can be encountered in London.

TATE MODERN

Tate Modern concentrates on modern and contemporary work from all over the world, incorporating as many of the multifarious movements that constitute the art world today as is possible. The focal points of the collection are Surrealism, Abstract Expressionism and Pop Art; other categories are more sporadically represented. Who can fail to be impressed by this cathedral to modern art or the proportions of the cavernous interior? The entrance down the long ramp into the Turbine Hall is dramatic in the extreme, as are the views from the galleries across to St Paul's Cathedral.

PABLO PICASSO (1881–1973)
Woman in a Chemise 1904
Canvas, 72.5 × 60 cm / 28¾ × 23⅛ in. Signed and dated

A tender portrait from Picasso's Blue Period

Picasso was not just an artist, he was an artistic phenomenon. Born in Malaga in Andalusia on the southern coast of Spain, he was the son of an art teacher. He received his first formal training in Barcelona, but Paris soon became the centre of his world: he settled there in 1904 (even remaining there for the German occupation during the Second World War) and rarely thereafter returned to Spain. His association with avant-garde artists, musicians and writers in Paris provided him with a stimulating environment in which he could develop a whole new range of styles, such as Cubism in 1907–8 with Georges Braque. After purchasing a villa near Antibes in 1948 he transferred his affections to the south of France, where Matisse also lived.

Picasso cannot be easily categorized as an artist: his output was prolific and his talent prodigious. Few painters were as creative or as anarchic in their approach to art, absorbing earlier styles (for instance Primitivism, Classicism, Surrealism), feeding off contemporaries, and establishing new parameters. The fertility of his genius and the intensity of his visual endeavour were mirrored in the tenor of his personal life and matched by an outpouring of art that spanned paintings, sculpture, drawings, prints, ceramics and designs (his œuvre amounts to some 20,000 items). Picasso is the kind of artist who respected tradition, but who at the same time needed to destroy it for the purposes of reinventing it. Ransacking and pillaging art empowered him to surpass all his predecessors and rivals. Although Spanish by birth and temperament (it is no accident that his most important work is the politically charged *Guernica* of 1937) and although living for most of his life in France, Picasso was not limited by national boundaries: his art is a conduit through which almost the whole of European art flowed, to re-emerge as something different. Chameleon he may have been, but his strength lay in his ability to cross-fertilize various strands of art and by doing so reinvent himself.

Tate Modern has a limited but reasonably comprehensive group of works by Picasso. My choice here is *Woman in a Chemise,* which belongs to the final phase of Picasso's Blue Period. It coincides with his decision to move for good from Spain to Paris, where he established a studio (the Bateau-Lavoir) in Montmartre. The subject-matter of the Blue Period is intensely moving and reveals the artist's humanitarian side. He concerned himself with the poor, the destitute, the sick and the ugly, frequenting cafés, bars, brothels and hospitals.

At the time Picasso had had no long-standing relationship with a woman and had sought inspiration with a string of mistresses. *Woman in a Chemise* was one such mistress – a model called Madeleine, whose distinctive features of hair drawn up into a chignon, aquiline nose, boyishly lean body and long tapering fingers became a dominant motif in his work for a few months in 1904. Her reign, however, was short-lived as an inspirational force in Picasso's art, which depended on seizing a person or an object that could be useful to him and then discarding them or it when his purpose had been served.

Woman in a Chemise is full of tenderness, reflected in the beautifully modulated blues in the background against which the pale tones of the face and chemise are set. Even the wine red on the lips is restrained. Picasso succeeds in elevating poverty and hardship onto the level of nobility.

PIERRE BONNARD (1867–1947)

The Bath 1925

Canvas, 86 × 120 cm / 33⅞ × 47¼ in.

A modern Ophelia

At first Bonnard seems an unlikely progenitor of modern art, and indeed it has taken some time to establish his true worth as a painter – a process not helped by Picasso's aggressive denial of the artist's credentials. Bonnard initially trained in Paris as a lawyer before committing himself to becoming an artist as a founding member of the avant-garde group called the Nabis. The formative pictorial influences of Monet, Renoir and Gauguin, together with the encroachment of Symbolism, enabled him to develop a personal style characterized early on by oblique viewpoints, strong contrasts and throbbing colour. Equally compelling was the personal nature of his subject-matter, which gives his pictures an intensity and sense of privacy that is almost offputting.

Bonnard's own uncertainty about his abilities as an artist is denied by his prolific output (including drawings, prints and photographs) and meticulous working methods. Having travelled quite extensively in the first part of his life, Bonnard, like many other artists of his circle, began to feel the lure of the Mediterranean and in 1926 he bought the small Villa du Bosquet at Le Cannet, close to Cannes in the south of France. Here he achieved the perfect fusion of style and subject-matter, painting landscapes, interiors and still-lifes awash with light and colour. He lived through painting, and his work not only celebrates the beauty of his surroundings, however mundane, but combines observation with memory in the same way as Marcel Proust, whose writings he appreciated. To a large extent his compositions are reveries or intimacies in which mood and atmosphere are evoked through the interplay of light and colour. The importance of Bonnard's work for the development of modern art lies therefore as much in its inflexions and its intensity

as its technique, which differs so markedly from that of Matisse. Bonnard, it might be said, holds the balance between the figurative and the abstract.

The figure in the bath is Maria Boursin (1869–1942), known as Marthe. Bonnard first met her in 1893 and often used her as a model until she became his life-long companion. He married her in 1925 – the date of this picture. Marthe was both 'muse and gaoler', whose domestic habits and chores Bonnard diligently recorded for posterity. She appears over and over again (sometimes only glimpsed) in the paintings done at Le Bosquet, and none is as haunting as the series devoted to her going about her daily toilette. Degas lurks behind the theme of these pictures, but Marthe was no ordinary model. Illness – probably tubercular laryngitis for which hydropathy was prescribed in France at this time – dominated her daily routine, perhaps more than her anxieties about her social inferiority. She did not make life easy for Bonnard, becoming more and more reclusive and obsessive, but his loving fascination with her is clear.

The ambivalence in *The Bath* between the tight geometric arrangement of the composition and the dissolution of form, evident in the depiction of the body below the water, perhaps indicates the nature of the relationship between artist and muse. There is also a premonition of death in so far as the bath resembles a sarcophagus and the body a mummified form. It is a disturbing image and all the more so because of its measured calm.

PIET MONDRIAN (1872–1944)
Composition in Yellow, Blue and Red 1937–42
Canvas, 72.7 x 69.2 cm / 28⅝ × 27¼ in. Signed and dated

Paintings in Mondrian's mature style must be among the most recognizable in any gallery. The familiar black grid lines and patches of strong colour immediately arrest the eye. The artist would have been shocked by the way that interior designers have purloined his pictures for merchandise. Mondrian's art should not be so debased, as he had a far greater sense of purpose linked to a philosophical system that aimed to solve nothing less than the mysteries of the universe.

There is a great deal more variety in Mondrian's art, just as there was in his life, than his pictures might suggest. His early paintings of nature executed in the aftermath of Van Gogh are imbued with the spirit of Symbolism: they are characterized by rich warm colours and rhythmical brushstrokes heavily loaded with paint. Exposure in Paris to Cubism led to the seascapes of 1912–15 entitled *Pier and Ocean* with their flickering surfaces and undulating movement. After these there ensued, almost as an act of purification, the grid paintings that he began to perfect towards the beginning of the 1920s. Arrival in New York in 1940, fleeing the war in Europe, saw a dramatic change of style with a reinvigorated use of colour and a grander sense of scale, all induced by the sights and sounds of the irrepressible lifestyle of modern Manhattan.

No room for error here

Mondrian presents a paradox. He was a painter–philosopher of great determination. It would be a mistake to describe his pictures as sterile or devoid of passion. On the contrary, they are the work of a man who loved to dance and listen to jazz while at the same time remaining calm and disciplined. His paintings are the sum of the opposing traits in his character, and it is from that emotional abutment and its meticulous distillation on canvas that they derive their power; thus, the tension that is built up by the interplay of vertical and horizontal and the precision required in the application of paint. Indeed, it was Mondrian's intention, and ultimately his belief, that his paintings represented paradise, albeit one that was thoroughly modern and basically secular.

A clue to Mondrian's achievement lies in his Dutch origins, although he spent most of his life out of the Netherlands. The proximity of the sea with towering skies and low horizon lines provided him with a sense of spatial intervals and shifting light. Equally, his Calvinist religious background determined his outlook on life, just as the bare white walls of churches and the elimination of unnecessary decoration underscored his aesthetic.

Composition with Red, Yellow and Blue was acquired by the Tate Gallery in 1964: it was somewhat surprisingly the first painting by this artist to enter the collection.

I remember the distinguished architect Sir Leslie Martin (designer of the Royal Festival Hall) saying in one of his Slade Lectures in Oxford, given in the late 1960s, that Mondrian's paintings were so strong that any owner of one was in danger of having to alter his house or change his lifestyle in order to accommodate it.

JACKSON POLLOCK (1912–56)
Summertime: Number 9A 1948
Canvas, 84.8 × 555 cm / 33⅜ × 218½ in.

Jackson Pollock's short life was tragic, but immensely important for the history of paint-ing. An early addiction to alcohol was compounded by depression, violence and all kinds of other psychological insecurities that prefaced the car crash on Long Island that killed him. Like Picasso, a mythology built up around Pollock during his lifetime, and the pro-jection of him as an artist was as influential as the work that he himself produced. Such celebrity brought additional pressures, which only exacerbated his personal problems, but in turn helped to establish his reputation as an archetypal modern existential artist.

Pollock's success helped to focus attention on the significance of American painting in general and Abstract Expressionism in particular. America now began to usurp the position in the world of art held by France since the 19th century. And Pollock was indeed quintessentially American – born in Wyoming, brought up in Arizona and California, before moving in 1938 to New York and eventually settling on the East Coast. That he altered the course of painting drew attention to the potential of American culture throughout the world.

Summertime belongs to the group of large-scale pictures made between 1947 and 1951 that now rank as his masterpieces. Before painting this group he was still engaged with figurative or totemic art, and he was to return to the exploration of such morphic forms and shapes after 1951 when he was far less productive. The burst of four years' activity in between was due to the refinement of his drip technique ('Jack the Dripper'). This involved the flicking and trailing of paint from hardened brushes or sticks. But he evolved the aes-thetic of the drip even further by also throwing paint at the canvas, which he laid flat on the studio floor for the purpose. He recorded that he had derived this idea from 'the Indian sand painters of the West'. The process was filmed and photographed by Hans Namuth among others. The artist wrote, 'On the floor I am more at ease. I feel nearer, more a part of the painting, since this way I can walk around it, work from all sides and literally be *in*

It's not as easy
as it looks

the painting . . . I prefer sticks, trowels, knives, and dripping fluid paint.' The medium itself was no longer restricted to oil, but included industrial paints and household enamels.

Although the application of the paint may seem uncontrolled or haphazard, Pollock in fact knew exactly what effects he wanted to achieve, admitting that each painting has a life of its own. 'I try to let it come through', he said, as though he was merely the mediator. The surface of these paintings, which he referred to as 'great webs', relies on the tension between the shallowness of the suggested space and the incrustation of the splashes, splodges and arcs of pigment on the surface. The eye becomes totally absorbed by the skeins of paint stretching across the canvas.

The surface of *Summertime* is less densely worked than some of the other 'all-over' canvases, but its rhythms are more fluid. Pollock produced so many of these abstract pictures in this four-year period of intense activity that he used a numbering system for reference, sometimes adding descriptive titles later.

The scale of these pictures should be seen in terms of the vast expanses of the American landscape – seemingly endless open spaces stretching for miles with wide horizons, shifting light and varying atmospheric conditions. Pollock depicts nothing less than the transcendental.

MARK ROTHKO (1903–70)
Black on Maroon 1958
Canvas, 266.7 × 365.8 cm / 33⅛ × 218½ in.

Sombre colours, subdued light, and unknown depths

One of the defining moments in the history of the Tate Gallery was the acquisition of eight paintings by the American artist Mark Rothko, who along with Barnett Newman, Clyfford Still and others was one of the main exponents (high priests might be a more suitable term) of Abstract Expressionism. The paintings presented by the artist to the Tate formed part of a group of some thirty or so canvases commissioned in 1958 to decorate the Four Seasons restaurant in the recently finished Seagram Building in New York

(designed by Mies van der Rohe and Philip Johnson). As the project for the building progressed, the artist became more and more disenchanted by it, claiming that his paintings were inappropriate for such a hedonistic setting. He eventually pulled out and the paintings, which were the first he conceived as a series on a closely defined compositional theme, remained in his studio on 69th Street in New York.

The idea of a donation to the Tate came about as a result of a meeting between the artist and the Director, Norman (later Sir Norman) Reid, in 1965. Initially, the gift was to have been of a much greater number of pictures, but in the end it was felt that eight of those painted for the Seagram Building would be sufficient for the purposes of creating a special Rothko Room. The negotiations lasted for five years and were never easy, owing to Rothko's declining health and delicate mental state. The pictures were delivered in February 1970, on the very day of the announcement of the artist's death by suicide.

The Rothko Room has since then been one of the gallery's principal attractions, making a stark contrast with the famous photographs of Rothko alone in his studio solemnly staring at his canvases. The prominent display of these paintings at the time of their acquisition demonstrated the gallery's firm commitment to modern art.

The artist was born Marcus Rothkowitz in Dvinsk, Lithuania, but his family emigrated to America in 1913. His Jewish upbringing was an important aspect in establishing his artistic purpose, although he vigorously denied that his canvases had any specific theological or symbolical meaning. From the late 1940s Rothko concentrated on colour field painting, with canvases made up of a single colour overlaid with stratified blocks or bars of other colours, often feathered or blurred at the edges. Such paintings were never hurriedly made: the dominant colour was laid on with great finesse and often in several

layers but never saturated. The brushwork is nuanced and the surface is further enlivened by the play of veiled light. The variations in these paintings are so minute and so subtle that their full effect is only properly appreciated after a lapse of time, as the artist intended. There is a danger, of course, that this suggests the paintings are suffused with some deep meaning, and indeed it is likely that the artist himself (but not necessarily others) did in some instances regard his work as prophetic – as evidenced by his later canvases for the interdenominational chapel in Houston, Texas.

The best way to look at the Seagram Building canvases, or other colour field paintings by Rothko, is by immersion in the sombre colours themselves – reds, maroons, blacks. Looking at them in a gallery with subdued lighting becomes an act of submission, leading into unknown depths: it is a joint act of faith by artist and viewer. Some will resist and will feel claustrophobic; others will yield to the meditative calm of what is aptly associated with the Abstract Sublime.

VICTORIA & ALBERT MUSEUM

The Victoria & Albert Museum is like a magnificent cornucopia. Founded in 1852 in the aftermath of the Great Exhibition as a Museum of Manufactures, based briefly at Marlborough House on the Mall and then at Somerset House, it was transferred in 1857 to its present location, whence it became known as the South Kensington Museum. The building developed rapidly (it had a restaurant from an early date and also late night openings made possible by the installation of gas lighting) to house disparate collections and organizations in need of a home. Only slowly did it discover its own unique sense of didactic purpose, stemming from an acknowledgment of the importance of design not just for utilitarian purposes but also for developing an aesthetic sense as a prerequisite for everyday life.

A proper appreciation of the Victoria & Albert Museum is only possible when it is seen in the broader context of its neighbouring institutions – the Natural History Museum, the Science Museum, the Royal Geographical Society and the Royal Albert Hall – that form what is called today 'Albertopolis', in honour of Queen Victoria's husband, Prince Albert, who had masterminded the Great Exhibition of 1851. His purpose then was to demonstrate the close relationship between the arts and manufacturing – in a word, design, which is why the museum remains so highly relevant today and could even be said to have a more important sense of purpose than ever before in its history. Long after Prince Albert's death, Queen Victoria in 1899 laid the foundation stone at the entrance for the completion of the building, designed by the architect Sir Aston Webb. It was the Queen's last public engagement. A full-length

effigy of Prince Albert by Alfred Drury, flanked by figures representing Inspiration and Knowledge, quite rightly presides over the portal which is still the main entrance.

The Victoria & Albert Museum is like an Aladdin's Cave. Its copious collections, predominantly of the decorative arts, from all over the world, aim to be comprehensive and many of them are of remarkable distinction. It is a building full of surprises and enchantments.

Visiting the museum is an education in the real sense of the word. Now, for better or worse, the collections are arranged as follows: Asia, Europe, Modern Materials and Techniques. The effect can be confusing and occasionally overwhelming. In scale and ambition the Victoria & Albert Museum is only challenged by the British Museum.

A reasonable question on entering might be 'Where are the paintings?' In one particular sense, the answer is 'At the very heart of the collection', with the Raphael Tapestry Cartoons, one of the supreme masterpieces of European art. But as might be imagined, there is a strong representation of British pictures. This is partly because of the general state of confusion in London throughout the 19th century as to what to do with works by British artists – both historical and contemporary – of which valuable collections had by then been formed. One example is that belonging to the cloth manufacturer John Sheepshanks (1787–1863), who specialized in collecting genre paintings by contemporary artists such as William Mulready, Daniel Maclise, David Wilkie, C. R. Leslie and Edwin Landseer. In 1857 he gave this collection of over 400 pictures and works on paper to the Victoria & Albert Museum, as opposed to the National Gallery, so that they could be seen, as he expressed it, 'in an open space and airy situation, preserving the quiet necessary to the study and enjoyment of works of art, and free from the inconveniences and dirt of the main thoroughfare of the metropolis'. He would be surprised to see the museum now buzzing with life and excitement, quite apart from the traffic racing along the Cromwell Road.

Another outstanding collection was that bequeathed by the wealthy trader Constantine Alexander Ionides (1833–1900). This included numerous paintings, drawings and prints of various schools – Italian, Dutch and French – as well as examples by contemporary artists such as Alphonse Legros and G. F. Watts. Of particular interest is the group of pictures by French 19th-century painters which moved beyond Delacroix and Ingres to include works by the Barbizon painters and an isolated example from the French avant-garde.

RAPHAEL (1483–1520)
Christ's Charge to Peter 1515–16
Paper mounted onto canvas, 340 × 530 cm / 135¼ × 209¾ in.

Christ's Charge to Peter is one of the cartoons or designs commissioned in 1515 by Pope Leo X for a set of tapestries to be hung along the walls of the Sistine Chapel in the Vatican in Rome, a space reserved exclusively for the use of the Pope and the Curia. Acquired by Charles I (while still Prince of Wales) in 1623 from Genoa, they were obtained specifically for use at the Mortlake tapestry works set up by his father, James I, in 1619. On acquisition, therefore, the cartoons were regarded as disposable, utilitarian objects and not as works of art in their own right to be carefully preserved. Considering that each cartoon when put into proper use was divided up into relatively small portions for the weavers' looms, it is a miracle that they have survived at all.

Fortunately, it was quickly realized that the cartoons were the only works on a monumental scale by one of the supreme masters of the Italian Renaissance to be seen out of Italy. Acknowledgment of their historical significance and of their status within the canon of classical taste followed swiftly. Christopher Wren designed a special gallery for their display at Hampton Court Palace during the late 1690s at the request of William III and Queen Mary II, by which time the numerous sets of engravings and painted copies had begun to be made.

George III incurred the wrath of John Wilkes among others by moving the cartoons to Buckingham House (later Palace). On 28 April 1777 Wilkes called attention to this

situation in a debate in Parliament, referring to the tapestry cartoons as 'those heavenly guests' which had once been accessible to the 'English nation' at Hampton Court Palace, but were now at Buckingham House 'perishing in a late baronet's smoky house at the end of a great smoky town'. George III characteristically ignored the polemics and moved the cartoons to Windsor Castle for several years before returning them in 1804 to Hampton Court, where their reputation continued to increase as the counterpart to the Elgin Marbles in the British Museum.

Prince Albert had a particular interest in the artist and in 1865, four years after his death, Queen Victoria and her family, presumably respecting the Prince's wishes, sent the cartoons on permanent loan to the museum, where they have been ever since.

For me the Raphael Cartoon Court is a hallowed space. I was indirectly involved with the most recent technical examination and analysis of the cartoons undertaken by the staff of the museum that preceded their re-presentation. This elaborate exercise took place between 1992 and 1996, and the huge gallery was reopened to the public by the Queen. No space can of course compare with the Sistine Chapel, and the Cartoon Court only approximates it, but the vast proportions, the apse at one end with an altarpiece and the penumbrous light (as with the Rothko Room at Tate Modern) create a suitably ecclesiastical atmosphere. For the reopening of the gallery the then Director, Dr Alan Borg, arranged for music written for the mass by Giovanni Pierluigi Palestrina to be sung by the choir of St Paul's Cathedral – the power of art and music perfectly calibrated.

There are seven surviving cartoons in all, although three additional tapestries from the series are known for which no cartoons exist. The scenes illustrate incidents in the lives of St Peter and St Paul with one only referring to the life of St Stephen. All the scenes are recounted in the New Testament.

The iconography is specific to the Sistine Chapel, aiming to demonstrate the primacy of the Church in Rome, as well as of the Popes in their descent from St Peter and their association with the early Roman martyrs. *Christ's Charge to Peter* is a conflation of two texts, the Gospel of St Matthew 16:17–19 and the Gospel of St John 21:15–17, where Christ gives St Peter 'the keys to the Kingdom of Heaven' and charges him to 'feed my sheep'. It is a seminal moment in papal iconography and nobody has represented it so powerfully, or as fluently, as Raphael.

There are many impressive aspects about all of the tapestry cartoons. First of all is the monumental scale (each composition comprises numerous separate sheets of paper). Then there is the compositional assurance displayed by Raphael in terms of overall design to which colour, individual forms and characterization are related. Above all – and what was of greatest value to succeeding generations – is the visual coherence. The compositions are immediately legible and arresting: they have remarkably fluid rhythms and internal dynamism. Raphael here demonstrates the grammar of art, and that is why artists need to return to each of the tapestry cartoons time and time again.

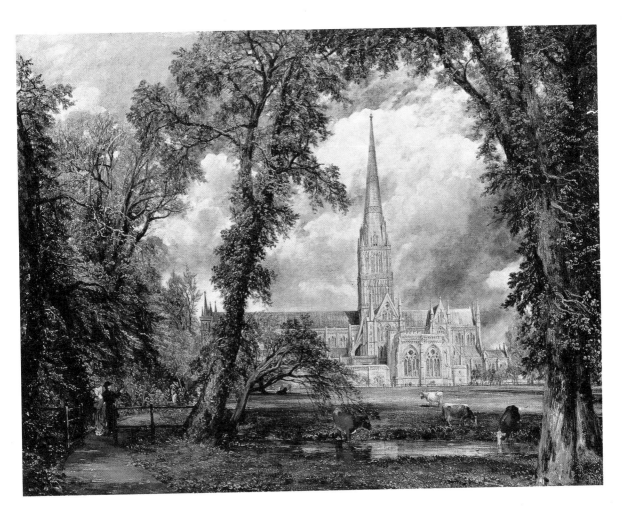

JOHN CONSTABLE (1776–1837)
Salisbury Cathedral from the Bishop's Grounds 1823
Canvas, 87.6 × 111.8 cm / 34½ × 44 in. Signed and dated

From today's perspective this is the finest of several pictures by Constable owned by John Sheepshanks. Taken together with the munificent gift by the artist's daughter Isabel, made in 1888, which included many of the famous cloud studies, this means that the Victoria & Albert Museum has the prime holding of Constable's work in the country. It bears the same relationship to Constable as Tate Britain does to his great rival J. M. W. Turner.

On the whole, while it could be said of Turner that he yearned to paint infinity, Constable preferred the particular, and especially those places which he came to know well and loved especially in Suffolk. Salisbury Cathedral with its precincts was another such place for Constable, as a result of his longstanding friendship with the Fisher family. He first knew Dr John Fisher, Bishop of Salisbury, as supporter and patron, but he was closer to the Bishop's nephew John and John's wife Mary. The younger Fisher also

enjoyed ecclesiastical preferment, becoming Archdeacon of Berkshire and Prebendary of Salisbury Cathedral with a comfortable house, Leydenhall, in the Close. Constable and his family thus had ample opportunity to stay in Salisbury, and depicting the cathedral became one of his most frequent activities.

Salisbury Cathedral from the Bishop's Grounds was actually commissioned (perhaps *c.* 1820) by the Bishop. It shows the cathedral seen from the southwest with Dr John Fisher and his wife in the left foreground and another figure under a parasol, probably one of their daughters, approaching on the path. The Bishop points to the spire. The picture was exhibited at the Royal Academy in 1823.

What is interesting, however, is that the Bishop objected to the dark clouds in the sky. 'Clouds are only black when it is going to rain. In fine weather the sky is blue', he wrote. But Constable, of course, was intent on painting what he saw and not an idealized version of nature. The artist did in the end relent and painted another sanitized version for the Bishop (now in New York, Frick Collection), allowing the picture exhibited in 1823 to be passed to Archdeacon Fisher, who later returned it to the artist.

The effervescent but detailed brushwork is wholly typical of Constable, but even more impressive is the compositional sophistication of the cathedral seen through the arch formed by the trees in the foreground – a balance between natural forms and man-made architecture.

EDGAR DEGAS (1834–1917)
The Ballet Scene from Giacomo Meyerbeer's Opera 'Robert le Diable' 1876
Canvas, 76.6 × 81.3 cm / 29¾ × 32 in.

Constantine Alexander Ionides and a few other collectors in Britain had owned paintings by Degas, but this was the first work by the artist to enter a public collection. It was painted in 1876 specially for the opera singer Jean-Baptiste Faure, who was one of the earliest collectors of Impressionist art in France.

Nothing in any painting by Degas is ever straightforward, and here he amalgamates several different genres by depicting a ballet scene from a contemporary opera (*Robert le Diable* was first performed in Paris in 1831) viewed from the stalls of the theatre across the orchestra pit where the portraits of at least three of his friends can be identified.

The composition falls neatly into two horizontal parts – the audience and musicians in the foreground and the stage above – but these parts are fused together by the agitated brushstrokes incorporating the movements of the audience and musicians and the more diaphanously dressed dancers on the stage. Another way in which Degas has successfully unified the composition is through the use of chiaroscuro, contrasting the darkened auditorium with the illuminated stage, further enhanced by the black-and-white male formal attire. The viewer is positioned near the front of the stalls, close to Albert Hecht

'I assure you no art was ever less spontaneous than mine'

DEGAS, AS REPORTED BY GEORGE MOORE, 1918

on the left who looks away from the stage through his opera glasses, Désiré Dihau (third from the left) who is one of the orchestral players, and Vicomte Lepic who is the bearded man in the front row of the stalls positioned in the right half of the composition.

Degas was a radical painter masquerading as a conservative, which is why his work was so readily appreciated by collectors with traditional taste who may not have realized exactly what they were buying. A permanent bachelor, inclined to be reclusive towards the end of his life, Degas had a caustic tongue and a mordant wit. He once remarked, 'A picture is something that requires as much trickery, malice and vice as the perpetration of crime.' Bravo, Mr Ionides!

APSLEY HOUSE

Apsley House (famously 'No. 1 London') was the home of the first Duke of Wellington and was donated to the nation with most of its contents by the 7th Duke in 1947. It was here in this house, designed by John Adam, that the Iron Duke lived from 1816 until his death in 1852 and it is in effect his memorial, touching upon most aspects of his long career and offering a veritable panorama of Wellingtoniana. At times there is an echo of Valhalla, with all the battle scenes and portraits of those monarchs, military commanders, soldiers and diplomats who caused the final downfall of the French Emperor Napoleon I.

Napoleon, too, rather surprisingly is present in the house – unforgettably so, as he is positioned at the foot of the main staircase naked in an over-life-size marble statue by Antonio Canova, adorned only with a strategically placed fig leaf. Visitors cannot avoid this confrontation.

Anyone with a vivid imagination will enjoy the displays which include many of the gifts (mainly dinner services in silver gilt and porcelain) made to Wellington by the countries grateful to him for saving Europe. A gallery was specially added where from 1820 onwards the Waterloo Dinners were held, commemorating the battle of 1815 (a painting by G. E. Salter on loan in the entrance hall shows the scene).

The collection of pictures at Apsley House is of the greatest historical importance, for many of them came from the Spanish royal collection. They were acquired by Wellington following the Battle of Vitoria in 1813, which put an end to the French occupation of Spain. Napoleon's brother, Joseph Bonaparte, who had been made King of Spain in 1808, was defeated there and escaped back to France, but his baggage and equipment were captured, and they were found to include over two hundred paintings (detached from their stretchers and rolled up) which he had appropriated from the Spanish royal palaces. The Duke of Wellington behaved properly and offered to return the pictures to Spain, but the newly restored king, Ferdinand VII, allowed him to keep 'that which has come into your possession by means as just as they are honourable'. Amongst these pictures are outstanding works by Correggio, Elsheimer, Velásquez and Murillo.

The Iron Duke also began to form his own collection after he moved into Apsley House. His taste for Dutch 17th-century cabinet pictures (Pieter de Hooch, Jan Steen, Nicolaes Maes) was characteristic of the time, but he commissioned several pictures from contemporary British artists such as David Wilkie and Edwin Landseer.

DIEGO VELÁSQUEZ (1599–1660)
The Water-Seller of Seville 1618–22
Canvas, 106.7 × 81 cm / 40½ × 31⅞ in.

A Spanish
masterpiece

The first writers on Velásquez referred to this type of painting, for which he had a considerable reputation during the early part of his career in Seville, as a *bodegón*. This was essentially a new kind of genre subject in Spanish art (more usually horizontal in format) often involving a still-life set in the context of a kitchen or tavern (*bodegón*). There are several examples in British collections, including another in Apsley House (*Two Young Men at a Table*). It is not known why Velásquez painted such pictures, appreciated today for their realistic treatment (note in this wonderful example the drips of water running down

the side of the pitcher and the sharpness of the reflected light), except as a faithful record of everyday life. Various interpretations have been proposed on the basis either of an implied narrative or of the possible use of symbolism, but these are not especially convincing. What is profoundly affecting is the dignity of the water-seller himself and what is absolutely magical is the accuracy with which the various textures are rendered.

The painting first belonged to Juan de Fonseca y Figuerosa, who was a canon of Seville Cathedral before becoming Chief Officer of His Majesty's Chapel in Madrid. An intellectual and an amateur painter, Fonseca was one of Velásquez's earliest admirers. After his death in 1627 the picture was sold and it had entered the Spanish royal collection by the beginning of the 18th century.

SIR DAVID WILKIE (1785–1841)

Chelsea Pensioners Reading the Waterloo Despatch 1822
Wood, 158 × 97 cm / 62½ × 39¼ in. Signed and dated

Commissioned by the first Duke of Wellington in the summer of 1816, this elaborate painting took the Scottish artist six years to complete, during which there was a great deal of discussion in changing political circumstances about what form the picture should take. There are in all some eighty preparatory drawings. In the final event, Wilkie produced a straightforward history painting by including, most appropriately, a Pensioner of

There is no escaping
the Battle of
Waterloo

the Royal Hospital for retired soldiers in Chelsea reading the official Waterloo Despatch (dated 19 June) from a special issue of the *London Gazette* of 22 June 1815. This turned the composition from being a genre subject into a history painting, which as it happens was also a pivotal moment in Wilkie's career – 'quite new to me in my professional progress'.

The scene is set very specifically in Jew's Row off the King's Road in Chelsea, with the Royal Hospital on the left. There is a remarkable degree of accuracy in the rendering of the buildings, uniforms and activities, reflecting the amount of research undertaken by Wilkie in order to please his patron. There can be no doubting the complexity of the composition, and the artist paid a great deal of attention to the arrangement of the figures in groups. (One critic observed in a carping fashion that the oysters seen for sale must be a solecism since they are not in season during June.)

When exhibited at the Royal Academy in 1822 the painting proved to be so successful that a railing had to be erected to protect it from the crowds. The picture retains its popularity today, which its companion, painted over ten years later by John Burnet (*The Greenwich Pensioners commemorating Trafalgar*), also in Apsley House, unfortunately never gained.

COURTAULD GALLERY

The Courtauld Institute of Art was founded in 1932 for the express purposes of studying and researching the history of art. Such an organization, affiliated from the start to the University of London and now an independent college within the University, was unusual, if not unique, in the United Kingdom and derived its intellectual ambitions from Germany and America. It was the first academic body in Britain to offer degrees in the history of art – a subject which even today in British universities can arouse suspicions of intellectual backsliding and legerdemain.

The instigators were from very different backgrounds – the politician Viscount Lee of Fareham (1868–1947), the industrialist Samuel Courtauld (1876–1947) and the lawyer Sir John Witt (1872–1952). Their collections formed the basis of the Institute, in the belief that the history of art should be studied not in isolation but in the context of original works of art. The Institute was based for many years at Home House, No. 20 Portman Square (originally occupied by Samuel Courtauld), but has since 1989 established itself in Somerset House off the Strand. Somerset House was built by Sir William Chambers for George III in 1780 to house various public administrative offices and institutions – including at one time, appropriately, the Royal Academy of Arts. The great advantage of this new location is not solely the spectacular setting, but the space that allows for the first time the teaching part of the Institute to exist contiguously with the collections. The cramped quarters at

Home House had resulted in many inconveniences, and from 1958 the collections had been shown across London in Woburn Square near the British Museum in a building belonging to a sister organization, the Warburg Institute, where the emphasis was on the study of iconography.

The Courtauld Institute of Art has gone from strength to strength. The founding collection of paintings has been augmented by those donated by Roger Fry (1934), Mark Gambier-Parry (1966), Count Antoine Seilern (1978) and Lillian Browse (1982).

The quality of its directors, together with the inspiration and range of its teaching, has assured the Institute a pivotal place in the academic and curatorial life of the nation. Some might think that its influence has not always been for the good, and a well-known jibe used to be that students who went there learnt their art history only from photographs. But there can be little doubt that in recent years the Courtauld Institute has maintained a dominant position in the art world, perhaps most aptly symbolized by the fact that two of the country's most distinguished museum directors, Neil MacGregor (National Gallery and British Museum) and Sir Nicholas Serota (Tate), hailed from there. Not least this is because of the range of what is on offer. Old-fashioned connoisseurship has been edged out by broader, usually contextual, considerations, but there are also departments of conservation for easel paintings and wall paintings, and a history of dress department which leads the world in that subject.

A perfect demonstration of the Courtauld Institute at work in its new location was the exhibition held in 2001, *Art on the Line: The Royal Academy Exhibitions at Somerset House 1780–1836*, which recreated the hang of the annual exhibitions organized by the Royal Academy in the Great Room on the top floor of Somerset House. The Great Room was designed by Chambers specifically for the display of pictures densely hung frame-to-frame from below the cornice to the floor, and to be in this space as it originally appeared was one of the most exciting visual experiences of a lifetime.

The range and diversity of what is on display today in Somerset House is astonishing. The many Impressionist and Post-Impressionist pictures from the Courtauld collection are outstanding and include Manet's *A Bar at the Folies-Bergères* and Renoir's *La Loge*, while the bequest of Count Antoine Seilern's collection, comprising 140 paintings and 350 drawings, complemented and extended Viscount Lee's founding collection of old masters. Seilern (1901–78), of Austrian descent, lived at No. 56 Princes Gate in South Kensington, and his bequest, which was described at the time as the greatest gift ever made to a public museum in Britain, is known officially as the Princes Gate Collection. During his lifetime he often took time to show people his collection, allowing one to experience at first hand the courtesy and immaculate manners of the Austro-Hungarian empire. Seilern compiled his own learned catalogues (guided by his mentor, the Michelangelo scholar Johannes Wilde). The trick while visiting him was to ask before leaving to see the rooms at the top of the house,

which were devoted to the oil sketches by Rubens and Giovanni Battista Tiepolo. Now these hang on public view at Somerset House as testament to an impeccable and traditional taste worthy of the greatest museums.

Somerset House is not for the faint-hearted, since sccess to the main galleries is by way of the famous spiral staircase that was the subject of one of Thomas Rowlandson's wittiest watercolours – *The Exhibition Stare Case* (c. 1800). This shows men and women on the staircase with those in the lower section, especially the women, cascading downwards revealing all (or rather mostly nothing). This, of course, was Rowlandson's way of undermining the serious intentions of the Royal Academy; it is important to keep a sense of humour when visiting the Courtauld Institute. (A lift has now been installed!)

The gallery containing the earliest art is on the ground floor, close to the entrance. Alas, few people notice it, but it is here that the pictures and medieval *objets d'art* collected by Thomas Gambier Parry (1816–88) are shown, supplemented by works of similar date from Count Seilern's collection, including triptychs by Bernardo Daddi and the Master of Flémalle. Gambier Parry was part of a small group of collectors in Britain, also numbering William Roscoe, James Dennistoun, the Hon. W. T. H. Fox-Strangways, later 4th Earl of Ilchester, and the Rev. Walter Davenport Bromley, who at the beginning of the 19th century became interested in Italian, Netherlandish and German painting dating from the 14th and 15th centuries – pictures known colloquially as 'primitives' or 'goldbacks'. The taste for such pictures was pioneering, but suited the historicizing principles being established by museums wishing to show the full extent of art from its beginnings.

Viscount Lee of Fareham's collection of old masters embraced the Italian, German, Flemish and British schools. Count Antoine Seilern's collection of old masters, on the other hand, was more specialized but no less varied, and it is for this reason that the holding of works by Northern European painters at the Courtauld Institute is extremely strong.

The essential core of the Courtauld Institute's galleries is the collection of works by Impressionist and Post-Impressionist painters formed by the eponymous founder, Samuel Courtauld. Many people have over the years been surprised to find such well-known pictures here rather than in the National Gallery. Yet, beyond his personal collection Samuel Courtauld played a vital role during the 1920s and 1930s – together with Sir Hugh Lane and the sisters Gwendoline and Margaret Davies – in arousing interest in French avant-garde art. This was done in the nick of time, just as the great exodus of such paintings to America began. Furthermore, the establishment in 1924 of the Courtauld Trust allowed other modern French paintings of the greatest distinction to be added to the national collections. Thus did Samuel Courtauld save Britain from national disgrace and cultural ignominy.

LORENZO MONACO (c. 1370–1426)
The Coronation of the Virgin c. 1394–95
Wood, c. 185 × 155 cm (pointed top) / c. 72 × 60½ in.

This panel was originally the central gable of the high altarpiece in the church of S. Gaggio in Florence. Other parts of the same altarpiece have been identified, but the whereabouts of the main panel (probably the scene of the Death of the Virgin) is not known. Such altarpieces, following the invasion of Italy by Napoleon and the sequestration of ecclesiastical property, were often removed from churches and divided up (literally with a saw) into different parts – known unprepossessingly as *membra disjecta* – for sale. This situation created a market for early pictures, and significantly one of the foremost collectors of works of this kind was Napoleon's uncle, Cardinal Fesch, who owned the *Coronation of the Virgin* before the Rev. Walter Davenport Bromley and Thomas Gambier Parry.

Lorenzo Monaco was a painter monk who entered the Camaldolese monastery of S. Maria degli Angeli in Florence in 1391. He was proficient at manuscript illumination as well as at painting altarpieces and frescoes. In these respects he was the most important artist in Florence before the emergence of Masaccio in the 1420s.

The most highly regarded painter in Florence before the Renaissance

The main figures are seated before a cloth of honour beneath a tabernacle-like structure. Christ crowns his mother attended by two angels on either side. Above in a trilobe is God the Father with his hand raised in blessing. On looking at a painting such as this forget accuracy of drawing or convincing poses: the artist is essentially a craftsman engaged in expressing the ethereal and in so doing hoping to transport the viewer into another world.

PIETER BRUEGEL THE ELDER (active 1551–69)
Christ and the Woman Taken in Adultery 1565
Wood, 24.1 × 34 cm / 9½ × 13⅜ in. Signed and dated

The Netherlandish painter Pieter Bruegel the Elder created some of the most memorable images in European art, endlessly replicated and widely appreciated. One only has to think of the *Fall of Icarus* in Brussels (Musée des Beaux-Arts), the *Hunters in the Snow*, *Peasant Wedding Feast* or the *Tower of Babel* (all in Vienna, Kunsthistorisches Museum) to conjure up an instant idea of the artist's abilities.

It is, however, easy to overlook the fact that Bruegel was also a powerful painter of religious themes and that they are not always given a landscape setting. Indeed, of the three grisailles in his œuvre to have survived, two are religious scenes set in interiors: *The Death of the Virgin* (National Trust, Upton House, Banbury) and *Christ and the Woman taken in Adultery*. Both are small in scale, notable for their refined brushwork, and painted in shades of grey with white highlights against a brown/yellow background.

The literary source for *Christ and the Woman taken in Adultery* is the Gospel of St John 8:3–11, where it is recounted that Christ is confronted by the Pharisees on a point of law regarding adultery. The accused woman (an exquisitely drawn figure worthy of Raphael) holds the centre of the composition, while Christ inscribes on the ground the words, 'He that is without sin among you, let him first cast a stone at her.' The apostles are on the left and the Pharisees (ugly in visage and shifty in deportment) on the right, some of them turning away. Christ's injunction at the end is to tell the woman 'go and sin no more'.

Apart from his strong narrative sense which gives his work such immediacy, Bruegel often combined medieval allegory and local proverbs with contemporary sources. Sometimes in the context of the Spanish occupation of the Netherlands this had a political edge, but even when it does not the strength of his art remains firmly based on human experience. It was this synthesis that appealed to the poet W. H. Auden, who refers memorably to Bruegel's work in 'Musée des Beaux-Arts', written on the eve of the Second World War.

Christ and the Woman taken in Adultery is a painting of exquisite beauty. Usually a work on this small scale would have been a prized possession in an important collector's cabinet, but in this case it was retained by the artist and given to his youngest son, the painter Jan Brueghel the Elder. As it happens, the family portrait of that artist with his second wife and two children painted by Rubens (c. 1613–15) was also owned by Count Seilern and so is now too in the Courtauld Institute of Art. The portrait is one of Rubens's most touching and from the brush of a family man par excellence.

PAUL GAUGUIN (1848–1903)
Nevermore 1897
Canvas, 60.5 × 116 cm / 23⅞ × 45⅝ Signed, dated and inscribed

Gauguin is not an artist who is easy to like. His personality, proclivities and posturing tend to obscure the art he produced in spite of the continuing popularity of W. Somerset Maugham's novel *The Moon and Sixpence* (1919) and the advantages of modern travel to those far-flung places in the southern hemisphere where the painter spent so much time. But, on the other hand, the story of his life – a late start and an insatiable sense of adventure – inspires admiration, and his personal suffering in often adverse circumstances, although for the most part self-inflicted, prompts sympathy. And then there is the sheer

'Pieter Bruegel the Elder belongs, with Michelangelo, Rembrandt and Van Gogh, to that select company of artists who enjoy almost universal esteem in our time'

WALTER GIBSON, 1977

beauty of his paintings with their sure sense of form, firm drawing, seductive colour and exotic subject-matter that often create a mood of reverie.

Nevermore was painted during the artist's second visit to Tahiti, in the year when he completed his enormous late masterpiece, *Where Do We Come From? What Are We? Where Are We Going?* (Boston, Museum of Fine Arts). Gauguin wrote of *Nevermore*, 'I wished to suggest by means of a simple nude a certain long-lost barbarian luxury.' Clearly, the artist had in mind the long tradition in European art of painting the female nude extending from Titian through Ingres to Manet, but there are added elements here, stemming from Gauguin's personal experiences on Tahiti (he often remarked upon the extraordinary silence and stillness) and his own imagination. The reclining figure is his model and some-time wife, Pauhura; behind her are two women conversing, and a raven – 'the Devil's bird' – is positioned on a window ledge (Gauguin denied any connection with Edgar Allen Poe's poem). The furnishings are highly decorated and may be symbolic. It is not clear what is going on in this picture – if anything – but that has not deterred art historians from interpreting it often in sexual terms. On a wider basis Gauguin's work is often criticized these days for seeming to be a representation of an innocent unspoilt society, when that society was in the process of being exploited and destroyed – a process in which Gauguin himself was active. But this need not necessarily detract from the enjoyment of his paintings.

Nevermore is an exquisitely made painting with a beautifully finished surface and a confident use of colour that resonate with the viewer. (It was in fact painted over an earlier landscape composition.) The picture was acquired by the British composer Frederick Delius soon after it was painted and it was exhibited in Paris at the Salon d'Automne of 1906, where Picasso and Matisse must certainly have admired it.

DULWICH PICTURE GALLERY

As the first purpose-built gallery in Britain, Dulwich Picture Gallery holds a special place in the history of museums in the British Isles. Designed by John Soane and begun in 1811, the building was opened to the public in 1814 – ten years before the foundation of the National Gallery in Trafalgar Square. Oddly, the focal point of the elegantly sparse top-lit gallery spaces is the mausoleum where the three principal benefactors are buried – Mr and Mrs Noel Desenfans and Sir Francis Bourgeois. (A comparable situation pertains to the Sterling and Francine Clark Art Institute at Williamstown, Massachusetts, USA.)

It is the pictures amassed by the collector/dealer Desenfans (1745–1807) and bequeathed to his protégé, the artist Bourgeois (1756–1811), that form the nucleus of the collection on display at Dulwich. The quality of these paintings, including outstanding works by Rembrandt, Rubens, Van Dyck, Murillo, Poussin, Cuyp, Claude, Reni, Guercino and Watteau, was acknowledged at the time, particularly in the absence of a national gallery. Yet the idea put forward by Desenfans in 1799 that these very pictures should be the basis of a national gallery did not meet with government approval.

Strangely, Dulwich's gain was Poland's loss, since in 1790 Desenfans' reputation as a collector/dealer was such that he was commissioned to form a collection of pictures for Stanislaus Augustus, King of Poland, as a nucleus of a national gallery in that country. This, however, never materialized owing to the abdication of the King in 1795 and his death in Russia three years later. The exceedingly fine group of pictures devolved to Bourgeois, who then developed the collection further.

The founding collection is augmented by 17th-century portraits associated with Edward Alleyn (1566–1626), founder of Dulwich College, and William Cartwright (1606/7–86) – both connected with the theatre – and by the pictures left by Charles Fairfax Murray in 1911. An extension to Soane's building to provide more modern facilities was designed by Rick Mather and Associates and opened in 2000. The gallery also initiated a policy whereby members of the public – individuals or representatives of institutions – are invited to 'adopt' a picture or a frame, thereby taking financial responsibility for its conservation treatment and presentation.

There is only one difficulty about Dulwich, and that is its geographical location in south London. In recent years, however, the gallery has made every effort to overcome such problems and met with considerable success. The perfect way to go to Dulwich is the short train journey from Victoria and then a quick walk from West Dulwich station. Take a copy of William Hazlitt's *Sketches of the Principal Picture Galleries in England* (1824) with you, for the section on Dulwich contains some of his greatest writing, and to a certain extent his spirit still presides there; however, he would undoubtedly have walked all the way.

NICOLAS POUSSIN (1594–1665)
The Triumph of David c. 1632
Canvas, 118.4 × 148.3 cm / 46⅝ × 58⅜ in.

The painting was undertaken at a most important moment in Poussin's career and shows him adopting a more heroic style. It is one of his early masterpieces, revealing the full powers of his pictorial skills. The grandeur of the setting and the sense of compositional unity imposed upon a crowded scene leave the viewer in no doubt of Poussin's power of invention, in which clarity of drawing and sophistication of colour play a major part. In this picture Poussin's style is tending more towards the abstract through a more controlled sense of form.

The scene, described in the Old Testament (I Samuel 17:54, 18:6–9), refers to the events after David has beheaded Goliath, culminating in a triumphal procession into Jerusalem. Poussin clearly allows David to remain the focus of the narrative, not simply by subtly

isolating him from the other figures, but by making all their gestures and poses relate to his moment of triumph.

Having previously been inspired by Venetian painting, as reflected in his earlier more poetic treatment of *The Triumph of David* (Madrid, Prado), Poussin here turns to Raphael and to the work of Raphael's followers such as Giulio Romano as a source of inspiration (particularly the Raphael of the Stanze in the Vatican, Rome). The plotting of the present composition was extremely carefully done (as the x-rays reveal) and the figures are skilfully grouped throughout – notably the women in the foreground, who are beautifully observed and convincingly drawn. There is a vivid sense of movement throughout and the agitation of the figures in the excitement of the moment creates an abundance of variety. Horizontal and vertical lines may predominate as a result of the architecture, but any deadening caused by geometric rigour is undermined by the circular trumpet that establishes more enclosed rhythms that are echoed elsewhere.

Even within such a unified narrative there are one or two idiosyncrasies characteristic of the artist. Note the upturned stone fragment in the lower left corner, which is no doubt included as an archaeological artefact, but could also serve as the 'key' to a system of measurement for the viewer. Note, too, the female form glimpsed disappearing behind the left-hand column of the temple, her fluttering draperies providing a heart-stopping moment as the eye scans the surface of this marvellous painting.

SIR ANTHONY VAN DYCK (1599–1641)
Venetia Stanley, Lady Digby, on her Death-Bed 1633
Canvas, 74.3 × 81.8 cm / 29¼ × 32¼ in.

Although works by Rubens and his pupil Van Dyck at Dulwich afford a revealing contrast, the portrait of Venetia Stanley (1600–1633) is most unusual. The relationship between Sir Kenelm Digby and Venetia Stanley is one of the great love stories in British history. It is also one of the best recorded.

Digby was a courtier in the 17th-century mould, pursuing many interests – writer, diplomat, adventurer, alchemist and a collector of manuscripts. Venetia Stanley was a great beauty, described by John Aubrey in glowing terms: 'She had a most lovely and sweet-turn'd face, delicate dark brown hair . . . Her face, a short oval, dark brown eyebrow, about which much sweetness, as also in the opening of her eyelids. The colour of her cheeks was just that of the damask rose, which is neither too hot nor too pale.' They first knew one another as childhood sweethearts, but were prevented from marrying and so went their separate ways. Digby travelled in Europe, but while on the Continent the letters he sent her were intercepted and it was then rumoured that he had died. Venetia Stanley felt free to pursue other relationships, which she did with a certain ardour, notoriously with two of the Earls of Dorset. On Digby's return the couple were eventually

There are fine British portraits at Dulwich by Hogarth, Gainsborough and Lawrence, but it is Van Dyck who steals the show

reconciled and married secretly in 1625. The marriage was happy and fruitful, although both parties were fairly independent-minded. They moved in the circle of Queen Henrietta Maria, Charles I's French wife, and were well known to Van Dyck. However, Venetia Stanley 'dyed in her bed suddenly' (Aubrey) on the night of 1 May 1633, apparently of a cerebral haemorrhage, and was much mourned. She was buried by night in Christ Church, Greyfriars, Newgate Street.

Digby requested that Van Dyck make a portrait of his wife on 'the second day after she was dead'. This, according to the widower's somewhat partial and not necessarily correct account, was done exactly as the body was found 'excepting only a rose lying upon the hemme of the sheete'. As might be expected, the portrait is thinly painted, swiftly drawn with a light touch.

Thereafter, Digby writes, the portrait 'is the onely constant companion I now have. It standeth all day over against my chaire and table . . . and att night when I go into my chamber I sett it close by my bed side, and by the faint light of a candle, me thinkes I see her dead indeed.' In addition to the portrait by Van Dyck, Digby had a version made in miniature by Peter Oliver to accompany him on his travels. He never remarried.

This is, therefore, an intensely private portrait. It differs markedly in that respect from the more formal family portraits both in Britain and on the Continent incorporating deathbeds, as in *The Saltonstall Family* by David Des Granges (see p. 65) or *Sir Thomas Aston* by John Souch (Manchester Art Gallery).

SIR PETER LELY (1618–80)

Nymphs by a Fountain *c.* 1650–55
Canvas, 128.9 × 144.8 cm / 50¾ × 57 in.

Lely was the leading painter of the Restoration period in Britain, known best for his portraits of the personalities of the reign of Charles II whom he served as principal painter. Of Dutch origin and trained on the Continent, he arrived in London as the Civil War was starting. One of his skills lay in finding a variety of poses to suit his numerous sitters, but there was also his use of rich and fresh colouring and fluent, confident brushwork, which was not improved upon in Britain until the 18th century. Regardless of these attributes, of which Lely himself was not unaware, some contemporaries and most modern critics have bemoaned the repetitive nature of his work. I do not share their view.

 An example of Lely at his most poetic is the arcadian portrait (once thought to be of Abraham Cowley) at Dulwich showing a young boy with a shepherd's crook holding a recorder, 'the eyes swimming with youth and tenderness' (Horace Walpole). Much in the

*Sensuous abandon
in the heat of
the day*

same vein is a small group of 'history compositions' of varying dates stemming ultimately from the pastoral tradition of Venetian painting. An early example is *The Concert* (Courtauld Institute of Art) and another is *Nymphs by a Fountain*. If Lely's portraits are regarded as being predictable, then these highly sensuous and compellingly beautiful 'historical compositions' are the perfect antidote.

Lely was an important and discriminating collector and may have known examples of Venetian pastoral painting at first hand, but there was already an awareness of it in Dutch art (for example, Cornelis van Poelenburgh and Adriaen van de Velde), quite apart from the influence of Van Dyck, whose absolutely entrancing and highly relevant *Cupid and Psyche* (see p. 129) Lely owned for a time after the sale of Charles I's collection. The composition of *Nymphs by a Fountain* is undoubtedly contrived, but the artist's soft pliant brushstrokes, which seem to caress the bodies, more than make up for any such deficiencies. The figures are overcome by the heat of the day and have abandoned themselves to sleep as the water trickles from the fountain. The mind of the viewer leaps forward to Watteau and Boucher.

FOUNDLING MUSEUM

The Foundling Hospital was established in 1739 by royal charter in response to the increasing concern over the plight of abandoned children in 18th-century London. Society's general lack of provision for orphaned and abandoned children, usually born in poor, unfortunate circumstances, together with the rising rates of infanticide, called for a more enlightened philanthropic approach. Thomas Coram, who had made a great deal of money on the east coast of America as a shipwright, campaigned vigorously for the establishment of a foundling hospital, following the example of other European countries. He received some support from the ranks of the aristocracy, but the greatest practical help came from artists such as William Hogarth, medical men such as Dr Richard Mead, and musicians such as G. F. Handel. The initiative taken by these individuals, and their encouragement of others, underpinned the financial position of the Foundling Hospital and convinced society of its legitimate purpose in solving social problems as opposed to promoting licentiousness.

Hogarth's role in encouraging his fellow artists – Ramsay, Gainsborough, Hayman, Highmore, Wilson and others – to present a work to the charity had unforeseen consequences. The Foundling Hospital served in effect as a showcase for work by British artists before any official institution came into existence for such a purpose. The artists held anniversary dinners and the paintings attracted crowds as though to an art gallery. Its collection remains one of the best introductions to 18th-century British painting.

The hospital moved and the building was demolished in 1928, but the Court Room and Picture Gallery were reconstructed in 1937 inside a building nearby and hung with the paintings that Hogarth cajoled his fellow artists into donating, as well as with works added subsequently. The Foundling Hospital received its modern charitable status in 2004 and the museum was opened to the public. It remains dedicated to the issues raised by the need to provide shelter, care and education for orphaned and abandoned children. Most moving of all are the never-to-be-forgotten identity tokens left by mothers hoping eventually to return and reclaim their children.

WILLIAM HOGARTH (1697–1764)
Captain Thomas Coram 1740
Canvas, 239.4 × 149.2 cm / 94 × 58 in. Signed and dated

Although Hogarth tried hard to comply with all the principles necessary to succeed as a history painter in the manner of his father-in-law Sir James Thornhill, his own character kept asserting itself. As a result, he found he had more success with portraits, conversation pieces, and most notably 'modern moral subjects'. In doing this he gave a sense of direction to British art and also provided it with a greater sense of purpose.

A rough diamond dedicated to charitable causes

Hogarth's individuality is apparent not only in his narrative powers, but also in his portraiture. His self-portrait in Tate Britain includes his pug dog, and his sitters were by no means limited to aristocrats, ecclesiastics or famous actors, as *The Shrimp Girl* and the studies of the *Heads of Six of Hogarth's Servants* (both Tate Britain) demonstrate.

The life-size portrait of Thomas Coram (*c.* 1668–1751) comes in the same category, since even though Hogarth uses the conventions of official portraiture he successfully subverts them. The column and the curtain are the usual trappings of the Grand Style, and the artist is careful to introduce a reference to the Foundling Hospital itself by making its Royal Charter and seal visible. Coram's other interests are acknowledged in the distant seascape, the globe turned to show the Atlantic Ocean, and the hat (he supported the Livery Company of Hatters). But what is most evident is the man himself with his ruddy face, bandy legs and twinkling eyes. A friend described Coram as full of 'cheerfulness, frankness, warmth, affection and great simplicity' (his language left a lot to be desired). What you see is what you get: he has a Falstaffian air with his unsophisticated clothes and unkempt hair. An enthusiast totally dedicated to charitable causes following his return from America in 1719, Coram neglected his own affairs and died in straitened circumstances, dependent on friends such as Hogarth, who was his neighbour.

There is a sense in which Hogarth is here domesticating grand portraiture – not simply by making someone lower down the social scale the subject, but by indicating that people like Coram can make a difference and therefore are just as worthy of being painted as any statesman or dignitary.

The Royal Charter

Painted and given by W. Hogarth. 1740

GUILDHALL ART GALLERY

The Guildhall Art Gallery was established in 1885 to house the collection of the Corporation of the City of London. The present building is a modern structure erected to a design by Richard Gilbert Scott and opened in 1999. It has a corporate air to it, but then it has to serve many different purposes. The collection includes a number of works that are displayed elsewhere, such as the important group of 17th-century Dutch and Flemish pictures once belonging to Baron Samuel of Wych Cross (1912–87) and now at the Mansion House.

The upper level and ground level of the gallery have an array of formal portraits and many views of London and scenes from the history of the City of London, all of varying dates. Prominently displayed as a climax is the gigantic picture by John Singleton Copley, *The Defeat of the Floating Batteries at Gibraltar, 1782* (1791). Such a subject was close to the heart of Alderman John Boydell, who presented the Corporation of London with several pictures between 1793 and 1800 which he hoped would have 'a moral influence . . . by holding forth affecting and impressive examples of great and good actions'. An engraver and print publisher who made a fortune from such enterprises as his 'Shakespeare Gallery', Boydell became Lord Mayor of London in 1790. A sense of public-spiritedness prevails in this part of the collection.

The more interesting part, however, is displayed on the walls of the undercroft level adjacent to the Roman amphitheatre (which had room for five thousand spectators) discovered on the site during the building of the new gallery. Here there is a group of Victorian pictures mostly acquired by the resourceful first director, Sir Alfred Temple, or from the bequest of Charles Gassiot, a wine merchant, in 1902.

Among the other smaller collections comprising the Guildhall Art Gallery's holdings, a slightly different chord is struck by the group of more than a thousand works by the British Fauve painter Matthew Smith. These were presented in 1974 by Mary Keene, the artist's model, and amounted to the entire contents of his studio. Only a small proportion is shown, but it is a refreshing experience.

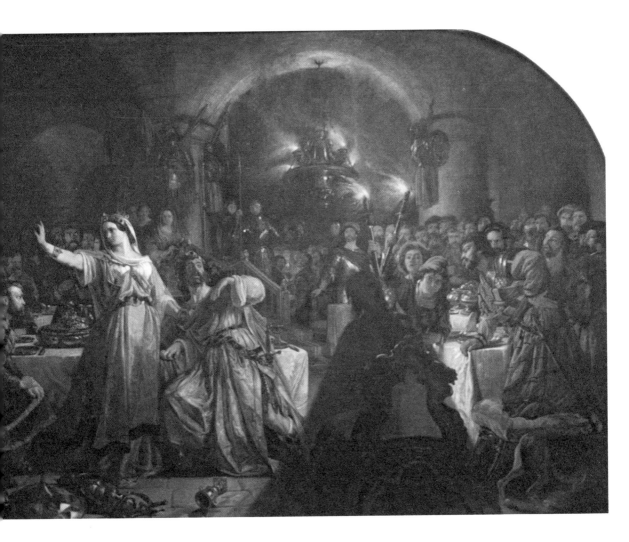

DANIEL MACLISE (1806–70)
The Banquet Scene in 'Macbeth' 1840
Canvas, 182.9 × 304.8 cm / 72 × 120 in.

The Irish-born Maclise was the quintessential artist of the Victorian age, equally proficient in all departments – portraiture, historical and literary themes, fairy painting, and genre. Added to his abilities as an artist were his handsome appearance, strong sporting physique and immense social charm. Living life to the full as he did and in great demand professionally, it is hardly surprising that his output began to slow in the 1850s, when he was not always in good health owing to overwork. He was a great friend of Dickens, Thackeray, and the influential man of letters John Forster.

Having attended the Royal Academy Schools (1828–31), Maclise made his name by publishing a series of caricatures of celebrated people of the day in *Fraser's Magazine*. His reputation as a painter was such that at the height of his powers he was asked to make a major contribution to the decoration of the new Palace of Westminster after the fire of

1834. There in a series undertaken by a number of artists as a sort of Sistine Chapel of democracy he painted murals of patriotic subjects such as *The Meeting of Wellington and Blücher at Waterloo* and *The Death of Nelson at Trafalgar*.

Maclise drew inspiration from Shakespeare throughout his working life. This scene from *Macbeth*, which is one of the artist's largest and most ambitious compositions, signals his passion for the theatre which he shared with Dickens and Forster, both of whom were amateur actors and zealous in the promotion of Shakespeare as the national bard. The melodramatic representation of this famous moment from Act III, scene 4, is no doubt an accurate reflection of contemporary theatrical practices and acting styles. The darkened setting illuminated by the flickering light of spluttering tapers, the horror-struck pose of Macbeth and the anxiety expressed by Lady Macbeth are thrilling in their own right, but especially good is the element of surprise visited upon the whole scene suggested by its oblique perspective. The *coup de théâtre* is the treatment of the ghost of Banquo seen from the back, all the more terrifying in its suggestiveness: as in the play, the *revenant* is only seen by the king, who has just arranged his murder, and not by his wife or the guests. The fascination the Victorians had for ghosts gives this painting an extra dimension.

JAMES TISSOT (1836–1902)
Too Early 1873
Canvas, 71.2 × 101.6 cm / 28 × 40 in. Signed and dated

Acquired by the wine merchant Charles Gassiot in 1873 when the painting was exhibited to considerable acclaim at the Royal Academy, *Too Early* is one of the first of numerous pictures of modern life undertaken by the French painter Tissot during his time in London, 1871–82 (cf. pp. 53–54). As it happens, Gassiot acquired a second painting by Tissot shown at the Academy in 1873 – *The Last Evening* – which he also bequeathed to the Guildhall Art Gallery.

The subject of *Too Early*, as the title suggests, is the social predicament of arriving too early at a ball. The ingenues are isolated in the vastness of the ballroom on the first floor of a grand house decorated in the Adam style. They are ignored by everyone and only observed by the smirking maids peering through the doorway. The hostess makes preparations with the orchestra while her embarrassed guests are full of uncertainty as to what to do or where to look. The sense of *froideur* stemming from the social awkwardness of the arrival is heightened by the wide open spaces and the emptiness of the room, with its high ceiling and large doorframes.

Tissot is here trying to balance the advances made in French painting, as in works by his friends Manet and Degas, with the need to satisfy the British taste for an intelligible narrative. He succeeds by combining a style notable for its visual accuracy with an

The visual counterpart
to novels by
Anthony Trollope

awareness of the psychological implications of the situation. This he could do as an outside observer of the social scene in London – which is what he remained, however determined he may have been to act like an anglophile. One critic was puzzled by how the artist could debase his traditional skills by indulging in 'caricature' and 'vulgarity' in the treatment of the subject. Another likened the picture to a comedy of manners as found 'in the novels of Jane Austen, the great painter of the humour of "polite society"'. And that really is the point: is Tissot recording the social scene as he saw it, or, alternatively, exposing the fatuity of social conventions? This dichotomy, quite apart from his dazzling technical skill (note the reflection of light in the violinist's spectacles), is the source of the fascination that we find today in Tissot's pictures.

KENWOOD HOUSE

Kenwood lies on the north side of London between Hampstead and Highgate, close to the edge of Hampstead Heath. The house is set in its own parkland and originally had a commanding view over London. It can truly be described as *rus in urbe* and was termed as such by J. C. Loudon in 1838 ('the finest country residence in the suburbs of London').

Kenwood, as it is seen today, was designed by Robert Adam for William Murray, 1st Earl of Mansfield, in the late 1750s and the parkland was developed by Humphry Repton in the 1790s. Subsequently, the house and grounds were purchased in 1925 by Edward Cecil Guinness, 1st Earl of Iveagh, whose family of Irish origin owed its fortune to brewing. Finding the house emptied of its original contents, Guinness provided works of art to furnish it in what may legitimately be called the country house style. Guinness had begun collecting pictures in the late 1880s for his other houses in Ireland and England. Most were acquired from one of the principal dealers of the day, William Agnew, but having bought Kenwood at the age of nearly seventy-eight it was a question of rearranging paintings rather than extending his collection. On his death Lord Iveagh bequeathed Kenwood – the house with the park, and the works of art – to the nation, so that it is now known as the Iveagh Bequest. At the time it was the finest group of old masters in Britain to have been so donated.

There was nothing pioneering about the Earl of Iveagh's taste, but he was buying at a propitious moment. Pictures from older British aristocratic collections were coming on to the market as a result of economic developments. This explains why Kenwood has such wonderful groups of pictures by Van Dyck, Reynolds and Gainsborough, as well as outstanding works by 17th-century Dutch (including exceptional paintings by Vermeer and Rembrandt) and Flemish masters with a topping of French 18th-century Rococo delights. Fortunately, Lord Iveagh was fractionally ahead of those rich and powerful American and South African collectors whose nostalgic interest in Georgian Britain drove the demand ever upwards to create what is now known as the Transatlantic taste of the 'Gilded Age'. Kenwood is in reality the direct British counterpart to the Henry E. Huntington Gallery, Library and Gardens at San Marino in California.

A journey to Kenwood skirting Hampstead Heath and past the Spaniards Inn is, as with Dulwich in south London, a serious and sometimes complicated undertaking, but the paintings are sensational and the ambience sympathetic.

JOHANNES VERMEER (1632–75)
The Guitar Player c. 1672
Canvas, 53 × 46.3 cm / 20⅞ × 18¼ in. Signed

The artist's modern reputation began with the first serious critical appraisal of his work by the French critic Théophile Thoré-Burger in 1866. Since then he has become a phenomenon aided by fiction and cinema. Vermeer's small output of thirty-four paintings (with the attribution of two others in dispute) together with the limited amount of tangential

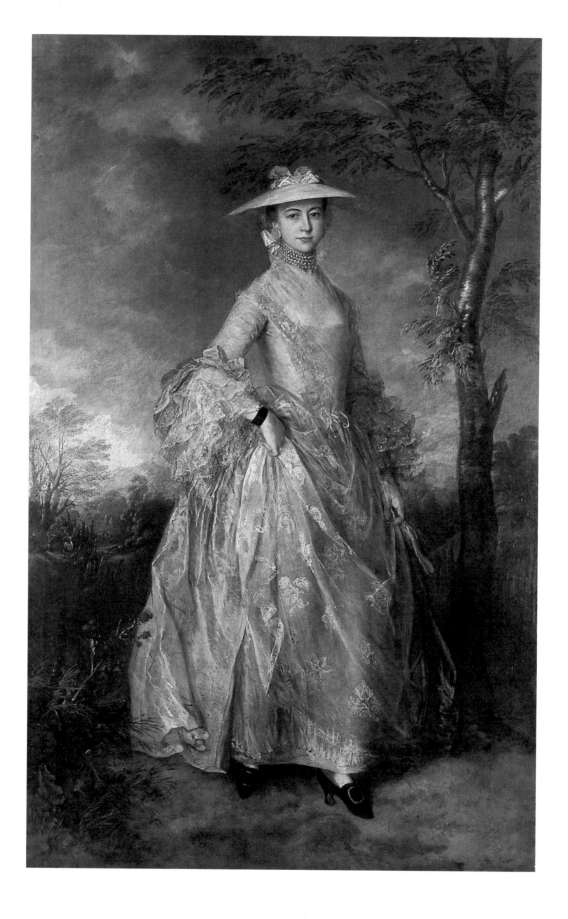

'The material
beauties of
Vermeer's world
uncover themselves
quietly, neither
sought for nor
unexpected'

LAWRENCE GOWING, 1952

documentation, as well as the often enigmatic nature of his subject-matter, has given rise
to endless fascination and discussion.

The Guitar Player is a late work and was still in the artist's possession at the time of his
death in his home town of Delft. It is in excellent condition, never having been restored or
relined, which is extremely rare. Vermeer's widow was forced to use this picture together
with another as payment of a debt, hoping to redeem both but failing to do so, being
declared bankrupt in 1676. Her concern to retain this particular picture might have been
because the sitter may be her eldest child, Maria.

Vermeer was evidently a slow and deliberate worker, painting on average only at most
three pictures each year, but the results are compellingly beautiful. Most of the composi-
tions are interiors limited to one or two figures. Striking aspects of *The Guitar Player* are
the lack of symmetry created by the figure being positioned left of centre and the 'close-
up' effect. Both features posed difficulties for the artist, which he solved with what seems
like effortless ease. Light and colour serve as correctives and give the composition a sense
of convincing immediacy. Vermeer displays his extraordinary technical skills, as in the
angle of the sitter's tilted head seen predominantly in half shadow, and the change of
focus in different parts. The fingertips and pearls, the end of the guitar and the highlights
on the picture frame behind the figure are all slightly blurred. Nowadays, it is customary
to argue that Vermeer could only have made such advances with an optical instrument
such as a camera obscura, but I think that Vermeer simply had a sharper and more curious
eye than his contemporaries, in addition to his technical ability.

Beyond all of this, though, is the startling effect of the image itself. Vermeer chooses
to show the figure distracted from her playing by someone outside the picture space.
Even if a deeper symbolic meaning is intended by the inclusion of the books or by the
picture within the picture (Vermeer used only a small number of studio props), it is the
deportment and expression of the sitter that engage our full attention.

A hallmark of all this artist's compositions is their almost frightening degree of self-
sufficiency. We do not know what prompted Vermeer to paint this singular moment, but if
we did the picture might not be so captivating. What is certain is that just as the sound of
the musical chord reverberates in the air so does the image in the viewer's visual memory.

THOMAS GAINSBOROUGH (1727–88)
Mary, Countess Howe c. 1764
Canvas, 243.2 × 154.3 cm / 95¾ × 60¾ in.

Gainsborough often protested about having to paint portraits for his living, but he
seems to have had no reservation about this life-size depiction of the wife of Richard, Earl
Howe, one of Britain's greatest naval heroes, responsible for the relief of the siege of
Gibraltar in 1782 and the victory of the 'Glorious First of June' in 1794. But at the time when

his portrait and that of his wife were painted by Gainsborough in Bath in the mid-1760s, he was not a man of such eminence. In fact, his own portrait is fairly routine by Gainsborough's standards, but for Mary, Countess Howe (1732–1800), Gainsborough was unstinting in his efforts to make a fine impression and in so doing produced a work that could easily be claimed as the finest made in Britain during the whole of the 18th century.

There is an air of the fashion catwalk here in the way the figure advances towards the viewer dressed in clothes that do ample justice to her social status and self-importance and are in fact quite unsuited to a country walk. The silk rustles, the ribbons flutter and the lace floats to create a general ensemble, but the accessories have been just as carefully chosen in order to impress – pearl choker, gloves, earrings, sunhat, black silk bracelet and shoes. The landscape, too, has some significance in so far as it suggests sensitivity to nature as well as ownership.

Gainsborough, like the Howes, at this time had still to establish his reputation outside of East Anglia where he was born, and he did just that in Bath with portraits of this calibre. This is painted very thinly, and many changes can be discerned in the process of making an image which is remarkable for its spontaneity and sense of movement, giving the whole an air of improvisation, just as the figure seems surprised to come across us on her path. Her expression is rather arch (note how the curve of her sunhat is echoed by her eyebrows) and she fixes us with her penetrating gaze.

The painter James Northcote, a pupil of Reynolds, said of Gainsborough's portraits, ''Tis actual motion, and done with such a light airy facility.' Quite so.

SIR THOMAS LAWRENCE (1769–1830)
Miss Murray 1824–26
Canvas, 135.9 × 108 cm / 53½ × 42½ in.

Lawrence was an infant prodigy and had a meteoric rise to fame. Even a man not unaware of his own abilities such as Reynolds was prompted to remark, 'In you, sir, the world will expect to see accomplished all that I have failed to achieve.' Lawrence became the most distinguished portrait painter in Europe, succeeding Reynolds as Principal Painter first to George III and then to George IV, as well as being elected President of the Royal Academy in 1820. He remained a bachelor and, although successful, experienced financial difficulties owing mainly to his activities as a collector of old master drawings.

There are aspects of Lawrence's portraiture that contemporaries disliked. Some thought his work was flashy and vulgar, tending towards the superficial and meretricious, when in fact his style was only mirroring the age of Romanticism. Similarly, paintings such as Miss Murray can today seem cloying and sentimental, anticipating the Victorian age or reaching beyond it to the Shirley Temples of this world. Lawrence, however, enjoyed the company of children and his style was ideally suited to capturing

'If ever this nation should produce genius sufficient to acquire to us the honourable distinction of an English School, the name of Gainsborough will be transmitted to posterity, in the History of the Art among the very first of that rising name'

SIR JOSHUA REYNOLDS, 1788

There are
representations
of children
by Reynolds,
Gainsborough,
Raeburn and
Romney at
Kenwood House,
but it is another,
younger, artist
who wins
the day

their playfulness and innocence. Commissioned in 1824 by her presumed father, General Sir George Murray (who was finally able to marry the girl's mother, Lady Erskine, two years later), Lawrence adapts the pose of figures of Flora used in Classical art and during the Renaissance. As the artist himself wrote to Sir George in 1824, 'All I can do will be to snatch . . . this fleeting beauty & expression so singular in the child before the change takes place that some few months may bring.' The success of the portrait was such that it has been endlessly reproduced in several forms into modern times.

Miss Murray (1822–91) married Captain Henry George Boyce, a grandson of the 1st Duke of Marlborough, in 1843, but her husband lived for only five years after the marriage, dying in Rome. She herself remained a widow for forty-three years, dying in Bordighera on the Gulf of Genoa just over the border from France.

Miss Murray, beribboned and bewitching, dances towards us along a path framed by a sylvan setting, a much younger version of Mary, Countess Howe as depicted by Gainsborough (see p. 118). Like her playmate 'Pinkie' in America (San Marino, Henry E. Huntington Gallery, Library and Gardens), earlier in date but older in age, the figure is seen from below as though the child were on a stage performing specially for us. How typically perceptive of Lawrence to realize that this is what children most like doing.

ROYAL ACADEMY OF ARTS

The Royal Academy was founded in 1768 under the patronage of George III and with Sir Joshua Reynolds as the first President. Amongst those holding official positions at the time of the foundation were Sir William Chambers (Treasurer), Dr William Hunter (Professor of Anatomy), Francis Hayman (Librarian) and John Flaxman (Professor of Sculpture). Honorary positions included Professor of Ancient History (Oliver Goldsmith), Professor of Ancient Literature (Samuel Johnson), and Secretary for Foreign Correspondence (Joseph Baretti, followed by James Boswell).

Strangely, the new Academy had no official premises in its formative years. It was housed in a set of auction rooms on the south side of Pall Mall, until, courtesy of George III, rooms in Old Somerset House were made available from 1771. Chambers then rebuilt this former royal palace in 1780 with the needs of the Academy in mind.

The Royal Academy remained at Somerset House until 1836, when it was forced out by the government of the day who required more office space. It then moved into the eastern half of the newly built National Gallery in Trafalgar Square, where it stayed from 1837 until 1868. The government at last offered a permanent home at Burlington House in Piccadilly – built for the 3rd Earl of Burlington at the beginning of the 18th century. A third storey was added to the original Palladian building and additions were made behind to accommodate exhibition galleries and rooms for teaching, both of these activities being part of the Academy's brief from its inception. This is where the Royal Academy has remained, with the recent addition of No. 6 Burlington Gardens to the north allowing for further expansion.

Most people are aware of the Royal Academy for two reasons: first of all, for the ever popular annual Summer Exhibition which shows the work of living artists and attracts huge crowds, and secondly for the wide-ranging temporary exhibitions which began in the 1870s. These last achieve good attendances and provide welcome income; more importantly, they counteract the perception that the Academy is essentially a conservative institution unwilling to acknowledge advances in art.

Few people realize that the Royal Academy has a collection of its own. Over the years a number of gifts and benefactions, with a smaller number of purchases, have meant that it came into possession of some outstanding works: Leonardo da Vinci's cartoon of the *Virgin and Child with St Anne and St John the Baptist* (sold in 1962 and now in the National Gallery), the *Taddei Tondo* by Michelangelo, and the *Leaping Horse* by Constable.

But the main source of acquisition was the requirement that each person elected to full membership had to deposit in the Royal Academy, 'to remain there, a Picture, Bas-relief, or other specimen of his abilities, approved of by the then sitting Council of the Academy'. Known as Diploma Works, these exist in considerable numbers and are by a wide range of artists. A selection can normally be seen in the John Madejski Fine Rooms.

SIR JAMES GUNN (1893–1964)
Pauline Waiting 1939
Canvas, 76.2 × 63.5 cm / 30 × 25 in.

Period style,
timeless poise

The sitter is posed in the lobby of Claridge's Hotel in London, but the subject is not an unfamiliar sight in the Royal Academy even today. The painting was deposited by the artist as his Diploma Work in 1961.

Born and educated in Glasgow, Gunn trained as a painter and printmaker at the Edinburgh College of Art before studying at the Académie Julian in Paris (1911–12). He travelled in Spain and North Africa in 1914, then enlisted for the duration of the First World War. Although he is established as a leading portraitist and painter of conversation pieces, his landscapes and urban views (often in the form of sketches) are also dazzlingly good and were mostly inspired by his travels. Gunn's status as a portraitist was confirmed by his commission to paint prime ministers and, in 1953, the Queen's state portrait.

The most impressive aspect of Gunn as an artist is his consistently refined technique with its sureness of touch, delicate tonal nuances and surprising variety of brushwork. After his second marriage in 1929 to Marie Pauline Miller in Paris, she often occurred

in his pictures. These are remarkably evocative and have a marvellous period flavour to them. You can almost hear the clipped speech of Celia Johnson in *Brief Encounter* (1945) as you look at Pauline patiently waiting in the hotel lobby. She died in 1956, but is unforgettable.

THE ROYAL COLLECTION

The paintings in the Royal Collection, which number some 7,000, are distributed throughout the royal residences. These fall into two groups: those occupied or used by the sovereign in an official capacity (Buckingham Palace, St James's Palace, Windsor Castle and the Palace of Holyroodhouse in Edinburgh) and those that are non-residential (including Kensington Palace, Hampton Court Palace, Kew Palace and Osborne House). Some of the royal residences associated with the monarch are privately owned (Sandringham House and Balmoral Castle). Clarence House and Highgrove House are the homes of the Prince of Wales. All of these residences are in one sense or another open at different times, or made accessible to the public either in part or in their entirety. Today Kensington Palace, Hampton Court Palace and Kew Palace are administered by the Historic Royal Palaces Agency and Osborne House by English Heritage – both working in conjunction with the Royal Collection.

Since 1993 the Royal Collection has been administered by a trust so that to all intents and purposes proper curatorial controls are applied as regards conservation, publications, presentation and loans. Temporary exhibitions, based solely on the holdings in the Royal Collection, are organized in The Queen's Gallery at Buckingham Palace, which was established in 1962 and rebuilt to a design by John Simpson in 2002 as part of the Golden Jubilee celebrations. There is another Queen's Gallery in Edinburgh, in a building adjacent to the Palace of Holyroodhouse, by the Scottish architect Bill Tindall.

By definition the Royal Collection is held in trust by the monarch for his or her successors on behalf of the nation. The course of history has resulted in the collection being a unique survival, remaining in close association with monarchy. The works of art are, therefore, seen in their rightful context.

The modern history of the collection begins in the 16th century with the Tudors and continues into the present reign. Its formation, development, and preservation have been the responsibility of each sovereign in turn through history. The greatest royal collectors were Henry, Prince of Wales, Charles I, Frederick, Prince of Wales, George III, George IV, and Queen Victoria with Prince Albert. It is largely as a result of their efforts that the Royal Collection has such distinguished holdings.

BUCKINGHAM PALACE

Acquired in 1761 by George III as a private residence for his wife, Queen Charlotte, Buckingham House (later Palace) was considered at first to be almost a rural retreat. It assumed far greater importance for George IV, who employed the architect John Nash to transform it into a proper palace, although the King never saw it completed. Nash's plans were carried through at less expense by Edward Blore. The Palace was considerably enlarged by Queen Victoria, using Sir James Pennethorne as her architect. The present appearance of the building – both exterior and interior – owes a great deal to Edward VII (particularly the Grand Entrance and the Grand Hall which evoke comparison with the Ritz Hotel) and to George V with Queen Mary (the façade by Sir Aston Webb facing the Mall), who between them obliterated many of the Victorian accretions.

Most of the paintings are hung in the State Rooms on the principal floor, which include the Picture Gallery. Here Nash broke with the tradition of the long gallery in country houses by designing a centrally located top-lit gallery space with long enfilades on either side. This gave the Picture Gallery a prominence that became a feature of other town houses owned by later collectors, such as those in Mayfair along Park Lane. The display in the State Rooms includes paintings pertinent to the history of the monarchy and of the Palace, but the Picture Gallery presents the whole collection in microcosm, usually with outstanding pictures by Van Dyck, Rubens, Rembrandt, Vermeer, Steen, Teniers, de Hooch, Cuyp, Claude and Canaletto.

ALLAN RAMSAY (1713–84)
Queen Charlotte with her Two Eldest Sons c. 1764
Canvas, 248.9 × 161.9 cm / 98 × 63¾ in.

Welcome to the
royal nursery

The Scottish-born painter Allan Ramsay was Principal Painter to George III, much to the chagrin of his younger rival, Sir Joshua Reynolds. It is likely that the King's attention had been drawn to the artist by his 'dearest friend', Lord Bute, when he was still Prince of Wales. Ramsay was commissioned in 1761 to paint the official coronation portraits of George III and Queen Charlotte (1744–1818), of which he was destined to make numerous replicas with the help of assistants.

Ramsay was a cosmopolitan painter who made four visits to Italy and was also conversant with developments in French art. Here, for example, the grandiose architectural setting with a curtain attached to one of the columns and the soft pastel tones are particularly redolent of contemporary French painting. However, if Ramsay uses the trappings of formal portraiture, he skilfully undermines it by creating a totally winning image of family intimacy and domestic harmony.

The two children are George, Prince of Wales (later George IV), who stands and Frederick, Duke of York, who is seated on his mother's lap. The future king is equipped with a drum and holds a bow as the attributes of martial valour, but this is balanced by the piano against which Queen Charlotte leans and at the foot of which is a portfolio. On the piano are placed a copy of John Locke's *Some Thoughts concerning Education* (1693) and a sewing basket, indicating not only the importance that George III and Queen Charlotte attached to family life, having 'their children always playing about them the whole time', but also their more sympathetic attitude to the ways in which children should be brought up.

Locke advocated reasoning and learning, which by the 18th century had been supplemented by the ideas of Jean-Jacques Rousseau, who believed that since children were born in a state of innocence, compassion and benevolence were what was required in their upbringing, for the benefit of mankind as a whole. Ramsay himself was a man of the Enlightenment, a scholar with a knowledge of several languages and a keen interest in philosophy and political theory.

The composition of this portrait was prepared with several drawn studies. The Queen's hands and the two children were painted on separate pieces of canvas and inserted into the main support. This was a procedure regularly followed by Ramsay and was an important expedient where royal portraiture was concerned, since only a few sittings were granted.

There is a wonderful tenderness about this huge portrait, derived not only from the delicate palette and quiet formality but also from the suffused brushwork, which gives the image a soft-focus effect.

KENSINGTON PALACE

Rather like Buckingham Palace, Kensington Palace originated as a rural retreat. The existing Jacobean house was acquired from the Earl of Nottingham for William III and Queen Mary II in 1689. The King suffered from chronic asthma and wanted purer air than Whitehall could offer, and the Queen preferred the more open setting. Christopher Wren made the initial conversion, with Nicholas Hawksmoor as his assistant. The palace was further developed by Queen Anne and by the early Hanoverians, who employed William Kent as architect and decorator with Henry Wise and Arthur Bridgeman having responsibility for the grounds. As a palace Kensington is not all that grand and in this respect it resembles Het Loo at Apeldoorn in the Netherlands rather than Versailles. There are strong historical associations. Queen Victoria was born in Kensington Palace and received the news of her accession here,

shortly followed by her first council. In modern times it was the last home of HRH Princess Margaret and Diana, Princess of Wales.

Most of the royal residences are richly documented through the centuries, and the various arrangements of the pictures are recorded in inventories so that it is possible to reconstruct different hangs according to separate reigns. Historical presentations are, therefore, based in part at least on primary sources and can be revealing. The present arrangement of pictures at Kensington Palace is based on the inventories made during the reign of George I and George II coinciding with Kent's programme of works. The 16th-century paintings (mostly Venetian) in the King's Gallery, for example, have frames specially designed by Kent. In the Privy Chamber, hung as an overmantel as at the beginning of the 18th century is one of the greatest paintings by Van Dyck.

SIR ANTHONY VAN DYCK (1599–1641)
Cupid and Psyche c. 1638–39
Canvas, 199.4 × 191.8 cm / 78½ × 75½ in.

The artist apparently painted several mythological subjects, but only two survive: *Rinaldo and Armida* (Baltimore Museum of Art) of 1629 and *Cupid and Psyche*, both commissioned by Charles I. It is not known for what purpose *Cupid and Psyche* was made, but it might be connected with a decorative scheme such as the one based on the story of Cupid and Psyche for the Queen's House at Greenwich. Certainly there is a link with the masques performed at court in the Banqueting House at Whitehall Palace with which Inigo Jones and Ben Jonson were both involved. The popularity of the masques was to a certain extent indicative of a court withdrawing from reality as the country edged towards civil war.

The story of Cupid and Psyche, based on *The Golden Ass* by Apuleius, written in the 2nd century AD, had been popular in the Renaissance, and was well known in court circles. Venus, jealous of Psyche who had fallen in love with her son Cupid, sets Psyche a series of tasks as a punishment. One of these is to go down to the underworld and fetch Proserpine's casket without opening it. Psyche, however, does open it and is overcome by sleep. At this point Cupid discovers her and rescues her. He then escorts her to Olympus for their wedding.

Van Dyck depicts Cupid alighting upon earth like the Angel of the Annunciation and coming upon the supine body of Psyche. The opened casket lies beside her. For Cupid it is a moment of discovery; for Psyche it is a moment of vulnerability. He represents divine Desire and she earthly Beauty. Their meeting, therefore, fits the Neoplatonic concept of Love or Desire sparked by Beauty. The subject was probably one of heightened personal significance for Charles I and Queen Henrietta Maria, who were a particularly amorous couple.

Van Dyck pays his respects to Titian

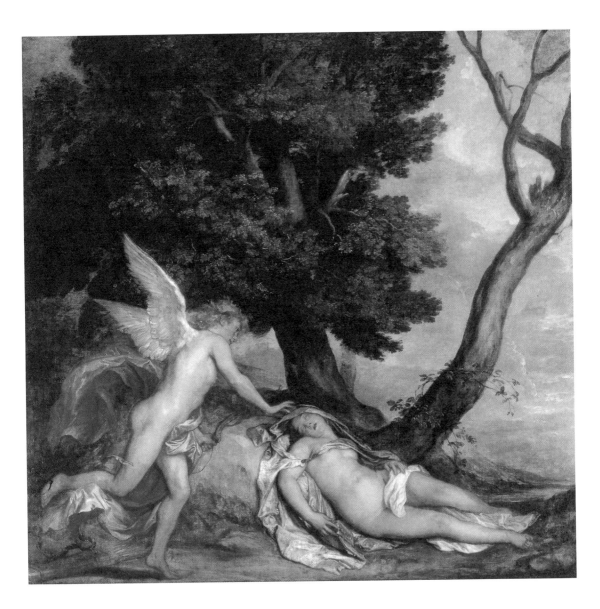

The surface of this picture is very thinly painted with a light and nervous touch. It may even be unfinished, but, nonetheless, this is a picture with a poetic resonance. The figures enact the scene in a sylvan setting against a roseate sky. The diagonals created by the bodies with their subtly differing flesh tones are echoed by the trees, one in full leaf and the other dead – a metaphor for the situation that Cupid and Psyche find themselves in. Van Dyck, like Charles I, was a great admirer of Titian and pictorially this was probably his starting point, but at the same time he seems to anticipate Watteau and Boucher. What is more, the picture was owned for a time by Lely.

WALLACE COLLECTION

V isiting the Wallace Collection is like entering Paradise. At the top of the main staircase straight ahead of you are magnificent paintings by François Boucher. The great French critic Denis Diderot described Boucher's art as a pleasurable vice, and although there is a great deal of naked flesh – mostly female – it is really an innocent world of gods and goddesses floating in a realm of their own making. Looking at Boucher's mythological paintings can seem like watching figures in free fall.

The Wallace Collection is where you come to see the best of French 18th-century art – not just its paintings, but furniture, bronzes and porcelain as well. It is a rich feast, made more glorious by the fact that Hertford House (formerly Manchester House), acquired in 1797 by the 2nd Marquess of Hertford, deliberately retains some semblance of a private home in spite of the quantity and range of works of art on display. By contrast with the unsurpassed welcome extended by Boucher, lurking at the foot of the staircase somewhat hidden away is Andrew Morton's *The Duke of Wellington with Colonel Gurwood at Apsley House* (1840), of which one of the official catalogues (1985) stated 'Wellington's right hand must be the most incompetent piece of painting in the Collection'.

The collection is the creation in the first instance of the Marquesses of Hertford, particularly of the 3rd and 4th Marquesses. The 3rd Marquess (1777–1842), a much disliked man (he was the model for Lord Steyne in W. M. Thackeray's *Vanity Fair*), acquired a number of genre scenes by Dutch 17th-century painters, as well as more surprisingly some 16th-century Venetian pictures, including Titian's *Perseus and Andromeda* once owned by Philip II of Spain. A far more consistent collecting policy was put in place by the 4th Marquess (1800–1870), whose taste was omnivorous: old masters, Dutch and Spanish 17th-century paintings, and – more unusually for the time – anything to do with 18th-century France, as well as British art, including numerous works by R. P. Bonington. Not unsurprisingly, towards the end of his life he decided to add 19th-century French and other paintings to the collection, choosing pictures illustrating Napoleonic and Orientalist themes. The quality and diversity of the pictures is principally the result of the efforts made by the efforts of the 4th Marquess.

All the Marquesses of Hertford were Francophiles, owning a number of houses in France. They lived for long periods abroad with whole sections of the collection gathered around them. The 4th Marquess's illegitimate son, Sir Richard Wallace (1818–90), was born and brought up in France, but from 1872 he decided to live permanently in London at Hertford House with his French wife. He set about re-presenting the collection he had inherited as an ensemble. He gave it a greater historical dimension by adding early Italian and Netherlandish pictures and European arms and armour, as well as Renaissance decorative objects. Essentially, he created the Wallace Collection

as we know it today and chose to live in what can only be described as a showcase for art. On her death in 1897 Sir Richard Wallace's widow bequeathed the collection to the nation, and it was formally opened to the public by another ardent Francophile, Edward VII (still but only just Prince of Wales), in June 1900.

The influence of the Wallace Collection can be felt in the Frick Collection in New York and to a lesser extent at the Jacquemart-André Museum in Paris, but it surpasses both of them in the range of objects on display.

VINCENZO FOPPA (1427/30–1515/16)
The Young Cicero Reading c. 1465
Fresco (fragment), 101.6 × 143.7 cm / 40 × 56½ in.

A Renaissance vision of a great Roman orator at his youthful studies

Painted by the leading exponent of the Renaissance style in Lombardy, this fresco fragment formed part of the decoration of the Palazzo or Banco Mediceo in Milan, which Cosimo de' Medici had had carried out after Francesco Sforza had given him the palace in 1455. The frescoes were in the courtyard and loggia as well as along the parapet, exposed to the elements until the remnants were saved c. 1863. Allowance must therefore be made for the condition of this survival.

In its original setting this scene probably represented one of the Liberal Arts, namely rhetoric. Cicero (106–43 BC), a notable orator and writer, was regarded as an infant prodigy. Plutarch records that at school he was already renowned for his 'quickness and readiness in learning'. His speeches, books and letters were of the greatest influence not just in the Renaissance, but also during the 18th and 19th centuries in Europe when Latin was still the basis of learning. There is a fetching disparity in Foppa's depiction between the nonchalant posture and the earnest intent in the act of reading. This little chap became the greatest orator of his time and one of the finest in history. Significantly, when President Barack Obama's talents as a speechmaker were first recognized he was instantly compared with Cicero.

PETER PAUL RUBENS (1577–1640)
The Rainbow Landscape c. 1636–37
Wood, 135.6 × 235 cm / 53⅛ × 92½ in.

Rubens was described as the Homer of painting by the French 19th-century painter Eugène Delacroix, on account of his high status amongst artists. Indeed, the reputation he gained during his lifetime only increased during the 18th and 19th centuries. Of all the various types of painting undertaken by Rubens my favourite is the landscapes. Not only are they wonderful evocations of nature in all its forms, celebrating the fecundity of the earth, they were also very personal to Rubens. The Wallace Collection owns one of his most famous.

The Rainbow Landscape was painted as a pendant to Het Steen (London, National Gallery), which depicted the country chateau at Elewijt (between Brussels and Antwerp) that Rubens bought fairly late in his life in 1635. He therefore knew this landscape intimately. Indeed, he hung the two pictures in the same room of the chateau, where he spent some of the happiest years of his life following his marriage to his young second wife, Hélène Fourment. The idea seems to have been that the rising sun illuminated the morning scene of Het Steen and the evening sun the scene of the peasants returning from the fields after rain of The Rainbow Landscape.

There is also in Rubens's landscapes a justifiable sense of national pride, not simply in the beauty of nature herself but in her bountifulness. This can in turn be related in a general sense to literary sources such as the Bible or Virgil's Georgics.

A source of wonderment for the viewer is the sheer scale of the picture, which as so often with Rubens is painted not on a single piece of wood but on numerous components. The artist provides a panoramic view, looking from an elevated, bird's-eye angle towards the distant horizon. Contained within that ever-expanding space is the whole panoply of nature, with people working in harmony with their animals and one another. The air is moist and you can almost see the vapour steaming from the earth as it dries out

'Possibly more than any other artist he could claim to be the *uomo universale* of his epoch'

CHRISTOPHER WHITE, 1987

after the passing storm. This is just the kind of skill displayed by Rubens that Constable so enjoyed.

Both pictures were sold after the artist's death and came to London in 1803, when they were offered to the nation but turned down. Sir George Beaumont acquired *Het Steen* and gave it to the National Gallery. Eventually in 1856 at considerable expense *The Rainbow Landscape* came into the possession of the 4th Marquess of Hertford, who was not overly fond of Rubens, but was certainly impressed by his reputation. The picture was kept in London while he remained in Paris.

JAN STEEN (1626–79)
The Lute Player c. 1670
Canvas, 36.4 × 53.2 cm / 14⅜ × 21 in. Signed

There is a remarkably strong group of Dutch 17th-century pictures in the Wallace Collection, most of them acquired by the 4th Marquess.

Jan Steen was a consummate narrative artist who painted several mythological and Biblical subjects, but is seen at his best in genre scenes. These are not always straight-forward, and often illustrate aspects of human folly or vanity, sometimes by reference to well-known Dutch proverbs of the time or emblem books.

Steen was the son of a brewer and ultimately he himself kept an inn, although for a time he attended the University of Leiden. Apart from intermittent visits to Haarlem during the 1600s, Leiden was the town with which he was most closely associated. A prolific painter, Steen ably balanced breadth of style with a detailed finish. Some of his compositions, including the present one, anticipate artists working at the beginning of the 18th century in France, such as Watteau.

All is not what it seems in *The Lute Player*, which is in reality a depiction of the senses. The laughing figure on the left with the pipe and wine glass represents smell and taste: it is in fact a portrait of the artist, who rarely missed an opportunity of introducing himself into his own pictures. The embracing couple in the background can be associated with touch, and the lutenist with sound. But the matter does not rest there, for the lovers are mismatched, the drinker's state of dissolution has led to impotence (as suggested by the flaccid but still smouldering taper on the stone ledge), and the lutenist is not as innocent as she looks, since her purse, so prominently shown, suggests an impure form of love.

'That strain again! It had a dying fall'

WILLIAM SHAKESPEARE, *TWELFTH NIGHT*, ACT I, SCENE 1

Most striking of all, however, is not the *double entendres* but the informality of the composition, which seems to be set on the terrace of a house in the country. Especially winning is the pose of the lutenist, who is wonderfully dressed in blue, yellow and lilac silks and is precariously balanced. This figure stays in the mind.

JEAN-ANTOINE WATTEAU (1684–1721)
Les Champs Élisées c. 1716–17
Wood, 31.2 × 41 cm / 12¼ × 16⅛ in. (made up to 33.1 × 42.6 cm / 13 × 16⅞ in.)

'The result is
a miniature
Mozart opera'

MICHAEL LEVEY, 1966

An artist who epitomizes 18th-century painting in France, though he was born in Flanders, is Jean-Antoine Watteau, who died of tuberculosis as early in the century as 1721, at the age of thirty-six. Watteau was greatly influenced by Rubens, particularly the historical paintings, but it was not a question of competing with his Flemish predecessor on his own terms. Rather, Watteau devised a new category of painting, the *fête galante*, which was officially accepted by the Académie Royale in 1717 on the receipt of his '*Embarkation for Cythera*' (Paris, Louvre). Such pictures with their delicately drawn figures became particularly sought after by collectors in Europe, in spite of the fact that their condition is often far from perfect owing to the artist's frequent changes to the compositions and imperfect technique.

Although the surface has suffered, this painting for me retains the magic of Watteau's special gifts. It is a *fête galante*, depicting elegant figures wearing a form of fancy dress seen in a park. The mood or atmosphere of this type of picture – amorous, reflective, elegiac, melancholic – is more important than any narrative element, which is indeed often underplayed by the artist. In these pictures Watteau builds upon the Venetian pastoral tradition as well as on Rubens's own interpretation of it in his *Garden of Love* (Madrid, Prado). But here Watteau also exploits contemporary literature and theatre, especially the *commedia dell'arte*.

The title is derived from a print of the picture dating from 1727, but do not think of the scene topographically. The reference is to the fields of Elysium as in Classical literature. Watteau always gives such scenes a theatrical air and treats his subject-matter enigmatically, which allows room for interpretation – not always a good thing in these days of new art history. *Les Champs Élisées* has been seen as representing the progress of love with the innocent dalliance taking place in the foreground contrasted with the cavortings in the mid-distance. Often in these pictures Watteau re-uses figures from other compositions or else takes them from an existing stock of drawings, but it is the way he fits these together that creates his unique magic. There is humour, too, in the juxtaposition of the man standing on the right immediately below the unusually posed statue of a sleeping woman lying on top of the fountain.

If you wanted to be prosaic, you would just describe Watteau's paintings as no more than picnics (as at the opera at Glyndebourne), but on a more poetic level we are dealing

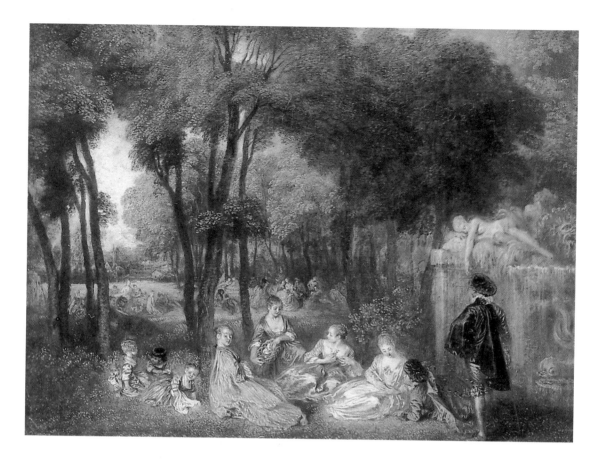

with an artist who can capture the poignancy and psychological import of the merest moment – a touch, a sound, a look, a rustle, a movement – that lasts forever. And the fountain plays on.

Constable wrote in a letter to his artist friend C. R. Leslie that Watteau 'painted in honey' and went on to say 'be satisfied if you but touch the hem of his garment'.

JEAN-HONORÉ FRAGONARD (1732–1806)
The Souvenir c. 1776–78
Wood, 25.2 × 19 cm / 10 × 7½ in.

Fragonard is a painter who fused the French and Italian styles of the mid-18th century. Eschewing grand historical subjects, he decided to meet the requirements of private patrons with a wider range of subject-matter more suitable for drawing rooms, boudoirs or studies. Even though his paintings can be overlaid with sentimentality, they are always executed – often vigorously – in an eloquent Rococo style with light brushwork and fresh colour. The artist had a long life extending beyond the Revolution of 1789, by which time he had given up painting in order to serve on the commission to set up the Musée du Louvre in Paris before returning to his birthplace, Grasse in Provence.

The Wallace Collection may trumpet forth its 18th-century French paintings on the main staircase, but there are quieter, more private moments

The Souvenir is a small painting of the greatest enchantment and of the highest quality. The young girl has received a letter from her lover and begins to carve his initials into the bark of the tree. She is watched over by her dog, representing fidelity. The subject is one associated with the 16th-century Italian poet Ariosto (*Orlando Furioso*), but on this occasion the connotations are purely personal and not intellectual. The highly individual composition is particularly deft, with the figure seen in profile framed within the arching branch of the tree. The upper part of the body is silhouetted against the sky, emphasizing the young girl's delicate features and beribboned coiffure.

The painting was engraved for popular consumption in 1786 – and no wonder. Today we pay our respects by excitedly buying a postcard on the way out.

EUGÈNE DELACROIX (1798–1863)

The Execution of the Doge Marino Faliero 1825–26

Canvas, 145.6 × 113.8 cm / 57¾ × 44⅞ in. Signed

Delacroix was the leading exponent of the Romantic style of painting in 19th-century France and was a deeply influential painter throughout Europe. In this respect he was the counterpart of the more classically inclined Ingres, who also had a large number of followers. As with their 17th-century forerunners Rubens and Poussin, the distinguishing features of their work (sometimes exaggerated) stem from an emphasis on colour in Delacroix as opposed to line in Ingres.

Delacroix was fortunate in his birth, linked through his father to the political world and through his mother to artists. He was well read and well travelled, receiving many official commissions for murals in Paris in the Palais Bourbon, the Louvre (Galerie d'Apollon), the Luxembourg Palace and the church of St-Sulpice. Although he visited London and admired British artists such as Constable, Lawrence, Wilkie, the Fielding brothers and Bonington, his work is not on the whole widely represented in this country.

Delacroix's great charm and winning personality are most evident in his *Journal* and letters, which are among the most readable and revealing documents in the literature of art. Quixotic in character, he at one moment relished the hustle and bustle of Paris only at another to pine for the solitude of the country or a glimpse of the sea. He never married and (like Lawrence) was looked after to the very end by a faithful servant, Jeanne Leguillou. His last studio in Paris was in the Place Furstenberg in St-Germain-des-Prés: it is now a museum dedicated to his memory where his passionate spirit still lingers.

The Execution of the Doge Marino Faliero was painted at a critical time in Delacroix's career, just as he was establishing his reputation and before many of his most famous works. The artist's source for this subject from Venetian history was Byron's tragedy *Marino Faliero, Doge of Venice* (1820), recounting the fate of a man who was doge for a single year (1354–55) before being executed for conspiring against the Venetian state. The vertical composition heightens the sense of drama, dominated as it is by the empty staircase. The Doge's body lies at the foot of the staircase, his recumbent figure bracketed by two standing attendants, that on the right being the executioner. The Doge's golden robe is held by other attendants on the left at the top of the staircase, while on the right the sword used for the beheading is displayed to the crowd below. The setting is the Doge's Palace, though it is not an exact representation. Delacroix here showed his admiration for Venetian 16th-century painting and also for Rubens. What fascinates me is the way in which the artist has contrived to push the action towards the edges of the composition, thereby granting the empty staircase an added eloquence.

The picture was well received by critics and was held in special esteem by the artist himself. The tension and drama in the scene are only equalled in operas by Giuseppe Verdi.

Tension and drama equal to a night at the opera

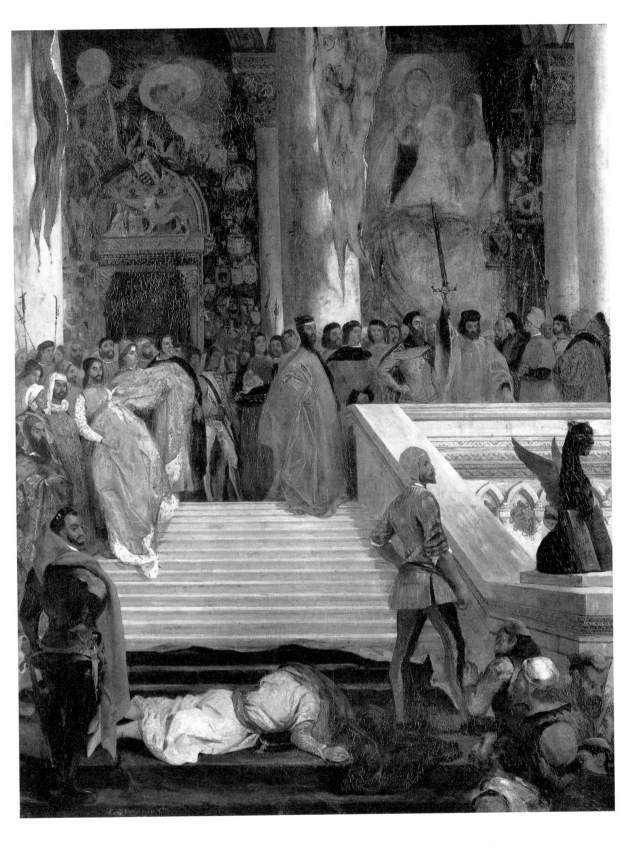

Part Two

ON THE ROAD: ENGLAND

Ford Madox Brown
Work (detail)
Manchester Art Gallery
(see pp. 372–73)

THE SOUTH-EAST

Proximity to London has its advantages and disadvantages. The surprise is that, in spite of the overcrowding and the dense road and rail network, so many areas of natural beauty survive: the North (Surrey) and South (Sussex) Downs, the orchards of Kent, a coastline of cliffs and beaches overlooking the English Channel, and a string of harbours culminating in the Solent protected by the Isle of Wight.

There is a similar variety in the public collections found in the South-East. Three royal residences offer unsurpassed opportunities to see paintings in their proper contexts: Hampton Court Palace, Osborne House on the Isle of Wight, and Windsor Castle.

Victorian painting is well represented at Royal Holloway and Bedford New College at Egham (part of the University of London). Southampton City Art Gallery is an important marker as regards quality, with Brighton Museum and Art Gallery and the Towner in Eastbourne not far behind. The much smaller Pallant House Gallery in Chichester is outstanding in its sense of purpose and consistently high quality.

An unusual aspect of the public collections in the South-East is the number devoted to individual artists: Hubert Herkomer at Bushey Museum and Art Gallery in Hertfordshire, Stanley Spencer at Cookham in Berkshire, and G. F. Watts at Compton in Surrey. Each of these is a place of pilgrimage for those with a special interest in those particular artists.

Brighton

BRIGHTON MUSEUM AND ART GALLERY

Brighton began as a fishing village, but developed into a popular bathing resort towards the end of the 18th century. Its reputation was made when the Prince Regent (later George IV) chose the growing town as his principal playground, symbolized by the creation by John Nash of the fantastical Royal Pavilion. Minarets and domes characterize the exterior, while the lavish interiors were decorated by Frederick Crace and Robert Jones. The heyday of the Royal Pavilion did not last long, and Queen Victoria was not amused, allowing it to be opened to the public in 1851.

The Museum and Art Gallery was purpose-built and opened in 1873. The architect was the local borough surveyor, Philip Lockwood, who adopted an idiom that blended in satisfactorily with the neighbouring buildings. It overlooks the gardens of the Royal Pavilion and forms part of a group in the Pavilion's shadow referred to now as the Cultural Quarter. Next to it is the Brighton Dome, built to house stables and a

riding school for George IV on an immensely grand scale by William Porden, whose 'Orientalizing' tendencies set the tone for the slightly later development of the Royal Pavilion. Part was later converted into a concert hall; it is now a performing arts venue, most recently updated in 2002.

The founding collection was given by Henry Willett (1823–1905). There is a varied group of old masters, some notable Victorian pictures which came from the collection of H. G. Simpkins, a strong representation of Camden Town artists (the first Camden Town exhibition was opened here by Sickert in 1913), and some work by contemporary painters. The recent bequest of Paul Otto Heyer (1937–97), who was born and educated in Brighton but emigrated to America in 1965 where he worked as an architect, has introduced a Transatlantic dimension to the collection. Heyer, President of the New York School of Interior Design, bequeathed eleven works in all – paintings, drawings and sculpture.

JOHN RITCHIE (active 1857–75)
Little Nell and her Grandfather Leaving London 1857
Canvas, 50.7 × 40.7 cm / 20 × 16 in.

Little is known about this minor Victorian artist, whose style could generally be described as Pre-Raphaelite, although there is an intensity about it that brings Richard Dadd to mind. The scene is from *The Old Curiosity Shop* by Charles Dickens, published in 1841. Little Nell looks after an old curiosity shop in London with her grandfather, Trent, but they fall on hard times and are forced to flee London, pursued by a grotesque moneylender, Daniel Quilp, who had seized the shop. They wander the country in fear of their lives and suffering destitution. The grandfather's brother comes to the rescue, but has difficulty tracing them and only does so shortly after Little Nell's death, which is soon followed by her grandfather's demise. In writing Little Nell's death Dickens created one of the greatest scenes in Victorian literature. It drained him emotionally, but engaged the public's attention in Britain and America to an unprecedented degree – not just on account of the story but because it focused attention on the issue of the high rate of child mortality: in 1839 almost half the funerals held in London were for children aged under ten. George Bernard Shaw, on the other hand, cynically described the novel as 'a sort of literary onion, to make you cry'.

The passage illustrated by Ritchie occurs in Chapter 15: 'Then came a turnpike; then fields again with trees and haystacks; then a hill; and on top of that the traveller might stop, and – looking back at old Saint Paul's looming through the smoke, its cross peeping above the cloud (if the day were clear), and glittering in the sun; and casting his eyes upon the Babel out of which it grew until he traced it down to the furthest outposts of the

Clear of London
at last

invading army of bricks and mortar whose station lay for the present at its feet – might feel at last that he was clear of London.' Little Nell and her grandfather take refreshment and say their prayers. A depiction of the same scene occurs in the illustrated edition of the book prepared by Hablot K. Browne (Phiz) and George Cattermole in 1848.

FRANK STELLA (b. 1936)
Red Scramble 1977
Canvas, 42.7 × 51 cm / 16¾ × 20⅛ in.

'What you see is what you see'

FRANK STELLA

As an artist Stella, like Picasso, enjoys reinventing himself at intervals. Tempted at the outset by Abstract Expressionism, he was encouraged by an examination of the canvases by Jasper Johns based on flags and targets to adopt a reductive style that came to be known during the 1960s as Minimalism. The essence of this style as seen in Stella's paintings lay in predetermined stripes and patterns contained within traditional canvas shapes. *Red Scramble* refers back in these respects to the artist's famous 'Black Paintings' of 1959, which announced the arrival of Minimalism. Quite unlike the Abstract Expressionists, whose works are open to interpretation, Stella insisted that his art is 'based on the fact that only what can be seen there is there ... All I want anyone to get out of my paintings, and all I ever get out of them, is the fact that you can see the whole idea without any confusion ... What you see is what you see.' Although the compositions remain very rigid, the juxtapositions of colour and the geometrical sequence of diminishing squares introduce a note of variety and even of improvisation.

Stella himself broke the fetters of Minimalism during the 1960s by using shaped canvases and metallic lines, which led during the 1970s and 1980s to his series of painted oblique reliefs in mixed media, which are exuberant and chaotic, amounting to a modern form of Baroque, and rupture all preconceptions about painting and sculpture.

Bushey

BUSHEY MUSEUM AND ART GALLERY

The Museum and Art Gallery opened in 1993, declaring its independence from Watford Museum. The collection highlights the life and career of Sir Hubert von Herkomer, one of the great names in Victorian art. Several of his social realist paintings became widely known through engravings, such as *Hard Times* of 1885 (Manchester Art Gallery) and *On Strike* of 1891 (Royal Academy), and influenced Vincent van Gogh.

Born in Bavaria, Herkomer came to Britain via America as a child in 1857, and first made a name for himself as an illustrator for the *Graphic* magazine. Early paintings reveal his German roots, and he regularly returned to the country of his birth (an award in 1899 allowed him to add 'von' to his name). He exhibited successfully at the Royal Academy as well as internationally. Most of his income was derived from portraiture.

From 1873 Herkomer and his family lived in Bushey, where he built a large house called Lululaund after his deceased second wife, Lulu. Designed by the American architect H. H. Richardson, this became the centre of the artist's multifarious interests. (The house was demolished in 1939.) Herkomer had an illustrious circle of friends; he succeeded Ruskin as Slade Professor at Oxford University, and was knighted in 1907.

SIR HUBERT VON HERKOMER (1849–1914)

Anna Herkomer 1876

Canvas, 48.7 × 58.2 cm / 19¼ × 22⅞ in. Signed and dated

Anna Weise was the daughter of a lawyer from Berlin. She met Herkomer through his first patron, Clarence Fry (he owned *The Last Muster*) who lived in Watford, and they were married at Bushey in December 1873. There were two children: Siegfried and Elsa. Anna appears to have been older than Herkomer, but she also suffered from consumption. The marriage was unhappy and the couple lived apart intermittently from 1877, Anna dying in Vienna in 1883.

The portrait, which is dedicated to the two children, shows the artist's wife resting in a hammock. It is informal and not unsympathetic, although Herkomer later disparaged Anna in his memoirs. Edmund Gosse, a friend of the couple, described her as 'a lady of charm and refinement, in social cultivation considerably superior to her husband when she married him', and 'devoted to his interests'. The intimacy of the portrait is striking.

Herkomer married twice more: Lulu Griffiths in 1884, and, after her death a year later, her sister, Margaret Griffiths, who lived until 1934.

Chichester

PALLANT HOUSE GALLERY

The creation of the Pallant House Gallery is one of the miracles of our time. The impetus came from the Very Rev. Walter Hussey, Dean of Chichester Cathedral from 1955 to 1977. Hussey had already built a reputation as a patron of contemporary British art and music while he was vicar of St Matthew's in Northampton, for which he commissioned major works by Henry Moore and Graham Sutherland. This outstanding patronage continued during his time as Dean of Chichester, transforming the cathedral into a centre of ecclesiastical and artistic interdependency. Hussey also formed a private collection, which he offered in 1974 to the city on the understanding that it should be shown in Pallant House, a Queen Anne town house (1712) previously used as council offices.

Pallant House Gallery opened in 1982 as a combination of historic house, furnished interiors and modern art, and proved to be a great success. It attracted other donations – notably the Charles Kearley Bequest in 1989 and the Sir Colin St John Wilson Gift in 2004. This second donation amounted to nearly 1,000 works, which necessitated an extension to the original house. After being put out to tender, this extension was designed by Long and Kentish with Colin St John Wilson and Associates (essentially a husband and wife team) and opened in 2005.

The collection put together by Colin St John Wilson, the architect of the British Library, was built up over a period of fifty years (in later years he was joined by his wife, M. J. Long), with many items acquired directly from artists on the basis of personal friendships. The result is that Pallant House Gallery now has one of the finest collections of modern British art to be seen anywhere.

GRAHAM SUTHERLAND (1903–80)
The Crucifixion 1946
Board, 67 × 41.3 cm / 26⅜ × 16¼ in.

This is one of eight oil studies made by Sutherland in connection with a commission in 1944 by Walter Hussey for St Matthew's in Northampton. The original request was for a painting of the Agony in the Garden, but the artist negotiated to depict the Crucifixion instead. The finished work, most of which was painted in 1946, remains in the church.

Sutherland's religious paintings are utterly compelling. He converted to Roman Catholicism in 1926. The searing images, often reinforced by the symbolism of what he saw in natural forms, are no less anguished than Matthias Grünewald's great *Isenheim Altarpiece* (1516). In fact, Sutherland's concern to paint a Crucifixion scene was determined

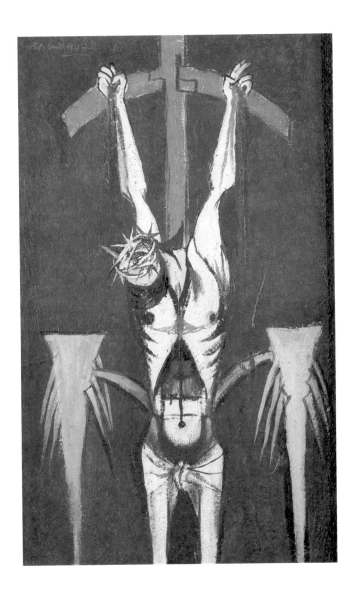

'That Graham
Sutherland is almost
the only living artist
capable of
expressing the full
intensity of a
Christian theme
is now proved'

ERIC NEWTON

by the images he saw in a book of photographs of the concentration camps of Belsen, Auschwitz and Buchenwald. 'The whole idea of the depiction of Christ crucified became much more real to me after having seen this book and it seemed to be possible to do this subject again. In any case the continuing beastliness and cruelty of mankind, amounting at times to madness, seems eternal and classic.'

An equally compelling *Deposition*, also dating from 1946, is in the Fitzwilliam Museum, Cambridge. The culmination of this phase in Sutherland's career occurred with the commission in 1952 for the design of the tapestry *Christ in Glory* for the new Coventry Cathedral, but he returned to religious subject-matter in 1961 at the behest of Walter Hussey for a *Noli me Tangere* to hang in the Chapel of St Mary Magdalene in Chichester Cathedral.

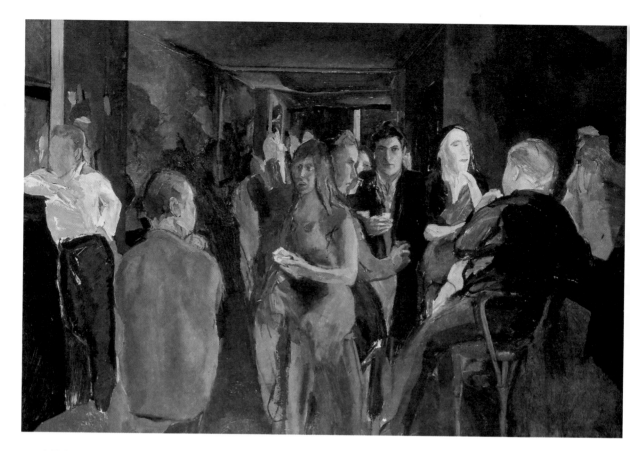

MICHAEL ANDREWS (1928–95)
The Colony Room 1 1962
Board, 120 × 182.8 cm / 47¼ × 72 in.

This modern conversation piece has become one of the key works in the history of the group of artists to which Michael Andrews belonged, known as the School of London. The scene takes place in the private drinking club called the Colony Room in Dean Street, Soho: it was owned and run by Muriel Belcher and so also went under the name of Muriel's. She became a legend in her time. Oddly, she had no interest in art whatsoever and this appealed to artists who only wanted to gossip after a day's work.

The painter depicted the scene from memory in his studio. In it he includes, from left to right, Jeffrey Bernard (writer), John Deakin (photographer), Henrietta Moraes (model), Bruce Bernard (photographer and writer), Lucian Freud (artist), Carmel (friend of Muriel Belcher), Francis Bacon (artist), Ian Board (barman), and Muriel Belcher herself at the right edge. In the background on the left is a mural painted by Andrews after Pierre Bonnard for the Colony Room.

The composition is notable for its tautness and complementary poses. There is here a visual coherence counteracted by the disorder and social interaction of a party. The figures are arranged like a relief, but there is also considerable penetration into depth.

'Mike is so economical. He only paints masterpieces'

FRANK AUERBACH

This proved to be the first of a series of pictures depicting social gatherings at a time when the artist was reassessing his style and seeking greater clarity in his compositions and handling of paint.

Andrews was born in Norwich into a devout Methodist family, but studied at the Slade School of Fine Art (1949–53) when William Coldstream took over as Professor, and he himself later taught there. Not obviously an artist in appearance (he was usually formally dressed), conventional in outlook and reserved in temperament, he essayed a wide range of traditional themes in his work, but at the same time revealed a daring imagination. In fact Andrews was perhaps the most surprisingly imaginative of all the artists belonging to the School of London, as in *A Man Who Suddenly Fell Over* of 1952 (Tate) or the sequence *Lights* (1970–74). Even so, he was never an impulsive painter like Francis Bacon, instead proceeding with deliberation and perfecting a meticulous technique which resulted in a comparatively limited output.

The picture was part of Sir Colin St John Wilson's Gift.

Compton

WATTS GALLERY

No artist epitomizes Victorian aspirations so poignantly and unequivocally as G. F. Watts, whose life and work are touchingly commemorated at Compton. His career spanned the whole of Queen Victoria's reign. At the time of his death he was the most famous artist in the country and had secured for himself an international reputation. The high regard in which Watts was held and which fell away so dramatically after his death was due first to the universal themes that he undertook in his paintings and sculpture; secondly to the terms of reference in which he couched his art; and thirdly to his vast output, which included such projects as the 'Hall of Fame' series of portraits now owned by the National Portrait Gallery.

What is now known as the Watts Gallery comprises a number of buildings. First to be erected was Limnerslease, a large house with studio, designed by Ernest George and built in 1890 initially as a winter retreat from the bad air of London. Then in the 1890s the artist's second wife, Mary Seton Fraser-Tytler, who belonged to the Home Arts and Industries Association, instigated the building of a pottery, a cemetery chapel and a village hall. The gallery proper, designed by a neighbour, Christopher Turnor, in a style influenced by Edwin Lutyens, opened in 1904, only a few months before the artist's death. It quickly became a shrine, and Turnor had to design an extension, which opened in 1906. An official curator was then appointed. One more gallery was added *c.* 1925, and further refinements were made to the display in 1930.

Thereafter, owing in part to the decline in Watts's reputation and in part to lack of funds, a visit to the Watts Gallery became an increasingly depressing experience until the complete refurbishment begun in 2009.

The pictures amount to a studio collection, and the first hang was undertaken by Watts himself. Some additions have been made since, enabling the visitor to have an overview of Watts's work. And what is presented is a remarkable panorama, extending from portraiture and landscape to allegorical, literary and historical subjects, as well as those confronting social issues. However overpowering Watts's paintings might seem, or however antithetical to modern taste, he was a wonderful artist in the technical sense – capable of magical effects in paint and powerful pulsating passages that few artists could match. Surely his time has come again.

G. F. WATTS (1817–1904)
Found Drowned c. 1848–50
Canvas, 119.4 × 213.4 cm / 47 × 84 in.

A woman's dead body lies at night half immersed in water beneath the arch of a bridge. Her arms are outstretched in a cruciform position and she still holds a chain and heart-shaped locket in her left hand. A star (or possibly the planet Venus) is visible in the night sky through the arch. The topography is quite specific: the arch is recognizable as part of Waterloo Bridge in London, with the Hungerford Suspension Bridge and industrial buildings on the South Bank visible in the background. Waterloo Bridge was famous for its use by suicides, and Watts had almost certainly read Thomas Hood's poem 'The Bridge of Sighs'.

Urban tragedy

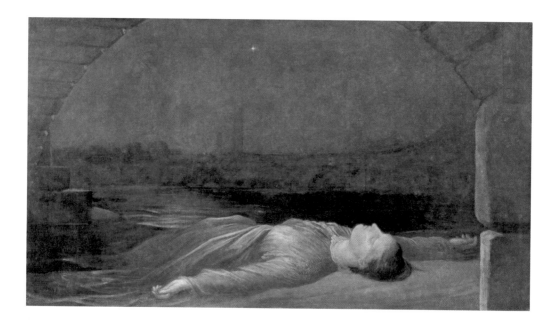

The fallen woman was the subject of several other Victorian paintings, but Watts's picture is earlier in date and forms part of a small group of paintings by him prompted by issues that were being discussed publicly in response to the social ills exposed by Charles Dickens in his novels. Female suicides were triggered by adultery, or financial hardship resulting in prostitution; the fact that the figure holds a locket suggests that love came into this particular case. 'Found drowned' is a legal term used in the courts and newspapers of the day that implied death by accident or as a deliberate act; death by suicide had a religious implication, since such deaths were forbidden a Christian burial.

Watts's painting, therefore, might be construed as implied social criticism. At the same time he is careful to balance out the ultimate despair of the young woman with hope, symbolized by the star in the night sky.

Cookham

STANLEY SPENCER GALLERY

Cookham, a village on the banks of the River Thames, is where Stanley Spencer was brought up and it was here that he sought his inspiration. Like William Blake and Samuel Palmer and other visionary artists, Spencer was extremely rooted, but at the same time a free spirit living within a universe of his own making. Its landmarks and villagers amounted to a paradise combining the divine with the quotidian. Spencer's symbiotic association with Cookham became the basis of his personal religion as he sought 'the wholeness of things', blending the physical with the spiritual in a search for universal love.

The Stanley Spencer Gallery is housed in the former Methodist Chapel. Opened in 1962, it was refurbished in 2008 and is the ideal space for a presentation of the artist's work in microcosm, with a number of supplementary loans. Although Spencer's œuvre is dominated by his religious paintings vividly expressed in a private modern idiom, there is a great deal more variety in his work than might at first be apparent, as indeed there was in his life. Trained at the Slade School of Fine Art (1908–12), he served as a medical orderly in the First World War while at the same time being acknowledged as an official war artist, which he was also during the Second World War, when he was posted to Glasgow. In all areas of his art Spencer's impact was exceptional – none more so than in his treatment of the nude, his still-lifes and his landscapes.

Spencer was prolific and he is on the whole well represented in public galleries, but mention should also be made of the Sandham Memorial Chapel at Burghclere in Hampshire, the Arena Chapel of British art, where between 1923 and 1932 Spencer covered the walls with paintings based on his own wartime experience in Macedonia.

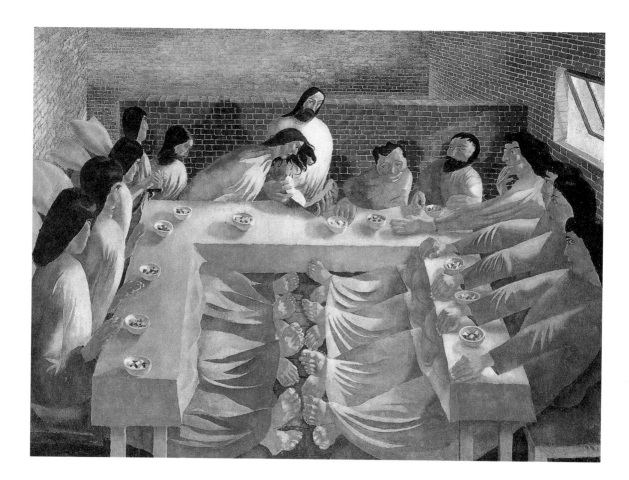

STANLEY SPENCER (1891–1959)
The Last Supper 1920
Canvas, 91 × 122 cm / 35⅞ × 48 in.

This is a characteristic example of Spencer's ability to recast traditional religious iconography according to his own terms. The Last Supper takes place on the upper floor of one of the malthouses in Cookham, a secluded space with suffused light creating a feeling of mystery. There is humour in the arrangement of the legs stretching out from under the tables and in the reactions of the apostles, but though such characterizations are dependent on Spencer's observation of individuals known to him he is searching for a universal truth. This is achieved by the simplicity and directness of the overall design, which was undoubtedly inspired by early Italian painting (clearly Giotto): note the repeated gestures of the disciples around the table, the simplified rhythms of the draperies, and the patterned brickwork. This helps to concentrate attention on the principal figures seen against the red brick wall, with Christ at the centre, St John leaning against him, and possibly Judas cowering on the other side. The tautness of the composition heightens the tension of the narrative – given added significance by the meals the artist must have eaten on active service.

Christ comes to
Cookham

Eastbourne

TOWNER

The gallery is named after a local benefactor, John Chisholm Towner (1840–1920), who bequeathed to the town a small collection of Victorian paintings and a sum of money as a contribution towards an appropriate building. The corporation decided to show the collection in the Georgian manor house in the Old Town, and it opened in 1923. Over the years this building proved to be insufficiently flexible, and a new purpose-built gallery, designed by Rick Mather and Associates, opened in 2009 in a different location. The new gallery abuts the Congress Theatre of 1963. Close to the pleasant Devonshire Park, it is also not far from the seafront.

The collection is strong in British art of the 19th and 20th centuries, although now there is more of an emphasis on the contemporary scene. Eric Ravilious – who was educated in Eastbourne – and Christopher Wood are well represented.

WILLIAM GEAR (1915–97)
Composition Blue Centre 1949
Canvas, 50 × 65 cm / 19⅝ × 25⅝ in. Signed and dated

A rarity – the painter curator

Born in Scotland and trained as an artist in Edinburgh, Gear served in the Royal Corps of Signals during the Second World War, but afterwards remained on the Continent, working in Germany for the Monuments, Fine Arts and Archives Commission. Moving to Paris in 1947, he became friendly with several of the avant-garde painters associated with the Ecole de Paris and was one of the only two British artists to exhibit with the Cobra group. He returned to Britain in 1950 and supplemented his income as a painter by working as a designer, as well as being appointed curator of the Towner Art Gallery (1958–64) and then head of the Faculty of Fine Art at Birmingham College of Art.

The abstract *Composition Blue Centre* dates from Gear's most radical phase, which occurred early in his life, reaching a climax with the antagonism of the public reaction to his *Autumn Landscape*, commissioned for the Festival of Britain in 1951. It comprises an assortment of bright jewel-like colours, held in place by an armature of dark lines rather like the leading of a stained-glass window. The roughly applied patches of colour have a three-dimensional quality that makes this a tough and uncompromising picture indebted as much to Byzantine art as to Fernand Léger or Nicolas de Staël, both of whom he knew.

Gear was engaging in abstract painting at the same time as the artists associated with the St Ives School, but his work has received less critical attention. This is partly because

he related more easily to mainland Europe than to America, which from the 1950s was beginning to dominate the world of avant-garde art.

During his curatorship at the Towner Art Gallery Gear, not surprisingly, placed emphasis on collecting contemporary art.

JEFFERY CAMP (b. 1923)
Beachy Head: White Windswept Project 1979
Canvas, 122 × 122 cm / 48 × 48 in.

Born in Lowestoft in Suffolk, Camp studied art under William Gillies at Edinburgh College of Art (1941–44). His work began to be widely exhibited during the late 1950s and early 1960s. An important moment in his life was his marriage in 1963 to Laetitia Yhap, of Chinese/Austrian origin, who was then still a student at Camberwell. She became his muse for a series of pictures inspired by the cliffs at Beachy Head, which he explored in all weathers and at all times of day while living in Hastings. This was the principal motif for a whole series of paintings made between 1969 and the early 1980s, many of which include Laetitia and sometimes the artist himself. The thin application of paint and loose technique reflect the artist's interest in the forces of nature, just as his experiments with the changing shapes of canvas are perhaps an attempt to simulate the effects of being buffeted by strong wind while positioned above a vertiginous drop. Here there is a hint (perhaps intentional) of humour as the couple try to shelter on the cliff top, but often when Laetitia is depicted alone the purpose is more allegorical.

Camp took time off painting to write two books, *Draw: How to Master the Art* (1981) and *Paint* (1986), after which his art changed direction entirely. Moving from Hastings, he concentrated on London themes with excursions to Venice. These paintings, often

'I am always aware of life being precarious; the relentless passing of time and the beating of waves on beaches'

JEFFERY CAMP, 1989

populated in the manner of Chagall by figures from his imagination, are sometimes of private significance.

My personal reaction on first seeing this particular picture was to think of Edgar's feigned description of the dizzying view from the cliffs near Dover to the blinded Gloucester in Shakespeare's *King Lear* (Act IV, scene 6): 'The crows and choughs that wing the midway air / Show scarce so gross as beetles: half way down / Hangs one that gathers samphire, dreadful trade! / Methinks he seems no bigger than his head. / The fishermen that walk upon the beach / Appear like mice . . . / . . . The murmuring surge, / That on the unnumber'd idle pebble chafes, / Cannot be heard so high. I'll look no more.'

Egham

ROYAL HOLLOWAY COLLECTION

Royal Holloway College, which is part of the University of London, was founded by Thomas Holloway (1800–1883), who initially made his fortune as a manufacturer of patent medicines; it was opened by Queen Victoria in 1886. (Just under a century later, Bedford College was merged with it, and the result was Royal Holloway and Bedford New College.) Holloway was one of the first to use the power of advertising to promote his business, and his success in this when combined with his financial skills enabled him to become a major philanthropist. The architect was William Henry Crossland, the style French Renaissance. The college was originally intended for women only.

Holloway stated that he expended more effort in spending his money than in making it. He began collecting pictures very late in life and bought solely in the saleroom. The collection is of remarkable quality considering that it was put together in only three years. It is formed of British – mainly Victorian – paintings. Works by Gainsborough, Turner and Constable preface major pieces by Millais, Landseer, Fildes and Holl, as well as examples by Scottish painters. Most famous of all is *The Railway Station* by W. P. Frith.

SIR EDWIN LANDSEER (1802–73)
Man Proposes, God Disposes 1863–64
Canvas, 91.4 × 243.8 cm / 36 × 96 in.

Landseer was the pre-eminent animal painter in British art since Stubbs. He studied with Benjamin Robert Haydon and attended the Royal Academy Schools where he was something of an infant prodigy. Although he was renowned from the start as a specialist painter of animals, his range was much wider than might at first be imagined, and it was marked by a brilliant technique.

The ultimate folly of human endeavour

Landseer was the most charming of men. Handsome and humorous, he found no trouble in securing powerful and influential patrons, including Queen Victoria, who exercised the utmost patience with his dilatoriness and nervous disposition. Some of his best and most varied pictures were undertaken for his royal patron.

The artist's love of animals led to his close association with Scotland, which he visited regularly from 1824 to hunt, shoot and fish. Many of his most famous compositions were inspired by life in the Highlands. Unfortunately, in 1840 he had a nervous breakdown and suffered thereafter from depression, hypochondria and paranoia, seeking relief in alcohol and on occasion confined under the care of a neurologist.

If any painting by Landseer puts the lie to the sentimentalism of many of his more anthropomorphizing images (for example *Laying down the Law* of 1840 at Chatsworth) it is *Man Proposes, God Disposes*. This is a profound work of national and personal significance.

The title is a quotation from *The Imitation of Christ* by Thomas à Kempis, but the subject is a topical one, referring to Sir John Franklin's search in 1845 for a north-west passage connecting the Atlantic with the Pacific. The voyage ended in disaster and several relief parties were sent out, beginning in 1848, until the remains of the original expedition were found in 1858–59 on King William Island. No further British voyages were attempted and it was the Norwegian explorer Roald Amundsen who made the navigational breakthrough in 1903–6.

Landseer depicts the wreckage impacted in the ice and at the mercy of two polar bears behaving as if at a kill. Human remains are evident, in addition to such objects as spars, a flag and a telescope. The unusual proportions of the composition give a sense of the infinity of the Arctic wastes, while the blue-grey tones of the ice create a sombre fatalistic mood. And indeed the folly of human endeavour in the face of the powerful forces of nature is the underlying message of this picture. Man ultimately is powerless against the will of God, who can so easily wreak vengeance through nature on man's attempt to assert himself within the universe. Such pessimistic thoughts arose from contemporary arguments that tied in with the discoveries of Charles Darwin, but equally the fragility of Landseer's own mind might have tempted him at this stage of his life to equate himself with Franklin in his own struggles for fulfilment as an artist.

Not surprisingly *Man Proposes, God Disposes* was the most talked-about picture shown at the Royal Academy in 1864.

SIR LUKE FILDES (1843–1927)
Applicants for Admission to a Casual Ward 1874
Canvas, 137 × 243.7 cm / 54 × 96 in.

Like Herkomer and Holl, Fildes after his training at the South Kensington School of Art (1863–65) and the Royal Academy Schools (1865–66) began his career as an illustrator of books and periodicals before establishing his reputation as a painter. He produced two of the most famous images of the Victorian era: the print of Dickens's study after his death known as *The Empty Chair* (1873), and *The Doctor* (1891, Tate Britain), a painting based on the final illness of his eldest son.

Not unusually for artists of the period, Fildes had his foot in several camps. His conscience stirred him to undertake five large-scale depictions of social realist themes, of which *Applicants for Admission to a Casual Ward* is the first. The composition is based on a drawing he made for the *Graphic* entitled *Houseless and Hungry*. What shocked the public was the treatment of such disturbing subject-matter as high art. As an antidote Fildes painted a number of pastoral themes and genre costume pictures, several done in Venice, which he visited often. Late in life he also became a successful and highly paid portrait painter, commissioned to do the state portraits of Edward VII and Queen Alexandra, followed by George V.

The illustrations published in the *Graphic* revealed the plight of the urban poor in industrialized cities. Beyond the novels of Dickens and Elizabeth Gaskell there were documentary works, such as Henry Mayhew's *London Labour and the London Poor* (1851–62)

High art used to expose the plight of the urban poor

and Gustave Doré's *London: A Pilgrimage* (1872), with which Fildes's social realist pictures should be compared. The artist came from a family with radical views and *Applicants for Admission to a Casual Ward* was inspired by a scene that he himself had witnessed. The Houseless Poor Act of 1864 required those seeking temporary shelter and food to report to a police station for admission to a local workhouse or casual ward. This is the scene that Fildes shows on a cold wintry night. He deliberately portrays several different types of poor – ageing alcoholics, abandoned wives, adventurers down on their luck, out of work artisans with sick children, and beggars. He contrasts the solid architecture of the police station with the crumpled exhausted figures, the posters on the wall (a £2 reward offered for a missing child as opposed to £20 for a missing dog), and the sombre palette is unrelieved by the sickly yellow light issuing from the single street lamp.

The picture aroused such interest when shown at the Royal Academy in 1874 that a railing had to be put in place to protect it.

Hampton Court

HAMPTON COURT PALACE

Situated on the banks of the River Thames, to the west of London, Hampton Court Palace is one of the most stirring historic buildings in the British Isles, comparable in many respects with Versailles in France. As one of the centres of court life from the end of the 15th century to the mid-18th century, its architecture, formal gardens and surrounding parks were of the utmost significance.

The Palace became a royal possession when Henry VIII's Chancellor, Thomas, Cardinal Wolsey, who had held the lease on the property since 1514, fell from power in 1529. The King then began in earnest and on a grandiose scale to develop Hampton Court into the magnificent palace that is seen today.

The next transformation came with the accession of William III and Queen Mary II in 1688, at the time of the Glorious Revolution. The new King and Queen preferred – partly for reasons of health – to live out of London. For them the Surveyor of the Royal Works, Sir Christopher Wren, built huge extensions to the Tudor palace on the east and south sides, complete with a new set of State Apartments. Wren's principal assistant for this commission was Nicholas Hawksmoor, with Grinling Gibbons among others designing and carving the interiors. The project slowed down following the death of Queen Mary in 1694 and Wren was replaced four years later by William Talman, but the building was more or less complete by 1700, apart from the mural decorations undertaken by Antonio Verrio and Sir James Thornhill for Queen Anne. What had been achieved was an exercise in the English Baroque style but with a

French twist, as William III was keen to emulate Louis XIV. Nowhere was this aim more apparent than in the formal gardens on the east and south fronts, providing wonderful vistas – the former towards a park and the latter towards the river.

Both George I and George II maintained an interest in Hampton Court and continued to use it as one of their main residences, which involved them in further additions and extensions to the existing State Apartments (principally the Queen's Apartments and a suite of rooms for the Prince and Princess of Wales). The last official court visit was in 1737. Neither George III nor George IV took an interest in the palace, and it was opened to the public by Queen Victoria in her accession year, 1837.

By that time several hundred pictures from other royal residences had been moved to Hampton Court, where the rooms now began to resemble a public art gallery. Correspondingly, the pictures that were assembled there were well documented in official lists, guides and catalogues. In many respects the rooms at Hampton Court amounted to a National Gallery *fuori le mura*. The arrangement, quality and condition of the pictures often gave rise to some stringent criticism from specialists, but the palace became a popular tourist attraction.

During the rest of the 19th century and throughout the 20th century the State Apartments have been re-presented to the public on several occasions. The earlier of these schemes were essentially exercises in straightforward antiquarianism, but recently the numerous inventories of the palace have formed the basis of more socio-historically based interpretations in line with modern museological thinking. The fire of 1986, which destroyed so much of Wren's south front (the King's Apartments), provided further opportunities for fresh thinking and research on how best to interpret the State Apartments and the gardens for the visitor so that there could be a better appreciation of how the palace worked at different stages in its history. The research was carried out by the staff of the newly created Historic Royal Palaces Agency, working together with the Royal Collection. A great deal of this work was carried out in time for the re-opening of the King's Apartments by the Queen in 1992, but it continued in other parts of the palace until 1995.

ANDREA MANTEGNA (c. 1430/31–1506)

*The Triumphs of Caesar: Canvas V – The Trumpeters, Sacrificial Oxen
and Elephants c. 1485–94*
Canvas, 267 × 277 cm / 8 ft 9¼ in. × 9 ft 1¼ in.

The nine canvases comprising the *Triumphs of Caesar* are shown as a sequence in a special installation in the Lower Orangery. They have been at Hampton Court Palace since the 17th century after being acquired by Charles I from the Gonzagas in Mantua, where they were considered to be the finest paintings in the collection. Following Charles I's

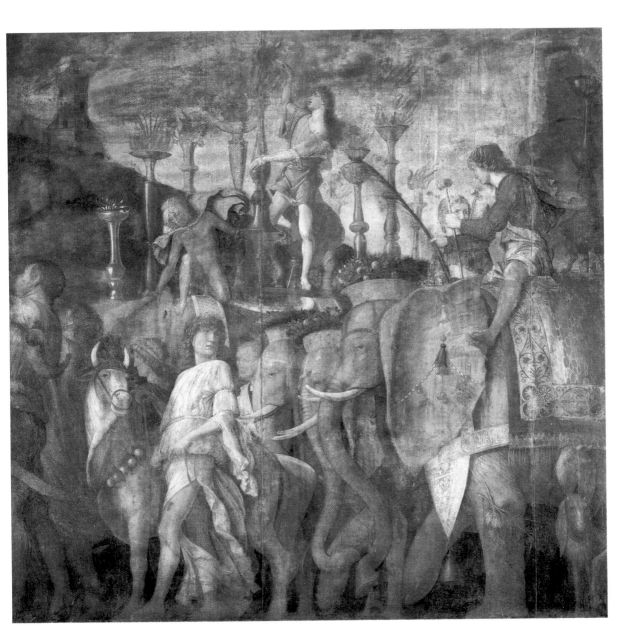

The greatest
example of early
Renaissance
narrative painting to
be seen out of Italy

execution in 1649 they were, like the Raphael Cartoons, not sold but retained for the Protectorate.

The canvases have been restored several times through the centuries, most notably in 1962–74. Hardly surprisingly for works of an early date painted on such a large scale, over the years they had suffered from damage and overpainting, so that the effect of the glazes and the subtlety of the modelling in some of the canvases have been seriously reduced. Their original impact, however, is by no means totally lost.

Mantegna was born near Padua and apprenticed to a local artist, Francesco Squarcione, who was an enthusiast for the art of Classical Antiquity. He was also exposed

to Venetian art (indeed he married the sister of Gentile and Giovanni Bellini) and to the style of those Tuscan artists who were working in the Veneto, most memorably the sculptor Donatello. From 1460 until his death Mantegna was court artist at Mantua in the employ of the Gonzagas, who allowed him to go to Rome in 1488–90. At the Mantuan court he undertook some major commissions in the Palazzo Ducale, including the frescoes in the Camera degli Sposi, and he was involved with the decoration of the Studiolo of Isabella d'Este, the wife of Francesco II Gonzaga.

The documentation for the *Triumphs of Caesar* is open to interpretation, so there is very little agreement as yet about many aspects of the work. Most probably the canvases were painted over a decade, *c.* 1485–94, for Francesco II Gonzaga, but it is not known if the sequence is complete. They may not even have been installed permanently in a single room and were perhaps only used as temporary decoration on special festive occasions. Several factors, however, such as the compositional continuity, colour repetition, direction of light and treatment of the backgrounds unify the narrative. The perspective suggests that the canvases were to be seen from below, and the pilaster frames suggest that the viewer is watching the scene from a loggia, thereby considerably enhancing the sense of movement and clamour.

Mantegna was a passionate admirer of Antiquity in the humanist tradition and a keen archaeologist; he was, in short, a learned painter. What he creates in these canvases is a composite triumphal entry of a conquering hero epitomized by Julius Caesar, who appears in the final canvas. The artist would have consulted ancient sources, both written and visual, but essentially what he achieved is an imaginative recreation of ancient triumphal processions.

Mantegna was a notoriously slow worker and he must have struggled for a long time over each of these canvases. There is an intense linearity and dryness of manner in his painting, which although softened by his use of colour results in an impression of severity and hardness that was sometimes criticized by his contemporaries. Even so, no less a critic than the 16th-century painter and biographer Giorgio Vasari remarked of Mantegna that the *Triumphs of Caesar* were 'the best thing he ever did' and that 'the entire work could not be made more beautiful or improved'.

ORAZIO GENTILESCHI (1563–1639)
Joseph and Potiphar's Wife c. 1630
Canvas, 204.9 × 261.9 cm / 79½ × 103⅛ in. Signed

The subject is recounted in the book of Genesis (39:7–20) at the start of the Old Testament and was popular in 17th-century Italian art. Joseph was working as a slave in Egypt in the household of Potiphar, the captain of Pharaoh's guard, eventually becoming his steward. Potiphar's wife, finding Joseph desirable, attempted on several occasions to seduce him.

On this occasion he escapes from the room leaving her clutching his garment, and on the basis of this evidence Joseph is falsely accused of rape and imprisoned.

Gentileschi was born in Pisa, but went to Rome before moving northwards to Genoa and Paris, finally reaching London in 1626. At first he worked for the Duke of Buckingham, who was assassinated in 1628, and afterwards principally for Charles I's French wife Queen Henrietta Maria. Most of Gentileschi's paintings for the crown are therefore associated with the Queen's House at Greenwich, including the ceiling *Allegory of Peace and the Arts* (now in Marlborough House in London) and *Joseph and Potiphar's Wife*.

By this stage of his career Gentileschi could temper his style to suit his circumstances, and these paintings, so appreciated by Henrietta Maria, have a sophisticated and international flavour, comparable with Franz Xaver Winterhalter's paintings in the 19th century. The scale of all these works is dramatic, the colours are high-toned and saturated, offsetting the porcelain flesh tones, and the compositions have a staged theatrical flourish. Here the horizontal thrust of Potiphar's half-naked wife grasping Joseph's garment is parried by the strong vertical of Joseph himself on the right disappearing behind the

curtain to make his escape. There is almost a Pre-Raphaelite air (notably of Holman Hunt) about the picture. The treatment of the fabrics – the heavy scarlet curtain forming a backdrop and the crisp white linen on the bed – and the still-life element in Joseph's discarded garment are superbly handled. Similarly, the effect of a darkened room and the sense of claustrophobia add to the drama.

Charles I very much wanted to employ contemporary Italian painters, but religious scruples and the English climate tended to put them off. The King had greater success with Rubens and Van Dyck. Gentileschi was aware of this preference, and wrote that 'all the Dutchmen had combyned togeather to weary mee, and mak me leave the Kingdome'. In fact, he never left and died in London. Yet the Gentileschi family as a whole had benefited from their experiences at the English court: two of Orazio's sons acted as art agents for the King, and several pictures painted by his daughter, Artemisia, were acquired for the Royal Collection, including her *Self-Portrait as the Allegory of Painting*.

SIR PETER LELY (1618–80)
Frances Stuart, Duchess of Richmond c. 1662
Canvas, 125.8 × 102.7 cm / 49½ × 40¾ in.

This painting belongs to a series of eleven portraits known as the 'Windsor Beauties', commissioned by Anne Hyde, Duchess of York, the first wife of the future James II. According to the Chevalier Philibert de Gramont, whose own wife was included in the sequence, the Duchess of York wished to have 'the portraits of the most beautiful women at Court' painted by Lely, 'who devoted all his powers to the task and could not have worked on more lovely subjects'. The portraits once hung at Windsor Castle, but they have been at Hampton Court Palace since the early 19th century and now adorn the Communications Gallery as an irresistible line of 'pin-ups'. An awareness of them at court seems to have inspired the set of 'Hampton Court Beauties' painted by Sir Godfrey Kneller for Queen Mary II, which ended up in William III's Private Dining Room, where they no doubt provoked some after-dinner ribaldry.

Lely's sitters are all shown in three-quarters length wearing richly coloured 'undress' (or informal) gowns, sometimes carrying or indicating attributes. They are often placed next to a curtain or a piece of garden statuary, in front of an unspecified but atmospheric landscape. The present sitter holds a bow – the attribute of Diana, the goddess of hunting – which is why the landscape is so dominant, but it is unlikely that Lely intended these portraits to be wholly allegorical.

It is often contended that Lely's portraiture is formulaic, but any sense of repetitiveness disappears before the rich texture of paint, the sonorous quality of colour and the fluid virtuosic brushwork inspired by Venetian 16th-century painting. Lely can here be acknowledged as the true successor of Van Dyck, who was an equally avid admirer of

A 'Windsor Beauty'

the Venetian school. All the 'Windsor Beauties' come across as voluptuous, but Lely also portrays their femininity or vulnerability by offsetting the vivid colours of the dresses against the whiteness of the skin and the cascading ringlets emphasizing the contours of the face. How Samuel Pepys must have enjoyed their company.

Unfortunately, the great early 19th-century critic William Hazlitt gave these portraits a bad press, describing them as 'a set of kept mistresses, painted, tawdry, showing off their theatrical or meretricious airs and graces, without one touch of real elegance or refinement, or one spark of sentiment to touch the heart'. For once my great hero, Hazlitt, was totally wrong.

Frances Stuart (1648–1702) became Lady of the Bedchamber to Queen Catherine of Braganza, the wife of Charles II. A renowned beauty, she was a particular favourite of the King, but eloped with Charles Stuart, 3rd Duke of Richmond, whom she married in 1667. A year later she caught smallpox, which greatly disfigured her, although she remained at court. Frances Stuart was the model for the figure of Britannia on Jan Roettier's Peace of Breda medal of 1667 – a figure that is still in use on the modern coinage.

SEBASTIANO RICCI (1659–1734)
The Adoration of the Magi 1726
Canvas, 330.2 × 289.6 cm / 130 × 114 in. Dated

Ricci's bold and colourful treatment of this familiar theme forges a link in Venetian painting between Paolo Veronese in the 16th century and Giovanni Battista Tiepolo in the mid-18th century. The composition owes a great deal to Veronese, but the éclat created by the arrival of the kings anticipates Tiepolo. The setting is dramatic, the brushwork full of verve and panache, and the colours iridescent. So loosely has the paint been applied that several changes of mind can be seen, especially in the centre.

Venetian Rococo on a splendidly grand scale

The Adoration of the Magi was acquired by George III from Consul Joseph Smith, the British Resident in Venice, whose extensive collection of pictures, drawings, prints, books and gems the King purchased in 1762. Apart from being an omnivorous collector, Smith was also an entrepreneur, acting as the patron of several artists, notably Canaletto. Normally, a painting of the Adoration of the Magi would have served as an altarpiece, but on this occasion it forms part of a series of six paintings by Ricci, equally large but with different formats, illustrating scenes from Christ's ministry. One explanation – the matter is still unresolved – is that the compositions illustrating Christ's ministry were begun as a specific commission (possibly for the Royal House of Savoy in Turin), but for some reason the commission was left unfinished and devolved upon Smith, who completed it and added this *Adoration*. Given the scale of the paintings, it is difficult to imagine how they would have fitted into the Palazzo Mangilli-Valmarana where he lived on the Grand Canal in Venice or in his villa at Mogliano near Treviso. Presumably, therefore, he did either initiate the project himself as a speculation or else took it on after the paintings became available. Prints and a written account of the series published in 1749 were perhaps part of a process to promote the paintings.

Whatever the circumstances, the *Adoration* is a wonderful demonstration of the Venetian Rococo style. Ricci travelled extensively in Italy and also worked in England (1711/12–16). He formed a partnership with his nephew Marco, who may have executed the architectural background in the *Adoration of the Magi* and the related pictures.

Isle of Wight

OSBORNE HOUSE

Visiting Osborne House on the Isle of Wight is like going on holiday, and that is exactly what was intended. Queen Victoria and Prince Albert wanted to create a family holiday home with an informal atmosphere. The setting is idyllic, with wonderful views over the Solent, formal terraces leading to extensive grounds, and a private beach. Of all the royal residences it is the most enchanting (if the weather is fine, of course), just as Balmoral Castle in the Highlands, also built by Victoria and Albert, is the most romantic.

Osborne House as seen today was designed in an Italian Renaissance style by Thomas Cubitt with the guidance of Prince Albert and built in 1845–51. The striking interior decoration was undertaken by Ludwig Grüner, who acted as adviser for the whole project and as agent in the acquisition of appropriate works of art. Several of the features in the grounds served a didactic purpose in the upbringing of the royal children: the Swiss Cottage was where they learnt about household management and created their own natural history museum, while Victoria Fort and Albert Barracks were used for tuition in military matters.

Queen Victoria continued to take an active interest in Osborne House after Prince Albert's death in 1861. The main addition she made to the house in 1890–91 was the Durbar Room for banquets, decorated in an Indian style under the direction of Lockwood Kipling, the father of Rudyard Kipling. The Queen made regular visits and died at Osborne in January 1901. The following year Edward VII gave the house to the nation, and two wings were opened as the Convalescent Home for Officers, which functioned from 1904 to 2000. Osborne House is now administered by English Heritage.

The paintings are principally by British and German artists, and contemporary for the most part with the date of the house. Many are by painters little known today, but there are some surprises, such as the mural of *Hercules and Omphale* by Anton von Gegenbauer in Prince Albert's bathroom.

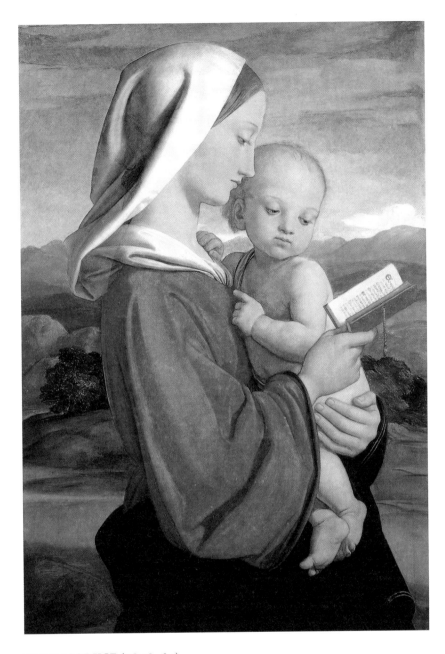

WILLIAM DYCE (1806–64)
Virgin and Child 1845
Canvas, 80.6 × 58.5 cm / 31¾ × 23 in. Signed and dated

'So chaste & exquisitely painted'

QUEEN VICTORIA

It is impossible to avoid the Scottish-born artist William Dyce at Osborne House, since his large mural, *Neptune resigning to Britannia the Empire of the Sea*, with a surprising amount of naked flesh, is positioned in the stairwell. By contrast, the *Virgin and Child*, which hung in Queen Victoria's bedroom where she died, is very demure. The artist was influenced early in his career by the German Nazarene artists, whom he first met in Rome.

Isle of Wight: Osborne House THE SOUTH-EAST 169

This fact was not lost on Queen Victoria, who wrote in her journal (9 August 1845) of this picture: 'quite like an old master & in the style of Raphael – so chaste & exquisitely painted'. As criticism Queen Victoria's words cannot be improved upon: she made her own copy of it in pastel.

Dyce was an extraordinarily dynamic figure in the Victorian art world, notable not just as an artist and teacher but as scientist, ecclesiologist and musician. He held many important administrative posts, including Superintendent of the School of Design in London (1837–43), and was consulted over such issues as the development of the National Gallery. He participated for many years in the mural decorations for the newly built Houses of Parliament. In undertaking such work he was again following in the footsteps of the Nazarenes, although several of his late easel pictures move closer to the Pre-Raphaelites (Titian's *First Essay in Colour* in Aberdeen Art Gallery and *Pegwell Bay: a Recollection of October 5 1858* in Tate Britain in London).

FRANZ XAVER WINTERHALTER (1805–73)
Florinda 1852
Canvas, 179 × 244.5 cm / 70½ × 96¼ in. Signed and dated

Principally a portrait painter, Winterhalter was the Van Dyck of his day. Born in Germany, he was essentially peripatetic, moving between the leading courts of Europe with consummate ease while basing himself in Paris. Although Queen Victoria set out to patronize British-born painters, her preference for Winterhalter, his fellow German Heinrich von Angeli and the Dane Laurits Tuxen soon established itself. Winterhalter was employed by the Queen from the early 1840s and painted well over one hundred portraits for her. She regarded him as unrivalled in the catching of a likeness, although his drawing was sometimes wooden.

Florinda is a rare excursion by Winterhalter into a literary subject. It was given by Queen Victoria to Prince Albert in 1852 as a birthday present, and for some time this large picture hung in the Queen's Sitting Room at Osborne House, opposite the desks (positioned side by side) where she and Prince Albert worked. What thoughts must have entered their minds as they gazed at this image?

The story of the Moorish maiden Florinda occurs in 16th-century Spanish ballads, which recount how she was spied on while bathing with her attendants by Rodrigo, the last king of the Visigoths. He falls in love with her and seduces her, but she is avenged by her father, who kills Rodrigo and so subjugates Spain to rule by the Moors. Although an obscure story, it was given a certain popularity in early 19th-century Britain by Robert Southey's poem 'Roderick, Last of the Goths' (1814) and was the subject of an opera by Sigismond Thalberg, performed in London in 1851 when it was seen by Queen Victoria.

A highly sensuous rendering of a rare literary subject, which once hung in Queen Victoria's Sitting Room

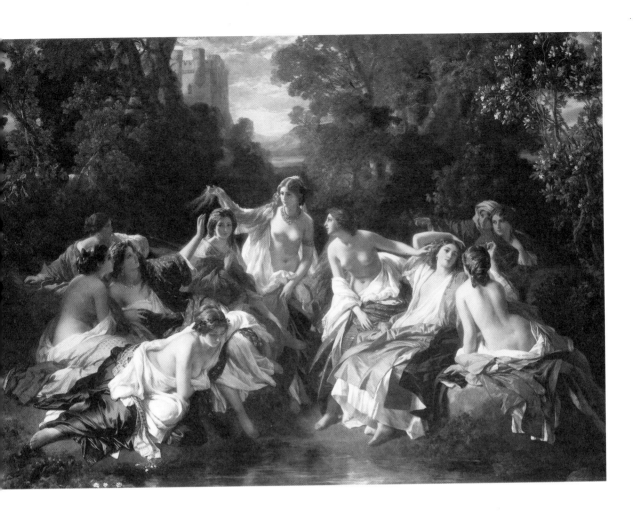

Florinda is to the left of centre, still fully clothed; Rodrigo can be seen (just) peering through the branches on the left. The voyeuristic element of the story suggests comparison with scenes of Diana and Actaeon, while the composition itself seems to have been handled more like Boucher. Certainly it is a sensuous picture – the shimmering heat, the silky sheen of the draperies, and the smooth female flesh of the attendants, all within a cool verdant setting including a distant view of a castle. It is heady stuff.

Winterhalter made a reprise of the composition three years later for *The Empress Eugénie surrounded by her Ladies-in-Waiting* (Compiègne), but for the sake of decorum not surprisingly he showed all the figures clothed. Queen Victoria and Prince Albert got the better deal.

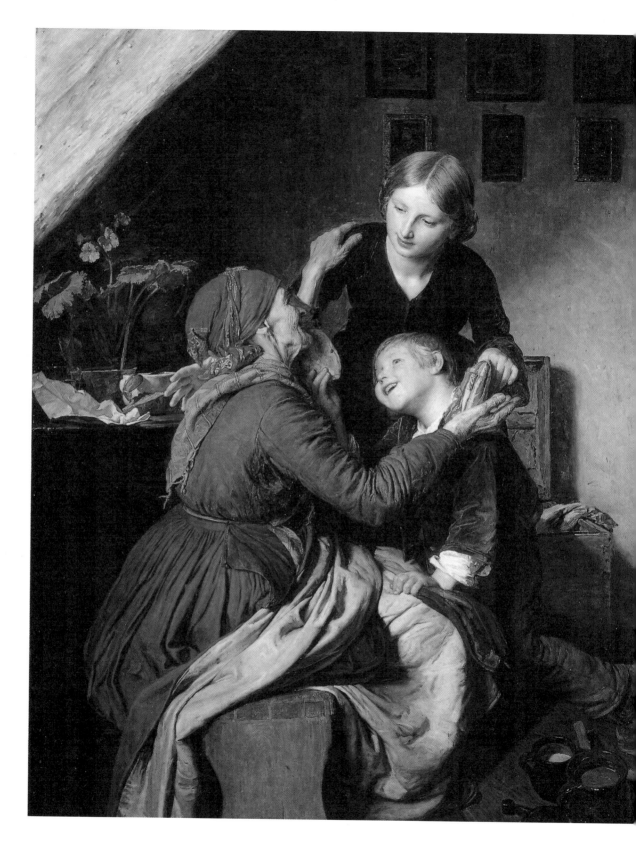

FERDINAND GEORG WALDMÜLLER (1793–1865)

The Grandmother's Birthday 1856

Wood, 71 × 57.8 cm / 28 × 22¾ in. Signed and dated

Waldmüller is now a much sought-after artist, but his work remains rare in Britain. He was the most important Austrian painter of the Biedermeier period in the first half of the 19th century and was Professor at the Academy of Fine Arts in Vienna from 1829. His tenure on this office was not without controversy, since he favoured realist painting and advocated reform, but his views did not in any way diminish his popularity or reduce his effectiveness as a teacher.

The Grandmother's Birthday was a birthday present given to Queen Victoria by Prince Albert in 1857. It is a fine example of the rustic genre subjects dating from late in Waldmüller's career, often extolling the moral virtues of family life. The care taken over the rendering of garments, the still-life and the surroundings is offset by the radiance of the figures' expressions and gestures. The circular composition harks back to Italian Renaissance art, especially Raphael and Correggio, whose work was much admired by 19th-century artists and collectors, among whom Queen Victoria and Prince Albert can be numbered.

Maidstone

MAIDSTONE MUSEUM AND BENTLIF ART GALLERY

The museum was founded in 1858 in the Elizabethan house of Chillington Manor, owned by Thomas Charles, who had bequeathed his collections three years earlier. The house itself was much altered by the Victorians and has had several further extensions and renovations, amounting in all to a complicated mish-mash of styles. The collections of old master paintings donated by Julius Lucius Brenchley (1816–73) and by Samuel Bentlif in 1897 on behalf of his brother George Amatt Bentlif are varied. The famous essayist William Hazlitt was born in Maidstone, and it was his grandson, William Carew Hazlitt, who in 1909 presented the paintings and other items relating to the Hazlitt family.

WILLIAM HAZLITT (1778–1830)
Self-Portrait c. 1802
Canvas, 70 × 60 cm / 27½ × 23⅝ in.

Hazlitt's fame is based on his literary reputation as the foremost essayist of his time, but he set out to be a painter. Inspired by his viewing of the Orléans collection on its arrival in London in 1798 and by a subsequent visit to Paris to see the Musée du Louvre during the Peace of Amiens in 1802, he determined to become an artist like his elder brother John. Although he was commissioned to paint several portraits and made copies of old masters, his career as an artist was short-lived.

 Like everything Hazlitt did, his self-portrait is direct and sincere. The technique is not sophisticated, but the image is open and vibrant. He observes himself with the candour with which he observed the world at large. Even though Hazlitt ceased painting, his love and knowledge of pictures resulted in some of the finest criticism of his day, plentifully

'Well, I've had a happy life'

WILLIAM HAZLITT
ON HIS DEATHBED, 1830

evidenced in *Sketches of the Principal Picture Galleries in England* (1824). The writer has the gift of awakening the reader to the pleasures of seeing.

Hazlitt is so much of his time that it is hardly surprising that his best-known book is *The Spirit of the Age* (1824), a series of pen portraits that capture the essence of the Romantic period. Hazlitt worked in many genres as a writer – parliamentary sketches, literary and dramatic criticism, political tracts, philosophical discourses, biography – but it is as an essayist that he achieved lasting fame, as the first exponent of this finest of literary forms of expression as it is practised (regrettably so rarely) today. What made Hazlitt such an outstanding essayist was his omniscience (he could write on anything, including sport); his facility to express himself in an informed, conversational manner (he was a brilliant lecturer) liberally laced with a wide range of quotation; his power of observation (he walked incessantly); and his energetic pursuit of fresh experiences. He knew many of the literary figures of his time – Coleridge, Wordsworth, Keats, Lamb, Hunt, Haydon, Stendhal, Landor. Not everyone liked him, and there were many fallings out. He lived in chaos and was unkempt and egoistic, and although he seems extremely energetic to us (he loved playing fives and racquets), some contemporaries thought him lazy.

Born into a household of radical persuasion, Hazlitt remained true to the principles of the French Revolution, regarding Napoleon (whom he glimpsed in the streets of Paris in 1802) as a hero even to the last. He was not a good judge of women and had two failed marriages. Busy to the end, he died in Soho in considerable poverty and was buried there in St Anne's Church.

Portsmouth

PORTSMOUTH CITY MUSEUM AND ART GALLERY

The museum and art gallery were originally situated in the High Street in the old Town Hall building opened in 1895. That was bombed in 1941 and its contents destroyed. New collections had to be assembled; an Arts Section was established in 1968; and the collections have been housed since 1972 in a former army barracks close to the University. There are paintings by the Camden Town Group, the St Ives School, and artists of local origin.

JOHN BRATBY (1928–92)
Table Top 1955
Board, 120.8 × 121 cm / 47½ × 47⅝ in.

During his lifetime John Bratby had a reputation for being a hell-raiser – the Angry Young
Man of the art world, so to speak, a hero to his fellow students and providing good copy
for journalists. An unhappy childhood and the late realization that he was destined to
become an artist gave him a demoniac determination to succeed. Trained first at Kingston
School of Art (1947–50) and then as a postgraduate at the Royal College of Art, he gained
public recognition very rapidly from the early 1950s, winning several prizes and becoming
a Royal Academician in 1971.

An 'angry young man'
of the visual arts

But his time in the sun was short-lived, and the critics were dismissive of his work from 1960 onwards, when other art movements seized their attention. Ironically, Bratby was commissioned in 1957 to paint the pictures for the film of Joyce Cary's novel *The Horse's Mouth* (1944) about a bohemian artist, Gulley Jimson (portrayed by Alec Guinness, who wrote the screenplay), who, like Bratby, was determined to make his mark on the world by any means.

Although Bratby's paintings continued to sell well after 1960, his manic output and his recourse to portraiture to make money led to great divergence in quality.

Table Top is one of the artist's earlier pictures that established his reputation, and by virtue of the realistic subject-matter earned him the designation of a 'kitchen sink' painter. Taking his cue from Sickert, Bratby depicted crowded still-life compositions with vertiginous viewpoints and thickly coagulated striations of paint. The treatment is far removed from the clarity and dignity of such works by Cézanne, Picasso or Braque, but that really is the point.

In many respects the early work for which Bratby was widely praised might be described as the visual equivalent of the contemporary novels by John Wain, Kingsley Amis, John Braine and Alan Sillitoe, or the plays of John Osborne.

Southampton

SOUTHAMPTON CITY ART GALLERY

The gallery is situated on the first floor of the Civic Centre. It first opened in 1939, to a design by Ernest Berry Webber, but was almost immediately bombed. Since the re-opening in 1960 the collection has grown considerably and is now one of the most important in the south of England.

The setting of the Civic Centre close to an extensive municipal park, which includes the *Titanic* Memorial, makes for a particularly pleasant approach. It is worth noting that to the left of the main entrance of the Centre is a small plaque commemorating the fact that a group of children from Guernica, the ancient capital of the Basque Region in Spain, had been sent over to Southampton for refuge after the terrible bombing on 26 April 1937 – an atrocity that inspired perhaps the most famous painting in all 20th-century art, by Picasso, which was shown in London at the Whitechapel Art Gallery in 1939.

The formation and growth of the collection has been an exemplary exercise. The gallery was founded with a bequest from a councillor, Robert Chipperfield (1817–1911), which was supplemented by a second bequest from another councillor, Frederick Smith (1861–1925). Chipperfield's contribution accounted for the building

and acquisitions; Smith's allowed for further acquisitions. In 1963 the pick of the collection and stock from his gallery came by bequest from the London art dealer Arthur Jeffress, following his suicide two years earlier in Venice. Jeffress's connection with Southampton City Art Gallery had begun in 1946 when he decided to live in the area, and a year later he lent a work by Jackson Pollock, which was the first to be seen in a public gallery in England. His benefaction was followed by the bequest in 2002 of works of art from the collection of David and Liza Brown, David Brown having been an Assistant Keeper in the Modern Collection at the Tate Gallery.

The quality of the Southampton collection stems in part from a stipulation made by Robert Chipperfield to the effect that the Director of the National Gallery (or his representative) should be consulted over proposed acquisitions. One such adviser was David Brown himself, who had practiced veterinary science for many years (mainly in Africa) before switching to the history of art in the early 1970s. His interest in the subject, and particularly his passion for collecting, had in turn been quickened by Michael Palmer, who was Curator at Southampton. Brown proceeded to form his own extensive collection of modern British art, befriending many artists along the way, and leading a life of relentless eccentricity. Most honourably he paid his debt to Southampton twice over, once by acting as adviser (1976–85) and secondly by a bequest of 220 items from his own collection, together with a fund for purchasing further examples of British art dating from after 1900. His lead is being followed to this day with a concentration on contemporary art linked to the Turner Prize.

The gallery space can hardly be described as ideal, but the central hall is well lit, while the more traditional subsidiary rooms on either side allow for a denser distribution of pictures.

A striking item is the triptych of *St Catherine disputing with the Philosophers* by Goswijn van der Weyden (grandson of the famous Rogier van der Weyden), which is believed to have belonged to Sir Thomas White, the founder in 1555 of St John's College, Oxford. The *pièce de résistance*, though, is the *Perseus Series* by Edward Burne-Jones, commissioned by Arthur Balfour in 1875 for his London house. The finished compositions in oil remained incomplete (now Stuttgart, Staatsgalerie), but Southampton purchased the full-scale cartoons in gouache in 1934 and they are displayed very effectively in a single room. Overall the collection is strong in French 19th-century painting and in British art of the 20th century, beginning with the Camden Town Group – Sickert, Gilman, Gore, Drummond and Ratcliffe.

CESAR VAN EVERDINGEN (c. 1627–78)
An Allegory of Winter c. 1660
Canvas, 91.8 × 71.2 cm / 36⅛ × 28 in.

A hauntingly
enigmatic image
by an artist
whose work is
exceptionally rare
in Britain

The artist came from Alkmaar to the north of Haarlem, which as a city was second only to Amsterdam in terms of artistic significance in 17th-century Holland. He specialized in history painting and portraiture and contributed to the elaborate decorative scheme in the Oranjezaal (1648–50) in the Huis ten Bosch, the royal palace near The Hague built by Amalia von Solms as a memorial to her husband, the Stadtholder, Prince Frederick Henry. His style is described as classicizing on the grounds that his paintings sometimes have refined generalized forms and clear outlines making his figures seem idealized. Such stylistic tendencies combine elements from both Utrecht and Haarlem.

The woman is shown warming her hands over a brazier of hot coals and is presumably meant to be interpreted in an allegorical vein. Representations of the other seasons, if they were undertaken, seem not to have survived.

Everdingen has created a haunting enigmatic image, with the figure seen slightly from below. The facial features and draperies are rather simplified, but the intricate lacework and cameo pearl drop earrings are exquisite. The shadows are fluidly handled and the palette light in tone. This woman with pursed lips and closed eyelids stays fixed in the memory.

There are only a few paintings by this artist in Britain.

CLAUDE MONET (1840–1926)
The Church at Vétheuil 1880
Canvas, 51 × 61 cm / 19⅞ × 23⅝ in. Signed and dated

Amongst the group of French 19th-century paintings there are some important works: Gustave Courbet's *The Wave*, Alfred Sisley's *Avenue of Chestnut Trees near La Celle-Saint-Cloud*, and J. L. Forain's *The Fisherman*. But this Monet is outstanding.

The date 1880 was added later by the artist, and it would seem that the painting was in fact made in the late summer of 1879 – the very time when Monet's first wife, Camille, was dying. On a personal basis, therefore, this marvellous sunlit view was painted in tragic circumstances. In addition to his wife's illness, Monet was desperately short of money. He was in effect working on two counts: to afford the treatment and medicine that Camille desperately needed and at the same time to affirm his confidence in life and art.

Monet had moved to Vétheuil from Argenteuil in 1878 and remained there until 1881. Two years later he settled for good in nearby Giverny. At Vétheuil Camille and Claude Monet shared a house with Alice and Ernest Hoschedé and their numerous children. Ernest Hoschedé, who had inherited a textile business, went bankrupt during this period and subsequently in 1892 Alice married Monet.

Vétheuil lies on the right bank of the River Seine to the west of Paris, close to the town of Mantes-la-Jolie. The river at this point is overlooked on the north side by steep chalk cliffs with some striking medieval fortifications along the way. In this view of Vétheuil, Monet is looking at the small town from Lavacourt on the other side of the river. The composition focuses on the church of Notre Dame, causing the artist to omit the hilly setting, which is retained in other paintings done at the same time.

The style is Impressionism in its purest form, which Monet, unlike his fellow Impressionists, continued to explore throughout his long life. Broken brushstrokes of pure colour have been applied to a lightly primed canvas, which shows through in several areas where the paint is thinner. The figures are mere ciphers in the centre of the composition. For me the most telling feature is Monet's innate sense of visual structure: he places

A turning point in Monet's life

the church high up on the canvas, thus giving himself ample space to show its reflection in the river, which fills the lower half of the canvas. It is a scintillating painting and forms such a contrast with those he did at Lavacourt during the freezing winter months of 1879–80 in the immediate aftermath of Camille's death.

DORIS (DOD) PROCTER (1892–1972)
Black and White c. 1930
Canvas, 61 × 50.8 cm / 24 × 20 in.

One of the first female Royal Academicians of the modern era

The artist was a huge success in her own time. Her painting *Morning* (London, Tate Britain) was voted picture of the year at the Royal Academy Summer Exhibition in 1927 and with the support of the *Daily Mail* caused a national sensation. Subsequently she established a reputation for herself as a painter of female figures – clothed and unclothed – that were sculptural in form, restrained in colour and heavily modelled. There is a

sublimated sexuality in these figures, often in alluring poses and considered controversial, that teeters on the verge of Surrealism, but in art-historical terms they are inspired by the example of Picasso's Neoclassical period of the early 1920s. Procter was elected a Royal Academician in 1942 only a few years after her friend Dame Laura Knight – one of the first women to be elected in the modern era.

Both Dod Procter and her husband Ernest, also a painter, were pupils of Stanhope Forbes at Newlyn in Cornwall where they made their home. They were together commissioned to paint murals in 1919 for the Kokine Palace in Rangoon in Burma, and after her husband's early death Dod continued to travel fairly extensively. Other than her depictions of young women she painted many views of the garden she created at Newlyn.

Black and White is very much a period piece, but it is an affecting still-life with an implied narrative of arrival or departure. The careful integration of muff, gloves and scarf lying on a table with a candleholder glimpsed on the right indicates a human presence, which is all the more marked by the physical absence of the owner.

BRIDGET RILEY (b. 1931)

Red Movement 2005

Canvas, 135.2 × 352.4 cm / 52 × 136 in.

It's like seeing the curvature of the world from space

In Bridget Riley's painting Isaac Newton meets Henri Matisse. As the prime exponent of 'Op' art – the exploration of optical phenomena in two dimensions – she gained an international reputation for her work when she won the prize for painting at the Venice Biennale in 1968. Riley's main preoccupation is with perception, which may be defined as the relationship between our visual sensation of the external world and our purely subjective response to it.

The artist initiated her abstract style in earnest during the 1960s, using only black and white. The visual effect of these often large paintings with their repeated stripes, curves or lozenge shapes was so striking that at her exhibitions gallery attendants (and sometimes visitors too) wore dark glasses. The sense of movement established by patterns made on the canvas was so dynamic that the viewer could easily become confused and destabilized. What Riley realized was that painting was about creating not a passive image but an energized and active one that was constantly in a state of flux, as in Futurism. Although the shapes are carefully calculated, they reflect those found in nature, and the viewer's response is intuitive and highly subjective. The strength of Riley's art is that it is strictly empirical, but its pleasure lies in opening up the world. There is a marked contrast between the rigid control exercised in the creation of these works and the sense of release experienced on viewing them.

A new dynamic appeared in Riley's work in the 1970s when she introduced colour, after a thorough investigation of its use by earlier artists. At first she reverted to simpler compositions and restricted herself to a paler palette. A gradual progression by way of mathematics and preparatory methods based on collage led to the sophistication of pictures such as *Red Movement* with its deep-toned colours and pullulating surface comprising arcs, curves, diagonals and lozenges.

The painting can be appreciated in terms of its two-dimensional qualities, but there is also a sense of recession into depth. By such means the appearance of perpetual movement is balanced or held in check by a feeling of stasis, while at the same time owing to the subtlety of the composition these two contrasting states seem to be interchangeable. The effect is like a flag fluttering in the wind or an ocean swell.

Windsor

WINDSOR CASTLE

The outline of Windsor Castle seen from a distance, rising above the River Thames with Eton nestling below, is one of the defining images of the British landscape. It is easy to see why William the Conqueror chose the site in the 1070s for one of a defensive ring of castles protecting London. The development of the castle during the Middle Ages owed most to Henry III in the 13th century and Edward III in the 14th century. Indeed, it was Edward III who in 1348 founded the Order of the Garter, which has since been so closely associated with the castle.

Charles II lavished a great deal of attention and money on Windsor Castle after the Restoration in 1660. New State Apartments, including two new focal points, the Royal Chapel and St George's Hall, were designed by the architect Hugh May in what passed in England as the Baroque style. The interiors were particularly distinguished, with murals by Antonio Verrio and carvings by Grinling Gibbons.

George III and Queen Charlotte made further refinements. Although it came to be associated with the King's later illness, the royal family liked the informality of Windsor, where George III could exercise 'the freedom of a small squire in a country village'. The precincts and terraces, as well as the State Apartments, were often open to the public throughout the 18th century without undue formality. The architect employed by George III, James Wyatt, set about turning the exterior of the castle into a Gothic palace, although the additions and alterations made to the interior maintained the character of Hugh May's state rooms.

Fundamental changes were made by George IV, who after his coronation in 1821 upgraded both Buckingham Palace and Windsor Castle in accordance with his official

status. Adding to his new-found authority was the fact that he was also the leading patron of the day and a tireless collector, fondly imagining that he was in possession of unlimited financial means. He transformed Windsor with the assistance of his architect Jeffry Wyatt (later Wyatville), the nephew and pupil of James. The castle was given a complete makeover externally in a Neo-Gothic style, and received a new set of private apartments on the east and south sides of the quadrangle. These included the Grand Corridor, specially designed to display the furniture, paintings, porcelain and bronzes from the growing royal collection. No expense was spared on the interiors, particularly the new semi-state rooms on the south side (White, Green, and Crimson Drawing Rooms and State Dining Room), over the design of which George IV himself presided and where his penchant for the French style predominated.

The creation of some of the rooms, notably St George's Hall, regrettably involved the destruction of what Hugh May had done for Charles II. George IV died before all his proposals were completed and the work (with some modifications) was brought to fruition by Queen Victoria and Prince Albert, although without the same élan.

Windsor Castle is now the principal residence of the royal family, so the fire of 1992 was an event of personal as well as national significance. The blaze broke out in the former Private Chapel and caused significant structural damage to St George's Hall, the Grand Reception Room, the State Dining Room, and the Crimson and Green Drawing Rooms, as well as many of the service areas. The restoration and re-presentation of these areas was completed exactly five years later, in November 1997.

ALBRECHT DÜRER (1471–1528)
Burckhard von Speyer 1506
Wood, 31.7 × 26 cm / 12½ × 10¼ in. Signed and dated

Dürer is one of the few artists in Europe whose complete œuvre can be said to have formed a watershed. Not to know his paintings, drawings and prints is to have an inadequate appreciation of art. Certainly he was prolific, but, equally, what he achieved in the long series of woodcuts known as the *Little Passion*, the *Great Passion* and the *Life of the Virgin* – all published in book form in 1511 – amounted to a veritable dictionary of art.

Dürer's range as an artist stemmed from his endless curiosity about the world, which he saw not so much in the scientific way that his contemporary Leonardo da Vinci did, but more in a sense of wonderment at the full panoply of nature. Much can be deduced about Dürer on the basis of what or whom he chose to depict, particularly in his wonderful drawings. And he kept a diary while travelling in the Netherlands in 1520–21 with his wife which is full of observations about daily life – a life lived against the background of the Reformation. All of these strands made Dürer a singular artist.

The portrait of Burckhard von Speyer belonged to Charles I, who, although not a great admirer of Northern European art, did have several works by Dürer, including the *Self-Portrait* (Madrid, Prado) and the *Portrait of the Artist's Father* (now in the National Gallery, London, although designated as 'Attributed to').

Dürer crossed the Alps to go to Italy twice in his life, once in 1494–95 when he made marvellous watercolours on his travels, and again in 1506–7 when he made a number of portraits in Venice. The latter are straightforward: the compositions are restricted to bust length, with plain backgrounds, so that the effect is direct and simple. The influence of Giovanni Bellini ('I am really friendly with him. He is very old, but is still the best painter of them all'), and of Bellini's younger pupils Titian, Giorgione and Vincenzo Catena, is readily apparent. Dürer's art had until this later trip to Italy been intensely linear, but now there is a greater sense of form and volume, derived from the modelling applied over a warm-toned underpainting. The sophistication of Dürer's technique extends from the finely drawn strands of hair to the use of his own thumb to soften or thin out the shadows on the nose.

Nothing is known of Burckhard von Speyer, but he appears among the figures on the left (behind the cardinal) in the altarpiece of *The Feast of the Rose Garlands* (Prague, National Gallery), which Dürer was commissioned to paint for the church of S. Bartolomeo in Venice on behalf of the German colony.

The only portrait in a British collection to be universally accepted as by Dürer

SIR ANTHONY VAN DYCK (1599–1641)

The Five Eldest Children of Charles I 1637

Canvas, 163.2 × 198.8 cm / 64½ × 78¼ in. Signed and dated with a later inscription

A perfect representation of privileged innocence

One of the finest group portraits by Van Dyck in existence, commissioned by his most important patron and displaying every aspect of the artist's skills. The characterization of the children – Charles, Prince of Wales, in the centre, Mary, Princess Royal, on the extreme left next to James, Duke of York, with Princess Elizabeth holding Princess Anne on the right – is especially telling, as Van Dyck treats them on a monumental scale without any attempt to patronize such young sitters. There are also remarkable passages in the handling of the still-life and the glimpse of distant landscape. The pose of the heir to the throne with his hand on the mastiff is a thoughtful way of suggesting authority in one so young, just as the more alert spaniel on the right echoes the restless group above. Add to this the supreme mastery of colour, drawing and texture and you have the quintessential Van Dyck working at the height of his powers.

An added poignancy is vested in *The Five Eldest Children* given the fate that was shortly to befall the family of Charles I.

The portrait left the Royal Collection at the time of the Civil War and was recovered by George III. It still hangs in the Queen's Ballroom in the State Apartments.

SIR THOMAS LAWRENCE (1769–1830)

Pope Pius VII 1819

Canvas, 269.2 × 177.9 cm / 106 × 70 in.

Simply the best

The artist was commissioned by George IV when still Prince Regent to paint a series of portraits commemorating those European heads of state, military commanders and diplomats responsible for the downfall of the Emperor Napoleon I. A specially designated room, known as the Waterloo Chamber, was allocated in Windsor Castle for the installation of the twenty-five or so portraits, amounting to a Valhalla.

Pope Pius VII, born Luigi Barnaba Chiaramonti (1742–1823), was elected in 1800 and became the most famous pope of the 19th century. Although he was present at Napoleon's coronation as emperor in Paris in 1801, Pius VII later excommunicated him. Three years later he was arrested by the French and held until Napoleon's abdication in 1814. Throughout he had advocated a policy of passive resistance, which he pursued with the utmost tenacity. After the defeat of Napoleon Pius VII was identified with the emerging nationalist movement in Italy, making Rome the spiritual and cultural capital of Europe. He restored many buildings in the city and consolidated the Vatican collections pillaged by Napoleon.

Lawrence travelled extensively in Europe to carry out George IV's commission in the immediate aftermath of the Napoleonic Wars. He painted Pius VII in the Quirinal Palace in Rome between 18 May and 21 September 1819, while staying as the Pope's guest. Part of the reason for the success of the portrait is the personal rapport that grew up between the two men, so vividly described in Lawrence's letters from Rome. Pius VII is shown enthroned on the *sedia gestatoria* on which he was carried when processing. His personal coat of arms with his motto PAX TIBI (Peace be with you) appears on the finials of the throne. He holds a document in his left hand inscribed 'Per / Anto. Canova', referring to Antonio Canova, the famous sculptor who was appointed Prefect of Fine Arts in Rome and Marchese d'Ischia. In the background on the left is a view of the unfinished Braccio Nuovo of the Vatican, built to house some of the finest antiquities in the collections.

The artist was all too conscious that when painting Pope Pius VII he was working in the tradition of Raphael, Titian and Velásquez, quite apart from the numerous depictions of this particular Pope that had already been produced by contemporaries such as Jacques-Louis David. Lawrence need not have worried, for he executed what is surely one of the outstanding portraits in European art. The artist himself referred to his 'undisputed victory' and wrote that he was pleased to have demonstrated 'the superiority of the English School in painting'. He did this not just by devising such a magisterial composition, but by his brilliant technique, evident in the richness of the colouring and the vividness of the lighting. The brushwork dazzles, as in the depiction of the hands and the papal slippers.

The portrait won universal praise. Benjamin West, President of the Royal Academy, said that Lawrence's portraits 'rise to the dignity of history'. In painting this portrait Lawrence bears witness to history, and so convincingly allows us as viewers to partake in history.

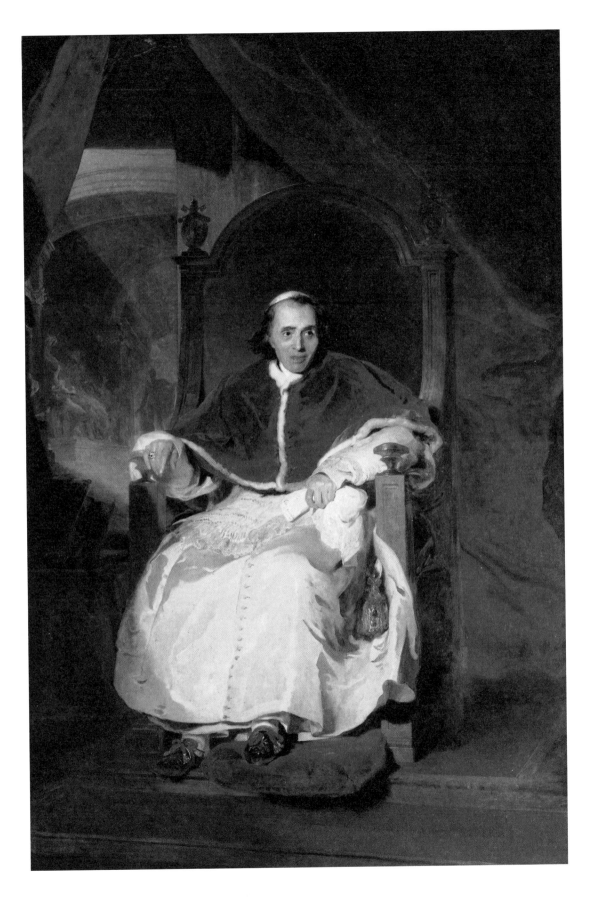

THE SOUTH-WEST

The South-West is a region of England that has played an important part in my life. Having been born in Falmouth on the southern coast of Cornwall, my earliest memories are of the sea and the cliffs, vibrant colours and rapidly changing weather conditions. It was then still very cut off from the rest of the country, with numerous coves and elegant houses hidden in copses sheltered from the fierce winds. Cornwall makes you into an out-and-out romantic. At the same time, because of its geographical location, it inculcates a spirit of independence, as evidenced by the work of such scholars and writers as Sir Arthur Quiller-Couch, A. L. Rowse and John Betjeman.

Artists have understandably been attracted to Cornwall: from the late 19th century they grouped themselves into colonies, first of all at Newlyn, then at Lamorna Cove, and subsequently with a more international flavour at St Ives. Of Cornwall Patrick Heron wrote, 'The quality of light ... is most un-English in its white brilliance. And this light seems to be travelling in all directions simultaneously.'

The picture collections in Cornwall at Truro, Falmouth and Penzance have tended to concentrate on those artists closely associated with the county. Fairly extensive collections of paintings can be found in Bristol City Museum and Art Gallery and the Royal Albert Museum in Exeter. The Holburne Museum and the Victoria Art Gallery at Bath have notable holdings. Swindon Museum and Art Gallery is a brave and comparatively new venture. The Russell-Cotes Art Gallery and Museum in Bournemouth is a special treat and full of surprises.

Bath

HOLBURNE MUSEUM

Located at the end of Great Pulteney Street in the former Sydney Pleasure Gardens, the Holburne Museum was established in an extremely elegant Georgian house designed by Charles Harcourt Masters in 1796–97, which had become a hotel before being converted into a museum in 1911–15 by Sir Reginald Blomfield. An extension designed by Eric Parry Associates opened in 2010. The founding collection was that of Sir William Holburne (1793–1874), comprising 17th-century Dutch, Flemish and Italian paintings; of British artists he admired Thomas Barker of Bath. Works by other 18th-century artists, including Ramsay, Gainsborough, Stubbs, Zoffany, Raeburn, Morland and Turner, came from other sources, principally in 1955 the bequest of Ernest E. Cook administered by The Art Fund (formerly the National Art-Collections Fund).

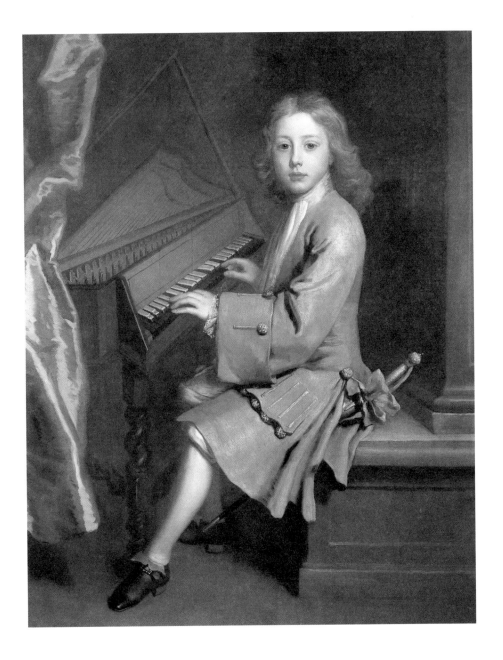

JONATHAN RICHARDSON (1667–1745)
Garton Orme at the Spinet c. 1709
Canvas, 122 × 96.5 cm / 48 × 38 in.

A fashionable
young heir

Bequeathed to the museum in 1962 by a descendant of the sitter, this is a classic example
of the dynastic portrait. Although aged only about thirteen, Garton Orme (1696–1758) is
treated as if he were an adult. The architectural feature of plinths and pilasters on the
right and the curtains on the left create a heroic public setting. The formal clothes, fash-
ionable shoes and powdered hair (as opposed to a wig) all declare the sitter's status, just

as his pose at the spinet with the correct turn of the leg denotes poise and sophistication. He is shown as the heir to a title and an estate (Lavington in Sussex) and not as a child.

Jonathan Richardson the Elder worked for John Riley and became a leading portrait painter at the turn of the 17th and 18th centuries, working in competition with Sir Godfrey Kneller, Johan Christian Dahl and Charles Jervas. He had a wide clientele, but refused the invitation to become court painter. He was also an excellent portrait draughtsman. His career as a painter began to slow after 1730, but he had a number of other interests: he collected old master drawings and wrote poetry (he was an admirer of Milton), and above all he was a prolific and highly influential writer on the theory of art and connoisseurship. *An Essay on the Theory of Painting* (1715) and *An Account of some of the Statues, Bas-Reliefs, Drawings and Pictures in Italy* ... (1719) – the second written with his son, Jonathan Richardson the Younger – amount to the most important criticism published in the early 18th century in Britain, and certainly influenced Sir Joshua Reynolds. And it should not be forgotten that there is a direct line of descent from Richardson through his pupil Thomas Hudson who taught Reynolds.

THOMAS BARKER OF BATH (1767–1847)
Priscilla Jones c. 1802
Canvas, 76.2 × 63.5 cm / 30 × 25 in.

It was the misfortune of Thomas Barker of Bath to have lived for the first part of his career in the shadow of Gainsborough, particularly when it was a question of painting landscapes. Although contemporaries endeavoured to uphold Barker's independence, he never really recovered from the comparison. Even so, there are many redeeming aspects. He received no formal training and learned his profession from making copies of pictures in possession of his patron, Charles Spackman, who also financed a study visit to the Continent (1790–93). On his return, unable to sustain a career in London, Barker re-established himself in Bath and commissioned a Neoclassical house from Joseph Michael Gandy with studio and picture gallery for the display of his work, which opened in 1805; later known as Doric House, it stands on Sion Hill overlooking the city. The project was not successful, and as a further attraction in 1825–26 he painted a mural in the house showing the massacre of Chios, no doubt inspired by Delacroix. Where honour is really due is in his pioneering role in the development of lithography, working closely with the local printer D. J. Redman on several publications at the beginning of the 19th century.

The problem was that Barker's skills did not match his ambition, except perhaps in portraiture. The self-portraits are confident and ebullient; the double portrait of himself with Charles Spackman (1789) is remarkably persuasive; and this image of Priscilla Jones is entrancing.

The artist's future wife, entrancingly portrayed

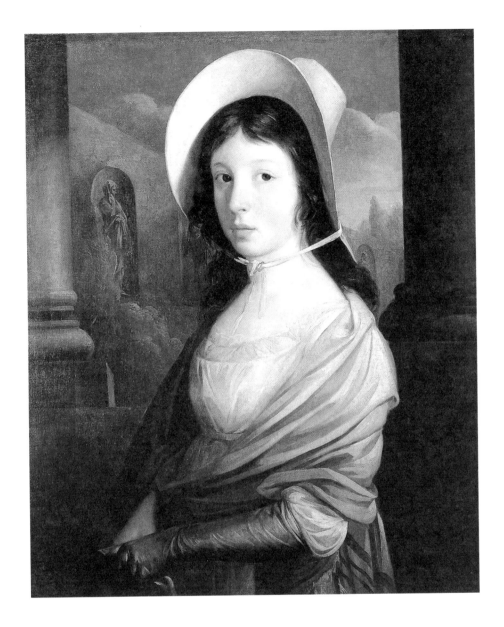

Priscilla Jones may well be an engagement portrait. The artist married her in 1803 and the portrait exudes love, with the face so beautifully framed by the hat and the shawl almost as a reprise wrapped around the body. Two columns on either side of the figure announce a Neoclassical garden with elaborate sculpture reminiscent of Italy but probably representing Doric House (built on land owned by the sitter's aunt). Clearly Barker had illusions of grandeur; it is sad to think that he died in poverty surrounded by pawnbrokers' tickets. (His wife had died a few years earlier, in 1843.)

The Victoria Art Gallery – the municipal museum – opened in 1900, just in time to honour Queen Victoria. A benefaction from Mrs Arabella Roxburgh, supplemented by public subscription, paid for a Neoclassical building in the centre of the city designed by James Brydon to incorporate a gallery and a library. The entrance is marked by a fine rotunda with a decorated dome and the interior is ornamented with a cast of the Parthenon frieze. The collection is a lively assortment of British painting from the 18th century to the present day. Many of the artists have close associations with Bath, such as Thomas Barker of Bath and Walter Sickert, or else, like Howard Hodgkin, attended the Bath School of Art based for many years at Corsham Court.

JOHN CALLCOTT HORSLEY (1817–1903)
The Truant in Hiding c. 1840
Canvas, 74.3 × 71 cm / 29¼ × 28¼ in.

No-one was more Victorian than Horsley. Although stern-looking in his portraits, he was one of the most sweet-tempered and innocent of men. He made an unfortunate protest about the use of naked female models (perhaps for religious motives) which attracted considerable ridicule: *Punch* nicknamed him 'clothes Horsley', and Whistler exhibited a pastel of a nude with an accompanying note which read 'Horsley soit qui mal y pense'.

Horsley, however, was by no means narrow-minded. He was born into a family of musicians and was related through his mother to the artist Sir Augustus Wall Callcott, who may have encouraged him to become a painter. He entered the Royal Academy Schools and later had a close association with the Royal Academy itself. His penchant was for pictures illustrating domestic themes in Elizabethan or Jacobean settings, of which *The Truant in Hiding* is an example. Horsley also painted murals, notably in the newly built Palace of Westminster (1844–45) and at Somerleyton Hall in Suffolk (1851). By the late 1850s he was spending much of his time in Cranbrook in Kent, where a colony of artists – F. D. Hardy, Thomas Webster and G. B. O'Neill – established themselves and depicted scenes of rural life. Horsley duly began to paint more contemporary subjects, but during the 1880s his popularity declined and he took refuge in portraiture.

The Truant in Hiding is very much in the mould of William Mulready or Richard Redgrave, but its real ancestor is the 17th-century Dutch painter Pieter de Hooch. The contrast between the darkened interior with the boy hiding behind the curtain and the bright exterior observed through the open window where his tutor paces up and down, as well as the precise treatment of light and the emphasis on still-life, are all redolent of de Hooch's work. Set in the 17th century (almost certainly during the Civil War) but very much of its own time, *The Truant in Hiding* is a carefully executed exercise in playfulness.

The man who designed the first commercial Christmas card, in 1843

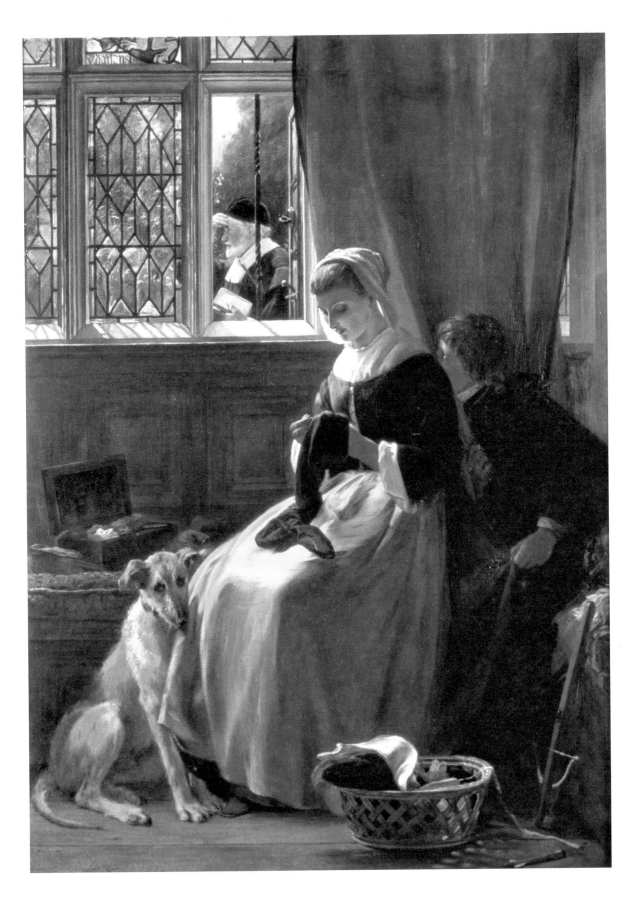

HENRY HERBERT LA THANGUE (1858–1929)

The Watersplash 1900

Canvas, 116.8 × 94 cm / 46 × 37 in.

Although his name might suggest a French origin, La Thangue was born in Croydon and attended the Royal Academy Schools, where he met Stanhope Forbes alongside whom he later worked. The lure of Paris was strong, however, and in 1879 he studied at the Ecole des Beaux-Arts under Jean-Léon Gérôme. More modern aspects of French painting, personified by Jules Bastien-Lepage and Jean-Charles Cazin, proved to be more challenging and

A painter of
rural scenes in
dappled light

La Thangue went to paint in Brittany in search of the avant-garde (1881–82). Returning to England, he was a founding member in 1886 of the New English Art Club, which was a focus for those British painters who had been to Paris and were influenced by French art. This affiliation did not last long, and he preferred to maintain his independence.

Like George Clausen, La Thangue was attracted to subjects that had first appealed to the French naturalist painters, but he executed them in a style fashioned by Impressionism. Although he very often painted on a large scale, he liked to work *en plein air*, as he no doubt did for *The Watersplash*. The composition with the geese waddling towards the viewer is bold, even humorous, leading the eye towards the goose girl seen in shadow in the upper half of the canvas. The dappled light effects highlight the geese and the use of the diagonal opens up the landscape behind. Dappled light was a feature of many of the artist's later works and allowed him to indulge his practice of applying paint with broken brushstrokes.

Bournemouth

RUSSELL-COTES ART GALLERY AND MUSEUM

The Russell-Cotes Art Gallery and Museum on the East Cliff overlooks the sea and is an Aladdin's cave. For those who have had too much of Bournemouth's air of respectability or too much sun on the beach, or are in danger of falling asleep in the conference halls, it provides the perfect antidote.

The building, first known as East Cliff Hall, was planned as the residence of Sir Merton Russell-Cotes (1835–1920) and his wife, whose local status was derived from the success of the nearby Royal Bath Hotel. Lady Russell-Cotes was also a cotton heiress, with considerable means. The house (built in 1894) was designed by John Frederick Fogerty, with an unusual exterior combining the styles of the Italian Renaissance with the Scottish Baronial, which upsets architectural historians. The interiors were done mainly by John Thomas and his son, Oliver, in an even greater mixture of styles, some very exotic indeed, inspired by the Russell-Cotes's extensive travels and in accordance with their diverse collecting habits. Although the house remained a family home, it soon evolved into a private museum, which was given in name to the people of Bournemouth in 1908 and opened to the public in 1922. Galleries for the display of paintings (especially the High Victorian works of Edwin Long) were added in 1919 and 1926 respectively. A modern extension was built in 1989.

Heterogeneity is the hallmark of the Russell-Cotes Art Gallery and Museum: it is where the Moorish morphs into Chinoiserie and where Japonisme segues into the Neoclassical. It is difficult to keep your balance. And then, suddenly, there is a room devoted to the life of the actor Sir Henry Irving – not forgetting the most delectable, but silliest, painting to be seen anywhere in the country, *The Butterfly* by the Spanish artist Luis Falero (1893).

ALBERT MOORE (1841–1893)

Midsummer c. 1886–87

Canvas, 159.8 × 153 cm / 63 × 60¼ in. Inscribed twice with the anthemion device used by the artist as a signature

Although the painting was not acquired in Sir Merton Russell-Cotes's time, he would surely have approved, and in many ways it summarizes the more refined aspects of his art gallery and museum as a whole.

A hot summer's afternoon

Albert Moore was born in York into a large family of artists, but his mother brought him south to London in 1855. He had rather an unfocused training and only lasted a short time in the Royal Academy Schools, preferring to be left to his own devices, which led him to intensive periods of study in the British Museum and the National Gallery.

At first he began to paint in the Pre-Raphaelite manner, but his treatment of Biblical subjects was pedestrian. A phase as a painter of decorative compositions for architectural settings during the 1860s helped him to establish his artistic priorities, which found their fullest expression in an aestheticism inspired by the Classical past and the Far East. These compositions, on which his reputation now rests, nearly always comprise young female figures dressed in Classical garments while absorbed in sedentary occupations such as conversation, reading, resting or doing their toilette. The figures have an ideal, dream-like existence and the titles lack specificity – *Dreamers, Reading Aloud, Summer Night* – or else refer to the natural world. The hypnotic effect is enhanced by the part frieze-like dispositions of the figures, the pale delicate palette, and the predisposition for symmetry and pattern. The technique matches the mood in the meticulously controlled brushwork and sensitivity to textures.

Moore's mature pictures epitomize the Aesthetic Movement, and when first exhibited ran counter to the strong narrative content of most Victorian art. It is hardly surprising that he was a close friend of Whistler, and supported him in the famous trial of Whistler v. Ruskin (1878).

Midsummer shows three young women in the bright light of a hot summer's afternoon. There is a sense of languor and ethereality, which is emphasized by the stillness evoked by the balanced composition. The objects – silver throne, inlaid Moorish chest, marble bench – reveal how carefully Moore did his research even though in the end he

makes little practical use of them. The orange colour of the women's outer garments is unusually strong for Moore, as is the clash with the green of the fans and the silvers and greys in parts of the setting. One observer commented that *Midsummer* was 'like a flood of sunshine, a bed of marigolds'.

The painting is a late work and may have intimations of mortality. The composition recalls Greek grave stelai or votive reliefs and the single fallen leaf on the wall behind on the right possibly implies the transition from life to death. Furthermore, marigolds are flowers associated with grief. In fact, Moore died of cancer not long after painting *Midsummer*, having suffered from the condition for several years and undergone two operations. One of his last visitors was Sir Merton, who had earlier been interested in acquiring *Summer Night* (Liverpool, Walker Art Gallery), but had been overruled by his wife.

CHRISTOPHER NEVINSON (1889–1946)

The War Profiteers 1917

Canvas, 91.5 × 71 cm / 36 × 28 in. Signed and dated

The War Profiteers strikes a discordant note in the Russell-Cotes Art Gallery and Museum in terms both of style and of subject-matter. It seems far removed from the exotic world evoked in the other rooms and introduces a note of realism.

For Nevinson, who had started out at the Slade School of Fine Art, a visit to Paris in 1912–13 proved to be influential. There he studied at the Académie Julian and the Cercle Russe, but, more importantly, he shared a studio with Amedeo Modigliani, met the Italian Futurists, and mingled with members of the French avant-garde. Coming from an intellectual background (his father was a foreign correspondent and his mother a women's rights activist), he tended to be combative in character and his main sources of inspiration were from mainland Europe.

Thus it was in the summer of 1914 that jointly with Filippo Marinetti, the founder of Futurism, Nevinson published *Vital English Art. Futurist Manifesto*. Certain assumptions that he made there alienated many of the artists with whom he had sided previously

A modernist view
of an age-old
practice

in such organizations as the Rebel Art Centre. Chief amongst them was the irascible Wyndham Lewis, who used the opportunity to form a rival group which he called the Vorticists. Nevinson decided to remain fiercely independent, basing his personal style on an amalgamation of the Italian Futurists (particularly Gino Severini) and the French Cubists.

In the First World War Nevinson gained first-hand experience as a Red Cross orderly (1914–15) and with the Royal Army Medical Corps (1915–16). He was discharged owing to ill health, and became an official war artist in 1917. Nevinson stated at the outset that 'This war will be a violent incentive to Futurism, for we believe there is no beauty except in strife, and no masterpiece without aggressiveness.' As a result, his earliest depictions of the war, *La Mitrailleuse* (London, Tate Britain) and *French Troops Resting* (London, Imperial War Museum) – the latter surely inspired by Géricault's *Raft of the Medusa* – are in a style intent upon depicting the dehumanizing aspect of modern mechanized warfare. Paintings of this date are amongst his finest and are only matched by his superb prints.

The horrors of war softened the approach of many avant-garde artists, who switched their styles to a form of elevated pictorial reportage, and *The War Profiteers* is such a picture. It shows two women in the immediate foreground: one looking at the viewer is dressed in fur and the other looking away is decked out in lace. They are walking the street at night, hoping in one way or another to take advantage of the looser morals that overcome society during times of war. The facial features, exaggerated almost to the point of ugliness, imbue the scene with a sense of evil, which is heightened by the use of the theatrical lighting. The way in which the various parts of the composition are fitted together reveals Nevinson's debt to Futurism, while the shape of the hats and the treatment of the features (note the columnar neck of the woman in the centre) come out of Cubism. As regards the content, the most surprising aspect of *The War Profiteers* is the way it anticipates the depiction of the Weimar Republic by Otto Dix and George Grosz.

Bristol

.....................................

BRISTOL'S CITY MUSEUM & ART GALLERY

Overall the collection of paintings Bristol's City Museum & Art Gallery could be described as the finest in the South-West of England, and it has a building to match. The impetus for the foundation of a museum in the city came originally from the Bristol Literary and Philosophical Society, which was officially absorbed into the Bristol Institution for the Advancement of Science and Art in 1823 and housed in a brand new building in Park Street. A further merger with the Bristol Library Society

resulted in a removal to another new building in the same street in 1872, although financial difficulties meant that in 1894 responsibility for the collections was passed to the City Council.

The present museum and art gallery is close to the original buildings. It was designed by Sir Frank Wills and made possible through the generosity of the tobacco manufacturer Sir William Henry Wills, later Lord Winterstoke (1830–1911), whose family have maintained their interest in the museum and the neighbouring University buildings to the present day. The architectural style has been described as Edwardian Baroque and the façade is truly imposing, with a certain confidence in the imaginative use of the Classical orders. The opening ceremony was performed by the artist Hubert von Herkomer in 1905. An extension was completed in 1930.

The small but respectable group of old master paintings is based on the donation made by Alfred de Pass (1861–1952) in 1936, followed by the bequest of Ferdinand Schiller, Recorder of Bristol, in 1946. The British pictures of the 18th century are certainly of interest; those of the 19th century are uneven (for example, few Pre-Raphaelites); both yield to the substantial holdings of 20th-century paintings. By contrast, the French pictures, particularly those of the 19th century, are of the greatest interest. For the most part, the quality of the collection in these areas is due to the discernment of Hans Schubert, who was Director from 1953 to 1968.

Bristol itself has proved to be an important base for many artists through the centuries, from Hogarth to Banksy. During the 19th century J. B. Pyne and W. J. Müller concentrated on the topography of the city and its environs. Edward Bird painted royal subjects and genre scenes. More varied and distinctive are the works by Francis Danby and Samuel Colman, while Rolinda Sharples provides astute insights into social life in the city.

GIOVANNI BELLINI (1430–1511)
The Descent into Limbo c. 1475–80
Vellum laid on wood, 51.6 × 37.3 cm / 20½ × 14¾ in.

The subject is arcane, but compelling. The Descent into Limbo (also known as the Harrowing of Hell) occurs between Christ's death on the cross and the Resurrection. Not recounted in the New Testament, it is narrated in the apocryphal gospels and other popular devotional works and is referred to in the Nicene Creed. Limbo, situated outside the entrance to Hell, was where righteous souls who had died before the time of Christ, such as Adam and Eve, the patriarchs and the Old Testament prophets, waited until Christ descended to rescue them and admit them into Paradise.

The painting shows Christ, accompanied by the Good Thief with his cross on the left, breaking down the doors of Hell. His arrival and victory are signalled by the reptilian-like devils flying through the air playing trumpets from which flames emerge. The figures on the right are Adam and Eve, who have been released from Limbo, accompanied by a third figure who covers his ears to block out the sound of the trumpets. Christ leans forward to help others out of Limbo before leading them to Paradise.

Although sometimes included in narrative cycles of Christ's Passion at the beginning of the 14th century, the Descent into Limbo was not often depicted by Renaissance artists. It seems to have appealed only at a later date to the ablest practitioners in the second half of the 15th century, such as Donatello and Mantegna. The present composition is based on one of the 1460s by Mantegna known through drawings and prints. As his brother-in-law, Giovanni Bellini obviously had access to Mantegna's designs, which he followed in outline but not in every detail. The handling is unmistakably Bellini's in the treatment of the figures, the warm tonality, the treatment of the soft light and the pantheistic feel to the landscape. The inclusion of fig, ivy and thorn amongst the plants refers to the Passion of Christ in symbolic form.

The technique of the painting is complex: the underdrawing is done in pen on vellum, before being developed further in oil or tempera. The use of vellum suggests that the finished object might have been conceived as a miniature, but the final appearance is more that of a painting than an illuminated work – and a miraculously good one at that. The view of Christ from the back is a remarkably sophisticated passage done with the greatest assurance, as is the foreshortening of the flying devils.

ROLINDA SHARPLES (1793–1838)
The Artist and her Mother c. 1816
Wood, 36.8 × 29.2 cm / 14½ × 11½ in.

Rolinda Sharples was the daughter of the pastellist James Sharples and his third wife, Ellen. The children of all three of the father's marriages became artists. He himself had a particularly successful career in America, where Rolinda was taken twice, in 1793–1801 and 1809–11. The family seems to have flourished as professional artists, although their income was supplemented by investments.

Rolinda started her career at the age of thirteen, having had some formal training in London from Philip Reinagle before being influenced by Edward Bird, who was based in Bristol. She lived in Clifton and specialized in portraits and genre scenes. Some of her set pieces (*The Cloak Room, Clifton Assembly Rooms* of 1818, *The Stoppage of the Bank* of 1822, *The Trial of Colonel Brereton* of 1832–34, and *Clifton Race Course* of 1836 – all in Bristol) are considerable undertakings, but they show signs of over-reaching. More successful are the intimate scenes, and this self-portrait has distinct charm.

'The only man who seems to me to have united the most intense feeling with all that is great in the artist'

JOHN RUSKIN TO DEAN LIDDELL, 12 OCTOBER 1844

Jane Austen of the brush

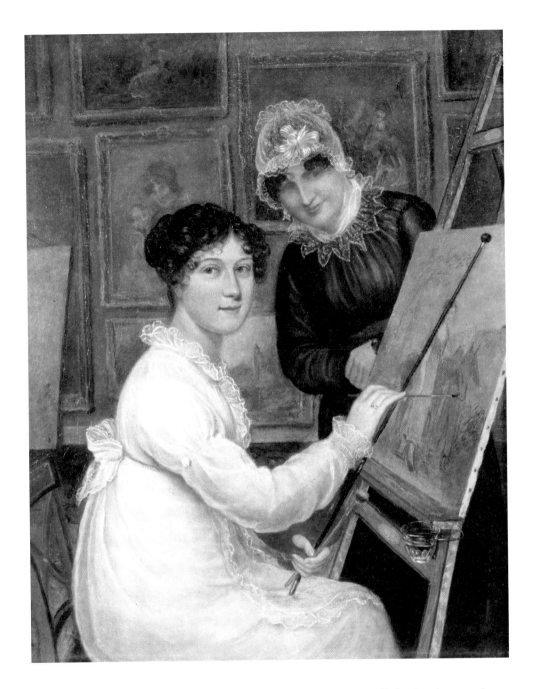

The Artist and her Mother is of particular interest in showing Rolinda Sharples at work in her studio. The painting has a Biedermeier quality in its intimate scale and finished technique. This is no allegory extolling the creative qualities of women: it is far more prosaic, but nonetheless socially revealing.

Rolinda died of breast cancer. Her mother outlived her by ten years and was a generous benefactor of the Bristol Academy of Fine Arts, now known as the Royal West of England Academy.

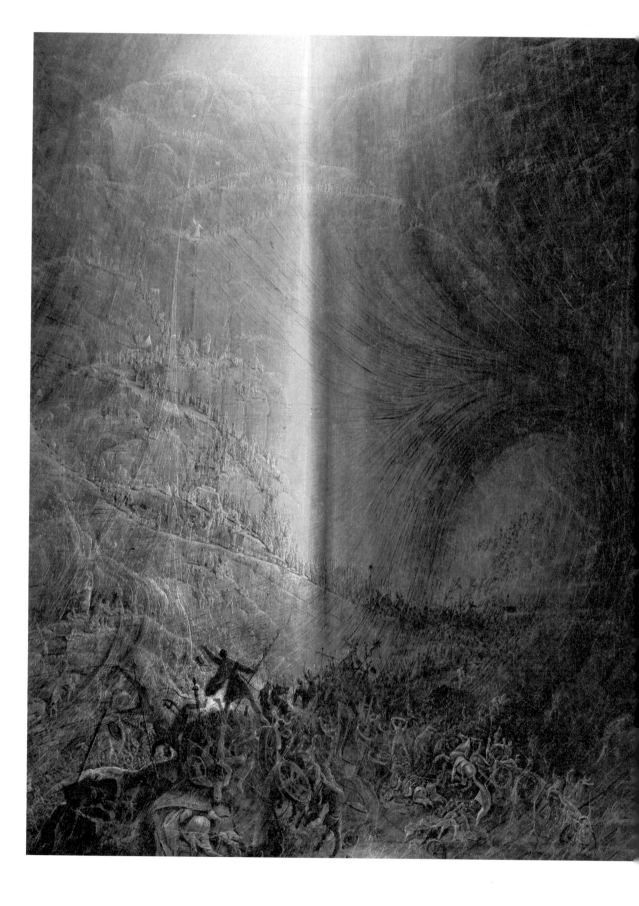

SAMUEL COLMAN (1780–1845)

The Destruction of Pharaoh's Host c. 1820

Canvas, 61 × 49.8 cm / 24 × 19⅝ in.

The wrath of God

This dramatic incident is described in the Old Testament (Exodus 14) as Moses leads the Children of Israel out of Egypt: a dry path across the Red Sea was specially made by God for them to cross in safety, and Pharaoh's army in pursuit was engulfed by the returning waters.

Such pictures are the epitome of Romantic painting, taking its lead from theories of the Sublime as pursued in the dramatic landscapes and historical fantasies of Turner. Lesser artists such as Francis Danby, who was in Bristol from 1813 to 1824, and John Martin continued to paint apocalyptic scenes inspired by Biblical texts from the Book of Revelation, often on a huge scale and to great popular acclaim.

Colman, like Danby, produced both views of Bristol of a rather tame nature and compositions full of cataclysmic horrors in which lurid colours, lowering skies and casts of hundreds of tiny figures create a sense of drama that absorbs modern viewers used to vivid cinematic effects, just as panoramas and dioramas or re-enactments fascinated contemporary viewers. Whether the final effect makes the hairs on your neck stand on end or makes you laugh at the preposterousness of it all, the artist's commitment is undeniable.

HENRY NELSON O'NEIL (1817–80)

The Last Moments of Raphael 1866

Canvas, 121.2 × 182.8 cm / 47¾ × 72 in. Signed and dated

The artist was born in St Petersburg, but he was trained at the Royal Academy Schools in London where he was enrolled by 1836. Throughout his career he remained closely linked to the Royal Academy, exhibiting over ninety pictures there between 1838 and 1879. Together with W. P. Frith, Richard Dadd, Alfred Elmore, Augustus Egg and John Phillip he formed part of a group of artists who called themselves The Clique and made a good living from their art.

O'Neil was a painter of historical genre – The Last Moments of Mozart, The Eve of Waterloo, Mary Stuart's Farewell to France. His most famous pictures, topical representations inspired by reactions to the Indian Mutiny, were immensely successful at the Royal Academy – Eastward Ho! August 1857 (Elton Hall Collection) and Home Again, 1858 (see p. 43).

O'Neil had diverse interests – writing and lecturing, as well as playing the violin. He was a member of the Garrick Club (unfortunately Forty-three Members in the Billiards Room of the Garrick Club, 1869, not being one of his more imaginative pictures), with a wide circle of friends. The fact that the quality of his work tailed off is probably the result of this diversity.

Scenes from the lives of the old masters grew in popularity throughout the 19th century in both France and Britain for historicizing reasons. O'Neil's *Last Moments of Raphael* was shown at the Royal Academy in 1866 and the Paris Salon in 1878. Usually such pictures were based on literary sources, but they were essentially imaginative recreations inspired paradoxically by the growth in serious scholarship of old master paintings. Sometimes their purpose was to elevate the status of the artist in contemporary society, but more often they have an antiquarian flavour, even when artists as distinguished as Ingres or Delacroix were depicting incidents in the lives of Raphael and Michelangelo.

The most famous death scene of a Renaissance artist was that of Leonardo da Vinci who, according to the 16th-century artist and biographer Giorgio Vasari, died in the arms of King Francis I of France. Vasari also describes Raphael's death in the Vatican, where the artist was then working, as having taken place after an unusually wild night on the tiles. Raphael, who Vasari says lived more like a prince than an artist, is surrounded by his pupils and by members of the Papal Curia, his mistress having left the room. His last important altarpiece, *The Transfiguration* (now in the Vatican Gallery), had been set up in his honour for all to admire while he was dying. Interestingly, O'Neil shows Raphael's personal transfiguration symbolically, with his dying body illuminated by the early morning light pouring through the open window.

'We may believe that his soul adorns heaven as his talent has embellished the earth'

GIORGIO VASARI, *LIFE OF RAPHAEL*, 1568

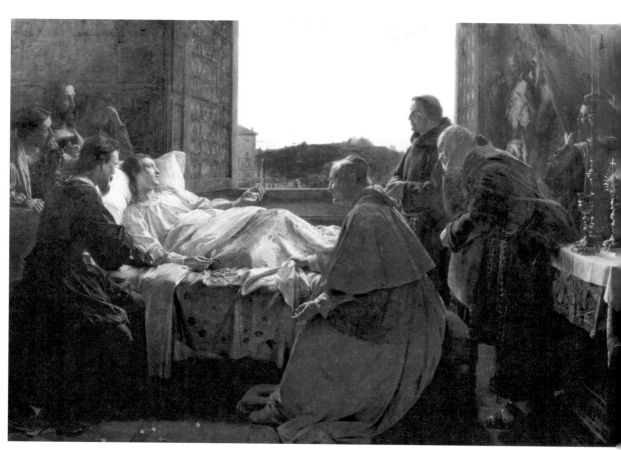

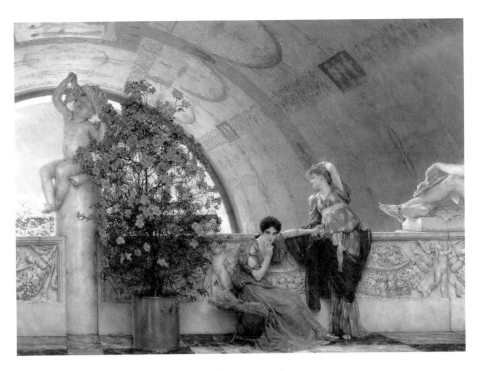

SIR LAWRENCE ALMA-TADEMA (1836–1912)
Unconscious Rivals 1893
Canvas, 45 × 62.8 cm / 17¾ × 24¾ in. Signed and dated

Pictures of this type recreating the spectacle, customs and habits of the Classical world made Alma-Tadema's reputation from the mid-1860s onwards. Like many other Northern artists (he was born in Holland), to him the light of the Mediterranean was irresistible. Indeed, Alma-Tadema was famous for painting the domed ceiling of his London studio with aluminium paint so that it enjoyed bright light even in the winter months.

Apart from his historical set-pieces, often painted on a large scale, the artist's most enjoyable pictures are those depicting intimacies or private moments – courting, bathing, dining, entertaining, conspiring. The architectural settings, the monuments, the fittings and sculptural embellishments were all carefully researched, but, as in Bulwer Lytton's novel *The Last Days of Pompeii* (1834), the figures remain quintessentially Victorian. Alma-Tadema's recreation of the ancient world, as in *Unconscious Rivals*, remains nothing more than a fiction or a costumed play.

His pictures work in the same way as travel brochures do today, enticing us to take the perfect holiday in the sun on the shores of the Mediterranean. This, however, was no idle dream, for symbolically the Roman Empire was an important forerunner of the British Empire, which during the artist's lifetime reached its apogee. It is unlikely that he wanted to cast his pictures in a political framework, but knowingly or not they undoubtedly had imperialist overtones.

ERIC RAVILIOUS (1903–42)

Tennis 1930

Wood, each panel 82.5 × 49.5 cm / 32½ × 19½ in.

Although Ravilious had such a short life, dying on an air–sea rescue mission during the Second World War, his art is omnipresent, mainly through his designs (think of the Wedgwood 'Alphabet' mug). Educated in Eastbourne, where he attended the local college of art, he went on to study at the Royal College of Art in London (1922–25). From the beginning he demonstrated a proclivity for design, book illustration and printmaking, while also producing numerous watercolours and murals. Close to Edward Bawden, he was part of the colony of artists associated with Great Bardfield in Essex, although he retained his love of Sussex. In 1939 he was appointed an official war artist, in which role his output was prolific.

Ravilious's watercolours place him in the tradition of Francis Towne and J. S. Cotman. Of his contemporaries, apart from Edward Bawden, he was much influenced by Paul Nash, and there is often a hint of Surrealism in his compositions. The pale palette, dry technique, delicate touch and quiet tonality evoke for many a type of 'Englishness' that had disappeared by 1945. The abstract quality of many of the watercolours invests them with an objectivity that was redolent of a man who, according to John Lake, a fellow student at Eastbourne, 'always seemed to be slightly somewhere else'.

A modern triptych
devoted to pleasure

The decorative murals that the artist undertook have not fared so well, although all are known through studies and photographs. Those for Morley College in London (1928–29) inspired by Elizabethan and Jacobean drama were destroyed by bombing; others at the Midland Railway Hotel, Morecambe (*Day* and *Night*), and the Pier Pavilion, Colwyn Bay, were destroyed through neglect. The ability to create a wholly imaginative world was shared by his immediate contemporary Rex Whistler.

Tennis is in many ways, therefore, a rare survival. The scene is continuous, extending through the three panels (a modern triptych devoted to pleasure), and was originally mounted on the doors of the music room in the London flat of Sir Geoffrey Fry, Private Secretary to the Prime Minister, Stanley Baldwin. Fry had made the arrangements for the Prime Minister to unveil the murals at Morley College and became the friend and patron of the artist. He gave *Tennis* to the museum and art gallery in 1945.

WILLIAM ROBERTS (1895–1980)
The Palms Foretell 1937
Canvas, 99 × 79.3 cm / 39 × 31¼ in. Signed

Like Stanley Spencer, Roberts had a strikingly individual style which is instantly recognizable. He attended the Slade School of Fine Art (1910–13) before working for a short period for Roger Fry's Omega Workshops, from which he and Wyndham Lewis broke away. He was a signatory of the Vorticist manifesto in 1914, and his mature style is a fusion of Cubism and Futurism in the dynamism of the broken forms on which his taut compositions depended. Roberts was predominantly a figurative artist and developed

Between Dürer and
Beryl Cook

a schematized, slightly exaggerated rendering of the human form that is almost sculptural. The simplified, rounded shapes of his figures may have been influenced by contemporary French art, although for me the clear drawing and strong colour recall Italian fresco cycles (for example Signorelli or Sodoma).

Roberts was a master at devising close-knit somewhat over-contrived figure subjects, which he prepared with great attention to detail in immaculate drawings. *The Palms Foretell* is a typical extrapolation of a scene from everyday life. There is an element of affectionate exaggeration in the vivid characterization of the figures (as in the puppets used in the television series *Spitting Image*) grouped in a circle for a reading of their palms by the fortune-teller on the left.

The treatment of the subject reminds me of compositions of *Christ disputing with the Doctors* by Renaissance artists such as Leonardo da Vinci or Dürer, where there is a similar emphasis on hands and gestures, as well as a close examination of the grotesque.

Exeter

ROYAL ALBERT MEMORIAL MUSEUM AND ART GALLERY

The museum was founded in 1861 in memory of Queen Victoria's husband, Prince Albert, who had died in that year. His full-length statue by E. B. Stephens greets you halfway up the principal staircase. The building is in the Neo-Gothic style and at first served several purposes – museum, school of art, public reading room and library. The architect was John Hayward and the opening occurred in 1868. It is one of the earliest dedicated spaces of this type in the country. The museum has recently undergone an extensive refurbishment.

The collection of paintings has been put together mainly by purchases made from specific funds and grants. It is, therefore, rather heterogeneous. Understandably, an emphasis has been put on artists associated with Exeter or on a wider basis with Devon, but there is an interesting group of 18th-century British paintings, including a series of wonderfully scurrilous oils by Thomas Patch. The early interest in portraits has been evened out by the acquisition of some notable landscapes. Victorian paintings and modern British pictures are evidence of a wider collecting policy and since 1968 the search for works by members of the Camden Town Group and the St Ives School has intensified.

W. P. FRITH (1819–1909)
The Fair Toxophilites 1872
Canvas, 98.2 × 81.7 cm / 35⅝ × 32¼ in. Signed and dated

Frith's popularity as a painter was matched only by Dickens's success as a writer. No less than six of the pictures he exhibited at the Royal Academy needed to be protected from the public's excited reaction by rails. By the end of his long career he had grown bored with his success, but nonetheless had to keep working since in effect he had two families: he had married Isabelle Baker in 1845, and on her death in 1880 he married his long-term mistress, Mary Alford, and had many children with both. His best-selling memoirs, *Autobiography and Reminiscences* (1887) and *Further Reminiscences* (1888), reveal intriguing insights into the Victorian art world.

As an artist Frith's upbringing was orthodox – Henry Sass's Academy (1835–37) followed by the Royal Academy Schools. His early work largely took the form of portraiture, historical genre and subjects based on literary sources, especially Shakespeare and Dickens. Around 1840 he and similar-minded artists including Egg, Dadd, O'Neil, Phillip and Elmore formed themselves into a group known as The Clique, planning to paint scenes from contemporary life. Frith succeeded in this endeavour beyond all expectations.

The pictures known as *Life at the Seaside – Ramsgate Sands* (1854, Royal Collection), *The Derby Day* (1858, London, Tate Britain) and *The Railway Station* (1862, Egham, Royal Holloway College) – are well known and frequently illustrated images of Victorian life. Such pictures can almost be 'read' like novels. *The Fair Toxophilites* comes into the same category. The inspiration for it, according to the artist, came from the sight of 'some lady-archers, whose feats had amused me at the seaside'. As models he chose three of his daughters from his first marriage, Alice, Fanny and Louise. Archery, like croquet, was a sport in which young women could openly participate and it had the seal of royal approval since Queen Victoria was an enthusiast. The Grand National Archery Society was founded in 1861 and became the official governing authority. Attached to the waist of the figure on the far right are additional items of the sport – a tassel for cleaning the arrows, a grease box for the bowstrings, a pencil for scoring and two ornamental acorns.

This is not great art, but it is pleasing. The picture reveals Frith's concern to be 'modern', and it is worth bearing in mind that it was painted two years before the first Impressionist exhibition in Paris. The artist himself wrote that 'the subject was trifling, and totally devoid of character interest; but the girls are true to nature and the dresses will be a record of the female habiliments of the time'. Actually it is not impossible to imagine Monet or Renoir painting this subject.

It is unlikely that Frith intended or would have taken seriously the thought that three young women grouped like this recall the Three Graces, or that the figure pulling the bow could be mistaken for a modern Diana, goddess of hunting.

Don't forget to duck – the Misses Frith as archers

Falmouth

FALMOUTH ART GALLERY

The gallery is housed on the upper floor of the Municipal Buildings in the centre of the town, overlooking a piazza-like space called the Moor. Opened in 1894, it was financed mainly by John Passmore Edwards (1823–1911), a self-made man, newspaper proprietor and philanthropist, who was one of the principal benefactors of the arts in Cornwall. Another important benefactor in the South-West was Alfred de Pass (1861–1952), who presented paintings between 1923 and 1939. The gallery in its present form opened in 1978 and was refurbished during the early 1990s, reopening in 1996.

The collection, with British pictures dating from the 18th century onwards, has considerable potential. The most distinguished Cornish painters of the second half of the 19th century, Henry Scott Tuke and Charles Napier Hemy, are represented, especially Tuke.

CHARLES NAPIER HEMY (1841–1917)
Along Shore Fishermen 1890
Canvas, 56 × 76.2 cm / 22¼ × 30 in.

The painting is of the greatest relevance for Falmouth since it is a view of St Anthony Head jutting out into the Carrick Roads at the entrance to Falmouth harbour. The lighthouse at the tip of the Roseland Peninsula, built by James Walker in 1834, was octagonal and was equipped with a two-ton brass fog bell – the heaviest ever used in a British lighthouse.

Hemy was the foremost marine painter of his time. Born in Newcastle upon Tyne into a musical family who emigrated to Australia for a brief period, on returning he trained at Newcastle School of Design with William Bell Scott. With an instinct for adventure, he ran away to sea as an apprentice and later had a brief period as a Dominican friar. On returning to art he attended the studio of Henri Leys in Antwerp before establishing himself in London. He settled in Falmouth in 1881 and amassed a huge amount of knowledge about the sea and local life. When he was made a member of the Royal Academy in 1910 he was the only painter working in Cornwall to have achieved such a distinction.

The original purchaser of this picture was Henry Herbert Hett, to whom the artist wrote in explanation: 'I painted it off Saint Antony [sic] lighthouse onboard my boat the Van-der-Meer and I think I may have caught something of the freshness of the sea. The net is what they call a trammel and is set overnight and hauled in the morning, and brings up mostly flat fish, John Doreys, Red Mullet. The fishermen never go out into deep water but set their nets close inshore hence the name of the picture.'

'I think I may have caught something of the freshness of the sea'

CHARLES NAPIER HEMY

Hemy was much admired by his contemporaries, especially Frank Brangwyn, for his skill in capturing the character and movement of the waves. His powerful technique matched his purpose perfectly.

A portrait of Hemy by John Singer Sargent painted in 1905 is also in the collection.

Penzance

PENLEE HOUSE GALLERY AND MUSEUM

Penlee House, built in 1864, is a typical Victorian villa in the Italianate style and not unlike Osborne House on the Isle of Wight in this respect. It was sold to Penzance Town Council in 1946 and adapted to become a museum and arts centre, but it was only in 1984 that proper galleries were created out of the ground-floor rooms; the building was completely overhauled during the 1990s with an extension, and finally re-opened in 1997. The gardens are now a formal park.

The permanent collection comprises the holdings of Penzance Town Council and the former Newlyn Art Gallery, but it is being added to as the result of an active programme of donations, bequests and purchases made with the help of grants.

Penlee House aims to be – indeed has perhaps already become – the focus of attention for the study of the works by artists associated with the Newlyn School and Lamorna Cove, either as part of its permanent displays or through special exhibitions.

NORMAN GARSTIN (1847–1926)
The Rain It Raineth Every Day 1889
Canvas, 94 × 163 cm / 37 × 64⅛ in.

Some artists are remembered for a single painting out of the whole of their œuvre and Norman Garstin is definitely one of their number. Many people probably recognize *The Rain it Raineth Every Day* without knowing who it is by or what it represents. Such pictures are often used as covers for Penguin Classics or some other similar literary enterprise.

The view in the painting is of the promenade between Newlyn and Penzance. The Queen's Hotel is prominent among the buildings on the left, with the parish church behind and terraced houses in the distance on the right. It is a wet and windy day, and only a few people are braving the elements. A spume of spray breaks over the wall by the hotel.

The title is taken from words spoken in Shakespeare's *King Lear* (Act III, scene 2) by the Fool accompanying Lear in a storm on the heath. The painter, who lived in Newlyn from 1886 but moved to Penzance in 1890, no doubt meant the title to be ironic. The scale of the picture suggests that Garstin had high hopes of it being a success at the Royal Academy, but the jury turned it down. It was probably too 'modern' for the academicians, with the wide open spaces of the glittering rain-soaked promenade emphasized by the plunging perspective. Full of atmosphere, the tonal passages are clearly inspired by Whistler.

The artist's early life was eventful. An Irishman, he studied engineering and architecture, but decided instead to make his fortune in diamond mining in South Africa, where he met Cecil Rhodes. He ended up in Cape Town working for a newspaper. On returning, an accident caused the loss of sight in his right eye, but nevertheless he now decided to become a painter, and trained in Antwerp (1878–79) with Charles Verlat and then in Paris

(1880–82) with Carolus-Duran. His true allegiance was to the Impressionists, particularly Manet and Degas, but like so many others he came under the influence of Jules Bastien-Lepage and so ended up painting in Brittany. His natural habitat as an artist thereafter was Newlyn, where he arrived with his wife (also a painter) in 1886.

Garstin was an inveterate traveller, but he remained loyal to the Newlyn School. For much of his later life he was short of money and so he wrote for the *Art Journal* and *The Studio* to supplement his income, as well as organizing sketching tours and opening an art school in Penzance. Although Stanhope Forbes was the acknowledged leader of the Newlyn School, Garstin was its intellectual mentor, full of unconventional ideas and witty observations.

Plymouth

PLYMOUTH CITY MUSEUM AND ART GALLERY

Several notable figures in the 18th- and 19th-century art world were born in or near Plymouth – Sir Joshua Reynolds, James Northcote, Benjamin Robert Haydon and Sir Charles Eastlake. As a young man in 1815 Eastlake – a future Director of the National Gallery – saw Napoleon in captivity on his way to St Helena on board H.M.S. *Bellerophon* while anchored in Plymouth Sound and painted the scene (the picture is now in the National Maritime Museum, London)

The museum was founded in 1898 and has occupied the impressive purpose-built premises by local architects Thornely and Rooke, close to the University, since 1910; extensions date from 1938 and 1975, and a re-presentation of the collections was completed in 2009–10.

The hub of the fine arts collection, setting the tone so to speak, is the Cottonian Collection, which was bequeathed to Plymouth in 1863 and transferred to the museum in 1915. William Cotton (d. 1791) inherited the collection formed by his brother-in-law, Charles Rogers (1711–84), a friend of both Reynolds and Horace Walpole. Displayed as a single entity, it gives a clear insight into 18th-century taste – paintings, drawings, prints, bronzes and books.

For the rest, apart from works by leading Devonian artists, among whom Beryl Cook should be included, the museum has a small group of old masters bequeathed by Alfred de Pass (1861–1952) and some paintings by members of the Camden Town Group (including *Plymouth Pier* by Charles Ginner, c. 1923) and the Newlyn School. The collecting of contemporary British painting is vigorously pursued.

STANHOPE ALEXANDER FORBES (1857–1947)

A Fish Sale on a Cornish Beach 1885

Canvas, 121.3 × 154.9 cm / 47¾ × 61 in. Signed and dated

Forbes was born into a successful and well-connected family much involved with the growth of the railway industry. A talent for drawing was kindled at school, which led to his admission to the Royal Academy Schools in 1874. As for many of his contemporaries, what was happening in Paris proved to be more challenging and in 1880 he became a pupil there of Léon Bonnat, although the work and example of Jules Bastien-Lepage were to prove a more decisive influence. The desire to paint naturalistic subjects observed in the open air and portrayed with a more direct technique encouraged him to work in Brittany at Cancale and Quimperlé during the years 1881–83. On his return to England in 1884 he sought a similar landscape to work in and discovered the fishing village of Newlyn on the southern coast of Cornwall, at Mount's Bay near Penzance overlooking St Michael's Mount.

Forbes became in many ways the doyen of the Newlyn School, although he was surrounded by other talented artists such as Norman Garstin, Walter Langley, Frank Bramley, Chevallier Tayler, T. C. Gotch and H. S. Tuke. He lived in the village for the rest of his life and in 1899, together with his wife, the painter Elizabeth Forbes, established an art school

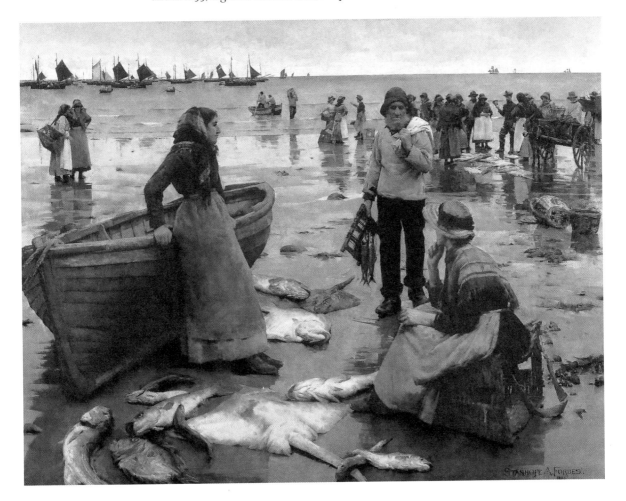

there. Although the Newlyn School was seen as an avant-garde group by British standards, Forbes did not pursue his connection with the New English Art Club, preferring to attract patrons through the Royal Academy where he exhibited frequently from 1886.

A Fish Sale on a Cornish Beach was shown at the Academy in 1885. Fishing was an immensely productive industry during the 1880s and 1890s. The artist shows the return of the fleet with the catch beginning to be unloaded; clusters of people pass the time on the beach in readiness to sort the fish for sale and packing. Sargent had painted a similar composition, *Oyster Gatherers of Cancale*, in 1877–78 (Washington, Corcoran Gallery of Art), but it is less elaborate, and even if Forbes had this in mind he had everything he needed in front of his eyes. He wrote later, 'From the first I was fascinated by those wet sands, with their groups of figures reflected on the shiny surfaces.'

The strength of *A Fish Sale on a Cornish Beach* lies in its organization: it is a very carefully planned and confidently executed painting using the square-brush technique. The figures, many in the background arranged in relief, are conceived on a monumental scale – heroic and proud – and painted with a muted palette; the boats make beautiful silhouettes against the sea and the sky. It is as strong as Manet and as uncompromising as Degas – in every sense an iconic picture.

Swindon

SWINDON ART GALLERY

The museum was founded in 1912, but the art collection was initiated much later, in 1944, and was quickly established with a donation of modern British paintings from H. J. P. Bomford – originally a stockbroker, later a local landowner and patron (he was the first patron of Francis Bacon). It is housed in a Neoclassical merchant's house in the Old Town, with an art gallery added in 1963–64 – this last unfortunately lacking in elegance and proper space for display. The diverse and interesting collection of modern British art was acquired over the years with the guidance of outside advisers (Sir Lawrence Gowing and Richard Morphet) and the help of the Contemporary Art Society: as a collection formed by a local authority with limited financial means, it is an exemplary achievement. As Kenneth Clark once famously but rather patronizingly remarked, 'They take art seriously in Swindon.' Works by Michael Ayrton, John Bellany, Richard Hamilton, Howard Hodgkin and Christopher Lebrun demonstrate the success of Swindon's venture, which is not so much to be comprehensive as to celebrate the art of actual mark-making. The collection is remarkably painterly.

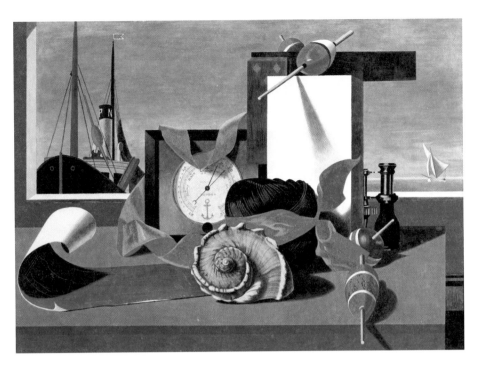

EDWARD WADSWORTH (1889–1949)
Bright Intervals 1928
Canvas laid down on wood, 63.5 × 88.9 cm / 25 × 35 in. Signed and dated

Magic Realism

Wadsworth invented the category of marine still-life and chose the medium of tempera with which to achieve the desired clarity and precision of technique. He tended to paint his pictures first and then choose the titles: *Bright Intervals* was probably inspired by the phrase used in weather forecast bulletins.

Through the window ships can be seen out at sea. Laid out on the table in front of the window are a barometer, a blueprint, a ball of tarred twine, binoculars, a joiner's square, the shell of a green snail, a white block, and fishing floats – all intertwined as a Rococo refinement by a red ribbon. The meticulous drawing reveals Wadsworth's training as an engineering draughtsman. The juxtaposition of the objects, predominantly maritime, is purely fanciful, but Wadsworth was not a Surrealist: rather, these marine still-lifes are a form of Magic Realism. They are highly poetic evocations of the sea without putting undue emphasis on water, and the viewer remains very firmly on dry land.

Wadsworth was in the forefront of Vorticism and he was a founder member of Unit One, organized by Paul Nash. During the First World War he designed dazzle camouflage for ships, then spent time in Paris during the 1920s. Later he was in demand as a mural painter (for the De la Warr Pavilion at Bexhill and the liner *Queen Mary*), while also designing the initial letters for T. E. Lawrence's *Seven Pillars of Wisdom*. Fascinated by the techniques of early Italian artists, he studied closely Cennino Cennini's *Il libro dell'arte* (*c.* 1300).

Truro

ROYAL CORNWALL MUSEUM

The Royal Cornwall Museum is the British Museum of Cornwall. Founded in 1818 as the Royal Institution of Cornwall (still its official designation), it occupies a building dating from 1919, adapted from a bank designed in 1845 by Philip Sambell Jr. It is full of surprises and has an appropriately intellectual atmosphere.

The collection of paintings serves in part to complement the main scientific collections and to honour the artistic traditions of the county. An international note is introduced as a result of the generosity of Alfred de Pass, whose family had business interests in South Africa and who was an important benefactor of many museums in the South-West (Bristol, Falmouth, Plymouth). To Truro between 1914 and 1947 he gave antique gems, paintings, miniatures and works on paper, and he paid for a special gallery for their display. Regrettably, some of these items were sold at Christie's in 1965–66.

The museum was renovated and re-presented during the 1980s.

JOHN OPIE (1761–1807)
*Thomas Daniell and Captain Morcom with Wheal Towan Mine
in the Background* 1786
Canvas, 99.5 × 112 cm / 34¼ × 44¼ in.

Tin-mining was for centuries one of the main industries of Cornwall, and John Opie's father was himself a miner carpenter at St Agnes, to the north-west of Truro close to the coast. This, therefore, is a picture that is archetypally Cornish. It shows the merchant and mine owner Thomas Daniell (1715–93) on the right holding a specimen of copper ore, which has been given him by Joseph Morcom, who points to the mine on the horizon. Presumably Morcom is attempting to interest Daniell in a financial investment in the mine. Everything about this picture suits the context of the Royal Cornwall Museum, not least the geological specimen.

The composition is an unusual rendering of the double portrait, and even more strange is the pose and gesture of Joseph Morcom, who leans into the picture space like the Angel Gabriel at the Annunciation.

But Opie was an unusual artist. His natural aptitude for art was ignored by his father, but 'discovered' by John Wolcot (more famous as the satirical versifier Peter Pindar), an amateur artist and critic, who was practising medicine in Cornwall during the 1770s.

'The Cornish Wonder'

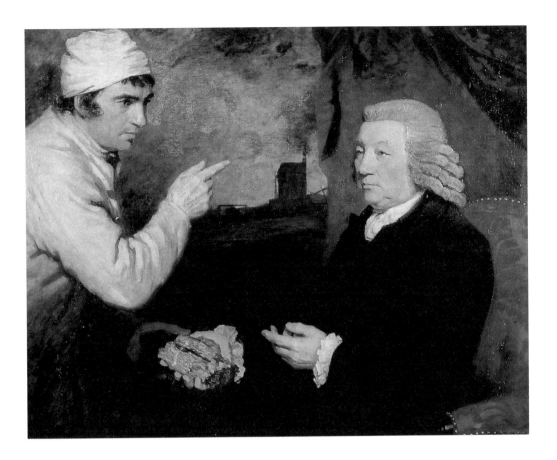

Wolcot's plan was to develop Opie's artistic talent and social skills in secret and then launch him onto the London scene as a self-taught prodigy. To some extent this plan worked, and Opie's success at the Royal Academy and elsewhere earned him the accolade of the 'Cornish Wonder', or the 'noble savage' (in the phrase of the contemporary philosopher Jean-Jacques Rousseau).

Opie's reputation rested on his portraits (particularly of children), fancy pictures in the manner of Reynolds and Gainsborough, and history painting. The style of his portraits is governed by Rembrandt and that of his history paintings by Caravaggio and his followers, knowledge of which in both cases was presumably garnered from prints. Elected a member of the Royal Academy in 1787, Opie was at the height of his powers with a prodigious output. Although he was something of a loose cannon, he was made Professor of Painting at the Academy in 1805 in succession to Fuseli. Wolcot remained cordial until 1798, the date of the artist's second marriage, to Amelia Alderson, novelist and poet, with whom he made a memorable trip to Paris in 1802 to see the Louvre (renamed the Musée Napoleon). By the time of his sudden death Opie's popularity was beginning to slip and he had reverted to the treadmill of portrait painting. Nevertheless, he was given a lavish funeral in St Paul's Cathedral, where he was interred in the same vault as Reynolds.

THE EAST MIDLANDS

The area of the East Midlands is one of contrasts. The landscape moves from the low horizon lines of the Fens to the verdant abundance of the Lincolnshire Wolds. It is rich in literary associations – John Clare, Alfred Tennyson, Lord Byron, D. H. Lawrence. While there is no similar roll-call for artists, Derby can boast of Joseph Wright of Derby, Lincoln is associated with Peter De Wint, and Nottingham can muster R. P. Bonington and Dame Laura Knight.

If the prosperity of Leicester and Lincoln depended on agriculture and the wool trade, the cities of Derby and Nottingham rose to prominence as the Industrial Revolution gave rise to a new-found wealth. Lincoln with its magnificent cathedral is still steeped in the medieval world, whereas Leicester embraces modernity (somewhat uncertainly). But each of these cities has accumulated groups of pictures that make their art galleries absorbing places to visit.

For a start, Leicester has the country's leading collection of German Expressionist art, which began to be assembled coincidentally while the Second World War was still being fought. The sense of drama provided by the location of Nottingham's Castle Museum is sustained inside by the wonderful display in the Long Gallery. Lincoln and Derby honour Peter De Wint and Joseph Wright of Derby respectively with considerable aplomb.

The museums and galleries of the East Midlands are spread over an extensive geographical area, but each has succeeded in retaining its independence as a lively and invigorating organization.

Derby

DERBY MUSEUM AND ART GALLERY

The museum and art gallery shares a building that also houses the city library. Opened in 1879, it was financed by Michael Thomas Bass (1799–1884), the greatest brewer in Victorian England (Burton Pale Ale), and Member of Parliament for Derby. The architect was R. K. Freeman. The building has been extended twice, in 1916 and 1964.

The art gallery is renowned for its holdings of the work of the 18th-century painter Joseph Wright of Derby. It has a comprehensive collection of paintings and drawings illustrating the wide range of the artist's interests – portraiture, landscape, scientific and industrial scenes, as well as literary subjects. Although he trained in London with

Thomas Hudson (1751–53 and 1756–57) before working in Liverpool (1768–71), travelling in Italy (1773–75) and returning to Bath (1775–77), Wright remained loyal to Derby, where he was able to witness at first hand the advances made during the Age of Enlightenment. So dominant and so fascinating is the representation of Wright's work in Derby that there is a danger of overlooking what other paintings there are in the gallery.

JOSEPH WRIGHT OF DERBY (1734–97)
A Philosopher Lecturing on the Orrery c. 1764–66
Canvas, 147.3 × 203.2 cm / 58 × 80 in.

Wright's scientific pictures are amongst the most intriguing painted in Britain during the 18th century and *A Philosopher lecturing on the Orrery* rivals *An Experiment on a Bird in the Air Pump* of 1768 (London, Tate Britain) as perhaps his best-known work. As a young

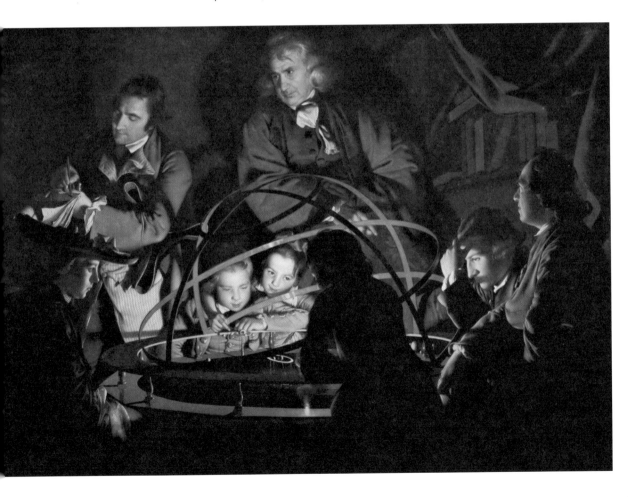

man the artist had an interest in mechanical apparatus and in general he seems to have had a scientific bent, as exemplified by his friendship with some of the members of the Lunar Society, who counted among their number Erasmus Darwin, Matthew Boulton, James Watt and Joseph Priestley. It was these radical thinkers with their belief in applied science and technology who ushered in the Industrial Revolution, based in and around Birmingham in the heart of the country. Wright in essence documents this vital moment in British history.

Orreries were instruments used for demonstrating the workings of the solar system. They were a feature of public lectures, such as that given in Derby by the Scottish scientist James Ferguson in 1764 – an event which Wright himself may have attended.

The artist perfected 'candlelight' scenes such as this where the light source emanates from below, producing remarkable silhouettes, as well as illuminating the faces of those listening to the lecturer with rapt attention. The lecturer may in point of fact be explaining the causes of an eclipse which might account for the special lighting effects. Wright depends on the tenebrist style of Caravaggio and his followers, particularly those in Northern Europe, but he is unusual in applying it to a modern subject. It also allows him to introduce symbolism into the composition, in so far as the light represents knowledge with the illuminated figures being the recipients of that knowledge, dispersing the darkness of ignorance. Similarly, the curtain behind is raised to reveal the books on the shelf as a further source of knowledge.

JOSEPH WRIGHT OF DERBY (1734–97)
The Rev. D'Ewes Coke with his Wife Hannah and Daniel Parker Coke MP c. 1782
Canvas, 152.4 × 177.8 cm / 60 × 70 in.

Wright's early portraits, often set in interiors, tend to be direct and unfussy, but towards the end of his career they became more expansive, and now set out of doors, with an awareness of the benefits of nature as described in the writings of Jean-Jacques Rousseau.

The Coke family portrait is a pyramidal composition, with the Rev. D'Ewes at the apex. One of his arms is extended around his wife's shoulders, while the other enfolds his relative within the group. The setting is the lush scenery of the family estate at Brookhill Hall, Derbyshire. A discussion is taking place about the content of the piece of paper, which may be a drawing of the view or a project for the estate. The paper has been taken out of the portfolio held by Hannah Coke. The sense of well-being is palpable and the unity of the group is underscored by the gestures that indicate a prospect that cannot be shared by the viewer.

An additional feature, which makes this one of the finest group portraits painted in 18th-century Britain, is Wright's technical mastery. The treatment of the different

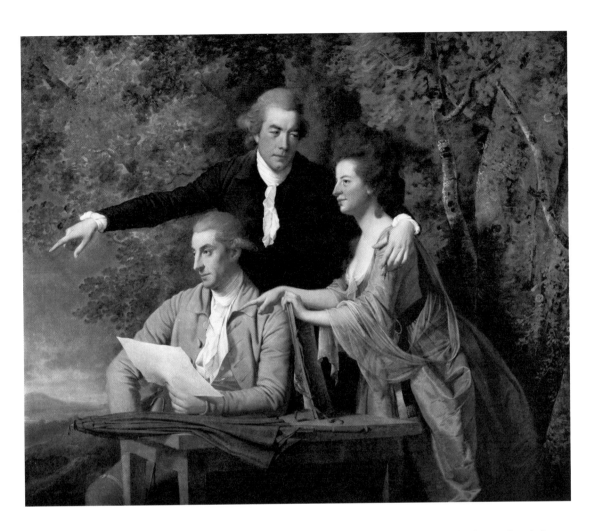

textures of male and female attire is spellbinding, notably the shot silk of Hannah Coke's dress. The quiet palette of green, grey/black, ochre and brown creates a sense of calm. The Cokes live in harmony with nature but also with themselves.

DEREK JARMAN (1942–94)
Avebury Series II 1976
Canvas, 121.9 × 121.9 cm / 48 × 48 in.

Painter, filmmaker, writer, theatre designer, horticulturist, campaigner, Derek Jarman packed a lot into his comparatively short life. The films, which include *Caravaggio*, *War Requiem*, *Edward II* and *Blue*, made a considerable impact, as did the creation of his garden at Prospect Cottage at Dungeness.

Jarman attended the Slade School of Fine Art after obtaining a university degree in English, History and the History of Art at King's College, London. His versatility allowed him to paint in a number of different styles.

The paintings known as the *Avebury Series* followed upon Jarman's film entitled *A Journey to Avebury* (1971–72), in which he explored the landscape and the circle of megalithic stones found there. They are really a set of variations and are painted extremely sparely on plain backgrounds. The lines on the canvas represent lay lines forming spiritual and cultural links across time, as well as referring to the archaeological links thought to associate stone circles of this type as places of ritual or sacrifice. Such connections evoke a distant historical past that dwarfs our own sense of time based on personal experience. This reductive approach to landscape relates Jarman to Paul Nash (for example *The Shore* of 1923 in Leeds), an artist who was an early influence.

On 22 September 1991 Jarman was canonized by the Sisters of Perpetual Indulgence as St Derek of Dungeness of the Order of Celluloid Knights. His was an irrepressible spirit.

MICHAEL PORTER (b. 1948)
Highlight through Trees 2008
Canvas, 120 × 110 cm / 47¼ × 43¼ in.

The artist was born in Derbyshire, but now lives in Newlyn in Cornwall. Since the 1990s his paintings have been inspired by a painstaking examination of natural forms - rocks, stones, plants, leaves, fungi, lichen - seen either in forested areas or along the sea shore. What is attractive about them is that they force the viewer to look carefully with total

A multi-talented man with a sense of time

'To see a world in
a Grain of Sand /
And a Heaven in
a Wild Flower /
Hold Infinity in the
palm of your hand /
And Eternity
in an hour'

WILLIAM BLAKE, 'AUGURIES
OF INNOCENCE', c. 1803

concentration. As the artist says, his paintings encourage 'those few minutes of reflection giving us time to see the world as it really is'. The intensity of Porter's gaze and his absorption in nature align him with the landscape tradition of British art epitomized by Turner, Constable, Palmer and Sutherland, but the belief in the moral authority of nature comes from John Ruskin, whose watercolour studies of flora and fauna have the same mesmerizing quality.

Porter has also brilliantly harnessed the techniques of modern painting to his cause. He uses mixed media and builds up the surface of his pictures in several layers. Similarly, the application of paint is derived from Abstract Expressionism so that his techniques involve puddling, dripping, staining, clotting and running. The visual effect resembles a form of camouflage. Yet there is nothing claustrophobic about these works, which are often shown in special installations: rather, it is like looking down a microscope and discovering a whole new world.

Leicester

NEW WALK MUSEUM AND ART GALLERY

The tree-lined pedestrian way called New Walk provides a pleasant approach to the museum: you could easily be in France, Italy or Spain. The museum opened in 1849 in a building that was designed originally by Joseph Hansom as a school. The impetus for its establishment came from the transference of the collections belonging to the Leicester Literary and Philosophical Society.

The collection of fine art began in 1881 and purpose-built galleries to display the pictures were added or updated at intervals through the 20th century up until the present day. The emphasis at first was on Victorian art, but this policy was widened in 1934 to include British painting of other periods without excluding foreign schools. There are groups of Italian and Dutch old masters and a strong representation of British art of the last century.

However, Leicester is most famous for its collection of paintings, drawings and prints by the German Expressionist groups Die Brücke and Der Blaue Reiter. This initiative was due to the Director, Trevor Thomas, who in 1944 against the spirit of the times organized an exhibition of German Expressionist paintings under the title 'Mid-European Art'. He did this with the help of the family of Alfred Hess, a wealthy shoe manufacturer and distinguished collector from Erfurt who had died in 1931. Hess's widow, Thekla, and their son, Hans, had come to England during the 1930s bringing what they could of their collection and settled in Leicester. Hans Hess embarked upon a museum career, first of all at Leicester as Thomas's assistant, before becoming Director at York Art Gallery in 1949 and then Professor of the History of Art at Sussex University. The first acquisitions made by Leicester from the Hess collection were works by Franz Marc, Emil Nolde, Max Pechstein and Lyonel Feininger. A later bequest of German art, mainly of works on paper by Karl Schmidt-Rottluff, was made by Dr Rosa Schapire in 1955 during the keepership of Peter Tomory. Acquisitions of German art of the early 20th century continue to be made – Gabriele Münter, Ernst Neuschal and Lotte Laserstein – and Leicester remains the best place for an overview of German Expressionist art in Britain.

GEORGES DE LA TOUR (1593–1652)
The Choirboy c. 1640–50
Canvas, 66.7 × 50.2 cm / 26¼ × 19¾ in.

Scientific
observation raised
to a poetic level

Georges de La Tour, like Vermeer, is one of those artists whose reputation is a modern phenomenon. He was born in Lorraine, and his style reveals a commingling of Italian and Northern Caravaggesque influences, but this does not necessarily imply visits to Rome or the Netherlands. Rather, it is apparent that his style is markedly individual and the product as much of local stylistic traits as any other. He seems to have been a man of independent means, and his artistic renown was recognized when he was appointed Peintre Ordinaire du Roi in Paris in 1639. There is only a limited number of signed or dated works, and the full extent of his œuvre is a much debated issue – in which *A Young Singer* has to be included.

The consensus is that if this painting is by the master himself then it dates from his later years, some time in the 1640s. There is a possibility that the picture might be by the artist's son, Etienne. Regardless of the final outcome of this debate, the treatment bears all the hallmarks for which Georges de La Tour is famous. There is the degree of naturalism with which the singer's tongue moves in the mouth, the mysterious nocturnal effect of the candlelight, and the eye for detail in the depiction of textures – cloth, book and skin.

There is a tendency in the style itself to divide the surface into planes and to simplify the features, particularly the fingers. But the silhouetting of the chorister's left arm and the book against the candle with the hint of translucency is a magnificent achievement and wholly characteristic of the artist. This passage gives the composition some depth while at the same time heightening the sense of drama.

As a painter La Tour lifts the area of scientific observation onto a poetic level. The intensity of what he creates overwhelms the viewer: singing is tantamount to the discipline required for looking.

MICHAEL SWEERTS (1618–1664)
Portrait of a Girl c. 1655–60
Canvas, 43.5 × 36.5 cm / 17⅛ × 14⅜ in.

Sweerts was Flemish, but worked for many years in Rome (c. 1646–54) – not an unusual excursion for a Northern artist during the mid-17th century. While in Rome he painted a number of genre scenes of street life in a style influenced by Caravaggio and his followers. On returning to Brussels he founded an academy for artists in 1656 and some of his best pictures reflect this pedagogical interest (*The Artist's Studio, The Academy, Mars Destroying the Arts*).

The course of Sweerts's life changed dramatically in 1660 when he is recorded as a member of a Catholic missionary group, the Société des Missions Etrangères. He joined a mission to the Far East in 1661, but on arriving in Persia he parted company with his fellow travellers, who deemed him unsuitable for missionary work. He is last recorded in Goa, where he died. It is clear that Sweerts, a good linguist, was a religious fanatic or became one during the second part of his life. According to one observer, he 'ate no meat, fasted almost every day, slept on a hard floor, gave money to the poor, and took communion three or four times a week'. The same writer, however, described Sweerts as 'one of the greatest, if not the greatest, painter in the world'.

The artist undertook a number of heads of this sort, which are not so much portraits as studies of specific types. There is an immediacy and alertness about the characterization, with the figure's inquisitive eyes and sidelong glance. In a way this runs counter to the controlled technique, which the subtle lighting, modelling of the flesh and delicate

Immediacy and mystery in a face from the Flemish world

colouring have allowed the artist to achieve. Many writers have likened the air of mystery, pellucid tones and poetic treatment to Vermeer, and there may be some justice in such a comparison, but equally the image has the purity that 15th-century early Netherlandish artists, such as Petrus Christus or Dierck Bouts, brought to their work.

The starched white hood and collar are a homely touch, given that Sweerts's father was a linen merchant.

ERIC FORBES-ROBERTSON (1865–1935)
Breton Children, Pont-Aven 1893
Canvas 71.1 × 91.3 cm / 28 × 36 in. Signed, dated and inscribed

A British follower of Gauguin

The artist came from a large family with artistic leanings. His father was an art critic and one of his older brothers, Johnston, trained as an artist, but chose to go on the stage instead, becoming in 1897 the greatest Hamlet of his time.

The family was decidedly Francophile, and apart from preliminary training in England, Eric Forbes-Robertson's real initiation as an artist occurred in Paris, where in 1885 he attended the Académie Julian. Together with another British artist, Robert Bevan, he fell in with the Pont-Aven circle of artists who took their lead from Gauguin and Emile

Bernard. Pont-Aven is a small picturesque village on the southern coast of Brittany where the community retained a strong sense of tradition. Gauguin remarked 'I love Brittany: I find there the savage, the primitive. When my clogs resound on the granite soil, I hear the muffled, dull, powerful tone that I seek in my painting.'

The Pont-Aven circle was international, and in the four years that he was based there (1890–94) Forbes-Robertson established close working relationships with artists such as Armand Seguin, Maxim Maufra and Paul Verkade, as well as the avant-garde writer Alfred Jarry. Returning to England in 1900, Forbes-Robertson retained an interest in France, but in the present state of knowledge it can only be said that his art became less distinctive.

A number of Forbes-Robertson's paintings of Breton subjects, including several of children, are in British collections. The present composition is striking because of its viewpoint, looking slightly downwards so that the top of the table is visible. The figures in the foreground are pushed out to the edges of the canvas and so frame the third figure on the other side of the table. Although no light source is evident, the *contre-jour* effect heightens the sense of drama contained within the room, giving it an almost religious atmosphere. Similarly, the slightly acidic colours and regular striations of the brushstrokes create a deliberately unsettling effect.

FRANZ MARC (1880–1916)
Red Woman (Girl with Black Hair) 1912
Canvas, 100.5 × 70 cm / 19½ × 27¼ in. Signed and dated on the reverse

A rarity in the
British Isles

Marc was a member of the Blaue Reiter group (1911–14), which was one of several strands comprising the art movement known as German Expressionism. Based nominally in Munich, the group included Wassily Kandinsky, Auguste Macke, Gabriele Münter, Alexei von Jawlensky and, for a time, Paul Klee. The name Blaue Reiter (Blue Rider) had symbolic significance: the horse represents creative energy, which by implication is controlled by a rider identifiable as the artist, while the colour blue is associated with the spiritual.

The German Expressionists were concerned to return to their national roots, thereby partaking in a reaction against the dominance of Paris in the late 19th century. Emphasis was put on traditional media such as the woodcut, and for Marc in particular the landscape and literature of medieval Germany were important sources of inspiration. Rejecting both academic art and more modern developments such as Impressionism because both were concerned solely with externals, the German Expressionists sought to articulate the mysteries of the inner self when confronted by reality. Paradoxically, the starting point for their art was Post-Impressionism – Gauguin and Van Gogh – but Futurism and Cubism were eventually added to their armory, pushing the movement more towards the abstract.

Red Woman is the only painting by Marc in Britain, and possibly the most important work by a German Expressionist painter to be found here. A related drawing was among the first acquisitions made from Thekla Hess in 1944. The painting was acquired in the same year and had also been in the Hess collection, but it came by a more indirect route.

The composition is marvellously sinuous, with the figure almost camouflaged in its sylvan setting. Marc was clearly aware of Gauguin's Tahitian paintings and places great emphasis on pattern and rhythm as well as on a warm palette. Seen from the back with a hand raised and flowing hair like a Far Eastern dancer, the woman is portrayed as being at one with the primal forces of nature. It is an image of Eve in the Garden of Eden before the loss of innocence. The picture thus works on two levels, in so far as its concern for spirituality is a comment on the real world.

A great deal of Marc's work is tinged with apprehension at the cataclysmic forces that would be unleashed on the world in the course of the First World War. The artist himself was killed at the battle of Verdun in 1916.

JOHN PIPER (1903–92)
Derelict Cottage, Deane, Hampshire, March 1941 1941
Canvas, 51.1 × 75.9 cm / 20¼ × 30 in.

A symbol of a country at war

John Piper was a man of many parts and he was capable of turning his hand to painting, drawing, printmaking, book illustration and design in several areas including opera and ballet, tapestry, ceramics, stained glass, fabrics, book covers, and even firework displays. In many ways, therefore, he was a key figure in British art during the 20th century, together with his second wife, Myfanwy. He nearly missed out on being an artist altogether, under parental pressure to join the family firm of solicitors, but he escaped in the nick of time to study at Richmond College of Art and then at the Royal College of Art (1928–29).

Piper first came to notice as an art critic, and he continued to write throughout his life, notably some of the texts (in addition to the illustrations) for the Shell County Guides and his book *British Romantic Artists* (1942), which reveal so much about his own artistic outlook. Having begun as an abstract artist influenced by French painters as much as by

his British contemporaries, he was never purely cerebral in his approach, since he always made a clear distinction between the real and the imagined.

Yet it was Piper's long-lasting interest in the topography of Britain and the variety of the country's buildings that was to be the key to his principal achievement as an artist. A close friendship with the poet and architectural writer John Betjeman inspired him, but it was the onset of the Second World War that presented him with an unrivalled opportunity. Piper travelled the length and breadth of Britain – first of all in connection with a project entitled 'Recording Britain' and then with his appointment by Kenneth Clark (another friend and patron) as an official war artist, depicting bombed-out buildings and war-torn cityscapes. At the same time Piper did not neglect the landscape, and he was interested in buildings of all types, extending from the grandest country houses to the most humble cottage. This pictorial survey, which continued after the war, was comparable with the earlier achievements of Girtin, Turner and John Sell Cotman and accounts for the appellation 'Neo-Romantics' that often recurs in discussions of the art of Piper and of several other artists of his generation.

Derelict Cottage is a fine example of the artist's personal vision and technical abilities: the architecture, the use of mixed media (with much scraping and scratching), the relationship between exact drawing and the encroachment of abstraction, the surrounding darkness and the sombre colouring. The building might be a metaphor for a country at war – its very existence threatened and its people suffering.

Lincoln

THE COLLECTION

The Collection is the name given to the new museum building (opened in 2005) housing the archaeological and historical artefacts from the city's collections, with additional temporary exhibition space. It also incorporates the Usher Gallery, an older separate building (designed by Sir Reginald Blomfield and opened in 1927), named in honour of one of Lincoln's most generous benefactors – James Ward Usher (1845–1921), a local jeweller, whose interest lay principally in the decorative arts. Usher endowed the building to house his personal collections and set the tone for future developments. Painters associated with Lincoln, or the county, are well represented as a result of various bequests and donations: Peter De Wint, William Logsdail, Frank Bramley and William Warrener.

BENJAMIN WEST (1738–1820)

Sir Joseph Banks 1773
Canvas, 234 × 160 cm / 92 × 63 in.

Banks (1743–1820) was the outstanding botanist of his generation, with an international reputation following his appointment as the leading scientist on Captain James Cook's first expedition to the southern hemisphere on H.M.S. *Endeavour* (1768–71). He did not go on Cook's second voyage, preferring to promote the official study of natural history in Britain. Having secured the patronage of George III, he was the virtual founder of the Royal Botanic Gardens at Kew and was President of the Royal Society from 1778 until his death.

Banks was the son of a wealthy Lincolnshire landowner, whose family seat was at Revesby Abbey. He used his wealth to advance scientific knowledge both locally (for example, draining the Fens) and nationally, frequently advising the government of the day on the value of expeditions to places such as Australia, Africa and Iceland. Although very much a man of his own time in outlook, temperament and behaviour, his intellectual curiosity paved the way for Charles Darwin's voyage in H.M.S. *Beagle* in the 1830s. The numerous objects and specimens Banks collected on his expedition with Cook from Tahiti, New Zealand and Australia were given to the British Museum and later transferred to the Natural History Museum.

Banks became an overnight sensation on his return to London in 1771, and was much lionized. Many portraits of him were painted, the most famous being that by Sir Joshua Reynolds (London, National Portrait Gallery), where he appears as a charismatic, debonair man of the world taking his ease seated by a globe. West was painting Banks at virtually the same time, but adopted a different approach and one more in line with

A famous local boy

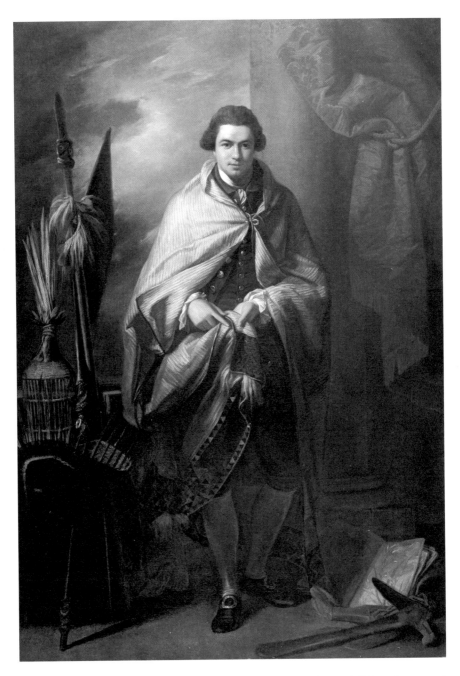

his own comparatively exotic origins in America. Banks is shown full-length wrapped in a Maori cloak of flax, surrounded by some of the artefacts he brought back from the southern hemisphere (a headdress, a canoe paddle, a fighting staff). The notebook at his feet refers to the copious notes he made on the voyage about the flora and fauna he found. Slightly incongruously, the artist gives Banks the attributes of a formal portrait (looped curtain and column), but in effect this contrast indicates something of Banks's infectious enthusiasm for his subject.

PETER DE WINT (1784–1849)
Lincoln from the South 1824
Canvas, 61 × 92.1 cm / 24 × 36¼ in.

Born near Stoke-on-Trent in Staffordshire, the artist entered into an apprenticeship in London in 1802 with the engraver John Raphael Smith, who recognized his talent as a landscape painter. Although De Wint advanced to the Royal Academy Schools, his preference was for watercolours, and so instead he began a long association with the Society of Painters in Water Colours (later the Old Water-Colour Society).

A favourite view

His life was closely intertwined with that of William Hilton, a fellow pupil of John Raphael Smith and a Lincoln man. Having married Hilton's sister and moved to Lincoln, he came to know the city and the surrounding countryside well, and such motifs were amongst his favourite subjects. Like many of the best watercolourists at the turn of the 18th and 19th centuries, he travelled extensively in Britain (but only once to Normandy) and had a base in London in order to promote sales and exhibitions.

By comparison with his prolific output as a watercolourist, oil paintings by De Wint are few in number, but in both media he made remarkably adept and sensitive transcriptions of the countryside subject to the fluctuations of sunlight, wind and rain. Constable

admired him and correspondingly some of his contemporaries regarded De Wint as being as gifted as Constable. His reverence for natural scenery was comparable with that of the contemporary poet John Clare. Strangely, he found it difficult to sell his paintings even though he exhibited them frequently, and hundreds were found in his studio on his death.

Lincoln from the South exudes a sense of calm. It is a peaceful scene with the great and glorious cathedral silhouetted against the sky. The panoramic view gives no indication of the narrow streets and gateways leading to the centre of the medieval city, but instead the eye searches out the hedgerows, the pathways or the crumbling brickwork of Little Bargate on the left. As the novelist Thackeray remarked about the artist, 'He spent his life in one revel of sunshine.' De Wint, like Constable, immerses himself in the English countryside. It is a very British way of painting, quietly confident in the beauty of nature and achieved in this instance without recourse to Continental influences.

Nottingham

NOTTINGHAM CASTLE MUSEUM AND ART GALLERY

Perhaps only the present Getty Museum in Los Angeles is as dramatically situated as the Castle Museum and Art Gallery in Nottingham. The building is the focal point of the city and has commanding views over the surrounding countryside. The site was originally a medieval fortress strengthened by Henry II, but was developed during the 17th century by William Cavendish, 1st Duke of Newcastle, and his son Henry as a private estate with a magnificent house designed in an Italianate style (1674–79). This still survives, but after being burnt out during the riots connected with the passing of the first Reform Bill in 1832 it was converted into a municipal museum and art gallery – one of the earliest in the country. The approach is equally enthralling, for it was in the grounds of the castle that Charles I raised his standard on 22 August 1642, signalling the start of the Civil War.

The collections have been assembled only comparatively recently, as a result of benefactions and acquisitions. A number of artists – Thomas and Paul Sandby, R. P. Bonington, Harold and Laura Knight – are associated with Nottingham or the county. A 'Temple of Worthies' at the entrance to the museum and art gallery celebrates local literary figures of renown, chief amongst them Lord Byron and D. H. Lawrence.

The paintings are for the most part displayed in the Long Gallery on the upper floor. This is traditionally hung with large pictures above and clusters of smaller ones below. On the protruding walls towards the far end are two fine full-length portraits: Harold Knight's *Ethel Bartlett* and Sir William Nicholson's *The Viceroy's Orderly*.

DOSSO DOSSI (c. 1489–1542)

The Christ Child Learning to Walk c. 1510

Wood, 43.8 × 42.1 cm / 17¼ × 16⅝ in.

This painting is a comparatively new addition to the œuvre of Dosso Dossi, who is most famous for his work at Ferrara where he was employed from 1514 by Alfonso and Ercole d'Este. He may have been born near Mantua, but there are stylistic elements of Titian and Giorgione, as well as of Raphael and Michelangelo, in his paintings, so he might have travelled extensively before settling in Ferrara. In many ways Dosso Dossi was an idiosyncratic artist, especially in his partiality for landscapes and for mythological themes, both aspects probably reflecting the demands of the Ferrara court where one of Italy's greatest Renaissance poets – Lodovico Ariosto – was a contemporary.

The subject of this small painting from the early part of Christ's life is extremely rare. There is no Biblical source and correspondingly few if any visual precedents. The pyramidal composition with the figures positioned under furled curtains is distinctly Raphaelesque and in its way quite dramatic. The dark temple-like interior allows the artist plenty of scope to indulge in his characteristically rich colouring – red, green, orange, blue – and sharp lighting. It is not clear why the female figure next to the Virgin is pointing, but the raised arms of both mother and child form a most affecting passage.

A very rare image of the childhood of Christ

A particularly telling touch is the way in which the Virgin leans forward in the throne encouraging the Child to come to her.

The painting was once owned by William Graham, MP for Glasgow and prominent as one of the most discerning patrons and collectors during the 1860s and 1870s, owning several old master paintings but equally keen on works by the Pre-Raphaelites, especially Rossetti and Burne-Jones. The picture was one of fourteen presented to Nottingham Castle Museum and Art Gallery by his son-in-law, Sir Kenneth Muir Mackenzie, in 1910.

CHARLES LE BRUN (1619–90)
Hercules and the Horses of Diomedes c. 1640
Canvas, 290 × 188 cm / 114⅛ × 74 in.

One of France's greatest painters announces himself

Charles Le Brun was a painter of exceptional importance in 17th-century France, but his paintings are rarely represented in British collections: even the National Gallery lacks an example. As part of a team of architects and artists formed by the First Minister, Jean-Baptiste Colbert, in the early 1660s Le Brun helped to establish the style associated with Louis XIV, culminating in the Palace of Versailles. He held highly prestigious positions: founding member and Director of the Academy, First Painter to Louis XIV, Director of the Gobelins tapestry works. For roughly twenty years (1661–83) Le Brun held sway, with his vast output matching the wide range of his activities.

From the first Le Brun succeeded in attracting the attention of immensely influential men who wanted to use art as a measure of their power. His style and range made him the perfect instrument for the translation of absolutism into visual terms, to such a degree that his manner was subsequently adopted by the leading courts of Europe.

Hercules and the Horses of Diomedes is an early work, painted as one of three over-mantels (the other two are lost) in the Palais Royal in Paris, which was at that time the residence of Cardinal Richelieu. Only twenty years old at the time, Le Brun was still working in the style of his first masters, Simon Vouet and François Perrier. Two years later he travelled to Italy with Poussin and it was while in Rome that he was able to inspect the decorative schemes by Raphael, Michelangelo and the Carracci that were to nurture his mature style. Returning to France in 1646, he painted a number of altarpieces and mythological subjects that quickly established his reputation.

This painting for Cardinal Richelieu reveals Le Brun's promise, and according to early accounts it impressed even Poussin. The composition is robust and energetic, with flowing rhythms suggesting the sudden uncoiling of a spring. The interlocking forms and the sheer compressed energy of the scene suggest some knowledge too of Rubens. It is an astonishing tour de force for so young a painter.

The subject is one of the twelve labours of Hercules undertaken as a penance. The horses belonged to Diomedes, King of Thrace, and were fed on human flesh. Hercules kills

Diomedes (trampled underfoot here) and then feeds him to his own horses before taming them. The labours of Hercules were often used by artists as a way of flattering a patron: in this instance Cardinal Richelieu would have interpreted his own achievements in terms of this display of Herculean strength.

The painting remained in the Palais Royal when it became the residence of the ducs d'Orléans and came to Britain in 1798 after the Revolution as part of the famous sale of the Orléans pictures.

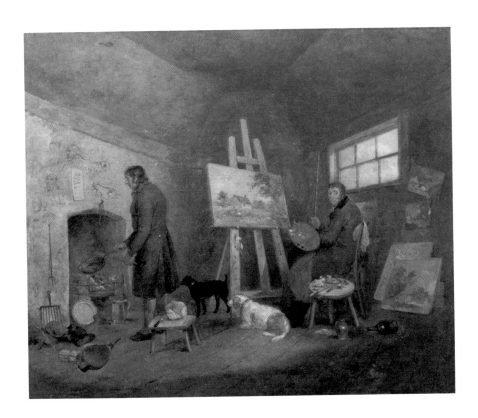

GEORGE MORLAND (1763–1804)
The Artist in his Studio with his Man Gibbs 1801
Canvas, 63.5 × 76.2 cm / 25 × 30 in.

One for the road

Morland was one of the most prolific artists of the 18th century (his output has been estimated at about four thousand paintings and drawings), but it is now quite rare to see his work on view in public galleries. This is due in part to its subject-matter and in part to its varied quality, but it remains a fact that Morland was an immensely popular artist in his own time, developing his own marketing methods and allowing his compositions to be disseminated widely through prints (over 250 in all), mostly in stipple or mezzotint.

Morland began by painting domestic genre scenes, often with didactic, moralizing overtones and imbued with feelings of sensibility. These were frequently produced in series and are close to works by Francis Wheatley. They have their origins in Hogarth, although without his satirical bite, being couched in a Rococo idiom. At the height of his career in the 1790s Morland began to paint rural genre subjects and adopted a more realistic style. His pictures now depict cottages, farmyards, animals, stables and country alehouses. Only twice did he attempt other subjects – gypsies and coastal scenes of shipwrecks, smuggling and fishermen. There is a Netherlandish connection in all of this, and comparisons with David Teniers the Younger or Adriaen van Ostade are valid.

It is clear that with these pictures Morland was trying to attract middle-class buyers as opposed to aristocratic patrons. Indeed, to a certain extent his whole life as a painter ran

contrary to establishment practices as advocated by the Royal Academy. His subject-matter ('brilliantly lacking in intellectual qualities' – Ellis Waterhouse) makes him an important link between Gainsborough and Constable or Wilkie.

Many of Morland's problems stemmed from his upbringing. His father was an artist and restorer who determined from the start that his son's talent should be used to save the family's declining fortunes (their London house had been sold to Sir Joshua Reynolds in 1760). As a result Morland was not allowed to attend the Royal Academy Schools and so learnt from copying old masters under his father's instruction. After leaving home in 1784 his independence led him into a life of perpetual extravagance and hard drinking, encouraged by bad company. This was to be a regular pattern: a life of dissipation leading to financial hardship, ill-health, and constant harassment from creditors who had to be avoided by subterfuge, only offset by hard work. It ended in an early death.

The present painting illustrates Morland's plight rather well. He lived most of his life in London in increasingly straitened circumstances. He turns from his easel to face the viewer with a haunted look; dogs solemnly watch the food being cooked; an empty bottle lies on the floor; the canvases are being mass-produced to assuage frustrated buyers and to pay off debts. Apart from what it reveals of Morland's circumstances, the painting also illustrates the abundance of his natural talent: sound drawing, accurate observation, and tonal sophistication.

MARCUS STONE (1840–1921)

In Love 1888

Canvas, 111.8 × 167.1 cm / 44 × 65¾ in. Signed and dated

Marcus Stone was an artist who found a successful formula and stuck to it. As the son of Frank Stone, the friend and illustrator of Dickens, Thackeray and Samuel Rogers, he began as an illustrator himself, but found the small scale of such work too constricting. He therefore switched to history painting (for example, *On the Road from Waterloo*, 1863, in the Guildhall Art Gallery, London), but by the 1870s he had gravitated to scenes of courtship which his father had first essayed in the 1840s. It was these pictures that made Marcus Stone's fortune, since after being shown at the Royal Academy they were often widely reproduced as photogravures.

A Victorian Garden
of Eden set in the
Regency

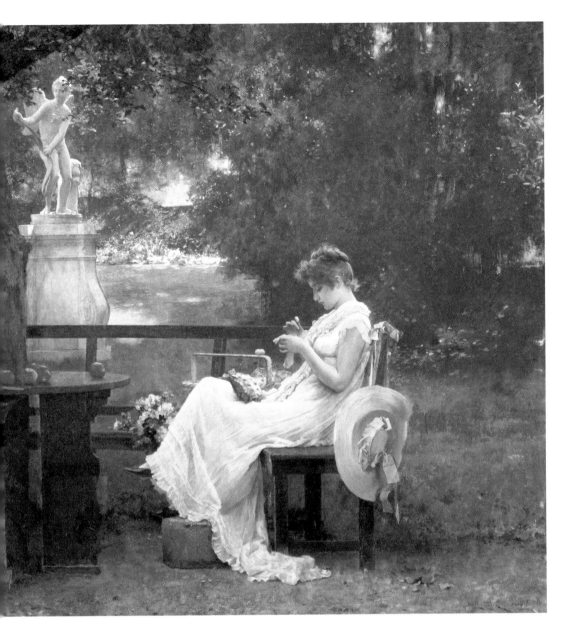

Stone became in essence the English equivalent of Tissot, although lacking the bitter-sweet overtones of the French artist's work. In choice of subject-matter and in the financial success he achieved, Stone was close to artists such as W. F. Yeames who belonged to the St John's Wood Clique. Indeed, with his plentiful earnings Stone commissioned the architect Norman Shaw to design a large house at No. 8 Melbury Road in Kensington (1875–76), close to the houses of several other successful Victorian artists. Such houses were intended to impress clients and were suitable for entertaining on a grand scale, as well as incorporating a studio. As Stone himself said, 'One sells one's birthright.'

As here, Stone's best confections are often period pieces set in what purports to be the Regency: a young man (evidently an artist) in a cocked hat gazes earnestly in a sunlit garden at a young woman wearing an Empire dress. She has been presented with a bouquet of flowers. As if the viewer required further prompts, there is a statue of Cupid with a bow in the background and a supply of apples on the spreading branches of the tree under which the couple are seated. This is a Victorian Garden of Eden. Who will pick up the one apple that has fallen to the ground?

In Love is the kind of picture that appealed to late Victorian taste. The narrative element is to the fore and the artist is technically competent. For us today the tone is somewhat insipid, with the male figure appearing to be simple-minded and the female simpering, and the fate of such compositions is to adorn chocolate boxes or tins of biscuits or to be turned into calendars; but they deserve better than that, and in some senses they should not be taken at face value, since they can also be read as critiques of Victorian society.

HAROLD KNIGHT (1874–1961)
Ethel Bartlett c. 1930
Canvas, 198.1 × 116.8 cm / 78 × 46 in. Signed

The artist was born in Nottingham and trained at the local school of art where he met his wife, Laura, whom he married in 1903. Both Harold and Laura (later Dame Laura Knight) became members of the Royal Academy – in her case notably as the first woman to be elected since the Academy's foundation in 1768. While at Nottingham School of Art Harold Knight won a scholarship to the Académie Julian in Paris (1895). As their careers developed, the Knights together became associated with two specific locations in England: Staithes, a fishing village on the coast of Yorkshire, and Newlyn in Cornwall where they joined the well-known colony of artists first established there in the 1880s. Landscapes, seascapes and genre subjects preoccupied them in these places, but Harold Knight in particular was influenced by Dutch 17th-century art and several visits to the Netherlands caused him to paint in the manner of the artists associated with The Hague School. Unlike his more broad-minded and wide-ranging wife who became interested in depicting scenes from gypsy, circus and theatrical life, Harold Knight ended by specializing in interiors and portraiture.

Ethel Bartlett (1896–1978) was a famous pianist, who studied with Tobias Matthay at the Royal Academy of Music in London and with Artur Schnabel in Berlin. In parallel with Harold and Laura Knight she met her husband, Rae Robertson, who was also a pianist, at the Royal Academy of Music. They pursued separate careers until 1927 (Ethel Bartlett also played the harpsichord and accompanied John Barbirolli in cello recitals) when they began to play duets in concert. They revived the established repertoire for four hands, and special works were also written for them by Arnold Bax and William Walton.

A Holbein revival?

Harold Knight painted the sitter on more than one occasion. A portrait – possibly the first – of her playing the piano was exhibited at the Royal Academy in 1929. An informal portrait (his Diploma Work, accepted in 1937) dates from 1930, which in the ambiguity of its pose anticipates pictures by Lucian Freud. The present full-length is a quiet reflective work, but nonetheless imposing. The head is turned away and tilted upwards – a pose denoting inspiration. One imagines that this is how Ethel Bartlett looked when she performed: the hair in a chignon, a string of pearls looped around the collar, and a dress notable for the puffs at the shoulders with slashed sleeves. Knight's allegiance to the ordered arrangement of interiors by Vermeer and de Hooch is apparent and the contrast in the subjects of the prints on the wall behind – one secular and the other religious – may be significant. A closer comparison lies with the portrait of Christina of Denmark by Hans Holbein the Younger (London, National Gallery).

THE WEST MIDLANDS

Historically, the West Midlands was the heartland of the Industrial Revolution. Although it is not overrun with museums and art galleries, it can boast one of the outstanding collections of paintings in the British Isles. This is to be found in Birmingham Museum and Art Gallery, which has a fine group of old master paintings and a famous – almost definitive – group of pictures by the Pre-Raphaelites. The building itself and its location at the heart of the city is testament to Joseph Chamberlain's vision of how a prosperous and flourishing society founded on industrial wealth in the mid-19th century should conduct itself.

A more recent development at nearby Walsall has been the housing of the Garman-Ryan collection in a new purpose-built gallery – the New Art Gallery – designed by Peter St John and Robert Caruso which opened in 2000.

Also not far from Birmingham are Wolverhampton to the west and Coventry to the south-east. The museums in these two cities were established nearly a century apart (Wolverhampton Art Gallery in 1884 and the Herbert Art Gallery in Coventry in 1960), but both came about because of the generosity of individuals prepared to use their wealth for the benefit of their local communities.

At Stratford-upon-Avon the Royal Shakespeare Theatre Gallery addresses the subject of William Shakespeare and art.

There are two distinguished university museums in the West Midlands. The Ashmolean Museum in Oxford was founded in 1683, but had to wait until the 19th century for its varied collections to be appropriately housed. The Barber Institute of Fine Arts is situated on the campus of the University of Birmingham and opened in 1939. The high quality of the paintings, and the quietly effective way in which the collection has been added to over the years, are an inspiration and make for one of the most rewarding visits to any museum in the British Isles.

Birmingham

BIRMINGHAM MUSEUM AND ART GALLERY

The founding of Birmingham Museum and Art Gallery was part of a wider expression of civic pride initiated by Joseph Chamberlain (1836–1914), first as the city's Mayor and then as its Member of Parliament. The growth of manufacturing industries and the financial stability that followed gave Birmingham the opportunity

to establish municipal independence and new powers of self-governance. It was the vision of men such as Chamberlain and the Nonconformist preacher George Dawson (1821–76) to transform Birmingham into a city as grand as Paris, Venice or Antwerp, with an array of civic buildings that were a measure not only of its economic success but also of its determination to improve the lot of those who lived there. That spirit is still evident today in Victoria Square and Chamberlain Square, even though the architectural integrity of the original plan has been impugned in part by the incursions of modern commercial architecture and diminished by demolition. The Town Hall (1832–50, by Joseph Hansom) and the Council House (1874–79, by H. Yeoville Thomason) predate the Museum and Art Gallery. As an ensemble, which also includes the School of Art and other attendant buildings, the Clock Tower, statues and memorials, this is one of the greatest public spaces in the country.

Like many other civic galleries, that of Birmingham stuttered into existence. The first gallery opened in 1867 in the Central Library. Its popularity led to the demand for a new and larger space: the foundations of the building designed by H. Yeoville Thomason were laid in 1881 and the work completed in 1885. The chief benefactors were the brothers George and Richard (later Sir Richard) Tangye, followed by John Feeney, the son of the founder of the *Birmingham Post*, who paid for an upper floor extension in 1912. Additional galleries and a new entrance were in place by 1919. The interiors, including the great Industrial Hall, were restored in the 1980s. The neighbouring Gas Hall opened in 1993 for the purpose of showing temporary exhibitions.

The aim of founding the museum and art gallery was clear-cut. In a city famous for its manufacturing industries, it was to perform the same function as the Victoria & Albert Museum in London, linking art and design. The original main two-storeyed entrance, flanked by statues of Raphael and Michelangelo and topped by a sculptured pediment, strikes a didactic note, just as the grand staircase leads the visitor straight into the domed Round Room reminiscent of the Tribuna Gallery in the Uffizi in Florence. An inscription on a tablet reads, 'By the Gains of Industry We Promote Art'.

The collections are suitably impressive: an array of old master pictures with an emphasis on the Baroque (second only to the National Gallery); a particularly strong representation of the Pre-Raphaelites (Burne-Jones was born in Birmingham) with many well-known examples of their work, complemented by an equally wide collection of their drawings, thanks to the foresight of the first Keeper, Sir Whitworth Wallis; and a cross-section of British painting up to the present day.

Birmingham Museum and Art Gallery has been fortunate in its directors, especially, during the second half of the 20th century, Sir Trenchard Cox (1945–55), later Director of the Victoria & Albert Museum, and Dr Mary Woodall (1956–65). Such inspiring leadership made it a perfect training ground for young curators, who went on to make their own reputations in the museum world.

GIOVANNI BELLINI (c. 1430–1516) AND STUDIO
Virgin and Child Enthroned with SS. Peter and Mark and a Donor 1505
Wood, 91.4 × 81.3 cm / 36 × 32 in. Signed and dated

First recorded in Verona during the 17th century, this altarpiece had reached Britain by the beginning of the 19th century, and soon belonged to the East Anglian collector and antiquarian Dawson Turner. It was acquired for Birmingham by public subscription with additional contributions from various sources in 1977.

The composition, known as a *sacra conversazione*, is one perfected by Giovanni Bellini and his many followers in Venice at the beginning of the 16th century. On a fairly intimate scale and destined no doubt for a small (perhaps private) chapel, it was commissioned by the unknown donor kneeling on the right. The inclusion of the two saints and the donor in the same space as the Virgin and Child is a development from the more traditional hierarchical format that made a distinction between the ethereal and the real worlds.

> 'He is very old and is still the best in painting'
>
> ALBRECHT DÜRER ON GIOVANNI BELLINI, 1506

The painting is in Bellini's late style, at the time when Giorgione and Titian were working in his studio. The rich warm colours, the soft tonal modelling and the wonderful understanding of the rise and fall of drapery are characteristic, even if there is an unevenness in the handling of the figures owing to the participation of assistants. The real magic, however, comes in the blending of all the figures into a single group, set against a perfectly rendered North Italian landscape that makes you want to leave for Italy immediately.

ORAZIO GENTILESCHI (1563–1639)
The Rest on the Flight into Egypt c. 1620–22
Canvas, 175.3 × 218.4 cm / 69 × 86 in.

Few pictures make you stop in your tracks, but this is one of them. The large-scale, unusual composition and unfettered sense of humanity are overwhelming. The tenderness of the Virgin feeding the Christ Child, the exhausted state of Joseph abandoned to sleep, and the attendant donkey looking away from the scene are intensely moving. There is also a formal clarity about the composition that gives the picture an immediacy

encouraging the eye to take in the immense amount of detail that Gentileschi paints with such precision – the crumbling texture of the wall enclosing the figures, the distant sky, the tied sack, the texture of the draperies, or the braiding in the Virgin's hair.

Even though the composition does break down into different parts, geometry helps to unify them. But, more than that, it is the treatment of the light and the tonality that fuse all the elements into a poetic harmonious whole. The subdued range of colour, too, has a subtlety and restfulness that is wholly appropriate.

Gentileschi was born in Pisa, but worked in Italy (Rome and Genoa) and France (Paris) before reaching London in 1626, when he was employed at the court of Charles I (see pp. 163–64). *The Rest on the Flight into Egypt* proved to be a winner, and he produced many variants. This is the first and finest, and it shows that Gentileschi should not be too readily dismissed as second-rate.

JACOB OCHTERVELT (1634–82)
The Music Lesson c. 1671
Canvas, 97.2 × 78.1 cm / 38¼ × 30¾ in.

Ochtervelt is not a well-known painter, and so his pictures generate surprise and pleasure when you come across them. Born in Rotterdam, where he lived predominantly for the first part of his life, he is recorded in 1674 for the first time in Amsterdam, where he was to die. Although he began as a versatile painter, Ochtervelt specialized more and more during his life in genre scenes. His output marks the end of that tradition as it was known in the second half of the 17th century. Writers tend to see Ochtervelt in the light of Pieter de Hooch, Frans van Mieris the Elder and Vermeer, and sometimes regard his compositions as derivative. This is not always the case, and he in fact popularized one special type of genre, namely the theme of the entrance hall showing figures being welcomed into a house, which anticipates later aspects of domestic genre painting.

The subject of the music lesson occurs frequently (there are examples by Terborch, Metsu and Vermeer). The present composition runs true to form, with the lady of the house seated at the virginals with a tutor (or seducer) standing in the shadows listening to her playing. A knowing maid accompanies the two figures. What Ochtervelt is good at doing is uniting the triad into an elegant, almost balletic, group. Paintings of this type were often replete with sexual undertones, mainly through the use of symbolism or subsidiary business, but Ochtervelt cleans up the act. The Latin inscription on the spinet, 'Musica laborum dulce levamen' (Music is a sweet relief from labours), suggests that music has a restorative effect rather than being an invitation to any baser instincts. Even if we do not know the exact meaning of the composition, his people do know their own minds. The features of the figure seated at the keyboard – high forehead, long neck, small chin – and the opulence of her satin dress are trademarks of this surprisingly adroit artist.

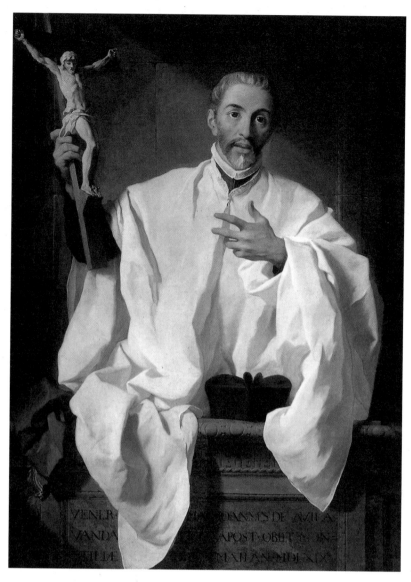

PIERRE SUBLEYRAS (1699–1749)

St John of Avila 1746

Canvas, 135.9 × 97.7 cm / 53½ × 38⅓ in.

Subleyras is a rare bird in British collections, and this portrait of St John of Avila (c. 1499–1569) is a rewarding example.

The saint, known as the 'Apostle of Andalusia', was a confidant of St Teresa of Avila. His main contribution was to the discussion on the state of the contemporary church, particularly the quality of the clergy and pastoral care (for which he fell foul of the Inquisition), conducted mainly in the form of an extensive correspondence. Attempts were made by Cardinal Annibale Albani during the first half of the 18th century to have

him canonized, and it is likely that this portrait was made to promote the cause by establishing a personal iconography. The attempt failed at the time: he was beatified in 1894 and canonized in 1970.

Subleyras painted one of the most engaging studio portraits ever, where his own work, mainly altarpieces and portraits, is shown in abundance (Vienna, Akademie der bildenden Künste). Although born in southern France and trained in Toulouse and at the Academy in Paris, he abandoned his homeland in 1728 and lived for the rest of his life in Rome, where he worked mainly for the papacy, cardinals and religious orders. His style, therefore, is an amalgam of French and Italian tendencies.

This portrait of St John of Avila manages to combine honesty with special pleading. He is shown in a marble pulpit bearing an inscription identifying the figure. The white surplice cascades over the edge. The treatment of the refined, suitably bronzed, features is convincing, with the hand skilfully positioned over the heart while at the same time indicating the crucifix that he holds. There is a gravity about the enterprise that encourages the viewer to take it seriously, while at the same time relishing the dazzling brilliance of the painting of the surplice.

Subleyras here combines the directness of Chardin in the characterization with the suavity of Mola or Sacchi in the handling of paint.

FORD MADOX BROWN (1821–93)
An English Autumn Afternoon 1852–55
Canvas, 71.2 × 134.8 cm / 28¼ × 53 in. Signed

Although never a member, Ford Madox Brown was closely associated with the Pre-Raphaelite Brotherhood, whose choice of subject-matter and style of painting stood apart from the mainstream of Victorian art. Much of his early life was spent out of Britain in Belgium and France, so he was initially open to the influence of the Continental schools. By inclination he was a history painter, but he developed an interest in social issues. By contrast, there are few landscapes in his output, but all are striking and in a more meticulous style than his normal expansive manner.

This panoramic view is taken from a back window of the artist's lodgings at No. 33 High Street, Hampstead, in north London. Across the Heath in the far distance is Highgate. The compositional format of a flattened oval evokes the view through a telescope, and this visual impression is enhanced by the amount of detail in the picture (note the still-life of the spade resting against the whitewashed wall in the middle distance on the left). Such a precise transcription of a landscape is in accordance with Pre-Raphaelite practice, but the most surprising aspect is the ordinariness of the scene. The view may be breathtaking, but Brown also chooses to emphasize its mundane features, epitomized by the rooftops and back gardens in the foreground. The foremost critic of the day,

John Ruskin, described the scene as 'such a very ugly subject' – but he was never wholly in favour of Brown's work.

Prominent at the lower edge are a young couple seen from the back. We look over their shoulders and share their view of the landscape, which the man is indicating to the young woman. Brown, however, states categorically that the figures, which he calls 'peculiarly English', are 'hardly lovers – more boy and girl, neighbours and friends'. Nonetheless, the dovecote on the right perhaps indicates the closeness of their relationship, and possibly the artist was being disingenuous, since in the course of painting this picture he married his second wife, Emma Hill. As it happens, his first wife, Elizabeth Bromley, was buried in Highgate cemetery, which lies in the distance.

Personal associations apart, the supreme quality of this painting is suggested by its detailed title. It is autumn: the residual warmth and green panoply of summer are giving way to the damper atmosphere and richer colouring of the new season. Or, in the artist's own words, 'The time is 3 p.m., when late in October the shadows already lie long, and the sun's rays (coming from behind us in this work) are preternaturally glowing, as in rivalry of the foliage.'

We share the unbounded joy that the couple find in nature and in one another's company: it seems to be a glimpse of the paradise that both are seeking. As a record of a particular landscape that was earlier admired by John Constable and John Keats, the picture contrasts strongly with Brown's *The Last of England*, painted at the same time and also in Birmingham Museum and Art Gallery.

'Season of mists and mellow fruitfulness, / Close bosom-friend of the maturing sun'

JOHN KEATS, 'TO AUTUMN', 1820

AUGUSTUS EGG (1816–63)
The Travelling Companions 1862
Canvas, 64.5 × 76.5 cm / 25⅜ × 30⅛ in. Signed

One of the greatest
railway pictures
ever painted

Egg was a gifted and popular if unimaginative Victorian artist. Trained first at Henry Sass's Academy and then at the Royal Academy Schools from 1836, he became a member of the group of artists known as The Clique, which included Frith, Elmore, Dadd, O'Neil and John Phillip. He painted numerous historical and literary (mainly Shakespearean) subjects. Many of his history paintings are fanciful and have ponderous titles – *Cromwell discovering his Chaplain, Jeremiah White, making Love to his Daughter Frances* (1842) or *Queen Elizabeth discovers she is no longer Young* (1848). Such pictures were exhibited at the Royal Academy and elsewhere and kept his name before the public.

Egg was passionate about the theatre and a friend of Dickens and Wilkie Collins, with both of whom he frequently performed in amateur theatricals. Clearly very convivial, he was elected to the Garrick Club in 1849, having been nominated by the actor-manager

Charles Kean and seconded by Dickens and Thackeray. He was also a generous supporter and collector of the Pre-Raphaelites.

Occasionally Egg painted modern subjects, and it is these pictures, such as *Past and Present* (1858, London, Tate Britain), that have more appeal today. *The Travelling Companions* is a late example and shows two identically dressed young women, evidently sisters, in a railway carriage. One reads while the other sleeps. The sense of enclosure is emphasized by the darkness of the upholstered interior and the amount of space taken up by the voluminous skirts. The sense of movement is cleverly suggested by the angle of the tassel of the blind. The picture is really a modern interpretation of an old theme – the contemplative life contrasted with the active life, or idleness versus industry.

The sunlit landscape in the background is identifiable as Menton on the French Riviera, which was popular with the Victorians as a health resort. It has personal significance for the artist, since Egg suffered badly from pulmonary illnesses and often travelled to the Mediterranean for his health. Indeed, he died of asthma in Algiers (known as the Torquay of Africa) – still a comparatively young man – and was buried there.

JOHN BYAM LISTON SHAW (1872–1919)
The Boer War 1900–1901
Canvas, 101.8 × 76 cm / 39⅜ × 29½ in. Signed and dated

Some pictures go straight to the heart, as this one does – of a lone figure dressed in mourning pondering the loss of a loved one in the Boer War (1899–1902). Although the figure has the beauty of Greek sculpture, the hand held to the face (a traditional gesture symbolizing melancholy) denotes fragility. Her grief is inspired by the quotation from Christina Rossetti's poem 'A Bird Song' (published in 1875) that accompanied the picture when it was exhibited at the Royal Academy in 1901: 'Oh last summer green things were greener, / Brambles fewer, the blue sky bluer.'

> 'This is the saddest story I have ever heard'
>
> FORD MADOX FORD, *THE GOOD SOLDIER: A TALE OF PASSION*, 1915

Privately educated, John Byam Liston Shaw attended the Royal Academy Schools in 1893. He began by painting large-scale allegorical compositions inspired by literature and then historical and modern subjects, some of them imaginatively conceived and others, such as the large fresco *Mary's Entry into London as Queen* AD 1553 for the Palace of Westminster, more predictable. The decorative quality in his art also lent itself to book illustration.

Byam Shaw was by no stretch of the imagination a modernist. He was an academic artist who tapped into the Pre-Raphaelite tradition as exemplified by Millais and Rossetti. The meticulous rendering of the setting in *The Boer War* owes a great deal to Millais. Nor was Byam Shaw a bohemian: he often appeared in a suit of loud checks, looking more like a bookie on a racecourse than an art master. His name lives on today as the founder of the Byam Shaw School of Art in London, which he opened with Rex Vicat Cole in 1910.

As it happens, my pleasure in this picture is heightened because it was painted by the father of my mentor, James Byam Shaw. A pastel by John Byam Liston Shaw entitled *My Wife, my Bairns and my Wee Dog John* (1903) is in the Ferens Art Gallery in Hull. Of the five children, James became an art historian and Glen was first an actor and then a director, notably at Stratford-upon-Avon (1952–59). Both had the appearance, good manners and eccentricities of the Edwardian gentleman.

BARBER INSTITUTE OF FINE ARTS

The Barber Institute of Fine Arts used to be one of the best-kept secrets in the British art world. The collection and the policy that established the gallery's priorities from its beginnings had quality as their touchstone. The powers of selection vested in the directors have resulted in a collection of outstanding quality equal to anything anywhere in the world and shown without fuss or undue extravagance.

Sir Henry Barber (1860–1927) was a wealthy property developer and solicitor in Birmingham. Having married in 1893 he moved away from the area, although he remained a benefactor of both the city and the university. On his death he entrusted the foundation of an institute at the University of Birmingham in his own and his wife's name to his widow, Martha Constance Hattie Barber (1869–1933), who formalized it in 1932. The building was to serve as an art gallery or museum and as a music room.

Robert Atkinson was appointed architect in 1935, and responsibility for the formation of the collection fell initially to the first Director, Thomas Bodkin (a former Director of the National Gallery of Ireland). The quality of the collection was an all-important consideration at the outset: Lady Barber stipulated that the Trustees should not accept gifts; they should not buy any works dating from after 1899; and all works acquired should be of 'that standard of quality required by the National Gallery and the Wallace Collection'. The building was opened in 1939 by Queen Mary.

Standing in the grounds of the University on the outskirts of Birmingham in the suburb of Selly Oaks, the Barber Institute is a perfectly proportioned, simply designed building. It has two storeys, the lower of Derby Dale stone and the upper of variegated brick. It is restrained and unostentatious, even demure in contrast with Sir Aston Webb's design for the main University buildings. The ground floor is devoted mainly to music and has the atmosphere of a conservatoire. The galleries are on the upper floor and aim to showcase an almost comprehensive display of the history of Western European art in all media, albeit on a modest scale. The terms of reference set down by Lady Barber certainly concentrated minds, and only one of those terms has since been changed: starting in 1967, works dating from the 20th century could be acquired – but only if they were at least thirty years old.

The Barber Institute was fortunate in its early directors, Thomas Bodkin and Ellis Waterhouse. All, however, have exercised great discernment in enlarging the collection in accordance with Lady Barber's stipulations, with the aid of grant-giving authorities and sometimes by joint purchases with other galleries.

Outside is a bronze statue of George I of 1722 by John Nost the Elder (or his workshop) and inside is a portrait of Lady Barber by J. J. Shannon. From that point onwards treasures galore await the visitor on the upper floor.

THOMAS GAINSBOROUGH (1727–88)
The Harvest Wagon c. 1767
Canvas, 120.5 × 144.7 cm / 47½ × 57 in.

What Gainsborough
loved to paint

One of Gainsborough's greatest and most effusive landscapes, *The Harvest Wagon* was painted while he was living in Bath (1759–74), where he had gone to extend his list of clients for portraiture. A quixotic and ebullient person, Gainsborough often tired of painting portraits, and as he once wrote to his friend William Jackson, he longed 'to take my Viol da Gamba and walk off to some sweet Village, where I can paint Landskips and enjoy the fag End of life in quietness and ease'. He went on to describe how he felt 'confined in Harn[ess] to follow the track, whilst others ride in the wagon, under cover, stretching their legs in the straw at Ease, and gazing at Green Trees and Blue Skies . . .' That is exactly what this composition conveys.

According to tradition, the setting is Shockerwick Park near Bath, the home of the carrier Walter Wilshire, who was known to Gainsborough. The two younger women – one riding in the cart, the other being helped aboard – are likely to have been based on the artist's own daughters, Mary and Margaret. Unusually, Gainsborough seems to have had other painters in mind as he planned this composition, although he rarely relied on other sources: it has been suggested that Antique sculpture, Raphael, Rubens (see p. 307) and Hogarth are echoed in the disposition of individual figures or the pyramidal grouping. In essence, however, the picture (thankfully) is much more than just an art-historical puzzle.

The mood of merrymaking is evident in the rumbustious treatment of the figures, who are either enjoying themselves at the end of a long day in the fields or else making their way to a special celebration. The broad sweep across the composition as the wagon is carefully manoeuvred around the pond is offset by the majestic trees and distant view beyond. Ultimately it is the facture that is so compelling: the speed and lightness of the brushwork, the high tonal colouring, and the overwhelming confidence maintained on this grand scale. It is a life-enhancing picture and quite different from the more sombre late landscapes of the 1780s that brought tears to Constable's eyes. This would have made him jump with joy.

JOHAN CHRISTIAN DAHL (1788–1857)
Mother and Child by the Sea 1840
Canvas, 21 × 31 cm / 8¼ × 12¼ in.

Moonlight held a deep-seated fascination for many German artists in the Romantic period: one thinks of the writings of Goethe and the songs of Franz Schubert. The connection in this picture is with the painter Caspar David Friedrich, one of whose most famous paintings, *Two Men Contemplating the Moon* of 1819 (Dresden), was owned by Dahl.

The two artists were close friends (also reciprocal godparents), having met when Dahl came to Dresden in 1818. He was Norwegian by birth, but he trained at the Academy in Copenhagen and after a trip to Italy in 1820–21 he settled in Germany for good. Until 1839 he lived on the upper floor of Friedrich's house in Dresden overlooking the River Elbe. Although content to exile himself from Norway, he made several visits to his homeland, which continued to be the main source of inspiration for his landscapes.

Mother and Child by the Sea was painted in the year of Friedrich's death and could even have been painted in homage to him. As painters, however, Friedrich and Dahl had different outlooks: the former was full of a Romantic yearning, melancholic and partial to religious symbolism, while the latter was much more straightforward in his literal and exact transcription of Dresden and its surrounding landscape.

The present composition has the air of a set-piece, as opposed to Dahl's studies of moonlight, which are comparable with Constable's cloud studies. A woman and child

The essence of Romanticism

stand looking out to sea at a boat approaching the shore. The child points expectantly, which suggests that his father is on board. It is a calm, peaceful night with the moon half hidden by clouds, but still strong enough to make the sea phosphorescent. Dahl's father was a fisherman and so he could well have experienced this custom himself on numerous occasions.

EDGAR DEGAS (1834–1917)
Jockeys before the Race c. 1879
Paper, 107 × 73 cm / 42¼ × 28¾ in.

'Degas' racecourse
pictures are
valueless for the
historian of the turf'

RONALD PICKVANCE, 1979

The racecourse was one of Degas's principal subjects in his depiction of modern life. As with the ballet and the *café-concert*, he persevered with it throughout his career, producing several paintings, pastels, drawings and sculptures. He was concerned less with the social scene or special events in the racing calendar than with the predicament of the jockeys, particularly at those tense moments before the start of a race. It is typical of Degas that he enjoyed the psychological import of such situations, which he found so revealing and which at the same time challenged him as an artist. At the centre of Degas's art there is always a paradox: a conventional subject is given a fresh interpretation in which the

spontaneity of the image is belied by the artifice of the creative process. 'I assure you,' he said, 'no art was ever less spontaneous than mine.'

Jockeys before the Race was shown at the fourth Impressionist exhibition in 1879. The imposing composition was derived from material in the artist's studio, rearranged to suit his purpose. 'A picture is something that requires as much trickery, malice and vice as the perpetration of a crime, so create falsity and add a touch from nature . . .' Many aspects are disturbing – the starting pole so brutally bisecting the scene and coming between the viewer and the main rider, the wide open space on the left, and the misty atmosphere through which the disc of the sun can be seen. One contemporary critic referred to the 'demi-lumière' or half-light effect, which also applies to the bleached colouring.

Just as Degas was unorthodox in his approach to subject-matter by confronting the world usually from an oblique angle, so too was he experimental in his technique. This large work was made on paper using oil and *essence* (diluted oil, much favoured by Degas) in combination with pastel and gouache. The various media are thinly and freely applied, adding to the ethereal feeling as the jockeys wait nervously for the off.

Oxford

ASHMOLEAN MUSEUM

The founder of the museum was Elias Ashmole (1617–92), whose collection was donated to Oxford University and opened to the public by the future James II in 1683. The original building is now the Museum of the History of Science. The Ashmolean Museum can claim to be the first institutional museum in Britain.

Ashmole was an astrologer, alchemist, antiquarian, courtier and collector – principally of coins, medals, manuscripts and books – and in 1659 he had been given the collection known as the 'Closet of Rareties' formed by John Tradescant and his son of the same name, who had been employed as royal gardeners at the Stuart court. The amalgamation at Oxford of the two collections amounted to a 'Cabinet of Curiosities' assembled in the first place as a result of extensive travel and an incurable desire to discover more about the natural world, followed by a process of classification. Perhaps today it is not so much the famous dodo that attracts attention as Powhatan's mantle.

The modern Ashmolean Museum is housed in an imposing building designed by Charles Robert Cockerell and completed in 1845. The architect used the Temple of Apollo at Bassae in Greece which he had personally examined in 1811 as the basis of his inspiration, but he was given a strange assignment in that the structure was to include not just a museum but also an institute for the teaching of modern languages (the Taylorian Institution). Today only the outer skin of Cockerell's building and a few parts of its interior, such as the entrance, sculpture gallery and main staircase, remain intact following the audacious and imaginative reconfiguration by Rick Mather and Associates to create a whole array of new gallery spaces (opened in 2009).

By the mid-19th century the objects in the 'Cabinet of Curiosities' had been greatly augmented and the collections consolidated, so that the new Ashmolean Museum began to assume the form of a modern museum, with several departments.

For twenty years (1968–88) I was employed in the Department of Western Art here. Whenever I became envious of the elegant galleries at the Fitzwilliam Museum in Cambridge I reminded myself that the strengths of the Ashmolean lay in the Print Room, with the outstanding series of drawings by Raphael and Michelangelo once owned by Sir Thomas Lawrence, and other wonderful examples by major artists.

By contrast, the collection of paintings was developed more hesitantly through a number of bequests and gifts, as well as by an acquisitions policy subject to considerable financial restrictions. Many of the galleries had comparatively low ceilings, so there are only a few large pictures. On the whole, the Ashmolean Museum's collection of paintings is on a reduced, intimate scale – so much so that Ellis Waterhouse characterized a particular type of painting as an 'Ashmolean picture'.

The collection has an important group of early Italian pictures assembled at the beginning of the 19th century by the Hon. W. T. H. Fox-Strangways, later 4th Earl of Ilchester (1795–1865), an extensive range of still-life paintings bequeathed by Daisy Linda Ward in 1939, outstanding examples by the Pre-Raphaelites, a distinguished representation of works by Camille Pissarro, and a strong group of works by members of the Camden Town Group, particularly Sickert and Bevan.

Of the early Italian paintings the two most popular are *The Hunt in the Forest* by Paolo Uccello (given by Fox-Strangways in 1850) and *The Forest Fire* by Piero di Cosimo (presented by the National Art Collections Fund in 1933 during the Keepership of Kenneth Clark).

PAOLO UCCELLO (*c.* 1396/97–1475)
The Hunt in the Forest *c.* 1465
Wood, 73.5 × 177 cm / 29 × 69⅝ in.

The Hunt in the Forest is a late – possibly the last – work by the Florentine artist Paolo Uccello. He was famed as one of the earliest exponents of mathematical perspective, as devised by Filippo Brunelleschi and recorded by Leon Battista Alberti in his treatise *De Pictura* (1435) for the purposes of creating an effect of heightened pictorial realism. According to the 16th-century artist and biographer Giorgio Vasari, Uccello specialized in painting animals ('uccello' is a sobriquet which in Italian means 'bird') and was so addicted to perspective that he studied it all night, much to the chagrin of his wife, who often had to remind him to come to bed.

An exercise in perspective

Uccello was trained in the workshop of the sculptor Lorenzo Ghiberti, who designed and executed two sets of doors for the Florentine Baptistery at the beginning of the 15th century. Apart from working for many years in Florence, he was also employed in Venice in 1425–30 as a mosaicist in S. Marco and later (1465–68) in Urbino. His most famous works include the frescoes in the Chiostro Verde of S. Maria Novella in Florence, the image – also in fresco – of the *condottiere* Sir John Hawkwood in the Duomo there, and the three battle scenes of *The Rout of San Romano* commissioned by Cosimo de' Medici for the Palazzo Medici and now divided between London (National Gallery), Paris (Louvre) and Florence (Uffizi).

The Hunt in the Forest amounts to a 'modern' treatment of a traditional subject frequently found in illustrated manuscripts and tapestries. Of the greatest interest is that Uccello has carefully concealed his use of any system of mathematical perspective by the excitement of the scene and the bright colours. Only slowly does it

dawn on the viewer that the four trees in the foreground divide up the picture space into equal parts or that the logs in the undergrowth serve as the orthogonals leading the eye to the central vanishing point.

Sir John Pope-Hennessy described this picture as 'one of the most unaffectedly romantic paintings of the quattrocento'. The ancient dark verdant forest is suddenly shattered by the noise of hunting cries, barking dogs and leaping horses. Above the green foliage of the trees in the blue sky is a crescent moon (the symbol as it happens of Diana, the goddess of hunting), a stream is on the right and a pond with bulrushes in the foreground. Stags flee into the depths of the forest pursued by a cavalcade of hunters and stalkers in full cry.

The poetry of the picture comes from this contrast between the impenetrable silence of the forest and the passing momentary clatter of the hunt. The excitement is palpable, but most memorable is the drawing of the open-mouthed men with heads thrown back and the lithe hunting dogs, many of them seen in sharp profile. There is enough conviction in the drawing and the amount of detail in the harnesses and collars of the dogs to forestall the criticism that the men on horseback resemble a fairground carousel. Or, as Kenneth Clark put it, the 'young Florentines' are as 'vital and elastic as the figures on a Greek vase'.

The Hunt in the Forest captures the imagination and its impact is comparable with seeing a film in 3D.

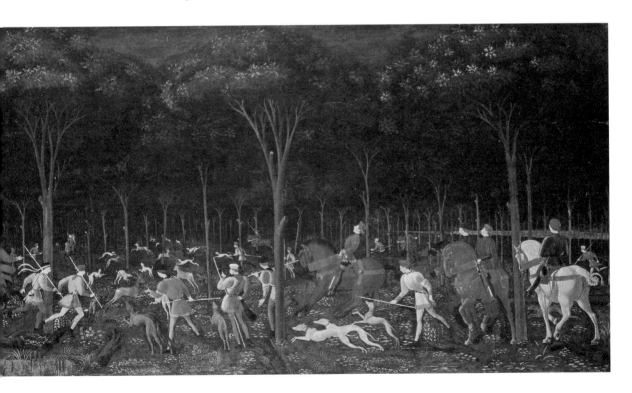

PHILIPS KONINCK (1619–88)
A View over Flat Country 1660
Canvas, 118 × 166 cm / 46½ × 65⅜ in.

Koninck is a refreshingly uncomplicated painter. He was a friend and business colleague
of Rembrandt's, but not a pupil, even though the pen work of his drawings reveals a pro-
nounced influence. Contemporary evidence indicates that he was proficient in all the
major categories of 17th-century Dutch painting, but it is for his large-scale landscapes,
painted between 1650 and 1665, that he is most appreciated today. The scale of some of
these canvases anticipates Constable's 'six-footers', and they are undoubtedly his finest
works. Although he lacked the variety or intuition of Jacob van Ruisdael, Koninck's
pictures are one of the great moments in Dutch landscape art.

Rembrandt himself painted very few landscapes, and his considerable skill in this
department is best evaluated in his drawings and prints. These were inspired by Hercules
Seghers, whose work is full of atmosphere and poetic drama. Koninck, too, may have
taken Seghers as the starting point for his panoramas. For these the artist chooses a high

viewpoint – not so much a bird's-eye viewpoint as one from the top of a building such as a church tower. The horizon is usually placed in the middle of the canvas, or just below, with the sky towering above full of scudding clouds. It is unlikely that the views are imaginary, but they do lack any specifically identifiable features. It has been stated that they are set in Gelderland, one of the more eastern of the United Provinces, bordering Germany.

For me the unalloyed pleasure of Koninck's pictures lies in seeking out the activity within the landscape, as here: people walking or on horseback, a coach party, two men talking in a doorway, and others in a boat. All this is in the foreground, but then there is the overall vista across the extensive countryside, full of subtle gradations and tonal nuances. It is a scene worthy of William Wordsworth in its pantheistic urge. You can almost feel the moisture in the air or the strength of the breeze on your face, just as you can almost hear the gurgling sounds of the countryside.

A satisfying element of Koninck's art is the variety of the brushstrokes, with many raised areas of paint, which makes the surface so tactile that it is not difficult to imagine the artist dabbing away at the canvas. The effect is somewhat monochromatic, but on closer inspection there is a lot of colour.

Only paintings by artists of the Barbizon School in France during the mid-19th century – Rousseau, Diaz, Daubigny, Millet – can match Koninck in his exuberance for the countryside.

WILLIAM HOLMAN HUNT (1827–1910)
A Converted British Family Sheltering a Christian Missionary from the Persecution of the Druids 1850
Canvas, 111 × 139 cm / 43¾ × 54¾ in. Signed and dated

An artist of conviction

The Pre-Raphaelite Brotherhood was formed in 1848 and the present picture was one of its first public manifestations. When it was shown at the Royal Academy in 1850 together with *Christ in the Carpenter's Shop* by John Everett Millais (London, Tate Britain) both pictures met with hostile criticism on account of their subject-matter and technique. For the Pre-Raphaelites clear distinct drawing and bright colouring, both enhanced by white priming, accorded well with the practice of early Italian, German and Netherlandish art, and was particularly suitable for subjects with religious overtones.

Of all those affiliated to the Pre-Raphaelite Brotherhood it was Hunt who remained most loyal to their ideals. His seriousness of intent is apparent in the preparation and execution of his paintings, which included four visits to the Holy Land in order to ratify the accuracy of those compositions inspired by the Bible. Such seriousness, however, ran counter to his personality, which was light-hearted and exuberant: he was a skilful raconteur, and much loved by children – possibly also because of his long beard.

A Converted British Family was Hunt's first major work on a religious theme. The subject had a certain historical validity as regards the acceptance of Christianity in Britain, but Hunt clearly intended his painting to be topical. The main part of the composition shows a wounded Christian missionary being sheltered by a converted British family, while in the background one of his colleagues is being expelled from the Druids' shrine. As with many early Pre-Raphaelite paintings, this picture has a home-grown feel to it as well as being very earnest. Hunt researched every aspect with the greatest care and used his friends as models, including Elizabeth Siddal for the young girl about to bathe the missionary's wounds – her first appearance as a muse in a Pre-Raphaelite painting before her marriage to Dante Gabriel Rossetti.

Hunt employed different levels of symbolism throughout, extending from Biblical quotations on the frame (the earliest example of a fully-fledged Pre-Raphaelite frame) to the compositional references to Christ's Passion (sponge, thorn, vine) and early Christianity (baptismal bowl and fishing nets). The pose of the missionary is that of Christ in a Deposition scene, and the red of his robes indicates martyrdom. The quotations on the frame referring to persecution and mercy respectively underscore Hunt's

purpose, which was to focus on the traditional tenets of Christianity at a time of growing concern about the role of the Anglican Church in British society, culminating in the Oxford Movement, which aimed to restore the High Church ideals of the 17th century.

Significantly, the picture's first owner was Thomas Combe, who was Printer to the University of Oxford, and together with his wife Martha a keen supporter from the start of the Pre-Raphaelites, especially the young Millais, and of the Oxford Movement. Their collection included a number of key works which Martha Combe subsequently bequeathed to the University in 1893 – the single exception being *The Light of the World*, which she gave to Keble College.

CAMILLE PISSARRO (1830–1903)
'View from my window in grey weather: Eragny-sur-Epte' 1886–88
Canvas, 65 × 81 cm / 25⅝ × 31⅞ in. Signed and dated

'Whoever is in a
hurry will not stop
for me'

CAMILLE PISSARRO
IN A LETTER TO HIS
ELDEST SON, LUCIEN,
20 NOVEMBER 1883

One of the more important donations to the Ashmolean Museum was made by Esther Pissarro in 1950 two years before her death. As the wife of Lucien Pissarro, the eldest son of the artist Camille Pissarro and an artist in his own right, she had inherited a collection of paintings, drawings, prints and archive material (notably the letters exchanged between father and son) of the utmost significance for the study of Impressionist and Post-Impressionist art in France. Lucien Pissarro married Esther Bensusan in 1892 and they lived in England thereafter.

This painting was exhibited in the eighth and last Impressionist exhibition, held in 1886. It appears from a letter written by the artist to his son on 30 July 1886 that the picture did not find favour with his dealer Paul Durand-Ruel: 'My grey weather does not please him . . . What kills art in France is that they only appreciate works that are easy to sell. It appears that the subject is unpopular. They object to the red roof and the farmyard – just what gave character to the painting which has the stamp of a modern primitive. . . .' Possibly prompted by these objections, Pissarro continued to work on the painting during the course of the next two years and then re-signed it with 1888 as the date of completion.

Camille Pissarro is always regarded as the stalwart of Impressionism, having been the only artist to have contributed to all eight of the Impressionist exhibitions, but he was a much more experimental artist than this implies. From the start he aimed to find an appropriate style for the most direct expression of those visual sensations that he experienced before nature. This process began with the broken brushstrokes and pure colour associated with the birth of Impressionism at the beginning of the 1870s, but Pissarro was never satisfied with the adoption of a single technique, and was open to new ideas. In the late 1870s and early 1880s, when he was becoming more interested again in figure painting, he felt that the surfaces of his canvases were tending to be overworked and visually

confusing. This concern coincided with the emergence of a new style of painting developed by younger artists such as Georges Seurat and Paul Signac, who advocated the application of paint in single dots (Divisionism) and the use of complementary colours – a style known as Neo-Impressionism.

'View from my window' is painted in the labour-intensive Neo-Impressionist style, which however did restore clarity to Pissarro's compositions. He championed the younger painters, contributed to their ideas on technical issues, and encouraged future artists to follow their example. Pissarro himself worked in this meticulous manner for the best part of five years (1885–90), thus aligning himself once again with the avant-garde. Later, during the 1890s, his highly developed technique allowed him to paint both urban and rural subjects of great complexity.

The view is from the artist's house in the small village of Eragny-sur-Epte in Normandy, north of Gisors, which was the family home from 1884. The church spire of the neighbouring village of Bazincourt is seen in the distance across the meadows. The tall building on the left became Pissarro's studio. The subject of the painting is shockingly – even provocatively – mundane, but that, combined with the technique, amounts in Pissarro's case to a political statement – as is suggested in his own description of this painting as a 'modern primitive'. Even though in the end Pissarro found that the Divisionist technique cramped his style, he achieved very beautiful passages in his Neo-Impressionist paintings, as here in the sweep across the orchard towards the meadows and trees beyond. Pissarro's soundness of judgment in art was paralleled by a sureness of touch that never abandoned him.

SIR LAWRENCE GOWING (1918–91)

Lady with Book 1941–42

Canvas, 92 × 120 cm / 36¼ × 47¼ in.

Lawrence Gowing was a hugely influential figure in the art world, particularly during the second half of the 20th century. Trained as a painter by William Coldstream, the founder of the Euston Road School, Gowing combined the talents of artist, writer, teacher, curator and exhibition organizer. The artists he championed extended from Hogarth through Thomas Jones and Turner to Cézanne and Matisse. Among his younger contemporaries he knew and admired Francis Bacon and Lucian Freud.

Gowing's influence was felt not just on the basis of his publications or the exhibitions he organized but also through his teaching and television series, in spite of a pronounced and unusually expectorative stutter. His enthusiasm captivated the young.

My experience of Gowing was limited to the hanging of the Camille Pissarro exhibition at the Hayward Gallery in 1980. Much to everyone's surprise, David Sylvester, another heavyweight in the modern art world, decided to come along too and there was some trepidation as to whether they might have different solutions to the hang. All was well, and squeezed between these two major authorities I witnessed the two best sets of 'eyes' in London arranging the pictures wall by wall with my opinion counting for very little.

The sitter in this portrait is Julia Strachey (1901–79), the artist's first wife, whom he married in 1952. She was seventeen years older and had previously been married to the sculptor Stephen Tonks, who had died in 1937. Her father, Oliver, had a varied career, eventually gaining a reputation as a code breaker. Julia was born in India and then virtually abandoned by her family and sent home to London to be looked after by her extended family, namely members of the Bloomsbury Group. She devoted her life to writing, but only published two novels (*Cheerful Weather for the Wedding* in 1932 and *The Man on the Pier* in 1951). Her great friend Frances Partridge published a memoir of her in 1983, *Julia*, which lovingly recounts the sad decline of a gifted but lonely, troubled and demanding figure, who never really came to terms with her upbringing.

The portrait was painted at Chilton Foliat in Wiltshire, with the sitter reading *The Art of Fiction* by Percy Lubbock. The style epitomizes work by members of the Euston Road School, based on careful observation, precise plotting on the canvas, sensitive brushwork, subtle tonal nuances and restrained colour. There is, I think, a link between the way Gowing painted and the way he looked at art and wrote about it. His analysis of Vermeer (1952), for example, is an exploration undertaken by a fellow artist, and therefore full of deeply considered insights .

CHRIST CHURCH PICTURE GALLERY

The considerable collection at Christ Church originated with the bequest made by General John Guise to the college in 1765, which included some 150 paintings and 2,000 drawings, predominantly by Italian artists. This was followed by the notable gifts of 36 early Italian paintings made by the Hon. W. T. H. Fox-Strangways in 1828 and 1834, and by the gift of 26 more pictures of the same period and school from the collection of the writer and poet Walter Savage Landor. My own interest in early Italian painting was inspired by the paintings presented by Fox-Strangways to Christ Church and later to the Ashmolean Museum. This led me to research into the life of Fox-Strangways himself, and to compare him with other collectors in the first half of the 19th century with a similar interest in the 'primitives'. Both Fox-Strangways and Landor were pioneer collectors, making their purchases in Italy. Other small bequests came from the diplomat Sir Richard Nosworthy in 1966 and the historian A. L. Rowse in 1997. Only very few of the pictures in the gallery came from other sources, notably *The Continence of Scipio* by Van Dyck, presented by Lord Frederick Campbell in 1809.

From the start the college had nowhere to display the collection and it was not until 1968 that a purpose-built gallery was designed, by Powell and Moya. The picture gallery has its entrance on Canterbury Quad and is partially subterranean, under the Dean's garden ('I like buildings you can't see', Philip Powell once remarked). It was paid for by Sir Charles (later Lord) Forte, and the Queen as Visitor of the college performed the opening ceremony. Having a flat roof, the gallery leaked from the start.

The first Curator of Pictures was one of my former tutors, Dr Daniel Bueno de Mesquita, an authority on Renaissance Milan. I was the first Assistant Curator, helping James Byam Shaw with the completion of his catalogue of *Paintings by Old Masters at Christ Church, Oxford* (1967) and assisting him at the start of his longer project, *Drawings by Old Masters at Christ Church, Oxford* (1976). During my year there I helped to hang the picture gallery and to fit out the print room, meeting many of the leading authorities on old master drawings as they came to assess the collection.

ATTRIBUTED TO PIERO DELLA FRANCESCA (active 1439–92)
Virgin and Child and Three Angels c. 1475
Wood, 88 × 58.2 cm / 34⅝ × 22⅞ in.

Tempting though it is at Christ Church to dwell upon the technical perfection of the fragmentary *Four Musical Angels at the Foot of a Throne* (Florentine School, c. 1340–50, now attributed to Bernardo Daddi), or to dilate upon the beauties of the two sets of *Sibyls* so close in style to Botticelli, my selection of an early picture is slightly more orthodox.

Although quite damaged, particularly along the right edge in the upper half, and although not recently conserved, this panel has a striking presence.

The monumentality of the composition, the severity of the Virgin and the dignity of the angels arrest the viewer's attention. Understandably, a connection with Piero della Francesca was favoured by earlier writers, even though for some the overall impression does not in the final analysis quite measure up to his standards. Similarly, at one time an attribution to Luca Signorelli, who was said by Vasari to have been greatly influenced by Piero at the outset of his career, was advanced, but has not won universal agreement. Essentially, however, the resolution of such art-historical issues is not really the point. The painting has a sense of majesty while retaining an air of innocence. As such, it serves as an admirable example of why collectors like the Hon. W. T. H. Fox-Strangways came to appreciate early Italian painting. Furthermore, I believe that we today are not wholly impervious to the magic that so enthralled him at the beginning of the 19th century.

ANNIBALE CARRACCI (1560–1609)
The Butcher's Shop c. 1583
Canvas, 190 × 271 cm / 74⅜ × 106⅝ in.

This large painting is a pivotal work in the history of 17th-century Italian art on account of its innovative style and subject. The artist was from Bologna and began as a pupil of his cousin Ludovico Carracci, being much influenced at the start by the work of Correggio in Parma and Venetian artists of the High Renaissance – Titian, Tintoretto and Veronese. Working in partnership during the 1580s and early 1590s with Ludovico and his own elder brother, Agostino, Annibale Carracci established a flourishing studio in Bologna out of which grew an academy.

Summoned to Rome in 1595 – some dozen years after *The Butcher's Shop* was painted – by Cardinal Odoardo Farnese, Annibale Carracci was instrumental in formulating a revised classical style amalgamating what he had absorbed from North Italian sources with the influence of what he saw by Raphael and Michelangelo in Rome. The extensive fresco decoration in the Palazzo Farnese was the outstanding demonstration of this new style, which proved to be deeply influential. It was the climax of the artist's career.

Annibale Carracci's highly individual and distinctive approach to painting was apparent from an early date, as is made clear in the degree of realism and sheer scale of *The Butcher's Shop*. The subject was not in itself unknown in North Italian art (both Bartolommeo Passerotti and Vincenzo Campi had attempted it) and there are also precedents in Netherlandish art (Pieter Aertsen and Joachim Beuckelaer), but Carracci concentrates on the occupational details of a butcher's shop in an almost documentary way. In this respect the picture can be tied in closely with the various engravings based

'No painter has shown more clearly the common foundations, in Mediterranean culture, of Christianity and paganism'

KENNETH CLARK, *PIERO DELLA FRANCESCA*, 1951

'A butcher in his shambles selling meat to a Swiss' – or three Bolognese artists in disguise?

on his drawings of local trades, published at a later date (*Le arti di Bologna*, 1646), but it is nonetheless an innovative painting.

If some knowledge of religious compositions by Michelangelo and Raphael is admitted – the Sacrifice of Noah in the Sistine Chapel and the Vatican Logge respectively, known to Annibale Carracci at this early stage of his life presumably through engravings – the context of a scene from everyday life only heightens the originality of the artist's conception.

An old tradition holds that the principal figures at work in the shop are portraits of the Carracci themselves. Individual identifications are disputed, but it is interesting to note that Ludovico was the son of a butcher.

The painting was recorded in the Gonzaga collection in Mantua, from which it was acquired in 1628/29 by Charles I. When it was seen late in that century by the diarist John Evelyn he aptly described it as 'A butcher in his shambles selling meat to a Swiss'.

Wolverhampton

WOLVERHAMPTON MUSEUM AND ART GALLERY

Wolverhampton Museum and Art Gallery has grown by fits and starts. Set in motion by exhibitions of art and industry held at the Mechanics' Institute in 1839 and 1869, the building was financed by local councillors on the initiative of Philip Horsman and opened in 1884. The design by Julius Chatwin in an Italianate style included a portico supported by six pink granite columns and relief sculptures representing the fine arts, architecture and astronomy that sent out a particular message.

The collection of paintings is varied, as a result of a well-intentioned but hardly auspicious start: both Horsman (1886) and Sidney Cartwright (1887) bequeathed copious numbers of works by artists associated with the Cranbrook Colony, whose principal subjects were anodyne scenes of rural life easily dismissed as merely sentimental. More substantial Victorian paintings and early 20th-century British pictures were then added, but it was not until after the Second World War that works by 18th-century British artists were acquired. Another change of direction occurred in the late 1960s when attention was paid to the more modern elements of 20th-century British painting, swiftly followed under the directorship of David Rodgers by the acquisitions of British and American Pop Art for which the gallery is now famed. The emphasis on contemporary art remains a feature of the collecting policy. Old masters are in abeyance.

JOSEPH HIGHMORE (1692–1780)
The Family of Sir Lancelot Lee 1736
Canvas, 237.5 × 298 cm / 93½ × 113¼ in. Signed and dated

Joseph Highmore epitomizes the more refined aspects of life in the early 18th century. He was trained as a lawyer, his friends tended to be literary figures rather than artists, and he seems to have led an unblemished life. His reward was longevity. He retired from painting in 1761 and published books or articles on such matters as philosophy, religion, and occasionally art. His wife, Susanna, whom he outlived, also had literary inclinations.

Highmore's equanimity is expressed in his self-portrait of *c.* 1725 and a portrait of his daughter Susanna of *c.* 1740 (both Melbourne, National Gallery of Victoria) and the convivial *Mr Oldham and his Guests c.* 1735–45 (London, Tate Britain), which is one of the most innovative works of its time, although of course wonderfully understated. The mood is far removed from the rough and tumble – or indeed wit – of Hogarth, whose taste was for the novels of Henry Fielding, whereas Highmore inhabited the world of Samuel Richardson. Indeed, not only was he a friend of Richardson, but he also produced a set of twelve painted illustrations of the novel *Pamela* (1740–41) which were successfully engraved.

British Rococo
portraiture
at its best

Highmore had no formal apprenticeship as a painter, but for many years he attended Sir Godfrey Kneller's Academy, and his early style is derived from Kneller in its breadth and ebullience. Having given up the law by 1715, in 1716 Highmore established himself as a portrait painter and thereafter thrived. He did not employ assistants: 'I do everything myself, which I believe is not true of one painter in England besides', he wrote in 1741. Visits to Holland and Germany in 1732 and Paris in 1734 made him aware of developments on the Continent. Of earlier artists Highmore had a particular interest in Rubens.

The Family of Sir Lancelot Lee is Rococo portraiture at its best. The family came from Coton Hall, Bridgnorth, in Shropshire. Sir Lancelot himself was dead, and is represented by the oval portrait on the wall behind, half obscured by a curtain as though spying on the proceedings. His widow is seated with her ten children disposed around her; a daughter who died in infancy is overhead on the right in the sky, content to be a cherub. The composition is a conversation piece on a large scale. Within the general family likeness, Highmore creates a magnificent gallery of individual poses and characterizations. The shimmering cascade of voluminous draperies adds to the pleasure of meeting this family. Benign and beguiling, such a portrait goes right to the heart of the 18th century.

EAST ANGLIA

E ast Anglia is an addiction. I know because for several years I have lived in Suffolk and grown passionate about the endangered coastline, the towering skies, the low horizons, the reflected light and the freezing winds. This extensive area of flat rural land is punctuated by churches of such proportions that they look, from a distance, like mini-cathedrals dominating the skyline – a lasting testimony to the former wealth of the region, based on wool and milling.

It is a part of the country that keeps itself somewhat separate, almost to the point of secrecy, and it looks outwards rather than inwards, to Scandinavia, Germany and the Netherlands; it is strange to think that from the north coast of Norfolk there is clear water all the way to the Arctic. The beach at Aldeburgh inspired the poet George Crabbe and more recently the composer Benjamin Britten, just as the coastal village of Walberswick within striking distance of Southwold attracted artists of the calibre of Charles Keene, P. Wilson Steer and Charles Rennie Mackintosh.

Symptomatic of East Anglia's independence is the fact that during the 19th century the Norwich School of artists (John Crome, John Sell Cotman, Joseph Stannard, Henry Bright) was the first nominated 'school' as such in Britain, with its own teaching facilities, exhibitions and local patrons, whose names still have a local resonance – Gurney, Turner, Colman. In fact, the Norwich School had been preceded in the 17th century by a group of artists centred on Bury St Edmunds – the portrait painters Charles and Mary Beale, whose work is displayed in Moyes's Hall in that town, the amateur Nathaniel Bacon, and the miniaturists Nathaniel Thatch and Matthew Snelling. And the tradition of independence continues to the present day, with Norwich School of Art and Design remaining a major force in the land.

There is a marked sense of tradition about East Anglia, based on an appreciation of rural crafts and skills which has been best recorded in the writings of Adrian Bell, Julian Tennyson, Ronald Blythe and Roger Deakin. In the visual arts it was John Nash and Edward Bawden, living on the Essex/Suffolk border – the first at Wormingford and the second at Great Bardfield – who gave expression to this awareness of tradition, which extends back to Gainsborough and Constable.

The quality of the museums and galleries in this area of England is high. The Fitzwilliam Museum at Cambridge has one of the premier collections of pictures in the country and is remarkably comprehensive. Norwich Castle Museum has many interesting paintings over and above its strong holding of the Norwich School. Both museums collect contemporary art, but Kettle's Yard at Cambridge and the Sainsbury Centre for the Visual Arts at the University of East Anglia, outside Norwich, celebrate the spirit of modernity more wholeheartedly, although in two totally different ways.

At Ipswich, the combined holdings of Christchurch Mansion and Wolsey Art Gallery, set in a surprisingly beautiful municipal park, honour both Gainsborough and Constable, but also have some surprises. Equally, Gainsborough's House at Sudbury and the Sir Alfred Munnings Art Museum at Castle House, Dedham, have very personal collections, which I find moving. Munnings was an arch-conservative and I derive a certain mischievous pleasure from the fact that Lucian Freud studied at the East Anglian School of Painting and Drawing at Dedham. Actually, I have a sneaking suspicion that if they had ever met they might well have enjoyed each other's company.

Cambridge

FITZWILLIAM MUSEUM

The Fitzwilliam Museum has one of the most imposing and opulent entrances of any museum in Europe. A flight of steps leads to a massive Corinthian portico beneath a tympanum enshrining the nine Muses. On reaching the entrance hall the visitor is greeted by a spectacular display of polychrome decoration incorporating marbles, mosaics and paintwork. Two flights of steps lead to a landing with elaborate entrances to the galleries, a parade of busts on pedestals, and an array of classicizing sculpture in niches above. The climax is reached in the elaborate ceiling dominated by the dome. You could easily be in Vienna, Dresden or Berlin.

The original architect of the museum was George Basevi, a pupil of Sir John Soane, but following his sudden death in 1845 after a fall in Ely Cathedral he was succeeded by C. R. Cockerell and then by E. M. Barry, who completed the entrance hall. The foundation stone had been laid in 1837 and the public were admitted from 1848. New galleries were created as the collections expanded during the 1920s and 1930s. Modern extensions were designed by David Roberts in 1966 and 1975, culminating in the successful light-filled Courtyard Development by John Miller and Partners in 2004.

The museum is named after its founder and benefactor – Richard, 7th Viscount Fitzwilliam (1745–1816) – whose interests extended beyond the visual arts to the world of music. The founder's collection of old masters has been supplemented over the years by numerous gifts and bequests that are wholly characteristic of a major university museum, although here the quality of the Italian, Dutch, Flemish, French and British pictures is satisfyingly even.

As part of the University of Cambridge with a commitment to teaching, the Fitzwilliam Museum has been fortunate in its directors, from Sir Sidney Colvin onward.

DOMENICO VENEZIANO (*c.* 1410–61)
The Annunciation *c.* 1445–47
Panel, 27.3 × 54 cm / 10¾ × 21¼ in.

Although I am an ardent admirer of all Italian Renaissance painting, Domenico Veneziano stands out as one of my particular favourites. His output lacks consistency, but this is probably because of a number of losses, and some of what remains is of the greatest beauty. Like no other painter of his generation, working in the mid-15th century, he represents in its purest form the culmination of the early Renaissance in Florence.

When in 1972–73 I was a Fellow at the Harvard Center of Renaissance Studies at Villa I Tatti (the former home of Bernard Berenson) just outside Florence, tea was always taken in winter in a room where an early *Virgin and Child* by Domenico Veneziano was hung. For me that is still the greatest picture of its kind painted in Italy during the early Renaissance. Suitably, the room was once Berenson's study.

The panel in Cambridge is from the altarpiece painted in the mid-1440s for the church of S. Lucia de' Magnoli in Florence (now in the Uffizi Gallery). The main section of the altarpiece shows the Virgin and Child flanked on the left by SS. Francis and John the Baptist and on the right by SS. Zenobius and Lucy. Below this main section were placed in the predella scenes from the lives of each of the figures depicted above. These became separated from the altarpiece at the beginning of the 19th century and are now in various museums. In addition to the *Annunciation*, the Fitzwilliam also has *A Miracle of S. Zenobius.*

Domenico Veneziano's St Lucy altarpiece is one of the most important painted in Italy during the early Renaissance. The figures are shown grouped together occupying the same carefully articulated architectural space, forming a *sacra conversazione* as opposed to the more traditional hierarchical altarpiece where the figures are separated by the framework. The close-knit relationship between the figures and the architecture is dependent upon the newly developed system of perspective devised by Filippo Brunelleschi and set down by Leon Battista Alberti, of which other artists such as Masaccio, Donatello, Fra Angelico, Paolo Uccello (see pp. 270–71) and Filippo Lippi were also aware. As such, Domenico Veneziano's St Lucy altarpiece was in the vanguard of Renaissance art.

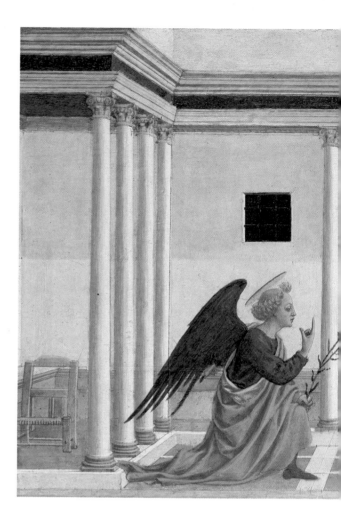

'I have hope in God to be able to show you marvellous things'

DOMENICO VENEZIANO
IN A LETTER TO
PIERO DE' MEDICI, 1438

The *Annunciation* was the largest panel of the predella, positioned centrally immediately below the Virgin and Child, and therefore a focal point – visually and theologically – of the altarpiece. (Allowance must be made for the fact that the panel has been cut down by some 6 cm / 2½ in. on the left.) The precision in laying out the architecture and establishing the vanishing point of the perspectival system can be seen in the use made of incised lines, visible to the naked eye. Besides the geometry, the outstanding feature of the composition – and indeed of the whole altarpiece – is the treatment of the light and the bright colouring. The figures of the Angel Gabriel and the Virgin are both seen in sharp profile, and are wonderfully well preserved. The positioning of the figures so far apart is supremely eloquent.

The sense of space is equally poetic, and brings to mind the fact that Piero della Francesca was once Domenico Veneziano's assistant. An archway leads to the *hortus conclusus*, the enclosed garden, representing the Virgin's purity. Beyond the trellis is a doorway, symbolizing redemption. Thus in the *Annunciation* the artist creates a perfect fusion between the art of Renaissance humanism and medieval mysticism.

TITIAN (*c.* 1490–1576)
Tarquin and Lucretia 1569–71
Canvas, 188.9 × 145 cm / 74⅜ × 57⅛ in. Signed

This highly dramatic painting by the ageing Titian is one of the highlights of the galleries in the Fitzwilliam Museum. Only Rembrandt and Goya rival the Venetian painter in the ability to create such dramatic tension in a composition.

Painting at the top of his form

The story of Sextus Tarquinius and Lucretia was well known in the Renaissance. As recorded by Livy in his *History of Rome*, Tarquin, the last Etruscan king of Rome, was angered by the claims of Lucretia's virtue made by her husband, and he forced her to submit by threatening to kill both her and her attendant (seen on the left). Following the rape, Lucretia confesses to her husband and her father before then killing herself. Tarquin was punished by being expelled from the city. For Renaissance artists and writers Lucretia was renowned for her heroism and was seen as a symbol of chastity. Normally painters preferred to depict Lucretia's suicide, and scenes of the actual rape are far less common.

By depicting an episode from the history of Rome in this way Titian's *Tarquin and Lucretia* is technically a history painting. It was undertaken for Philip II of Spain and remained in the Spanish royal collection until it was confiscated in 1813 by Joseph Bonaparte when he was forced to return to France. Titian himself described the painting as 'an invention involving greater labour and artifice than anything, perhaps, that I have produced for many years'. The challenge was worth it, for the picture is a masterpiece in his late style and must have fitted in well with Philip II's extensive collection of Titian's work.

The sense of drama is poignant, as Tarquin with raised dagger and thrusting knee forces the raised body of Lucretia backwards on to her bed. The contrast between the two figures is striking: Tarquin is clothed in red garments and a rich doublet sparkling with gold thread, while Lucretia is naked. The tension arises from the interlocking of the figures, reinforced by the scissor-like movement of the flailing arms.

The composition in itself is powerful enough, but the overall effect is increased by the amount of detail. The surroundings have a degree of opulence that Titian relished – Lucretia's jewelry, the slipper in the foreground where the artist has placed his signature, and the quality of the bed linen. The tears coursing down Lucretia's cheek are contrasted with the gleaming blade wielded by Tarquin. The scene takes place at night, with chiaroscural lighting: as in depictions of Judith and Holofernes, this not only heightens the sense of brutality, but also quickens Titian's imagination and formidable technical skills. *Tarquin and Lucretia* is an unforgettable painting.

ALFRED ELMORE (1815–81)
On the Brink 1865
Canvas, 114.3 × 83.2 cm / 45 × 32¾ in. Signed and dated

The perils of gambling

The reputation of certain artists often rests on a single painting, and this is certainly the case with Elmore, whose *On the Brink* was exhibited at the Royal Academy in 1865. Born in Ireland, Elmore entered the Royal Academy Schools in 1832 and supplemented his training by a visit to Italy (1840–44). Subsequently, he exhibited regularly at the Academy, specializing in historical, literary and Biblical subjects.

On the Brink is in many ways an unusual picture for Elmore, although the subject of the 'fallen woman' is not difficult to find in Victorian art - examples are *Past and Present* by Augustus Egg (1850) and *The Awakening Conscience* by W. Holman Hunt (1854), both in Tate Britain in London. Elmore's purpose was to paint a modern morality tale disguised as a genre scene.

Contemporary critics identified the scene as taking place in the Kursaal at Hamburg or the Conversationhaus at Baden – both fashionable spa towns frequented by British travellers. There is no evidence that the artist visited either place on his way to Italy.

Elmore shows a young woman outside a crowded gaming room, seated in the moonlight. At her feet are the torn fragments of a marking card: the implication is that the purse she carries is empty as a result of heavy losses at the gaming table. The opulence of the gaming room behind and the intense activity of those playing the game of 'rouge-et-noir' is clear, and contrasts with the isolation of the young woman outside. A young man, cast in shadow and presumably a potential seducer, leans out of the window. The red glow of the interior suggests the heightened emotion of the scene, but there is added significance in the choice of flowers on the right – white lilies representing purity contrasted with purple passionflowers. Here is a young woman in a moral predicament: she has to choose between virtue and vice. Her losses have led her to the brink of seduction, the consequences of which in Victorian eyes led to prostitution and to suicide. The young man is waiting to seize the opportunity.

The subject is handled in an operatic style – Verdi's *La Traviata* was first performed in London in 1857 – and the poses of the two principal figures covertly engaged in conversation are memorable, as is the *hauteur* of the couple standing in the room behind them. Elmore's use of the diagonals in the composition is particularly eloquent.

My personal pleasure in this picture is increased by the fact that it once belonged to A. N. L. Munby, Librarian of King's College, Cambridge, and a noted bibliographical historian and book collector. His *magnum opus* was a study of the 19th-century bibliomaniac Sir Thomas Phillipps, in five volumes (1951–60). I wonder why he liked this picture.

SIR LAWRENCE ALMA-TADEMA (1836–1912)
94° *in the Shade* 1876
Canvas laid down on wood, 35.3 × 21.6 cm / 13⅞ × 8½ in. Signed

A summer idyll

Born in Holland and trained in Antwerp, Alma-Tadema moved to London in 1870, taking British citizenship and eventually achieving the highest social and artistic success in his adopted country. Although he started out as a history painter, he came to specialize in depicting imaginary scenes from everyday life in Egyptian and Roman times (cf. p. 209). These were based on close research and detailed examination of ancient sites, particularly in Italy. Such paintings were financially rewarding, and he lived in considerable luxury near other popular Victorian artists in St John's Wood. Alma-Tadema himself had a lively sense of humour, but retained to the last a marked Dutch accent that rendered many of his incessant jokes totally incomprehensible.

Though he moved in the top echelons of Victorian and Edwardian society, Alma-Tadema resisted the temptation to practice formal portraiture. The few portraits that he did undertake were of family and friends. 94° *in the Shade* is one such, showing Herbert Thompson (1859–1944) aged seventeen reading in a cornfield at Godstone in Surrey on a hot summer's day. So intense is the heat that any attempt at catching butterflies has been

forgotten. The vertical emphasis of the composition is cleverly used, with most of the picture space taken up by the harvested field baking in the sun and the figure at the lower edge secluded in the shade.

Herbert Thompson was the son of Alma-Tadema's close friend and doctor Sir Henry Thompson – a distinguished surgeon pioneering urological treatments, amateur artist, gastronome, and an early advocate of cremation. Herbert had similarly wide-ranging interests based on a legal and scientific training, but ended up as the leading Egyptologist and Coptic scholar of his day, with a special interest in demotics. Indeed, the chair of Egyptology at Cambridge University is named in his honour. He claimed, in addition, to have spoken in his lifetime with three men who had known Beethoven.

The composition has a startling and (for Alma-Tadema) unusual informality: it is a totally bewitching painting and was presented to the Fitzwilliam by the sitter.

AUGUSTUS JOHN (1878–1961)
Sir William Nicholson 1909
Canvas, 190.2 × 143.8 cm / 74⅞ × 56⅝ in.

An extrovert artist looks at a self-disciplined friend

Osbert Lancaster's observation that Augustus John's death marked the end of an era characterized by 'a form of life-enhancing exhibitionism which grew up and flourished before the Age of Anxiety' perfectly captures the visual impact of this portrait. John was an uneven portrait painter, particularly frustrated when having to undertake formal or

official commissions, but totally inspired when asked to paint fellow artists or writers he admired and women who aroused his curiosity. He worked at a frenetic pace whatever the subject – landscape, gypsy life, rural scenes – and much of the brilliance of his work stems from the panache of the brushwork, the intensity of the colour and the vibrancy of the drawing. Wyndham Lewis hit the mark when he described John as 'a great man of action into whose hands the fairies had stuck a brush instead of a sword'.

This portrait surely reveals feelings of mutual respect between two young but successful artists. William Nicholson (1872–1949) and John were in most ways direct opposites: John playing the role of a rumbustious bohemian and Nicholson assuming the air of a man about town. Both were gregarious and had large extended families; both frequented the Café Royal, but where John was an extrovert Nicholson practiced strict self-control. Nicholson made his reputation during the 1890s with a series of posters and woodcuts issued in partnership with his brother-in-law, James Pryde, under the pseudonym of the Beggarstaffs, but then, like John, found himself in great demand as a portrait painter, although his real bent was towards enigmatic figure subjects, lyrical landscapes and poetic still-lifes.

John was undoubtedly on his mettle when painting this portrait, which he asked to do and undertook in his own studio at No. 153 Church Street, Chelsea, in London. The influence of Velásquez, Manet and especially Whistler – all artists admired by Nicholson – is apparent in the pose and the dominance of black, relieved only by discreet touches of colour. The degree of self-confidence in the sitter is awe-inspiring, with the left arm nonchalantly placed against what seems to be one of John's own paintings. Wearing his overcoat and armed with a cane, it is as though Nicholson has merely dropped in for his sitting and is not prepared to stay long.

Nicholson was a meticulous and fastidiously unconventional dresser, not unlike Sir Michael Levey or Sir Roy Strong in their heydays. His distinct personality is readily apparent in this portrait, which hopefully gave pleasure to both men.

EDOUARD VUILLARD (1868–1940)
Interior with a Lady and a Dog 1910
Millboard, 59 × 73.6 cm / 23¼ × 29 in. Signed and dated

Vuillard specialized throughout his long career in painting intricate domestic interiors. At first, during the 1890s, when he allied himself with the Post-Impressionist group known as the Nabis, which included Pierre Bonnard and Maurice Denis, he concentrated on the environment of his own home, observing the activities of his mother who was a seamstress employing several assistants.

Following the success of his first solo exhibition at the Galerie Bernheim Jeune in Paris in 1900, Vuillard entered a new social milieu which included aristocrats, art dealers,

An elegant editor in her Parisian flat

bankers, actors and writers. His treatment of the domestic interior retained its intimacy, but instead of sombrely lit claustrophobic settings with overtones of Symbolism he pulled back from the scene and painted brighter, more realistic compositions, stressing the dynamics of personal relationships acted out in opulently furnished spaces. In these canvases, as in *Interior with a Lady and a Dog*, the artist is more of a detached observer, with a more dramatic sense of recession into depth, a process in which the brushwork and the treatment of light have a determining role. Such paintings with their attention to detail and busy, tremulous surfaces could easily become overworked, but here Vuillard manages to render the poetics of domesticity with admirable clarity and luminosity.

The figure in the painting has been identified as Marguerite Chapin (1880–1963), who later became Princess Marguerite Caetani di Bassanio, Duchess of Sermoneta. She was the editor of several international journals and is shown in her apartment at 44 avenue d'Iéna in Paris before her marriage. In this rather relaxed and almost haphazard way Vuillard records how the prosperous sections of French society of the Third Republic lived and loved before the First World War. This is the world of the series of novels *A la Recherche du temps perdu* by Marcel Proust, who remarked that Vuillard's canvases 'often kindled my memory'.

Kettle's Yard is a place to savour. It was founded by H. S. ('Jim') Ede (1895–1990), whose great skill lay in befriending artists such as Ben and Winifred Nicholson, Christopher Wood and David Jones, whose work he collected, in addition to that of Alfred Wallis, Henri Gaudier-Brzeska and Constantin Brancusi.

Trained initially as a painter at the Slade, Ede pursued a peripatetic life, but in 1957 he acquired a row of four derelict 17th-century cottages in Cambridge where he had been an undergraduate and had found inspiration in the early Italian paintings in the Fitzwilliam Museum. He converted them into a single dwelling, and there housed the considerable collection that he had by then amassed, keeping an open-door policy to a wider and predominantly young audience. The house and its contents were given to the University in 1966, although Ede and his wife continued to occupy the premises until 1973. An extension designed by Sir Leslie Martin and David Owens was opened in 1970 and several other additions and alterations have since been made to facilitate access and provide more exhibition space.

Kettle's Yard is imbued with a special ethos emanating from Jim Ede's own attitude to collecting. Inspired by the Phillips Collection and Dumbarton Oaks, both in Washington, D.C., he aimed to create 'a living place where works of art could be enjoyed, inherent to the domestic setting, where young people could be at home unhampered by the greater austerity of the museum or public art gallery and where an informality might infuse an underlying formality'. Thus it was that works of art were displayed alongside an array of rural crafts, geological artefacts, flowers and numerous *objets trouvés*. The atmosphere of the light-filled rooms of Kettle's Yard remains deeply spiritual, and a visit there is always richly rewarding.

CHRISTOPHER WOOD (1901–1930)
Portrait of a Boy with a Cat 1926
Canvas, 150 × 59 cm / 59 × 23¼ in.

Christopher Wood was a modern Icarus, whose lifestyle took him too close to the sun and led to his early death by suicide. A secluded upbringing clouded by illness was cast aside when he left to train as a painter in Paris in 1921. Good looks, a winning personality and instinctive good taste, combined with a natural innocence, led him into a higher social circle that included the collector Alphonse Kahn, the diplomat Antonio de Gandarillas and the poet Max Jacob. To a certain extent his social success assisted his progress as an artist, as he met Picasso, Sergei Diaghilev and Jean Cocteau amongst others. Wood passed the rest of his life between Paris, Provence, Brittany, St Ives and London, his restlessness fuelled by feelings of insecurity exacerbated by his bisexuality and his addiction to opium.

A Cocteau youth meets a doomed Englishman

The artist was in effect self-taught. His resolve to become a famous painter was matched by his determination to develop a style of his own that was 'full of English character'. In this aim he was aided by his friendship with Ben and Winifred Nicholson and then by their discovery of the 'primitive' painter Alfred Wallis. Wood in turn adopted a similar childlike treatment of subject-matter, based on simplified drawing and strong colouring, that gives his work a fairytale appearance in which the magical mingles with the sinister (see *Le Phare* of 1929, also in Kettle's Yard). Wood's work was exhibited in his own lifetime, but his wider reputation was only established posthumously.

Boy with a Cat is a portrait of Jean Bourgoint, one of the models for Cocteau's novel on the theme of disaffected youth, *Les Enfants terribles* (1929). It is an early, somewhat hesitant, awkward work, thinly painted and relatively unfinished, with several changes in pencil underdrawing evident on the surface. But in its artful simplicity can be discerned the careful balance between clumsiness and naiveté that is the essence of Wood's style of painting. The portrait has something of the artist's own vulnerability, but with humorous passages such as the silhouetted finial of the chair, the tie half-hidden by the jacket, and the extended claws of the cat. Comparison with Wood's self-portrait painted only a year later, also in Kettle's Yard, demonstrates how quickly he developed.

Dedham

SIR ALFRED MUNNINGS ART MUSEUM

Castle House, in the middle of Constable territory, was acquired by Munnings in 1919 and it was here that he lived until his death in 1959. The museum comprises the house (with two galleries added), studio and grounds, administered by a trust which acquires pictures and organizes loans to present a representative collection (including sculpture) of Munnings' varied and considerable output.

Born in Suffolk at Mendham, the son of a miller, Munnings was brought up with a particular love of horses. Trained at first as a commercial artist, he spent time in Paris at the Académie Julian, joined the Newlyn School of painters in Cornwall, and then

became an official war artist. His early subject-matter reflects his knowledge of country life, but after the war he specialized in equestrian portrait painting. With the Second World War, he returned to landscape painting, mainly on Exmoor and in Suffolk, until he was elected President of the Royal Academy in 1944. His controversial years as President are reflected in the later satirical painting, *Does the Subject Matter?* (1956), on view at Castle House. Munnings was ebullient, short-tempered, outspoken and a tremendous bon vivant, but at the same time given to bouts of melancholy. He enjoyed huge financial success but there was sadness in his life: he lost the sight of his right eye at an early age, his first wife committed suicide two years after their marriage, and he yearned for the style of country life that he had experienced in his youth.

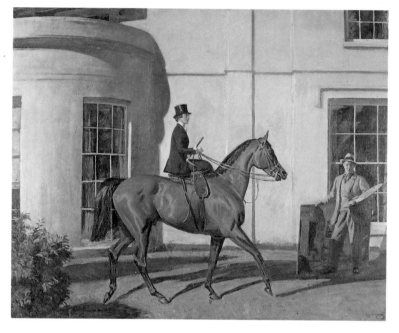

SIR ALFRED MUNNINGS (1878–1959)
'My Wife, My Horse and Myself' 1935
Canvas, 101.6 × 127.1 / 40 × 50 in. Signed

The painting reflects all the artist's interests at the height of his career. He depicts himself palette in hand with his second wife on horseback in front of Castle House. The painting he holds is the one we are looking at. When exhibited at the Royal Academy in 1935 it must have seemed to be as much an advertisement as a display of Munnings' technical skills. The artist married Violet McBride (b. 1885) in 1920, a year after he acquired Castle House. He was always susceptible to women who rode sidesaddle. Apart from being an excellent horsewoman, she gave her husband's career a sense of direction that made him a great

A man of forthright opinions

deal of money, but forced him to undertake more society portraits than he welcomed. To keep up such an output, Munnings perfected a technique of vibrant brushwork and bright colour. Like John Singer Sargent, he painted very fast: here the surface is thinly applied and the shadows rapidly laid in before the light changes. Even Violet McBride admitted, somewhat brazenly, 'He was never such a good artist after he married me. It meant painting for money.' Financial success did mean, however, that the artist could live on a grand scale in the country (he kept thirty-four horses) and in London, where he belonged to a number of clubs. There were no children by the marriage, and Lady Munnings established the museum at Castle House in her husband's memory. The Castle House Trust was formed in 1965 when Lady Munnings moved to London, where she died in 1971.

Ipswich

CHRISTCHURCH MANSION AND WOLSEY ART GALLERY

Christchurch Mansion and Wolsey Art Gallery are set in a spacious landscaped park near the town centre beyond the church of St Margaret. Christchurch Park has been the focus of public social activities since it was saved from developers by the local MP, Felix Cobbold, during the 1890s; it is impressive, with two fine war memorials, and, mercifully, it has escaped the deadening hands of municipal garden designers.

Christchurch Mansion was established as a museum in 1896. It is a Tudor house, and the museum as such is presented as a series of period rooms extending in style from the Tudors to the Victorians. An outstanding feature is the display of sixty painted panels of 1610 from Hawstead Place, the home of Sir Robert and Lady Drury, near Bury St Edmunds, which decorated a room used by the high-minded Lady Drury for prayer and meditation – she was a friend of the poet John Donne. An inscription at the entrance to the Mansion reads: 'Observe frugality that you may not run into dissipation.' This reminds the visitor that East Anglia supported Oliver Cromwell during the Civil War and inclined towards Puritanism.

Although paintings are shown in Christchurch Mansion, an addition made in 1932 forms the Wolsey Art Gallery, where there is a greater concentration of pictures. The gallery is named after Cardinal Wolsey, Henry VIII's powerful Chancellor, who was born in Ipswich.

The Wolsey Art Gallery has a strong representation of the early work of two Suffolk-born painters: Thomas Gainsborough and John Constable. Typical of Gainsborough's sense of humour is the illusionistically painted figure of Tom Peartree (c. 1752) leaning over a wall, which could easily be mistaken for a real person.

Two landscapes by Constable – *Golding Constable's Flower Garden* and *Golding Constable's Kitchen Garden*, both of 1815 – are views from the back windows of the house in which the artist was born. Although very ordinary views, they are intensely personal, the first evoking memories of his mother and the second associated with his long courtship of his future wife, Maria Bicknell. Only Stanley Spencer, much later, could equal Constable's total immersion in the landscape, rendering it with a similarly mesmerizing technique.

THOMAS GAINSBOROUGH (1727–88)
Portrait of William Wollaston c. 1758–59
Canvas, 120.6 × 97.8 cm / 47½ × 38½ in.

Thomas Gainsborough was born in Sudbury in Suffolk. He trained as an artist in London, but established his reputation first in Ipswich and then in the more socially conscious Bath before returning to London in 1774, where he was recognized as one of the greatest painters of his day. In portraiture he was the only artist who could rival Sir Joshua Reynolds. The key to his success was his independence, and although a member of the Royal Academy, he was often in conflict with it over the display of his pictures, particularly towards the end of his life, when his style became looser and his paintings less finished.

Gainsborough's main source of income was portraiture, but as his reputation increased he came to regard it as a chore (see p. 265). This was not the case, however, when he painted his closest friends, such as William Wollaston (1730–98). This lively portrait, undertaken while the artist was still living in Ipswich, exudes immediacy, intimacy, and a sense of fun. Wollaston was an important local landowner and MP for Ipswich. Dress, pose and expression are all indications of status, but of greater significance is the flute held by the sitter. Any friendship between Gainsborough and Wollaston would have been based on a shared love of music.

The composition reveals the artist's natural predilection for portraiture. The figure is seated on a chair in three-quarters length. His form is pyramidal in shape, but the vivid characterization is derived from the twist of the body and the play on the short opposing diagonals built around the flute. Wollaston looks off to the right as though in conversation with someone outside the composition. The artist must have observed him like this on many occasions, fingering his musical instrument with the sheet music carefully balanced on his knees. Indeed, the gentle swaying motion suggests the rhythms of music itself. The foreshortening of the arms and legs pushes the figure back in the picture space so that it seems as though air is circulating round the body.

General impressions are enhanced by an accumulation of detail in the dress – the edge of the coat, the frogging in the shape of ears of wheat (a local reference), the

'Gainsborough's profession was painting, but music was his amusement. Yet there were times when music seemed to be his employment, and painting his diversion'

WILLIAM JACKSON

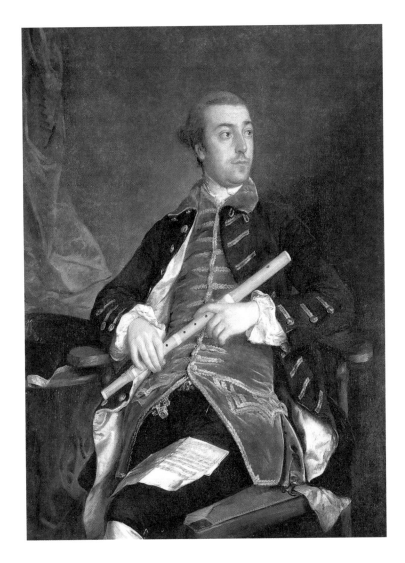

phosphorescent white of the cravat and cuffs. The treatment of such motifs is testament to the influence of French Rococo art on the young Gainsborough.

The portrait is really about friendship and a shared appreciation of music.

PHILIP WILSON STEER (1860–1942)
Knucklebones, Walberswick c. 1888
Canvas, 61 × 76.2 cm / 24 × 30 in. Signed

A British
Impressionist

Lurking on the walls of Christchurch Mansion are two interesting paintings connected with Impressionism. One is an early work by Camille Pissarro, *The House of Père Galien, Pontoise* (1866), a carefully balanced composition with beautifully nuanced tones and wonderfully rhythmical brushwork. The other is by a British artist deeply influenced by the Impressionists.

Steer frequently worked at Walberswick, a hamlet at the mouth of the River Blyth close to Southwold, during the mid-to-late 1880s. Surrounded by mudflats and marshes inland, Walberswick's shore, which slopes quite steeply, is mainly of shingle. A pier, now broken, juts out to sea. It is here that the artist painted what have come to be regarded as his most 'modern' pictures, including *Knucklebones*, which always strike me as being the visual equivalent of novels by Virginia Woolf or plays by Stephen Poliakoff.

Steer's early style was based on Whistler, but he spent two years in Paris (1882–84) and in 1886 was a founding member of the New English Art Club, to which painters sympathetic to avant-garde French art belonged.

Knucklebones has several radical features. The composition has a high horizon line and lacks a single focus. The brushstrokes comprise myriad dabs of pure colour that denote an awareness of the methods and theories of the Neo-Impressionists. Steer is here acknowledging the advances made by Degas, Monet, Gauguin and Seurat, although in the next decade he turned back to search for inspiration among his British forebears, such as Turner and Constable.

Knucklebones is an ancient game involving tossing and catching the bones of animals. The children in this picture are using beach pebbles rather than bones. In the end Steer's magic is nothing to do with stylistic sources. Rather, it lies in his vision of an idyllic ethereal world. The air of innocence is apparent and the mood wistful. Time will pass; the sun will disappear below the horizon; the sea will advance over the shingle; and the children will grow old. This age of innocence will be lost forever.

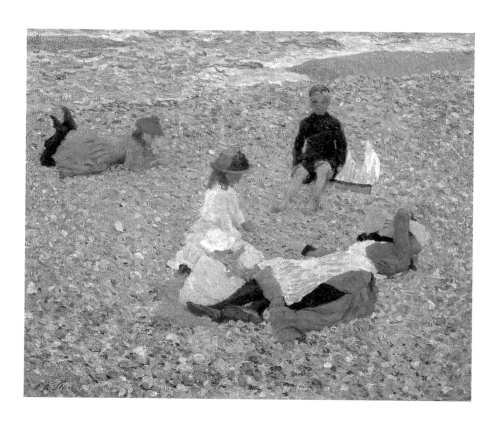

Norwich

NORWICH CASTLE MUSEUM AND ART GALLERY

The museum and art gallery are housed in the Castle, which dates from Norman times and is one of the principal landmarks in the city. Having served as the county gaol for many centuries, it was converted into a museum in 1894 and further developed in 1969. The result is compact and well laid out, with galleries on two levels radiating out from a central rotunda. The principal strength of the picture collection is the representation of the Norwich School, centred on John Crome and John Sell Cotman, with many examples presented at the turn of the 19th and 20th century by the Colman family, who made their fortune in the production of mustard. There is a small group of Dutch 17th-century pictures and several 18th- and 19th-century British paintings, many with local associations, such as the delightful family group by Henry Walton, *Sir Robert Buxton, 1st Bt, with his wife, Juliana, and his elder Daughter, Anne* or *Mr and Mrs John Custance of Weston and their Daughter Frances* by Sir William Beechey. The *Ashwellthorpe Triptych* by the Master of the Legend of the Magdalen, dating from the early 16th century, impresses in the same way as the portrait of *Francis Matthew Schutz* being sick in bed by William Hogarth fascinates. The modern and contemporary paintings liven things up.

JOHN CROME (1768–1821)
Norwich River: Afternoon 1819
Canvas, 71.1 × 100.3 cm / 28 × 39½ in.

Glimpsing the past

John Crome was the leading artist of the Norwich School at the time of its foundation. His reputation as one of the finest landscape painters working in the British tradition has to some extent been tempered by the numerous imitations and pastiches perpetrated by members of his family and his numerous followers.

Acquired in 1994, *Norwich River: Afternoon* is undoubtedly one of Crome's finest late works recording the city's past. The artist himself was a keen admirer of Dutch 17th-century painting, but here in a perfectly balanced composition he shows an awareness of Poussin and Claude.

The scene is reposeful by today's standards, but the treatment of light and the shimmering reflections in the waters of the River Wensum that runs through the city bring the painting to life. The picture also records an important source of Norwich's wealth:

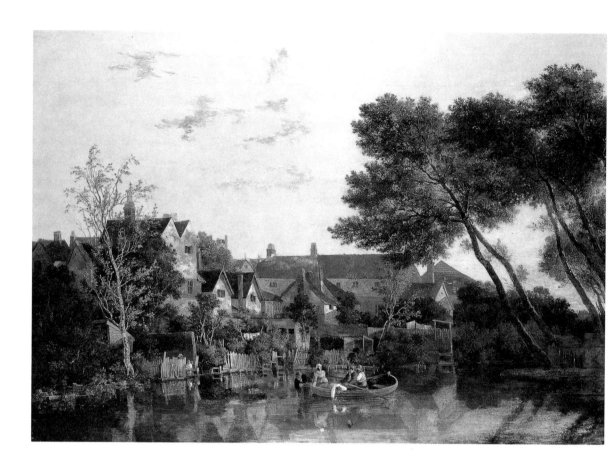

the long building in the centre background, identifiable as the New Mills, was the property of the city, and at one time all the bakers were obliged to grind their wheat there. Stretches of the riverbank similar to this are preserved, but only in parts, and then only as the result of a miracle, as the city has virtually been destroyed by modern town planners.

FREDERICK SANDYS (1829–1904)
Autumn c. 1860–62
Canvas, 79.6 × 108.7 cm / 31¾ × 42¾ in.

The artist was born in Norwich, but came to prominence in London during the 1850s. He was a close friend of the Pre-Raphaelites, particularly Millais and Rossetti. Although gaining considerable success for his large-scale portrait drawings in colour crayons, he had an extravagant lifestyle, mixing with fashionable society and living beyond his means, which resulted in considerable financial hardship. Sandys supplemented his income by undertaking illustrations for literary magazines such as the *Cornhill*, but never really had the necessary peace of mind to develop his style, which became increasingly repetitive as his creative powers declined.

'Old soldiers never die,
They simply fade away'
J. FOLEY, 1920

As it happens, Sandys came to the attention of the Pre-Raphaelites by caricaturing the painting *A Dream of the Past: Sir Isumbras at the Ford* by Millais (Port Sunlight, Lady Lever Art Gallery), which is reflected in a more serious vein in the tranquil landscape of *Autumn*. The title suggests a series of the seasons, and a composition for Spring is known through a drawing. The mood of *Autumn* is very much in the spirit of late Pre-Raphaelitism, veering towards Symbolism with suggestions of Romanticism. Essentially, though, the subject could well be the three ages of man.

The reclining soldier has been identified as Charles Faux, who as the uniform and medals denote fought in the Sikh War in India (1845–49). It is possible that he is recounting the story of his experiences to the woman and child (possibly members of his family) at his side. The attention to detail, particularly in the foreground, is typical of Pre-Raphaelite painting. Presumably the still-life items in the lower left corner, which include a Chinese jar, belong to the mother and child. Tempting though it is to see them symbolically, no such interpretation has yet been attempted.

There is a marked contrast between the foreground and the more broadly painted background seen in the twilight. Sandys uses local knowledge for some of the main features: the bridge is identifiable as Bishop's Bridge across the River Wensum leading to the cathedral in Norwich, and the castle on the hilltop closely resembles Norwich Castle before its reconstruction in the 1890s. The mood is one of melancholy and reverie, with the twilight in the background implying the passing of life. It is a strangely moving picture and indicative perhaps of the artist's own quirky personality.

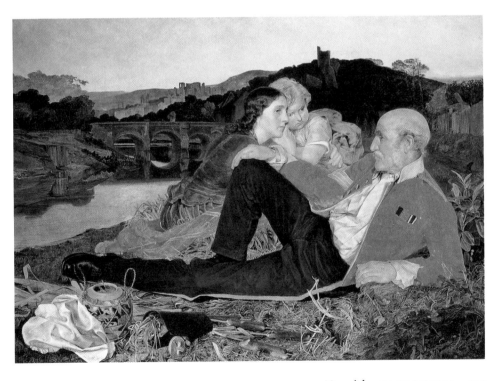

Sudbury

GAINSBOROUGH'S HOUSE

Thomas Gainsborough was born in 1727 at No. 46 Sepulchre Street (now Gainsborough Street) in the small Suffolk town of Sudbury. He was the youngest of nine children born to John and Mary Gainsborough. His father had a varied career, working first as a crape maker for the funeral trade and then as a weaver before becoming an innkeeper. Even though he was declared bankrupt in 1733, the house remained in family possession, thereby allowing John Gainsborough to pursue his final occupation as postmaster to the town. The last family member to occupy the house died in 1792. It remained in private ownership until 1950 when the Gainsborough House Society was formed to save it for the town. Following restoration, Gainsborough's House officially opened to the public in 1961.

The collection provides an overview of the artist's life, but in a discrete way owing to the size of the house and financial constrictions. The emphasis is on early work, including the fine *Group Portrait of Charles Crokatt, William Peable and Peter Darnell Muilman* (bought jointly with Tate Britain), but there is one late picture of distinction, *Wooded Landscape with Cattle by a Pool*, of the type so admired by Constable. A more comprehensive representation of Gainsborough's work can be found in the collection of drawings. Some memorabilia and works by contemporary artists, including Gainsborough Dupont, the artist's nephew, are also on display.

THOMAS GAINSBOROUGH (1727–88)
The Descent from the Cross (after Rubens) late 1760s
Canvas, 125.5 × 101.5 cm / 49⅜ × 40 in.

This painting reveals the artist's working methods as well as his use of sources. It is a copy of the central part of Rubens's great altarpiece painted in 1611–14 for the cathedral at Antwerp. Although a modello by Rubens for the finished painting was at Corsham Court near Bath during Gainsborough's lifetime (now in the Courtauld Gallery, London), the fact that in this study the composition is reversed indicates that Gainsborough used the print made after Rubens by Lucas Vorsterman the Elder (1620) as his source. Gainsborough's copy is unfinished and it was still in his studio at the time of his death.

The vibrant underdrawing and blocked-in areas of colour predominate; the more finished areas are limited to the figure of Christ and to Nicodemus on the right. There is a possible connection with the pyramidal arrangement of the figures in Gainsborough's

Homage to Rubens

landscape of *The Harvest Wagon* in the Barber Institute of Fine Arts, Birmingham (see p. 265). It is, however, not a question so much of direct quotation as of the re-use in a different context of a motif that had sunk deeply into the artist's consciousness.

Gainsborough did in fact visit Antwerp on his only sojourn abroad, in July–September 1783, towards the end of his life, but any comments he made about the altarpiece if he saw it are not recorded.

Significantly, Gainsborough also painted copies of works by Rubens's pupil Van Dyck, one of which (*Portrait of Lord Bernard Stuart*) is also in the collection at Gainsborough's House.

THE NORTH-EAST

G eography has played a major role in the distribution of museums and galleries in this area. Although the distances between them may be great, the rewards are correspondingly rich. Civic traditions of public beneficence and education are much in evidence and are still proving to be advantageous, threatened though they are by financial pressures and occasional outbreaks of philistinism.

The principal collections are to be found in the Cartwright Hall Art Gallery in Bradford, the Ferens Art Gallery in Hull, Leeds Art Gallery, the Laing Art Gallery in Newcastle upon Tyne, and the Graves Gallery in Sheffield. For old master paintings the Ferens Art Gallery and York Art Gallery are particularly strong, but in addition it is striking how well British painting of the 19th and 20th centuries is represented in all these galleries. Berwick-upon-Tweed, Doncaster, Gateshead (Shipley Art Gallery), Harrogate (Mercer Gallery), Huddersfield and Wakefield have smaller holdings, but do not lack interest.

Important artists born in this part of the British Isles include Thomas Bewick and John Martin in Northumberland, David Hockney in Bradford and William Etty in York. Joseph Joel (later Lord) Duveen, the art dealer and benefactor of so many museums and galleries in the British Isles, was born in Hull. Several artists' colonies were attracted to the coastline of this area at Cullercoats, Staithes and Robin Hood's Bay.

There are some surprises in the North-East: Jacopo Tintoretto's *Christ washing the Disciples' Feet* at Gateshead, Georges de La Tour's *The Dice Players* at Stockton-on-Tees, and Francis Bacon's *Figure Study 11* at Huddersfield. Above all there are the Spanish pictures at the Bowes Museum in Barnard Castle, where the building itself also quite takes the breath away.

Barnard Castle

BOWES MUSEUM

Abuilding in the style of a French chateau is a surprising sight in the countryside of County Durham. You could be forgiven for thinking that you were in the Loire Valley. The Bowes Museum has been called 'the Wallace Collection of the North', although it is perhaps better compared with Waddesdon Manor in Buckinghamshire built by the Rothschild family.

The Bowes Museum was built by John Bowes (1811–85) and his wife for the display of their collections, acquired mostly during the 1860s and 1870s. Bowes was the illegitimate son of the 10th Earl of Strathmore and was never recognized as his father's titular heir. The family's wealth derived principally from coal, but Bowes' passion was for horse-racing. He also had theatrical interests in Paris, and in 1852 he married the actress Joséphine Benoîte-Coffin-Chevallier (1825–74). As a wedding present he gave her the pavilion at Louveciennes near Paris designed by Claude-Nicolas Ledoux for Madame du Barry, the mistress of Louis XV, and they lived there until 1860. Before his marriage Bowes represented South Durham in Parliament.

The design for the Bowes Museum was drawn up in 1865 by the French architect Jules Pellechet, and the foundation stone laid in 1869. Supervision of the work fell to the English architect John Edward Watson, based in Newcastle upon Tyne; progress was slow, and neither of the owners ever saw the completed building, which finally opened in 1892.

The collection of paintings is patchy, since Bowes was not prepared to pay high prices on the open market, but there are some good moments among the Italian and French 18th-century pictures and some interesting 19th-century French pictures (Joséphine Bowes was herself a painter). The highlight of the collection is the group of Spanish paintings – now second in importance only to those of the National Gallery, but in 1892 by far the largest group in the country. Strange though it might seem, during John Bowes' lifetime it was not difficult to see paintings by Spanish masters in or near County Durham. There was, for example, the *Toilet of Venus* (the '*Rokeby Venus*') by Velásquez belonging to the Morritt family at Rokeby and *Jacob and his Twelve Sons* by Zurbarán at Auckland Castle belonging to the bishops of Durham. The Spanish pictures collected by John and Joséphine Bowes came from a single source in Paris: the collection of Condesa de Quinto, widow of Francisco Javier de Quinto y Cortes Guin y Centol (1810–60), created Conde de Quinto in 1859, companion of the exiled Queen Maria Christina, wife of Ferdinand VII. The go-between was the dealer Benjamin Gogué, who in 1863 became curator of the Bowes art collections.

Additions continue to be made to the holdings of the museum.

SASSETTA (STEFANO DI GIOVANNI) (active by 1423–50)
A Miracle of the Sacrament 1423–26
Wood, 24.1 × 38.2 cm / 9½ × 15 in.

For many years it was believed that the art of Siena during the 15th century was of little importance in comparison with what was happening in Florence: it was felt that the artists were bound by an overwhelming sense of tradition stemming from Duccio and Ambrogio and Pietro Lorenzetti, active in the first half of the previous century. A gradual reassessment has been taking place in recent years, arguing that such artists as Sassetta and Giovanni di Paolo were in fact reinterpreting the work of their predecessors in the light of contemporary advances, rather than maintaining the Gothic tradition of their own city: there are elements of modernity in Sienese Renaissance art if you look for them. Sassetta was not unaware of what was happening in Florence, first of all through Gentile da Fabriano and then on account of a personal visit, but he never surrendered his own individuality to Florentine tendencies.

For a whole year, 1972–73, at Villa I Tatti in Florence I was privileged to see each day the overpowering panel of *St Francis in Glory*, which was a key part of the elaborate altarpiece that Sassetta painted in 1437–44 for the church of S. Francesco in Borgo San Sepolcro. It was impossible not to be aware of how well the artist balanced the sense of monumentality in the saint with outspread arms against the utmost refinement of the subsidiary figures. It inspired the owner, Bernard Berenson, to one of his finest written descriptions of a work of art.

There is the same sense of control in *A Miracle of the Sacrament*, which comes from the predella of a triptych painted by Sassetta for the Arte della Lana (guild of wool merchants) for their chapel dedicated to the feast of Corpus Christi in the church of the Carmine in Siena. It was his first major commission. The original format of the altarpiece, which was dismantled in the late 18th century, is known only from an early description. There were seven narrative panels in the predella at the bottom, with scenes concerning the Eucharist – central to the feast of Corpus Christi and the principal act of Christian worship in so far as the consecrated wafer or Host taken at the service of Holy Communion symbolizes the sacrifice of the body of Christ. Six of these panels survive and demonstrate the artist's visual imagination, as he had no recourse to any known literary source for these scenes.

A Miracle of the Sacrament takes place in a church, at the crossing, where a priest offers a young monk the Eucharist. As this happens the monk's soul is stolen by the Devil and the Host bleeds to denote a sinful communicant. The miracle is the discovery of this transgression.

The perspectival view of the church, with the main altar seen obliquely on the right and a series of altars stretching down the nave, is a remarkable example of empirical painting. The figures fall into three groups: on the left male and female members of the congregation, in the centre the monks, and on the right the officiating priest with the

An early and unusual purchase by John Bowes of an artist now promoted to the first division

communicant. Sassetta's skill lies in the adroit rendering of the architecture and the convincing placement of the figures within the divisions of the building. This scene and those portrayed on the related panels provide many insights into monastic life in Sassetta's time.

EL GRECO (DOMENIKOS THEOTOCOPOULOS) (1541–1614)
The Tears of St Peter c. 1580–85
Canvas, 108 × 89.6 cm / 42½ × 35¼ in. Signed

The Tears of St Peter was not quite the first work by El Greco seen in the British Isles, but its acquisition in 1869 long preceded the comparatively recent appreciation of this artist.

El Greco was born in Crete and probably learnt to paint in the Byzantine tradition. This changed when he went to Italy – first of all c. 1567 to Venice, where he may have worked in Titian's workshop, and then in 1572 on to Rome. From Italy he moved to Spain, where from 1577 he spent the rest of his life. His first Spanish commissions were for churches in Toledo, but he also tried to gain a foothold at the court of Philip II. However, his highly individual style did not find favour with the King, and he moved back permanently to Toledo, the city with which he is most closely associated.

The painter's attenuated figures, intensity of feeling, disembodied forms, fluid compositions and cool colouring make his work not only distinctive but also strikingly original. Added to this is the fact that he was well versed in several categories of painting – altarpieces (sometimes on a huge scale), landscapes and portraits. While El Greco was concerned to give visual expression to the spirit of the Counter-Reformation in his exploration of religious themes, he has been a formative influence on many modern painters, from Picasso to Bacon.

The Tears of St Peter depicts the repentant saint when he realizes that he has just fulfilled Christ's prophecy of his denial three times during the course of the Passion. There is a narrative element in the left background, where Mary Magdalene can be seen carrying her jar of ointment, having visited Christ's tomb which is guarded by an angel (Gospel of St Matthew 28:1–8): her mission is to inform St Peter of Christ's resurrection.

El Greco specialized in depicting figures in half- or three-quarters length, and he executed many series of the apostles in this format. The compact nature of the composition,

'And Peter called to mind the word that Jesus said unto him, Before the cock crow twice, thou shalt deny me thrice. And when he thought thereon, he wept'

GOSPEL OF ST MARK 14:72

with the pyramidal form of the swaying figure, the imploring gesture and tearful eyes emphasize the saint's anguish. The ivy behind him symbolizes immortality and suggests that St Peter will sustain his faith. Religious fervour has never found a greater exponent than El Greco.

FRANCISCO DE GOYA (1746–1828)
Interior of a Prison c. 1810–12
Tinplate, 42.9 × 31.7 cm / 16⅞ × 12½ in.

A prison scene not
unlike Beethoven's
opera *Fidelio*, first
performed in 1805

There are two outstanding paintings by Goya in the Bowes Museum, both acquired in the early 1860s: *Portrait of Don Juan Antonio Meléndez Valdés* and *Interior of a Prison*.

Around 1793–94 Goya became unwell with an undiagnosed illness that among other afflictions left him deaf. He also found it difficult to paint, but he embarked upon a series of small cabinet pictures of uniform size on the unusual support of tinplate. The subjects were varied, but two were sinister: *Interior of a Prison*, and *Yard with Lunatics* (Dallas, Meadows Museum, Southern Methodist University).

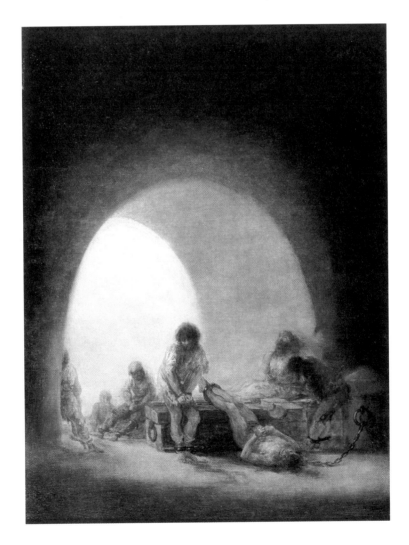

The exact date of these two pictures has proved difficult to establish, as sometimes happens with very great works. For most scholars the subject-matter suggests a connection with the Peninsular War (1808–13) and the Spanish insurgency against the French, which Goya witnessed early on at Saragossa. The experience manifested itself not only in paintings, but also in a famous set of prints, *The Disasters of War* (1809–14). Alternatively, on a more psychological basis, it has been argued that a prison scene representing human hopelessness is really a metaphor for Goya's deafness and, therefore, more likely to be closer in date to the onset of his illness.

Whatever the outcome of the debate, there is no denying the power of this tragic picture. The seven shackled male prisoners in various states of wretchedness and despair are immured within a space dominated by a huge Piranesian arch that gives some idea of the thickness of the walls. The cold light filtering through the arch suggests yet further cells of this type rather than freedom. The architecture weighs heavily on the puny, pitiful figures, implying the frailty of man. As Robert Hughes has written, 'The theme of the painting is leaden immobility – leaden in colour, but also in the immense and meaningless weight of time creeping by.'

Bradford

CARTWRIGHT HALL ART GALLERY

The imposing building, opened in 1904, was designed by John W. Simpson and E. J. Milner Allen, architects of the recently opened Kelvingrove Museum and Art Gallery in Glasgow. Here they favoured the Edwardian Baroque style, with a highly decorated and heavily rusticated façade employing paired columns and pilasters, a massive two-tiered arcaded portico and an elaborate cupola. Approached across Lister Park – the site of the house of Samuel Cunliffe-Lister, 1st Baron Masham (1815–1906) – Cartwright Hall exudes confidence and civic pride. It was built as a result of the generosity of Cunliffe-Lister, who gave the site and financial assistance as well, but named after Edmund Cartwright (1743–1823), inventor of the power loom: it was Cartwright's invention, taken a step further, that had enabled Cunliffe-Lister to make his own fortune in the textile industry.

The collection is lively. Small groups of old masters and British 18th-century portraits give way to heavyweight late Victorian paintings. The strengths of the collection lie in the representation of the Newlyn School, the New English Art Club and 20th-century British painting. Due homage is paid to Bradford-born artists, especially David Hockney.

HENRY LA THANGUE (1859–1929)

The Connoisseur 1887

Canvas, 114 × 60 cm / 44⅞ × 23⅝ in. Signed and dated

La Thangue was essentially a painter of rural life, having come under the influence of Jules Bastien-Lepage and spent time painting in Brittany with Stanhope Forbes during the early 1880s. He returned to England armed with French practices and helped to found the New English Art Club, only slowly reconciling himself with the Royal Academy, of which he became a member in 1912. In one sense his life was a search for an arcadia which he found increasingly elusive in the British countryside, with the result that as he grew older he sought his motifs in France and Italy.

The Connoisseur is an unusual work for La Thangue, being an interior scene. It shows the Bradford collector Abraham Mitchell (1828–96) sitting in his picture gallery examining a painting on the easel before him. His family is taking tea on the other side of the room. The Mitchells lived at Bowling Park and owned a worsted spinning firm specializing in mohair for the luxury trade. The painting has come in recent years to epitomize the taste of the Victorian collector, whose preference was for paintings by contemporary British artists with a strong narrative content (if possible with moral overtones) and a high finish. Interestingly, Mitchell was introduced to La Thangue by John Maddocks, a successful merchant, who collected pictures by younger, more advanced French and British artists among whom La Thangue himself must be numbered.

Gateshead

SHIPLEY ART GALLERY

The gallery was named after a successful local solicitor, Joseph Shipley (1822–1909), who practised in Newcastle upon Tyne but lived at Saltwell Park on the other side of the river in Gateshead. He formed an eclectic collection of pictures, relying heavily on intermediaries, amassing some 2,500 examples in all. The collection was bequeathed to Newcastle with the intention of displaying it in a specially built gallery alongside the newly opened Laing Art Gallery. This plan, however, was frustrated, even though Shipley had provided money in his will for the purpose, and so it was left to Gateshead to honour the bequest. This was duly done in an imposing Neoclassical building designed by Arthur Stockwell, although only after Shipley's collection had been considerably reduced in size to about 500 pictures.

The gallery opened in 1917 and includes paintings of the German, Dutch and Flemish schools ranging in date from the 16th to the 19th centuries. There is also a strong representation of British paintings, particularly by 19th-century artists, including *The Poor Teacher* by Richard Redgrave – Surveyor to Queen Victoria – and *Autumn Regrets* by Atkinson Grimshaw. After a hesitant start the gallery has proved to be a considerable success.

JACOPO TINTORETTO (1518–94)
Christ Washing the Disciples' Feet c. 1547
Canvas, 213 × 518 cm / 7 × 17 ft

This enormous canvas once adorned the right-hand side of the chancel of the church of S. Marcuola in Venice, where it was balanced on the left by the *Last Supper*. While the latter remains in the church, this seems to have been removed for some reason, possibly as early as the 17th century. It may have belonged to Sir Joshua Reynolds in the 18th century; in 1814 it was sold in London to Sir Matthew White Ridley, who presented it to the church of St Nicholas in Newcastle upon Tyne four years later. Shipley Art Gallery purchased it in 1987, adding one of the finest Venetian pictures in the country to its collection.

A triumvirate of artists dominated the High Renaissance in Venice – Titian, Tintoretto and Veronese. Tintoretto reputedly described his distinctive style of painting as an amalgam of Titian's colouring and Michelangelo's drawing.

While he was clearly trained in Venice in the shadow of Titian, a visit to Central Italy most probably made in the 1540s accounts for the more expansive style evident in his mature work. He seems to have relished working on a large scale (often using several pieces of canvas sewn together) and consequently developed an energetic sketchy style of brushwork that enabled him to apply paint at a furious pace. The extensive series of paintings undertaken over several years for the Scuola di San Rocco in Venice, for example, is an unforgettable tour de force that few other painters could have achieved. In addition, Tintoretto was a hugely imaginative artist, forever reinventing and re-presenting traditional themes (both religious and secular) in new and enterprising ways. In his visual imagination he anticipates his 18th-century Venetian confrère Giovanni Battista Tiepolo.

Christ Washing the Disciples' Feet is a scene forming part of the narrative of the Last Supper before Christ's death. The painting is an early work by the artist, notable for the breadth of its composition and its localized setting with a canal (evoking Venice) lined with extravagant buildings. There is a tendency to push the figures towards the edges, increasing the size of the room, where the obliquely angled table around which some of the disciples sit holds the centre. Tintoretto makes eloquent use of wide open spaces, but typically he fills the lower corners of the canvas with key elements of the narrative: Christ performs the act of washing lower right and one of the disciples is tying up his sandal lower left, in a pose based on classical sculpture that Reynolds himself used in his *Portrait of Colonel Tarleton* (London, National Gallery). The scene is full of memorable vignettes – the maidservant bringing the water, the disciples adjusting their clothing, the dog

simply observing the proceedings with canine inquisitiveness. There is a sense of dynamism in the figures (as in the two helping each other to undress left of centre) which in turn echoes the plunging perspective.

Contrasts of light also play an important part in activating the surface through the differentiation between interior and exterior. Tintoretto basks, as all Venetian painters did, in the warm tones of his colours, but at the same time he makes the scene fizz like electricity by the application of white highlights, as though he was painting with light itself. It is almost as if Tintoretto anticipated Dan Flavin's method of making art with fluorescent tubes.

Hull

FERENS ART GALLERY

Overlooked by a statue of Queen Victoria unveiled in 1901, the year of her death, the Ferens Art Gallery houses one of the most rewarding collections of paintings on public view. Compared with many civic galleries, it was a latecomer. The founder, Thomas Robinson Ferens (1847–1930), a local industrialist and MP, frustrated by the desultory efforts made to establish an art gallery in the City Hall, took the decision to provide funds for it, together with an endowment for the purchase of pictures. The new purpose-built gallery was designed by the London architects S. N. Cooke and E. C. Davies, and opened in 1927.

The building is distinguished and is a pleasure to visit. Neoclassical in style, the façade in Portland stone has bronze entrance doors flanked by Corinthian columns. A central rotunda with a balcony where pictures are hung just beyond the entrance is a surprise, and the galleries radiate outwards from this space.

The paintings are memorable for their high quality throughout, and there are works by some great artists (Hals, Ruisdael, Canaletto, Eustache Le Sueur) as well as interesting examples by lesser names. Italian, Dutch and French paintings, including some marine pictures – appropriately, since Hull is a port – prepare the way for the powerful representation of the British School. The emphasis here is very much on the early 20th century: the Camden Town Group, the New English Art Club, as well as Wyndham Lewis (for example *Mr Wyndham Lewis as a Tyro*) and Stanley Spencer (particularly *Nude: Portrait of Patricia Preece*). Attention is also paid to the second half of the 20th century, and the contemporary scene is not ignored. The collection attests the remarkable 'eye' of past and present curators responsible for this very rewarding gallery.

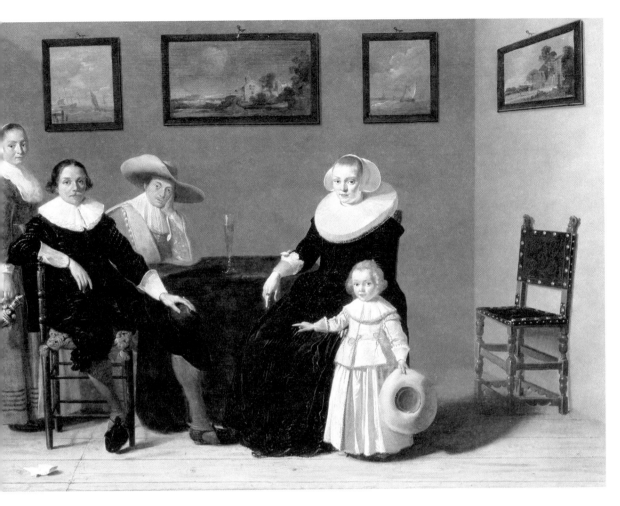

JAN OLIS (*c.* 1610–76)
Dutch Family in an Interior 1634
Wood, 38.4 × 49.8 cm / 15⅛ × 19⅝ in. Signed and dated

Self-portrait of the
artist as vintner?

The painter is not at all well known, and the acquisition of this fine picture in 1992 demonstrates how well the Ferens Art Gallery has continued to develop its collection of Continental pictures (the *Portrait of a Woman* by Hals was bought in 1963).

Olis was born in the Netherlands at Gorinchem to the east of Dordrecht, where he entered the guild in 1632; he married in Dordrecht in 1637, and is recorded as having pupils there until 1641. Later he seems to have moved to Heusden near s'Hertogenbosch, where during the second part of his life he held several public positions – alderman, burgomaster and tax collector. What is known of his artistic output is not unusual for a painter working in Holland during the 17th century: portraits, still-lifes, history subjects, guardrooms and festive scenes.

Of possible significance for *Dutch Family in an Interior* is the fact that Olis is recorded in 1638 as a vintner. The prominence of the single glass of wine on the table suggests that

this might well be a self-portrait of the artist with his family. If so, we can see that the painter was fairly successful – as indeed his role in public life also implies. Posed as if for a photograph, the artist (if it is indeed he) and his wife are seated with their daughter, who stands by her mother dressed in a contrasting yellow. The other seated figure is either a relative or a factotum; a female servant stands behind at the left edge. All the figures fix us with their stares: there is no escape.

The finery of the clothes is balanced by the precision with which the interior is painted – the disposition of the pictures on the wall, the bare floorboards, the placing of the chairs, and the positioning of that tempting glass of wine. Particularly skilful is the artist's use of colour, not just in the recording of the sitters' wealth (look at the cushion), but also in the eloquent articulation of space. Note also how the servant, closing the composition on the left, is balanced by the entirely empty corner of the room on the right. And see also what emphasis is given to the child in the forefront of the group: she is not only dressed in a vibrant colour and proffers her hat with great elegance, but casts a strong shadow on the pristine floor.

What a pity that so few of Olis's pictures are known. Maybe this is his masterpiece.

FRANS HALS (1582/83–1666)
Portrait of a Woman c. 1655–60
Canvas, 60 × 55.6 cm / 23⅝ × 21⅞ in.

Hals stands second only to Rembrandt in the development of Dutch painting. He was born in Antwerp in Flanders, but his parents settled soon after his birth in Haarlem, in the northern breakaway provinces of the Netherlands, where he was based for the rest of his life. Although he lived to a considerable age and his style remained so vibrant, Hals was not a prolific painter. His œuvre is dominated by portraiture; his religious works are very few in number, and even his genre subjects seem like veiled portraits.

His artistic origins lie in Mannerism, so it is surprising that he emerged as a leading portrait painter of the new Dutch Republic. His portraits of individuals (sometimes conceived as pendants) are notable for their confidence and candid characterization. The group portraits of militiamen and officials not only imply a growing sense of corporate identity, but are extraordinarily skilful compositions involving a number of sitters.

Portrait of a Woman is unusual because of its intimate scale, but even within the relatively small dimensions there is plenty of evidence of Hals's deft brushwork. The fact that the pose is *en face* indicates that the portrait did not have a pair. Apart from the features, the artist enlivens the image by the slight tilt of the head and the asymmetrical positioning of the large kerchief. But in the end the vibrancy of the portrait depends on the handling of the paint, which is impulsive and fluid to the point that it seems as though it is in danger of just sliding down the canvas. In fact, the brushwork only really

'Frans Hals must have had twenty-seven blacks'

VINCENT VAN GOGH
IN A LETTER TO
HIS BROTHER THEO,
OCTOBER 1885

coalesces into a whole when the portrait is seen from a distance. It is of course Hals's ability to capture the momentary and to seize the instantaneous that made him such a hero for later artists such as Manet, Van Gogh and Sargent.

ELIZABETH THOMPSON, LADY BUTLER (1846–1933)
The Return from Inkerman 1877
Canvas, 104.4 × 185.6 cm / 41⅛ × 73⅛ in. Signed and dated

Elizabeth Thompson, later Lady Butler, was the leading battle painter of her day. She rose to fame with three sombre depictions of the Crimean War: *Calling the Roll after an Engagement* ('The Roll Call') (Royal Collection), *Balaclava* (Manchester Art Gallery) and *The Return from Inkerman*. 'The Roll Call', shown at the Royal Academy and subsequently sent on tour around the country, was one of the most popular paintings in the 19th century.

What is notable about all three paintings is the sombre realistic tone illustrating – indeed emphasizing – for the first time in British art the pathos of war and the plight of the ordinary soldier. The Crimean War, fought against Russia by Britain, France

and Turkey in 1854–56, was the first to have been widely reported in the newspapers and journals of the day: in these respects it can be seen as the first 'modern' war, and it marks the start of a changing attitude to heroism and valour.

The artist always prepared her paintings very carefully, showing tremendous respect for accuracy and often interviewing people who witnessed the scene. *The Return from Inkerman* depicts a ragged column of exhausted soldiers, many of whom are wounded, trudging back to camp from the heights of Inkerman on the evening of 5 November 1854. The soldiers are mostly of the Coldstream Guards and the 29th (East Devonshire) Regiment. The battle had been fought in the most adverse conditions of rain and fog, making it difficult for officers to give effective orders. The hardship and tragedy of war are evident.

Elizabeth Thompson was born in Switzerland and spent most of her early life in Italy. Her training was limited, and she did not really enjoy the Female School of Art at South Kensington in London which she attended in 1866. Her interest in painting battle scenes, aroused by seeing the work of the French painters Edouard Detaille and J.-L.-E. Meissonier, was first expressed in a scene of

the Franco-Prussian War. She married a soldier, and remained committed to painting aspects of military life throughout her career. Many of her subjects were historic, set in the Crimean War or the Napoleonic Wars, but she also confronted potentially controversial contemporary issues such as the colonial wars in Africa during the last quarter of the 19th century, the Boer War, and even the First World War, in which two of her sons served.

Lady Butler introduced a realistic note into battle paintings by pointing up the suffering and courage of ordinary soldiers, but this could not be sustained in a time of fluctuating attitudes to war, and her work did not remain popular either with the public or with her peers at the Royal Academy. Other battle painters such as Richard Caton Woodville benefited from the advances she had made, but pandered to the public's taste for more uplifting pictures. Yet, as the great Detaille himself said, 'L'Angleterre n'a guère qu'un peintre militaire; c'est une femme' (England has only one military painter; and it's a woman).

'Lady Butler has done for the soldier in Art what Mr. Rudyard Kipling has done for him in Literature – she has taken the individual, separated him, seen him close, and let the world see him'

WILFRED MEYNELL, 1898

RICHARD CARLINE (1896–1980)

Gathering on the Terrace at 47 Downshire Hill, Hampstead 1925

Canvas, 195 × 161.3 cm / 76¾ × 63½ in.

This group portrait is an early but important work by a member of a gifted family that contributed a great deal to British painting during the first half of the 20th century. George and Annie Carline (both artists) married in 1885 and had five children, the three youngest of whom became artists – Sydney, Hilda and Richard. The family home in London on Downshire Hill was acquired in 1916 and became a centre (a veritable 'cercle pan-artistique' according to Henry Lamb) for informal discussions between the family and a wide circle of friends on art, politics, religion and life, until they moved to another address in Hampstead in 1936. Such discussions were leavened by frequent travel for painting holidays and wide reading, resulting in an intellectual independence tinged with radicalism.

The participants in this painting are (from left to right) Stanley Spencer, James Wood, Kate Foster, Hilda Carline, Henry Lamb, Richard Hartley, Annie Carline and Sydney Carline. Each figure was carefully prepared in an oil study before being fitted into a fairly complex composition, and the individual characterizations remain one of its principal strengths. The artist said that he 'sought to convey the conflicting personalities gathered at our house – Stanley peering up and down as he expounded his views on this or that, James Wood hesitating in the doorway whether to come or go, Hilda absorbed in her own thoughts, Hartley sitting at ease, Lamb courteously attentive to my mother, with Sydney always helpful'.

Richard Carline studied art at Percyval Tudor-Hart's schools in Paris and Hampstead in 1913 before attending the Slade School of Fine Art (1921–24). The intervening war period was spent first of all with the Royal Flying Corps and then as an official war artist. Together with his brother Sydney he was posted to the Middle East, where they depicted war zones from the air, producing a breathtaking series of paintings and studies (London, Imperial War Museum). His art at this period and during the 1920s was notable for its directness, with bold simple forms defined by a sympathetic treatment of light emulating contemporary French avant-garde painting. His style and colouring were influenced, and in turn appreciated, by Stanley Spencer, who married his sister Hilda in 1925 (a marriage that ended in divorce in 1937).

A change came over Richard Carline's art during the 1930s when he began to address socio-political issues and take up national and international causes, to promote art of all kinds across geographical boundaries regardless of intellectual differences or limitations.

One would not expect anything else from the painter of *Gathering on the Terrace*, and even in the Ashmolean Museum when I worked there between 1968 and 1988 the Carline family was still much in evidence (Sydney had been Master of the Ruskin School of Drawing 1922–29 and Richard taught there from 1924) as witnesses to an extraordinary – and perhaps still underestimated – contribution to the artistic life of the nation.

MEREDITH FRAMPTON (1894–1984)

A Game of Patience (Miss Margaret Austin-Jones) 1937

Canvas, 106.7 × 78.7 cm / 42 × 31 in.

Frampton was one of the most regular and popular exhibitors at the Royal Academy during the 1930s, specializing in portraiture, particularly of people active in artistic or intellectual pursuits. His pictures make for compelling viewing as a result not just of the exact drawing, pale tonality and bright illumination, but also because of the settings and attributes which in their random distribution can give the compositions a Surrealistic air. Not surprisingly, Frampton was a slow worker, but what his pictures reveal is a wonderful feeling for different textures and for the three-dimensional quality of objects.

Frampton lived in a style that is suggested by his paintings. He began at the St John's Wood Art School and proceeded to the Royal Academy Schools (1912–15). *A Game of Patience* demonstrates his skills in all departments – portraiture, still-life and landscape – but it also reveals his ability to fit everything (even quite random objects) so neatly together. He was a master of trompe-l'œil effects.

If this love of materials and textures came from his father, the sculptor Sir George Frampton, the commitment to workmanship came from his own long association with the Art Workers' Guild. There is something satisfying about the fact that in the First World War he was involved with a field survey company making aerial sketches of enemy trenches. Then during the 1930s he designed his own house at Monkton Deverill in Wiltshire, the interior of which evidently reflected the perfection of one of his own paintings. Indeed, such was Frampton's concern for perfection that he stopped painting in 1945 when his sight began to deteriorate, and in 1953 he formally retired from the Royal

'The lady's not for turning'

PRIME MINISTER
MARGARET THATCHER,
10 OCTOBER 1980

Academy, of which he had been a member since 1942. So decisive was this step that he fell completely from public view, and it was not until 1982, when he was eighty-eight, that he had his first retrospective. Even so his work has influenced younger generations.

The unusual format of *A Game of Patience* suggests an affinity with early Netherlandish painting, particularly Van Eyck, but otherwise the picture is redolent of the decade in which it was made. It has the flavour of one of T. S. Eliot's verse plays, and is disturbing in its almost obsessive attention to verisimilitude. The objective clarity brought to the figure provides a sense of emotional distance: it is not a particularly intimate portrait (though in a slightly earlier portrait Meredith Frampton had painted the then twenty-three-year-old Margaret Austin-Jones in a dress made by his mother from a Vogue pattern), and one feels that there might be a lot of symbolism at work. The claw-like hand with elongated fingers is simply terrifying.

Leeds

LEEDS ART GALLERY

Leeds Art Gallery is centrally situated on the Headrow next to the Town Hall and City Library. It was founded by the Art Gallery Committee of Leeds City Council in 1888 in the aftermath of Queen Victoria's Golden Jubilee celebrations. The impetus came from Colonel T. W. Harding, chairman of the Committee, and the building was duly opened by the artist Hubert Herkomer. The architect was W. H. Thorpe, who created an exhibition space as opposed to a series of galleries, since Leeds at that stage had only a small permanent collection. Beyond the Victorian entrance hall and stair-case, which are the vestiges of the original building, there are now a number of upgraded galleries dating from the early 1960s.

The collection of paintings has been built up only slowly, beginning with a small phalanx of Victorian pictures (although without the Pre-Raphaelites) under the first Curator, George Birkett. Its development owes a great deal to the supportive Leeds Art Collections Fund and a run of good appointments to the position of curator: Frank Rutter, who had the confidence of Sir Michael Sadler (Vice-Chancellor of Leeds University), John Rothenstein (later Director of the Tate Gallery), Philip Hendy (later Director of the National Gallery and Slade Professor of Fine Art at Oxford), Ernest Musgrave, Robert Rowe and Christopher Gilbert. The art theorist and critic Sir Herbert Read was also closely associated with Leeds.

A number of donations and bequests were made early on, especially during the 1920s and 1930s, including the collections of Sam Wilson, a local cloth manufacturer with an interest in works by members of the New English Art Club (given in 1925), and

of Charles Roberts, whose preference was for French 19th-century painting (given in 1937). The emphasis on making acquisitions and keeping astride developments in modern art was strong, and the creation in Leeds of the Henry Moore Institute provided an extra impetus.

Leeds Art Gallery has two outstations where paintings in keeping with the locations are displayed: Lotherton Hall and Temple Newsam.

GUSTAVE COURBET (1819–77)
Les Demoiselles de Village 1851–52
Canvas, 54 × 65.4 cm / 21 ¼ × 25 ¾ in.

Courbet was the *enfant terrible* of French 19th-century painting. His larger-than-life personality, with his fixation on self-portraiture denoting an unusual concern for his own image, combined with radical political beliefs so forthrightly expressed, gave him a special place in the unfolding of French art. A champion of realism (by which he meant subjects taken from everyday life but treated seriously and uncondescendingly), in the 1840s and 1850s he painted a series of pictures that were uncompromising in both scale and subject, including *The Burial at Ornans* and *The Artist's Studio* (both Paris, Musée d'Orsay), all of which have given rise to much discussion amongst scholars in the light of the political and economic travails of mid-19th-century France.

Courbet always managed to keep a high profile. A friend of the poet Charles Baudelaire, the anarchist philosopher Pierre-Joseph Proudhon, and the writer Champfleury (a pseudonym), whose book *Realism* was published in 1857, he had a tendency to run counter to established authority, as when he set up his own exhibition spaces in 1855 and 1867 at the Expositions Universelles held in those years. His intransigeance continued throughout his life, and in 1871 he took part in the Commune in Paris and oversaw the demolition of the Vendome Column, for which after the defeat of the Commune he was arrested and imprisoned. Eventually in 1875 he was forced into exile in Switzerland, where he died.

Courbet courted heroism, and he was a powerful painter who not only engaged in subjects open to political interpretation but could also be intensely poetic in his treatment of subject-matter – the female nude, landscape, still-life, hunting scenes, and extraordinary seascapes where he reveals the immensity of nature before which man (including rather surprisingly and endearingly himself) is powerless. No other 19th-century painter depicted the texture of female flesh or fruit with such a tender touch or sensual feeling for colour.

Les Demoiselles de Village shows three middle-class women (the artist's sisters) in conversation with a young cow girl. The setting is near Ornans in the Franche-Comté where Courbet was born. The theme is the exercising of charity to alleviate the plight of the rural

Bonjour
Monsieur Courbet

poor. A much larger version of the composition (with some changes) was exhibited at the Paris Salon of 1852 and is now in New York (Metropolitan Museum of Art). It has always been thought that the picture in Leeds was painted before the other one as a sketch, but there is technical evidence to show that it was in fact a reprise. Both paintings were shown in Paris in 1855 – the larger one in the main Exposition Universelle and the smaller one in the Pavillon du Réalisme. One of the advantages of the composition is that it unites two of the aspects for which Courbet's art is famous – genre and landscape.

WYNDHAM LEWIS (1882–1957)

Praxitella 1921
Canvas, 142.2 × 101.6 cm / 56 × 40 in. Signed

Combative, angry, pugnacious and, above all, contrary, Wyndham Lewis was a man with a mission – namely, to introduce modernism into British art – and he did not mind what lengths he had to go to to succeed. His self-portrait entitled *Mr Wyndham Lewis as a Tyro* (Hull, Ferens Art Gallery) is terrifying, just as his *Portrait of the Artist as the Painter Raphael*

(Manchester Art Gallery) underlines his egocentricity, and it is not uncharacteristic that his autobiography should have been called *Blasting and Bombardeering*, even if it does recount his experiences of the First World War. Lewis's petulant manner and bombastically expressed views were easily misinterpreted, as indeed they were (perhaps with some justification) when he lurched towards Fascism in the early 1930s.

Born off the coast of Nova Scotia to an American father and a British mother, who soon separated, he was brought up in England and studied at the Slade School of Fine Art (1890–1901). From the first he had literary leanings, which he practised throughout his life (fiction, polemics, art criticism), and it is perhaps significant that some of his best portraits are of famous writers (Ezra Pound, James Joyce, Edith Sitwell, T. S. Eliot).

As a painter it was Lewis's concern to jolt contemporary British art from what he saw as its atrophied and complacent state into the modern world. This he did by advocating Vorticism, which owed its origins to Futurism and was launched upon the world in his magazine *Blast* (1914). Typically, Lewis set up the Rebel Art Centre in answer to Roger Fry's Omega Workshops, but quite soon he also divorced himself from the Futurists and in the end Vorticism was cut short by the First World War.

'I was both an artist and a lion'

WYNDHAM LEWIS, *BLASTING AND BOMBARDEERING*, 1937

Called up in 1916, Lewis was soon appointed an official war artist and painted some of his most compelling pictures. Warfare was a modern subject, and his clear hard-edged style was a powerful means of depicting it. *Praxitella*, like many of his portraits, partakes of the same style. The seated figure appears to be encased in armour plating like a character in *Star Wars* or a modern Japanese toy. The grey flesh tones have a metallic lustre and the hands resemble gauntlets. It comes a surprise, therefore, that the sitter was not just his partner, but also bore him two children. The relationship was stormy, and in Iris Barry (1895–1969), who went on to be the founder and first curator of the film department in the Museum of Modern Art in New York in 1935, Lewis may have met his match.

PAUL NASH (1889–1946)

The Shore 1923

Canvas, 62.2 × 94 cm / 24½ × 37 in. Signed and dated

The experience of being an official war artist during the First World War deeply affected Paul Nash and released his imagination, so that his paintings of those years have a searing quality. The impact of war was heightened by the fact that as a person he was highly organized and most fastidious – in appearance, speech and outlook. It was these attributes that made him such an outstanding designer and printmaker, in addition to his perspicacity as a critic and essayist. Never a retardataire painter, Nash embraced developments made on the Continent, particularly in Paris.

To recover from the war, Nash settled at Dymchurch in Kent close to Romney Marsh. Here he painted a series of pictures of the sea, the breakwaters and the flood defences, including *The Shore*. These subjects preoccupied him during the 1920s, and he occasionally returned to them. The compositions are all notable for their careful structuring, as though inspired by geometry, and showing awareness of advanced theories of theatre design.

His work moved during the 1920s and 1930s more towards abstraction and Surrealism, but always within his own terms, which were quintessentially English. As Myfanwy Piper, the wife of John Piper, wrote, 'his work had none of the shock tactics of continental surrealism but retained the sweetness of the English landscape, the uncertainties of the English weather, and the whimsicalities of a cultivated English mind.'

Great play is made in *The Shore* of the sea wall, the ramp and the breakwaters, but even more remarkable is the shimmering, opalescent light derived from the mistiness of summer sun on water and sand, creating that characteristic pearly luminosity of the southern coast of England. This is the same insight that Nash had brought to the First

World War battlefields, which show a similar simplicity. Nash believed strongly in the sense of place, so that his unpopulated compositions can be thought of as having personalities in their own right. In *The Shore* the barrenness of the battlefield is replaced by the soothing calm of peace.

FRANCIS BACON (1909–92)
Painting 1950
Canvas, 198 × 132 cm / 77⅞ × 51⅞ in.

For a man who was essentially reserved and private, a great deal is known about the life and opinions of Francis Bacon. In addition to all the critical apparatus of standard art-historical literature there are countless interviews, both printed (most famously with Michael Peppiatt and David Sylvester) and filmed. By the end of his life he was the most celebrated British artist of the 20th century and certainly the one most readily associated with the so-called London School of painters.

Born in Dublin, the son of a racehorse trainer, Bacon had come to painting, which he basically taught himself to do, through design. He began to establish a reputation in the 1930s, when the main theme concerning what he called 'the ferocity of life' began to emerge in his work. Although he travelled a certain amount, Bacon remained an urban figure almost totally landlocked latterly in London in the chaos of his Reece Mews studio (re-created in Dublin City Gallery The Hugh Lane) or in the bars and clubs of Soho.

His use of visual sources, often known only at second hand through reproductions frequently ripped, torn or splattered with paint, was promiscuous: Bacon stated that specific images were needed 'to unlock the deeper sensations'. In many ways he was a highly traditional artist, honouring his great forebears such as Velásquez, Cézanne, Van Gogh and Picasso and time-honoured formats such as the triptych; but the world he depicted was very much based on his own experience, which revealed 'the basic and unalterable acts of existence' or ultimately man's conscious or unconscious inhumanity to man. Thus he was very dependent on a cast-list of friends and lovers for his subject-matter, elevating them in his paintings to the status of the heroes and heroines of the ancient Greek stage. Most unnerving of all is the fact that the pictures reveal so much about the artist himself, as he watches his 'own decay in the interval that separates life from death'.

Painting dates from a time when Bacon was still exploring a wide range of subjects. Here there is an emphasis on the body and a sense of movement suggested by the shadowed form seen behind as though a transparent curtain. There are surprising abstract elements in the picture, evoking comparison with Mark Rothko or Barnett Newman in particular. The play of vertical and horizontal lines or patches of paint creates a feeling of entrapment: the figures exist in a space from which they can never escape, or from which they will forever be seeking the means to escape. But *Painting* also stands as testimony to

Bacon wanted his pictures 'to look as if a human being had passed between them, like a snail, leaving a trail of the human presence'

Bacon's unalloyed enjoyment of the sheer craft of painting: note the wonderful treatment of the flesh, comparable with Rembrandt in the figure, and the Venetian sumptuousness of the colours.

Throughout his career, however violent or animalistic the image or whatever the scale, paintings by Bacon are always immaculately made. 'You have to be disciplined in everything, even in frivolity – above all frivolity', he once said. As in his carefully groomed appearance and as in his taste for the best vintages of champagne or his careful mode of speech, so Bacon insisted that his canvases be shown behind glass set into gold frames. 'Real art', he said, 'is always evolved no matter how much has been given by chance.'

Newcastle upon Tyne

LAING ART GALLERY

One of the most exciting galleries in the North-East, founded by a Scotsman, Sir Alexander Laing (1820–1905), who created a successful business in the city as a brewer and wine merchant. He proposed the idea of an art gallery in 1900 and offered the Council £20,000 to build one. The architects J. T. Cackett and Robert Burns-Dick, whose work abounds in Newcastle, designed the building in Edwardian Baroque.

Initially there was no permanent collection. The first purchases were made in 1919, and many then and subsequently were made by two directors, C. Bernard Stevenson and his son B. Collingham Stevenson, who held sway from 1904 until 1976. The holdings are strong in 18th-century British portraits and landscapes, followed by a group of Pre-Raphaelites and a wide selection of modern (including contemporary) works. There are memorable – and sizeable – pictures by John Martin and Sir Edwin Landseer. Prepare to be overwhelmed.

JOHN MARTIN (1789–1854)
The Bard 1817
Canvas, 270 × 170 cm / 106¼ × 66⅞ in.

British painting sometimes produces artists whose imaginations outsoar their skills: Benjamin Robert Haydon is one and John Martin another. Martin, born at Haydon Bridge, to the west of Newcastle upon Tyne, into an eccentric family, began as a painter of china and glass, but graduated to portraying sensationally dramatic scenes on an increasingly large scale, to be viewed sometimes in sequence as panoramas. He took the subjects from literary sources, primarily from the Old Testament. At first he dealt in the Romantic Sublime, as in *The Bard*, but soon he became increasingly absorbed by apocalyptic scenes full of extraordinary effects and massive architectural recreations foretelling the world's catastrophic end. Not content to do this in oil paint, he also turned to making illustrations of the Bible and of Milton's poetry for printed books. These, however, were not as remunerative as the mezzotints he made after his pictures.

Martin also turned his hand to urban improvements involving lighting, sewage and transportation, which anticipated future developments by many years. Given the fact that his main theme was the spectacle of natural disaster portrayed on such a vast scale, it is hardly surprising that he found it hard to secure regular patronage, and he eventually fell foul of the Royal Academy. However, his career revived towards the end with further scenes of destruction and visions of paradise which were increasingly popular with the public.

'On a rock, whose haughty brow / Frowns o'er old Conway's foaming flood, / Robed in the sable garb of woe, / With haggard eyes the Poet stood'

THOMAS GRAY, 'THE BARD', 1795

The Bard is based on the poem of the same name by Thomas Gray, dating from 1755, which had already inspired several artists. It relates an incident in the conquest of Wales by Edward I (1276–95). The departing King had ordered that all bards should be slaughtered, as they were the focus of Welsh resistance, but one held out: 'On a rock, whose haughty brow / Frowns o'er old Conway's foaming flood, / Robed in the sable garb of woe, / With haggard eyes the Poet stood; / (Loose his beard and hoary hair / Streamed, like a meteor, to the troubled air) / And with a master's hand and prophet's fire, / Struck the deep sorrows of his lyre. / Hark, how each giant-oak, and desert cave, / Sighs to the torrent's awful voice beneath! . . .' He curses the departing King, 'As down the steep of Snowdon's shaggy side / He wound with toilsome march his long array.' At the end – after the moment depicted by Martin – the Bard commits suicide. 'He spoke, and headlong from the mountain's height / Deep in the roaring tide he plunged to endless night.'

The scale of the composition, the panoramic effect of nature, and the operatic gestures struck fear into Martin's contemporaries, just as today we still stand back from his pictures in utter amazement.

SIR GEORGE CLAUSEN (1852–1944)
The Stone Pickers 1887
Canvas, 107.6 × 79.2 cm / 42⅜ × 31¼ in. Signed and dated

Of Danish descent and once mistaken as a Dutch artist, Clausen played an interesting role in the development of British art, symbolized by his appointment as Professor of Painting at the Royal Academy in 1904. He had begun as a run-of-the-mill late Victorian painter, trained at the South Kensington School of Art (1873–75), but a visit to the Académie Julian in Paris (1881) and the discovery of the work of Jules Bastien-Lepage caused him to take off in a different direction. He became a painter of rural scenes, honestly observed out of doors and painted in a more direct style influenced by the technical advances made by the Impressionists, notably Monet's treatment of colour from the 1880s. Clausen was a founder member of the New English Art Club, which championed connections with French art and Bastien-Lepage's methods in particular. He assiduously pursued rural themes for the rest of his long life, although he became an official war artist for the First World War, and in 1925 was chosen to paint a mural for a series in the Palace of Westminster.

The Stone Pickers looks back to Clausen's visit in 1882 to Brittany, where many French (and several British) avant-garde painters took up themes suggested by rural life and customs. He sets the main figure against a high horizon line formed by a sloping hillside where a second figure is bent over her work preparing the field for ploughing. The vertical format emphasizes the monumentality of the main figure, who is dropping the stones she has gathered onto the pile in the foreground. Clausen has depicted the scene with

An Anglo-French alliance

considerable accuracy, emphasizing exhaustion and the repetitive nature of the work, but he refused to be categorized by the critics as a social realist, and indeed the hardship of rural labour is here subverted by the sheer quality of the work, compositionally assured and with great variety in the handling of paint. The Raphaelesque beauty of the young woman (modelled by his children's nursemaid, Polly Baldwin) and the carefully graduated tonal passages reveal Clausen's technical skills at their best.

There are several such scenes by Clausen in British galleries and they always impress.

Sheffield

GRAVES GALLERY

The museums in Sheffield have been subject to a recent amalgamation, and are now known collectively as 'Museums Sheffield'. The Graves Gallery is on the top floor of a Portland stone building in classical style that it shares with the Central Library, designed by W. G. Davies and opened in 1934.

The collection of pictures is an amalgamation of those given by two local philanthropists – J. N. Mappin (1800–1883), a brewer, and J. G. Graves (1866–1945), an alderman and founder of one of the first mail-order businesses in the country. Until recently these two benefactions were shown in separate buildings. Mappin's taste was for Victorian pictures, which he bequeathed to the city; Graves collected old masters, but became an important advocate of British 20th-century painting and enjoyed works by contemporary artists. In this last interest he was keenly supported by Sir John Rothenstein, whom he appointed as the first director. There is also a strong group of pictures by French 19th-century painters. The pattern of collecting established by Graves has been continued by later directors, notably by Frank Constantine and Julian Spalding.

JEAN-LÉON GÉRÔME (1824–1904)
The Death of Marshal Ney 1868
Canvas, 64 × 103.5 cm / 25¼ × 40¾ in. Signed

Gérôme was one of the most feted artists in France during the second half of the 19th century. A pupil of Paul Delaroche and Charles Gleyre, he achieved popularity as a salon painter with his realistic treatment of Classical and Oriental subject-matter. These pictures – often on a large scale – ranged from genre scenes to historical renderings, sometimes of remarkable accuracy, based on his numerous research trips to the Near East. His popularity was enhanced by the warm critical reception extended to his works, the vigorous promotion orchestrated by his father-in-law, the dealer Adolphe Goupil, and the dissemination of the images by photogravure.

Gérôme received major honours for his work, including membership of the Institut de France in 1865. Appointed one of three professors of painting at the Ecole des Beaux-Arts two years before, he exerted an immense influence on his numerous students, both French and otherwise. His work was avidly collected in America, but fell from popularity when the Impressionists and Post-Impressionists began to win acceptance. Now that a broader appreciation of French 19th-century art abounds, Gérôme's paintings (and his sculpture) are being re-assessed. There are only a few pictures by him in Britain.

'The bravest of the brave'

NAPOLEON
ON MARSHAL NEY

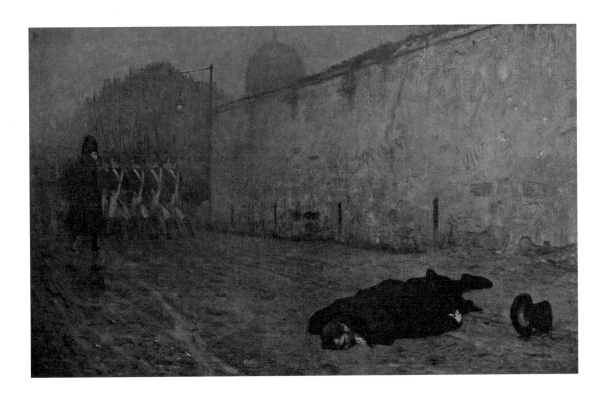

The full title of the picture at the time of the Salon of 1868 – *Le 7 décembre 1815, neuf heures du matin (L'Exécution du Maréchal Ney)* – echoes the titles of two of Goya's most famous paintings. Born in 1769 of humble origins, Ney rose rapidly in rank during the Revolutionary Wars and was one of Napoleon's generals. Nowhere was his bravery more on display than in Russia, where having played a major part in the advance on Moscow in 1812 he covered the French army's rear during its disastrous retreat. Following Napoleon's abdication in 1814, Ney supported the restored Bourbon monarch, Louis XVIII. Upon Napoleon's escape from Elba, Ney returned to the Emperor's side and fought at Waterloo. After Napoleon's defeat he was tried for treason and shot.

The scene as shown by Gérôme is a dismal one on a dank winter morning in the Place de l'Observatoire in Paris. The Marshal is dressed in civilian clothes instead of military uniform, and had chosen not to be blindfolded. He himself had given the order to fire. His body lies face down in the mud with his hat to one side. The wall behind is daubed with political graffiti. The firing squad marches off to left into the morning mist: the officer glances back to check that the body has not moved, but possibly also with a look of regret at the passing of a great hero.

Marshal Ney was already a popular figure because of his exploits on the field of battle, and his death was surrounded by legend (some thought that he had escaped to America). This picture has an edge to it that other works by Gérôme sometimes lack. The Marshal's son wanted it removed from the Salon, but the artist refused.

WALTER RICHARD SICKERT (1860–1942)
L'Hôtel Royal, Dieppe c. 1894
Canvas, 50.5 × 61 cm / 19⅞ × 24 in. Signed

Sickert was by nature a contrarian, an attitude of mind that eventually made his art distinctive. Although he was conscious of the innovations in art that occurred during his long lifetime, he remained a dispassionate observer, retaining a fair degree of independence even when associated with such bodies as the Camden Town Group or exhibition organizations including the New English Art Club and the Allied Artists' Association.

His outlook was determined by his cosmopolitan upbringing. He was born in Munich of Danish descent, and came to London with his family in 1868. He was fluent from an early age in German and French, as well as English. Initially he worked as an actor, and throughout his life he retained an interest in the stage, as evidenced by many of his paintings. It was a chance encounter with Whistler that inspired Sickert to become a painter. During his career he lived for various periods and worked frequently in Dieppe, Venice, Paris and London. His final home from 1938 was at Bathampton near Bath.

As a character Sickert was larger than life, as though acting out a part. His unusual appearance, vivid conversation and chaotic studio were often remarked upon. Here was a

The seafront seen by
the Canaletto of
Dieppe

man who was totally dedicated to his art, who enjoyed teaching it and who wrote vivid criticism. He relished the music hall and popular songs, quoted reams of Shakespeare, made rambling speeches, and pronounced coruscating bon mots of the type that can destroy friendships. Degas was his hero and a strong influence on his work. His Camden Town paintings in particular captured the world as seen through a window by a passer-by. He thought that the greatest danger to art was good taste.

Sickert lived in Dieppe, the popular resort on the Normandy coast, from 1898 to 1904, but he had visited the town earlier and continued to do so into old age. He was interested in painting the architecture, to the extent that his close friend Jacques-Emile Blanche – an early owner of *L'Hôtel Royal* – christened him the Canaletto of Dieppe. He seems to have painted the hotel in about 1894 and again in 1898. Built in 1830 (and demolished in 1900), it overlooked the sea across a marine parade of lawns and flowerbeds on the Rue Aguado (now Boulevard de Verdun), and was popular with fashionable visitors from London and Paris.

The painting is eye-catching because of its lurid colour. The rose-violet sky suggests a moment between sunset and nightfall. The remaining light is reflected in the hotel's windows, while its white façade has a livid greenish hue. The two female figures in the centre are so deftly painted that they resemble candle flames fluttering in the wind. The influence of Whistler is apparent throughout the picture, which underscores its early date, and the figures suggest an awareness of Aubrey Beardsley, who died in 1898.

ROGER FRY (1866–1934)
Edith Sitwell 1918
Canvas, 61 × 45.5 cm / 24 × 18 in. Signed and dated

Both the artist and the sitter were in their different ways proponents of modernism in Britain and moved within the orbit of the Bloomsbury Group. After Cambridge University Fry abandoned the natural sciences for art and proved to be the most influential writer, lecturer and broadcaster of his generation. Of his books the most famous is *Vision and Design* (1920), still in print. Fry was fairly outspoken and had an awkward relationship with official bodies. On the other hand, in a practical way he supported the launch of the important learned journal the *Burlington Magazine* and the setting up of the National Art Collections Fund (now The Art Fund) – both in 1903.

Fry's output as an artist reflected his intellectual concerns. He explored first of all classicism, which led to

an espousal of formalism that in turn encouraged him to think of abstract design, which culminated in the foundation in 1913 of the Omega Workshops. His own landscapes, portraits and still-lifes vary enormously in quality, and Fry could never have made a living just from being an artist.

The portrait of Edith Sitwell (1887–1964) is an exceedingly touching example of Fry's portraiture at its best. It belongs to a type of likeness that he termed 'imaginative characterization'. The sitter was already established as an innovative poet interested in experimental techniques, word patterns and sounds. Her initial platform was a periodical entitled *Wheels* (1916–21), but welcome notoriety came later with the first performance of *Façade* (1922). In all these ventures she was supported by her younger brothers, Osbert and Sacheverell, with whom she had shared an extraordinary upbringing at Renishaw Hall in Derbyshire, suffering from the whims of an eccentric and sometimes cruel father.

Throughout her life Edith Sitwell emphasized her individuality, and she was one of the most frequently depicted women of her time in all media. Apart from her output as a poet, she was also a fine biographer and an occasional novelist. She adopted a persona helped by her most unusual appearance: tall and aristocratic in demeanour, extended aquiline nose, oval face, tight lips and slender fingers. All of this is evident in Fry's portrait, which successfully suggests her fragility and vulnerability. Still young, the sitter (her hand posed as in the portrait of Madame Moitessier by Ingres in the National Gallery, London) is unguarded, and not yet the rather formidable priestess decked out in flowing gowns and turbaned headdresses with spectacular jewelry.

Edith Sitwell was given an honorary degree by Sheffield University in 1955.

SIR WILLIAM COLDSTREAM (1908–87)
View of Rimini with the Tempio Malatestiano in the Distance 1944–45
Canvas, 70.5 × 90.2 cm / 27¾ × 35½ in.

For much of his life Coldstream was associated with the Slade School of Fine Art at the University of London, first of all as a student and later, after having taught at Camberwell School of Arts and Crafts, as professor. He was an influential teacher, with many public duties as a trustee and on committees. By the end of his life he was seen very much as an establishment figure (an impression not counteracted by his preference for suits and an iron self-discipline), but earlier during the 1930s he had contributed to more socially engaged projects such as the General Post Office film unit, working alongside W. H. Auden and Benjamin Britten, and participated in the activities of the Mass-Observation Unit.

In the late 1930s Coldstream joined with Claude Rogers and Victor Pasmore in starting the Euston Road School of drawing and painting. The School closed at the start of the Second World War, but it had a steady (some would say baneful) influence on the future of British painting, fortified no doubt by its links with the Bloomsbury Group.

'I wore a green evening dress, the colour of the leaves of lilies . . . in the full glare of the midsummer light of midday . . .'

EDITH SITWELL,
TAKEN CARE OF, 1965

'Rimini is not an attractive town'

ADRIAN STOKES, 1934

From the start Coldstream was filled with self-doubt and was almost overly concerned with the process of painting. Like Cézanne, he strove above all for objectivity. This was achieved by constant observation, careful measurement, precise markings, much deliberation and an economy of brushwork.

Appointed an official war artist in 1943, at first in Egypt he was involved principally in portraiture, but in Italy he turned more to landscape and topography. In Rimini from December 1944 until May 1945, he was particularly concerned with two buildings there, the Opera House and the church of S. Francesco, both much damaged in the war. The church, known as the Tempio Malatestiano after the ruler of Rimini, Sigismondo Malatesta, who had it remodelled, is one of the most fascinating buildings of the early Renaissance, and was the subject of a book written by Coldstream's friend Adrian Stokes. It is seen right of centre at a distance, set among other buildings so that it is not obviously the subject of the painting, but its campanile still standing among the ruins seems symbolic. The tonal nuances, as much as the architecture, provide a sense of recession as in paintings by Corot.

As was his habit, Coldstream worked on the painting incessantly, his frustration mounting with the changing weather and shifting light, which constantly altered the tonal values of the pink masonry: in the rain the walls were deep red, and they became pink as they dried out in the sun. On 28 March Coldstream wiped his canvas clean and began again for another nineteen sessions before he had to leave Rimini. Technically, he regarded it as unfinished, but in that respect it stands comparison with Cézanne.

Stockton-on-Tees

PRESTON HALL MUSEUM

Formerly a privately owned early 19th-century house set in a park, Preston Hall became a museum in 1953 following its purchase by the local Council to house two bequests, both of which had been in the Council's possession for several years. These were the Clephan Bequest of paintings and watercolours and the Colonel Gilbert Ormerod Spence Bequest of arms and armour and decorative arts. *The Dice Players* by Georges de La Tour came from the Clephan collection.

GEORGES DE LA TOUR (1593–1652)
The Dice Players c. 1650
Canvas, 92.5 × 130.5 cm / 36½ × 51⅜ in. Signed (possibly added later)

La Tour was born in Lorraine and spent most of his working life there, in Lunéville. His compositions fall broadly into two categories – single figures, often of saints in contemplative mood, and groups engaged in such activities as card-playing or fortune-telling. Only very occasionally did he paint religious narrative subjects. All his pictures have a surprising degree of realism in the treatment of facial features and attributes. Similarly, his 'types' tend to divide between closely observed depictions of the ravages of age on the one hand, and on the other younger people, sometimes of indeterminate sex, with idealized features. A notable aspect of La Tour's work is his preference for sources of light from within the picture, such as candles or tapers. These create the nocturnal tenebrist effects that align his œuvre with the northern followers of Caravaggio such as Gerrit van Honthorst, Hendrick ter Brugghen and Dirk van Baburen. So little is known about La Tour's artistic training and development that it is not clear how he came across all the elements that comprise his style, but what is clear is that he bound them together to make paintings of great poetical beauty.

The Dice Players is most probably La Tour's last depiction of a theme that he treated quite often earlier in his career, and he may have been assisted in it by his son Etienne. The broad unbroken surfaces of the armour are features observable in other late pictures by the artist.

All is not quite what it seems

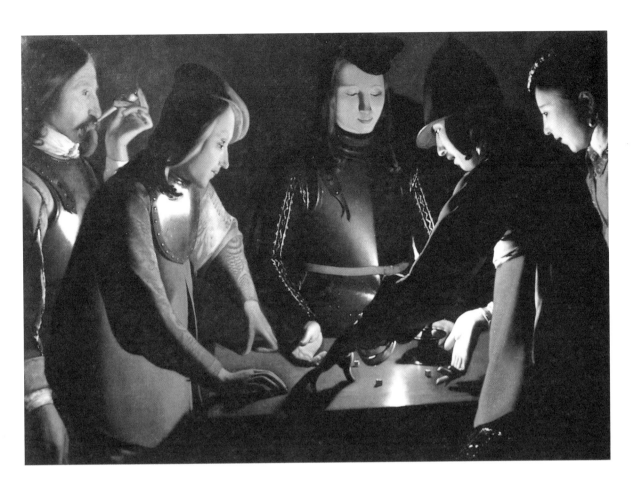

The arrangement around the table involves three men playing dice, an older man smoking a pipe on the left and a younger person (possibly a woman) on the right. The chiaroscuro effect is strong, and note how La Tour cleverly has the figure of the dice player on the right stretch out his arm so that it partly obscures the candle flame. All is not quite what it seems: the older man on the left is about to pick the pocket of his neighbour, and the role of the youthful figure balancing him on the extreme right is open to interpretation.

This ambivalence carries over to the meaning of the picture as a whole. Paintings with themes such as fortune-tellers and card-players are not often the straightforward renderings that their titles might suggest. An allegorical implication is possible, for both activities can be interpreted in terms of idleness or cheating. Smoke such as that rising from the older man's pipe here, for example, is a symbol of vanity or inconstancy. Sometimes a link with the story of the Prodigal Son is posited as the real subject of these paintings.

All such matters will undoubtedly continue to be debated, but the great beauty of *The Dice Players* cannot be denied. There are remarkable passages which give the picture a magnetic appeal.

York

YORK ART GALLERY

The building was erected for the second Yorkshire Fine Art and Industrial Exhibition, held in 1879. Designed by Edward Taylor in Italian Renaissance style, it is approached through an elegant arcaded loggia flanked by 'mosaics' with scenes from the lives of Leonardo da Vinci and Michelangelo. Beyond the entrance hall is an area created in 2007 especially for temporary exhibitions, off which the ground floor galleries radiate. A fine staircase leads to the galleries on the upper floor. The gallery was acquired in 1891 by the Corporation of York.

The collection of paintings provides a reasonably coherent survey of developments in Western European art through the centuries. Many of the old masters were presented in 1955 by the industrialist and engineer F. D. Lycett Green, whose family was closely associated with the city. Victorian genre paintings had been bequeathed by a local businessman, John Burton, in 1882. Of greatest interest from the Victorian period is the extensive holding accumulated since 1911 of the work of William Etty, the city's most famous artist; appropriately, a statue of him stands outside the gallery. Many late 19th- and early 20th-century British pictures were given by the Very Rev. Dr Eric Milner-White, Dean of York, between 1948 and 1963.

The curators have shaped the collections by making appropriate acquisitions and attracting the right kind of donations. York Art Gallery was lucky in these respects with the appointment of Hans Hess (see p. 232) as Curator in 1947. He restored the building after war damage and brought a greater sense of direction to the gallery as a whole. He made it a training ground for younger curators who have over the years endeavoured to maintain his high standards.

PARMIGIANINO (FRANCESCO MAZZOLA) (1503–40)
A Man with a Book c. 1523–54
Canvas, 70 × 52 cm / 27½ × 20½ in.

Parmigianino was born in Parma and influenced at the outset by Correggio. His talent was spotted early on, and he undertook some major works in fresco for his home town at different stages of his life. Time spent in Rome in 1524–27 was crucial for his development: what he saw there of late works by Raphael and Michelangelo formed the basis of the style he elaborated following his return to Parma in 1531, which is known as Mannerism. During his lifetime he was famed more for his prints and drawings than for his paintings.

This portrait, which formed part of F. D. Lycett Green's donation, is one of the most haunting of the Italian Renaissance. There are a number of very fine portraits in

York Art Gallery excels in portraiture

Parmigianino's œuvre of both men and women, and early intimate ones such as this (no doubt of friends) reveal the artist's markedly individual powers of psychological penetration. The image is disturbing because it is so introspective, with the light only illuminating one half of the face properly and the sitter appearing generally dishevelled. He is dressed almost entirely in black and wears finger rings. The fact that he holds a book implies that he might be a scholar, totally absorbed in his subject. The composition, too, is arresting because the figure is set back behind what appears to be a piece of furniture, over which his arm protrudes towards the viewer. The curvilinear rhythms in the fore-ground are steadied by the vertical strip of fabric to the right.

As *A Man with a Book* might suggest, Parmigianino was an unusual man. The 16th-century artist and biographer Giorgio Vasari refers to his interest in alchemy and haphazard approach to his work: 'he allowed his beard to grow long and disordered, which made him look like a savage instead of a gentleman. He neglected himself and grew melancholy and eccentric.' As might be imagined, he has received a great deal of atten-tion from modern scholars.

FRANCIS COTES (1726–70)

The Hon. Lady Stanhope and the Countess of Effingham as Diana and her Companion 1765

Canvas, 240 × 152.5 cm / 94½ × 60 in.

Cotes was apprenticed to George Knapton, who was not only a painter but a connoisseur with an important collection of drawings. Knapton used pastels, or crayons, as part of his practice of portraiture, and seemingly encouraged Cotes to do the same. The younger man's initial success in the 1740s was due to his work in pastels, and he continued to use the medium throughout his career, which goes some way to explaining why the complexions of his subjects have what has been called a 'milk and roses' appearance. Horace Walpole thought that 'Cotes succeeded much better in crayons than in oils'.

Cotes began to work in oils seriously in the late 1750s and established a thriving practice which allowed him to move in 1763 to a large house in Cavendish Square in London. As his clientele increased he took in pupils, and employed a drapery painter, Peter Toms. He was soon seen by many as a challenge to Sir Joshua Reynolds, and on occasion, as in the present portrait, he emulated Reynolds's methods, although essentially he lacked his rival's intellectual application. Reynolds was annoyed by Cotes's acceptance at court and royal commissions, but Cotes's death in his early forties removed the threat of further competition. His house was taken over by George Romney.

The Hon. Lady Stanhope and the Countess of Effingham is a typical confection, a light and airy composition with a Rococo impulse. The figures gambol in the open air, adopting specific roles for which they are dressed in quasi Classical garb. Lady Stanhope (1737–1812) commands the landscape as Diana, the goddess of hunting (identified by her crescent moon headdress), while Lady Effingham (d. 1791) acts as her faithful attendant, about to unleash the hound to chase the stag in the distance. They could easily burst into song, and indeed there may well be some connection with contemporary opera. But the portrait beguiles us with its innocent charm – and why not?

EDWARD MATTHEW WARD (1816–79)

Hogarth's Studio in 1739 – Holiday Visit of the Foundlings to view the Portrait of Captain Coram 1863

Canvas, 120.6 × 165 cm / 47½ × 65 in.

Ward specialized in painting literary and historical scenes, with a penchant for incidents illustrating British 17th-century history and the Ancien Régime in France, usually on a large scale and in an ebullient style, with high-toned colour. Such subjects were popular with the public in the mid-19th century as a result of historical writing such as Thomas Carlyle's *French Revolution* and T. B. Macaulay's *History of England from the Accession of James II*, and illustrated volumes such as Joseph Nash's *The Mansions of England in the Olden Times*.

Ward attended the Royal Academy Schools (1834–36), then spent time in Rome and Munich where he learnt from the Nazarenes about fresco technique. Thereafter in London he exhibited regularly at the Academy, and in 1851 he was commissioned to participate in the decoration of the Palace of Westminster. His wife, Henrietta, was the granddaughter of James Ward, the distinguished animal and landscape painter. Sadly, E. M. Ward committed suicide while temporarily insane. Of their children, Leslie Ward was 'Spy', the famous caricaturist for *Vanity Fair*.

In the Victorian age Hogarth was greatly respected, and the moralizing subject-matter of his paintings and prints was approved of. Ward had read George Augustus Sala's articles on Hogarth serialized in the *Cornhill Magazine* in 1860. *Hogarth's Studio* is a happy scene built around Hogarth's portrait of Thomas Coram (see p. 111), who established the Foundling Hospital in London. Ward imagines himself in the studio observing the foundlings looking at the portrait. Hogarth and Coram are hiding behind the canvas to overhear the various comments of the children and those which Mrs Hogarth, pointing at the canvas, is encouraging a visitor to make. The picture includes some references to Hogarth himself (such as his dog Trump) and to specific works by him (for example, the couple by the screen at the back on the left). It is thrillingly painted, with a clever use of reflected light, as in the lower right corner.

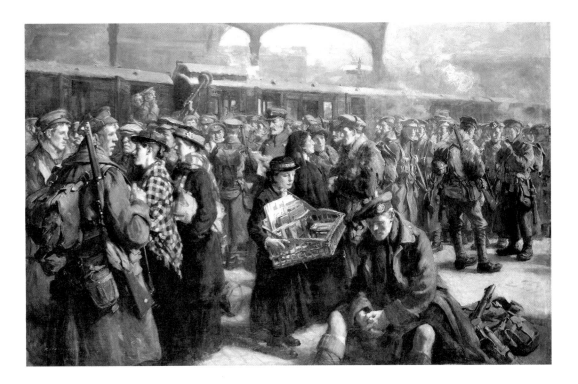

RICHARD JACK (1866–1952)
The Return to the Front: Victoria Railway Station 1916
Canvas, 203 × 319 cm / 79⅞ × 125⅜ in.

'"Good morning;
good morning!"
the general said /
When we met him
last week on our
way to the line. /
Now the soldiers he
smiled at are most
of 'em dead, /
And we're cursing
his staff for
incompetent swine'

SIEGFRIED SASSOON,
'THE GENERAL', IN
*COUNTER-ATTACK AND
OTHER POEMS*, 1918

Jack was at his best in documentary paintings of this sort. He was born in Sunderland and studied at York School of Art before attending the South Kensington Schools in London and the Académie Julian in Paris. Back in London by 1891, he worked as an illustrator for the *Idler* magazine before making his debut at the Royal Academy in 1893. He began as a society portrait painter (including George V and Queen Mary), but his œuvre also comprised interiors and landscapes. He was elected a member of the Royal Academy in 1921.

In 1916 during the First World War Jack was commissioned to go to France to paint for the Canadian War Memorials Fund, which resulted in two very large canvases of battle scenes at Ypres and Vimy Ridge (both Ottawa, National Gallery of Canada). *The Return to the Front* is a sombre scene in muted tones, observed at Victoria Station in London, the place from which travellers then set out for mainland Europe. It includes touching details, and captures the atmosphere of mixed feelings – part elation and part dejection – at the prospect of going back to the front line in France. The frieze of figures is skilfully knitted together on a shallow diagonal, the women forming a contrast with the uniformed men. The artist is clever in making space in the right foreground for the vignette of the girl selling magazines, who approaches the disconsolate Scottish soldier seated alone, his equipment cast to one side. It is a beautifully observed private moment amid the frenzy and wistfulness of departure. Jack finally emigrated in 1938 and settled in Montreal.

THE NORTH-WEST

Manchester and Liverpool are the main hubs in the North-West because of the number of museums and galleries built as a result of fortunes made in manufacturing and commerce during the 19th century and the first half of the 20th. Technical advances, population growth and financial confidence enabled them to become two of the greatest cities in the world. Learned societies founded in the late 18th century took the lead, out of which museums and galleries grew for the greater benefit of wider sections of the population. The result was an increase in civic pride that also manifested itself elsewhere in the area, in such places as Birkenhead, Bury, Oldham, Preston, Rochdale, Salford, Southport and Stockport.

As an exercise in philanthropy on an unusual scale the Lady Lever Art Gallery at Port Sunlight stands alone. Founded by William Hesketh Lever, 1st Viscount Leverhulme, in memory of his wife, the building is a nodal point in the model village of Port Sunlight that he created for the employees at his soap-manufacturing company. The circumstances that brought the Lady Lever Art Gallery into existence, the peculiarities of its location, and the quality of the collection make it a high point in any visit to the North-West.

Two smaller museums established by local authorities in former private houses are at Carlisle (Tullie House, opened in 1893) and Kendal (Abbot Hall, opened in 1957). They stand like sentinels at either end of the Lake District and give pleasure not only through the quality of the works of art themselves but through the way in which the works are presented.

Birkenhead

WILLIAMSON ART GALLERY AND MUSEUM

Birkenhead had a museum attached to its library from 1912, but the present purpose-built gallery was financed by John Williamson, a Director of Cunard, and his son Patrick. It was opened in 1928. Designed by the local architects Leonard Hannaford and Herbert Thearle, it was praised at the time for its natural lighting. There is a rather mixed small collection of paintings dating from the 19th and early 20th centuries, in addition to an extensive collection of watercolours and prints. Philip Wilson Steer was born in Birkenhead and is honoured here.

LEONARD CAMPBELL TAYLOR (1874–1969)
The First Born 1921
Canvas, 105 × 135 cm / 41⅜ × 53⅛ in.

A lullaby

Taylor attended the Ruskin School of Drawing in Oxford and the St John's Wood Art School before entering the Royal Academy Schools in 1905. He exhibited at the Royal Academy from 1899 onwards and was elected a member in 1931.

Although he did paint landscapes, Taylor felt unsettled by nature, apparently suffering from a 'subconscious distrust of that which is not already part of a human order'. He built his reputation on quiet domestic interiors, painstakingly composed and meticulously executed. The soft-focus treatment of the pictures revealing his debt to Vermeer, whom he particularly admired, is unfortunately not always very appealing today.

The First Born complies with all of the artist's principles, but it is made of sterner stuff. The baby seems to be dressed in a christening robe and the mother's formal garb suggests that the portrait might have been made to mark such a celebration. The flatness of the composition is inspired by Whistler, although in the end the emphasis is linear rather than tonal. The expanse of wall behind with the cut-off gold frame is reminiscent of Orpen. I found myself thinking of *Eliza Wyatt and her Daughter, Sarah* by Millais, of c. 1850 (London, Tate Britain), which is stiffer and rather unyielding, whereas what is striking about *The First Born* is its tenderness – of a type that is found in Raphael's Madonnas or Hans Holbein the Younger's portrait of his wife, *Eliza Binzenstock with her two Children, Philip and Catherine*, of c. 1530 (Basel, Öffentliche Kunstsammlung). In the end to me this picture seems closer to Scandinavian art than to British painting.

Kendal

ABBOT HALL ART GALLERY

Originally a private house built by Colonel and Mrs George Wilson in the mid-18th century, Abbot Hall lies in a beguiling setting on the edge of Kendal close to the River Kent. The house and gardens were acquired by Kendal Corporation in 1859, but a century later they were threatened with demolition. A campaign was mounted to save the building and convert it into an art gallery, which was duly opened in 1962. The rooms on the lower floor have been carefully preserved in period style, but those upstairs have been converted into a series of galleries.

Abbot Hall Art Gallery is therefore a success story, and this is reflected in the quality of the collections and exhibitions. There is an enlightening mixture of old and new. While due emphasis is given to topographical depictions of the Lake District and to artists associated with the area such as Daniel Gardner and John Ruskin, there is a strong and exciting holding of 20th-century and contemporary British art.

The gallery is famous for its association with two particular artists – George Romney, who spent part of his early life in Kendal and whose masterpiece, *The Leveson-Gower Children* (1776–77), is here, and the German Expressionist Kurt Schwitters, who devised painted constructions made of found objects for which he coined a special term, 'Merz'. However, my attention was grabbed by something totally different.

ATTRIBUTED TO JAN VAN BELCAMP (1610–53)
The Great Picture of Lady Anne Clifford 1646
Canvas, centre 254 × 254 cm / 100 × 100 in.; side panels each 254 × 119.4 cm / 100 × 47 in.

This large and intriguing painting memorializes a single woman and her family. It appeals not because of its artistic skill but on account of its literalness. Commissioned in 1646 by Lady Anne Clifford (1590–1676), the painting has the format of an altarpiece but is in fact wholly secular in intention. Its sole purpose was to declare to the world Lady Anne's legitimate – although unusual for the time – claim to the title and lands (mainly in the north of England) of the Clifford family, which had eluded her owing to her father's disregard for the law, and to commemorate the successful prosecution of many years of litigation. The somewhat elaborately pedantic use of inscriptions, heraldry and portraiture throughout is tantamount to reading an official Law Report.

The central panel is occupied by Lady Anne's parents: her mother, Lady Margaret Russell, and her father, George Clifford, 3rd Earl of Cumberland, who was Elizabeth I's Champion, which is why he is shown wearing parade armour. The two children accompanying them are Lady Anne's brothers Robert and Francis, both of whom died young.

A most disputatious lady

The portraits on the wall behind are all of other members of the family. Lady Anne appears first as a child aged fifteen in the left-hand panel, where reference is made to her musical and intellectual accomplishments. The portraits behind are of her governess, Anne Taylor, and her tutor, the poet Samuel Daniel.

By contrast, the right-hand panel shows Lady Anne aged fifty-six – at the time of the commissioning of the *Great Picture* – accompanied by her domestic pets. The portraits behind are of her first husband (above), Richard Sackville, 3rd Earl of Dorset (d. 1624), and of her second husband (below), Philip, 4th Earl of Pembroke (d. 1650), Lord Chamberlain to Charles I. Neither husband was particularly congenial, and Lady Anne lived her final days alone. It is incredible to think that she was the chatelaine of both Knole in the first instance and then of Wilton House at the time of its rebuilding by Inigo Jones.

A fascinating aspect of the *Great Picture* is the depiction of the large number of books, which are carefully arranged in the left-hand panel, but for some reason seen in disarray in the right-hand panel. The books are identifiable and chosen with care to reveal not only Lady Anne's intellectual proclivities but also her independence of mind. Her interests ranged over Classical texts, history, Continental publications, contemporary literature (Philip Sidney, Edmund Spenser, George Herbert, John Donne), cartography, architecture, and above all philosophical and devotional works. Like her mother, Lady Anne had a stoical cast of mind and a frugal approach to life, and was directly spoken: she must have been formidable to meet. Indeed, on meeting her at Knole Donne remarked that 'she knew how to discourse of all things from Predestination to Slea-silk' – the last being a reference to her skill at embroidery.

Liverpool

WALKER ART GALLERY

The approach up Lime Street past St George's Hall (according to Pevsner 'the finest neo-Grecian building in England and one of the finest in the world') is an awe-inspiring demonstration of the power of Victorian civic architecture. It is a miracle of survival. Equally inspiring is the array of sculpture of notables, including Queen Victoria and Prince Albert, and finally the Wellington Monument soaring skywards. All this serves as an introduction to the grand sweep of buildings in William Brown Street which include the World Museum of Liverpool, the Central Library and Record Office, the Picton Library and the County Sessions House, as well as the Walker Art Gallery. The entrance to the gallery is notable in itself, with statues of Raphael and Michelangelo on either side and Commerce crowning the pediment.

The Walker Art Gallery was paid for privately by the Mayor of Liverpool, Sir Andrew Barclay Walker (1824–93), a successful brewer. The architects were Cornelius Sherlock and Henry Hill Vale, and it opened in 1877. There was at that stage no permanent collection, but the gallery was a successful venue for annual exhibitions similar to those at the Royal Academy in London – a tradition that continues today with the Sir John Moores prize founded in 1957. One collection proved to be of the greatest significance, that once belonging to the banker William Roscoe (1753–1831), which included many fine examples by early Italian and Netherlandish artists. Roscoe was MP for Liverpool and was a considerable scholar of Italian history (Medici) and literature (Dante); his publications and opinions gave great kudos to the city. However, he was declared bankrupt in 1816 and forced to sell his collection, which was only saved in part for the city by a body of subscribers. The pictures were presented shortly afterwards to the Liverpool Institution, who later deposited some on loan to the Walker Art Gallery on its opening. The official transfer of Roscoe's collection was recognized in 1948.

The accumulation of pictures in the wake of William Roscoe was spasmodic and lacked direction, but there was a lot of good will from wealthy local benefactors wanting to enhance the cultural status of their city: Philip Henry Rathbone (d. 1895) is an example. The efforts of such directors as Frank Lambert, Hugh Scrutton and Timothy Stevens have resulted in a more rounded collection, with considerable inroads also being made into contemporary art.

The Walker Art Gallery possesses some famous paintings, as well as paintings that were once famous. It is to the gallery's great credit that it makes a virtue of the latter: they include W. F. Yeames's 'And when did you last see your father?' (1878), L. E. Fournier's The Burning of Shelley's Body (1889), W. D. Sadler's Friday (1882), and Henry Holliday's Dante and Beatrice (1882–84).

SIMONE MARTINI (c. 1284–1344)

The Christ Child Discovered by his Parents in the Temple 1342

Wood, 49.6 × 35.1 cm / 19½ × 13⅞ in. Inscribed and dated

Simone Martini's style epitomizes Sienese painting of the early 14th century, with its emphasis on firm outlines and intense colour. He worked extensively in fresco, painted numerous panels for altarpieces, and also illuminated manuscripts. Active mainly in Italy (Siena, Assisi, Naples), he died in Avignon when working for the exiled papacy, having established a reputation for himself as the greatest Sienese painter of his generation. He was personally known to, and much praised by, the famous poet Petrarch. This is the last dated work in his œuvre and was painted in Avignon.

The subject is relatively rare. Its Biblical source is the Gospel of St Luke (2:48), who is the only Evangelist to devote so much space to the childhood of Christ. While celebrating the feast of the Passover

in Jerusalem, the twelve-year-old Christ became separated from his parents, who after searching for him for three days eventually found him in the Temple engaging in an argument with the priests. Clearly the story is intended to anticipate Christ's future role as a teacher. The potential drama lies in the contrast between the boy's eager assertion of his independence and the realization by the parents of their son's destiny, which is why in popular religious texts of the time the episode is treated as an incident not only in Christ's life, but also in the Virgin's. All this is captured by Simone Martini's use of gesture and expression. The Virgin, seated (an indication of her humility), remonstrates, while Joseph puts an arm around the boy and indicates his wife's anxiety. The perturbation of the parents contrasts with the defiant look of the Christ Child, who supports a book in his folded arms: 'Did you not know that I must be in my Father's house?'

The artist expresses all this within the conventions of early Italian painting. The careful craftsmanship of the panel itself with its engaged frame, the gold background offsetting the haloed figures, and the decorative qualities of the arched inner moulding at the top are well preserved. The panel served as a work of art for private devotion: it was not part of an elaborate altarpiece and perhaps not even the wing of a diptych. Acquired by William Roscoe in 1804, it is an outstanding example of early Italian painting and was a brave purchase that helped to foster British interest in such an early period of painting.

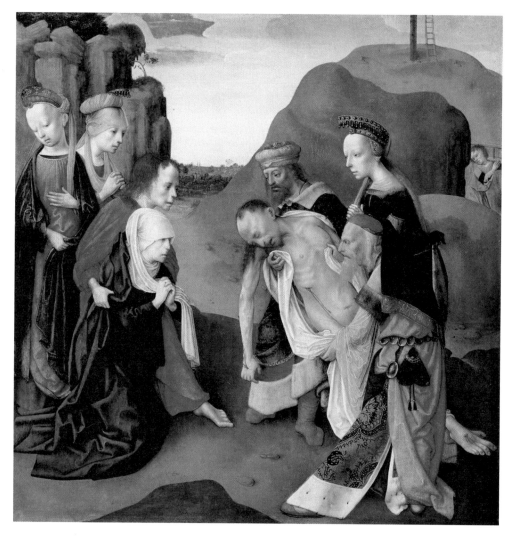

MASTER OF THE VIRGO INTER VIRGINES (c. 1480–98)
The Entombment c. 1486
Wood, 55.2 × 56.3 cm / 21¾ × 22⅛ in.

The tendency is to regard paintings not attributed to a named artist as residing in a no-man's land, but this often means that their stylistic characteristics are seen in isolation and need to be more sharply defined. The Master of the Virgo inter Virgines derives his temporary name from a painting in the Rijksmuseum in Amsterdam depicting the Virgin with SS. Catherine, Cecilia, Ursula and Barbara, which formerly hung in a convent in Koningsveld near Delft in the Netherlands, the city where the artist was presumably based. Certainly the same hand was responsible for the woodcut illustrations in a number of religious books published in Delft by Jacob van der Meer. The distinctive personality of this painter was established in the early 20th century, but his identification remains unsolved.

Emotional intensity by a distinctive artist whose name remains unknown

The figures are easily recognizable: doll-like types with large heads with wisps of hair and high domed foreheads, particularly the women (as a sign of courtly refinement). They always seem to be in a state of agitation, mainly because of their vigorous movements. Another feature is the bareness of the landscape settings, which do, however, suit the many scenes of Christ's Passion that the artist was obviously commissioned to undertake.

The subject of the present picture is not in fact the Entombment, but an earlier moment between the Deposition and the Lamentation. The figures fall into two groups: the Virgin supported by St John and accompanied by the Holy Women (Mary Salome and Mary Cleophas) on the left and the Dead Christ with Joseph of Arimathea, Nicodemus and Mary Magdalen on the right. The location is Golgotha (the cross is partly visible top right) and Jerusalem lies in the distance beyond the two hillsides. The bleakness of the place is only relieved by the rich panoply of Joseph of Arimathea's robes.

The painting belonged to William Roscoe and reflects his interest in early art. Its importance was confirmed by inclusion in the 'Art Treasures' exhibition held in Manchester in 1857, which was one of the greatest art exhibitions ever organized, with huge attendance figures. For us today, as for Roscoe and other pioneer collectors of early Italian art, it is the searing quality and emotional impact of the picture that feed the imagination.

WILLIAM HOGARTH (1697–1764)
David Garrick as Richard III c. 1745
Canvas, 190.5 × 250.2 cm / 75 × 98½ in.

'David Garrick raised the character of his profession to the rank of a liberal art'

EDMUND BURKE

This exciting and evocative portrait brings together two of the most flamboyant figures in the art world of mid-18th-century Britain. Hogarth had already established his reputation; Garrick (1717–79) had yet to do so. The significance of this portrait is that it depicts Garrick at the very moment when he scored his first public success in Shakespeare, and in the process changed the course of the British theatre for ever.

It helped that Hogarth was also passionate about the theatre, and so, apart from moving in the same social milieu, the two men became firm friends, as evidenced by the later double-portrait by the artist of *David Garrick with his wife Eva-Maria Veigel (La Violette)* (Royal Collection), which was still in his studio at the time of his death. Hogarth and Garrick fed off each other's energy and ambition, as both endeavoured to raise the standards of their professions. The potency of the portrait, therefore, stems from a personal chemistry derived from this determination to leave a mark on their times.

It is likely that Hogarth witnessed one of Garrick's performances of *Richard III* in 1741 at the Goodmans Fields Theatre in London. The effect of Garrick's new, more naturalistic style of acting was electrifying, and one of the older stars of the stage, James Quin, commented, 'If the young fellow is right, I and the rest of the players have all been wrong.'

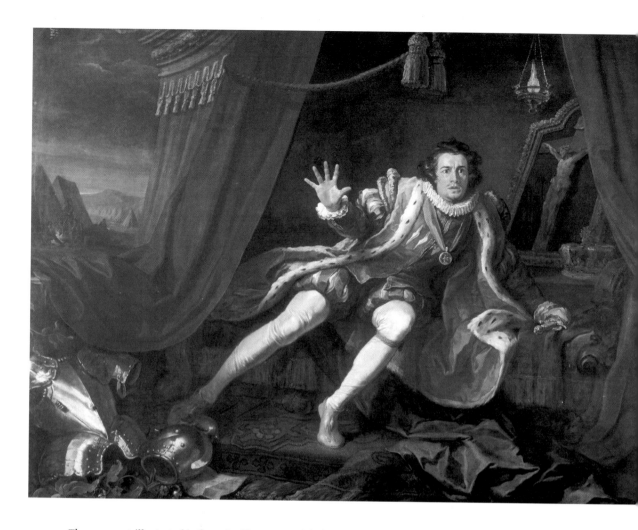

The moment illustrated is from Act V, scene 3, with the King on the eve of the Battle of Bosworth waking in his tent from a fitful night disturbed by dreams. 'Give me another horse! Bind up my wounds! / Have mercy, Jesu! Soft! I did but dream. / O coward conscience, how dost thou afflict me! '

Although Hogarth is in one sense painting direct from life in recording a specific performance, he is at the same time having to work consciously within the traditions of Baroque history painting, as can be seen in the considerable effort put into the expansive treatment of the tent with dawn breaking on the left over the battlefield. Garrick's face was particularly mobile, and Hogarth had enormous difficulty in fixing the expression. He resorted to making several facial studies on a separate piece of canvas, eventually cutting out the most satisfactory one and sewing it into the present portrait.

The challenge for the actor was to find a new psychological depth in the portrayal of a historical character; for Hogarth the challenge was to find appropriate means to record that effect. The artistic accord comes from both men transcending traditional means to establish new parameters. Just as Hogarth added a new dimension to British painting,

Garrick transformed the style of acting, and when he became an actor-manager he introduced new methods and standards of production. Not surprisingly, he was very keen on self-promotion and was frequently depicted – a process that Hogarth set in train.

PAUL CÉZANNE (1839–1906)
The Murder c. 1867–68
Canvas, 64 × 81 cm / 25⅛ × 31⅞ in.

'Cézanne ...
combines traditional
and contemporary
elements in
a style of such
uncompromising
power and
originality that it
seems to stand
outside of its time'

RICHARD VERDI, 1992

Cézanne's early paintings done during the 1860s in his native Aix-en-Provence are for the most part dark and sinister; they are very different from the more objective analytical canvases that he painted during his maturity. A considerable amount is known about the young Cézanne from the accounts of his childhood friends, including the novelist Emile Zola. Cézanne himself looked back on the freedom of his youth with considerable nostalgia.

Although he did have some tuition in art at Aix-en-Provence, these early paintings with their sometimes violent and macabre subject-matter and unforgiving febrile style seem like the birth pangs of a strong artistic personality keen to enter the world. They also reveal deep-seated romantic longing, which emerged while Cézanne was growing up but which he eventually sublimated or controlled. These passionate canvases ran counter to his upbringing (his father was a banker) and the projected career in law or finance that he rejected. Perhaps this dichotomy is what caused them.

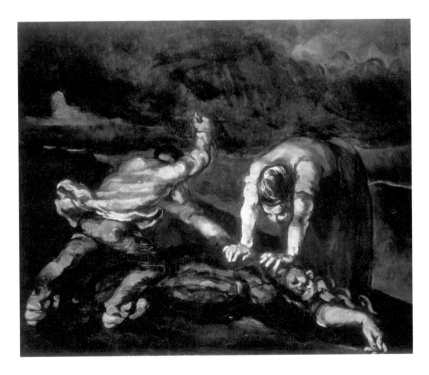

The Murder is on a small scale and full of compacted energy. It is likely that Cézanne took the idea for the image from a published illustration or written account, but even so nothing prepares the viewer for the brutality of the scene set on an open hillside against a stormy lowering sky. The distortions and exaggeration in the figures and the sophistication of the composition in the use made of diagonals attest the artist's instinctive abilities which he would soon bring firmly under control.

The temptation to impose psychological interpretations on these early works of the 1860s by Cézanne has proved irresistible for some, but in the final analysis the wide range of subjects essayed and the diversity of sources consulted show that these paintings are in essence experimental: in short, they are something that Cézanne had to get out of his system.

WILLIAM FREDERICK YEAMES (1835–1918)
'And when did you last see your father?' 1878
Canvas, 131 × 251.5 cm / 51⅝ × 99 in. Signed and dated

This has become a famous picture more for its popular appeal than for any artistic reason, but its fame only increased slowly, after unenthusiastic reviews when first shown at the Royal Academy in 1878. Once it was engraved the painting took off and was then used by political cartoonists, songwriters, and waxwork tableaux. Furthermore, it was frequently illustrated in history textbooks right up until the present day.

Yeames belonged to a group of artists who called themselves the St John's Wood Clique, who lived rather comfortably in that part of London and formed close friendships, sometimes intermarrying. The others in the group included P. H. Calderon, D. W. Wynfield (Yeames's brother-in-law), H. S. Marks, G. A. Storey, J. E. Hodgson and G. D. Leslie. Following the example of French painters such as Paul Delaroche, they all specialized in history painting, depicting either actual events or scenes of lesser significance imaginatively recreated. Inspired no doubt by such publications as Joseph Nash's *Mansions of England in the Olden Time* (1839–49), they took holidays at Hever Castle in Kent – associated with Henry VIII and Anne Boleyn – and visited places like Hardwick Hall in Derbyshire. History was in their veins. At a later stage Yeames turned to modern topics, as in *Defendant and Counsel* of 1895 (Bristol's City Museum & Art Gallery).

Dipping into the
dressing-up box to
portray a moral
dilemma

'*And when did you last see your father?*' is a scene from the Civil War in the mid-17th century, which by the 19th century was already proving to be a fertile ground for historians in both England and France, often as the basis for debate on constitutional issues, but painters and novelists also weighed in. Over two hundred paintings of Civil War subjects are known to have been undertaken during the 19th century and at least 150 historical novels.

There is, however, some depth to this painting by Yeames. There is considerable tension between the Cromwellian soldiers and the young innocent Royalists – the boy being questioned and his sister standing to one side (both modelled by relatives of the artist). The scene is one of interrogation, and the technique being used by the soldiers is to trick the boy by lulling him into a false sense of security. The moral issue is whether he becomes a hero by lying and thus protects his father, or tells the truth, as he was no doubt brought up to do, and so endangers his father. Which is the more heroic course of action? The girl weeps because she understands the danger. Perhaps the boy does not.

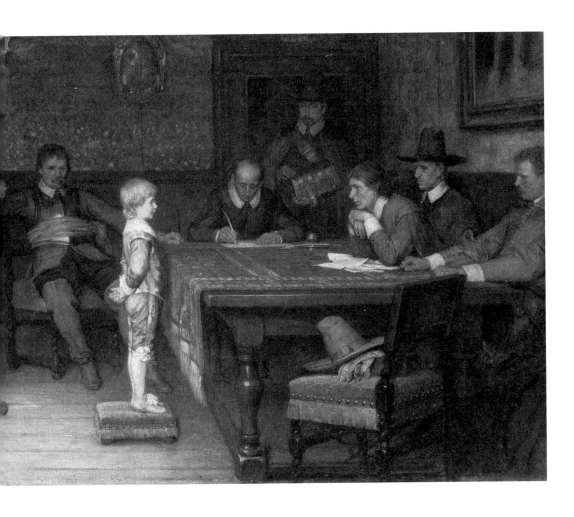

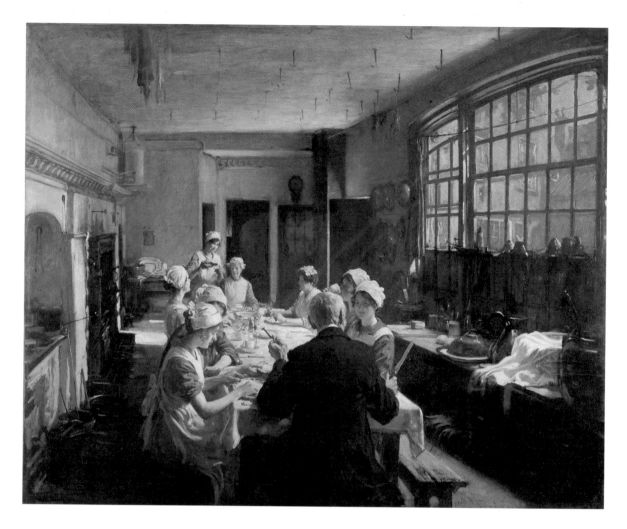

FREDERICK WILLIAM ELWELL (1870–1958)
An Old Inn Kitchen 1922
Canvas, 122.5 × 151 cm / 48¼ × 59½ in.

There is something very reassuring about Elwell's interior views, solidly painted, firmly composed, and accurately drawn with an eye for the minutest detail, which are well represented in collections throughout the country. He specialized in naturalistic renderings of people and their surroundings, seemingly without any political axe to grind. Neither was he indulging in sentimentality: this is good honest descriptive painting and much to be admired for what it is.

Elwell was born in Beverley in East Yorkshire, but attended Lincoln School of Art. In 1889 he went abroad, first to the Academy in Antwerp and then in 1892 to the Académie Julian in Paris. Although he did not adopt Impressionist techniques, he was aware of them, and was ultimately more interested in the Impressionists' approach to subject-matter. Returning to Britain, he passed through London briefly before establishing

'Painting is 90 per cent perspiration and 10 per cent inspiration'

FREDERICK WILLIAM ELWELL

himself in Beverley. Marriage to a wealthy woman (also a painter) in 1914 gave him greater freedom during the 1920s to travel on the Continent and pursue themes of shared interest such as the circus. He exhibited regularly at the Royal Academy from 1909 and was made a member in 1938. On his death he endowed an annual Fred Elwell Prize for Still Life Painting. Augustus John, Laura Knight and Alfred Munnings were among his friends.

An Old Inn Kitchen portrays the staff of the Beverley Arms Hotel having lunch. A painting of the same kitchen showing the staff at work is in Tate Britain (acquired in 1919). Part of the attraction of the scene is the 18th-century kitchen itself, with the flagstone floor, wide window and extensive oven range allowing Elwell to play to his strength of combining genre with still-life painting.

The composition recedes dramatically into the background and the viewer is positioned as though entering the room. Presiding at the head of the table is the butler, while opposite him at the other end is the cook, being served with a sustaining glass of stout. It is sometimes easy to dismiss such paintings as being no more than exercises in nostalgia or mere reportage, but Elwell's treatment of light, and the careful integration of so many figures seen in perspective, are testimony to his consummate skills.

LUCIAN FREUD (b. 1922)
Interior in Paddington 1951
Canvas, 152.4 × 114.3 cm / 60 × 45 in.

'My work is purely autobiographical. It is about myself and my surroundings'
LUCIAN FREUD, 2002

An important early painting by Freud, this received a considerable amount of publicity when it was shown at the Festival of Britain exhibition, 'Sixty Paintings for '51', organized by the Arts Council. It won a prize, and has remained popular with the public ever since.

Freud was born in Berlin, the grandson of Sigmund Freud. In 1933 the family moved to Britain, where the artist went to school and later attended the East Anglian School of Drawing and Painting at Dedham run by Cedric Morris. He emerged first of all as a brilliant draughtsman and only slowly by the end of the 1940s did he begin to make an impact as a painter. The scale and compositional grandeur of this picture announced the arrival of a new force in British art.

Interior in Paddington was painted during the winter of 1950–51 in the artist's flat in Delamere Terrace in Paddington overlooking the Grand Union Canal, which is visible through the railing on the right of the picture. The flat subsequently served as a studio. The figure is Harry Diamond, who worked first as a stagehand, then as a photographer. He was not an easy sitter, constantly complaining not only about his personal circumstances but also about the fatigues of modelling. Something of his feeling of resentment is apparent, just as the potted palm with which he is paired seems unduly spiky, although this is probably not intended symbolically. Freud painted Diamond on five occasions before they fell out in 1970.

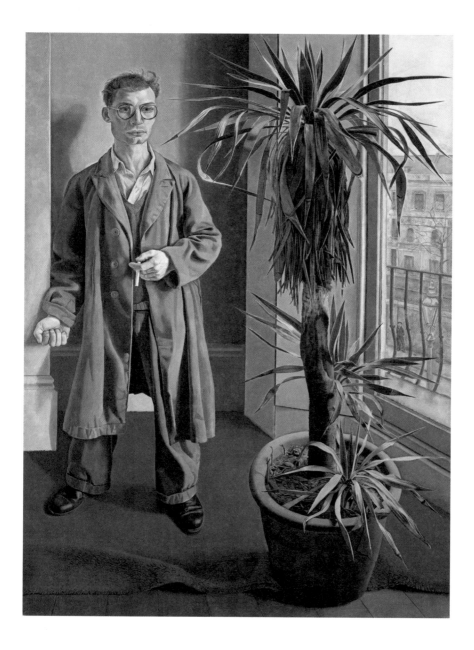

The composition of a closely observed interior looking down through a window to the scene below was exploited by the Impressionist artist Gustave Caillebotte and then by Matisse, but the effect here is totally different. There is a sense of entrapment and of disillusion – the figure seeming to be more hemmed in than the plant.

The firm precise drawing throughout reveals Freud's kinship with German art and is enhanced by the bleached colour. This attention to detail is balanced by the more broadly applied areas of paint used for the walls, the clothes and the carpet. The treatment of the palm demonstrates Freud's ability as a painter of vegetation, which he indulges in occasionally, as opposed to his proclivity for the nudes on which his reputation is now based.

Manchester

MANCHESTER ART GALLERY

For many, by the beginning of the 19th century Manchester defined the Industrial Revolution. The success of its cotton industry, owing to the development of new technology and the building of the Bridgewater Canal, turned the city into the textile centre of the world. The emergence of 'Cottonopolis' attracted a great deal of attention from politicians, social commentators and journalists. Two of the most vivid, and in many ways the most condemning, descriptions of the city were written by visitors from the Continent: Alexis de Tocqueville in *Journeys to England and Ireland* (1835) – 'From this foul drain the greatest stream of human industry flows to fertilize the whole world' – and Friedrich Engels in *The Condition of the Working Class in England* (1845), the latter one of the most gripping descriptions of urban life ever penned.

As with all burgeoning Victorian cities, wealth encouraged the advancement of learning and the appreciation of culture. Even though, somewhat surprisingly, Manchester has never had a purpose-built art gallery, it has nevertheless accumulated one of the greatest collections in the British Isles. At the start a significant role was played by the exhibition entitled 'Art Treasures of the United Kingdom', held in Old Trafford Park in 1857 and seen by 1,300,000 people over a six-month period. It was the grandest and largest exhibition of its type ever staged, and has never been surpassed.

Close to the Town Hall where Ford Madox Brown was commissioned in 1878 to paint a mural cycle recording the principal events in the city's history is the Manchester Royal Institution, designed by Sir Charles Barry and completed in 1834. Its Neoclassical style, with an imposing portico of Doric columns, betokened a sense of purpose, which was to promote 'the interest of literature, science and the arts, and the obtaining of a channel by which the works of meritorious artists might be brought before the public'. Its motto was 'Nihil pulchrum nisi utile' (Nothing beautiful unless useful). The Institution organized exhibitions, promoted lectures and collected artefacts including works of art. This building, incorporated as Manchester City Art Gallery in 1882, was on several occasions adapted to accommodate a growing collection and temporary exhibitions. Adjacent buildings were acquired in 1898, but it was not until the nearby Athenaeum (also designed by Barry in 1836, in an Italian Renaissance palazzo style) was acquired in 1938 that the gallery had a unified space. The Athenaeum was physically united with the rest of the gallery in an architectural project undertaken by Sir Michael Hopkins and Partners in 2002.

The collections are particularly strong in British art. There is a handful of works of quality by 17th-century painters, but richer holdings of works by 18th- and 19th-century artists, and the holdings of Pre-Raphaelites and late Victorian painters are

outstanding. The Edwardians are well represented, thanks in the main to the Charles Rutherston gift of 1924, which laid the foundation for acquisitions by modern British artists. Works of the Italian, French and Dutch schools are fewer in number, but have been added to in recent years. Of particular significance was the Assheton-Bennett bequest of Dutch and Flemish 17th-century pictures in 1979.

Manchester has been fortunate in its directors, both in their judicious use of acquisition funds and in their concern to conserve and develop the setting of the collections: Lorain Conran with his deputy Dr F. G. Grossmann during the 1960s and then Timothy Clifford (1978–84), who was instrumental in restoring the original buildings to their former architectural splendour and reverting to the principle of the historical hang. Part of the achievement of these directors has been their success in maintaining the very special Mancunian character of the gallery and playing to its strengths. Alexander von Wagner's *The Chariot Race*, for example, is an undeniably magnificent picture: you are reluctant to admit to liking it, but you do. It is unmissable.

DUCCIO (active 1278–1318/19), OR A FOLLOWER
Crucifixion c. 1310–15
Wood, 59.7 × 38 cm / 23½ × 15 in.

This is early Italian painting at its best, even though the exact attribution and date of this excellently preserved panel are still open to discussion. However, such niceties are unnecessary for the appreciation of the drama of the scene or the quality of its execution.

Duccio's work is distinctive because of its linear intensity and incandescent colour – features that help to differentiate the early Sienese school of painting from the Florentine. Compositionally there is a close connection with Duccio's rendering of the scene on the reverse of his huge altarpiece, the *Maestà*, painted for the cathedral in Siena (1308–11), but the terms of reference may be widened to include comparisons for some of the figures with sculpture by Nicola and Giovanni Pisano and frescoes by Cimabue.

The contorted poses of the figures on the crosses are powerful enough, but the figures at the foot of the crosses are notable characterizations, full of anguish. They fall into two groups: to the left the fainting Virgin and the despairing Mary Magdalen, and to the right the pointing centurion and the half-hidden soldier at the back, Longinus, spattered by blood running down his spear after he has pierced Christ's side. The painter succeeds in combining the realistic with the ethereal. The skull is a grim reminder of reality.

The panel has had a long history in Britain. One of the most sought-after pictures in the 19th century, it was owned by three important mid-century collectors of early Italian paintings: E. Joly de Bammeville, the Rev. Walter Davenport Bromley, and the Lord Lindsay, 25th Earl of Crawford and Balcarres, author of the influential book *Sketches of the History of Christian Art* (1847), whose family sold the picture in 1976. It was acquired in 1984.

Duccio, Master of Città di Castello, Ugolino di Nerio? Just looking at the picture provides enough fulfilment

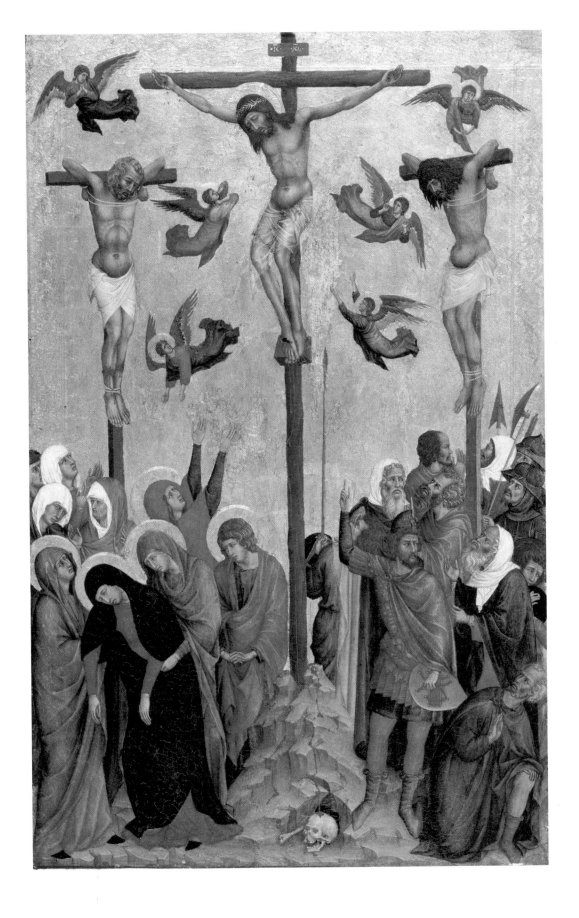

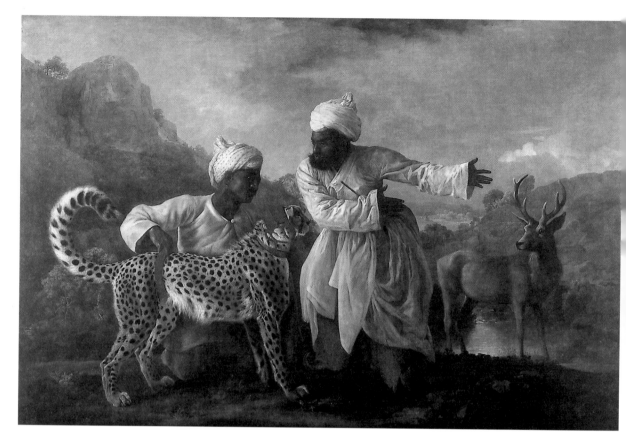

GEORGE STUBBS (1724–1806)
Cheetah and Stag with two Indians c. 1765

Canvas, 180.7 × 273.3 cm / 71⅛ × 107⅝ in.

The artist was an outstanding painter of horses, but his interest – scientific as much as aesthetic – in animals extended to the exotic. Lions, tigers, cheetahs, monkeys and zebras were all painted by him. One of his oft-repeated subjects was of lions attacking horses, which are inspired by Classical sources but also in essence exercises in the Sublime (Edmund Burke observed that 'there are many animals . . . capable of raising ideas of the sublime because they are considered objects of terror'). Stubbs's painting of a zebra (New Haven, Yale Center for British Art) is a more benign image; the animal, brought from the Cape of Good Hope and presented to Queen Charlotte in 1762, was the first of the species to be seen in Britain.

The cheetah in the present picture also came into the country as a gift. Two, accompanied by two trained Indian keepers, were sent to George III in 1764 from Lord Pigot, Governor of Madras. They were given by the King to his uncle William, Duke of Cumberland, who was Ranger of Windsor Forest and in charge of the royal menagerie in the Great Park. The painting records a demonstration intended to show the speed and hunting prowess of the animals, held on 30 June 1764. Although encouraged by its

An unwilling predator

keepers, the particular cheetah chosen for this occasion failed to live up to expectations, and on the third attempt was actually tossed by the stag. It then retreated into the woods and killed a deer before it could be recaptured.

An odd aspect of the composition is the landscape, which resembles the Lake District more than Windsor. Admirable, though, is the way in which the figures and animals are placed prominently in the foreground, almost in relief and silhouetted against the background, which is seen in recession. What Stubbs achieves here in the final analysis is an unforgettable portrait conceived on a monumental scale of a magnificent beast with its exotic (although increasingly desperate) keepers.

DAVID COX (1783–1859)
Rhyl Sands c. 1854
Canvas, 45.8 × 63.5 cm / 18 × 25 in.

The artist is most closely associated with Birmingham, where he was born and spent a great deal of his life. He established a reputation as a professional watercolourist just at the time when the production of watercolours for exhibition and sale in competition with oil paintings was at its height. For the purpose of advancing his career Cox spent two periods in London (1804–14 and 1827–41), with the intermediary years based in Hereford and Birmingham. Throughout his career he exhibited regularly at the Royal Academy and the Society of Painters in Water Colours. He was a prolific artist, becoming influential through the publication of several drawing manuals and teaching (his pupils were from

a wide range of society). Like all professional watercolourists, Cox travelled a great deal in England and Wales and sometimes ventured across the Channel to northern France.

Cox was not a painter in oils by instinct, and only Turner had managed to succeed in the public eye in the practice of painting both in oils and in watercolour. Normally there was a clear-cut distinction between the two, and even when Cox took up working in oils during the 1840s with a greater sense of purpose only a few of his paintings were shown in public, most being sold or given away privately. These paintings are, therefore, far less known than his watercolours and in some ways are a revelation, as in the case of *Rhyl Sands*.

From 1844 to 1856 Cox made annual trips to Betwys-y-Coed in North Wales. His views of the sands at Rhyl are among the most surprising paintings made in the mid-19th century in the British Isles – only comparable in some aspects with works by Boudin or Monet executed in France during the 1860s. Full of atmosphere, with empty foregrounds, expansive skies and distant horizons, the freshness of the seaside scene is matched by the variety of the loose and blurred brushwork. Cox suffered a stroke in 1853 and it is possible that the suppression of detail in the composition, especially in the rendering of the people on the sand, may have been imposed upon him, but he did nonetheless have specific ideas about what a painting should be. For example, he responded to critics of his paintings, 'They forget they are the work of the mind, which I consider far before portraits of places.' In short, the process of actually creating a painting was in itself more significant than the mere depiction of place – a concept ahead of its time.

'Give me oil.
I only wish I had
begun earlier in life;
the pleasure in
painting in oil is so
very satisfactory'

DAVID COX

FORD MADOX BROWN (1821–93)
Work 1852–63
Canvas, 137 × 197.3 cm / 53⅞ × 77¾ in. (arched top). Signed and dated

Brown was born in France and spent the early part of his career in Belgium, where in the late 1830s he trained at Bruges, Ghent and finally Antwerp. In many respects he remained very much a Continental painter, influenced by movements in France and Germany. He was never a Pre-Raphaelite in the technical sense, although he saw them as allies and was interested in their methods and aims. Brown taught Dante Gabriel Rossetti, and his abilities as a designer of furniture and stained glass caused him to be a founder member of the decorating firm Morris, Marshall, Faulkner and Company. After his Pre-Raphaelite phase during the 1850s Brown returned to his earlier interest in historical and literary subjects, in a powerful loose style that lent itself to mural painting. Some of his pictures have become very famous (for example, *The Last of England* in Birmingham Museum and Art Gallery), but his work never achieved great popularity in his lifetime.

Brown's interest in Pre-Raphaelite subjects and techniques culminated in *Work*, which he began in 1852 but developed consistently from 1856 to 1863, partly to accommodate the

A sermon in paint

wishes of T. E. Plint, who commissioned the picture's completion. The scene is set in London on the Mount, half-way up Heath Street in Hampstead, on a hot day in July. The composition is built around a group of navvies laying drains and is intended as an allegory on the role of work. A suitable cross-section of society is depicted going about its daily business: in contrast to the toiling navvies are the rich, who do not have to work; the street traders, who have no officially recognized form of employment; and the unruly children, who with the unemployed lying in the ditch below the railings demonstrate the effects of lack of work. Other such groups can be made out on the street beyond the trees.

Key to the picture are the two polemicists leaning against the rails, who converse while watching the proceedings. They are the historian Thomas Carlyle and the Rev. F. D. Maurice, a pioneer of education: both are men who work with their brains. The various posters and some of the identifiable buildings underscore the theme of the picture and the theories propounded by Carlyle and Maurice in which Brown was seriously interested.

Shown in 1865 at a private exhibition organized by the artist himself, the picture virtually disappeared from view until it was bought by what was then Manchester City Art Gallery in 1885 when Brown was painting his murals of the history of Manchester in the Town Hall.

FREDERIC, LORD LEIGHTON (1830–96)
Captive Andromache c. 1886–88
Canvas, 197 × 407 cm / 77⅝ × 160¼ in.

Leighton was one of the most notable artists of the Victorian age, becoming President of
the Royal Academy in 1878 and receiving first a knighthood and then just before his death
a peerage – the first artist on whom such an honour had been bestowed. Accumulated
wealth had allowed him to build a large house in Holland Park Road in London where he
entertained lavishly, making use of the famous Arab Hall. After his death his body lay in
state in the Royal Academy before burial in St Paul's Cathedral.

 Leighton, however, had had to work very hard for his success, and needed to overcome
a certain amount of prejudice, having been precocious and having spent a great deal of
his early life on the Continent. Trained abroad, fluent in several European languages, and
intellectual in outlook, Leighton was not the average Victorian artist. He achieved early

success in 1851 with his huge picture of *Cimabue's Madonna carried in Procession through the Streets of Florence*, which was bought by Queen Victoria (Royal Collection), but the chief problem he faced thereafter was deciding what kind of painter he wanted to be.

There was a public side, evident in his religious pictures and in such commissions as the decorative schemes for the South Kensington (later Victoria and Albert) Museum dating from the 1870s. There was a distinctly aesthetic side, expressed in single-figure compositions tending towards the abstract in settings without any narrative context. His formal portraits were by preference of friends, and his landscapes were inspired by journeys made during the 1860s to the Mediterranean and the Orient, including a number of oil sketches of the greatest quality.

Yet what Leighton was most famous for was his compositions of Classical, specifically Hellenistic, subjects, usually on a massive scale, which for the Victorians evoked an ideal combining physical and mental attributes with moralizing overtones. These

compositions, of which *Captive Andromache* is one of the finest, were much admired. What Leighton set out to paint here was not an incident in Homer's *Iliad* but an imagined event later to be fulfilled that occurs to Hector, the Trojan leader, as he contemplates his possible death in battle and the subsequent fate of his wife Andromache as a captive. She is the pivotal figure dressed in black in a vast frieze of figures divided into two groups: on the left those waiting to fill their pots, and on the right those at the well. Light and colour help to differentiate between the groups, while stretched across the front of the painting, as though in the orchestra pit, are bystanders, commenting like a Greek chorus on the plight of Andromache now brought low after the death of her husband ('This is she, the wife of that same Hector that fought best of all the Trojans when all fought for Troy').

Leighton prepared his paintings meticulously with drawings and oil sketches. He was a fine draughtsman of the nude, but in the actual picture the draperies make the figures resemble models displaying clothes like mannequins. In a way Leighton always tried too hard, but at the same time it should be acknowledged that he set himself the difficult task of recreating a lost civilization whose ideals underpinned his own world. This is the last of Leighton's great processional compositions.

SIR WILLIAM ORPEN (1878–1931)
Homage to Manet 1909
Canvas 162.9 × 130 cm / 64⅛ × 51⅛ in. Signed and dated

This large and elaborate conversation piece is an important document in the history of taste. Although the conception is based on the examples of Henri Fantin-Latour (*Homage to Delacroix* of 1864 or *A Studio in the Batignolles* of 1870), the present picture was of personal significance for Orpen.

The setting is a room in a house in South Bolton Gardens in London, which the artist shared at that time with the art dealer and connoisseur Sir Hugh Lane, a fellow Irishman. On the wall is the portrait of Eva Gonzales by Manet which Lane had bought in Paris with Orpen's encouragement in 1904 from the notable supporter of the Impressionists Paul Durand-Ruel. Around the table below it, from left to right, are George Moore, Philip Wilson Steer, Henry Tonks and Sir Hugh Lane; D. S. MacColl and Walter Sickert stand behind on the right. All these people were influential in the art world or played an important role in Orpen's own life: Moore (also an Irishman) was a leading supporter of modern French painting, Sickert and Steer were the main exponents of the Impressionist style in Britain, MacColl was a critic and curator, and Tonks an influential teacher of art.

Lane and Orpen went their separate ways after the completion of *Homage to Manet*, although both remained deeply conscious of the Irish heritage they had in common. Orpen excelled in portrait painting, but also became an outstanding war artist in the First World War. Lane continued as a successful dealer, making valiant attempts to establish a

'I have nothing but my taste'

SIR HUGH LANE,
EMULATING OSCAR WILDE

municipal gallery of modern art in Dublin (see p. 478). But the fate of his own collection, which included a large group of major Impressionist pictures, was not straightforward: in his will, drawn up in the light of his frustrating negotiations with the Dublin authorities, he effectively left his French pictures to the National Gallery in London, and an attempt to reverse this in a codicil made in favour of Dublin was not witnessed and so could not be honoured in law. The matter was finally resolved only in 1993, when a way of sharing his pictures between London and Dublin was duly agreed.

Lane drowned when the liner *Lusitania* was torpedoed in 1915, but his interest in Impressionist art was of the greatest significance for the future. The collection he formed proved to be a key factor in the enthusiasm for French avant-garde art shared by Samuel Courtauld and the sisters Margaret and Gwendoline Davies. Without these pioneering collectors there would be very few major Impressionist pictures in the British Isles.

Oldham

GALLERY OLDHAM

The gallery was founded in 1885 at the instigation of Dr James Yates and Samuel Buckley with the support of Oldham Corporation. The original gallery was replaced in 2002 by one designed by the architectural firm of Pringle Richards Sharratt.

The collection of paintings has a distinctly local flavour, having been made initially from annual exhibitions held in the town. Works by local artists abound, and this is still a marked feature of the collecting policy today. A donation of works on paper made in 1888 by Charles Lees, whose wealth was derived from iron and cotton manufacturing, was matched later by a smaller one of his collection of paintings. The emphasis, therefore, is on late Victorian painting and early 20th-century art, but this is counterbalanced by the zealous pursuit of contemporary art which makes Gallery Oldham such a lively place.

WILLIAM STOTT (1857–1900)
The Birth of Venus or *Venus: Born of the Sea Foam* 1887
Canvas, 187.9 × 187.9 cm / 74 × 74 in.

The artist was from Oldham and attended Oldham School of Art. His family owned a cotton mill, so he had a degree of financial independence from the start. This enabled him to travel to France in 1878 where he spent some time at the Ecole des Beaux-Arts under Jean-Léon Gérôme and Léon Bonnat. His artistic instincts, however, led him to seek out Jules Bastien-Lepage, around whom many young British and American painters grouped themselves because of his practice of painting everyday subject-matter in a realistic style *en plein air*. Stott was in fact an early member of the colony of artists who painted at Grez-sur-Loing near the Forest of Fontainebleau during the 1880s. It was here, in idyllic rural surroundings, that he painted some of his finest pictures – *A Girl in a Meadow* (London, Tate Britain), *The Bathing Place* (Munich, Neue Pinakothek) and *The Ferry* (private collection) – which led to his success at the Paris Salon.

Important though his time in France proved to be, Stott subsequently found it difficult to win acceptance at the Royal Academy on his return to England. *The Birth of Venus* was one way in which he strove to demonstrate the seriousness of his intentions by allying himself with more traditional subject-matter. But Stott was too independent-minded to become an establishment figure, as the diversity of his work and technique demonstrates. His astonishing landscapes alone set him apart, as they include seascapes in Cumbria, torrents and mountains in the Alps and shipboard studies of the sea. Many were executed in pastel in a style evoking Romanticism, Symbolism and photography all

One artist's mistress is another artist's Venus

at the same time – a very peculiar mix. Degas and Whistler, both of whom he knew, were influential in the exploration of new media, but the alliance with Whistler was for a time more significant for the development of Stott's figure compositions. The trouble was that in trying to align his style with more conservative expectations, Stott lost his own identity and tended to be pulled in different directions.

The Birth of Venus was the cause of the break-up of Stott's friendship with Whistler. The model for the figure of Venus was Maud Franklin (1857–c. 1941), a painter in her own right and Whistler's long-standing mistress. Unaware of Stott using her as a model until he saw the picture in an exhibition held at the Society of British Artists, Whistler was taken aback (an unusual reaction for him). Added to this was the fact that the picture was intensely disliked by the critics; indeed, G. B. Shaw described Venus as looking like 'an idiotic doll'. The consequence was that Whistler ditched Maud Franklin and secretly married Beatrice Godwin. The two men came face to face at the Hogarth Club in London and a scuffle broke out. Rarely can a picture have had such an effect.

The truth of the matter is that Stott's work moved between Realism and Symbolism, and in this respect he was more admired in avant-garde circles in Paris and Brussels than in Britain. The Birth of Venus may have been slammed by the critics, but it proved immensely popular with the public, even in Britain. Its heavy Symbolist overtones were much appreciated in Ghent, Munich, Prague and Venice – all a long way from Oldham.

Port Sunlight

LADY LEVER ART GALLERY

There is an air of unreality about Port Sunlight, the model village built for the employees of the soap manufacturing firm of Lever Brothers in the late 1880s. The founder was William Hesketh Lever, 1st Viscount Leverhulme (1851–1925), whose collecting was on a scale that has not been matched in Britain since his death. The gallery was named in honour of his wife, who died in 1913. The foundation stone was laid in 1914; the opening, delayed by the First World War, took place in 1922.

The Lady Lever Art Gallery stands out in Port Sunlight because it is in a totally different architectural idiom from the rest of the village. Designed by the firm of William and Segar Owen, it is in the Beaux-Arts style. Between the Portland stone cladding of the exterior and the plasterwork of the interior there is a layer of reinforced concrete – one of the first public buildings in Britain constructed in this way.

Lever began collecting in the late 1880s for business reasons – paintings that could be used to advertise bars of household soap, such as W. P. Frith's *The New Frock*. This part of the collection has since 1996 formed a separate display in the gallery. Lever's interests widened during the 1890s as a result of meeting James Orrock, an artist, collector and dealer with a particular passion for British art. Lever took up the cause and outstripped Orrock's achievements. At first the collection was destined for Lever's own private residences, but the collection of paintings, sculpture, furniture and ceramics, as well as antiquities, armour and Oriental art grew so rapidly (apart from a lean period from 1906 to 1911) that it quickly became apparent that only a purpose-built gallery would serve. Correspondingly, Lever began to buy works of art – sometimes on a massive scale – with his gallery in mind, as opposed to his homes. Even so he added a picture gallery to his London house after the opening of the Lady Lever Art Gallery.

Lever's acquisitions in the early 1900s were similar to those of American collectors such as J. Pierpont Morgan, Henry E. Huntington and Henry Clay Frick. He relied heavily on dealers and kept an eye on the salerooms. His aim was to provide a balanced overview of 'classic' British painting: portraits and landscapes of the 18th and early 19th centuries, and nearer his own time examples of Victorian and Edwardian art.

There are many famous pictures in the Lady Lever Art Gallery that leap from the walls (for example by Millais, Holman Hunt, Herkomer and Leighton). And there are also some amusing ones, which provide extra entertainment, such as W. Quiller-Orchardson's *The Young Duke* and Eleanor Fortescue-Brickdale's *The Forerunner*.

The gallery is now administered by National Museums Liverpool.

WILLIAM ETTY (1787–1849)
Cleopatra's Arrival in Cilicia 1821
Canvas, 107.2 × 132.7 cm / 42¼ × 52¼ in.

'The barge she
sat in, like a
burnish'd throne /
Burn'd on the water:
the poop was
beaten gold, /
Purple the sails . . .'

ENOBARBUS IN SHAKESPEARE,
ANTONY AND CLEOPATRA,
ACT II, SCENE 2

Etty, born in York, came late to painting, having been apprenticed initially to a printer, but he entered the Royal Academy Schools in 1807 and in addition spent a year in the studio of Sir Thomas Lawrence. Poorly educated, he placed great importance on travelling in France, Italy and the Netherlands, which he did on several occasions, notably in 1822–24, when he went to Paris, Naples, Rome and Venice. A great admirer of Titian and Rubens, Etty aspired to be a history painter, using literary and religious sources as well as prints for inspiration, and transposing his ideas on to large canvases that are comparable with the *grandes machines* of the French academic tradition.

Etty was loyal to and successful at the Royal Academy, but his work is difficult to categorize. It is perhaps significant that he was much admired in France, and can in some respects be compared with Delacroix. His work never loses its British tincture, but somehow the final effect seems to be foreign.

While he reveals himself on occasions to be a more than competent painter of portraits, still-lifes and landscape, his supreme ability lay in depicting nude figures.

Cleopatra's Arrival in Cilicia shows how hard Etty found it to master the principles of history painting. The treatment of the subject, taken from Plutarch's *Life of Antony* and Shakespeare's *Antony and Cleopatra*, reflects his respect for Veronese and Rubens, but the composition is awkward and almost overwhelmed by the number of figures arranged across the surface, and the barge is disproportionately big. Etty still had a lot to learn before rivalling the efforts of French painters such as Jean-Baptiste Regnault. The problem is that he overreaches. His forte for painting the nude is apparent; indeed, his bold and sensual rendering of naked bodies worried the critics. As *The Times* wrote in 1822 of another famous picture by Etty, *Youth on the Prow and Pleasure at the Helm* (London, Tate Britain), 'Naked figures when painted with the purity of Raphael, may be endured; but nakedness without purity is offensive and indecent.' Etty's pictures often raised eyebrows in this way, but they are undoubtedly spirited, particularly when he achieves proper compositional balance as in *The Judgment of Paris* (1826) also at the Lady Lever Art Gallery.

The artist never married and his devotion to the female nude, which continued throughout his life, may have been some form of sublimation.

SIR JOHN EVERETT MILLAIS (1829–96)
The Black Brunswicker 1859–60
Canvas, 99 × 66 cm / 39 × 26 in. Signed and dated

Millais had a fortunate start in life, and in 1840 at the age of eleven he was the youngest student ever admitted to the Royal Academy Schools. Sustaining this early promise was a cause for anxiety, but in the end he accumulated many honours, being the first artist in Britain to be created a baronet (in 1885) and elected President of the Royal Academy in the year of his death.

A founder member of the Pre-Raphaelite Brotherhood in 1848, Millais succeeded in developing a personal style and retaining his popularity with the public. He is, in fact, a far more varied painter than is popularly imagined, moving beyond historical or literary genre scenes to pictures with Symbolist overtones as well as portraits and pure landscapes, and book illustrations.

The catalyst for *The Black Brunswicker* was the success of a similar historical genre picture, *A Huguenot on St Bartholomew's Day*, which Millais exhibited at the Royal Academy in 1852. The public clamoured for him to paint another picture in this vein, as opposed to the more introspective themes that he had essayed in the mid-1850s. He came up with an idea similar to that of *A Huguenot*, but set a few days before the Battle of Waterloo, when the German cavalry regiment known as the Black Brunswickers made such a valiant attempt at Quatre Bras in trying to turn back Napoleon's initial advance.

'I have it all in my mind's eye, and feel confident that it will be a prodigious success'

MILLAIS IN A LETTER TO HIS WIFE, EFFIE, 18 NOVEMBER 1859

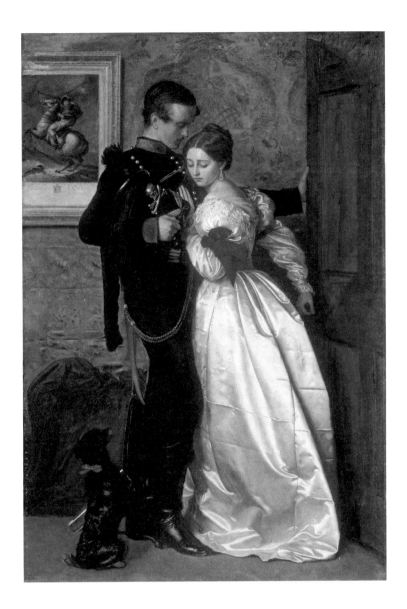

The young man in his distinctive uniform is anxious to depart for the battlefield, but is detained by the young woman (modelled by Kate Dickens, the daughter of the novelist); he holds the door open while she grasps its handle in a tug-of-war. Her pet, sensing the tension, echoes the young woman's concern. The print on the wall after Jacques-Louis David's famous picture of Napoleon crossing the Alps points up the historical context, but the black uniform together with the regiment's insignia of a skull and crossbones indicates an unhappy outcome.

For me this is a wonderfully passionate composition, almost operatic in its intensity. The interlocking of the two bodies and the gestures are brilliantly conceived and most moving. How many people in time of war must have experienced the anguish of such partings?

EDWARD JOHN GREGORY (1850–1909)

Boulter's Lock, Sunday Afternoon 1882–97

Canvas, 215 × 142 cm / 84⅝ × 55⅞ in. Signed

Boulter's Lock is near Maidenhead on the River Thames, not far from Cookham, where Stanley Spencer interpreted the river very differently. Gregory sets out to depict the social aspects of boating on a Sunday afternoon in high summer. The river was at its most popular during Ascot Week or the Henley Regatta: on such occasions around 800 boats and some 72 steam launches entered the lock. Gregory records the lock, which was built in 1830 and has a 6-foot (some 2-metre) drop, in great detail. He was a painstakingly slow worker and spent many years teasing this painting out. Indeed his progress was so slow that fashions in dress had changed before it was finally exhibited at the Royal Academy in 1897.

The high viewpoint and steep perspective add to the excitement of the composition, so that the lock becomes a funnel, heightening the sense of crowding and hyperactivity. Among the smaller craft trying desperately to keep out of the way of the steam launch bearing down on them are a sailing boat, sundry rowing boats, canoes and punts. There are perhaps some sharp social observations intended by the artist: the woman in the foreground with her pet is contrasted with the woman strenuously canoeing on the left. The artist himself nonchalantly surveys the scene, looking over his shoulder in the punt on the right, which in turn forms a contrast with the man vigorously punting left of centre.

The critics were divided, but the painting was deemed to be successful enough to secure Gregory's election to the Royal Academy. A watercolourist and illustrator, as well as a painter, he was said to be devoid of ambition, although it was reported that he was among the best-read men in London. The bulk of his work was owned by the Manchester industrialist Charles Galloway. Herkomer and Sargent were admirers.

GERALD LESLIE BROCKHURST (1890–1978)

Jeunesse Dorée 1934

Board, 76.2 × 63.1 cm / 30 × 24⅞ in. Signed

Brockhurst showed remarkable promise from a very young age, entering Birmingham School of Art in 1901 and the Royal Academy Schools six years later. A trip to France and Italy was to prove as influential in his art as the role of women was in his life. These two factors came together in his portraiture, for which he made a formidable reputation.

Unable to fight in the First World War, Brockhurst went to Ireland with his first wife, Anaïs Folin, and there met Augustus John and experimented with various styles and techniques. On returning to London his career both as a painter and as an etcher began to take off. For many of his allegorical and symbolic portraits Anaïs acted as his model and muse, until in the late 1920s he transferred his affections, amidst much gossip, to Kathleen Woodward, a considerably younger woman whom he later married as his second wife after

divorcing Anaïs in 1940. He re-christened Kathleen 'Dorette', and it is her features that are the hallmark of his most famous and popular portraits. At the same time he was being commissioned to paint portraits of leading personalities, including the actresses Merle Oberon and Marlene Dietrich and the Duchess of Windsor. At the start of the Second World War Brockhurst moved with Dorette to America, where he remained for the rest of his life.

Jeunesse Dorée is based on Dorette's features and is a typical allegorical portrait by the artist, remarkable for its psychological intensity and unyielding pose. Clearly inspired by 15th-century Italian portraits, the positioning of the figure so close to the picture plane against an empty landscape gives a slightly unsettling, hallucinatory effect. The viewer is confronted by the sitter's stare and does not quite know how to react: it is like a close-up in a film by Alfred Hitchcock. Added to this is the underlying sexuality that is evident in so much of Brockhurst's work (vividly epitomized by the etching *Adolescence* of 1932, which is like a work by Edvard Munch rather than an English artist). The title may well be a pun on 'Dorette'.

There are a number of Brockhurst's portraits in public collections in the British Isles and they are equally disturbing, in the sense that all is not quite as it seems on the surface. A contemporary critic wrote that the artist gives 'an edge to forms which vision does not experience'.

Fatal attraction in a disturbing allegorical portrait

Preston

HARRIS MUSEUM AND ART GALLERY

The building, which was begun in 1882 and opened in 1896, is without doubt one of the grandest and most awe-inspiring in the British Isles. Its virtually unknown architect, James Hibbert, pulled out all the stops. The massive portico comprises six fluted Ionic columns with a sculptured pediment (inscribed 'To Literature, Arts and Science') and behind it is a recessed façade articulated by a series of giant pilasters. Another inscription on the outside reads 'The mental riches you may here acquire abide with you always'. This is Neoclassicism at its most compelling and almost on the scale of German museums by architects such as Schinkel, Klenze or Semper. The entrance is equally grand on the interior, but switches idioms and becomes French, with a central rotunda and lantern based on the Invalides in Paris. Just so you know what the purpose of the building is, the walls of the balconies are decorated with friezes cast from the Elgin Marbles, reliefs from Nineveh and Thorvaldsen's Alexander Frieze.

All this was readily paid for by a local benefactor, Edmund Robert Harris (1804–82), whose inherited wealth and successful practice as a lawyer financed several major projects in Preston undertaken to commemorate the family name. The foundation stone was laid in 1893.

Harris's example was swiftly followed by other local benefactors, and the collections have been accumulated as a result of numerous donations and bequests. The British School is well represented from the 18th century onwards and there is a certain pride in local artists, beginning with Arthur Devis and members of his family.

ARTHUR DEVIS (1712–87)
Francis Vincent, his Wife Mercy, and Daughter Ann,
of Weddington Hall, Warwickshire 1763
Canvas, 106.7 × 100.7 cm / 42 × 39⅝ in. Signed and dated

'... his wood-notes
are among the
most purely native
in English painting'

ELLIS WATERHOUSE, 1953

Devis is the kind of artist who in France would be called a 'petit-maître'. He specialized in one branch of painting, namely the conversation piece, but his work has great charm and it is much appreciated by social historians for what it reveals about life and manners in the Georgian age. As one writer put it, he has 'the charm of a minor novelist'. For me looking at a painting by Devis reminds me of watching a performance of Tom Stoppard's play *Arcadia* (1993).

The association of Devis with Preston is clear-cut and his father, Anthony, was a town councillor. Even when based in London from 1742 onwards the artist solicited a number of

commissions from families in Lancashire, Cheshire and Derbyshire. Although trained by the topographical and sporting painter Peter Tillemans, Devis quickly saw the advantages of painting conversation pieces – a type of composition derived from Dutch 17th- century and French 18th-century art. Less formal than full-length portraiture and intended to stress the decorum and gentility of life amongst the landed gentry, Devis's paintings are usually on an intimate scale.

The figures are carefully posed with nonchalant airs, in sparsely furnished interiors or panoramic landscapes. Extraordinary to relate, Devis relied very heavily on studio props – costumed lay figures in particular, which is why his figures seem so doll-like and stiff. The interiors and the landscape settings are often based on the artist's imagination, architectural treatises or design manuals. The point was to show his sitters to full advantage in an idealized setting, so that each of his pictures often amounts to a general inventory of 18th-century life rather than a personalized one.

Francis Vincent was a barrister at the Inner Temple. He married Mercy in 1758 following the death of her first husband the previous year. The child shown in the painting, Ann, was born in 1759/60. A son, Dormer, who was born c. 1761, is not included. Francis himself died in 1766 aged forty.

Devis suffered from the success of Johann Zoffany and the rise of Sir Joshua Reynolds during the 1760s. To survive he undertook restoration work and took students. He officially retired in 1783 and died in obscurity in Brighton.

GEORGE ROMNEY (1734–1802)
Serena Reading c. 1780–81
Canvas, 152.5 × 120.5 cm / 60 × 47½ in.

'Possess'd by Sympathy's enchanting sway, / She read, unconscious of the dawning day'

WILLIAM HAYLEY, 'THE TRIUMPHS OF TEMPER', CANTO 1, 1780

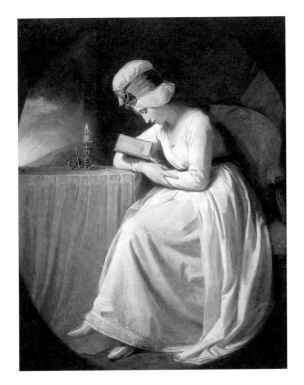

Like Reynolds and Gainsborough, Romney was born out of London but determined to be successful in the capital. His principal aim was to be a history or literary painter, and he never lost this ambition, contributing, for example, to the Boydell Shakespeare Gallery, although in the end his reputation (and his income) rested on portraiture. In this department he was unfortunate in being a contemporary of Reynolds and Gainsborough, but he succeeded in building up an aristocratic clientele, specializing in touching images of mothers with children or children by themselves, while at the same time achieving popularity through his 'fancy' pictures in which Emma Hart, the wife of Sir William Hamilton and Nelson's mistress, had a dominant role.

Romney's portraiture is of interest because it fused so many elements of his art: in this respect he forms a bridge between Reynolds and Gainsborough and their successor, Sir Thomas Lawrence. Having received a solid but limited training in the north of England (York and Kendal), a visit to Italy in 1773–75 was crucial for his development, particularly what he saw in Rome, Bologna and Venice. A note of increasing confidence enters his work after this trip, characterized by a more impulsive style with simplified contours, bold brushstrokes and distinctive colouring (salmon pink, bottle green, sky blue and phosphorescent white). His spontaneity led him to paint his portraits directly on to the canvas, with a preference for a lack of finish – a breadth of style that is also apparent in his magnificent ink drawings made with pen and brush.

Serena Reading was inspired by the poem 'The Triumphs of Temper' written by William Hayley (1780), which describes the tribulations visited upon a young woman who after

overcoming them makes a happy marriage. The poem was immensely popular, although today it might be criticized for being overlong and unduly sentimental. The poet and the artist became close friends: they shared the same political views, stemming from a sympathy for the French Revolution, and enjoyed the company of women, after making unfortunate marriages. Hayley wrote the first biography of Romney (1809), whom he described (perhaps tongue in cheek) as 'having as many sultanas as an Asiatic prince'.

Serena Reading is a wonderfully affecting composition. Its appeal lies in its simplicity, with the young woman totally absorbed in her reading. The creamy white of her dress is particularly powerful and overwhelms the two light sources – one natural, in the streaked sky, and the other artificial, emanating from the candle.

CAREL WEIGHT (1908–97)
Crucifixion 1959
Wood. 243.8 × 152.4 cm / 96 × 60 in.

Carel Weight's paintings are widely distributed in public museums and galleries in the British Isles. He was a prolific artist whose work had a popular appeal, exhibiting at the Royal Academy regularly from 1931: in fact, one critic in the year in which *Crucifixion* was painted referred to him as 'the John Betjeman of painting'.

A deeply unhappy childhood and an undistinguished schooling left Weight fearful, anxious and lacking in confidence. He first studied at Hammersmith School of Art and was offered a scholarship to the Royal College of Art, which he was unable to take up. Eventually he went to Goldsmiths' College before teaching at Beckenham School. He served in the army during the Second World War, but continued painting, becoming for a time an official war artist. Subsequently from 1947 to 1973 he taught at the Royal College of Art, where he was immensely popular. His outward appearance (he stood with his feet apart, stooping like Winnie the Pooh) and kindliness belied the tensions and anxieties that preyed upon him.

These uncertainties emerge vividly in Weight's paintings, where ordinary scenes from life can suddenly appear menacing and irrational. Like Stanley Spencer, his imagination gave everyday occurrences – in his case in the suburbs of south-west London where he lived – a different level of meaning: 'The products of memory, mood and imagination rise upon the foundation of fact. My art is concerned with such things as anger, love, hate, fear and loneliness emphasized by the setting in which the drama is played.'

There are a number of scriptural subjects in Weight's œuvre, although the theme is not always obvious at first. Even the unmistakable subject of the Crucifixion is here given an unusually dramatic treatment, comparable in its elements of surprise with works by James Tissot or Salvador Dalí. Raised on an unsightly rocky crag representing Golgotha, the three crosses are seen from behind. Some of the figures are Biblical in the sense that

'One is always slightly careful what one says about God in case he really is there'

CAREL WEIGHT, 1996

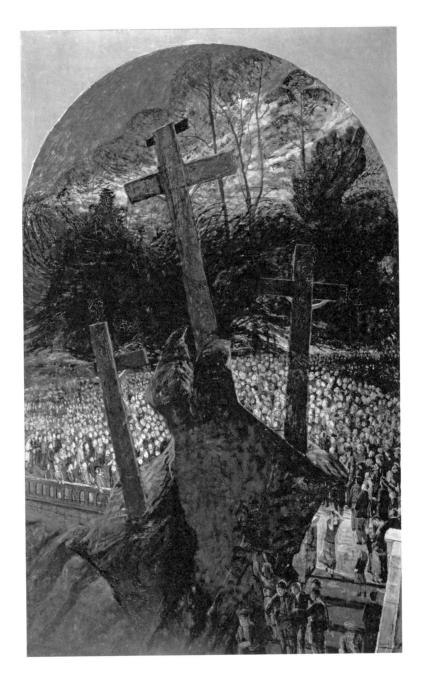

their roles at the scene are described in the Gospel of St John, but the artist's concern for humanity is revealed in his interpretation of the crowd, who gaze upwards in an act of communal witness while registering different emotions. By contrast, only the arms of the crucified (each catching the light) are visible, with the crosses silhouetted against the reddening sky, which reminds me of the passage in the Gospel of St Luke, 23:45, 'And the sun was darkened, and the veil of the temple was rent in the midst'. It is a disturbing image worthy of William Blake.

Part Three

SCOTLAND

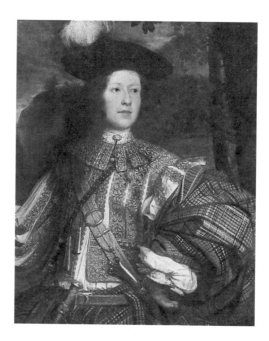

John Michael Wright
Lord Mungo Murray (detail)
Scottish National Portrait Gallery
(see pp. 404–6)

Edinburgh

The National Galleries of Scotland comprise three separate elements, each with its own buildings and collections: the National Gallery, the Scottish National Portrait Gallery, and the Scottish National Gallery of Modern Art.

NATIONAL GALLERY OF SCOTLAND

The National Gallery is perfectly located on the Mound in Princes Street Gardens in the centre of the city, acting as a fulcrum between the Old Town and the New Town. The building, opened in 1859, was designed by William Henry Playfair to house both the National Gallery and the Royal Scottish Academy. The growth of the collections and the incompatibility of two such different organizations was not propitious. And so in 1906 the Royal Scottish Academy moved into an earlier building nearby, closer to Princes Street, also designed by Playfair, previously known as the Royal Institution for the Encouragement of the Fine Arts in Scotland. In 1912, after some modifications, the National Gallery assumed the function it has today. Together, these two building designed according to the strictest Classical principles (though Playfair never travelled to Greece or Italy), the earlier according to the Doric order and the later according to the Ionic order, with large porticoes, extensive peristyles and vast balustrades, helped to give the impression that Edinburgh was a 'Modern Athens'.

Throughout the 20th century, however, tensions continued to exist between the Gallery and the Academy. They were only resolved by the audacious plan (known as the Playfair Project) masterminded by the Gallery's Director, Timothy Clifford, and completed in 2004, of linking the two buildings in order to provide the National Gallery with increased exhibition space and enhanced facilities. The buildings are connected underground by the Western Link, designed by John Miller and Partners. A further initiative by Clifford was to reinstate in the National Gallery the original colour schemes and installations devised for the galleries by Playfair's collaborator, David Ramsay Hay.

In addition to its ideal location, the National Gallery of Scotland achieves near perfection in other ways. The scale of the building, the size of the galleries and the number of pictures are not intimidating. The quality of the paintings, ranging from the 14th century up to the Impressionists and Post-Impressionists, is of the highest order and includes a solid core of works by Scottish artists. The major artists of the Western European tradition are represented with superb examples.

The group of old masters formed by the Institution for the Encouragement of the Fine Arts in Scotland, founded in 1819, was the starting point for the National Gallery's

own collection. Such acquisitions had been made or encouraged by canny Scottish dealers, William Buchanan, Andrew Wilson and James Irvine, who had operated during the Napoleonic Wars when so many pictures suddenly became available. Added to these acquisitions were 'modern' paintings collected by the Royal Scottish Academy. Some of the old masters collected by Sir James Erskine of Torrie and bequeathed to the University of Edinburgh in 1825 (now mostly to be found in the University's Talbot Rice Gallery) are displayed here.

The National Gallery's collections gathered impetus with further bequests and purchases during the 20th century. One of the glories of the gallery – as it would be in any of the greatest galleries in the world – is the loan since 1946 of over twenty paintings by Raphael, Titian, Rembrandt and Poussin amongst others from the Duke of Sutherland, who inherited a large proportion of the Bridgewater House collection formed at the turn of the 18th and 19th centuries during a golden moment in the history of collecting in Britain. Indeed, two outstanding works by Titian were recently bought from the Duke of Sutherland – *Venus Anadyomene* and *Diana and Actaeon* (this last acquired in 2009 jointly with the National Gallery in London).

WORKSHOP OF DOMENICO GHIRLANDAIO (c. 1448–94)
Virgin and Child c. 1468–70
Canvas transferred to wood, 106.7 × 76.3 cm / 42 × 30 in.

The great beauty of this painting lies in the simplicity of its design. It exudes a powerful sense of religious feeling that is for me one of its principal attractions. The attribution has been much debated over the years, giving the picture considerable status on account of references to Andrea del Verrocchio, the teacher of Leonardo da Vinci. The fact that the surface is not perfectly preserved does not detract from the painting's qualities, nor does the fact that the incised lines determining the perspectival system are clearly visible.

The subject of the kneeling Virgin adoring the Christ Child while alone is distinctly private and profoundly moving. The building in the background is identifiable as the Basilica of Constantine (or Maxentius), a huge ruined structure in the Forum in Rome. According to the *Golden Legend*, written c. 1275 by Jacopo da Voragine, it collapsed on the night Christ was born. It often features in scenes of the Adoration of the Child, where it symbolizes the passing of the Old Law in favour of the New Law. In such ways the spirit of humanism with its interest in the Classical past enters Italian Renaissance art.

An additional reason for my liking this picture is the fact that it was owned by John Ruskin, who acquired it from the Manfrin collection in Venice in 1877. It became part of the didactic museum formed in connection with the Guild of St George in Sheffield that Ruskin had established to alleviate the hardship of industrial workers and labourers in the city. The Guild sold the picture in 1975.

The ultimate religious picture, once owned by John Ruskin

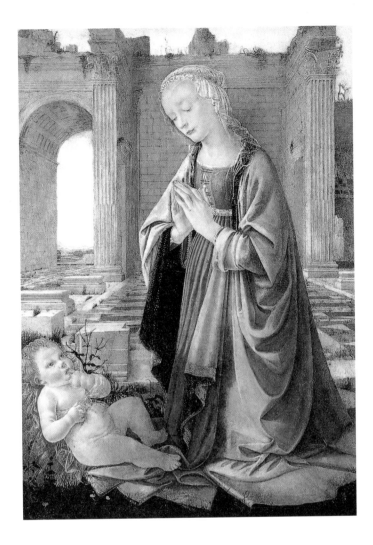

Although Ruskin wrote so memorably on art, he does not seem to have described this *Virgin and Child*, but Bernard Berenson certainly did in his *Drawings of the Florentine Painters* (1903), in a passage that matches the beauty of the painting itself: '…this picture leaves in the memory a longing to see it again and again. No doubt it owes much to the impressive simplicity of the design, consisting, as it does, of two figures only, almost, indeed, of one figure, for the Virgin so compels and absorbs attention that we look at the Child as the object of her adoration, and not in and for himself. Yet without the background of majestic ruins we should not know what scale to give her if we could not realize that her proportions are grander even than theirs. She cannot be merely human: she must be divine. And looking across the patterned pavement over empty bases for pillars, gemlike in elegance of carving, to walls of daintily jointed masonry, and through a coffered arch to the low hills on the distant horizon, I am overcome as but seldom in my long aesthetic experience by a romantic yearning for the far-away and long-ago, which noble vestiges of classical antiquity so unfailingly arouse.'

ADAM ELSHEIMER (1578–1610)

The Stoning of Stephen c. 1603–4

Copper, 34.7 × 28.6 cm / 13⅝ × 11¼ in.

St Stephen was the first deacon of the Christian Church and its first martyr. His preaching incurred the hostility of the Jews and he was stoned to death outside the walls of Jerusalem. As Stephen was being put to death he experienced a vision of heaven: a beam of light streams down from the figures of Christ and God the Father as angels descend with the palm of martyrdom and a crown. The scene is presided over by the figure on horseback at the left, who is Saul – later a convert to Christianity, the future St Paul.

The German painter Adam Elsheimer was born in Frankfurt-am-Main, but while still a young man he travelled to Venice where he worked with Hans Rottenhammer. By the

'In my opinion
he has no equal
in small figures, in
landscapes and in
many other subjects'

RUBENS, IN A LETTER TO
JOHANN FABER, WRITTEN IN
ANTWERP, 14 JANUARY 1611

spring of 1600 he was in Rome working for many of the leading patrons, and he remained there for the rest of his relatively short life. Beyond these basic facts not much else is known for certain.

Elsheimer specialized in paintings on a small scale, often on copper, and even his two surviving altarpieces (Berlin and Frankfurt) are restricted in size. Apart from his meticulous technique that allowed him to combine crowded compositions with sumptuous landscape settings, Elsheimer was famous for his night scenes and darkened interiors which partook of the tenebrist tradition evident in the work of artists from both sides of the Alps. Such works achieved immense popularity with collectors in Europe at the beginning of the 17th century.

On Elsheimer's death Rubens wrote to a mutual friend, the doctor Johann Faber: 'Surely, after such a loss, our entire profession ought to clothe itself in mourning. It will not easily succeed in replacing him . . . For myself, I have never felt my heart more profoundly pierced by grief than at this news . . .'

The Stoning of Stephen was painted in Rome. It fuses intense lyricism in the treatment of the narrative with powerful chords of colour and provides an effective demonstration of Elsheimer's ability to produce elaborate compositions on a reduced scale. The picture was owned by Paul Bril, a fellow painter in Rome famous for landscapes, but other contemporary artists also admired it.

The composition attests Elsheimer's awareness of Raphael and Caravaggio without any loss of his own individuality. In the beams of light, for example, extending from the heavens (top left) to illuminate the kneeling figure of St Stephen, he demonstrated his skill at different optical effects.

Many of Elsheimer's paintings were engraved (several by the wonderfully named Count Hendrick Goudt, who was also one of his patrons) and consequently became widely known. Apart from Rubens, as a young man Rembrandt looked at Elsheimer, as did Samuel Palmer in a later century. Considering his limited output, it is remarkable that there are several examples of his work in British collections (Royal Collection, National Gallery and Apsley House in London, Fitzwilliam Museum in Cambridge, Petworth House) and the National Gallery in Scotland itself owns a second Elsheimer, the esoteric *Il Contento*.

JEAN-BAPTISTE-SIMÉON CHARDIN (1699–1779)
Vase of Flowers c. 1755
Canvas, 43.8 × 36.2 cm / 17¼ × 14¼ in.

'It is nature itself'

DIDEROT

Chardin was the son of a distinguished cabinet-maker and it is undeniable that there is something well made or carefully crafted about his own paintings. He was destined at first to become a history painter, but his reception piece for the Académie Royale in Paris in 1728 was an elaborate still-life. He remained loyal to the Academy for the rest of his

career, holding several official positions, even though his work while much praised ran counter to contemporary trends. His restrained manner of painting, quotidian subject-matter and carefully contrived compositions form a striking contrast to the pulsating animated brushwork of Rococo artists.

Chardin's output falls into three categories: early still-life, based on the Dutch 17th-century tradition; domestic genre scenes that are intended as objective descriptions of everyday life without any moral overtones; and finally a return to still-life painting of increased sophistication, including important royal commissions for decorative schemes illustrating the Liberal Arts.

Vase of Flowers is the only surviving flower piece in Chardin's œuvre. The structure of the composition – a Delft vase placed on a stone ledge seen against a plain background – is of an overriding simplicity. The confidence of the brushwork used both for the smooth texture of the vase and for the varied tactility of the flowers has wonderful strength without being overbearing. In the end, however, what matters for Chardin is a question not of surface quality but of what lies beneath.

The poetry lies in the timeless quality of the image. The fact that the flowers on the ledge are not dead but merely superfluous stems suggests that this is not a *vanitas* subject, reminding the viewer of the passing of time, but a celebration of beauty.

The visual effect seems rather subdued, but this is more the result of Chardin's technique, which Diderot (1763) described: 'At times it seems as if a mist has been blown onto the canvas; and sometimes as if a light foam has been thrown over it . . . Come close and everything becomes blurred, goes flat and disappears; stand back and everything comes together and takes shape.'

As with Vermeer (an obvious comparison), relatively little is documented about Chardin. We know him through his paintings. He had no immediate followers, but his spirit lives on in Cézanne and Giorgio Morandi rather than in Henri Fantin-Latour.

SIR JOSEPH NOEL PATON (1821–1901)
The Quarrel of Oberon and Titania 1849
Canvas, 99 × 152 cm / 39 × 60 in.

'Ill met by moonlight, proud Titania'

SHAKESPEARE,
*A MIDSUMMER NIGHT'S
DREAM*, ACT II, SCENE 1

Born in Dunfermline in Fife, Paton was recognized as the prime exponent of the popular Victorian genre of fairy painting. His reputation rested on two large pictures based on Shakespeare's *A Midsummer Night's Dream*. The first to be painted (1847) was *The Reconciliation of Oberon and Titania* (Act IV, scene 1), also in the National Gallery of Scotland, and the second (1849) is the present subject, based on Act II, scene 1. Both

paintings were well received and still today impress by the variety in the poses, attitudes and characterization of the fairy population and the detailed treatment of the flora, fauna and insect life.

The quarrel referred to in the title is precipitated by Oberon, King of the Fairies, demanding that his Queen, Titania, hand over an Indian boy born to one of her attendants who had died in childbirth. Oberon wanted the child to serve as his pageboy. Titania refuses and, as shown here, protects the child from Oberon.

Early in his career Paton had been involved in designing fabrics and book illustration, and there is a sense in which this composition can be regarded as a form of patterning or illustration, but it is also a remarkable demonstration of painting the nude. Compared with the apocalyptic world of the 15th-century Flemish artist Hieronymus Bosch, Paton is far less terrifying: indeed, his universe is a playfully domesticated one.

The public was so taken by the intricacy of the compositions that in 1864 both pictures had to be glazed in order to deter visitors from pointing and touching. Lewis Carroll 'counted 165 fairies!' when he saw the picture in 1857. In fact, so impressed was Carroll that he invited Paton to illustrate *Alice in Wonderland* (1865) and *Alice through the Looking Glass* (1871), but by then the artist had moved on to contemporary and religious subject-matter and so refused the offer.

FREDERICK EDWIN CHURCH (1826–1900)
Niagara Falls from the American Side 1867
Canvas, 260 × 231 cm / 102³⁄₈ × 90⁷⁄₈ in.

Paintings in British collections by American artists of the 19th century on this dramatic scale are exceptionally rare. Stranger still is the fact that the picture was presented to the National Gallery of Scotland in 1887, merely twenty years after it was painted, having been commissioned by the London dealer Knoedler. Only in recent years, however, has it been on permanent display.

A pupil of Thomas Cole, Church established an international reputation early in his career as America's premier landscape painter, closely associated with the Hudson River School. (Church lived at Hudson in New York State, where he had a farm, but he also built a villa nearby, Olana, in an Oriental style – a place that is perfectly in tune with his art.) Two large-scale paintings – *Niagara* of 1857 (Washington, D.C., Corcoran Gallery of Art) and *The Heart of the Andes* of 1859 (New York, Metropolitan Museum of Art) – in particular were rapturously received and subsequently sent on tour to Europe. Critics recognized such pictures as an exercise in the portrayal of the Sublime in nature, but at the same time they interpreted the subject-matter in religious and nationalist terms. Church was fortunate that his work was widely and energetically promoted, but the public response was genuine and the widespread sale of prints after many of his pictures was an added advantage.

'The external world in all its rich variety of forms' transformed into 'heroic landscape painting'

ALEXANDER VON HUMBOLDT, *COSMOS*, 1849

Following the example of Cole, the artist transformed the course of landscape painting in America by elevating it far above the merely topographical. He did this in a carefully considered way, travelling extensively during the 1840s and 1850s in New England and in South America, Nova Scotia, Newfoundland and Labrador. Only after 1860 did he venture to Europe, North Africa and the Near East. Most of this travelling was done during the

summer months, with the winter reserved for painting. Even the largest compositions were carefully prepared with numerous wonderfully fresh oil sketches, which on the basis of 'less is more' are often more beautiful than the finished paintings.

Niagara Falls mark the border between Canada and the United States and are formed of two sections. Although not exceptionally high, it is the width and the mass of water that makes them the most powerful waterfall in North America. Church evolved his paintings of Niagara in the mid-1850s, but continued to paint the subject during the following decade. The power of nature is evoked not just in terms of the sheer scale, but also in the precision with which the spray, the vegetation and the rainbow are rendered, as well as by the presence of two diminutive figures on the left.

The term often applied to painters of the Hudson River School is 'luminist', which refers not so much to the treatment of light in itself as to the artist's total absorption in the subject, to the extent that all aspects of personality and stylistic idiosyncrasies become subservient. By such means the viewer partakes equally with the artist in the sense of wonder experienced in front of the force and beauty of nature.

PAUL GAUGUIN (1848–1903)
Martinique Landscape 1887
Canvas, 116 × 89 cm / 45½ × 35 in. Signed and dated

The holdings of Impressionist and Post-Impressionist pictures in the National Gallery of Scotland are particularly choice, owing for the most part to two benefactions: Sir Alexander Maitland (1960) and Sir John Richmond through his niece Mrs Isabel Traill (1979). *Tropical Vegetation* (which belonged to Sir Alexander Maitland) is often described as the masterpiece of Gauguin's short visit to Martinique in May–October 1887.

The island was a French colony and although no longer unblemished by modern developments still retained unspoilt parts and traditional customs that had an immediate appeal for Gauguin. In fact, his time on Martinique ('home of the Creole gods' as he described it) encouraged the artist in his search for the exotic which eventually led him even further afield. His visit would probably have lasted longer had it not been for illness, which forced him to hurry back to France.

If the subject-matter of the few paintings undertaken on Martinique anticipates Gauguin's later experiences in the Marquesas Islands in the Pacific Ocean, the style is in essence the summation of his earlier Impressionist years. The iridescent colours and the variety of brushwork, which in the middle distance seems carefully regulated, evoke comparison with those of his mentors, Camille Pissarro and Cézanne, although with a greater tendency towards the decorative than they would have counselled.

The view is of the bay of St-Pierre seen from the volcanic peaks of Morne d'Orange. The scene was often pictured in postcards, but Gauguin has edited out any indications of

'home of the Creole gods'

PAUL GAUGUIN ON MARTINIQUE

modern civilization in order to emphasize the Edenic qualities of the landscape. What is particularly apparent is Gauguin's enthusiasm for its tropical nature, which he was discovering for the first time. Apart from the lushness of the vegetation (as in the silhouetted papaya tree), the viewer is made strongly aware of the sultry atmosphere and throbbing heat intensified by the overcast sky.

SCOTTISH NATIONAL PORTRAIT GALLERY

The portraits in the Scottish National Portrait Gallery honour the contribution made by a host of individuals to the history and life of Scotland. Since the influence of Scots throughout the world has been considerable, it provides a record of achievement that extends far beyond national boundaries. Part of the fun of visiting the gallery is to see how it is being kept up to date with commissions for paintings of contemporary personalities.

The idea of such a collection being formed in Scotland has its roots in the late 18th-century tradition of Temples of Fame. One such, a 'Temple of Caledonian Fame', was created by David, 11th Earl of Buchan, in the chapter house of Dryburgh Abbey, but the concept was not a success. Only in 1889 was the present Scottish National Portrait Gallery established, and then as the result of a public campaign. This was led by John Ritchie Findlay (1824–98), a local newspaper proprietor, who became the founder and chief benefactor of the gallery. As architect he chose Sir Robert Rowand Anderson, who adopted a Neo-Gothic style to create one of the most extraordinary buildings in Edinburgh. Although Anderson's design is for a purpose-built gallery, the exterior suggests a large-scale reliquary festooned with sculpture of Scottish monarchs, statesmen and poets. The main entrance is protected by William Wallace and Robert the Bruce. The dark interior has an even greater surprise in the main hall, where there are two friezes by William Hole depicting important scenes and leading personalities from Scottish history. These murals with their antiquarian air are a little overpowering. Escape lies in entering the galleries where the collections, including wonderful groups of portrait miniatures, await your inspection.

JOHN MICHAEL WRIGHT (c. 1627–94)
Lord Mungo Murray c. 1683
Canvas, 224.8 × 154.3 cm / 88½ × 60¾ in.

This portrait is an early example of the international flavour of Scottish art. Lord Mungo Murray (1668–1700), fifth son of John Murray, 2nd Earl and 1st Marquis of Atholl, is elaborately dressed for hunting with a belted plaid folded to form a kilt and with a mantle over which is a doublet with slashed sleeves. He is armed to the hilt with a flintlock sporting gun, two scroll-butt pistols in his belt, a dirk and a ribbon basket sword. The Murrays were related to the Irish dukes of Ormonde, and the young Lord Murray was attached to the Duke of Ormonde's entourage at Kilkenny Castle during the early 1680s, when this portrait is most likely to have been painted – probably so that the Duke could show his people a Scotsman in national dress. (A companion portrait showing the Irishman Sir Neil O'Neill, also dressed in national costume, is in Tate Britain in London.)

John Michael Wright was born in London, but apprenticed to the Scottish painter George Jamesone in Edinburgh during the late 1630s, after which he spent more than ten years in Rome from 1642 – a period when Poussin and Velásquez were also in the city. Rome must have been an invigorating experience for Wright as an artist, but he also established himself as a collector and dealer. During the 1650s he travelled in several countries in this joint capacity and he was employed for a time by the great collector Archduke Leopold Wilhelm, Governor of the Spanish Netherlands. Thereafter, Wright sought royal patronage in London at the court of Charles II, where he painted the King's exceedingly fine state portrait (Royal Collection). With Catholicism still in the ascendancy during the reign of James II, Wright formed part of the embassy headed by the Earl of Castlemaine to Rome in 1686–87 which sought a closer alliance with Pope Innocent XI. He designed many of the processional decorations and costumes, including those for a

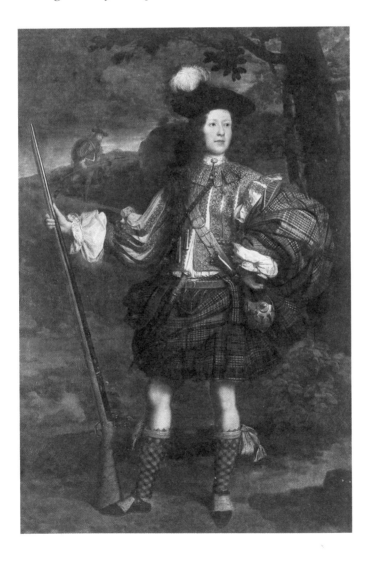

banquet for over a thousand guests, and subsequently published a colourful illustrated account of all the proceedings.

In regular demand as a portrait painter, Wright suffered from the fact that contemporaries preferred the more effusive style of Lely. As Samuel Pepys wrote after visiting Lely's studio, 'Thence to Wright's the painter's: but Lord, the difference that is between their two works.' Today such implied criticism has been reversed: Wright is now seen as a portraitist with a wide repertoire, notable for his particularly sympathetic treatment of women and children. The political and religious consequences of the Glorious Revolution in 1688, with the accession of the Protestant William III, in effect brought Wright's career to a close.

ANONYMOUS ITALIAN
Fiesta before the Palazzo Muti-Papazzuri, Rome c. 1747
Canvas, 196 × 297 cm / 76¾ × 116⅞ in.

This is a very theatrical painting, commemorating a significant event in the history of the exiled Stuarts. Following his years in France at St-Germain-en-Laye and the abortive campaign of 1715, Prince James Francis Edward Stuart – James VIII or III, the Old Pretender

– went to live in Rome, establishing his court at the Palazzo Muti-Papazzuri, which is the building dominating the present composition (in reality it was not as grand as it seems here). The façade is a temporary one, marking a special ceremonial occasion: it is surmounted by three heraldic shields bearing the arms of the Old Pretender, Pope Benedict XIV and the city of Rome.

The picture almost certainly records the appointment of Henry Benedict, the second son of the Old Pretender and Clementina Sobieski, as Cardinal York in July 1747. A crowd has gathered in front of the palace and is perhaps dispersing after the ceremony. Between two lines of soldiers the Old Pretender, wearing the Order of the Garter and accompanied by his two sons, Charles Edward Stuart (the Young Pretender) and Henry Benedict Stuart, is in conversation with a cardinal. The grouping of these figures is entertainingly done and some are skilfully painted.

The picture belonged to Cardinal York (also styled Henry IX). It hung in his villa at Frascati where Sir Walter Scott was shown it in 1832. The 11th Duke of Hamilton acquired it in 1845 for his collection at Lennoxlove.

The exiled Stuarts fared well in Rome. Both the Old and Young Pretenders died in the Palazzo Muti-Papazzuri and it is said that the sound of bagpipes can sometimes be heard at night. All were buried in St Peter's and Pope Pius VII commissioned the sculptor Antonio Canova to erect a monument in the nave over their tombs. The Scottish National Portrait Gallery also has other historical pictures relating to the exiled Stuarts: *The Marriage of Prince James Francis Edward Stuart and Princess Clementina Sobieski* by Antonio Masucci and *The Baptism of Prince Charles Edward Stuart* by P. L. Ghezzi.

ROBERT SCOTT LAUDER (1803–69)
John Gibson Lockhart and Sophia Scott c. 1840
Canvas, 76.8 × 64.8 cm / 30¼ × 25½ in.

'What shall be the
maiden's fate? /
Who shall be the
maiden's mate?'

SIR WALTER SCOTT,
THE LAY OF THE LAST
MINSTREL, 1805,
CANTO I, XVI

The key to a full appreciation of this moving double portrait – always a challenging composition for any artist – is the writer Sir Walter Scott, author of the Waverley novels, a landmark in the literature of the Romantic Movement. John Gibson Lockhart (1794–1854), a brilliant Classicist, novelist, poet and editor of the *Quarterly Review*, married Scott's daughter Sophia in 1820 and settled for a time in a cottage on Scott's estate at Abbotsford in the Borders. They had three children, but Sophia died young in 1837. This portrait is almost certainly commemorative, which accounts for the prominence given to Sophia, who shows her wedding ring and holds a veil. Lockhart, a man described as exceedingly good-looking with 'Hidalgo airs', has a more retiring pose in the background.

Lauder had set out to be a portrait painter, but was easily diverted into historical and literary subjects. A period in Italy (1833–38) allowed him to extend his repertoire further to include genre scenes and landscape. Although successful in Edinburgh, he

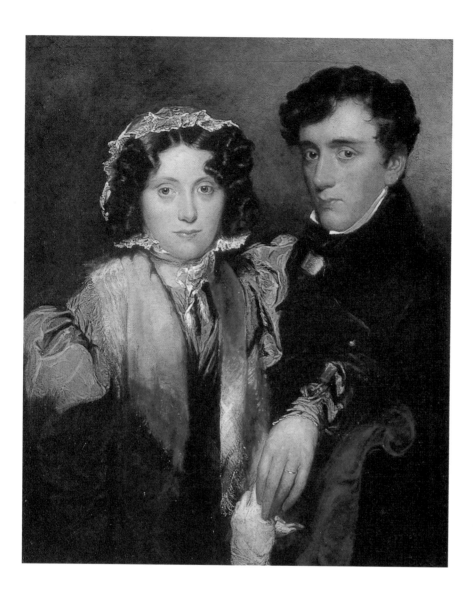

failed to win such high regard in London after returning from Italy. A gifted teacher, Lauder was invited back to Edinburgh in 1852 to take up a post at the Trustees' Academy, where his unorthodox approach proved to be immensely influential on a whole generation of Scottish artists.

Lockhart, who was a gifted linguist, first met Scott through a shared interest in the work of Goethe and Schlegel. He is most famous for the extended biography of his father-in-law, the *Life of Scott* (1837–38, revised 1839, abridged and revised 1848), which, along with James Boswell's *Life of Johnson*, is one of the greatest contributions to the art of biography. All the profits from this work went to pay Scott's creditors following the financial difficulties the famous author's publishers got into in 1826. Lockhart is buried at Dryburgh Abbey and was laid to rest as requested at the feet of Scott.

SIR WILLIAM NICHOLSON (1872–1949)

Sir James Matthew Barrie 1904

Canvas, 58.4 × 52.7 cm / 23 × 20¾ in. Signed and dated

The date of this portrait is of the utmost significance, as it coincides with the first performance of Barrie's play *Peter Pan* for which Nicholson was the designer. In fact, Barrie (1860–1937) sat for this portrait between the rehearsals for the play, which he was punctilious in attending.

The artistic progenitors of Nicholson's style of portraiture here are Velásquez and Whistler. He silhouettes Barrie, who is seen almost in full profile, against a plain background, which is activated only by the shadow cast by the figure and the three-dimensional quality of the brushwork. The strikingly nonchalant pose and carefully controlled formal elements not only enhance the level of objectivity in the likeness, but also reveal a great deal of the sitter's withdrawn personality. Peculiarly, but probably deliberately, Nicholson cuts the figure in such a way that the portrait is neither a half-length nor a three-quarters length, which perhaps reflects the fact that Barrie was less than five feet (1.5 m) tall.

Barrie was born in Kirriemuir in Angus where, following school in Dumfries and university in Edinburgh, he became a journalist. Moving south to London in 1885 he turned his hand to writing novels and short stories. It was the theatre, though, that really absorbed his attention from the 1890s and he made his reputation with such plays as *Dear Brutus* (1917) and *Quality Street*, *The Admirable Crichton* and *Mary Rose* (all 1920). None – and there were many – proved to be as popular as *Peter Pan* both with contemporaries and posthumously. Barrie's gifts as a writer were publicly acknowledged by his appointments as Rector of St Andrews University and Chancellor of Edinburgh University, as well as honorary doctorates from Oxford and Cambridge.

Barrie had a sad personal life. His relationships with women were complicated and unresolved, many of his closest friends died in tragic circumstances, and his close friendship with younger people was often misunderstood or over-interpreted (even more so after his death). As a human being he was profoundly lonely and what he loved most was the world of fiction and dreams, which is why he related so easily to children and why the theme of childhood and the loss of childhood was so important to him. Characteristically, he instructed that his gravestone in the cemetery at Kirriemuir should be 'with no embellishment of any kind'.

'I have long ceased to be on speaking terms with my face, so why have it painted?'

JAMES BARRIE

AVIGDOR ARIKHA (1929–2010)
Alexander Douglas-Home, 14th Earl of Home and Baron Home
of the Hirsel 1988
Canvas, 91.8 × 71.3 cm / 36¼ × 28¼ in.

British politics, or indeed the Conservative party, will never see the likes of Alexander Douglas-Home (1903–95) again. He was the 14th Earl of Home, the thirteenth Prime Minister to have been educated at Christ Church, Oxford, and the eighteenth to have emerged from Eton. It has been well written that he represented the last flowering of a highly sympathetic tradition of political service based on a mixture of patriotic duty, personal ambition and inherited land. His background gave him a strong sense of priorities – loyalty, consideration for others and diligence. He did not naturally assume that he was destined for high office and his approach to politics was distinctly pragmatic, always being confident in himself and his beliefs, as well as calm and polite in their exposition. Throughout he kept a sense of balance by a love of country pursuits on the family estate in the Lowlands and his love of cricket.

The last of a
rare breed

Returned as Member of Parliament for Lanark in 1931, Douglas-Home became Parliamentary Private Secretary to Neville Chamberlain when Chamberlain was Chancellor of the Exchequer and Prime Minister, accompanying him to Munich for the final meeting with Hitler in September 1938. Subsequently, Douglas-Home had a growing and expert interest in foreign affairs, serving first as Commonwealth Secretary (1955–60) and then as Foreign Secretary (1960–63 under Harold Macmillan and 1970–74 under Edward Heath). After Macmillan gave up the premiership as a result of illness, Douglas-Home became Conservative Prime Minister for one year – 1963–64. But the tide had turned and the age of satire had dawned. Caricaturists had a field day and Douglas-Home was one of their main targets. Even though he stayed on to hold high office again, retirement back to the Hirsel beckoned.

Arikha was born in Romania, but after the considerable hardships experienced during the Second World war ended up in Israel where he studied at the Bezalel School of Art in Jerusalem (1946-49) before moving to the Ecole des Beaux-Arts in Paris. He then based himself in Paris, where he became a close friend of Samuel Beckett. There was as much emphasis on drawing and printmaking in his career as on painting, and he also wrote on art, gave lectures and organized exhibitions. His depiction of Douglas-Home is perfectly pitched, with the figure positioned along the left edge of the canvas emphasizing his height and stooping, ponderous gait. There is a feeling of diffidence in the pose and the flicker of light across the face, but equally a suggestion of strength and determination in the jutting facial features. The contrast between the ice-blue background and the dark cloth of the suit gives an added sense of presence.

There are two other paintings by Arikha in the gallery: *Queen Elizabeth the Queen Mother* (1983) and *Sir Ludovic Kennedy and Moira Shearer* (1993). Otherwise his work is well represented in the Department of Prints and Drawings in the British Museum as a result of a gift made by the artist in 2005.

SCOTTISH NATIONAL GALLERY OF MODERN ART

Of the triumvirate of national galleries in Edinburgh the Scottish National Gallery of Modern Art is the youngest, and its birthpangs were difficult. It was founded in 1960 to collect works of art on an international basis dating from the 1890s to the present day, and there is inevitably a slight overlap with the National Gallery of Scotland. An added difficulty was that the foundation occurred at just the moment when the art market was rising, so that any official purchasing grant or supplements to it were unlikely to go very far. Nonetheless, a combined policy of careful purchasing buttressed by bequests, donations and loans has enabled the collection to become fairly representative of developments in modern art in Europe and America.

Two outstanding acquisitions have transformed the gallery's reputation in recent years. Items from the magnificent collections put together by Sir Roland Penrose (1900–1984) and Mrs Gabrielle Keiller (1908–95) came to the gallery over an extended period of time, and the result is that Scotland now has one of the greatest holdings of Dada and Surrealist art in existence. Gabrielle Keiller's interests included Eduardo Paolozzi, who was born in Edinburgh and who in turn made a large donation of his own work in 1994.

The Scottish National Gallery of Modern Art began life in Inverleith House in the Royal Botanic Gardens, but that was always intended as a temporary home. In 1984 it moved to John Watson's School, a Neoclassical building on the west side of the city designed in 1825 by William Burn as an institution for fatherless children from professional families. As the collections grew so the need for extra space became more pressing. Fortunately, close to John Watson's School another building became available: originally an orphanage, designed in 1831 by Thomas Hamilton, it is now known as the Dean Gallery. May the wonderful progress made since 1960 long continue.

FERDINAND HODLER (1853–1918)
Lake Thun and the Stockhorn Mountains 1910
Canvas, 83 × 105.4 cm / 32⅝ × 41½ in. Signed and dated

My reason for including this painting is based on my love for the Bernese Oberland in Switzerland where family holidays were taken for a number of summers during my childhood. Lake Spiez and Lake Thun I came to know well and I enjoyed going on the steamers and walking in the mountains, sometimes alive to the sound of yodelling and alpine horns, quite apart from the comfortable hotels and the cream meringues served for tea.

Hodler, however, saw the landscape of his Swiss homeland rather differently. Following in the wake of Impressionism he sought, like many of his contemporaries, to find something deeper in his work than the naturalistic representation of genre scenes, landscape or even portraiture. Often repeated simplified forms set against flattened backdrops allowed him to balance reality with highly abstract designs so that actuality could be invested with mystical meaning. He believed that his so-called Parallelism of repeated motifs and lines intensified meaning, although often his larger, more bombastic, canvases can seem boring. Hodler's own tragic personal circumstances (many members of his family died from tuberculosis) helped to make him into a Symbolist, and together with French, Belgian, Finnish, German and Norwegian artists who shared this interest in Symbolism Hodler became one of the leaders of modern art. His work was much admired in Paris, Berlin and Vienna, although not in Switzerland.

'Infinitely beyond all that we had ever thought or dreamed, – the seen walls of lost Eden could not have been more beautiful to us; not more awful, round heaven, the walls of sacred Death'

JOHN RUSKIN, ON FIRST SEEING THE ALPS IN 1833 (*PRAETERITA*, 1885–89)

Religion played a major role in Hodler's work and he liked to assert that there was an underlying order in both nature and life. The late landscapes of Lake Thun and Lake Geneva give expression to this idea, the symmetry established by the reflection of the mountains rising above the horizon which are mirrored in the still water below. The horizontal line dividing the two parts of the composition is symbolic of death.

As a subject, death preoccupied Hodler. The series of paintings he made of his mistress, Valentine Godé-Darel, dying of cancer in 1914–15, which reveal his respect for the works of Hans Holbein the Younger, are among the most tragic images ever painted.

HENRI MATISSE (1869–1954)
The Painting Lesson 1919
Canvas, 73.4 × 92.2 cm / 28¾ × 36¼ in. Signed

Matisse's art is a celebration of life. There is a joyous quality in the colour, exuberance in the line and a candour in the compositions that is immediately appealing. At the same time Matisse was very conscious of his responsibilities as a painter, as though keen to make proper use of his special gifts. This self-consciousness perhaps accounts for the number of paintings showing an artist (often himself) at work, usually in an improvised studio in a hotel room, with due emphasis given to the mechanics of art – easel, brushes, model.

The Painting Lesson dates from Matisse's first campaign in Nice where he spent the winter of 1919, as he was to do for many subsequent years. Nice attracted Matisse because of the light, which had a Mediterranean brilliance and evenness that the artist found liberating and challenging. This visit to the south of France marked a turning point in Matisse's development as an artist and there is something symbolic in the fact that he frequently visited the ageing Renoir at nearby Cagnes-sur-Mer.

Matisse took a room overlooking the sea in the small Hôtel de la Méditerranée on the famous Promenade des Anglais, and a whole series of pictures, often looking out to sea, were painted in this room. Matisse was attracted by the theatricality of Nice and the events that he witnessed on the Promenade below; the interior scenes are more introspective, while at the same time luxuriating in the beauty of the surroundings.

The composition of *The Painting Lesson* is enclosed and the outside world seen from the hotel window is only reflected in the oval mirror on the table. For this painting it would seem from the reflection that Matisse must have rearranged the furniture in the room, making the dressing table the central feature. Creating a wider circular effect around the table are the two figures – the artist on the left and the model on the right. The mirror, precipitously balanced on the edge, serves as a link. The contrast between the luminosity of the table and the dark background is boldly done. The light emanating from the imagined window behind the viewer bounces off the frilled muslin dressing-table top to illuminate the scene. The model is identifiable as Antoinette Arnoud, aged eighteen, who posed regularly for the artist at Nice until 1921. She was pale, chic in an urban way, obedient, but prone to become bored easily and often sulked.

'I do not paint things, I paint only the difference between things'

HENRI MATISSE, 1943

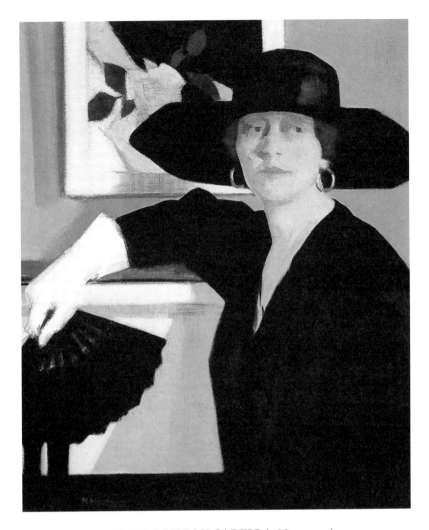

FRANCIS CAMPBELL BOILEAU CADELL (1883–1937)
Portrait of a Lady in Black c. 1921
Canvas, 76.3 × 63.5 cm / 30¼ × 25 in.

A lady in black by a
Scottish Colourist

Cadell belonged to a loose association of artists (known as the Scottish Colourists) whose work has in recent years become immensely popular. The other three in the group are J. D. Ferguson, S. J. Peploe and G. L. Hunter, all but the last born in Edinburgh.

A surgeon's son, Cadell was encouraged in his wish to become a painter, but eschewed Edinburgh for his training and went to the Académie Julian in Paris (1899–1903). The family then spent two years in Munich (1906–8). A visit to Venice in 1910 helped Cadell master an Impressionistic style involving light and colour that gave way after the First World War to a harder, more geometric, style. He found it difficult to adjust to the changing social mores brought about by war and he survived as a painter for the most part through generous patrons and the friendship of fellow artists. The distinctly middle-class Edinburgh New Town air of his portraits, figure subjects and still-lifes is relieved by his

luminous landscapes of the island of Iona where he began to paint *c*. 1913. By the time he was elected to the Royal Scottish Academy in 1935 he was living in reduced circumstances.

The model in *Portrait of a Lady in a Black Hat* is Bertha Hamilton Dou-Wauchope (1864–1944), who often posed for Cadell. The location is the artist's studio at 6 Ainslie Place in Edinburgh, where he worked from 1925 to 1932. There is a brittleness accentuated by the number of acute angles and the rigorous patterning extending throughout the composition. Echoes of Velásquez, Rembrandt and Hals abound; it is not surprising that Cadell painted many similar portraits of this type. I think that they are perhaps not so hidebound by Edinburgh society as people claim, and for me they have a distinctly cosmopolitan air: Ford Madox Ford comes to mind.

RENÉ MAGRITTE (1898–1967)
Representation 1937
Canvas laid on plywood, 48.8 × 44.5 cm / 19¼ × 17½ in.

Appearances can be deceptive, and this certainly applies in the case of the Belgian René Magritte, whose immaculate presentation of himself and his art belies the endlessly puzzling, often amusing, and sometimes disturbing pictures that he painted. Trained at the Academy in Brussels, he began working as a wallpaper designer before becoming a full-time painter in 1926. For three years (1927–30) he lived near Paris, during which time he came to know the founder of Surrealism, André Breton, but he then returned to Brussels where he remained for the rest of his life.

The gallery has four superb paintings by Magritte – all very different. The others are *The Magic Mirror* (1929), *Threatening Weather* (1929) and *The Black Flag* (1937). *Representation* also dates from 1937, but it has more in common with *The Magic Mirror*. It was originally square in format, but the artist cut the canvas down and remounted it on plywood with a new frame specially made in the shape of the curves of the female body. It is the only shaped frame in Magritte's œuvre: such an action was more typical of Salvador Dalí's interventionist methods.

Magritte's originality stemmed from his ability to juxtapose the familiar with the unfamiliar, thereby challenging causality and ultimately identity. The image we see in the 'mirror' in *Representation* is certainly not one of the viewer, and therefore it is unexpected; yet at the same time the essential properties of a mirror are not denied. This simply does not behave as a mirror should, and the shock element is the chief characteristic of Magritte's art: 'an object never fulfils the same function as its name or its image'. Magritte wrote to Breton about this picture, 'It constitutes a rather surprising object, I think.' You can say that again. *Vive la différence*.

'Mirror, mirror, on the wall, / Who is the fairest of them all?'

BROTHERS GRIMM, *SNOW WHITE*

NICOLAS DE STAËL (1914–55)
The Boat 1954
Canvas, 46.3 × 61 cm / 18¼ × 24 in.

De Staël was born in St Petersburg into a Russian military family who left at the Revolu-tion. They settled first in Poland, then moved to Brussels and to Paris in 1938. Influenced at that stage by Fernand Léger, de Staël was later close to Georges Braque. He was a culti-vated man, passionate about literature and music and a constant visitor to museums.

During the 1940s de Staël worked as a pure abstract painter, but by the 1950s he had begun to introduce identifiable elements into his pictures – figures, boats, still-life objects, landscape motifs. One of the reasons for this change of direction was his move away from Paris to the south of France. *The Boat*, however, was apparently painted on a visit to the English Channel in the early summer of 1954.

For me paintings by de Stael have two supreme qualities, both of which are evident here: the texture of the paint surface and the strong colour. At the time of *The Boat* the style of his earlier abstract pictures, thickly encrusted with paint and densely impasted with the palette knife, had given way to a thinner application of paint with greater use of brushes, but the luscious texture of the paint is extremely sensual, just as the rich tones of the colours – dark blues and greys offset by red and white – have an amazing resonance.

De Staël was a tall, large-framed man and had a prodigious appetite for life (Picasso on first seeing him said 'Take me in your arms'). According to Douglas Cooper, he lived out his life between a series of violent extremes. He committed suicide by throwing himself on to the ramparts below his studio at Antibes on the evening of 16 March 1955.

ROY LICHTENSTEIN (1923–97)
In the Car 1963
Canvas, 172 × 203.5 cm / 67¾ × 80⅛ in.

Lichtenstein's art is born of consumerism and the exploitation of popular culture. Although he began as an Abstract Expressionist following his training at the School of Fine Arts of Ohio State University in Columbus and war service (1943–46), by 1961 he had transformed himself into a Pop artist. Inspired by comic strips and by advertisements, he played upon the perceived differences between 'high' and 'low' culture. *In the Car* depends upon the viewer recognizing the source, but at the same time admiring its elevation on to the scale of grand art, even if essentially the resemblance is with an advertising hoarding. A sense of irony, therefore, underlies Lichtenstein's treatment of subject-matter, which deals not only with traditional themes such as war, love and landscape, rendered in the comic strip format, but also the flotsam and jetsam of modern life that impinge upon us through the medium of advertising – the hidden persuaders.

Not content with using popular culture as a visual source, he also borrowed its techniques, imitating by hand the Ben Day dots and speech balloons of comic strips and the lettering used in mechanized printing. Transference, projection and replication were other methods he began to adopt as his work became more popular, until during the 1970s he widened the range of his visual sources in a Postmodernist way by reference to works by Cézanne, Matisse, Léger and Mondrian.

What's he thinking?

In the Car was executed shortly after Lichtenstein's breakthrough. Enlargement and cropping intensify the dramatic impact of what is going on in the car, which otherwise would seem bland and inconsequential owing to its source and mechanical means of production. Lichtenstein's art presents, for better or worse, an archetypal image of modern America which now has wider global connotations.

ANDY WARHOL (1928–87)
Portrait of Maurice 1976
Canvas, 65.8 × 81.4 cm / 25¾ × 32 in.

Say hello to Maurice

Warhol once famously declared that everyone could be world famous for fifteen minutes. Well here is Maurice, the pet dachshund belonging to Mrs Gabrielle Keiller, who in 1995 became one of the most generous benefactors of the Scottish National Gallery of Modern Art. Warhol made several animal pictures during the 1970s and *Maurice* was a specially commissioned work. A set of Polaroid photographs taken in London served as the basis for this screen-printed image heightened with oil paint.

The artist was born in Pittsburgh, where he attended the Carnegie Institute of Technology (1945–49) before moving to New York, which became the centre of his activities. Beginning as a commercial artist and illustrator, by 1960 Warhol had started the ascent that ended with his being the most influential figure in the modern art world. Such a position was attained for two reasons. First is the content of his work, extending from the purely mundane (Coca-Cola bottles, soup cans, paper money, Brillo boxes) to the representation of famous people (film stars, statesmen, musicians, celebrities); many of these images are now iconic. Secondly, he revolutionized the practice of art, mixing traditional techniques with modern printing processes and film to achieve his ends. Warhol indulged

in serial imaging and engaged the services of numerous assistants which allowed much of his work to be mass-produced. His studio, known as The Factory, was aptly named in so far as his purpose was to blur the distinction between artistic and industrial production. He achieved the ultimate in the commodification of art: mass-production as art and art as mass-production – a world of signage and packaging for the most part devoid of belief except in its own importance.

Warhol has been so influential because he shows us how the later 20th century was. His images retain a timeless eloquence, which is only now beginning to be properly appreciated.

Aberdeen

ABERDEEN ART GALLERY

Everything is right about the Aberdeen Art Gallery – the building and the collection. Both have an outstanding sense of quality and certainty of purpose. Built initially as a grand exhibition space, designed by James Matthews and Marshall Mackenzie in 1885 in Renaissance style, the galleries are approached through a rotunda. This rotunda is matched by a second one that is a memorial court for those lost in the First and Second World Wars and also for those who have died in the oil-fields off the Aberdeenshire coast. This arrangement gives the whole gallery a reassuring feeling of *gravitas*.

The permanent collection was initiated by Alexander Macdonald (1837–84), the son of a granite manufacturer, whose paintings came to the gallery in 1900. Macdonald favoured works by contemporary artists, including a long series of specially commissioned portraits and self-portraits. He also endowed the gallery, stipulating that it should have a sustained interest in contemporary art, which has proved to be a mainstay of its current policy. Where Macdonald led others followed, in particular Sir James Murray (1901), who also later paid for an extension, and Alexander Webster (1921).

The main thrust is on British painting of the 19th and 20th centuries, with a particularly strong representation of works by Scottish artists and members of the Camden Town Group. There are smaller representations of old master paintings and French Impressionists. Look out for Herkomer's *Our Village*, Landseer's *Flood in the Highlands*, Renoir's *La Roche-Guyon* and Sir John Lavery's *Tennis Party*. Aberdeen Art Gallery never disappoints.

PIETER BRUEGEL THE YOUNGER (1564/65–1637/38)
after PIETER BRUEGEL THE ELDER (active 1551–69)

The Parable of the Unfaithful Shepherd c. 1600

Wood, 74.6 × 105 cm / 29⅜ × 41⅜ in.

'The hireling fleeth, because he is an hireling, and careth not for the sheep'

GOSPEL OF ST JOHN 10:11

The original composition dates from c. 1568 and was devised by the artist's father, Pieter Bruegel the Elder, as an illustration of the parable recorded in St John's Gospel 10:7–18: 'I am the good shepherd: the good shepherd giveth his life for the sheep. But he that is an hireling, and not the shepherd, whose own the sheep are not, seeth the wolf coming, and leaveth the sheep, and fleeth: and the wolf catcheth them, and scattereth the sheep. The hireling fleeth, because he is an hireling, and careth not for the sheep. I am the good shepherd, and know my sheep, and am known of mine.' The original painting is lost, but several copies exist, including this one by his son.

Pieter Bruegel the Elder was regarded by Abraham Ortelius (admittedly a friend) as 'the most perfect painter of the century'. He is certainly as much appreciated today for his landscapes and elaborate compositions based on Flemish proverbs as for his imaginative interpretations of Biblical and mythological themes. Many of these were published as

prints, which helped to make his work well known. A member of the guild of painters in Antwerp, he travelled in Italy for three years (1552–55) before returning and settling in Brussels. Towards the end of his life, during the 1560s, instead of the intensely detailed and crowded compositions of previous years in which several incidents are portrayed, the elder Bruegel concentrated on a single motif. The mocking humour characteristic of so much of his work now takes on a more tragic dimension, with the cares of the world borne on the shoulders of a solitary individual representing society as a whole.

Here the hireling runs away as behind him the wolves attack the sheep he was meant to be tending. The lumbering figure is wonderfully drawn, as is the undulating Flemish landscape stretching into the distance punctuated by a windmill and a church steeple.

WILLIAM DYCE (1806–64)
Titian Preparing to Make his First Essay in Colouring 1857
Canvas, 91.4 × 67.2 cm / 36 × 26½ in.

Dyce was born in Aberdeen, the son of a lecturer in medicine at Marischal College (since 1860 part of the University of Aberdeen), and took considerable pride in his birthplace, although he was resident for much of his life in London. This painting of an imagined episode in Titian's life has a literary source (Carlo Ridolfi's *Le maraviglie d'arte*, 1648), but is indicative of Dyce's polymathic interests. It is a late work and very much in the style of the Pre-Raphaelites – on whom he himself had to a certain extent exercised a formative influence. John Ruskin, the champion of the Pre-Raphaelites, remarked on seeing this picture that it was 'quite up to the high-water mark of Pre-Raphaelitism' and praised the artist for choosing 'a subject involving an amount of toil only endurable by the boundless love and patience, which are the first among the Pre-Raphaelite characteristics'.

Scenes from the boyhoods of famous artists were not all that unusual (for example, the anecdote of Cimabue coming across the youthful Giotto drawing while tending sheep, told by Giorgio Vasari in his *Lives of the Artists*, was sometimes illustrated). But it is not clear why Dyce chose this particular anecdote about Titian, unless there is a veiled reference to the contemporary discussion about the display of polychromed sculpture in churches.

The young Titian is seated with his sketchbook on a chair, which has been purloined from the house. He stares up at a marble statue of the Virgin and Child positioned on a tree stump. The boy is clearly destined to be there for some time: his cap and stick have been set on one side and a flask of water is on the ground. The basket of flowers, leaves and grass, so precisely and intensely recorded by Dyce, forms the basis of Titian's rudimentary knowledge of colour as found in nature, which will inspire his art. Such is the implication, but there are puzzling aspects to the picture. The garden, for instance, is so obviously not Italian, although the distant landscape seen through the trees more closely

Sentimental or scientific?

resembles Italy. Then there is also, or so it seems to the modern eye, an imbalance between genuine scientific enquiry and suspicion at the precociousness of an infant prodigy. But it remains an endearing image and one perhaps not unrelated to Dyce's professional interest in art education.

SIR STANLEY SPENCER (1891–1959)
Southwold 1937
Canvas, 67.5 × 97.9 cm / 26⅝ × 38½ in.

A favourite picture of mine, since I live in Suffolk near Southwold and visit it regularly at all times of the year. The shingle beach is viewed from the road above, and Spencer includes a glimpse of one of the much-admired beach huts at the left edge. Otherwise, it is a familiar scene: deck chairs, swimming gear, windbreaks, beach towels, sunhats.

Typically, Spencer prefers to record the scene on the beach before him rather than the distant horizon out to sea. By doing this he provides an inventory of the equipment associated with annual seaside holidays of which everyone always has such high expectations. I once heard Alan Bennett lecturing in the National Gallery in London on his favourite pictures, which included *Southwold*. He said it caused him to reflect whether the social history of the swimming towel had yet been undertaken.

The painting, however, meant more to Spencer than summer holidays, as his visit to Suffolk coincided with a particularly traumatic moment in his life. In 1925 he had married Hilda Carline (see pp. 324–25) at Wangford, inland from Southwold, where she had been happy as a Land Girl during the First World War. His subsequent involvement with Patricia Preece (she of those astonishing nude portraits) led to divorce from Hilda in 1937. Marriage in the same year to Patricia, however, was a disaster from the start and the recoil from it caused Spencer to revisit places such as Southwold where he had been happy with Hilda. He remained close to Hilda, by whom he had had two children, throughout the 1940s until her death in 1950. Nothing that Spencer painted at this stage of his life is without an element of the emotional turmoil that was never far below the surface. He was knighted in 1959, the year of his death.

Dundee

THE McMANUS

Initially designed by Sir George Gilbert Scott as a 'Public Library and Great Hall' and opened in 1867, the building displays a mixture of Gothic Revival and French Renaissance styles with pronounced Scottish Baronial features. An unusual aspect is the horseshoe staircase on the west side. A second phase of construction (1871–73) initiated the art galleries and museum, followed by a third phase (1888–89) which created the additional Victorian galleries. The public library moved out as recently as 1978, setting in train the full conversion to a museum. A recent refurbishment (2006–9) restored the building to its original glory. The institution had been founded in honour of the memory of Prince Albert, who died in 1861, and the Victorian theme continues on the north side with the massive bronze monument of the enthroned Queen Victoria by Harry Bates, marking her Diamond Jubilee in 1897.

From its inception the institution has depended on strong local support, led by senior office-holders and leading industrialists such as Maurice McManus (1907–82), twice Lord Provost, after whom the building is now named. Between 1877 and 1891 local benefactors organized annual selling exhibitions, as well as supporting contemporary artists. The engineer James Guthrie Orchar, the marmalade tycoon John Keiller and the MP George Duncan were local collectors whose generosity benefited the museum. A small group of old masters, mainly by Italian (including the impressive *Rest on the Flight into Egypt* by Pompeo Batoni), Dutch and British artists, heralds a wider representation of Victorian pictures, many with Scottish connections. An admirable policy for acquisitions, made possible in the first instance by a bequest from John Morris, has been conducted over many years and extends up to the present day with regular, intelligent additions of works by contemporary Scottish painters.

THOMAS FAED (1826–1900)
The Visit of the Patron and Patroness to the Village School 1851
Wood, 98 × 132 cm / 38½ × 52 in. Signed and dated

Faed was born into a family of artists. Initially trained at the Trustees' Academy in Edinburgh under Sir William Allan and Thomas Duncan, he progressed to the Royal Scottish Academy (1849–52). Success at exhibitions came quickly with paintings of literary subjects, but his genre paintings were even more appreciated when he started to exhibit at the Royal Academy in London in 1851. Buoyed up by such success, Faed moved to London in that year and became a member of the Royal Academy in 1864. He enjoyed

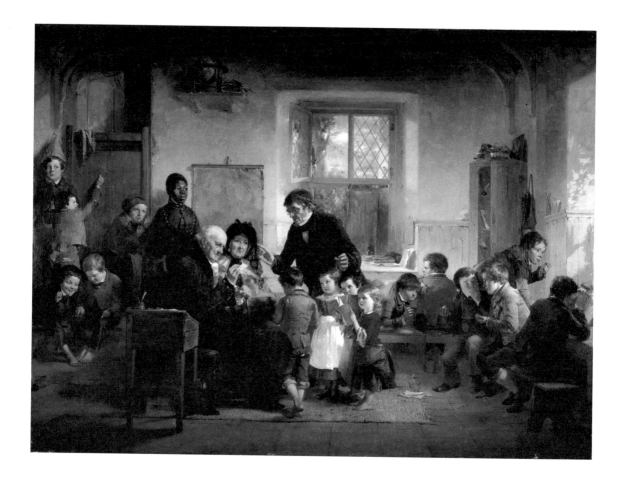

considerable prosperity from the copyright held on prints made after his increasingly popular compositions, which during the second half of his life dealt with contemporary Scottish issues such as poverty and emigration.

The Visit of the Patron and Patroness to the Village School is a masterpiece dating from the start of his career. It was shown at the Royal Academy in the year in which it was painted, and again at the 'Art Treasures' exhibition in Manchester in 1857. It is a genre subject probably based on his own upbringing and certainly inspired by the example of Sir David Wilkie. The influence of 17th-century Flemish (David Teniers the Younger) and Dutch (Jan Steen) art is also apparent, but the treatment of the bright light, the fresh colouring and the range of characterization are formidable personal achievements by Faed.

The patron is depicted holding a pair of spectacles, which for some reason seem to be the subject of discussion with the schoolmaster – unless an allegorical interpretation is intended. The black boy is presumably a servant to the grandees, since he stands immediately behind them. No doubt it is possible to put a political slant on this painting, but there is also an air of innocence about it. There is no hint of sentimentality or nostalgia, but rather an acknowledgment of the balance between the realities of life and its rich potentialities.

Best behaviour
in a Scottish
village school

Glasgow

KELVINGROVE ART GALLERY AND MUSEUM

The creation of an art gallery and museum in Glasgow was an act of deliberate cultural aggrandizement by the City Council acting on behalf of its citizens. Civic identity, and more than a certain amount of civic pride, had been established by the opening in 1888 of the City Chambers on George Square in the centre, but the need for a major art gallery was another of the Council's priorities. Accordingly, an international exhibition was held in Kelvingrove Park on the west side of Glasgow, which also opened in 1888. The profits from this were immediately put towards the building of the art gallery and museum on the same ground opposite the University. The design is a high-octane mixture of architectural styles – Gothic, Renaissance and Baroque – in red sandstone with a plenitude of sculpture by George Frampton and others on the exterior. The architects, John W. Simpson and E. J. Milner Allen, had previously been responsible for Worcester Art Gallery and Museum and Cartwright Hall at Bradford, but Kelvingrove is their masterpiece. The interior does not disappoint either – a vast arcaded central hall three storeys high and a grand staircase straight ahead from the entrance. Emblazoned on a shield hung high in the hall are the words 'Let Glasgow Flourish'. This outburst of municipal pride outdoes even Birmingham and Leeds. Kelvingrove Art Gallery and Museum opened in 1902.

The founding collection of pictures came from Archibald McLellan (1797–1854), a politician and coachbuilder, who bequeathed five hundred paintings to the city, intending that they be shown in a specially built gallery on Sauchiehall Street. Regrettably, McLellan died insolvent and so in 1856 the Council had to buy the pictures and the premises. The result was the first civic-funded gallery in the British Isles. The collection was fairly wide-ranging, including works by Italian, French, Dutch and Flemish artists, with some major items by artists such as the Master of Moulins, Titian, Rembrandt, Monet, Van Gogh and Matisse. It was transferred to Kelvingrove in 1902. Further bequests and donations followed, including those by John Graham Gilbert (1877), James Donald (1905), William Chrystal (1939), William McInness (1944), Sir John Richmond (1948) and David W. T. Cargill (1950). The representation of old masters at Glasgow is strong, but the palm goes to the large group of French 19th-century pictures, bearing in mind that this had some significance for the emergence around 1900 of the group of painters known as the Glasgow Boys.

One of the reasons for the exceptional collections at Kelvingrove is the tradition of international dealers based in Glasgow: Craibe Angus, Daniel Collier and Alexander Reid. A purchasing policy was made possible by the Hamilton Trust, which the Director Dr T. J. Honeyman was able to use to such good effect between 1939 and 1954.

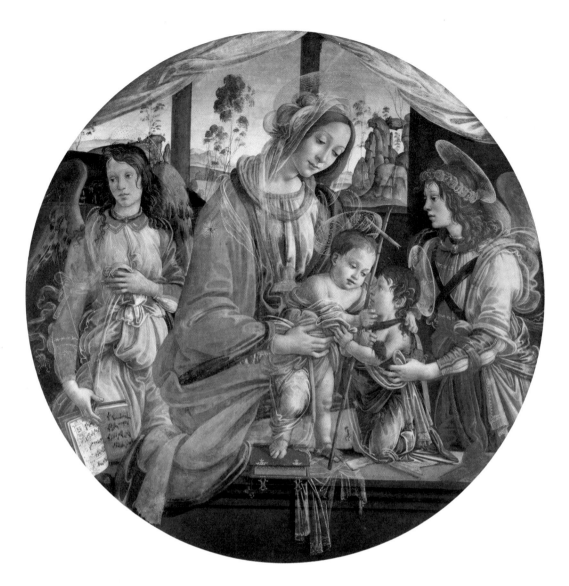

ATTRIBUTED TO RAFFAELLINO DEL GARBO (1466–1524)
Virgin and Child with the Infant St John and Two Angels c. 1485
Wood, diam. 118.5 cm / 46⅝ in.

Previously attributed to the Florentine painter Filippino Lippi, this panel is now accred-
ited to his pupil Raffaellino del Garbo at the outset of his career. Filippino had been taught
by Botticelli and the continuation of that tradition can be seen in the facial types and
the drawing in this picture. The really exciting aspect, though, is that the composition is
contained in a circular, or *tondo*, format. The Virgin holds the centre supporting the Christ
Child, who stands on a marble parapet where the young St John the Baptist kneels. Behind
the parapet are two angels on left and right bracketing the main figures. Loose curtains
close off the interior at the top, while beyond the columns stretches a rocky landscape. As

Renaissance
refinements

pictorial design this is first-rate and shows how the example of Botticelli and Filippino Lippi, who often exploited the compositional possibilities of *tondi* in this way, could still be effective.

The impact of this *Virgin and Child*, which was probably painted for a private chapel, is enhanced by the sumptuous quality of the colour. While there is purity in the drawing, it is interesting to see how fussy the painter becomes in the depiction of the folds of drapery and the transparent veils that waft about, increasing the sense of movement. There is a good eye for detail: look at the way the Christ Child steps on the manuscript that the Virgin has placed on the parapet or at the layout of the musical notation on the paper of the hymnal held by the angel on the left. For me the painting is a magical conflation of honest craftsmanship and pure invention.

Raffaellino del Garbo is a difficult artist to identify on documentary grounds: he is best described as a transitional figure in Florence, linking the mid-century with the developments that usher in the High Renaissance. Although sometimes dismissed as derivative, the quality of this *Virgin and Child* demonstrates to me how superb Florentine painting of the 15th century could be even when left to lesser masters.

MASTER OF MOULINS (active *c.* 1480–1500)
St Maurice (or St Victor) with a Donor *c.* 1480–1500
Wood, 58.4 × 49.5 cm / 23 × 19½ in.

Get out your magnifying glass

This anonymous painter (sometimes identified as Jean Hey) derives his name from a triptych showing the Virgin of the Immaculate Conception in the cathedral of Notre-Dame at Moulins, in central France. The present example of his work is almost certainly a fragment of another altarpiece, but even in this piecemeal state it is perhaps the most important early French painting in the British Isles.

At first sight one might be forgiven for thinking that this is an early Netherlandish painting by someone like Hugo van der Goes in view of the close technique, but this kind of realistic treatment can also be found in French art. Jean Fouquet, for example, had worked in this style; and if to that you add the influence of Netherlandish artists such as Van der Goes, Gerard David and Hans Memlinc you arrive at the style of *St Maurice with a Donor*. The painting has all the attributes of late Gothic art, combining intense realism with unconcealed piety.

The suit of armour worn by the standing figure suggests a military saint. St Maurice commanded a Roman legion of Christian soldiers (the 'Theban Legion'), who around 450 mutinied at what is now St-Maurice-en-Valais in Switzerland on being commanded to slaughter fellow-Christians. For their refusal to obey they were themselves killed. The wreath worn in the saint's hair suggests a Roman connection, but otherwise the link is tenuous.

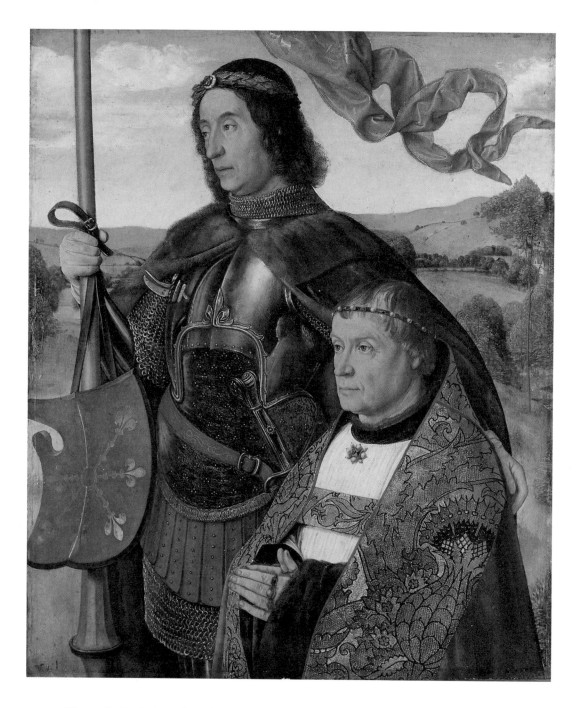

The eye is slowly drawn into the painting, which abounds in a mesmerizing amount of detail: the texture of the garments (the fur mantle worn over the saint's armour, and the donor's cope), the jewelry, the facial features and the house glimpsed amidst the trees on the far right. The *pièce de résistance*, however, is the donor's reflection seen in the saint's suit of armour, which in itself is a masterpiece of still-life painting. Late 15th-century painting is rarely, if ever, better than this anywhere in Europe.

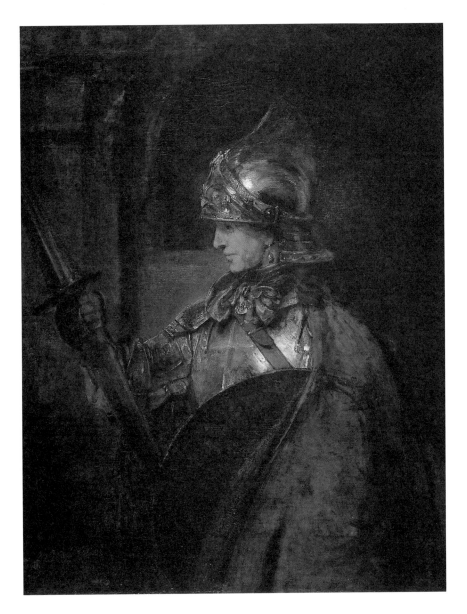

REMBRANDT VAN RIJN (1606–69)
A Man in Armour 1655
Canvas, 137.5 × 104.5 cm / 54⅛ × 41⅛ in.

Few pictures are ever straightforward and some pose problems that remain unsolved. Certainly this type of subject is unusual in Rembrandt's œuvre and various identifications have been suggested for this strange and mysterious figure – Alexander the Great, Mars, Pallas Athene. A connection with a group of pictures of 'philosophers' commissioned from Rembrandt by Don Antonio Ruffo in Messina in the mid-1650s has been posited, but not proved: the famous *Aristotle contemplating the Bust of Homer* in New York (Metropolitan Museum of Art), for example, is one of those that did definitely belong to Ruffo.

Rembrandt kept numerous props in his studio and no doubt the various parts of the armour (the helmet is decorated with a stylized owl) would have been specially assembled for this picture. He re-used an old canvas, scraping off an earlier composition, and at the same time he appears to have extended the canvas on all four sides. Such changes make the picture seem even more enigmatic. The effect of placing the figure in half-light emerging from a dark background is very theatrical, just as the way that Rembrandt unifies the composition by the warm tones and the distribution of light is very persuasive. I always think that the painting would look magnificent hanging in a castle staircase.

Of further interest is the fact that *A Man in Armour* once belonged to Sir Joshua Reynolds, who had a considerable collection of old master paintings and drawings. He refers to it in one of his discourses to the students of the Royal Academy, delivered in his capacity as the first President: 'Rembrandt, who thought it of more consequence to paint light, than the objects that are seen by it, has done this in a picture of Achilles, which I have. The head is kept down to a very low tint, in order to preserve this due graduation and distinction between the armour and the face: the consequence of which is, that upon the whole the picture is too black' (*Discourse* VIII, 1778). In spite of this rather bold criticism, Reynolds had a deep veneration for Rembrandt, which is most evident in his long series of self-portraits that were in part inspired by the earlier master.

VINCENT VAN GOGH (1853–90)
Portrait of Alexander Reid 1887
Canvas, 42 × 33 cm / 16½ × 13 in.

Alexander Reid (1854–1928) was instrumental in introducing Impressionist and Post-Impressionist art into Scotland and in encouraging collectors to take an interest in the French avant-garde. He was one of a small coterie of dealers, based for the most part in Glasgow, and it is because of them that Scotland has such a strong representation of French late 19th-century paintings today.

A fruitful partnership

Reid was in Paris for two years and worked for a brief period at the prestigious art dealers Boussod, Valadon & Cie, where Theo van Gogh was manager. For six months or so, indeed, Reid shared lodgings with Theo and Vincent van Gogh, and it was then that he began to purchase pictures. Van Gogh painted two portraits of Reid in 1887: one shows him seated in a room (Oklahoma City Museum of Art) and the other is the present full-face composition.

On returning to Scotland in 1889, Reid opened his own gallery in Glasgow, calling it rather grandly La Société des Beaux-Arts, and appointed his father, James Reid, who had already established his own dealing partnership in the city in the late 1870s, as a director. Eventually, in 1926 La Société des Beaux-Arts was amalgamated with the Lefevre Gallery in London and the business became known as Alex Reid & Lefevre.

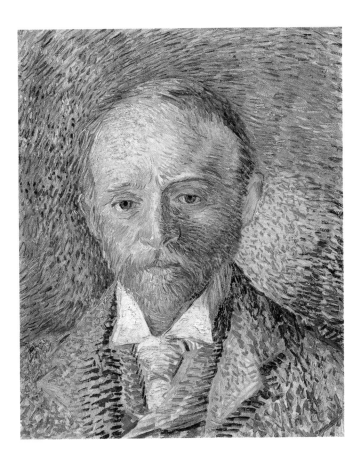

Van Gogh's portrait of Reid is vibrant both in colour and in technique. It bears a similarity with the artist's self-portraits of the same date in the close intensely scrutinized features. The influence of the dotted technique known as Pointillism advocated by the Neo-Impressionists is beginning to be apparent in Van Gogh's repeated brushstrokes and colour contrasts. The radial effect of the brushstrokes around the head like a nimbus animates the surface and suggests that the portrait was painted rapidly and with great powers of concentration.

GEORGES ROUAULT (1871–1958)
Circus Girl c. 1939
Paper laid on canvas, 64.3 × 45.3 cm / 25¼ × 17¾ in.

Rouault was born in the working-class district of Belleville in Paris in the middle of a bombardment during the Commune. He was apprenticed to a stained-glass maker before enrolling at the Ecole des Arts Décoratifs, but then decided to become a painter. At the Ecole des Beaux-Arts he became a pupil of Gustave Moreau together with Matisse. Moreau's initial influence was profound and on the master's death in 1898 Rouault became the curator of the newly founded Gustave Moreau Museum in Paris.

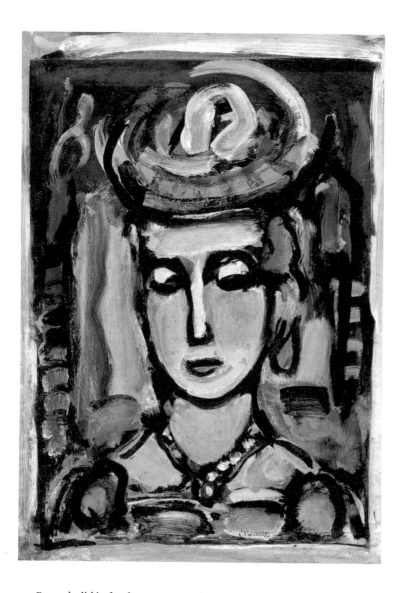

Rouault did in fact become more than just a painter, involving himself with ceramics and principally with printmaking, including a number of magnificent *livres d'artiste*. A turning point in his life was the intervention of the dealer Ambroise Vollard, who in 1913 bought his entire œuvre to date and then from 1917 set him up in a studio, ostensibly controlling the flow of his output (Rouault frequently reworked his paintings, sometimes incessantly) and encouraging him to illustrate such books as *Cirque de l'Étoile filante* (1938), *Passion* (1939) and *Miserere et Guerre* (1948) with texts by André Suarès.

As with Daumier, Rouault's prints tend to be better known than his paintings, and he shared an interest in the same subject-matter – the circus, law courts, street markets, prostitutes. His sympathies lay, as with many other avant-garde artists from the 1880s up until Picasso's arrival in Paris, with the less fortunate in life and the outcasts of society with whom he also identified.

'I experienced things that cannot be expressed by words. And I began to paint with an outrageous lyricism that disconcerted everyone'

GEORGES ROUAULT, 1926

Circus Girl has a singular purity of form. The heavy, dark outlines are the hallmark of Rouault's style and resemble those of a stained-glass window, as do the colours. Even within such a small space there is a great deal of compressed energy in the fluid broken brushstrokes. The face is seen in close-up and has an impact similar to that of an icon. But most moving is the downward glance, expressing a moment of passing sadness. Rouault was a deeply religious man and many of his friends belonged to the Catholic revival movement in France. His imagery of clowns and circus people was often fused with Christ's Passion, implying a shared belief in the acceptance of human fate.

BURRELL COLLECTION

Sir William Burrell (1881–1958), a shipowner, formed one of the greatest collections of art in Britain in the 20th century. His interests – antiquities, ceramics, furniture, carpets, armour, stained glass, tapestries, ecclesiastical furnishings, paintings – were by no means limited to Europe, and the collection is comparable in size (some six thousand items) with those assembled by collectors active during the 18th and 19th centuries. Burrell's principal home was Hutton Castle near Berwick-on-Tweed, but he formed and developed his collection with the intention from quite an early date of establishing a museum in which to display it.

Having decided in 1944 that he wanted his museum to be in Glasgow and having laid down certain stipulations, Burrell also donated the money for the building. There then followed an immense saga as to where the museum should be built, and the problem had still not been solved by the time of Burrell's death. The collection was put into store and remained in limbo, although some loans were made upon request.

A solution was found when Pollok Park was given to Glasgow City Council in 1967. A competition for the new gallery was declared in 1972, which was won by the firm of Barry Glasson Architects. The building opened in 1983 and is one of the most enthralling museum experiences you can have. The open spaces of the gallery allow the collection to be properly viewed and the extensive glazing heightens the distinct pleasure of seeing works of art against the natural surroundings of the woodlands and park outside. Bear in mind also that Burrell acquired a number of architectural fixtures and panelled rooms (some from William Randolph Hearst, no less) and these have been skilfully blended in with the modern architecture.

Sir William Burrell bought a number of paintings from dealers such as Craibe Angus and Alexander Reid in Glasgow, which accounts for the strength of the French holdings: Courbet, Daumier, Manet, Sisley, Degas, Cézanne, Rodin. But there are also good examples of Northern Renaissance art, as well as Dutch paintings of the 17th century and French 18th-century pictures. The Burrell Collection is an unbeatable experience.

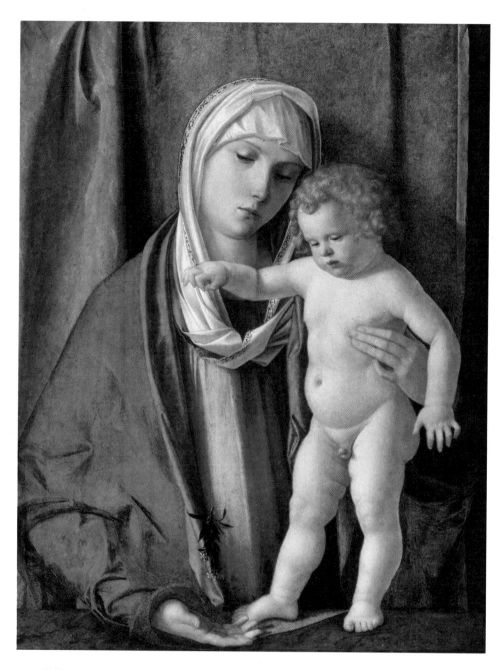

GIOVANNI BELLINI (*c.* 1430–1516)
Virgin and Child *c.* 1488–90
Wood, 62.2 × 47.6 cm / 24½ × 18¾ in.

Although the theme of the Virgin and Child is frequently found throughout Italian art, few artists could invest the subject with as much poetry as Giovanni Bellini. His ability to weave variations on this theme seems endless, with the two figures bound so lovingly together in poses that are sometimes playful and sometimes sad in a premonition of the

Maternal love
simply expressed

Christ Child's future death. Here the artist has placed the figures in front of a curtain with the Virgin supporting the Child, who is playing with a flower dangling on a thread. The composition is pyramidal, but any sense of strict geometry is removed by the tenderness that the Virgin expresses for her Child, which lifts the picture on to a different plane. There is no escape for the eye, even though the curtain does not extend all the way to the edge on the right. The modelling of the Child is almost sculptural and it is more than possible that Bellini is trying to emulate marble or bronze reliefs that he had seen, particularly in the play of light across the body.

Another virtue is the colouring: a lapis lazuli blue for the Virgin's mantle (the surface now rather worn, and therefore without its modelling), pink for her chemise, green for the curtain and a creamy white for her veil. This chord creates a visual harmony that complements the subject and gradually fills the viewer with a sense of wellbeing.

JEAN-BAPTISTE OUDRY (1686–1755)
Dog in a Fireplace with a Blue and White Porcelain Bowl 1751
Canvas, 90.2 × 113.1 cm / 35½ × 44½ in. Signed and dated

A visual trick

The clue to the original location of this picture is the strong cast shadow across the dog's body. It seems as though the animal is peering from a darkened space into the light, and that is exactly what is intended. For this is a trompe-l'œil painting of a type known as *devant de cheminée*, used to close off a fireplace during the summer months, and therefore meant to be viewed as an illusion. It was exhibited at the Salon of 1751 and is one of the several categories of animal paintings for which Oudry won plaudits.

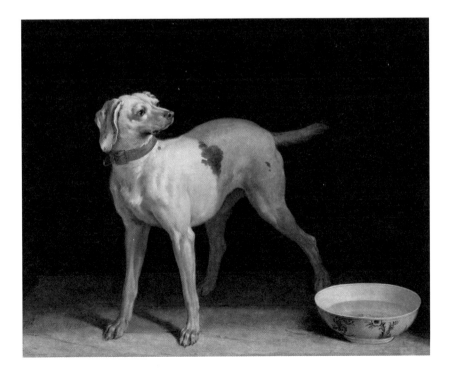

He did not, however, begin as an animal painter, having been apprenticed to Nicolas de Largillière, who was principally a portraitist. Proceeding to the Académie de St-Luc and then to the Académie Royale, Oudry began by the 1720s to paint allegories, still-lifes and landscapes, many of which feature animals. His style was decorative and his attitude to nature initially rather tame, but after entering the service of Louis XV in 1726 he was commissioned to execute numerous large paintings of the royal hunt, sporting scenes and the wild animals in the royal menagerie, which led in turn to compositions of wild animals being attacked or attacking one another. Added to this was his appointment as official designer to the tapestry works at Beauvais (1726), followed by a similar association with the tapestry works at the Gobelins (1736). The royal connection in France led to similar prestigious commissions in other parts of Europe. You could say that Oudry worked hard.

An interesting aspect of *Dog in a Fireplace* is the inclusion of the porcelain drinking bowl. This beautiful still-life, its passivity in sharp contrast with the attitude of the dog, brings Chardin to mind. He was younger and far less prolific than Oudry, but even though not in direct competition they were certainly aware of each other.

EUGÈNE BOUDIN (1824–98)
The Empress Eugénie – The Beach at Trouville 1863
Wood, 34.3 × 57.8 cm / 13¼ × 22¾ in.

You can tell instantly that Boudin loved the beaches of northern France as you can feel the warmth of the sun and the freshness of the breeze coming off his paintings – that is, if it is a fine day. He was born at Honfleur in Normandy, but spent the first part of his life in Le Havre. Fond though he was of Normandy and Brittany (he married a Breton woman), Boudin did venture further afield to other coastal regions of France, Belgium, Holland, and towards the end of his life to Venice. The sea, beaches, harbours, ports and marine life were his chosen subjects, and the beach at Trouville during the 1860s is where his reputation was established.

Boudin's interest in Trouville and the neighbouring Deauville coincided with the growth of the tourist industry. The extension of the railway system to the coast (the Trouville-Deauville station opened in 1863) made access for holidaymakers from Paris much easier. Most of those who came were wealthy – aristocrats, financiers, celebrities – all carefully observed and deftly painted on a small scale by Boudin. The present picture depicts an informal visit by the Empress Eugénie (1826–1919), the Spanish wife of the Emperor Napoleon III, who is the figure dressed in white in the group on the right. In the background is the Hôtel de la Mer and to the left of it is the Casino; both buildings were demolished in the 1930s. Boudin allows a generous portion of sky, positioning the figures in the foreground walking across the beach towards the sea. He manipulates the

Monet's predecessor

fashionably dressed women (the crinoline was championed by the Empress Eugénie) like puppets. The helter-skelter effect is gained from the swing of the crinolines, the ribbons flying from the hats and the angle of the umbrellas, but the small dabs of paint are equally animated. As the critic Jules Castagnary put it in 1875, the figures 'are viewed from a distance, but what finesse and liveliness in these figures which, standing or sitting, move on the sand. How good they look under the sky, the tide rises, the breeze plays with flounces and skirts. This is the ocean and you can almost smell the salty fragrance.' Not surprisingly Monet was influenced by Boudin at an early stage in his life.

EDGAR DEGAS (1834–1917)
The Rehearsal 1874
Canvas, 58.4 × 83.8 cm / 23 × 33 in. Signed

The ballet was one of the principal subjects in Degas' searching examination of modern life. He returned to the subject again and again in different media and towards the end of his career mainly in pastel and bronze. His first thorough exploration of the ballet occurred in the early 1870s in elaborate compositions of the utmost refinement. These were carefully prepared in numerous preliminary studies (many of the greatest beauty in their own right) that were kept in the artist's studio for re-use at a later date.

Degas was in many respects a conservative figure, in so far as he had the utmost respect for the art of the past, but he also thought about art in radical terms and so in the end reinvented tradition. The early ballet scenes, for example, have their origins in Poussin or Watteau, but break all the rules. *The Rehearsal* deliberately confuses the viewer: the staircase on the left makes little sense, many of the figures are cropped or partially concealed, the lighting is *contre-jour*, and there are wide open spaces at the very centre of the composition. Degas gauges these imbalances and inconsistencies with pinpoint accuracy, which is echoed in the perfect pitch of his use of colour (pink, green, orange, red, black) articulating the surface.

Why was Degas so fascinated by the ballet? It was in its time a modern subject, far removed from the historical or literary themes favoured in the past, but it can also be seen as a metaphor for his own art. He, like the dancers he studied and got to know, spent long, arduous hours perfecting his art, always trying to find ways of improving it or attempting to discover new solutions to old problems. Additionally, it was characteristic of Degas that he preferred the rehearsal room or the dressing room to the performance. Even on the rare occasions when he depicted the stage itself, it was often either in rehearsal, before the curtain went up, or as it was coming down with figures visible in the wings. Degas shows the physical effort involved in dance and at the same time reveals something of the social context. It is a world of sweat, tears, injuries and physical endurance with dance masters, chaperones and the subscribers (usually older males) in tow. The psychological import of Degas' work rests on a foundation of physical frailty, social insecurity and human uncertainty.

'The dancer is nothing but a pretext for drawing'

EDGAR DEGAS

HUNTERIAN ART GALLERY

Named after Dr William Hunter (1718–83), the famous physician and anatomist, who was born near Glasgow and subsequently rose to prominence in the medical world in London, the Hunterian Art Gallery is part of the University of Glasgow. Hunter was appointed Physician Extraordinary to Queen Charlotte in 1762 and moved in court circles. On the foundation of the Royal Academy in 1768 Sir Joshua Reynolds appointed him to the post of Professor of Anatomy: his lectures were attended by Adam Smith, Edmund Burke, David Hume, Edward Gibbon and Samuel Johnson. A younger brother, John, was also a successful anatomist, but he became a surgeon. Both brothers collected and formed museums. John's collection, specializing in natural history and comparative anatomy, remained in London. William's collection was more diverse and extended beyond his medical interest to include coins, minerals, books, manuscripts and pictures. In some of these areas, particularly coins, the collection was of the greatest significance. It was left to the University of Glasgow and was transferred there in 1807 by his nephew, Matthew Baillie. The Hunterian Museum where it was shown, built by William Stark, was one of the first public museums in the country. The original building was demolished in 1870 and, although another was redesignated as the museum, most of the elements of the collection were distributed around different departments of the University.

The quantity and quality of William Hunter's fine arts collection, augmented by other bequests and donations, led to the building of the Hunterian Art Gallery within the University precincts. This was designed in 1973 by William Whitfield Partners of London and opened in 1980. Arguably it is one of the more successful buildings of the 1970s. In its structure of cast and hammered concrete provision was made for a series of top-lit galleries for pictures, a special gallery for works on paper, and a sculpture courtyard. The entrance is notable for the huge cast aluminium doors by Eduardo Paolozzi, and incorporated in the interior are sections of Charles Rennie Mackintosh's house from 78 Southpark Avenue.

Hunter's own collection included a group of old masters and 18th-century British paintings – Ramsay, Reynolds, Stubbs. Beyond Mackintosh, the other artist specially celebrated in the gallery is Whistler. The gift in 1935 by Whistler's sister-in-law (also his ward and executor), Rosalind Birnie Philip (1873–1958), of a substantial cross-section of Whistler's work and her subsequent bequest immediately turned the Hunterian Art Gallery into the British equivalent of the Freer Art Gallery in Washington. Other bequests and donations have strengthened the existing holdings and extended the collection in different directions. Altogether the Hunterian Art Gallery is exemplary in every way.

JEAN-BAPTISTE-SIMÉON CHARDIN (1699–1779)

A Lady Taking Tea 1735

Canvas, 80 × 101 cm / 31½ × 39¾ in. Signed and dated

This painting, dated on the back to February 1735, has not only personal significance in Chardin's life, but also represents a change of direction in his development as a painter. Previously engaged in still-life painting, during the 1730s he widened his repertoire to include domestic genre scenes. Dr William Hunter owned three superb examples: the present picture, and *The Cellar Boy* and *The Scullery Maid*, which formed a pair. *A Lady Taking Tea*, which Hunter acquired at a sale in London in 1765, also originally had a pendant, *The House of Cards* (private collection).

A feature of all Chardin's genre scenes of this date is the emphasis placed on the figures. The woman drinking tea in this picture is almost certainly the artist's wife, Marguerite Saintard, who died only two months after this painting was made (April 1735), thus adding poignancy to the image. The tray-table with raised edges and the earthenware teapot are both listed in an inventory of her belongings drawn up in 1737.

The figure is seen from surprisingly close and very slightly from below, so that there is a certain monumentality about her. She is stirring her tea, which has just been poured from the teapot: steam rises from both the cup and the pot. The wall behind, possibly with a corner indicated on the right, is articulated by pilasters. Sharp-eyed art historians have observed some infelicities in the perspective of the back of the chair, the slope of the

'Chardin is the irrefutable witness who makes other painters look like liars'

JULIEN GREEN, 1949

table and the spout of the teapot, but this in no way detracts from Chardin's achievement in devising a composition that is full of tenderness. Two aspects help to create this effect: the lighting, at its most emphatic on the figure, and the colour harmony, with the cooler blues and greys on the left offset by the warmer reds and browns on the right. Most pleasing is the treatment of the bonnet, the dress where the grey-green stripes are picked out in red, and the powder evident towards the top of the shawl.

The subject, as so often in Chardin, is uncomplicated, although here there is less activity than usual and the mood is more ruminative. The emotional honesty is matched by the directness of the artist's technique and particularly by the sense of the materiality of things. Recent academic writing about Chardin has linked his paintings to contemporary theories about perception, which may help us to understand the context in which they were made, but has no bearing on the way in which they should be interpreted. Always with Chardin it is better to remain earthbound.

CAMILLE PISSARRO (1830–1903)
Misty Morning, Rouen 1896
Canvas, 54 × 73 cm / 21¼ × 28¾ in. Signed and dated

'It's as beautiful as Venice'

CAMILLE PISSARRO, IN A LETTER FROM ROUEN TO HIS ELDEST SON, LUCIEN, 2 OCTOBER 1896

Rouen lies on the River Seine halfway between Paris and Le Havre. Throughout the 19th century it was a popular place with French and British artists. However, by the end of the century it was a busy, heavily industrialized inland port, although its medieval quarter dominated by the cathedral was still evident and frequently the subject of popular topographical illustration.

Pissarro had made exploratory visits before embarking on a thorough examination of the city in 1896 and 1898 in numerous paintings and prints. Monet was also working in Rouen during this same decade, painting his famous series of the façade of the cathedral, but Pissarro's approach was much broader. He was fascinated by the contrast between the medieval and the modern, just as in his œuvre as a whole there is a highly significant division between urban and rural subject-matter. The views painted in 1896 are the first he did as a series, a practice he later adopted also in Paris, Dieppe and Le Havre. Friends referred to Pissarro's depictions of Rouen, of which there are nearly fifty in all, as his 'Rouenneries'.

Misty Morning was in all probability made during Pissarro's second visit to Rouen, in September–November 1896, when he stayed at the Hôtel d'Angleterre on the Cours Boieldieu. He usually worked in his hotel room during these painting campaigns and here he looks across the river to the new industrial quarter of the Quai St-Sever with all its warehouses. Immediately below are the docks, which the artist observed carefully: 'Rouen is admirable; here at the hotel, from my window on the second mezzanine floor, I see the boats glide by with their plumes of black, yellow, white, pink smoke. I see the ships loaded with planks of wood being moored, being unloaded and setting off.'

Such animated scenes were difficult to paint and Pissarro's great skill was to reduce all the bustling activity to manageable and intelligible proportions. His compositions, however complex, always have great authority. The surfaces are also heavily worked with a multitude of small brushstrokes and a wide range of colour. In these respects Pissarro remained a true Impressionist to the end, and the success of this picture lies in his ability to capture the effect of the sun burning up the morning mist. The mother-of-pearl quality of the light is worthy of Claude Lorrain and Turner – both artists Pissarro admired.

JAMES ABBOT McNEIL WHISTLER (1834–1903)
Brown and Gold: Self-Portrait c. 1895–1900
Canvas, 95.8 × 51.5 cm / 37¾ × 20¼ in.

One of the more colourful personalities in the art world of the late 19th century, Whistler may have been good to know, but he was also dangerous to know. A volume of his correspondence was published (with his blessing) in 1890 aptly entitled *The Gentle Art of Making Enemies*. Charming and witty though Whistler undoubtedly was, he was also highly litigious and his friendships, as with Oscar Wilde for example, rarely lasted the course.

As an artist Whistler had a cosmopolitan air, having been born in Massachusetts and trained in Paris in the studio of Charles Gleyre before settling in London. Added to this he was an inveterate traveller, especially in Europe, and in many ways he can be described as a true citizen of the world. His chameleon, somewhat dandyish, qualities in life are also characteristic of his art (his signature was a butterfly), where he moved easily from paintings through to pastels and watercolours to prints (both etchings and lithographs).

Setting out as a realist, Whistler became an impassioned advocate of 'art for art's sake', in the sense that beauty existed in its own right and had no use in serving a moral or didactic purpose. The modernity of his work gained extra impact from the titles, which often incorporated the words 'symphony' for figure subjects or 'nocturne' for views of the River Thames, thereby lending them Symbolist overtones favoured by contemporaries such as Dante Gabriel Rossetti and Algernon Charles Swinburne. Whistler was brilliant at obtaining fugitive effects by tonal nuances in his paintings and watercolours and by fleeting lines in his pastels and prints. He was also successful at devising decorative schemes for rooms inspired in part by Japanese art.

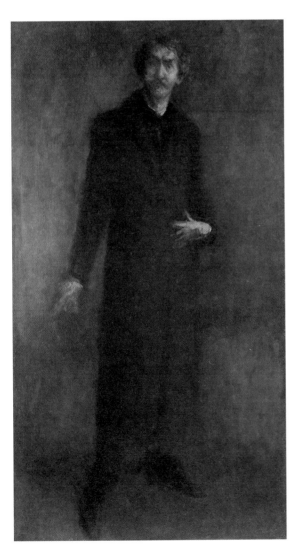

Although in many respects an unconventional figure, Whistler won many commissions from aristocrats and wealthy businessmen, mainly through the help of friends. He had many followers (Sickert and Mortimer Menpes among them), including several Americans. Although for a time there was an element of modernity in his art, it was not enduring and to a certain extent his work represents closure rather than progress.

Brown and Gold: Self-Portrait is in every way a summary of Whistler. He looms out of a vaporous, misty background adroitly nuanced and with the lower part of the body barely discernible. The hair, facial features and fingers are stealthily drawn, as in his pastels. The pose is knowingly and wittily based on a famous painting by Velásquez of Philip IV's court jester, *Pablo de Valladolid* (Madrid, Prado). Critics had already observed that *Arrangement in Grey and Black No. 1, Portrait of the Painter's Mother* of 1871 (Paris, Louvre) and *Arrangement in Grey and Black No. 2, Portrait of Thomas Carlyle* of 1872–73 (Glasgow, Kelvingrove Art Gallery and Museum) were influenced by Velásquez. Typically and contrarily Whistler objected to the comparison, remarking 'Why drag in Velásquez?', but was no doubt flattered.

Stromness, Orkney

PIER ARTS CENTRE

The Pier Arts Centre, established in 1979, occupies a complex of buildings overlooking the harbour at Stromness, centred on the former office and stores of the Hudson's Bay Company and recently expanded into a neighbouring property; the buildings were unified by a contemporary structure by Reiach & Hall Architects, and the result, opened in 2007, is one of the most beautiful galleries in the British Isles. Rarely has there been such a happy conjunction between exhibition space and permanent collection. The scale of the light-filled rooms complements the works of art perfectly.

The inspiration for setting up the Pier Arts Centre came from the philanthropist, social reformer and peace activist Margaret Gardiner (1904–2005), who first visited Orkney in 1956 and subsequently became deeply attached to the islands. She was also a collector, primarily of works by artists associated with St Ives – Ben Nicholson, Barbara Hepworth, Alfred Wallis, Terry Frost, Roger Hilton, Margaret Mellis, Patrick Heron and Peter Lanyon. A sense of place defines Gardiner's taste and it was this same inspiration that encouraged her in later life to give her collection of sixty-seven items to Stromness. The irony is that you have to go to Orkney to see outstanding works by artists of the St Ives School (particularly Nicholson and Hepworth), representative of a key moment in the development of modernism in the British Isles. But it is worth every effort, for the Pier Arts Centre is a profound aesthetic experience.

The collection continues to grow through a policy of assisted purchases, and it now numbers over one hundred works.

BEN NICHOLSON (1894–1982)
1929 *(Fireworks)* 1929
Board, 30 × 46 cm / 11¾ × 18¼ in. Signed and dated

Nicholson is a rarity in the history of early 20th-century British art, namely a modernist painter with a truly international reputation. The son of Sir William Nicholson (see pp. 293–94), he was slow to commit himself to a career as a painter and even then progressed only hesitantly towards abstraction. He embraced this style during the 1930s, and it was to become his prime means of expression thereafter. Apart from being fortunate in his artistic heritage, Nicholson benefited from travel in France and Switzerland at an early stage where he was able to observe new developments such as Cubism and

'The kind of painting which I find exciting is not necessarily representational or non-representational, but it is both musical and architectural'

BEN NICHOLSON, 1948

Surrealism at first hand. These contacts were of far greater importance than attendance at the Slade School of Fine Art (1910–11) where he did, however, meet Paul Nash. Marriage first to Winifred Roberts in 1920 (divorced 1938) and then to Barbara Hepworth in 1938 (divorced 1951) helped him to formulate ideas about colour and form respectively, but meetings with Alfred Wallis in St Ives in 1928 and Piet Mondrian in Paris in 1934 were equally influential.

Nicholson's progression towards abstraction was a logical evolution from his treatment of still-life and landscape and even in his maturity he often used several visual vocabularies in single works. The painted reliefs, of which there are several in the Pier Arts Centre from Margaret Gardiner's collection, dating from the 1930s and 1940s, remain the summit of his achievement owing to their purity of form and colour.

1929 *(Fireworks)* stands at the start of this process of purification. The naiveté of the representation, which both he and his friend Christopher Wood adopted with greater confidence after meeting Alfred Wallis, suggests a less selfconsciously complicated approach to subject-matter – almost humorous in this instance. Similarly, the scratched and roughened surface demonstrates Nicholson's sense of materiality. It was the conflation of these two aspects of his work that resulted in the painted reliefs which, as he realized, if enlarged could also be invested with an architectural dimension.

Part Four

--

WALES

Pompeo Batoni
Sir Watkin Williams Wynn, 4th Bt, Thomas Apperley
and Captain Edward Hamilton (detail)
National Museum of Wales
(see pp. 451–52)

Cardiff

NATIONAL MUSEUM OF WALES

Set in Cathays Park amidst other civic buildings, the National Museum of Wales is a notable structure. It was founded by Royal Charter in 1907; construction began in 1912 to the design of A. Dunbar Smith and Cecil C. Brewer, but the formal opening did not take place until 1927. The main entrance lies behind a row of double columns and introduces the visitor to a magnificent hall beneath a majestic dome. The building has undergone two transformations: an extension was completed in 1993, and further galleries have just been created.

The desire for a National Museum of Wales had been triggered in the late 19th century by the accumulation of collections by successful local businessmen such as William Menelaus (1818–82) and James Pyke Thompson (1847–97), matched by an acquisitions policy set in train by Sir Frederick Wedmore (1844–1922). The focus of attention at that time was on the Free Library and Museum set up in 1882.

The creation of a proper national museum brought a greater sense of purpose. The declared aim was not just to honour Welsh artists or to acquire art associated with Wales, but to show such art in an international context. Owing to this enlightened policy, the National Museum of Wales has acquired over the years an outstanding collection of old master paintings and Impressionist art thanks to the generosity of two remarkable sisters, Gwendoline (1882–1951) and Margaret (1884–1963) Davies, and modern British art due to the perspicacity of Derek Williams (1930–84).

The collection formed by the Davies sisters was a formidable achievement and of considerable consequence for the appreciation of French avant-garde art in the British Isles. Their grandfather, David Davies, had made a fortune as a contractor in coal and railways. Neither of the sisters married, and each pursued her own interests – Gwendoline in medicine and Margaret in welfare work. They began to collect at the start of the 20th century, buying principally from dealers in London and Paris with the advice of Hugh Blaker, a man of many parts, including painter, curator and dealer. By 1924 their collection, still growing, comprised some 250 works, half of which were modern French paintings. On Gwendoline's death in 1951 her part of the collection entered the National Museum of Wales, followed by Margaret's in 1963. The Davies sisters' interest in artists such as Manet, Monet, Renoir, Cézanne, Van Gogh and Rodin, quite apart from Daumier or Eugène Carrière, was pioneering in Britain. Their collection became known through loans to exhibitions, and in opening Samuel Courtauld's eyes to the wonders of Cézanne it proved to be immensely influential.

The National Museum of Wales is a success story – an inspiring building matched by collections of real quality.

JAN VAN DE CAPELLE (1626–79)

A Calm 1654

Canvas, 110 × 148.2 cm / 43¼ × 58½ in.

Van de Capelle specialized in marine painting and winter scenes. The marine paintings, more numerous, often portray calm seas at river mouths or inner harbours with ships usually at anchor or setting sail seen at early morning or evening. In these Van de Capelle develops the tradition of Jan Porcellis and Simon de Vlieger, but prefers to concentrate on compositional balance and tonal harmony.

 A Calm is a fine example of Van de Capelle's œuvre where the boats are adroitly positioned in the middle distance. Great play is made of the verticals created by the masts offset by the horizontals of the hulls, just as the eye is led towards the horizon along the channels opened up by the boats at anchor. The sea is like a mirror and there is a towering, beautifully painted sky overhead. Reflections play an important part in the composition, as does the silver-grey tonality. Although his works are sometimes described as rare, Van de Capelle has been a favourite with British collectors. Indeed, *A Calm* may have been known to Turner: its influence on his early marine paintings is readily apparent.

'As idle as a
painted ship /
Upon a painted
ocean'

SAMUEL TAYLOR COLERIDGE,
*THE RIME OF THE ANCIENT
MARINER*, 1798

Van de Capelle was more than just a painter. His family was from Amsterdam and owned a dye-works. The artist himself engaged in the business, as well as investing in real estate and owning a pleasure yacht. Consequently, he was a rich man and in addition had an extensive art collection amounting to more than 200 paintings (many by fellow marine artists) and 6,000 drawings: the inventory lists 9 paintings and 1,300 drawings by De Vlieger, 16 paintings by Porcellis, 10 paintings and over 400 drawings by Jan van Goyen, nearly 900 drawings by Hendrick Avercamp and some 500 drawings by Rembrandt. His portrait was apparently painted by both Rembrandt and Hals, although neither picture is known today. Van de Capelle was clearly worth knowing.

POMPEO BATONI (1708–87)
Sir Watkin Williams Wynn, 4th Bt, Thomas Apperley and Captain Edward Hamilton 1768–71
Canvas, 289 × 196 cm / 113¾ × 77⅛ in.

Perhaps the finest portrait of members of the British aristocracy making the Grand Tour in 18th-century Italy. Batoni was born in Lucca, the son of a goldsmith, but moved to Rome in 1727 where he set about becoming a religious painter. From *c.* 1740, however, he began painting a prodigious number of portraits of foreign visitors. His reputation became so widespread that he eventually included heads of state – emperors, popes, kings – among his sitters. On arriving in Rome Batoni had been more struck by the Antique and works by Raphael and Annibale Carracci than by anything by his contemporaries. As a result he was ideally placed to express in paint the pleasures of Rome as experienced by those visiting the city.

This is the only triple portrait of British sitters undertaken by Batoni. Sir Watkin Williams Wynn (1749–89) is on the left, holding a drawing made by himself after a fresco by Raphael; Thomas Apperley (1734–1819) of Plas Grono near Wrexham, a neighbour of Sir Watkin, is seated reading Dante; and the cavalry officer Captain Hamilton is shown with a flute in his hand, and gestures with his other hand to indicate the seriousness of the occasion. The scale is enhanced by the Classical rotunda behind and by the allegorical sculpture of Painting overlooking the figures.

Sir Watkin Williams Wynn was one of the greatest patrons emanating from Wales. He owned estates in Denbighshire, Shropshire, Monmouthshire and Merioneth, and derived his huge wealth not only from landed property but from coal, lead, tin and copper. He spent lavishly on the arts. His house in St James's Square in London was built and furnished by Robert Adam, from whom he also commissioned a magnificent dinner service, and he collected pictures of the Italian, Dutch, Spanish, French and British schools, as well as supporting theatre and music. But even his great wealth had begun to run out by the 1780s.

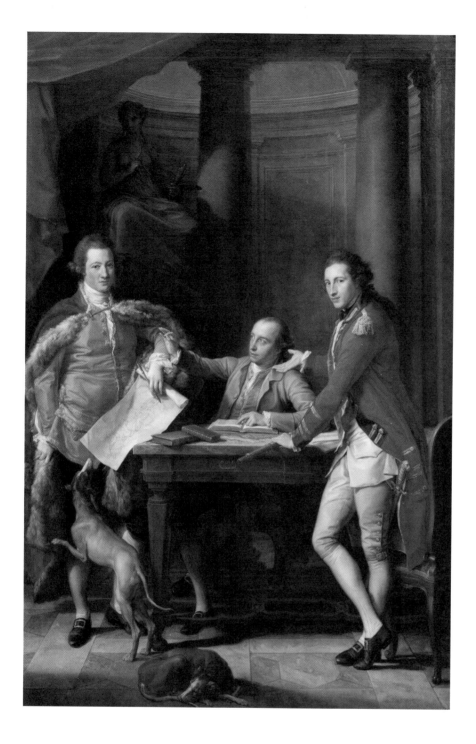

The National Museum of Wales has paid due respect to this great patron by acquiring numerous items that once belonged to Sir Watkin, including two paintings by Reynolds: a double portrait with his first wife, Lady Henrietta Somerset, and a portrait of his second wife, Lady Charlotte Grenville, with their children.

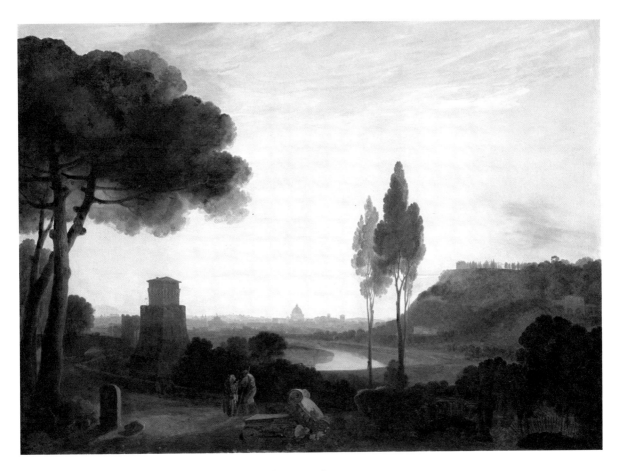

RICHARD WILSON (1713–82)
Rome and the Ponte Molle 1754
Canvas, 97.2 × 133.3 cm / 38¼ × 52½ in.

Richard Wilson was one of the finest landscape artists of the 18th century. The son of a clergyman who was rector of Penegoes in Montgomeryshire, he received a Classical education although he did not go to university. Instead he was apprenticed as an artist to Thomas Wright in London (1729–35). At first he specialized in portraiture.

In 1750 he went to Italy, and converted to landscape painting. He began in Venice, where he was influenced by Francesco Zuccarelli and Marco Ricci. On moving to Rome the following year he became more aware of the classical tradition of landscape painting represented by Poussin and Claude. This is clearly evident in *Rome and the Ponte Molle*, which depicts the view of Rome from the north at sunset, with the bridge on the left topped by the guard tower rebuilt by Pope Nicholas V in the 15th century. Monte Mario is on the right, with the Villa Madama, designed by Raphael for Cardinal Giulio de' Medici, nestling at the foot of its slopes. The horizon line at the centre of the composition is punctuated by St Peter's and the Castel Sant'Angelo. The Ponte Molle, now the Ponte Milvio, played an important role in the history of ancient Rome – the Emperor Constantine defeated his

rival Maxentius at the Battle of the Milvian Bridge in AD 312 – and would have been known to anyone undertaking the Grand Tour. It was for such patrons that Wilson painted idealized landscapes like this of Rome and its environs during the early 1750s.

On returning to London in 1757 he was forced to widen his perspective, and in addition to pursuing Italian themes he began to paint views of private estates and of Welsh scenery. These are usually in the manner of Claude or of Gaspar Dughet and often with dramatic, sometimes historical, elements recalling works by Salvator Rosa. He was a founding member of the Royal Academy in 1768 and became Librarian in 1776; but his output, which now included several repetitions, began to decline. This was due partly to ill-health and partly to drink. He returned to Wales in 1781 a broken man.

THOMAS JONES (1742–1803)
Buildings in Naples 1782
Paper, 14.2 × 21.6 cm / 5½ × 8½ in. Dated

Born in Radnorshire into a property-owning family, Jones was destined for the church and went to Jesus College, Oxford, but left without a degree and decided to be an artist. After training at Shipley's Art School and St Martin's Lane Academy in London, he became a pupil of Richard Wilson (1763–65). He then set himself up as a history painter, choosing episodes from literary sources, including contemporary poetry, that allowed him to emphasize his skills as a landscapist (for example *Landscape with Dido and Aeneas* and *The Bard*).

Emulating Wilson, he set out for Italy, living in Rome from 1776 and then from 1780 to 1783 in Naples, a time well documented in his highly entertaining *Memoirs*. Returning to London he found the prospect of employment gloomy, and when in 1787 he inherited the family estates he returned to Radnorshire, and painted and sketched only for pleasure.

Buildings in Naples is one of the twelve or so small studies in oil on paper that Jones made in Naples. It is these works, made for his own purposes and not for sale, that are now so highly prized. They fall outside what 18th-century connoisseurs would have regarded as proper view paintings, but they have a particular appeal for a more modern aesthetic. Jones moved house several times while in Naples, but the exact dating on the back of the present picture makes it clear that he was working in the first apartment he rented, on the second floor of a house overlooking the port. It is Jones's individuality in selecting such ordinary views of sundry buildings from a window or rooftop that gives these little pictures a remarkable individuality. Only works in the same vein by Pierre-Henri Valenciennes, who might have known Jones in Italy, are comparable. Both artists stand at the start of a tradition of *plein-air* painting that came into its own in the 19th century.

Buildings in Naples fascinates because the artist has brought such precision to the detailing of a mundane façade while at the same time indicating something of the city's character, above all the heat. Perhaps because he was so overcome by heat he drew what

'It is just a white façade with a window and a door, which penetrate the radiant stucco with a clarity of other times'

LAWRENCE GOWING, *THE ORIGINALITY OF THOMAS JONES*, 1985

was in front of him without having to move far or carry his painting apparatus great distances. Close examination reveals a mathematical basis to the architectural features, which was probably instinctive rather than measured, just as the stepped rooflines on the left seem to hold the whitewashed building up for our inspection.

HONORÉ DAUMIER (1808–79)
Lunch in the Country c. 1867–68
Board, 26 × 34 cm / 10¼ × 13 in.

'He draws as the great masters draw. His drawing is abundant and easy – it is a sustained improvisation and yet it never descends to the "chic"'

CHARLES BAUDELAIRE ON DAUMIER IN *CURIOSITÉS ESTHÉTIQUES*, 1868

Daumier is best known as a political caricaturist, producing some 4,000 or so lithographs for journals such as *La Caricature* and *Le Charivari* throughout the many years of constitutional upheaval in 19th-century France. His range was formidable and was matched by his fluid style.

He sided with the underdog against hypocrisy, injustice, poverty and corruption. His exposure of the political, legal, financial and ecclesiastical systems was merciless and was carried over into his sculpture. While the impact of his art was a threat to the establishment (he was imprisoned for six months in 1832), his influence over other artists was immense. Degas, Toulouse-Lautrec, Cézanne and Picasso – to name but a few – admired his directness and technical facility. Contemporary critics compared him with Michelangelo and Rembrandt. Most amazing of all was the sustained power of his art, which only began to fail when his eyes started to trouble him in 1872.

Daumier did make paintings, but comparatively few and often on a small scale. Their appearance is sometimes sketchy and their tones somewhat subdued. The Davies sisters

owned several, of which this is one. The bucolic scene is treated with panache, with the undulating brushstrokes superbly painted. It demonstrates how Daumier's art can pack a punch with all its compressed energy. The subject treated *en plein air* has enabled the artist to lighten his palette, and the still-life on the white tablecloth becomes the focus of the whole composition around which the figures are assembled.

JEAN-FRANÇOIS MILLET (1814–75)
Winter – The Faggot Gatherers 1868–75
Canvas, 82 × 100 cm / 32¼ × 39⅜ in.

Millet's art strikes an ambivalent note. His principal subject was rural life, particularly the plight of the peasants, into which class he had himself been born and whose life he observed at first hand at Barbizon in the Forest of Fontainebleau south-east of Paris. When first shown, his paintings were often dismissed as socialist and therefore political, but Millet was keen not only to depict the hardships of rural life in a realistic way but also to stress its dignity and its sense of values in so far as they were linked to the rhythms of nature. He was extremely well read (the Bible, Theocritus, Virgil) and tended towards melancholy, which also had a bearing on his art. There is, therefore, a certain nostalgia about Millet's paintings, since beyond the relentless toil that they portray there is also a concern that it is a way of life under threat from the increasing urbanization in France.

'I love the delicious silhouette of a man marching so solemnly on the heights [but not] the noise of the wheels of an omnibus or the "music" of a street pedlar'

JEAN-FRANÇOIS MILLET

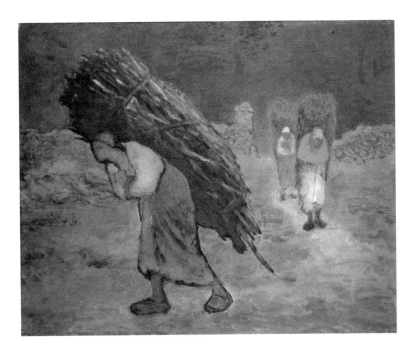

Winter – *The Faggot Gatherers* belongs to a cycle of the seasons dating from the end of Millet's life (commissioned by the wealthy industrialist Frédéric Hartmann). He began the cycle in 1868 and completed three of the pictures, but *Winter* was unfinished at the time of his death.

Millet sets the scene at sunset with the stooping figures returning home for the night. The weight of the burdens carried on their backs is matched by their ponderous gait. It is an unforgettable image of the unremitting toil associated with working in the country. The figures advance slowly and silently and will soon pass us by on their way home, only to begin again tomorrow.

PIERRE-AUGUSTE RENOIR (1841–1919)

La Parisienne 1874

Canvas, 160.3 × 108.3 cm / 63⅛ × 42⅝ in. Signed and dated

Without any doubt this is the finest full-length portrait in all Impressionism. It was shown in the first Impressionist exhibition held in Paris in 1874. The model was Henriette Henriot (1857–1944), who worked for the artist on several occasions during the mid-1870s. She was born Henriette Grossin and became an actress, performing (not very successfully) in light comedy and vaudeville until she retired in 1900. Contemporary photographs suggest that she was not quite as pretty or as demure as Renoir makes out.

The title suggests that Renoir meant it to be the representation of a 'type' seen on the streets of Paris. And this is exactly the effect that he creates, with a wonderful sense of air surrounding the figure who turns so elegantly and invitingly to greet us as we approach.

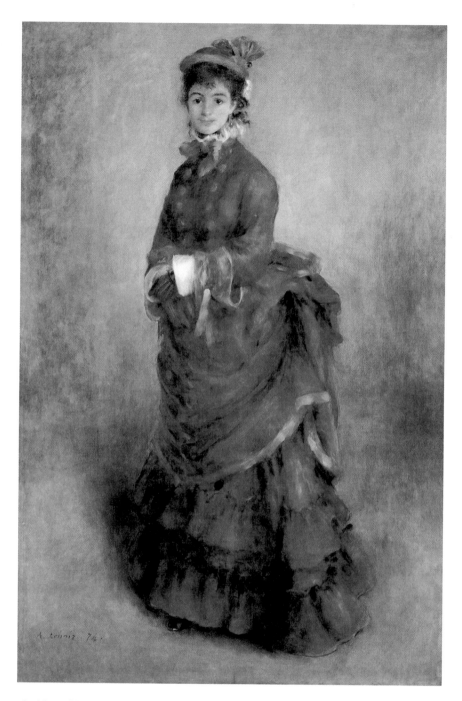

The blue of the dress and the accessories stays in the mind; but the background comprises much more colour (blue, yellow, pink) than is first suspected. Renoir's feathery brushwork is at its very best, as it flickers over the gatherings of the dress and delicately strokes the face. Typical is the love of detail: the foot appearing from beneath the dress, the flash of white cuffs, the pendant gold earrings, loose strands of hair, and the glimpse of a ribbon below the hat – all done with such a light touch and thin layers of paint.

As good as
Gainsborough,
Goya, Fragonard –
possibly better

VINCENT VAN GOGH (1853–90)
Rain: Auvers 1890
Canvas, 48.3 × 99 cm / 19 × 39 in.

Last will and
testament

Acquired by the Davies sisters in 1920, this was one of the first of Van Gogh's works purchased by a British collector. Added poignancy is given by the fact that it is one of the artist's last works, painted in July 1890 shortly before his death.

Van Gogh spent May–July 1890 in Auvers-sur-Oise, a small town by the banks of the River Oise where Pissarro and Cézanne had painted during the 1870s, and was looked after by Dr Paul Gachet. In his last letter to his mother and sister he wrote, 'I'm wholly absorbed in the vast expanse of wheatfields against the hills, large as a sea, delicate yellow, delicate pale green, delicate purple of a ploughed and weeded piece of land, regularly speckled with the green of flowering potato plants, all under a sky with delicate blue, white, pink, violet tones. I'm wholly in a mood of almost too much calm, in a mood to paint that.' To his brother Theo he wrote that he had painted 'immense stretches of wheatfields under turbulent skies, and I made a point of trying to express sadness, extreme loneliness'.

Auvers lies in this picture in the middle of the composition, with a wheatfield in the foreground balanced by a hillside in the background. Only a small portion of sky is visible at the top of the canvas. The surface is scoured by a series of near vertical brushstrokes creating the effect of rain, which Van Gogh had seen in a Japanese print by Hiroshige. It is a remarkable passage and one that anticipates the freedom of modern art.

On Sunday 27 July 1890 Van Gogh shot himself, and died two days later. He was buried in the cemetery at Auvers; Theo, who died on 25 January 1891, was later buried at his side. The cemetery overlooks the town: to visit it is an experience not to be missed.

Part Five

--

IRELAND

Hugh Douglas Hamilton
*Frederick Augustus Hervey, 4th Earl of Bristol and
Bishop of Derry, with his Granddaughter Lady Caroline
Crichton, later Lady Wharncliffe* (detail)
National Gallery of Ireland, Dublin
(see pp. 472–73)

Belfast

ULSTER MUSEUM

The Ulster Museum, situated in the Botanic Gardens, had rather a hesitant entry into the world. A museum was founded by the Belfast Natural History and Philosophical Society in 1831, and an art gallery was instigated by Belfast Corporation in 1890. These two institutions joined forces in 1909 to create a new municipal museum and art gallery. Designs for a building were drawn up by James Cumming Wynne, but work was not completed until 1929, when the institution officially became the Belfast Museum and Art Gallery. An extension by Francis Pym was added in 1972 and a total refurbishment completed in 2010.

The collection comprises a handful of old masters and a group of 18th- and early 19th-century British portraits. To these have been added impressive examples of 20th-century British paintings. An active policy of acquiring contemporary British and American pictures has proved very successful. The collection of works by Irish painters, particularly Sir John Lavery, is strong.

SIR JOHN LAVERY (1856–1941)
Under the Cherry Tree 1884
Canvas, 150.8 × 150.4 cm / 59⅜ × 59¼ in.

Vive la France!

The artist was born in Belfast, but early in life became more closely associated with Glasgow. He trained in that city as a photographer before attending Heatherley's School of Art in London for a year, and after returning briefly to Glasgow he left for France in 1882 where he studied at the Académie Julian. This was a turning point, as so far Lavery had only attempted to paint costume pieces. The influence of Jules Bastien-Lepage proved decisive, encouraging a change in subject-matter and approach.

Like several artists from Scotland later known as the Glasgow Boys, Lavery began to paint scenes of everyday life in the open air. Their activity was centred on the village of Grez-sur-Loing on the edge of the Forest of Fontainebleau south-east of Paris, where an artists' colony gathered during the 1880s (the composer Delius also lived there). Some of Lavery's best pictures, including those undertaken at a later date, are of this area, where he observed aspects of rural life and also leisure pursuits on the river. All of these works are notable for the close attention paid to nature, superbly handled tonal effects and brilliant sense of colour.

Under the Cherry Tree proves Lavery to be a virtuoso painter. The bridge – a favourite subject – is partly concealed by foliage and the tone is quite subdued, but the detailed handling of the foreground and the reflections in the water are extraordinarily effective. The theme too has a bucolic flavour and as always with Lavery retains a narrative element.

The continuation of the stylistic advance made by Lavery on his first visit to France is manifested in such pictures as *The Tennis Party* (Aberdeen, City Art Gallery), which is one of his most famous. Later he transferred the depiction of the riparian pleasures of Grez-sur-Loing to the River Thames.

SIR JOHN LAVERY (1856–1941)
The Green Coat 1926
Canvas, 198.2 × 107.3 cm / 78 × 42⅜ in.

Some artists have a knack of defining the period they lived in, and Lavery is one of them. This is partly because he set out to be a socially acceptable artist, and was therefore granted access to privileged locations and special occasions. On his return to Glasgow from France in 1884 he set out to be noticed and to paint influential sitters. Such pictures as *The State Visit of Queen Victoria to the International Exhibition, Glasgow, 1888* (Glasgow, Kelvingrove Museum and Art Gallery) got him noticed and he began to paint portraits of

Enter the second
Mrs Lavery

the great and the good. He was elected a member of the Royal Scottish Academy in 1896 and started to exhibit at the Royal Academy in London. The move to London in 1896 set the seal on Lavery's career and he became not only a leading portrait painter (including royalty), but also a recorder of important historical and social events. His appointment as an official war artist for the First World War led to a knighthood in 1918 and election to the Royal Academy in 1921. Thereafter honours came flooding in from all over Europe.

Marriage to Hazel Marty Trudeau (1880–1935) *en secondes noces* in 1909 sustained Lavery's position in society, as she was one of the great hostesses of the day and closely involved with politics. The Laverys were keen supporters of Irish nationalism and spent a great deal of time in Dublin. Hazel became his muse and he painted her numerous times, even seeing her as a personification of Ireland – quite literally so when he incorporated her image in his design for the banknotes of the new Irish Republic, where she appeared

from 1928 until 1975 in the guise of Cathleen ni Houlihan. In *The Green Coat* she was originally shown *en deshabillé*: the coat itself was added after the picture was shown at the Royal Academy. The sitter regarded the portrait as her husband's best. Her waxen features appealed to the advertisers of Pond's Cream, who used the image to promote their wares. After her death Lavery went to America, where he remained in demand as a portrait painter, but he returned to die in Ireland.

Lavery's visits to Tangiers in Morocco (from 1890) inspired some wonderfully spirited and loosely painted landscapes, and trips to Europe were also formative, particularly that to Spain in 1891–92 where he saw works by Velásquez, to whom many of his portraits, including *The Green Coat*, pay homage. *The Green Coat* has a luscious effusive quality of paint reminiscent in its bravura of Franz Xaver Winterhalter and in its tonal qualities of Lavery's friend Whistler.

REPUBLIC OF IRELAND

Dublin

NATIONAL GALLERY OF IRELAND

The National Gallery of Ireland in Dublin owes its existence to an Act of Parliament passed in 1854, inspired by the success of the display of paintings at the Great Exhibition held in the city the previous year. Responsibility for the task was vested in the specially appointed Royal Institution, who arranged exhibitions of old master pictures to retain interest in the project and solicited donations of works of art and money. In this the generosity of the railway magnate William Dargan (1799–1867) was influential.

A site was chosen, and an architect – Captain Francis Fowke – appointed, and the National Gallery opened in 1864. The exterior of the building is restrained, but for the interior the divided staircases and spacious galleries with abundant use of Corinthian columns are noteworthy. Additions to the collection resulted in an extension by Sir Thomas Newenham Deane opened in 1903; 1968 saw more galleries and another staircase designed by Frank du Berry, and there were still more refinements made in connection with the museum's Millennium project.

The collections grew with the aid of government grants and the help of public subscriptions, put to excellent use over the years by a string of exceptionally talented directors. Major donations have augmented the holdings: the Milltown Gift of almost two hundred pictures from the Countess of Milltown in memory of her husband, the 6th Earl of Milltown (1902); the Sir Alfred Chester Beatty Gift (1950); donations by Sir Alfred and Lady Beit (1987); and the bequest of Máire MacNeil Sweeney (1987). The Beit pictures are particularly beautiful. The purchase of paintings was further facilitated when George Bernard Shaw in 1950 left the National Gallery a substantial part of his estate.

There is a comprehensive collection of European old masters. El Greco, Rembrandt, Murillo, Goya, Hals, Velásquez and Poussin are all here, together with an extensive and outstanding holding of works by Irish painters.

The National Gallery of Ireland has had some amazing luck in recent years. *The Meeting of Jacob and Rachel* given to the collection in 1990 has since been identified as an important work by Murillo relating to a major commission, and *The Taking of Christ*, put on long-term loan in 1993 by the Jesuits in Dublin, is recognized as an autograph work by Caravaggio.

FRA ANGELICO (1395/1400–1455)

The Attempted Martyrdom of SS. Cosmas and Damian c. 1440–42

Wood, 37 × 46 cm / 14⅝ × 18½ in.

The altarpiece to which this belonged is one of the most significant painted in the early Renaissance, and a response to one of the greatest challenges in Fra Angelico's career. The commission was for the high altarpiece in the Dominican church of S. Marco in Florence, the refurbishment of which was paid for by Cosimo de' Medici and his brother Lorenzo. The central panel (now in the Museo di S. Marco) includes an unusual number of saints and angels in attendance on the enthroned Virgin and Child, and they are grouped not in separate compartments in the traditional manner but in a single continuous space. This new type of composition, called a *sacra conversazione*, depended for its success on the artist's skill in arranging the figures convincingly in space with the aid of a system of mathematical perspective.

Along the bottom of the altarpiece there was as usual a predella – a sequence of smaller pictures. Here in the centre, immediately below the Virgin and Child, was an *Entombment of Christ*, and flanking that four scenes from the lives of Cosmas and Damian, who were regarded as the patron saints of medicine and as such closely associated with the Medici family (*medici* means doctors). It is thought that Cosmas and Damian were twin brothers who practised medicine free of charge in Cilicia, but suffered martyrdom. Their cult spread rapidly and was established by the 5th century AD.

The compositional skills deployed in the main panel are also found in the predella scenes. *The Attempted Martyrdom of SS. Cosmas and Damian* depicts one of the incidents when the Proconsul Lycias endeavoured to put the two saints with their brothers to death. On each occasion he was thwarted, and in this scene the flames burn the executioners instead. Fra Angelico's narrative abilities appear in the shocked reactions of the onlookers and executioners, and he manages to give an appearance of monumentality to a panel of small dimensions.

GIAMBATTISTA MORONI (active 1546/47–78)
Portrait of a Widower and his two Children c. 1565
Canvas, 126 × 98 cm / 49⅝ × 38⅝ in.

Moroni was born near Bergamo and worked mainly there and in Brescia. His religious paintings are derived in many respects from his master, Moretto da Brescia, and from greater luminaries such as Titian. His portraits, however, are of a different order, and there are many of them. All are notable for their directness and restrained realism. He does not seem to have painted aristocratic sitters, but concentrated instead on lawyers, merchants and clerics, so that his portraits are sociologically revealing about life in Northern Italy in the mid-16th century.

It is difficult to tell the profession of this widower. The books on the shelf behind and the letters on the table suggest that he might be a notary. He stands looking out at us forlornly with his two charming children, inviting us to sympathize with his predicament, which we of course readily do. Contrasting with the black of their father's clothes the children are stylishly dressed. Moroni was extremely good at painting the tonal nuances of grey and black; the strong chord of green, yellow and red in the lower half of the picture is also striking. Similarly, the detailing of the clothing and accessories – the flowers in the little girl's hair and the ring worn by her father – make this an intensely personal as well as a sad portrait. One wonders what happened next in their lives.

Unjustly known as the 'poor man's Titian'

JACOB VAN RUISDAEL (1628/29–82)
Bentheim Castle 1653
Canvas, 110.4 × 144 cm / 43½ × 56⅝ in. Signed and dated

Ruisdael was the greatest pure landscape painter in the Netherlands in the 17th century and deeply influential in the development of European art. A prolific artist, he also had a vast range, incorporating panoramic vistas, sudden glimpses of clearings in forests, shafts of sunlight, meandering paths, rushing torrents, sluggish rivers, tempestuous seas and lowering skies. Ruisdael did not so much bring order to nature as harness it for his brush. To examine one of his paintings closely is to become totally absorbed by nature, almost to the point of actually being immersed in it. His powers of pictorial organization were considerable and he was never a slave to topographical accuracy, but his attention to detail was so acute that his pictures have been examined by meteorologists, oceanographers, botanists, arborologists and economic historians.

'I have seen an affecting picture this morning by Ruisdael. It haunts my mind and clings to my heart'

JOHN CONSTABLE
TO ARCHDEACON FISHER,
28 NOVEMBER 1826

Ruisdael was born in Haarlem; little definite is known about his training, and there are few documents. No portraits of him survive. Clearly he was fairly precocious, as the early pictures of the landscape around Haarlem – sea, dunes, roads, forests – show, but he then widened his repertoire to include ruins, watermills, windmills and waterfalls, as well as general views of Haarlem and Amsterdam. The early compositions are visually coherent, although constricted and immensely detailed. Gradually during the early 1650s the landscapes open out more and are more solidly painted; the same amount of detail abounds, but always encased in a larger, more dramatic setting. These works have such force and are so atmospheric that they have often been interpreted symbolically as statements about life. Goethe saw *The Jewish Cemetery* in Dresden in 1887 and wrote, 'One cannot find in the paintings of other artists of his country a poetry as moving as that which he puts into his own.'

An important moment in Ruisdael's progress as an artist was a visit made *c.* 1650 to Bentheim in Westphalia, just over the border into Germany. This view of the castle from the south-west is certainly dramatic, with the building offset by the clouds. What is more impressive is the attention to detail throughout, without any loss of clarity in the overall composition. The eye marvels at how much information the artist gives to the viewer: see, for instance, the houses in the middle distance, nestling in the wooded hillside. The actual castle is not raised up as Ruisdael shows it here, but what he is more interested in doing is involving the viewer in the transformative effects of nature.

GIOVANNI ANTONIO PELLEGRINI (1675–1741)
Bathsheba c. 1708–11
Canvas, 127 × 101 cm / 50 × 39¾ in.

'David walked upon the roof of the king's house: and from the roof he saw a woman washing herself; and the woman was very beautiful to look upon'

2 SAMUEL 11:2

The story of Bathsheba is told in the Old Testament (2 Samuel 11:2–27). One evening from the rooftop of his palace David, King of Israel, espies Bathsheba washing herself, and determines to make her his mistress. He arranges for her husband, Uriah the Hittite, to be killed on the battlefield, and she subsequently gives birth to King David's son, Solomon.

The story is not particularly pleasant but the painting is wonderful, and just the kind of colourful confection that Pellegrini was sensationally good at. Born in Venice and a pupil of Sebastiano Ricci, he exported the Rococo style, of which he was a prime exponent, to Britain, Germany, the Netherlands and France. The pastellist and miniaturist Rosalba Carriera was his sister-in-law. Pellegrini was also a collector: his collection, which included Vermeer's *The Music Lesson*, was acquired in 1741 by Consul Joseph Smith, from whom it passed twenty years later to George III.

Pellegrini's style is a delight to behold – free, spontaneous, fresh. The colours are light, the brushwork lively, and the compositions stunningly theatrical. There is nothing solid or solemn about this artist's world: he prefers celebration to deliberation or pontification.

His visits to England (1708–13 and 1719) proved to be influential for the emergence of a British school of painting. As a painter of decorative scenes in great houses such as Kimbolton Castle, Narford Hall and Castle Howard, he opened a window for British artists and revealed new, more exciting, possibilities. The peripatetic Pellegrini failed to secure a proper and rightful position for himself in Venice, but seen with the advantage of hindsight he paved the way for Giovanni Battista Tiepolo.

SIR JOSHUA REYNOLDS (1723–92)
A Parody on Raphael's School of Athens 1751
Canvas, 97 × 135 cm / 38⅛ × 53⅛ in.

Reynolds embarked on a tour of Italy in 1750 and spent two years travelling there. The trip was an eye-opener, as it provided him with the opportunity to see the greatest works of art of Antiquity and of the Italian schools in Rome, Florence, Bologna and Venice. The overwhelming effect of this experience was to turn Reynolds into a great portrait painter, as what he saw in Italy became the basis of his theories for the Grand Manner in history painting and enabled him to elevate the status of portraiture.

Reynolds
unbuttoned

Presumably Reynolds had to pay his way when in Italy and for this reason he painted a number of portraits, including caricatures of fellow travellers. If someone on the Grand Tour wanted a formal portrait of himself or his friends then Pompeo Batoni was the artist to turn to (see pp. 451–52). But equally potent, although in a different spirit, were the caricatures from which Pier Leone Ghezzi for one made a living. Thomas Patch, who moved from Rome to Florence in 1755, also specialized in these *jeux d'esprit*. It is hard to imagine Reynolds indulging in such japes except to make money. A group of his caricatures came to the National Gallery of Ireland with the Milltown Gift.

A Parody on Raphael's School of Athens is particularly elaborate. It seems to have been commissioned by Joseph Henry, the brother-in-law of Joseph Leeson, who became the 1st Earl of Milltown in 1763. The original fresco by Raphael is in the Stanza della Segnatura in the Vatican. For his parody Reynolds has replaced Raphael's ancient philosophers with British aristocrats (many from Irish families) and their hangers-on (antiquaries, doctors, dealers, tutors) in Rome on a prolonged Grand Tour. Reynolds left a list of names of those he included, but not all of the figures can be firmly identified in the picture today. Joseph Henry, though, reclines on the steps in the centre as 'Diogenes', and his brother-in-law Joseph Leeson is in the back row with a magnifying glass as 'Plato'. Significantly, Reynolds

changed Raphael's Classical background (an unrealized project for St Peter's) to a Gothic setting, which in the 18th century often signified barbarism.

Reynolds wisely ceased to paint caricatures on his return to England and concentrated instead on serious portraiture (as, for example, the swagger image of Charles Coote, 1st Earl of Bellamont, in the National Gallery of Ireland). Discretion and good manners were essential for his reputation. As it happens, that reputation is challenged in another picture in the National Gallery of Ireland, namely *The Conjuror* (1775) by Nathaniel Hone – an irreverent attack on Reynolds's theories and personal life. Check it out.

HUGH DOUGLAS HAMILTON (1739/40–1808)
Frederick Augustus Hervey, 4th Earl of Bristol and Bishop of Derry, with his Granddaughter Lady Caroline Crichton, later Lady Wharncliffe c. 1790–91
Canvas, 230 × 199 cm / 90½ × 78⅜ in.

Hamilton was Ireland's most successful painter during the late 18th century. A prolific portraitist in oil and particularly in pastel, sometimes on a considerable scale, he was trained at the Dublin Society Schools (1750–56). Having established a successful practice he moved to London in 1764 and in 1782 to Italy, where he spent ten years between Florence, Venice, Naples, Sicily and Rome before returning to Dublin. In Italy he increased his output and widened his clientèle by painting those making the Grand Tour.

The eccentric Earl of Bristol (1730–1803) was the epitome of an 18th-century cleric, achieving high rank in the church without much effort or great theological learning. For him politics and religion were of lesser significance than travelling – Bristol Hotels are named in his honour – and collecting art. His friends included both Voltaire and Lady Hamilton. He built two houses in Northern Ireland, at Downhill and Ballyscullion near Londonderry, as well as Ickworth near Bury St Edmunds in Suffolk. He visited Italy frequently, often for long periods. He is seen here with his granddaughter in the gardens of the Villa Borghese in Rome, next to the marble Altar of the Twelve Deities. In the upper register are Apollo, Diana, Vulcan and Minerva; Lady Caroline is pointing to figures variously identified as the Hours or the Seasons. The gardens were designed by the Scottish landscape painter Jacob More; visible in the background is the lake, with the Temple of Aesculapius.

Apart from being a charming family portrait, there is added significance in that the Temple of Aesculapius had been completed in 1787 to designs by Mario Asprucci, who went on to design Ickworth for the Bishop. The portfolio at the foot of the Altar of the Twelve Gods may well be connected with Asprucci's designs for the house.

The Altar itself is now in Paris (Louvre), having been sold to Napoleon by Prince Camillo Borghese. No doubt at the time this portrait was painted the Earl of Bristol was contemplating making an offer for it himself.

Pay attention, Grandpa! The widely travelled Earl-Bishop with his granddaughter in the gardens of the Villa Borghese

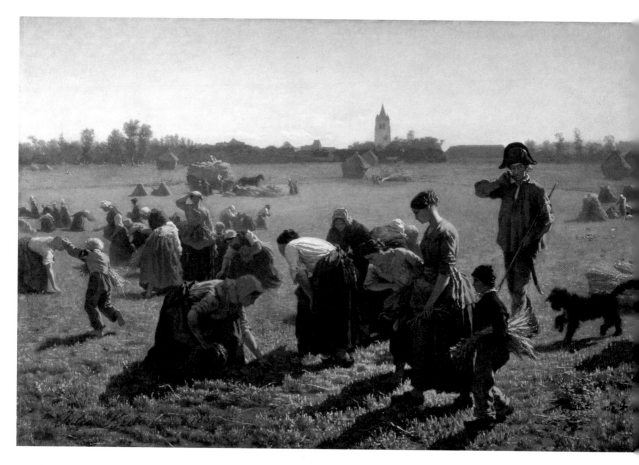

JULES BRETON (1827–1906)
The Gleaners 1854
Canvas, 93 × 138 cm / 36⅝ × 54⅜ in. Signed and dated

Breton was one of the principal painters of peasant life in 19th-century France and his work was much admired. He was born in the north, in the village of Courrières in the Artois, and had a profound understanding of rural life – its economics, its traditions, its hardships, its beauties – but he chose, in Théophile Gautier's words, to depict 'the grave, serious and strong poetry of the countryside, which he renders with love, respect, and sincerity'. The artist received a Classical education at Douai, but trained in Belgium at Ghent (1843–46) and Antwerp before spending one year (1847) studying with Martin Drolling at the Ecole des Beaux-Arts in Paris. He was a poet as well as an artist and wrote three accounts of his life.

Breton began to paint rural subjects in the mid-1850s and chose many of his motifs from his home region before also turning his attention to Brittany from the late 1860s onwards. *The Gleaners* was painted in the fields near Courrières and was exhibited in the Salon of 1855. As he himself wrote, 'These moving groups that dotted the sunburned plain, defined in dark shadow against the sky as they bent in varied attitudes over the

Van Gogh said that Jules Breton devoted as much attention to depicting rural figures as other artists did to Parisian women

earth gathering the ears of grain, filled me with admiration. Nothing could be more Biblical than this human flock...'

Gleaning was a vital economic perk for the rural community, who were allowed to pick over the fields after the harvest had been gathered in and keep what they collected for their own use. The artist shows women and children watched over by the comic-looking *garde-champêtre* with his dog on the right. Gleaning was hard and thirsty work, but Breton gives his figures heroic forms, just as the golden sunlight towards the end of the day creates an arcadian setting. Unlike Millet, he wanted to stress the timeless beauty in rural themes as opposed to the toil and sweat. That he could do this so well was due to his academic training; each of his compositions was carefully prepared with superb drawings.

Van Gogh admired Breton as much as Millet or L'Hermitte, although as artists they were so different. He even made a special pilgrimage to Courrières – only to find that he did not have enough courage to disturb the great man.

JACK B. YEATS (1871–1957)
In the Tram 1923
Board, 23 × 36 cm / 9⅛ × 14⅛ in. Signed

An Irish tram seen with an eye worthy of Bonnard

It is difficult to escape the name of Yeats in the emergence of modern Ireland. While one brother, W. B. Yeats, played such a crucial role in Irish literature, another, Jack B. Yeats, is now recognized as the greatest Irish artist of the first half of the 20th century. Owing to the unreliability of his father, Jack B. Yeats spent most of his youth with his grandparents in Sligo, which was the place to which he related most readily at all stages of his life.

By 1887 he was in London attending a number of art schools and began to pay his way as an illustrator and designer. After marriage in 1894 he settled in Devon and made drawings and watercolours of scenes of local life – horse-racing, fairgrounds, boxing, rural pursuits and customs – which sold well and started to make him better known. These were really a dress rehearsal for his return to Ireland, which he did permanently in 1910.

From that date on he became a recorder in paint (even though he was not properly trained in that respect) of all aspects of Irish life, including the political upheavals that led to independence. Yeats worked out his own rhythmical virtuosic style of painting, which he perfected during the 1920s. At the end of that decade he decided to adopt a more expressive style, using larger canvases, brighter colours and the palette knife instead of the brush; he refined this style during his remaining years. Although a prolific artist, Yeats sometimes eschewed painting or drawing for novel-writing and playwriting.

In his art Yeats succeeded in capturing the essence of Irish life. This is certainly the case with *In the Tram*, where in the half-light on the right three women engage in conversation. A man sits apart on the left, alone with his thoughts. The thick coagulated paint, warm tones and vivid characterizations show the artist at his best, but just as skilful is the angling of the women's bodies, which implies the swaying motion of the tram as well as the animation of their conversation. Yeats embraced modernity in his work as a means of increasing his powers of expression. *In the Tram* is worthy of the French painters Bonnard or Vuillard.

SIR WILLIAM ORPEN (1878–1931)
Sunlight 1925
Wood, 50 × 61 cm / 19¾ × 24 in. Signed

Orpen was a highly successful but unusual artist. Of Irish birth, he was a prodigy, advancing from the Metropolitan School of Art in Dublin (1890–97) to the Slade School of Fine Art in London (1897–99), where he achieved a phenomenal success early in life alongside people of the calibre of Augustus John. His early pictures, mainly interiors, emulate Dutch 17th-century works and often deploy mirrors in an interesting way. He quickly established himself as a portrait painter with a wide clientele. Many of his more swagger portraits (particularly *Mrs St George*, c. 1912, and *Lady Rocksavage*, 1913) successfully evoke society on the eve of the First World War and in stylistic terms combine aspects of Velásquez, Manet and Whistler.

His attitude to Ireland – both politically and culturally – was ambivalent and is best demonstrated by the strange allegorical compositions that sometimes took his fancy. His war paintings are also highly individual. His series of self-portraits reflects a high level of self-consciousness, stemming from his conviction that he was ugly. The difficulties of his personality are just as evident in his writings, some of which are autobiographical.

Homage to the nude and to Monet

Orpen began by exhibiting with the New English Art Club, but from 1908 he was a regular exhibitor at the Royal Academy, of which he became a member in 1919. There is I think a wonderful delicacy about Orpen's brushstrokes and palette: he is a very neat, controlled, painter, like Degas, with few slapdash or lazy passages, even though he often worked under immense pressure.

Most of all, Orpen was a brilliant painter of the female nude. *Sunlight* is a fairly late example, showing a model pulling on her stockings lit by the dappled sunlight coming through the window. Over the bed hangs the painting by Monet (*The Seine at Marly* of 1874) which Orpen owned.

DUBLIN CITY GALLERY THE HUGH LANE

The idea of establishing a gallery of modern art in Dublin was the brainchild of Sir Hugh Lane (1875–1915; see pp. 376–77). It proved to be a difficult mission and it was only through Lane's own generosity, knowledge and persistence that the project eventually succeeded. Although his parents were Irish, Hugh Lane was brought up in England, and Dublin was very much his adopted city. His purpose was to form a collection of modern European art (with an emphasis on paintings by Irish artists), and he campaigned vigorously to acquire works of art and public support for this project. The Municipal Gallery of Modern Art opened in 1908 at Clonmell House in Harcourt Street. Lane certainly led by example: in addition to making his own collection of British and Irish pictures and important modern French paintings available, as a picture dealer he also had access to other sources. But this was all contingent upon a purpose-built gallery being established, and this drew Lane further and further into local politics. In frustration he lent his modern French paintings in stages to the National Gallery in London, which led to more complications on his death in the sinking of the *Lusitania* in 1915. A disputed will resulted in protracted negotiations between London and Dublin over the ownership of the French pictures, a situation only resolved in 1993 by a special loan agreement between the Municipal Gallery of Modern Art and the National Gallery in London.

Sarah Purser (1848–1943), an artist, took over Lane's role, and for a building in which to display the growing collection compromised on another Georgian house, Charlemont House in Parnell Square, built in 1762–70 for James Caulfield, 1st Earl of Charlemont, by Sir William Chambers with additions by his pupil James Gandon. After remodelling and extension by Horace O'Rourke the house officially opened as the Hugh Lane Municipal Gallery of Modern Art in 1933. It is now known as Dublin City Gallery The Hugh Lane.

The collection begins in the late 19th century with fairly small groups of Barbizon and Impressionist pictures, supplemented by numerous works by Irish and some British artists of the late 19th and early 20th centuries. An effective purchasing policy and donations have enabled incursions into 20th-century European, Irish and American art to be made. A remarkable recent addition has been Francis Bacon's Studio (7 Reece Mews in London), which was given by John Edwards in 1998. Bacon was born in Dublin and the recreation of his studio, transferred by methods perfected by archaeologists, has proved an imaginative way of honouring the great artist.

JEAN-BAPTISTE-CAMILLE COROT (1796–1875)
Rome from the Pincio 1826/27
Canvas, 18 × 29 cm / 7⅛ × 11⅜ in.

Corot forms an important link in French 19th-century landscape painting between the Neoclassical tradition in which he was trained and the emergence of Impressionism. Camille Pissarro never ceased to acknowledge his debt to Corot for encouraging him to consult nature at first hand, but Degas, Morisot, Monet and Cézanne also came under his influence.

Of all the aspects of Corot's impressive œuvre it is the Italian scenes that are most appreciated today. He travelled to Italy in 1825, and although he visited Venice and Naples he was based principally in Rome and its environs, remaining there until the autumn of 1828. It was during these years that he made his most eloquent views of Italy, although he did return for much shorter visits in 1834 and 1843.

No doubt Corot was fully aware of the longstanding tradition of view painters working in Italy, but one of the most striking aspects of the pictures he did there is how he modernized the standard motifs. *Rome from the Pincio* is a perfect example of this. From his position in the gardens of the Villa Medici (the French Academy) St Peter's appeared at an angle, so that while the smaller dome on the left was visible, that on the right disappeared in front of the massive central dome. To maintain the compositional harmony of his picture, Corot makes the spout of the fountain balance the smaller dome on the left.

By doing this he not only strengthens the central axis but also emphasizes the recession from foreground to background. The modern eye is excited by the internal patterns in the scene instinctively picked out by the artist, such as the way the umbrella pines framing the view echo the lantern of the central dome and the alignment of the fountain with the buildings in the distance. Such visual felicities are matched by the tonal sophistication of this small painting, with the dark forms in the foreground giving way to the distant rooflines bathed in sunshine. And then there is the substance of the paint itself, so deftly and yet so precisely laid on to the canvas.

Corot combines delicacy of touch with solidity of form as few other painters could: it was this that intrigued and encouraged the younger generation.

JOSEPH ALBERS (1888–1976)
Homage to the Square – Aglow 1963
Board, 101 × 101 cm / 39¾ × 39¾ in. Signed and dated

One of the most influential artists of his time, Albers was born in Germany and studied art in Berlin, Essen and Munich between 1913 and 1920, when he went to the Bauhaus in Weimar. His teacher in Munich, Franz von Stuck, had taught Klee and Kandinsky, and it was in this tradition that he embarked upon his career. Indeed, it was as a teacher himself at the Bauhaus from 1925, when it moved to Dessau, that Albers began to have an impact. After the Bauhaus was closed down by the Nazis in 1933 he moved to America and taught at the avant-garde Black Mountain College in North Carolina before becoming

'Maximum effect from minimum means'

JOSEF ALBERS

Principal of the Yale School of Design in 1950. Through his teaching in America Albers was able to introduce and develop the Bauhaus style. His influence can be felt in different ways in the work of Donald Judd, Elsworth Kelly and Robert Rauschenberg, although he was not always pleased to acknowledge this fact. As regards his own work, which included designs for furniture and stained glass, his thinking was also determined by the De Stijl movement in the Netherlands and Russian Constructivism.

Homage to the Square was a series begun in 1950 and pursued for the rest of his life. Numbering over a thousand works, both paintings and prints ('platters to serve colour'), in it Albers explores the dynamics of shapes and colours within a grid or diagrammatic format, showing how the various juxtapositions could suggest different thoughts and emotions in the viewer. *Aglow* has four superimposed squares with a broader margin at the top and a smaller one below. As an image it has a great deal of energy and throbbing vitality. The simplicity of the form certainly has a kinship with the priorities of classical art, but the diversity of visual response evoked by the squares engages the emotions in a way that is more closely related to Romanticism.

Where many people find this kind of work dull and uninspiring, for me it has the endless fascination of a philosophical conundrum. These works are never as stilted as they look. A great deal of rhythmical movement is created by the bands of colour, and any amount of feeling is generated by the colour values themselves. Another aspect of Albers's work is the high level of craftsmanship in the actual application of the paint. He goes so far as to supply technical details on the back of each canvas. Altogether *Aglow* has a purity and ethereality that make it transcendental.

Cork

CRAWFORD ART GALLERY

The building was originally the Custom House, created in 1724, but it was taken over in 1832 by the Royal Cork Institution, who encouraged a school of art to flourish on its premises. In 1850 this was incorporated as one of the government's Schools of Design (after 1884 renamed the Crawford School of Art) and it did not move out until 1972. The conversion into a proper art gallery with new spaces for display began in 1884 as a result of the generosity of William Horatio Crawford, who was from a local family of brewers. A bequest in 1919 by Joseph Stafford Gibson enabled a number of purchases to make the holdings more 'National in character'. The strengths of the collection lie in the 19th and 20th centuries, with an emphasis on Irish art and particularly on artists born in the south of Ireland. Both James Barry and Daniel Maclise had close connections with Cork.

JAMES BARRY (1741–1806)

Portraits of James Barry and Edmund Burke in the Characters of Ulysses and his Companion Fleeing from the Cave of Polyphemus 1776

Canvas, 127 × 102 cm / 50 × 40⅛ in.

Barry was born in Cork and received his first training from a local artist before proceeding to the drawing school of the Dublin Society for the Encouragement of Arts. His talent was immediately recognized and he was fortunate in being supported by the statesman and aesthetic theorist Edmund Burke, who pointed him in the direction of London, arranging for him to work for the architect James ('Athenian') Stuart and recommending him to Reynolds. A visit to Italy financed by Burke lasted from 1765 until 1771. A bright

future lay ahead, and to a certain extent it was fulfilled when he became a member of the Royal Academy in 1773 and was elected Professor of Painting in 1782.

History painters, however, often have a querulous nature (Benjamin Robert Haydon was another) combined with an over-inflated opinion of themselves. Idealists by nature, their public stance is very much *contra mundum*. They are often in financial difficulties and live in reduced circumstances; they may use any means to succeed or be noticed; and their achievements are often underestimated. Ellis Waterhouse, who described Barry as having 'more than a spark, perhaps the real fire, of genius in his make-up', went on to write, 'but he had a wild and arrogant enthusiasm, the tongue of an asp, and a voluble un-considerateness for others which led to his undoing'. Although acting in good faith, Barry remained unduly critical of the Royal Academy and was abusive to his colleagues there. For this he was expelled in 1799 – the only artist to hold this distinction.

Barry's history paintings are wide-ranging and often recondite, but they are also remarkably good. He was in many ways a forerunner of William Blake. His finest work is in the Great Rooms of the Royal Society of Arts in London: it is on a colossal scale and its subject is nothing less than 'The Progress of Human Culture'. Completed in 1783, these canvases amount to an unsurpassed example of history painting as advocated by the President of the Royal Academy, Sir Joshua Reynolds.

Ulysses and Polyphemus is based on the *Odyssey* by Homer. On their journey back to Ithaca after the end of the Trojan War, Ulysses (Odysseus) and his companions land on an island where they are held prisoner in his cave by the giant Polyphemus, who begins to eat them. Ulysses devises a way of blinding the giant, and the next morning the Greeks escape by clinging to the undersides of his sheep as he lets them out to pasture, feeling their backs – which he is shown doing in the top left corner. The two figures in the foreground are, however, recognizable: Ulysses, on the right, is Burke, and his companion on the left is Barry himself. This implies a deeper meaning: it would seem that Burke is cautioning the artist against being so outspoken or rushing into print as he so often did. Combined here, therefore, are Classical mythology, contemporary history, and autobiography – a potent mix like no other in the hands of someone like Barry.

SEÁN KEATING (1889–1977)
Men of the South 1921
Canvas, 127 × 203.4 cm / 46⅛ × 80 in.

A history painting

Seán Keating can be described as a modern history painter, who was not afraid to tackle controversial issues in Irish life. He was a pupil at the Metropolitan School of Art in Dublin in 1911 when William Orpen was teaching there and he went on to work as Orpen's assistant in London in 1915. His later career was distinguished – Professor at the National College of Art in Dublin (from 1934) and President of the Royal Hibernian Academy (1948–62).

Keating's association with the Irish nationalist movement began in 1914 with his visit to the Aran Islands, where the landscape and the way of life seemed to him (and to others) to be the essence of traditional Irish values. His painting *Men of the West* (Dublin City Gallery The Hugh Lane) summarizes his general view of cultural nationalism.

Men of the South takes the viewer to the heart of Ireland's War of Independence. It represents a 'flying column' who used guerrilla tactics against British forces. The picture is based on studies and photographs made by Keating in Dublin of individuals active within the resistance movement. He then worked these up into compositions arranged like a relief resembling Assyrian or Classical art. This turns what is essentially a realistic picture into a more ritualistic one, with all the figures united by their intense gazes into the distance as they set about the task of changing the course of history. Keating captures the spirit of the times – indeed its heroism – but he himself grew disillusioned by the violence, and by the end of the 1920s had turned his attention to symbolic treatments of nationalist themes such as the Shannon Hydroelectric Scheme.

Keating was a brave and honest artist in so far as his work reflects the political and cultural tensions of Irish life as he saw them, many of which remain significant today.

PATRICK HENNESSY (1915–80)
Portrait of Elizabeth Bowen at Bowen's Court c. 1955
Canvas, 91 × 71 cm / 35⅞ × 28 in.

Elizabeth Bowen (1899–1973) was a prominent novelist and short-story writer of Anglo-Irish descent whose family home, Bowen's Court at Kildorrery in County Cork, played a major role in her life. The Bowens first came to Ireland during the Protectorate of Oliver Cromwell, but the house dated from the mid-18th century. It featured a great deal in her childhood and she often entertained there after her marriage to Alan Cameron, an educationalist. Although she lived at different stages of her life in Oxford and London, where she moved in the highest literary and intellectual circles, it was the house in Ireland that was her emotional anchor, as is evident from her family memoir, *Bowen's Court* (1964). Financial circumstances after the death of her husband in 1952 led to the sale of the house in 1959 to a farmer. The new owner demolished it, which she described as 'a clean end'.

A legend in her own time

Hennessy paints Elizabeth Bowen at the head of the staircase of Bowen's Court and very much as the chatelaine. The house was apparently difficult to keep up (Virginia Woolf complained about moth-eaten carpets) and in many ways it symbolized the plight of the landowning Anglo-Irish. Hennessy painted a number of portraits early in his career before turning to landscapes. This image has a vivid intensity derived from the sharply defined light, cool colours and precise drawing of the architectural features. Geometry plays an important role in establishing the figure within the composition, but the sense of realism is so potent that the portrait has a Surrealistic air, as in Meredith Frampton (cf. p. 326). This may not be inappropriate, as many of Bowen's novels deal with displacement, disloyalty and emotional disruption. Virginia Woolf described Bowen as 'A very honourable horsefaced, upper class hard constricted mind'. But according to Sir Isaiah Berlin she was 'a wonderful talker, highly intelligent, very sympathetic, charming and interesting and agreeable . . . she was Christian, she was religious, she liked mainly men, she liked joking and she voted Conservative and wanted people to be masculine and no nonsense, hated pacifists and vegetarians and that kind of thing . . . she wanted a sort of clashing of swords.'

GAZETTEER

ENGLAND

London

Apsley House
 (Wellington Museum)
Hyde Park Corner
J1J 7NT
www.english-heritage.org.uk

Buckingham Palace
SW1A 1AA
www.royalcollection.org.uk

Courtauld Gallery
Somerset House
Strand
WC2R 0RN
www.courtauld.ac.uk

Dulwich Picture Gallery
Gallery Road
SE21 7AD
www.dulwichpicturegallery.
org.uk

Foundling Museum
40 Brunswick Square
WC1N 1AZ
www.foundlingmuseum.org.uk

Guildhall Art Gallery
Guildhall Yard
EC2P 2EJ
www.cityoflondon.gov.uk

Imperial War Museum
Lambeth Road
SE1 6HZ
www.iwm.org.uk

Kensington Palace
Palace Road
W8 4PX
www.hrp.org.uk/
kensingtonpalace

Kenwood House
Hampstead Lane
NW3 7JR
www.english-heritage.org.uk

National Army Museum
Royal Hospital Road
SW3 4HT
www.national-army-
museum.ac.uk

National Gallery
Trafalgar Square
WC2N 5DN
www.nationalgallery.org.uk

National Maritime Museum
Romney Road
Greenwich
SE10 9NF
www.nmm.ac.uk

National Portrait Gallery
St Martin's Lane
WC2H 0HE
www.npg.org.uk

Royal Academy of Arts
Burlington House
Piccadilly
W1J 0BD
www.royalacademy.org.uk

Tate Britain
Millbank
SW1P 4RG
www.tate.org.uk

Tate Modern
Bankside
SE1 4RG
www.tate.org.uk

Victoria & Albert Museum
Cromwell Road
SW7 2RL
www.vam.ac.uk

Wallace Collection
Hertford House
Manchester Square
W1N 3BN
www.wallacecollection.org/

✻

Barnard Castle, Co. Durham

Bowes Museum
DL12 8NP
www.thebowesmuseum.org.uk

Bath, Somerset

Holburne Museum
Great Pulteney Street
BA2 4DB
www.holburne.org

Victoria Art Gallery
Bridge Street
BA2 4AT
www.victoriagal.org.uk

Birkenhead, Cheshire

Williamson Art Gallery
 and Museum
Slatey Road
CH43 4UE
www.artguide.org/museums

Birmingham, West Midlands

Barber Institute of Fine Arts
University of Birmingham
Edgbaston
B15 2TS
www.barber.org.uk

Birmingham Museum
 and Art Gallery
Chamberlain Square
B3 3DH
www.bmag.org.uk

Bournemouth, Dorset

Russell-Cotes Art Gallery
 and Museum
East Cliff
BH1 3AA
www.russell-cotes.
bournemouth.gov.uk

Bradford, West Yorkshire

Cartwright Hall Art Gallery
Lister Park
BD9 4NS
www.bradfordmuseums.org

Brighton, East Sussex

Brighton Museum and
 Art Gallery
Royal Pavilion
BN1 1EE
www.brighton-hove-museums.
org.uk

Bristol, Avon

Bristol's City Museum
 & Art Gallery
Queen's Road
BS8 1RL
www.bristol-city.gov.uk/
museums

Bushey, Hertfordshire

Bushey Museum and Art Gallery
Rudolph Road
WD23 3HW
www.busheymuseum.org

Cambridge

Fitzwilliam Museum
Trumpington Street
CB2 1RB
www.fitzmuseum.cam.ac.uk

Kettle's Yard
Castle Street
CB3 0AQ
www.kettlesyard.co.uk

Chichester, West Sussex

Pallant House Gallery
9 North Pallant
PO19 1TJ
www.pallanthousegallery.com

Compton, Surrey

Watts Gallery
Down Lane
GU3 1DG
www.wattsgallery.org.uk

Cookham, Berkshire

Stanley Spencer Gallery
High Street
SL6 9SJ
www.stanleyspencer.org.uk

Dedham, Essex

Sir Alfred Munnings Art Museum
Castle House
Castle Hill
CO7 6AZ
www.siralfredmunnings.co.uk

Derby

Derby Museum and Art Gallery
The Strand
DE1 1BS
www.derby.gov.uk

Eastbourne, East Sussex

Towner
Devonshire Park
College Road
BN21 4JJ
www.townereastbourne.org.uk

Egham, Surrey

Royal Holloway Collection
University of London
Egham Hill
TW20 0EX
www.rhul.ac.uk

Exeter, Devon

Royal Albert Memorial Museum
 and Art Gallery
Queen Street
EX4 3RX
www.rammuseum.org.uk

Falmouth, Cornwall

Falmouth Art Gallery
Municipal Buildings
The Moor
TR11 2RT
www.falmouthartgallery.com

Gateshead, Tyne and Wear

Shipley Art Gallery
1 Prince Consort Road
NE8 4JB
www.twmuseums.org.uk

Hampton Court (East Molesey), Surrey

Hampton Court Palace
KT8 9AU
www.hrp.org.uk/
hamptoncourtpalace

Hull, East Yorkshire

Ferens Art Gallery
Queen Victoria Square
HU1 3RA
www.hullcc.uk/museums

Ipswich, Suffolk

Christchurch Mansion
 and Wolsey Art Gallery
Christchurch Park
IP4 2BE
www.visit-ipswich.com

Kendal, Cumbria

Abbot Hall Art Gallery
LA9 5AL
www.abbothall.org.uk

Leeds, West Yorkshire
Leeds Art Gallery
The Headrow
LS1 3AA
www.leedsartgallery.co.uk

Leicester
New Walk Museum and
 Art Gallery
53 New Walk
LE1 7EA
www.leicester.gov.uk/
museumsandgalleries

Lincoln
The Collection (Usher Gallery)
Danes Terrace
LN2 1LP
www.thecollection.
lincoln.museum

Liverpool, Merseyside
Walker Art Gallery
William Brown Street
L3 8EL
www.liverpoolmuseums.org.uk

Maidstone, Kent
Maidstone Museum
 and Bentlif Art Gallery
St Faith's Street
ME14 1LH
www.museum.maidstone.
gov.uk

Manchester
Manchester Art Gallery
Mosley Street
M2 3JL
www.manchestergalleries.org

**Newcastle upon Tyne,
Tyne and Wear**
Laing Art Gallery
New Bridge Street
NE1 8AG
www.twmuseums.org.uk/
museums

Norwich, Norfolk
Norwich Castle Museum and
 Art Gallery
Castle Mound
NR1 3JU
www.museums.norfolk.gov.uk

Nottingham
Nottingham Castle Museum
 and Art Gallery
Friar Lane
NG1 6EL
www.nottinghamcity.gov.uk

Oldham, Greater Manchester
Gallery Oldham
Greaves Street
OL1 1AL
www.galleryoldham.org.uk

Osborne House, Isle of Wight
East Cowes
PO32 6JX
www.english-heritage.org.uk/
osbornehouse

Oxford
Ashmolean Museum
Beaumont Street
OX1 2PH
www.ashmolean.org

Christ Church Picture Gallery
St Aldates
OX1 1DP
www.chch.ox.ac.uk

Penzance, Cornwall
Penlee House Gallery
 and Museum
Morrab Road
TR18 4HE
www.penleehouse.org.uk

Plymouth, Devon
Plymouth City Museum
 and Art Gallery
Drake Circus
PL4 8AJ
www.plymouthmuseum.gov.uk

Port Sunlight Village, Cheshire
Lady Lever Art Gallery
CH62 5EQ
www.ladyleverartgallery.org.uk

Portsmouth, Hampshire
Portsmouth City Museum
 and Art Gallery
Museum Road
PO1 2LJ
www.portsmouthmuseums.
co.uk

Preston, Lancashire
Harris Museum and Art Gallery
Market Square
PR1 2PP
www.harrismuseum.org.uk

Sheffield, South Yorkshire
Graves Gallery
Surrey Street
S1 1XZ
www.museums-sheffield.org.uk

Southampton, Hampshire
Southampton City Art Gallery
Civic Centre
SO14 7LP
www.southampton.gov.uk/art

Stockton-on-Tees
Preston Hall Museum
Yarm Road
TS18 3RH
www.stockton.gov.uk

Sudbury, Suffolk
Gainsborough's House
46 Gainsborough Street
CO10 2EU
www.gainsborough.org

Swindon, Wiltshire
Swindon Art Gallery
Bath Road
Old Town
SN1 4BA
www.swindon.gov.uk

Truro, Cornwall
Royal Cornwall Museum
25 River Street
TR1 2SJ
www.royalcornwallmuseum.
org.uk

Windsor, Berkshire
Windsor Castle
SL4 1NJ
www.royalcollection.org.uk

Wolverhampton, West Midlands
Wolverhampton Museum
 and Art Gallery
Lichfield Street
WV1 1DU
www.wolverhamptonart.org.uk

York
York Art Gallery
Exhibition Sqaure
YO1 7EW
www.yorkartgallery.org.uk

NORTHERN IRELAND

Belfast, Antrim
Ulster Museum
Botanic Gardens
BT9 5AB
www.ulstermuseum.org.uk

REPUBLIC OF IRELAND

Cork
Crawford Art Gallery
Emmet Place
www.crawfordartgallery.ie

Dublin
National Gallery of Ireland
Merrion Square West
www.nationalgallery.ie

Dublin City Gallery
 The Hugh Lane
1 Parnell Square West
www.hughlane.ie

SCOTLAND

Aberdeen
Aberdeen Art Gallery
Schoolhill
AB10 1FQ
www.aagm.co.uk

Dundee, Tayside
The McManus
Albert Square
DD1 1DA
www.themcmanus-dundee.
gov.uk

Edinburgh, Lothian
National Gallery of Scotland
The Mound
EH2 2EL
www.nationalgalleries.org

Scottish National Gallery of
 Modern Art
75 Belford Road
EH4 3DR
www.nationalgalleries.org

Scottish National Portrait Gallery
1 Queen Street
EH2 1JD
www.nationalgalleries.org

Glasgow, Strathclyde
Burrell Collection
Pollok Country Park
2060 Pollokshaws Road
G43 1AT
www.glasgowmuseums.com

Hunterian Art Gallery
University of Glasgow
G12 8QG
www.hunterian.gla.ac.uk

Kelvingrove Art Gallery
 and Museum
Argyle Street
G3 8AG
www.glasgowmuseums.com

Stromness, Orkney
Pier Arts Centre
Victoria Street
KW16 3AA
www.piersartscentre.com

WALES

Cardiff
National Museum of Wales
Cathays Park
CF10 3NP
www.nmgw.ac.uk

FURTHER READING

Palaces of Art. Art Galleries in Britain 1799–1990. Catalogue of an exhibition organized by Dulwich Picture Gallery (27 November 1991–1 March 1992) and the National Gallery of Scotland, Edinburgh (12 March–3 May 1992)

Art Treasures of England. The Regional Collections. Catalogue of an exhibition organized by the Royal Academy of Arts, London (22 January–13 April 1998)

Francis Haskell, *The Ephemeral Museum. Old Master Paintings and the Rise of the Art Exhibition* (New Haven and London: Yale University Press, 2000)

Edward Morris, *Public Art Collections in North-West England. A History and Guide* (Liverpool University Press, 2001)

The Public Catalogue Foundation, 25 vols. (2004–)

For fuller accounts of the museums and galleries featured, and of others that I have reluctantly had to omit, reference should be made to two invaluable guides: *The Fine and Decorative Art Collections of Britain and Ireland* by Jeannie Chapel and Charlotte Gere (1985) for the National Art-Collections Fund, now The Art Fund, and *Britain's Best Museums and Galleries* by Mark Fisher (2004).

ACKNOWLEDGMENTS FOR ILLUSTRATIONS

INDEX

Bold type indicates museums and galleries featured in the text, and pages on which illustrations appear